BRUSHES WITH HISTORY

BRUSHES WITH HISTORY

WRITING ON ART FROM

1865-2001

—

EDITED BY PETER G. MEYER

INTRODUCTION BY ARTHUR C. DANTO

THUNDER'S MOUTH PRESS / NATION BOOKS
NEW YORK

Published by
Thunder's Mouth Press/Nation Books
161 William St., 16th Floor
New York, NY 10038

BRUSHES WITH HISTORY: *Writing on Art from* The Nation *1865–2001*

Library of Congress Cataloging-in-Publication Data
Brushes with history: Writing on Art from The Nation: 1865–2001 / ed-
ited by Peter G. Meyer.
 p. cm.
 ISBN 1-56025-329-0
 1. Art. I. Meyer, Peter G. II. Nation (New York, N.Y. : 1865)
N7443.2 B78 2001
701'18 0973–dc21

 2001034710

 9 8 7 6 5 4 3 2 1

Designed by Pauline Neuwirth, Neuwirth & Associates

Printed in the United States of America
Distributed by Publishers Group West

For my mother, Gloria Gettinger-Meyer, for, among so many other things, sending me to a preschool program at our local museum; and for my late father, Elliott Meyer, for a thousand history lessons.

‖‖ CONTENTS ‖‖

PART 2
Modernism and Other Oddities

||| 6 |||

SOMETHING NEW UNDER THE SUN

||| 7 |||

THE AGE OF MACHINES: BEWITCHED, BOTHERED AND BEWILDERED

‖ 9 ‖

ALL SHOOK UP

||| 10 |||

SEEING RED
TRIALS AND TRIBULATIONS (PART III)

PART 3
From Soup Cans to Nuts

‖ 11 ‖

HAPPENINGS

EDITOR'S NOTE

THIS BOOK IS haunted by P. T. Barnum. One of the earliest pieces *The Nation* published on art was about Barnum's American Museum. It should be possible, the magazine reasoned, to show people the wonders of art without resorting to hucksterism; *The Nation* took that idea as something of a mandate. In charting nearly a century and a half of the rise of art movements and markets, the pieces in this book present not just a glimpse of the history of art and American art criticism but, in a way, a kaleidoscope of America itself. Reading about the new art of each epoch, however, you can almost hear art dealers encouraging customers, with the imploring tone of circus barkers, to see the new mysteries that lie just behind the curtain or inside the tent. And this book does have its share of mysteries and wonders: the true identity of the critic "N.N.," John Singer Sargent's debut at the National Academy, the controversy over the almost forgotten murals of Anton Refregier, Jackson Pollock's first show, the enthusiasm for the portraits of George Watts, and de Kooning's "three-seater."

An early advertisement for *The Nation* promised potential readers "competent criticism of art exhibitions and works of art, the drama, etc." This modest promise has been well-kept. My hope is that you will find competence in this volume as well; if so, it is because of the efforts of the many people who assisted in its preparation. First,

I must thank the Three Graces of this book: Pamela Barr, Virginia Cannon, and JoAnn Wypijewski. All of them valiantly assisted with the text, as did Carl Bromley, who is the Fourth Grace, for without his daily encouragement, thoughtful suggestions, and constant reminders about deadlines, this book simply would not have happened.

A very special thanks goes to Arthur Danto for his wise and generous counsel, for his often astounding knowledge (including where to get the best hamburger in New York), and for so many wonderful discussions about art over the years. I am also grateful to *The Nation*'s Victor Navasky, who led me into thinking that the nexus between politics and culture could someday earn me a decent living; Richard Kim, for his perennial support; William Lin, for his tireless, good-humored efforts on behalf of this book; Dan Weaver, editor of Nation Books; and Ghadah Alrawi, from Thunder's Mouth Press, for her patient guidance.

I must acknowledge three key political and personal influences who sadly are no longer with us but whose spirits still guide me and so many others: Haywood Burns, Andy Kopkind, and Daniel Singer. I also should cite the influence of my late aunt Kitty Meyer, who instilled in me her love of contemporary art. There are others whose influence, advice, support (moral and otherwise), and friendship were most important: Adam Bellow; Rocky Collins; Vania Del Borgo; Vivette and Denman Dhanukdhari; Kristin Eliasberg; Edward Jay Epstein; Libby and Donald Fagen; Hamilton Fish; Lee Gelernt; Martin Gettinger; Heather Green; Taya Grobow; Rick and John Wolf Hertzberg; Katrina vanden Heuvel; Amber Hewins; John Holtz; Belinda Lanks; Alvin, Buf, Geoffrey, and Risa Meyer; Joe, Janice, Alex, and Dan Meyer; Anne Navasky; Elizabeth Pochoda; Katha Pollitt; John Scagliotti; Bruce Shapiro; Ken Silverstein; Ben Sonnenberg; Susanna Sonnenberg; Julia, Jonathan, and Sarah Steinberg; Alison and Carly Stock; Landey Strongin; Shirley Sulat; Eric and Susan Wald; Art Winslow; and the staff of the New York Public Library at Forty-second Street and Fifth Avenue.

And, finally, thanks to the green light at the end of the dock.

PETER GETTINGER MEYER

New York City
April 2001

INTRODUCTION

Arthur C. Danto

N OT LONG AFTER I began to write art criticism for *The Nation,* the catalog from an exhibition of American Pre-Raphaelite painters was sent to me by an enterprising publicist from the Brooklyn Museum. I was entirely unaware that there had been such a movement in American art, and, judging from the somewhat insipid landscapes and still-life paintings with which the catalog was illustrated, I could hardly feel that I had missed very much. Leafing through the text, however, I saw that Russell Sturgis, the art critic for *The Nation* when it was founded in 1865, had strongly championed the "Pre-Rafs," as they affectingly called themselves. Sturgis was mentioned, along with Clarence Cook—"the first great American art critic"—as having begun the discipline of professional art criticism in America. Both Sturgis and Cook had written for *The New Path,* the publication through which the Pre-Rafs expressed their philosophy of art, and they, like *The New Path* painters themselves, were deeply influenced by the thought and writing of John Ruskin. As I was to discover, Ruskin cast a long shadow over the art criticism of *The Nation* during the first decades of the weekly's existence. But the fact that these tiny and seemingly innocuous paintings owed their program to the most advanced thinking about art in the mid-

nineteenth century gave me a reason to visit the Brooklyn Museum and indeed to devote one of my early columns to work that hardly would have recommended itself to contemporary attention without such impressive credentials. But it also awoke in me an interest in the history of art criticism in America, and the role *The Nation* had played in its formation.

The art world, as we know it today, emerged in Victorian times, and much of it was the product of the Pre-Raphaelite Brotherhood, which more or less invented the idea of the hot artist, the art movement, the breakthrough, the press release, the manifesto, the buzz of sensational openings, and the idea that art must be set upon a new path. It was they who realized how important the support of a major critic could be in getting their work talked about and acquired. Nothing if not brash, the young artists approached John Ruskin, a figure of daunting reputation, and pressed him for some public endorsement of their work. Against all probability, Ruskin published two famous letters in the *Times* (London), signing them "Author of *Modern Painters*," the book on which Ruskin's authority as a critic solidly rested. Ruskin's biographer, Tim Hilton, writes that "This is the first time that one meets the modern notion of a young artist, or group of young artists, at a turning point: a point that could be a 'breakthrough' in a career." It was not, of course, the first time that an art critic championed an artist. Diderot wrote admiringly of Chardin and extravagantly about Greuze; Baudelaire put his reputation on the line with Delacroix, Daumier, and "The Painter of Modern Life," Constantin Guys. But it was perhaps the first time a critic identified a group of artists with a new direction in art. When Clement Greenberg, *The Nation*'s art critic from 1942 to 1949, made himself famous by making Jackson Pollock famous, he was following Ruskin's example as a critic not content merely to review art shows but to help redirect the course of art history.

Ruskin had ideologized the idea of visual truth in discussing the work of Joseph Turner in *Modern Painters*, and he saw the Pre-Raphaelites as pursuing this same goal:

> These young artists . . . intend to return to the early days in this one point only—that in so far as in them lies, they will draw either what they see, or what they suppose might have been the actual facts of the scene they desire to represent, irrespective of any conventional rules of picture making; and they have chosen their unfortunate though not inaccurate name because all artists did this before Raphael's time, and after Raphael's time did *not* this, but sought to paint fair pictures rather than represent stern facts, of which the conse-

quence has been that from Raphael's time to this day historical art has been in acknowledged decadence.

It was exactly in Ruskin's spirit that Cook wrote in the first issue of *The New Path* that "The future of Art in America is not without hope." In reviewing the National Academy's 1863 annual exhibition, Cook dismissed the established Academicians as irrelevant to that future, and turned to "greet the young Americans who are to inaugurate the new day." The "new day" of painting was to be marked by the exact and detailed transcription of visual truth. The hot artists of *The Nation*'s first years aspired to emulate the effect of the camera in setting down all and only what met the eye—"You would think it had been done by a camera" was the highest praise in their inventory of critical phrases. In practice, this meant that they limited themselves to the tiniest of motifs—a twig with two blossoms, a clump of weeds, a nest with four eggs, one dead thrush, a single anemone. It would be characteristic of *The Nation* to support revolution and oppose the established order—but without the benefit of art historical scholarship, it would be impossible for a late-twentieth-century audience to see in these almost heartbreakingly limited and positivistic paintings the dawn of a new era.

The exhibition hardly made me an enthusiast for the perhaps deservedly forgotten work of Thomas Charles Farrer or John Henry Hill—though as a feminist I was grateful to learn about Francesca Alexander, who was "praised and exalted by John Ruskin as the perfect manifestation of the principles he advocated in *Elements of Drawing*" (Ruskin indeed gave the artist her name—she had been Esther when they met—and wrote prefaces to her books.) But it did give me an appreciation for *The Nation*'s early critics for the high seriousness with which they addressed the art of their time. I was struck by the fact that from the beginning, the magazine regularly published art criticism. The pieces were mainly unsigned, but Frederick Law Olmsted, who with Calvert Vaux had designed Central Park, appeared on the masthead, and I was pretty sure that an essay on public art from 1865 must have been by him. I read in Leon Edel's biography of Henry James that James wrote on art for the magazine, and that one of his pieces so impressed Ruskin that he proposed James as his successor as Slade Professor of Art at Oxford. As London correspondent, James filed a deliciously wicked report on the 1878 trial in which James Abbott McNeill Whistler sued Ruskin for libel because of a singularly hostile review. (Ruskin called Whistler a "coxcomb" who asked "200 guineas for flinging a pot of paint in the public's face.") James wrote:

> I quite understand [Whistler's] resentment. Mr. Ruskin's language quite transgresses the decencies of criticism, and he has been laying about him for some years past with such promiscuous violence that it gratifies one's sense of justice to see him brought up as a disorderly character—he has possessed himself by prescription of the function of a general scold.

This reveals the obverse side of advocacy—the critic as scourge of art that goes counter to his or her prescription for art's future. In periods of artistic stability, critics would praise or disparage art on the basis of perceived competence. But with the dawn of modernism, when the line between incompetence and innovation grew faint, criticism became ideologized, as happened with the Pre-Raphaelites. James, whose tastes were on the conservative side—he only grudgingly and late came round to Impressionism—felt that Whistler's work was "so very eccentric and imperfect" that Ruskin's judgment was not so much wrong as too vehemently expressed.

The following year James reported on a polemical pamphlet published by Whistler (who really *was* something of a coxcomb), in which the artist urged "the absolute suppression and extinction of the art critic and his function." It may be doubted that Whistler would have felt that way had Ruskin raved about his work the way he had about Turner and the Pre-Raphaelites—or late in his life about Kate Greenaway! But James discerned a larger issue. "Art is one of the necessities of life; but even the critics themselves would probably not assert that criticism is anything more than an agreeable luxury—something like printed talk." If anyone believed that art was one of the necessities of life, it would have been Ruskin. I once wrote that Ruskin saw art as defining the central questions of his era, and indeed of every era—as something that belongs on the front pages of life and not merely a distraction to be followed or not in the section devoted to culture and leisure. He was a prophet rather than a reviewer, a thundering champion of aesthetic virtue, an epic poet of architecture, nature, and beauty. It was, I believe, because of the high seriousness of Ruskin's attitude toward art that *The Nation* felt obliged to publish art criticism in its first issues. The editors must have felt that if art indeed is one of the necessities of life—opposing the rather more commonplace view that art is a luxury—then its necessity is something that has to be explained, and that criticism is a necessity if art is. And since the future of American art was seen by Sturgis to depend upon the painters of *The New Path*, it was that much more important to explain to the readership what they were trying to do as artists.

If James held the view that art criticism is "something like printed talk"—the dilettantish conversation between gentleman *amateurs* over port and cigars in the library after dinner—then indeed the Ruskinian view of the importance of art in the formation of a good society had greatly weakened. And perhaps it had begun to weaken by the time the Whistler fiasco took place. Ruskin lost the case, but poor Whistler, who had hoped to get rich, was hardly compensated. "Mr. Ruskin," James wryly noted, "is not gratified at finding that the fullest weight of his disapproval is thought to be represented by the sum of one farthing." But if Ruskinism as such was not to have in the minds of *The Nation*'s later critics the profundity it was clearly accorded in the magazine's early phase, the sense remained that art had some deep social meaning, and that art criticism must accordingly be more than agreeable chatter. How else are we to explain the intensity with which critical judgments are pressed as art itself underwent the great transformative adventure into modernism?

Had it not been for my fortuitous encounter with the Pre-Rafs, my main idea of *The Nation* as a critical venue was due to the writings of Greenberg, which so powerfully inflected the way my contemporaries though about art, however much or little they agreed with him. But a certain curiosity was now implanted in me as to whom were the other critics in the magazine's long and singular history: I was convinced that one might get a pretty interesting picture of the history of art in America were one to follow their responses down the years. I would now and again mention to my friends in art history that at least one interesting dissertation could be written on the subject. When Nation Books was launched, it all at once occurred to me that here was an opportunity to mine the archives for an anthology made up of past columns. The proposal was received with uncommon enthusiasm, and I was thrilled when Peter Meyer agreed to take on the task of going through the old bound volumes, and pulling out what seemed to merit a second life. What I had not appreciated was that we would be getting, in addition to a body of critical writings, a marvelous record of how the concept of art itself worked toward a definition of itself through a sequence of "brushes with history" in which the critics wrestled with work for which they were not always entirely prepared. It is this constant sense of having to deal with the new and often dangerous that makes criticism here something considerably in excess of "printed talk."

The Pre-Raphaelite revolution, if that is not too energetic an expression to apply to such wan images, was a pale foretaste of what it was in Whistler's work that Ruskin failed adequately to appreciate. On April 14, 1892, *The Nation*'s then critic "N.N." declares, in "Mr.

Whistler's Triumph," that far from flinging a paint box in the public's face, Whistler "was a quarter of a century or more in advance of his contemporaries." He was "An Impressionist almost before the name impressionism in art had been heard." N.N. was the *nom de plume* of Elizabeth Robins Pennell, quite the liveliest writer on art the magazine had published up to then, and one of the liveliest and most insightful it has ever published. Pennell was one of our discoveries—the subject of a dissertation in her own right. Like her husband, the American etcher, Joseph Pennell, Elizabeth Pennell was an advocate for Whistler's art, and coauthored with him a major biography of the artist. "It should not be forgotten that Mr. Whistler is an American of Americans; it may therefore be appropriately asked, What has America done for him?" America, she writes with undisguised indignation, "has treated him with—if possible— even more ignorance and coldness than England." She obviously has Ruskin in mind, and one of the great treats of this collection is to be able to pick up the thread of a conversation between artists and critics across the decades, as artists who at one moment can barely be tolerated, become visibly great as the dialogue of art history unfolds. She can, like Ruskin, be a scourge, as in her memorial essay on William Morris: "He was quite the most illogical and fanatical of speakers . . . But in the history of the nineteenth century, yet to be written, he will figure as a very Savonarola among artists."

Pennell was, on the other hand, at somewhat of a loss at the threshold of the twentieth century in dealing with a work today regarded as a masterpiece of her moment—Rodin's tremendous sculpture of Balzac:

> I could defy any one who saw the back of this curious monument first, not knowing that it was the Balzac, that it was the figure of a man, to understand what this statue was meant to represent. I had come prepared to admire. If I did not admire, however, I was far from scoffing. And the longer I looked, the more I was fascinated by the strange work; the more I felt the dignity, the emotion, the grandeur really in the artist's intention. [But] to me it seems but another proof of the modern artist's disdain of technical accomplishment.

What baffled her—who in the critical establishment of the time could have done better?—was her recognition that it was not incompetence but innovation, and that "the inchoate expression [Rodin] has given to his conception of Balzac is deliberate." Just under sixty years later, John Berger, writing in the magazine about the "Balzac," offers a speculation that Elizabeth Pennell could not have allowed

herself to entertain, that the work was "such a direct confirmation of Rodin's own sexual power that for once he was able to let it dominate him."

Another great "brush with history" is between Frank Jewett Mather and the Armory Show of 1913, to which he devotes two columns. The Frank Jewett Mather Prize is awarded annually by the College Art Association for "distinction in art or architectural criticism during the year," but few of the highly distinguished critics who have received it have had to come to terms with what Mather encountered at the Armory. It was America's first sustained experience of what Mather describes—using the vocabulary James had employed in describing Whistler—as "this latest eccentric work" from Europe—the Fauves and the Cubists, including Duchamp's notorious *Nude Descending a Staircase*. It is impossible not to sympathize with him when he says, somewhat plaintively, "I wish it were possible to ignore urgent tendencies and merely discuss good art." Mather's problem is that, like Pennell, he is uncertain how the new art is to be addressed in terms of good, better and best: "Unquestionably, Matisse is more exciting than George de Forest Brush; it doesn't at all follow that Matisse is the better artist." He feels—he would say he *knows*—that "Post-Impressionism is mostly ignorant splurge, and Cubism merely an occult and curious pedantry." So it is inspiring to follow Mather as he attempts to deal with Matisse—"an original and powerful draughtsman. . . . For the rest, raw color, mean surfaces—a prodigal expenditure of violent means to achieve a passing and negligible effect." So far as the radical new work is concerned, he writes that

> On the whole, the case calls for cheerfulness. Either these new movements are aberrations and will promptly vanish, or else there is to be henceforth no art as the world has formerly understood the word and the thing. But this, I am assured by a friend of the new art is highly desirable. In the future every man is to see nature and his own soul with the artist's eye, and the artist and the work of art will naturally become superfluous. Humanity has merely to breed a race of little Post-Impressionists and Cubists, and the thing is done. Let common sense hesitate to thwart or defer so evidently desirable a consummation.

I cannot say how much I admire Mather for taking on, like the hero of an epic, a powerful and unknown antagonist. "My business is not with artists, who, I assume, know their own affairs; but with the public, which in this matter emphatically *doesn't.*"

At its best, this has been the role of *The Nation* from the magazine's inception. It is a surprisingly Ruskinian role in the end, and in truth it is the public's interest that the artist as well as the critic is engaged upon, beginning with the American Pre-Rafs, whom James would have described, had he known about them, with the epithet one of his characters in *The Ambassadors* bestows upon himself as "a little artist man." The "brushes with history" accelerate as modernism does, after the Armory show. There is the great controversy over Rivera's mural at Rockefeller Center, the first shows of Gorky and de Kooning, the challenge of the Metropolitan Museum's exhibition "Harlem on my Mind," and the issues of public art, the challenges to public morality, and, as the advertisements say, much, much more. I am honored to have been chosen to carry this collective mission forward as art critic for *The Nation*, and it is a privilege to be able to present, with the indispensable help, historical imagination, and enthusiasm of Peter Meyer, the courage and insight of my predecessors, beginning with the father of us all, Russell Sturgis, through the often anonymous writers, to Henry James, Elizabeth Pennell, Kenyon Cox, Paul Rosenfeld, Frank Jewett Mather, Thomas Craven, Clement Greenberg, Fairfield Porter, Manny Farber, Max Kozloff, Hilton Kramer, Lawrence Alloway—and a whole roster of distinguished visitors like Anatole France, Alfred Stieglitz, Bernard Berenson, Marsden Hartley, Meyer Schapiro, and John Berger.

New York City
April 2001

PART 1

FROM BARNUM TO BERENSON: DISCOVERING AMERICA

1

THE GREATEST SHOW ON EARTH

O N JULY 13, 1865, P.T. Barnum's American Museum burned to the ground. The museum featured all sorts of "curiosities" and "natural wonders," animals both alive and in glass jars filled with formaldehyde. While the Museum, which was on lower Broadway, had some pictures on exhibit, the main art museum in New York (The Metropolitan Museum was founded in 1870.) was the New-York Historical Society, which never drew the sort of crowds that the great showman's museum did. The American Museum was the home of the midget Tom Thumb, a live great white whale, the "FeeJee Mermaid" (actually the upper half of a monkey sewn onto the tail of a fish), and other oddities. The spectacular fire caused quite a sensation, unleashing bears, monkeys, kangaroos, a Bengal tiger, and lots of snakes into downtown New York and drawing a crowd estimated as high as forty thousand people, probably more than had ever attended any single art exhibition in New York. At the time it was said that an orangutan found its way into the offices of the editor of the *New York Herald*, a rendezvous that a wag at the rival *New York Tribune* suggested was possibly a job interview. A short stroll away from the Museum and the *Herald*, on Vesey Street, were the offices of *The Nation*, a brand-new weekly magazine that counted among its early contributors Frederick Law Olmsted, Henry Wadsworth Longfellow, William James, Charles Eliot Norton, and William

Lloyd Garrison. While the more grisly details of the fire were left to the local tabloids, *The Nation* took the occasion to comment in this unsigned piece on the relatively feeble state of American culture and to lobby for a grander art museum that would rival those of Europe.

—

from A WORD ABOUT MUSEUMS

JULY 27, 1865

BARNUM'S MUSEUM IS gone at last. It has fallen before that conflagration with which it has often been threatened, and which it has more than once barely escaped. The children will miss an accustomed place of amusement for their Saturday vacations. The occasional visitors to the city from the "rural districts" will no longer yield to its irresistible attractions. The worst and most corrupt classes of our people must seek some new place of resort, and other opportunities of meeting one another. A most dangerous man-trap is removed, and without loss of human life. These four considerations make the sober citizen of New York hesitate whether to regret this burning and destruction or not.

But there is another consideration. Were the lovers of curiosities—whether of natural history or of human ingenuity or of historical association—the more pleased by the existence of the collections which are now destroyed, or more insulted by their insufficiency, disorder, neglected condition, and obviously secondary importance! It is one thing to love shells and minerals, and to enjoy collections of them, but quite another to enjoy *every* collection of them. The more truly one loves a good collection well arranged, the more he will be offended by a chaotic, dusty, dishonored collection. The more one loves the order and system of scientific enquiry, the more he will feel personally injured by disorder and lack of system among the materials of scientific enquiry. The more one aspires to neatness, exactness, and care in his own private "cabinet," the more he will revolt at slovenliness in a larger and more public museum. And it is probably that no class of the community was less satisfied with the museum of Mr. Barnum than that class for which it would seem to have been originally intended.

This class is not an unimportant or even a small one. The host

of readers whose favorite reading is natural science, the armies of listeners to lectures on geology, that large proportion of our boys and young men who collect and study "specimens" of minerals, all belong to it. The profoundly scientific are not those who care for public museums, unless containing this or that unique treasure. The frequenters of museums are those who cannot themselves give much time or means to the collection, classification, and study of specimens, but who read in the evenings, and would gladly see by day a larger number and a greater variety of helps to understand than their own limited time has sufficed to discover—than their own limited means have sufficed to procure. There are thousands of these earnest amateur students, whose amateur studies are not to be despised even by the profounder scholar. These would visit the lost museum rarely, early in the morning when no disreputable crowd was thronging it, looking along the crammed and disordered shelves in the hope of lighting on something which they wished to see, finding it or not as the blind deities of chance might order. Without scientific arrangement, without a catalogue, without attendants, without even labels, in very many instances, the heterogeneous heap of "curiosities," valuable and worthless well mixed together, could not attract our students very often or detain them long.

This class of visitors was never wholly ignored in the advertisements which announced to the world the charms of Barnum's Museum. The "million of curiosities" were mentioned, and their scientific value hinted at. These curiosities were never, so far as we are aware, turned out of the building to make room for fat women, giants, dwarfs, glass-blowers, mermaids, learned seals, and dog-shows. The *aquaria* had a certain attraction for the intelligent, and, in almost any other place, would have been worth frequent visits. Dog-shows in themselves are harmless and not without interest. We desire to give the late "American Museum" all the credit it deserves. For it needs it all. Its memory is not pleasant. It pandered to the most foolish curiosity and to the most morbid appetite for the marvellous. The most gross deceptions were shamelessly resorted to to cause a week's wonder and to swell the week's receipts. The "Lecture Room"—once a sort of "lyceum" hall, latterly a minor theatre in look and character—furnished for the entertainment of its patrons the most vulgar sensation dramas of the day. Its patrons were suitably entertained. It has been many years since a citizen could take his wife or daughter to see a play on that stage.

That respectable people never went to this so-called museum we do not assert. There were hours in the day when the halls were nearly empty; and, where certain shells, stuffed birds, and Indian

relics arc, there is always something to see. But we hold that the class of students of whom we have spoken deserve better mental fare than this dreary refectory could afford.

It is in behalf of this class that we ask for a real museum. It is in behalf of all classes of the community, except that vicious and degraded one by which the late "American Museum" was largely monopolized, that we ask the community for a building and for collections that shall be worthy of the name so sadly misapplied. Μουσειον, *museum*, *musée*, the word seems full of honorable meaning in every language but our own, and with reason. Home of the Muses, it means, and is akin to "music" and "musing," and to "amusement," too, which is a good word with a good meaning. Collections of animals belong to it, indeed, both living and prepared, collections of minerals and shells, of historical and personal relics, and not only these, but collections representative of all the arts, both industrial and decorative, fine art and artisanship. All those valuable things which men do not consume but keep (money, of course, as it has no value except to represent value, is not in itself a valuable thing, and is not included in our statement) have a home in a museum. And "American," "The American Museum!" when that name is again written across the front of a building, let it be a building worthy in itself and in its contents of the honorable and responsible rank which, by taking that name, it assumes.

The British Museum is a national institution, founded and supported by the revenues and the government of an empire. The American Museum of the future will be such another, and even more worthily lodged. It would be good taste if all local institutions, whether belonging to individuals, to companies, to cities, or to States, would adopt names less inappropriate to their natures. But as long as we have American institutes of various kinds, and American companies of many sorts, all incorporated under State laws and limited in their spheres of action by State boundaries, such observance of fitness as we might desire we certainly cannot hope for. Let New York City, then, create for itself an "American Museum." And let the thing itself be not unworthy of the name it rashly assumes.

By the perseverance and the intelligence of some, aided by a series of happy accidents, New York obtained a park, which was put into the hands of good managers and ingenious and conscientious artists, and was carried on by them to such a point of *quasi* completion that it can hardly be spoiled now, and is likely to remain for ever, to cause posterity to doubt the truth of the future historian's account of misgovernment and corruption in New York in the nineteenth century. Let us try to make our descendants still more in-

credulous on this point. Let us have a place of public instruction as well as of public enjoyment. Perhaps in the neighborhood of the Central Park itself would be the best place for it; let us establish it there, and try to draw encouragement and a stimulus to exertion from our beautiful neighbor.

• • •

But of one thing let us be certain. No individual or stock company which may undertake to form and manage a museum as a way of making money will be of any great or permanent service to the community. Let those who are disposed to aid any of these movements remember this, that the efforts of an ingenious showman to attract popular attention and make money rapidly are not likely to accrue to popular enlightenment. It would not seem well to such a showman to spend money, time, and thought to make valuable antiquarian and scientific collections, classify and catalogue them accurately, and build a fitting and permanent building to contain them. Perhaps the British Museum, charging twenty-five cents admission fee, would take in less money in a year than did Mr. Barnum's old museum at the same price. Let the would-be stockholder invest his money in a proper enterprise, properly guarded, and take dividends for his reward. Of his abundance let him give to the foundation of a real museum for his own enlightenment, the good of his children, and the honor and benefit of the community.

—

Mr. Barnum on Museums

August 10, 1865

P.T. Barnum

Bridgeport, Conn., July 29, 1865

To the Editor of *The Nation*:

"The Nation" is just the journal *our* "nation" needed, and it delights thousands besides my humble self. But the article on "Museums" in the last number exhibits a little of the slashing style of the London *Saturday Review*, or else I am blinded by my prejudices or interests.

I am not thin-skinned, and I know my Museum was not so refined or classic or scientifically arranged as the foreign governmental institutions, for mine had to support my family, while those require

annually from the government thousands of pounds. "That class for which it [my Museum] would seem to have been originally intended" would *not support* a proper museum pecuniarily. More's the pity—but such is the stern fact. Hence, to make it self-supporting, I was obliged to popularize it, and while I still held on to the "million of curiosities," millions of persons were *only* induced to see them because, at the same time, they could see whales, giants, dwarfs, Albinoes, dog shows, *et cetera.* But it is a great error to state that I ever permitted "vulgar sensation dramas." No vulgar word or gesture, and not a profane expression, was *ever* allowed on my stage! Even in Shakespeare's plays, I unflinchingly and invariably cut out vulgarity and profanity. It is equally incorrect that "respectable citizens did not take their wives and daughters" "to see a play on that stage." Your writer doubtless supposed he was stating facts, but let him enquire, and he will find that *nothing* could be further from the truth. I am sensitive on these points, because I was always extremely *squeamish* in my determination to allow nothing objectionable on my stage.

I permitted no intoxicating liquors in the Museum. I would not even allow my visitors to "go out to drink" and return again without paying the second time, and this reconciled them to the "ice-water" which was always profuse and free on each floor of the Museum. I could not personally or by proxy examine into the character of every visitor, but I continually had half a score of detectives dressed in plain clothes, who incontinently turned into the street every person of either sex whose actions indicated loose habits. My interest even depended upon my keeping a good reputation for my Museum, and I did it to a greater degree than one out of ten could attain who had charge of a free museum, or even a free picture gallery. Now, I beg of you to submit the above to the writer of the article in question, and ask him, as an act of justice, to set me right before the public. Humbug with me has had its day, and although I always gave the money's worth of that which was *not* demoralizing, I often grieved that the taste of the million was not elevated. But now, having made *my* "million" nearly twice told, I really aspire to do a good and great thing, and I ask hereby the aid of you and your writer in accomplishing it. *Listen:*

If I build another museum—1st, It will be fire-proof; 2d, It will be almost infinitely superior in its collections and its classifications and accommodations to the old one; 3d, When I build a new American Museum, I shall also erect a large wing, or an additional adjacent building, the contents of which shall form and be a *Free National*

Museum. There I will place classified specimens of natural history, paintings, statuary, armor (especially that worn by historical personages), old weapons of war, musical instruments, costumes and furniture of the middle ages, and a thousand other useful and novel features which will be an honor to our country. Here, too, will be placed *all* free contributions of novelties from *everybody*, including missionaries, ship-owners, foreign persons of distinction, and foreign museums. The Smithsonian Institution can loan its duplicates, the Patent Office, War and Navy Departments can lend their trophies, models, etc., gentlemen can loan their statuary and other objects, and myself, my heirs or assigns, shall always exhibit the whole *free* (I paying expenses by means of rent of stores and out of my own pocket), and whenever we fail to do so, every article not loaned by individuals to the Free Museum is vested in the *general Government*, and may be removed to a suitable building in Central Park or elsewhere. Indeed, if my *paying* Museum prospers as I expect, myself or heirs will eventually erect and present to the public the land and a proper building containing these curiosities, which in ten or twenty years will have accumulated to an amazing extent if properly pushed and encouraged. I have tried to hire Bayard Taylor to scour Europe with me to make purchases and obtain contributions of duplicates from institutions abroad. He *will* go next summer; but this summer I want an educated, intelligent gentleman, like the writer of that article on Museums, and will *pay* him liberally to aid me, for, after all, his taste, so far as a Free Museum is concerned, exactly coincides with mine. I know Europe pretty well, and for the Free Museum I shall be manfully backed up by the leading officials of our Government at home and abroad, and, with experience and *vim*, I can in a single year accomplish more in this line for "The Nation" (I mean the American people) than the sleepy Historical Society could do in half a century. At all events, at the least I can form a magnificent nucleus for a Governmental Free Museum. I owe the youth of this nation a debt of gratitude, and I am anxious to pay it, at least partially. I hope that the fire of the late Museum will have fumigated and burned out the humbug from the public mind to such a degree that it can discover that Barnum has got neither horns nor hoofs, and that he has as much love for refinement and the elevation of the race, especially in this country, as even your excellent writer, "or any other man." I merely hope that this writer will carefully and *impartially* ponder this hastily written letter, and manfully give me *justice*. If he will, at the same time, lend me a helping hand in the way of counsel, he will confer a great

favor on myself, which I will endeavor to transfer for the benefit of my countrymen.

IN GREAT HASTE, TRULY YOURS,
P.T. BARNUM.

Four months after the Civil War ended, leaving at least six hundred thousand people dead, The Nation *published the following article, offering guidelines to builders and donors for the construction of appropriate monuments and memorials. Although this piece is unsigned, it is believed to have been written by Frederic K. Law Olmsted, the designer (with Calvert Vaux) of New York City's Central Park and, like most of the founding contributors to* The Nation, *an ardent abolitionist.*

—

from SOMETHING ABOUT MONUMENTS
AUGUST 3, 1865

LET US ASSUME that about one-half of the memorial buildings which it is now proposed to erect within the United States will be built during the next two or three years. It appears, then, that many American cities and villages, now somewhat bare of other ornament than wayside trees, will either be adorned by good buildings or disfigured by very bad ones, and that many cemeteries will either gain their first good monuments or be more than ever burdened by those which are poor and tame. For it is difficult to build a monument of negative merit. Such buildings, as they have no utilitarian character, must be truly beautiful, or they are ugly and hurtful; they cannot be respectable because appropriately designed; like statues, they must be noble, or they are worthless. And there is a necessity, similar and almost as positive, of great artistic excellence in those buildings which unite a practical use with their monumental purpose.

It will be well, therefore, if those who intend to give money or time to build monuments, will give a little thought on the subject as well. We Americans are not so sure of ourselves in artistic enterprises that we can afford to omit the common precaution of thinking about the work we mean to do. Good monuments are not so

plenty anywhere in the world that habit has grown to be second nature, and that monuments in the future will somehow be good also. But, in both these cases, the converse is true. Of thousands of sepulchral and commemorative monuments built during the last three hundred years in Europe, statues, triumphal arches, columns, temples, towers, obelisks, scarce one in a thousand is good. Out of hundreds of architectural enterprises brought to some conclusion in America, scarce one in a hundred has been even reasonably successful. There is no undertaking for which most people in the United States are less ready than this of building the monuments which they earnestly desire to build—monuments to their townsmen, college-mates or associates who have fallen in the war—monuments to the more celebrated of our military heroes—monuments to the honored memory of our dead President.

Peculiar difficulties will surround and hinder these undertakings, because nearly all these proposed memorials will be built, if at all, by associations; few by private persons. When a gentleman of average intelligence wishes to erect a monument to his brother or friend, there is a reasonable chance that he will employ an architect or sculptor of reputation and professional ambition, even if not of the first artistic skill, and so get a memorial that neither artist nor employer need be ashamed of. But there is much less chance of this in the case of action by a community or association. If a city or society employ an artist, without experimenting with a "competition," they very seldom select the best or even one among the best of the artists within their reach; political influence, private friendship, personal popularity, accidental availability, or temporary popular favor, always interfere to govern the choice. If they resort to competition the result is not practically different; for, supposing the most absolutely fair and careful consideration by the judges of the submitted designs, and supposing the submission of a great number of good designs, what likelihood is there that the judges are fit to judge? How many committees of management, or boards of trustees, or building committees with power, contain each a majority of men who understand the complex and many-sided art of ornamental architecture? How many persons are there in the land, not professed architects or sculptors, who can select the best among twenty or ten designs, each design illustrated only by formal and technical drawings, or by these aided by a fancifully colored and shaded "perspective view" of a building which it is proposed to erect? It is not enough to have "good taste"—to have a correct natural feeling for beauty of form, or to be accustomed to drawings. No man is at all fit to pick out one design among many, unless he has some knowledge of

what has been and of what can be done in actual marble, stone, and bronze. There is apt to be a gentleman on every committee who has travelled in Europe, and who gets great credit for knowledge and judgment, and great influence over his colleagues on that account. But that gentleman must give proof of a better than guide-book knowledge of what he has seen, and of a less confused memory than most travelers bring home, and of having bought photographs of the best buildings instead of those most beloved by *valets de place*, before he can be considered an authority by sensible stayers-at-home. It will often be better if the judges will decide by lot—as judges have been known to—among the designs laid before them. There will then be a reasonable chance that they accept the best design, which chance dwindles indefinitely when most committees of selection attempt to select.

It will be well, therefore, if the people will give some thought to this matter during the months that are to come, that they may learn to bring some wisdom of choice and some appreciation of beauty to their chosen task of grateful remembrance, and that the nation may give its best art and its most poetical feeling, as well as its material abundance, to honor its noble dead.

2

DRAWING THE LINE
TRIALS AND TRIBULATIONS
(PART 1)

*T*HE *NATION*'S LIST of contributors included a number of artists
such as the painters Frank Millet, William A. Coffin, and Ken-
yon Cox. Their reviews were almost always unsigned (though au-
thorship was sometimes revealed by the magazine's records) and in
the early days were almost exclusively about art shows held at New
York's National Academy of Design. At the time, the Academy was
the leading exhibitor of the work of living American artists—includ-
ing most of *The Nation*'s critics—and its shows were major events in
the nascent art world of New York.

*In the mid-nineteenth century, American artists were still trying to estab-
lish an authentic school of painting, separate from the European tradi-
tion, and a small group of critics was trying to invent a way of writing
about it. These early authors were essentially inventing American art
criticism, which took much experimenting. Many of the early pieces in*
The Nation *were by Russell Sturgis, who was an architect and a critic
who served as president of both the Fine Arts Federation and the Archi-
tectural League of New York. His assistants included Charles McKim
and William Mead, who would later form their own firm with Stanford*

White. Sturgis not only reviewed art exhibits but also ruminated on such subjects as wallpaper and window treatments. Even then, the question of what exactly is art was a recurring theme. Many of The Nation's *painter contributors were actively trying to create a truly "American" art while looking for trends that might encourage them in the conviction that such an art was in fact emerging. The era was not without its controversies, and given the relatively small circle of critics and artists in New York—which, then as now dominated the American art world—and the uncertainty of whether there really was any truly original art being produced in America, even the mildest criticism could provoke strong reactions. George Hall was a leading still-life painter who is known primarily for his fruit and flower pictures.*

—

MINOR TOPICS

MARCH 22, 1866

George Hall and unknown writer

We have received the following note from Mr. George H. Hall:

To THE EDITOR OF *THE NATION*:

Your art critic, in noticing my fruit-pieces, says "his purple is shaded not with darker purple, but with grey." If he will hang a bunch of purple grapes against a grey wall, he will see, as I did, that its shadows are filled with grey reflections.

The American artist bears with patience a great deal of crude writing published by so-called art critics, and I think it only fair that he should sometimes expose the ignorance of these oracular gentlemen.

YOURS RESPECTFULLY, GEO. H. HALL.

WE AT first thought of refusing it insertion as an act of kindness to Mr. Hall himself, because we fear the last paragraph will not raise his temper in public estimation, and it certainly cannot serve his pictures. One can accomplish no more by telling a critic he is an ignoramus than by telling an artist or an author that he is an ass. The process to be gone through in all these cases was well described some years ago, we believe, in "Household Words," in a controversy between two pot-house politicians: " 'Prove it,' says I. 'Facts proves it,' says he. 'Prove *them*,' says *I*." Whatever authors and artists may think or expect, the public will never accept the theory that a critic

is *prima facie* unworthy of attention because he is a critic and not a painter or a historian or a poet. It is now too late to get people to believe that nobody can form a correct opinion of works of art who is not capable of producing them. The fact unfortunately is, that it is the opinions of those who were neither poets nor artists which have built up all the great reputations that ever existed, and consigned all the daubers and rhymesters to obscurity or oblivion. And we must protest against the notion that the artist himself is the best judge whether his coloring is good or his drawing correct. If no one were allowed to differ with him on this point, of course every picture that is painted or that ever was painted would be a masterpiece. It is the critics after all—that is, in the vast majority of cases, men who can neither paint nor draw—who give an artist his fame or sentence him to damnation. We should like to know what artist has ever acknowledged that an unfavorable judgment passed on his picture by a fellowman, whether lay or professional, was well founded?

We think, for our part, that American artists display in the matter of criticism an absurd and, let us add, very raw sensitiveness. We deny that they "bear with patience a great deal of crude writing," or any other kind of writing, about their pictures, that is not laudatory. They find themselves now, for the first time, subjected to the ordeal of hostile, perhaps often over-censorious, comment—something to which the artists of other countries have been exposed for two centuries, but no more think of flying into a rage about than they do of blubbering. We do not know any better proof of immaturity and "greenness" than a tendency on the part of either author or artist to lose temper over the public expression of unfavorable opinions of his work, and anybody who finds this tendency still strong in him may feel satisfied that his education in his profession is still far from complete.

There is one thing that artists should bear in mind, and that is that pictures are not put on exhibition for sale simply, like fish or butter. They are to be seen and commented upon. People will differ in opinion about them. Some will think them masterpieces—others daubs; and some people will publish these opinions, and others simply retail them at the dinner-table or in the club. But no matter where or how they may be expressed, the artist has no right to complain, much less to lose his temper or feel personally aggrieved, unless his motives or his character are assailed. The mere fact of exhibition is a challenge to criticism. If a critic says that he thinks either color, or drawing, or expression, or thought is bad, why it is simply an invited expression of opinion; and there is nothing more certain—we mention it for Mr. Hall's consolation—than that no good painter was ever yet written down by one critic or two or three.

In fact, any criticism, let it be ever so hostile, is of service to any artist who has any merit at all. It leads to discussion; it causes the public to examine his work more carefully; and, if it is good work, of course the more it is examined, the better it will appear; if it is bad work, the interest of art requires that it be driven out of the field, and the artist be convinced of his own shortcomings as soon as possible. And we must remind Mr. Hall that if the artists have had to bear with a good deal of "crude writing," the critics and the public have had to bear with a monstrous deal of crude painting. People do see now and then historical pictures that are none the better for having had the subject strained through the artist's imagination; figure-pieces of all kinds that are simply bits of maudlin sentiment or affectation; fruit and flower pieces which, in spite of the artist's having taken the greatest pains with the coloring, are not well colored, after all, and are not so considered by the public, and will adorn the trunk-rooms of posterity. Of course, in saying all this, we neither express nor imply any judgment on Mr. Hall's work.

There were, of course, more serious controversies raging in the art world, and nearly all of them centered around John Ruskin, the influential English art critic who championed both morality in art and the Pre-Raphaelite school of painting. Ruskin's views on art preoccupied most critics on both sides of the Atlantic, and Russell Sturgis seized on the reprinting of Ruskin's most famous work, Modern Painters, *as an opportunity to bring the debate to the pages of* The Nation.

—

RUSKIN'S MODERN PAINTERS

AUGUST 27, 1868

Russell Sturgis

ALL THE MORE important of Mr. Ruskin's writings have been republished in America by Mr. Wiloy's house, though in a form very different from that of the beautiful English editions. The appearance of a new issue of the reprint of *Modern Painters* gives occasion for a brief review of the author's work as artist and writer upon art. It is our purpose to abstain from all consideration of those writings upon ethics, government, and society which have given Mr. Ruskin a wider and, for the present at least, a less enviable notoriety than his artistic labors. His largest book, that mentioned above, with twenty-five years between the dates of its

first and its fifth volume, begun for the purpose of proving and establishing an important fact in modern art history, never forsaking its original end, but, in the task, ranging over earth and the world of thought in search of the profoundest truths of nature and spirit, is in itself an embodiment of Ruskin's mind from early manhood up to a mature age. During those years through which there went on the slow growth of *Modern Painters* other books were produced which are nearly as well known. *The Seven Lamps of Architecture, The Stones of Venice,* several smaller books, and many lectures, pamphlets, articles, and letters received and contained the surplus matter, the outside accretion of thought which found no proper receptacle in the central book itself. In all these we find the same strong conviction that good in art is much like good in other things, not a creation of law, but the reason why laws are created; an absolute thing which, indeed, one may fail to reach and yet be forgiven, but which is never to be ignored or denied without ruin following. It is not without an effort that the author keeps to his self-allotted task; the truth outside of the world of art seems to him not altogether distinguishable from truthfulness in art itself; so that his peculiar views upon political economy occasionally find brief utterance. But up to the close of the fifth volume of *Modern Painters* the thought upon these subjects is confined to generalization, and does not crystallize into those sumptuary laws the unskillful promulgation of which has made even the admirers of the author stand aghast.

The first object of Mr. Ruskin's life as a writer was to claim for Turner the landscape painter, then an old man and past his artistic prime, the place and character of the greatest of all landscape painters, and a genius fit to rank with the few great painters of the world. To this task he was called by his own impatience at foolish, captious, and ungrateful fault-finding—a tone of discussion adopted by the English press of the time in regard to Turner's noblest works, too narrow and inconsiderate to be called criticism, too absurd to be worthy of serious refutation but for the mischief it was doing. During the half-dozen years before the appearance of the first volume of *Modern Painters* the most magnificent of Turner's works had been exhibited upon the walls of the Royal Academy, and had been greeted with unanimous abuse and foolish jesting by press and people. To Ruskin the pseudo-criticism of the wiseacres of the day was in every way horrible. As a constant student of landscape and of all natural beauty—as a lover of good art and of verity of every kind, he hated to see such falsehoods circulated in regard to noble pictures; as a lover of men, he chafed at the folly which kept his countrymen from a pure and lofty pleasure; as a personal friend and devoted admirer of Turner, he suffered from the attacks which were wearing out the soul of the great

artist. He commenced a letter to the editor of some review—a mere
protest against foolish carping at Turner. The letter grew into a vol-
ume. It was published as Volume I, of *Modern Painters,* and received
with great interest and more general approval than has been given to
any of Ruskin's subsequent works. People had not then found out
how many vested interests were attacked, and how many favorite old
humbugs were endangered by this new Quixote.

The publication of this volume, and the fact that it found readers,
seem to have startled the author into recognition of the truth that
he had made himself an art critic without sufficient preparation. It
was one thing to cry out against the gabble of the newspapers and
show that Turner was the greatest of living landscape painters; to a
practised draughtsman and close observer this was easy; it was an-
other thing to establish Turner's claim to a seat beside Titian and
Leonardo. He had not proposed to himself the devotion of his life
to the study of art; but now something very like that was forced upon
him. The work upon *Modern Painters* was suspended, and in the
prime of early manhood he went at the study of the fine arts with
the same energy and devotion which most men give to money-
making business. Already a skillful draughtsman, his power grew
with every day's work; already familiar in more than the usual sense
with the greatest works of art in Europe, he studied them now as
other men study the markets and the tendencies of trade. His notion
of studying Lombard architecture was to copy line by line its most
precious remaining buildings, and stone by stone its loveliest sculp-
ture. If he sought to know Florentine painting, it was by setting up
his easel and copying the precious originals in form and color. In
this way he studied art for ten years, while still retaining his hold on
nature by that careful drawing out of doors, both in black and white
and in color, which had been familiar to him from early youth.

One interest grew out of his study on the continent of Europe
which threatened to put to one side the interpretation of Turner to
the world, and did delay that primary work. The fancy for Gothic ar-
chitecture which was then taking hold of the educated classes in Eu-
rope was causing the ruin, under the name of "restoration," of some
of the noblest buildings left from the Middle Ages, while it had not
availed to save any of them from destruction out and out to make
room for modern buildings. Tortured every day by the sight of this
hopeless and remediless destruction going on around him, [Ruskin]
busied [himself] in making careful drawings of parts of buildings
which the morrow would see dashed to pieces, powerless to prevent
or delay the annihilation of works of art which could never be re-
placed, and of which perhaps the only record would be left in his own

drawings—he turned more and more towards this part of his work, and for a time followed the study of ancient architecture as an end instead of a means. The attempt to awaken a living interest in Gothic architecture, an interest which should suffice to save his beloved monuments from destruction, became a secondary duty, not conflicting with the primary object of interpreting Turner and his relations to landscape painting, but pursued side by side with it, and never relinquished until years had shown the utter futility of the task. Some little good has come to modern building through the exertions of Ruskin and his followers, but for the preservation of the noble buildings they loved it has been in vain that they strove. Within thirty years half the best architecture in Europe has been swept off from the face of the earth and the remainder mostly renovated into nothingness.

Books so large as *Modern Painters* and *The Stones of Venice* find but few readers in our days. Even the charm of the illustrations cannot keep many men or women attentive to the text through hundreds of large octavo pages. It is because of this that these books fail of their effect. There are few men who have read *Modern Painters* carefully through, and yet no one but he who has can be said to know much about Ruskin's writings. The smaller books are generally inferior, the lectures notably so, and, though crowded with information and suggestion, are incomplete in reasoning, sometimes hasty in assertion, and nearly always unfortunate in expression. But *Modern Painters* is of a completeness and gravity not attained by any part of any of the smaller works except one. It grows, as Mr. Ruskin himself has said in another case, like a tree, branching in many ways, but developing always into fuller life. One who wishes to be lead into a true feeling for art ought to read and re-read *Modern Painters*.

The general tendency of Ruskin's teachings in art is always right. The separate and detached expressions of opinion are always worthy of careful consideration, and are nearly always stimulating to thought, but are open to question as to their complete or partial rightness. In saying this, we mean not only the early opinions which maturer thought has modified, as in the notable instance of the relative rank given to Venetian painting in the first and in the fifth volume of *Modern Painters*. These changes are the best proof of real, growing knowledge, and of that flexible-mindedness essential to the investigator. We refer rather to hasty generalizations, and assertions too sweeping because too hotly made. But this consideration does not prevent us from giving this advice to the student of art about to visit Europe— copy every piece of description and of criticism of pictures, statues, buildings, and scenery from all Ruskin's writings, classify them geographically, and study each thing commented on with the aid of

the comments. It is not too much to say that it is altogether impossible to study art aright, nowadays, without seeking aid continually from Ruskin's books. And as to the questionable accuracy of some statements, it is safe to say that the student had better take them all at first as absolutely true, and gradually learn to discriminate, than to close his eyes and ears by too much doubting.

Sturgis's devotional description of Ruskin's teachings provoked a response from W. J. Stillman, the art critic for the Evening Post, *and the founder of the journal* The Crayon, *who had studied with the landscape painter Frederic Edwin Church, and was a protégé of Ruskin (after whom he named his eldest son). He had a falling out with Ruskin, whose views he said had a disastrous effect on his painting, and spent most of his time working at various consular positions in Europe. Stillman was also a correspondent for the* Times, *the* Herald, *and other New York papers, often writing about art as he traveled around Europe.*

—

RUSKIN AND HIS WRITINGS

NOVEMBER 26, 1868

W. J. Stillman

TO THE EDITOR OF *THE NATION*: *The Nation* in No. 165 has a notice of the *Modern Painters* which states so many of the commonly received and utterly erroneous dicta concerning the ideas advanced in that book, and its general theory of art-study and criticism, that I am induced to ask room to controvert it in the interest of art-education, not to say of *The Nation*, whose critical authority should rest on better premises.

Modern Painters was published at intervals extending from *about* 1845 (having no copy by me, I cannot be precise) to 1859, the first volume, and the only one known in *popular* reading, being put out when the author was about twenty-seven years of age; and being, as might be expected, a work of intense enthusiasm and immature thought, it was no exception to the dictum that books which acquire rapid and general success are superficial and probably unworthy to occupy permanently the place at first assigned them. While no other

book can be quoted so full of intense perception and rapturous appreciation of nature and her claims on the artist, no other can be found which, with such thorough and conscientious seeking for art, manifests so little attained knowledge of its real character and uses. Ruskin's nature was over-freighted on the *moral* side (using that word in its general acceptation with us), and ran too strongly into the devotional-didactic to be able to explore the sister but independent realm of artistic development.

The public in general knowing nothing of art as distinguished from pictorial representation, the young and reverent painters, still warm with that passionate love that makes a religion of anything and makes anything it loves religious, adopted this first volume as the canon of criticism; but so universal was the dissent of the older artists and the deeper students that I should not have thought it necessary ever to controvert the popular opinion had I not found it expressed in a journal of the gravity and justice of *The Nation.*

Your critic's assertion that "the general tendency of Ruskin's teachings in art is always right," is just the contrary of what I believe to be the truth. I believe (and I have known him and his book for many years, and regard him as the most unhesitating lover of truth I have ever known) that Mr. Ruskin's *art*-teachings are utterly wrong, based on an entirely erroneous estimate of the position of art in the intellectual system, and calculated to bewilder most and to lead the most widely astray—and to lead them to a greatest loss of time and heart—the most reverent and earnest of those who study his works. To show just wherein he is wrong in the abstract would require an exposition of what art is, which would demand space you could not spare and time I cannot now devote to the subject; but I can illustrate just as well by examination of his concrete judgment.

The first volume of *Modern Painters* recognizes insight into nature as the great gift of the painter, and, with the third and fourth (the second being an episode of great value, but foreign to art), goes to prove that Turner possessed this gift more than all other painters, and that the English school possessed it in a degree far beyond the older schools; in the fifth he recognizes the claims of the great technical qualities, previously overlooked in his system and never fully appreciated, since he has no sense of the value of Greek art, in which they attained their greatest development. He seeks to establish by his researches and demonstrations that Turner is the greatest of landscape painters because of his greater insight into nature, and that Stanfield, Harding, *et id genus omne*, are greater artists than Claude, because they have clearer eyes, while in point of fact Turner's insight into nature was incidental to his genius as an artist,

and Claude was an artist, though feeble; while Standfield, Harding & Co. are only clever painters, with scarcely the most hazy and incomplete perceptions of what art is.

To speak of Turner as the greatest of landscape painters *because* he told the most truth is an egregious *non sequitur*, for no other painter ever told so many falsehoods on canvas. I do not believe he ever gave a thought to truth either of detail or color; forms and motives of color that pleased him by their expression and fitness to his moods he retained and reproduced in a more or less exact degree. I have seen many of his studies of nature, and never saw an attempt to reproduce the actual truth of landscape. I do not believe that his feeling would have permitted him to sit down to match-trails with nature any more than Beethoven would have sat down to write a score of the modulations of voice in a drawing-room conversation. He defied all the actualities; he put rainbows at right angles to the sun, threw shadows across clear water, gave tints of purple, scarlet, and gold in skies when the sun was yet an hour high, mixed shadows of moonlight and sun light, put his lights on the opposite side of the objects from the sun, relieved verdant mountains in light against a blue sky, painted pictures in which scarcely the most fanciful resemblance to natural objects can be discerned, and which are yet *as great art as anything he did.*

His great artistic gifts were the intense fusion of his perceptions into conceptions (a quality different, I believe, from either idealism or creative imagination, or even imaginative conception), and his unapproached and almost unsuggested orchestration (if I may borrow an analogic term) of color, which alone would have placed him in the front rank of artists of all time. Titian's color-harmony was as faultless as Turner's, but compared with it as a vocal quartette with the most elaborate concerts.

Ruskin's ends of art are only its means; its most characteristic and noble revelations of ends are expressive, not representative; what is in the artist, not the language borrowed from nature in which he tells it.

I do not set Mr. Ruskin too low; his value is other than the usually accepted one. He belongs to the school of noble speculative minds, teeming with suggestions of the highest value, and this especially in his sociological and socio-political works, but by his inevitable limitations is forbidden to prescribe rules or organized systems. His political economy is not of the school of Adam Smith but of Plato, with an infusion of sorrowing, heartaching philanthropy, of human love and despair at human folly and shortcoming (to him madness and wickedness), which the "Republic" would never admit nor its author have felt. Similarly, his artistic studies were dispersive, analytic, iconoclastic; what he pulled down was in the main well pulled down, but

what he built was builded of bricks without mortar. His instincts
went to the heart of a falsehood as a surgeon's knife to its work of
extirpation, but he would no more make or guide an artist than an
anatomist a human body.

YOURS RESPECTFULLY, W. J. STILLMAN.

Athens, Greece, October 28, 1868.

—

[We are very glad to give Mr. Stillman an opportunity of stating his
opinions about Mr. Ruskin and his teachings, but an adequate de-
fence of our position or an adequate attack on Mr. Stillman's would
take more space than we can spare, or are likely ever to be able to
spare. We have the consolation of knowing that should the above let-
ter fall under Mr. Ruskin's eye he will avenge us.—ED, *THE NATION.*]

*Gustave Moreau's strange, otherworldly paintings roused quite a debate
whenever they were shown. In 1876, Moreau exhibited two pictures,*
Salome Dancing Before Herod *and* Hercules and the Lernaean
Hydra, *at the Paris Salon. This report from Paris was written by Henry
James, who contributed more than 200 essays and reviews to* The Nation.

—

GUSTAVE MOREAU

JUNE 20, 1876

Henry James

THESE ARE THE two pictures of the year, in the sense that they are
the two pictures that have been most talked about. If it is true of
any picture that it must be seen to be appreciated, it is peculiarly
true of these strange, elaborate, fantastic, and erudite compositions
of M. Gustave Moreau. They are extremely difficult to describe, and
at first they are difficult to enjoy; but they improve vastly on ac-
quaintance, and they end by acquiring a singular fascination. They
are open to a dozen charges which, with regard to works of a dif-
ferent sort, would be damning charges of want of drawing, want of
knowledge, of sense of possibility, of proportion, of most things, in
short, that a well-regulated picture is supposed to rest upon. The only
want of which they have not been accused is, we believe, that of color.
The best plan for M. Moreau's defenders, I think, is to give up de-
fending him, and to content themselves with enjoying him. He
charms, he takes possession of the imagination, and leads it away into

regions untrodden and unexplored. His "Hercules" is a beautiful but somewhat ill-drawn young man, strangely caparisoned, and standing erect in the midst of a fantastic and unearthly landscape of jagged rocks and mose-hung caves. Face to face with him rises the many-headed Hydra out of a bed of mouldering victims, bound together and strewn about in every shade of lividness and every form of agony— a great cluster of gray-green serpents, which, without being as fine as those which encircle the terrible Gorgon-mask of Leonardo da Vinci at Florence, are yet sufficiently ghastly. The coloring is capricious but exquisite, and the whole scene, if unreal enough to common sense, has a great deal of truth to the imagination. The "Salome" perhaps has even more. The daughter of Herodias is bedizened with embroideries and jewels, and, while she holds out a great lotus-flower with her gem-encrusted arm, spins round, with her head bent and her long eyes askance, on the tips of feet that support her by the help of sandals that are stiff with precious stones. Herod sits upon his throne like some human idol that has successfully accomplished the feat of seeing himself as others see him, and a long, lean slave stands beside him with a drawn sword, casting a diabolical oblique glance at the young girl. Above and behind is an indescribably gorgeous architecture, which, like most of the rest, has been evolved from the moral consciousness, of the artist—a moral consciousness, however, evidently fed by a great deal of curious culture. The picture produces the same sort of effect as Coleridge's poem of "Kubla Khan"; it is like a strange dream made visible. The arbitrary in painting must always strongly justify itself, and one may say that with M. Moreau it does.

The controversy surrounding John Ruskin reached its apogee in the sensational libel suit filed against him in London by the American painter James Abbott McNeill Whistler. It was, at least in the world of art, the trial of the century. The Nation's man on the scene was Henry James, who filed these dispatches from London.

—

THE RUSKIN/WHISTLER TRIAL—PART I

DECEMBER 19, 1878

Henry James

—A correspondent writes from London under date of December 4: "The London public is never left for many days without a *cause*

célèbre of some kind. The latest novelty in this line has been the suit for damages brought against Mr. Ruskin by Mr. James Whistler, the American painter, and decided last week. Mr. Whistler is very well known in the London world, and his conspicuity, combined with the renown of the defendant and the nature of the case, made the affair the talk of the moment. All the newspapers have had leading articles upon it, and people have differed for a few hours more positively than it had come to be supposed that they could differ about anything save the character of the statesmanship of Lord Beaconsfield. The injury suffered by Mr. Whistler resides in a paragraph published more than a year ago in that strange monthly manifesto called *Fors Clavigera,* which Mr. Ruskin had for a long time addressed to a partly edified, partly irritated, and greatly amused public. Mr. Ruskin spoke at some length of the pictures at the Grosvenor Gallery, and, falling foul of Mr. Whistler, he alluded to him in these terms:

> " 'For Mr. Whistler's own sake, no less than for the protection of the purchaser, Sir Coutts Lindsay ought not to have admitted works into the gallery in which the ill-educated concert of the artist so nearly approached the aspect of wilful imposture. I have seen and heard much of cockney impudence before now, but never expected to bear a coxcomb ask 200 guineas for flinging a pot of paint in the public's face.

Mr. Whistler alleged that these words were libellous, and that, coming from a critic of Mr. Ruskin's eminence, they had done him, professionally, serious injury, and he asked for £1,000 damage. The case had a two days' hearing, and it was a singular and most-regrettable exhibition. If it had taken place in some Western American town, it would have been called provincial and barbarous; it would have been cited as an incident of a low civilization. Beneath the stately towers of Westminster it hardly wore a higher aspect. A British jury of ordinary tax-payers was appealed to to decide whether Mr. Whistler's picture belonged to a high order of art, and what degree of 'finish' was required to render a picture satisfactory. The painter's singular canvases were handed about in court, and the counsel for the defence, holding one of them up, called upon the jury to pronounce whether it was an "accurate representation" of Battersea Bridge. Witnesses were summoned on either side to testify to the value of Mr. Whistler's productions, and Mr. Ruskin had the honor of having his estimate of them substantiated by Mr. Frith. The weightiest testimony, the most intelligently, and apparently the most reluctantly, delivered, was that of Mr. Burne-Jones, who appeared to appreciate the ridiculous character of the process to which he had been summoned

(by the defence) to contribute, and who spoke of Mr. Whistler's performances as only in a partial sense of the word pictures—as being beautiful in color, and indicating an extraordinary power of representing the atmosphere, but as being also hardly more than beginnings, and fatally deficient in finish. For the rest, the crudity and levity of the whole affair were decidedly painful, and few things, I think, have lately done more to vulgarize the public sense of the character of artistic production. The jury gave Mr. Whistler nominal damages. The opinion of the newspapers seems to be that he has got at least all he deserved—that anything more would have been a blow at the liberty of criticism. I confess to thinking it hard to decide what Mr. Whistler ought properly to have done, while—putting aside the degree of one's appreciation of his works—I quite understand his resentment. Mr. Ruskin's language quite transgresses the decencies of criticism, and he has been laying about him for some years past with such promiscuous violence that it gratifies one's sense of justice to see him brought up as a disorderly character. On the other hand, he is a chartered libertine—he has possessed himself by prescription of the function of a general scold. His literary bad manners are recognized, and many of his contemporaries have suffered from them without complaining. It would very possibly, therefore, have been much wiser on Mr. Whistler's part to feign indifference. Unfortunately, Mr. Whistler's productions are so very eccentric and imperfect (I speak here of his paintings only, his etchings are quite another affair, and altogether admirable) that his critic's denunciation could by no means fall to the ground of itself, I wonder that before a British jury they had any chance whatever, they must have been a terrible puzzle. The verdict, of course, satisfies neither party: Mr. Ruskin is formally condemned, but the plaintiff is not compensated. Mr. Ruskin too, doubtless, is not gratified at finding that the fullest weight of his disapproval is thought to be represented by the sum of one farthing.

—

THE RUSKIN/WHISTLER TRIAL—PART II

FEBRUARY 13, 1879

Henry James

—A correspondent writes to us from London under date of Jan. 28:

"I may mention as a sequel to the brief account of the suit Whistler v. Ruskin, which I sent you a short time since, that the plaintiff has lately published a little pamphlet in which he delivers himself on the subject of art-criticism. This little pamphlet, issued by Chatto & Windus, is an affair of seventeen very prettily-printed small pages; it is now in its sixth edition, it sells for a shilling, and is to be seen in most of the shop-windows. It is very characteristic of the painter, and highly entertaining; but I am not sure that it will have rendered appreciable service to the cause which he has at heart. The cause that Mr. Whistler has at heart is the absolute suppression and extinction of the art-critic and his function. According to Mr. Whistler, the art-critic is an impertinence, a nuisance, a monstrosity—and usually, into the bargain, an arrant fool. Mr. Whistler writes in an offhand, colloquial style, much besprinkled with French—a style which might be called familiar if one often encountered anything like it. He writes by no means as well as he paints; but his little diatribe against the critics is suggestive, apart from the force of anything that he specifically urges. The painter's irritated feeling is interesting, for it suggests the state of mind of many of his brothers of the brush in the presence of the bungling and incompetent disquisitions of certain members of the fraternity who sit in judgment upon their works. "Let work be received in silence," says Mr. Whistler, "as it was in the days to which the penman still points as an era when art was at its apogee." He is very scornful of the 'penman,' and it is on the general ground of his being a penman that he deprecates the existence of his late adversary, Mr. Ruskin. He does not attempt to make out a case in detail against the great commentator of pictures; it is enough for Mr. Whistler that he is a 'littérateur,' and that a littérateur should concern himself with his own business. The author also falls foul of Mr. Tom Taylor, who does the reports of the exhibitions in the Times, and who had the misfortune, fifteen years ago, to express himself rather unintelligently about Velásquez. 'The Observatory at Greenwich under the direction of an apothecary,' says Mr. Whistler, 'the College of Physicians with Tennyson as president, and we know what madness is about! But a school of art with an accomplished littérateur at its head disturbs no one, and is actually what the world receives as rational, while Ruskin writes for pupils and Colvin holds forth at Cambridge! Still, quite alone stands Ruskin, whose writing is art and whose art is unworthy [of] his writing. To him and his example do we owe the outrage of proffered assistance from the unscientific—the meddling of the immodest— the intrusion of the garrulous. Art, that for ages has hewn its own history in marble and written its own comments on canvas, shall it

suddenly stand still and stammer and wait for wisdom from the passer-by?—for guidance from the hand that holds neither brush nor chisel? Out upon the shallow conceit! What greater sarcasm can Mr. Ruskin pass upon himself than that he preaches to young men what he cannot perform? Why, unsatisfied with his conscious power, should he choose to become the type of incompetence by talking for forty years of what he has never done?' And Mr. Whistler winds up by pronouncing Mr. Ruskin, of whose writings he has perused, I suspect, an infinitesimal small number of pages, 'the Peter Parley of Painting.' This is very far, as I say, from exhausting the question; but it is easy to understand the state of mind of a London artist (to go no further) who skims through the critiques in the local journals. There is no scurrility in saying that these are for the most part almost incredibly weak and unskilled; to turn from one of them to a critical feuilleton in one of the Parisian journals is like passing from a primitive to a very high civilization. Even, however, if the reviews of pictures were very much better, the protest of the producer as against the critic would still have a considerable validity. Few people will deny that the development of criticism in our day has become inordinate, disproportionate, and that much of what is written under that exailed name is very idle and superficial. Mr. Whistler's complaint belongs to the general question, and I am afraid it will never obtain a serious hearing, on special and exceptional grounds. The whole artistic fraternity is in the same boat—the painters, the architects, the poets, the novelists, the dramatists, the actors, the musicians, the singers. They have a standing, and in many ways a very just, quarrel with criticism; but perhaps many of them would admit that, on the whole, so long as they appeal to a public laden with many cares and a great variety of interests, it gratifies as much as it displeases them. Art is one of the necessities of life; but even the critics themselves would probably not assert that criticism is anything more than an agreeable luxury—something like printed talk. If it be said that they claim too much in calling it 'agreeable' to the criticized, it may be added on their behalf that they probably mean agreeable in the long run."

3

INNOCENTS AT HOME
AND ABROAD

BY THE 1880s America was well on its way to becoming a world power, and its art, too, was emerging as something that finally seemed as if it might someday rival that of Europe. Writers began to refer more and more confidently to "American art" and began to notice that important world-class artists such as Thomas Eakins, Winslow Homer, and Albert Pinkham Ryder were working in their midst. With robber barons beginning to buy crateloads of European art—even the new art of the Impressionists—the New York art scene became more cosmopolitan, as did both the subject and the tone of *The Nation*'s reviews:

—

from FIFTY-SIXTH ANNUAL EXHIBITION OF THE
NATIONAL ACADEMY OF DESIGN
APRIL 21, 1881

NOTHING THAT MR. Eakins does fails to be interesting in some way, for the reason that it is sure to have some import, which distin-

guishes it at once from what is rightly enough termed shop-work. Shop-work abounds at the Academy, and without much more relief this year than usual; accordingly Mr. Eakins's "May Morning in the Park" (No. 645), though it has not in itself qualities particularly striking, no one will be apt to pass over, in spite of the position assigned it in a corner of the little North-west gallery. It is perhaps a little paradoxical that what fault there is to be found in it discovers itself in its expression. In general it is in Mr. Eakins's conception that the weaknesses of his pictures are felt. An inadequate sense of beauty, and, indeed, a contentedness with what is conventionally ugly almost involving a sniffing contempt for anything convention-ally aesthetic, he sometimes discloses with apparent satisfaction. Nev-ertheless it is not too recondite an explanation of this to say that be seems to fail as an artist, when he does seem thus to fail, mainly because he fails as a painter. In spite of his evident ability, his pos-session of what it is possible to acquire in drawing and color, and an obvious native felicity in handling this effectively, it is not unrea-sonable to infer that occasionally, when his work falls short in point of art, it is due to the insufficiency with which he has expressed what he had in mind. It would be easy but, like most *à priori* reasoning when it is specific, unconvincing to infer that what has evidently impressed so deeply a painter of such force could not originally have had as little attractiveness as it sometimes has in his pictures, even though the technical insufficiency of these is neither felt nor to be perceived. This "May Morning," however, palpably confirms such an inference in its own case, and suggests the reasonableness of the same in other instances. There is just enough of a May morning effect in the landscape and atmosphere of the picture to show clearly the artist's intention, and just enough indistinctness and lack of accent to indicate the imperfectness with which it has been exe-cuted. There is also, perhaps owing to the same reasons, an agree-able lack of the rather labored and conspicuous light and shade which distracts the attention in some of Mr. Eakins's work—in, for example, the "Lady Singing a Pathetic Ballad" of which we spoke a fortnight ago; but the harmonious concert of contrasting color-values which should take its place is lacking too in some degree, the result being that at the necessary distance the canvas looks as if the paint-rag, or the "blender," or some degree of scumbling, had un-happily blurred its appropriate piquancy into something almost common. Actually, thus, it fails in the blithe freshness of "ethereal mildness" which, nevertheless, it is perfectly evident it was designed to express. The indubitable success of the picture is to be found elsewhere—in the happy way, namely, in which the coach, its horses,

and its freight of ladies, gentlemen, and footmen are painted. The slow, swinging gait of the horses—a particularly difficult variety of action to fix upon canvas, we should imagine—and the bearing of the group on the front of the coach are capitally caught.

—

from THE WATER-COLOR EXHIBITION

FEBRUARY 15, 1883

AS COMPARED WITH what was done in water color in this country ten years ago, the works which make up this, the sixteenth annual exhibition, show a marked advance as regards command of the means of expression. They do not, however, always show a wise and true use of those means; nor do they, in many cases, show a fine or sufficient artistic motive. As we have before intimated, our American artists have not yet, as a general rule, evinced even a fair degree of that primal artistic gift which impels a man to lay hold of the element of beauty, and to regard the expression of it as the chief end of his art. There are still very few beautiful, or well-chosen, subjects among the six hundred and odd pictures in the present display. But it is fair to say that there are, perhaps, more examples of quiet portrayal of familiar nature, and fewer of those which give expression to decidedly ungraceful or offensive themes, than has sometimes been the case in the immediate past. There is one tendency which, more or less distinctly, we have noticed of late with apprehension, and which is very marked in some portions of this exhibition, and that is a tendency to mannerism—to an artificial way of doing things—which is always characteristic of an unprogressive state. We feel, also, that there is in some degree lacking a just sense of the peculiar capabilities and limitations of the processes of water-color painting, whence it results that the essential beauties to which the medium naturally lends itself are in corresponding measure lost. Yet we would not push our remarks on this head too far; for it is certain that recent improved methods of preparing the materials, and the use of what is known as body-color—a perfectly legitimate use—have vastly extended the range and power of this medium, and have, perhaps, well-nigh revolutionized it.

Foremost among the exceptionally vital works in this exhibition are, we think, those of Mr. Winslow Homer. His most important

picture is No. 157, "A Voice from the Cliff." It represents three fig-
ures of rough fisherwomen in a group, which comes grandly dark
against a distant chalk-cliff in broad, though quiet, light. Although
the group tells dark against the background, yet the local colors are
nowhere extinguished in shade, but bear out everywhere, in sub-
dued fulness, though in complete subordination, as in the works of
[Tintoretto.] Modern art rarely accomplishes this so well, and it is
a great accomplishment. There is a slightly unpleasant tendency to
purplish hues all through the group, and something of hardness
and want of mystery in the execution—everything, flesh, drapery,
chalk-cliff, sky, and water, being done in the same way. The same,
substantially, may be said of the other contributions of Mr. Homer,
namely, Nos. 32, 272, and 425. But there is a largeness and veracity
of feeling in them all which goes far to redeem their defects. These
works evince a power of design, too, which is very admirable, and,
in modern art, uncommon. In No. 157 the sympathy of action in
the three figures, and the way in which they are encompassed by
the line of the chalk cliff, are noticeable in this regard. In No. 32,
"Tynemouth," the largeness and vigor of conception and expression
render the work powerful, in spite of the want of fullness and mys-
tery just alluded to. Mr. Homer's habit of simplifying verges on a
fault, and gives a finiteness to his work that detracts from its excel-
lence. The boat outline in this example is too sharp everywhere. It
does not lose itself enough in the weltering sea or in light catching
on its wetted gunwale. The smoke of the distant steamer is heavy
and ill drawn; and the steamer itself and the distant city are not
aerial enough in hue. Moreover, there is an inharmonious red, with-
out sufficient light in it, in the upper sky to the right. Also, there is
a want of local sea color in the near unreflecting faces of the waves.
More detailed veracity without any more elaboration would have
greatly enhanced the beauty and value of the work. In No. 272,
purity is lost in the low tones by too great prevalence of brown and
black. And in No. 425 we feel the artist's mannerism (and a ten-
dency to mannerism shows itself strongly in Mr. Homer's work) per-
haps more than in the preceding examples. The lack of the unity
and variety of nature is here painful. The three horizontal bands
into which the sky, water, and sands resolve themselves are unpleas-
antly and untruly marked off the one from the other; they are not
enough interfused by harmonizing color. The foreground sand
would naturally reflect something of the color of the sky, and the
cloud reflections in the water instead of being lighter, as they are,
would be at least as dark as the clouds themselves, since there is no
veil of mist interposing to pale them. But, after all deductions, we

regard Mr. Homer as perhaps our very strongest painter. He has a true painter's powers and true designer's instincts. He is not an imitator of any prevailing style; but he appears to have studied the best art understandingly and to good purpose, while he has retained an independent feeling for nature from which he mainly draws his inspiration. Even the mannerism which we have noticed is his own rather than an adopted one.

—

from THE ACADEMY EXHIBITION—I

APRIL 17, 1884

THE DOMINANT IMPRESSION which the exhibition of the Academy leaves us, after a careful review of the 700 pictures exposed, is one of executive feebleness largely varied by sketchiness—or, rather, insufficiency of execution due to want of knowledge of nature—with here and there a noteworthy exception of faithful study and solid execution, but so few as hardly to modify the impression that it is an exhibition of the work of amateurs. An affectation of cleverness is too generally apparent, a most unmistakable indication that the body of the exhibitors care more to be thought experter than they really are, than to be sincere in their method or thorough in their results. It would be hard to find half a dozen pictures which bear evidence of exhaustive study of their subject—of a resolute attempt to know completely the material of which the picture is composed. Of the so-called pre-Raphaelite work there is nothing, and there is no need of anything, for the sole advantage of that intense investigation of nature's facts is as study, for the training of hand and thorough acquaintance with the parts of the subject-matter which enable the artist to express himself with facility and thoroughness. That none of this concentration and uncompromising struggle with nature and determination to get to the extreme limit of fidelity should be found in the younger men, is a discouraging symptom of our future art progress. The extreme realism in painting is not an end of art; but as matter of training, both for certainty of hand and complete knowledge of the material of which pictures are to be made, there is no evading it; and the young painter who cannot bring himself to it as matter of discipline and education will never go beyond the merely clever, the legerdemain of art, for which the

French have coined the convenient word *chic*. The painter who is satisfied to work for *chic* may be left to flounder as he may; there is no real greatness in him or good work to be hoped for from him. All the great schools and all the great painters have begun in this absolute devotion to the faithful representation of their material, and with the most entire absence of any pretension to display of their own cleverness. Even Rubens, who can in no wise be considered a purist, began in a vein of elaborate rendering of detail which may be recommended even to American genius. To be clever or great is given a man; to be conscientious in training, sincere in study of the means of expression, which is the only way of fully developing the greatness, depends on the artist's will—on himself.

—

from THE ACADEMY EXHIBITION—II

APRIL 24, 1884

THE LANDSCAPES (INCLUDING marines, etc.) of the exhibition not noticed in regard to the special quality of fidelity to nature, fall mainly into two classes, conventional (which includes almost all commonplace work) and ideal, i.e., in which color or composition is distinctly the motive. The most widespread error in regard to art (and especially erroneous as applied to landscape) is that its chief function is to imitate nature. No landscape which is simply content with this office can be classed with the noblest art. There are, and always will be, painters of power and great sincerity, whose abilities will be distinctly limited to the straightforward and more or less rigorous realism which, to the uneducated mind, represents nature. These painters in their place are worthy [of] all the success they attain, and it would be well if every landscape painter were compelled to begin with a course of this severe attention to the facts of nature. If there be in him the higher ideal qualities, they will come out with time and training; without the latter they will never get full expression. "Despise not the day of little things" is a maxim which should lie near the heart of every young painter. The work of Albert Ryder, No. 191, indicates native powers of a high order and the feeling of a true colorist, but neither a good method nor tolerable execution. It is typical of a large class of painters who, sometimes from want of executive ability, sometimes from want of self-discipline

and artistic conscience, avoid the study of nature, which "puts them out," and trust to unassisted "feeling," wherein they are as sensible as poets who dispense with grammar and reading. Nature furnishes painters with their alphabet and vocabulary, better, on the whole, than any which they can invent for themselves. They are not forbidden to invent, modify, and suppress at will, but they will hardly do wisely the one or the other without having a thorough knowledge of that which nature has provided. Mr. Ryder's work, which is the admiration of a large class of artistically minded people, not only proves his natural abilities, but his utter failure to improve them by proper study and discipline. The history of art (especially American art) abounds in instances of this kind of sterile talent—of painters who only lack training to become great painters, but whom this want limits rigorously to the artistic limbo of still-born genius. Mr. Blakelock (No. 468) lies under the same sentence. The great mind of da Vinci delivered the sentence which in one shape or another has been repeated over and over by every subsequent supreme artist: "Thou, O God I sellest us all good things at the price of labor." Sir Joshua put it in another shape: "Nothing is denied to well-directed labor." While we recognize with pleasure the evidence of so poetic a talent as that of Mr. Ryder, and that it is of the finest grain, we can only lament that the want of adequate training (and a peculiar and eminent talent is more exacting in this respect than a commonplace one) should condemn it to such maimed and incomplete results.

The Nation *developed a peculiar obsession with the work of George Watts, an English painter of portraits and sweeping allegorical scenes. While largely forgotten today, Watts was a major artistic celebrity during his lifetime and twice refused a baronetcy. From October 1884 to January 1885* The Nation *published no less than four major articles on Watts. One of the most effusive reviews (of Watts or any other artist, for that matter) is this unsigned piece.*

—

THE WATTS EXHIBITION

NOVEMBER 20, 1884

IN THAT ANALYSIS of all art on which alone can be founded sound and comprehensive criticism, we must separate, and weigh apart,

the various powers and sympathies whose combination makes the artist. There is no such thing as an abstract standard of excellence for the artist, any more than there is for the poet: the horizon varies—the man is dominant in one, the musician, the inspiration, in another. One is supreme brush-master, like Velásquez; another the mighty moulder, like Michael Angelo, and another the idealist, like Raphael; and therein is the sound application of the maxim, *De gustibus nil disputandum* for the world at large. Not this one, nor that, was the greatest artist, except to one who regarded his peculiar power as more wonderful because more completely foreign to him, the judge. To an ancient Greek, for instance, a Donatello might have been no surprise, but a Titian most certainly would have been a revelation. One critic remains always overcome by the method which is to another the simplest matter in art. One whose sense of color is imperfect may be quite insensible to qualities which stir to rapture a finer eye or more largely educated. And compared with any really great artist, the best critic is ill-educated and poorly qualified to pronounce on the supreme attainments of the art. The work of a painter like Watts, whose greatness no one can dispute, although critics may differ as to the grounds of the claim to greatness, and whose intellectual power is clear to the least competent judge of ancient and pure art, compels a certain modesty of opinion and a definite recognition of what art critics in general are too little disposed to grant—i.e., the right of a great artist to make his own language and impose the standard by which he shall be judged. A master in art does not accept the measuring-stick of the student— he imposes his own; and it needs no profound education to see that Watts's work is magisterial, and of that kind which in time creates a standard by which alone it can be rated. Like it or dislike it, one may, but the like or dislike will be a matter of education or constitutional competence, or both combined; but so far as it embodies certain views of the artist which are personal or not yet admitted among the canons of criticism, we are compelled to confess that, as indisputable master of his means of expression, the language of art, he is more likely to know what is the adequate expression of his ideal and the comparative value of the ideal itself, than any other man not equally master of the art.

And the proof of Watts's magistry is, to the most commonplace critical ability, evident in his portraits. There is a reported saying of Titian that all art was contained in a bunch of grapes, and in one sense all art may be said to be in a simpler subject, for a rose or a pomegranate which Titian would have painted would have betrayed all his technical powers as did Giotto's O all his drawing. But a

portrait shows not only all an artist's art, but all his intellectual power; and we believe it to be a rule without exception that the truest artists as well as the ablest painters of any age were the best portraitists. Watts's art is to us new. (i.e., as far as an art whose fundamental character is the same as that of the great Venetians can be said to be new), and so antipodal in all technical and ideal qualities to that which has been the chief pabulum of the American art student so long—the modern French painting—that it will be a great revolution in taste to learn to accept it as what it really is, higher in aim, nobler in its sphere, and really of a stronger quality of workmanship than any modern painting, except the pictures of Millet. Those who are not prepared to accept this judgment will do well to devote their study for a time to the portraits of the collection now visible at the Metropolitan Museum of Art, leaving in abeyance any opinion on the more elaborate works until they have seen how, in every sense of the word, Mr. Watts responds to the demands made of a great portrait painter, *the* portraitist of his day. The portraits are unequal, some less fortunate than others in the subject, and others betraying the varying physical powers of the painter, whose uncertain health has probably interfered with his work in more ways than one. In the most successful of the examples shown in this collection, such as those of Burne-Jones, Leslie Stephen, Mill, the Duke of Argyll, and Calderon, we are quite of the opinion that the present epoch of art has no other work to show which can be claimed to equal it. Not only are these revelations of character of the subtlest touch, which indeed it needs personal acquaintance fully to appreciate, but they are, as technique, of a *maestria* which the best French work does not approach. Compare, for instance, the portrait in the next gallery, by one of the greatest of living French portraitists, Bonnat, with its aggressive realism and melodramatic rendering of character, with that of Burne-Jones, by Watts, luminous and splendid in color, subdued in its relief, and dignified as a head of Titian, which it more resembles than does any other modern work. It is, indeed, painted substantially on Titian's method, with pure color over a modelled monochromatic under-painting. Look into the execution— large, vigorous, firm in touch, and yet light-handed—no uncertainty or timidity anywhere, with every modulation of tint as pure and transparent as water-color; with some experience in painting one can follow its method down to the under-painting. But take again the portrait of Leslie Stephen, painted in a single sitting, a rapid, certain execution such as no other modern has ever been able to combine with the quality of color here given. It is such an *allaprima* as we have not had since the great Dutch painters. The painting of

the brown beard with a thin, transparent tint rapidly brushed over a white ground, showing the canvas for all its lights, is a piece of execution not in the least ostentatious, but which Rembrandt might have been content with—it is as unaffected as though it had been the painter's signature, and as free. It is not only the highest quality of execution that this portrait gives us, but almost the highest quality of color (the highest being reserved for such painting as that in the Burne-Jones, where the method is more elaborate and adequate); with realization of character of which one can only say that it is, with all its rapidity, quite equal to the more studiously painted—i.e., so far as we are competent to judge, from long acquaintance with both originals. It is that absolute portraiture which embraces the complete individuality. The head of Motley, again, is a rendering of character that haunts one; the strangely searching eyes follow you around the room like a ghost-inhabited canvas. As a study of methods we have never had such a lesson in this country, for there is no prescription in it. It shows the results of many years' researches into the secrets of the *métier*, and if some are more successful in the completed result than others, it is impossible that it should be otherwise, because even in the hands of a master all methods are not alike good. If Mr. Watts had never painted anything but his portraits, we must have given him a position among the greatest painters of all nations and times.

In 1886 the pioneering French art impresario Durand-Ruel staged an exhibition of the works of Manet and others, no doubt to expand the market for their work (which he owned in great abundance) among New York's collectors.

—

EXHIBITION OF THE "PLEIN-AIRISTES."
APRIL 15, 1886

THE EXHIBITION AT the American Art Galleries is a fuller demonstration of the aims and daring of a certain revolutionary set than has ever been made in Europe, not excepting the collection there made of the works of Manet himself. The pictures are brought to us by M. Durand-Ruel, himself an interesting and apostolic figure, a friend of the new painters, who has impoverished himself to keep

their art alive, and who has paid for his sympathies at the expense of a considerable fortune. He is pointed out in Paris as a curious unworldly type, a dealer with a religion, whose estate has constantly been hypothecated to maintain the necessary advances to his protégés, and whose means have been greatly wasted in the interests of his propaganda. He is one who should be peculiarly sympathetic to the American people, since he has always been forward with practical recognition of American talent, and has made a flourishing market, for instance, for the fine Indian studies of our compatriot, Mr. Weeks, one or more of which are always to be seen in the brilliant windows of the establishment on the Rue Royale. As M. Durand-Ruel arranges, however, his ample exhibition for the eyes of the New Yorkers, it may occur to us to doubt whether he has the full courage of his convictions; he has made of the principal room a sort of choice showing of elected pictures, somewhat like the Square Salon of the Louvre or the Tribune of the Uffizi; and in this sifted company there are not to be found the specimens which most plainly show the ardors of the school; it is not there that we find the great "Bathing" (170) of Seurat—a picture which really seems composed in quite arbitrary camaïeu colors; nor the "Bather" (220) of Renoir, whose shadowless white flesh is a mere enlargement of some Eve out of an old missal. In this room of the elect, on the contrary, where the visitor gets his first impression, the pictures are comprehensible by anybody. And a rare lot of masterpieces they are; they are so good, and show so much sanity, that it is hard to suppose that their owner quite believes in them.

It is there, for instance, that we find the "Study" of Roll, the nude sunshiny girl leading a young black bull down toward her bathing-place. This painting was certainly recognized by artists as the most marvellous piece of technic in the last Salon; the flash and glare of noon-light on naked flesh, relieved with flushed shadows scarcely less luminous, was acknowledged to be masterly. The want of sympathy, though, with flesh as flesh, as a live tissue fed by circulation, was at the same time pointed out. "It is a glorious trick," said a competent artist, "but I feel as if the painter believed he was painting something dead—like sunshine on a patch of dried grass." In this room, too, is the "Marcean" of Laurens, a picture not at all in harmony with the school, a grand piece of sculptural repose in the midst of things whose business it is to flicker and flutter. Near it is the impressive Manet, "Faure as *Hamlet*," where the actor's neck, illumined by the footlights, is frankly made the high-light of the picture, rather than the face. Manet's "Still Life" (28), again, is one of the *natures-mortes* in which he was confessedly incomparable, and

is one of his best and most easily understood; it contains a specimen of his capitally scaly fish, and a cut lemon, surely the most cruelly sour lemon ever painted. The same artist's "Rochefort" shows mysteriously, as did the "Zola," how a likeness can be hit without the possession of a single vestige of drawing. The individual is there, yet not one of the forms is right. The young "Fifer of the Guard," another Manet, though more unconventional in treatment, a mere flash of red breeches in the air, awakens interest in the Philistine because it is gallant and youthful. In this room, too, is the most reasonable of the studies of Degas, the artist who wholly forsakes civilization to live in the other-worldliness of the theatre; it is the ballet in "Robert," with a foreground of correct spectators relieved against the white orgy of the wicked nuns. Again, in this saloon we perceive the Dumaresqs and John Lewis Browns which are the commonplaces of the picture market; and here is the large Lerolle, "The Organ"—a fair singer alone in the giddy space of the upper gallery, which somehow hangs visibly in the air in the emptiness and starkness of its proper elevation above a (supposed) crowded floor; and which is a canvas sufficiently evident and explicable to the world of plain folk; and alongside is the "Grand Toulon Road" of Montenard, whose white expanse, done in palette-knife work, successfully blinds the mere gallery-haunter's eye, and whose admirable painting may recall to American spectators the sunny beauty of Mr. Picknell's "Route de Concarneau."

These popular attractions, concentrated in the room first entered, are not the revolutionary explosions on which M. Durand-Rual has staked his faith. It is upstairs that the courageous visitor will find, in unprecedented profusion, the magnificent insanities of which, in their general manifestation, Gérôme said latterly: "Ah, mon ami, nous nageons à plein dans la cochonnerie!"

In 1888 two artists made their debuts at the Academy. Both Augustus Saint-Gaudens and John Singer Sargent would be known forever after as principal figures in the American Renaissance, and made a vivid impression on the author of this unsigned review.

—

from THE ACADEMY EXHIBITION

APRIL 19, 1888

THE SIXTY-THIRD ANNUAL exhibition at the Academy of Design contains 598 works in all. Only seventeen or eighteen of these are sculptures. The current exhibitions of American art are all alike in this respect, consisting almost entirely of pictures, and what few examples of the sculptor's art they may include are placed at random in the picture galleries, and are not even thought important enough to have a separate department in the catalogue. The present Academy exhibition, however, though the display of sculpture is comparatively meagre, shows a marked advance on its predecessors, in the superior quality of at least three of the pieces of sculpture which it contains. We refer, of course, to Mr. St. Gaudens's two works, and Mr. Warner's excellent bust of Mr. Alden Weir. The latter, which is here shown in bronze, was exhibited in plaster some years ago, if we mistake not, at one of the exhibitions of the Society of American Artists. It is well worth seeing again in its present form, in which its simplicity in the treatment of details and its fine ensemble are admirably expressed in the severer material. Mr. St. Gaudens's appearance as an exhibitor at the Academy is the most promising sign of the long-looked-for improvement in this the oldest and best-known of American exhibitions; and the presence of his two works, "Bust of General Sherman," No. 597, and "Portrait of a Lady—Medallion," No. 598, is of itself enough to make the sculpture exhibition a notable one. The distinguishing characteristic of the bust of Gen. Sherman is virility. It is, above all else, manly, firm, and vigorous. Granting that the sculptor was fortunate in his model, the treatment of this head calls for particular notice as to the way in which the characteristic is expressed. Here, as in the Lincoln, the sculptor has had to deal with a head which in no way suggests the classic ideal, and which has yet such a strong personality, such an individual style, that it produces very much the same impression of grandeur in looking at it as one receives from some of the antiques. In this treatment of an American type Mr. St. Gaudens was eminently successful in the Lincoln, which differs, however, from the bust of Gen. Sherman in having the whole figure with its fine, large

lines to give it a reposeful feeling—one of the best things about it—while the head of Gen. Sherman is all moving energy. The firm-featured visage of the soldier, even in such details as the wrinkles in the brow and the creases in the weather-beaten cheeks, and the stiff beard and hair, is reproduced with fidelity: yet details are so well subordinated to the ensemble that a breadth of mass is obtained which is rare enough in portrait busts to be especially mentioned here. The sample handing of the collar, and the excellent effect given by the half-raised lapels of the military coat, set the head off well, and the pedestal, with its laurel bordering cleverly incorporated in the design, is fitly proportioned.

In the "Portrait of a Lady" Mr. St. Gaudens has made a delicate relief in marble of a lady with a bridal veil. The figure is about one-third life size and three-quarter length, and is tastefully framed in a wooden plaque of creamy white, which accords with the colder tones of the marble. In these days of mere prettiness and over-elaboration of stuffs, which are such prevalent vices in what sculpture comes to the United States from Italy, it is worth noting that in this work of Mr. St. Gaudens, in which he has to deal with just such a subject as nine out of ten Italian sculptors of our time would be sure to make a botch of, he has treated his subject with a simplicity that forms its greatest charm. It is conceived and carried out in harmony with the tenets of the modern French school, with a certain delicate grace of his own which always makes itself felt in Mr. St. Gaudens's work of this class.

"Portrait of a Lady," No. 260, "Venetian Street," No. 213, and "Venetian Interior," No. 219, are three works by John S. Sargent. It is Mr. Sargent's first exhibition at the Academy, and it is a most brilliant début. Those who remember the portrait of a young lady in black with a rose in her hand, exhibited by Mr. Sargent at the Society of American Artists in 1888, or the two portraits of an elderly gentleman and lady in the Society's exhibition at the Metropolitan Museum in 1886, and retain the impression of quiet dignity made by contemplation of them, will perhaps receive something very like a shock at the first glance at the "Portrait of a Lady" at the Academy. The other portraits were reserved; this one is aggressive. In the former works, ease and grace were united with the most skilful painting, in this later one we find restlessness and a sort of brilliant dash, with painting quite as skilful as before, but with less of absolute truth to nature. The head, which is the principal thing of course, is quite the best part of this portrait, for the arms are none too well drawn and none too well modelled, and, like the chest, have more of the

false brilliancy of chalk or powder than the clear luminosity of a white skin covering palpitating flesh. But the head is fresh in color and thoroughly alive. One may not like over-well the treatment of the whites of the eyes, which are startlingly white, nor the cherry-red *taché* of the under lip, and one may object that simplicity is in these parts of the painting of the head pushed too far; but it is well to remember that the artist must have determined to sacrifice something of subtlety in order to obtain such brilliancy of effect. Brilliancy is the quality which best describes this portrait, and it is a brilliancy most becoming in this intensely modern piece of work. It has the air of modernness which pervades the drawing-room without a trace of the studied ceremony of the court, it is an attractive head that grows more and more real and living as you look. Considered purely from the point of view of the technician, it is one of the very cleverest things of the year's art.

Of the two Venetian pictures, though there is much delicacy of observation and subtle painting in the picture of the street, with its graceful figures, of the girl, whose pink dress is partly covered by her clinging black shawl, and the men at the doorway, we find more solid merits than these in the "Venetian Interior," No. 219. This picture of a sombre room, with its group of girls stringing heads in the foreground, is the work of a veritable artist. It is so essentially a work that appeals to those who are capable of appreciating art purely for its own sake, that it seems out of place on the Academy walls, where there is so much that is disturbing by comparison. Admirable in its quiet color scheme, full of atmosphere, and delightfully painted throughout, it is one of those pictures whose charm never fades and of which one can never grow weary.

• • •

Quite the most remarkable picture in the exhibition, and the one which is most impressive as the work of a strongly individual talent, is "Eight Bells," No. 370, by Winslow Homer. This picture of two seamen on the deck of a coasting vessel, quadrant in hand, taking the noon-day observation, the figures painted in sunlight with a heavy blackish sky of breaking clouds, and the rolling waves green and white-capped, forming the background, is painted in Mr. Homer's usual robust manner. The effect of the glinting sunshine as it flashes on the wet timbers of the ship and the wet oilskins of the sailor men is realistic to a degree, and has a rare look of truth. Compared with his "Undertow" of last year, it possesses all the qualities that made that picture so remarkable, yet in both composition and the purely technical side of painting it is a distinct advance on

it. Mr. Homer now stands in a place by himself as the most original and one of the strongest of American painters.

—

from THE FINE ARTS AT THE PARIS EXHIBITION

SEPTEMBER 19, 1889

William A. Coffin

Meanwhile, in Paris, the American painter and critic William A. Coffin had this to say about Monet:

There are but three pictures here by Claude Monet, all of them small and all good. It is not possible to judge him from these, however, for his painting covers a wide range, of which these three canvases are no more than fractional notes. There is an exhibition of about 150 of his works at the Petit Gallery in the Rue de Sèze, and it is necessary to go there to arrive at an intelligent understanding of his value. It may be said of what is shown in the Champ de Mars that it is landscape painting of great excellence, which differs widely in intention from the work of most of his contemporaries. It is essentially impressionistic, and is surprisingly real in the rendering of the effect of light. It does not go far enough to be complete, and it is not likely that it ever will, for Monet is now an old man. His influence is already apparent in some quarters, and it is as an important factor in the transition state through which landscape painting, or that part of it which is worth serious consideration, is now passing in France, that his work really demands our notice. Whatever comes out of it will have been strongly influenced by Monet and by Cazin.

The New York art world—and the world of Nation *art writers—was a rather incestuous one. Records show that Kenyon Cox was the author of the bulk of this unsigned review of the Society of American Artists exhibition but cite William A. Coffin as the writer of the following paragraph within the same review.*

—

from SOCIETY OF AMERICAN ARTS EXHIBITION

MAY 8, 1890

Kenyon Cox and William A. Coffin

Mr. Cox, who is always a prominent contributor to the Society exhibitions, and who is as notable as a painter of portraits as of the nude, is represented by three pictures: "An Eclogue," No. 40, "The Birth of Venus," No. 50, and "Diana the Huntress," No. 51. In the last-named two pictures, both small canvases, we find single female figures painted with his usual technical excellence, and in the "Diana" especially, a young and slander woman whose body is lithe and strong, great delicacy of line and modelling. It is, moreover, refined and just in color, and loses nothing—as the "Venus" does to some extent—by its background, which is quite in harmony with the figure and well disposed as to mass. "An Eclogue" is the most ambitious composition which the painter of "Poetry and Painting" and the author of the admirable designs for "The Blessed Damosel" has exhibited. Certainly no reproach of insufficiency or lack of thought can be brought against the picture, and it stands, perhaps, as the completest work in the exhibition. There are four female figures; the group is excellent in the great lines, and the landscape, simply treated, possesses the decorative element which painters of today so often seem to find it hard to attain. It is an excellent canvas to cite as proof that the art of *picture-making* is not lost sight of by some of our figure-painters, in these days when so much praise is given to the more dashing successes obtained by striving not for all, but only for one or two of the many things in the wide range of the painter's art.

In the very next paragraph, the review of the show continues, written by Mr. Cox:

In landscape-painting there are several distinctly marked and divergent tendencies. Apart from one or two surviving examples of the "brown-tree" period, American landscape painters, as shown at the Society's exhibition, may be divided into three schools, the naturalists, the sentimentalists, and the impressionists. At the head of the first of these are Mr. Coffin and Mr. Donoho. Mr. Donoho's

"Grouse Cover," No. 64, is a thoroughly manly and straightforward piece of work, firm in drawing and construction, and sufficient in truth of color. It lacks, perhaps, a little in charm and sentiment, but, on the other hand, his second picture, "November," No. 65, with its rising moon, goes as far in the direction of sentiment as is desirable, or as is compatible with his robust personality. Mr. Coffin's "The September Breeze," No. 46, is one of the best of these simply realistic landscapes. In method it is perfectly direct and simple, without affectation or mannerism, and the feeling of a sunny day in late summer is perfectly given. Its color is full and agreeable without being either black and sombre or glitteringly brilliant. It is quite unobtrusive and as simple as good-day, but nevertheless it is perhaps the best landscape in these rooms. His other picture, "A Pennsylvania Farm—After the Thunder Shower," No. 45, is marked by the same sincerity of manner, while dealing with a much more difficult and unusual effect. It would be hard to say whether it is better than the other or not; the effort is more ambitious, the success less unquestionable. At any rate, it is one of the notable pictures of the year.

4

"N.N." AND OTHER MYSTERIES

THE NATION'S *critics were often quite kind to those within their personal social circles, as this letter from the noted printmaker Joseph Pennell, written in response to an otherwise laudatory review by his colleague Kenyon Cox, demonstrates.*

—

SO MUCH THE BETTER FOR THE ART

DECEMBER 25, 1890

Joseph Pennell

TO THE EDITOR OF *THE NATION*:

SIR: Will you kindly correct the statement, on page 464 of *The Nation*, made by your reviewer, that I used photos for the drawings in "From Charing Cross to St. Paul's"? The drawings were made, every line of them, as Mr. McCarthy says, "on the spot," in the midst of a London crowd, without any photographic aids whatever.

YOURS RESPECTFULLY, JOSEPH PENNELL.

The Art Club of Philadelphia, Dec. 16, 1890.

[We hasten to apologize for what proves to have been a rash judgment. It seemed incredible to us that drawings so elaborate could have been done under the conditions indicated by Mr. McCarthy. That they were so done proves that Mr. Pennell is even more clever as an artist than we thought him.—ED. *NATION*.]

No one, however, was closer to Pennell than the critic "N.N.," who wrote reviews for The Nation *from 1890 to 1918. N.N. was Elizabeth Robins Pennell, Joseph's wife, who may have been the first regularly published female art critic in American letters. Until World War I, the Pennells lived mostly in London, where their circle included James Abbott McNeill Whistler, Ford Madox Ford, Henry James, and John Singer Sargent. Elizabeth Pennell often wrote signed pieces on cooking for other magazines (she amassed a collection of 431 cookbooks that she donated to the Library of Congress) as well as a number of travel articles for* Harper's, The Atlantic, *and* The Century. *Some of their titles—"Over the Alps on a Bicycle," "Italy from a Tricycle," "To Gipsyland," "The Witches of Venice"—suggest what an adventurous and unconventional woman she was, especially for the Victorian era. At least once in her many* Nation *reviews she slyly mentions a signed piece she has written in another magazine, so the cognoscenti of the period must have known who she was. Her identity, however, remained secret from most readers, which was especially useful when, now and again, she would write ever so briefly of the accomplishments of Joseph Pennell. While her food and travel writings are well-documented, her art criticism, being mostly anonymous, has not been given the attention it deserves.*

—

from THE NEW GALLERY

MAY 28, 1891

N.N. (Elizabeth Robins Pennell)

London, May, 1891.

IF AT THE Royal Academy cheap sentiment and indifferent technique prevail, at the New Gallery indifferent technique and affectation are the order of the day. In England genuinely good work is the last quality looked for in painting, or indeed in any branch of art. If a man be but eccentric or self-assertive enough, whatever he

may choose to do is pronounced great by the artless public. Where would be the fame of Mr. Irving but for his mannerisms! But for his repeated praise of his own methods, where Mr. Henry Arthur Jones's reputation! The Neo-Gothic primitives, with Mr. Burne-Jones as high priest, have ever been distinguished by their firm belief in themselves, and eccentricity has been their one standard of art. That at home they have achieved a popularity second only to that of the sentimentalists of Burlington House, therefore, is not strange. If their renown were confined to England, it would be matter of small surprise; but the result of their taking themselves so seriously is that they are sometimes accepted no less seriously even on the Continent. There was a curious proof of this not long ago. A group of artists in Brussels, supposed to represent all that is most modern and most thoroughly artistic in contemporary art, every year invite two English artists to contribute to their exhibition. This year their invitation included Mr. P. Wilson Stear, a member of the New English Art Club, a self-styled London Impressionist, and Mr. Walter Crane. The latter has also quite a following in Paris, not only as an illustrator of children's books and a designer, when he is often delightful, but as a painter, when he is almost always execrable. Of course, if a little of the work of one of the English medieval schools is seen, it does well enough, its very eccentricity appealing to the morbid modern craving for novelty and excitement; and on the Continent it is only this little which is seen. But it is another question in England, where, year after year, not one but all paint exactly the same subjects in exactly the same manner, until their affectations have become unendurable.

Certainly Mr. Burne-Jones's favorite tricks of drawing have never seemed more irritating than in the two large works he sends to the exhibition just opened at the New Gallery. His color, which is usually supposed to make up for imperfect draughtsmanship, worse perspective, and, in a word, for his every technical shortcoming, this year is extremely unpleasant. Both his pictures are inharmonious arrangements in blue and green, while in both his deformed rendering of the human figure is absurdly exaggerated. This is specially the case in the larger of the two, "The Star of Bethlehem," an adoration of the Magi, painted for the Corporation of Birmingham. The Virgin sits under an arbor covered with sweetbriar, like that which trails through the "Briar Rose" series. To one side is St. Joseph, in front the angel and the three kings, and all alike have the same impossible, misshapen neck, bent forward at an ugly angle; all, even the negro, have the same type of face; all are equally fleshless and bloodless, made apparently of parchment and wood. The detail,

particularly in the robes of the negro, shows remarkable patience and care, but, while it might be appropriate in a small cabinet picture, it is sadly out of place in a piece of mural decoration of such enormous proportions, meant to be looked at from a distance, in which the broadest handling would be the most effective. The unpleasantness of the color is the more marked because the design is almost the same as that which, a year ago, was reproduced in one of his fine tapestries by Mr. William Morris, who carried it out according to his own color scheme, using only Mr. Burne-Jones's drawing. The result was harmonious brilliancy very delightful to the eye, and it proved Mr. Morris the better colorist of the two.

The second large Burne-Jones picture is the "Sponsa de Libano" of Solomon's Song, with the South Wind and the North Wind blowing upon her garden. There is in the foreground the usual lay figure, graceful in pose according to the Burne-Jones convention; but the two Winds, hovering in the air, are the veriest abortions, and anything more grotesque than the Burne-Jones face, with cheeks puffed out and lips projected in the act of blowing, could not be, except, indeed, the sickly greenish-blue draperies, twisted and knotted in a great parody of the Japanese swirl of life behind them. To the initiated there is scarcely a brushmark but has its hidden or literary meaning; the lover of good painting, however, would prefer less literature and more art.

Of the immediate followers of Mr. Burne-Jones, none rise above mediocrity of imitation, while at least one, his son, Mr. Philip Burne-Jones, sinks to the abyss of puerility by endeavoring to paint "Earth-Rise from the Moon." The belief that art is concerned with any and everything rather than beauty of form, and line, and color, and perfection of workmanship is the curse of English painters; but none has it misled so hopelessly as the little group who teach—for the English painter of today is nothing if not didactic—that the highest duty of the artist is to paint, not what he sees, but what he imagines. This doctrine recently has been very eloquently expounded by Mr. Richmond. Portrait-painting he holds in contempt, because it is the mere rendering of real men and women. It is with the creations of the imagination alone that the true artist should be concerned; and he extols Mr. Burne-Jones because, when the latter introduces a casket, for example, in one of his pictures, he places no model before him, but paints one which he sees only with his mind's eye, this accounting, no doubt, for much that is otherwise incomprehensible in his drawing. Where a painter finds his models, or what he selects as subject, has nothing to do with the results which he chooses to show to the world: it is his affair, not ours. But when the spiritualism

or idealism or morality or eccentricity of his subject preoccupies him so entirely that he gives nothing else on his canvas, that he is wholly indifferent to the manner in which he expresses it, then it is within one's right to say, This is not art, and pass on.

—

from THE SALON IN THE CHAMP DE MARS

JUNE 25, 1891

N.N.

Paris, May, 1891.

THAT THE CRY at present, whether from Impressionist or *Décadent*, is all for individuality is not the mere *fin de siècle* affectation it may seem; for individuality is but the new name for style, and without style no man's work, in art or literature, can have the least value. If with artist, as with author, "to know when one's self is interested is the first condition of interesting other people," the second is to express this interest in a manner which will at once stamp one's creations with a character of their own. To succeed in this is to write, or to paint, with style, with individuality. It is because neither condition is fulfilled in the great mass of the paintings at the Champs-Elysées that that exhibition is so tedious and dull; the fact that their necessity is at least realized gives zest and life to the collection in the Champ de Mars.

The genuine individuality there, however, is not as great as it at first appears to be. The striking activity displayed upon the walls, in the contrast it presents to the passive acceptation of established conventions in the old Salon, may be mistaken for originality; but it is really the result of the astonishing influence two or three unquestionably original men have had upon the present generation of painters, and even upon a number of the older men who had already developed methods of their own. A few leaders, like Whistler, Manet, Degas, and, above all, at the present moment, Claude Monet, have revolutionized the art of painting in our day, and the Champ de Mars Salon is the most eloquent tribute to their power. To appreciate the wide difference between active imitation and true individuality, one has but to turn from the many sham Whistlers to the master himself, who, with his usual love for a jest, exposes the false pretences of the much-vaunted modernity in painting by send-

ing a portrait and a marine done twenty and thirty years ago, both masterpieces in their way, and both full of those qualities prized as the most modern attributes of art. They have been seen before, I think, and are too well known to be described in detail. One is the portrait of Miss Corder, or an arrangement in black; the other, a harmony in green and opal at Valparaiso. Whistler has never triumphed so completely.

But the influence of Monet is the most wide-spread. He, who has never exhibited, who does not exhibit now in the large shows, is here supreme. The open-air problems which he first sought to solve have become common property; the technical methods which he first employed assert themselves on every other canvas. Indeed, the two chief characteristics of this exhibition are the prevalence of *plein-air* experiments and the increasing tendency manifested to get one's effects by means of spots or points of color which fall into harmony when seen from the proper distance. It is curious, too, to note how the late popularity of pastels has in many cases exaggerated this tendency, painters seeking to produce in oils the effects peculiar to pastel. The results are anything but happy; Monet's method knows no half way between success and failure, while the painter who borrows his technique from the pastellist becomes either niggling, or else liny like Raffaelli, in whose work undoubted cleverness is marred by no less undoubted affectation.

James Abbott McNeill Whistler, one of the towering figures of the nineteenth century, was a close friend of the Pennells; in 1908, they wrote a biography of him and their bequest to the Library of Congress included some four hundred letters he had written to them.

—

MR. WHISTLER'S TRIUMPH

APRIL 14, 1892

N.N.

London, March 28, 1892.

IT WAS REVERSING the usual order of things when the French, for a fad, affect indifference to technique in art, and the English show signs of beginning to appreciate its value. But just as in Paris the *fin de siècle* Rosicrucians and Idealists, under Sar Peladon and Octave

Uzanne, are extolling idea and pretending to despise form in a work of art; in London, etchings by Mr. Whistler and Mr. Haden, from the late Hutchinson and Drake collections, have brought enormous prices when productions of popular Academicians have been resold for a song instead of the original thousands, while at the present moment all the world is rushing to see the exhibition of Mr. Whistler's paintings. It is true that the presence of New York art dealers at Sotheby's and Christie's had much to do with sending up the prices of rare states and prints, that the purchase by the French Government of the portrait of Mr. Whistler's mother has suddenly revealed to Englishmen that he might after all be a painter as well as an eccentric creature who indulges in amusing law-suits, and whose pencil is a clever weapon in newspaper duels. But no matter whence came the inspiration, the fact remains that just now artistic interest centres in the Bond Street Goupil Gallery rather than at Durand-Ruel's.

To those who look only for eccentricity from Mr. Whistler the show must be a disappointment. There are none of the yellow canopies and yellow walls, none of the fluttering butterflies and original schemes of decoration which his name suggests. The pictures, many in old and tarnished frames, hang on Messes. Boussod & Valadon's red walls as at other times do those of the ordinary exhibitor, and the visitor looks at them from the upholstered sofa of commonplace commerce. The one old Whistler touch is in the catalogue, in which he has collected, as of yore, choice criticisms by men of note who ridiculed him once but to turn the laugh now against themselves. The device lacks novelty, but just after his triumph in France it is natural, and appropriate too, that he should have his jest again at the expense of the blundering English critics who mistook the master for a mountebank. Ruskin's teachings are already obsolete, save in the provinces; Whistler's power has grown with the years.

But to those who delight in the artistic qualities of his work, in its beauty of color and form, its truth to the most subtle effects of nature, its perfect impressionism in the best sense of the word, the exhibition is almost inexhaustible in its interest. It is probably the most representative he has ever given. The forty-four canvases include all his most famous pictures save a few—the portrait of his mother and the "White Girl," now in New York, being the most notable among the missing—and also fine examples of his every period and manner: his earlier studies of detail, his Nocturnes and Symphonies, his wonderful portraits—of Miss Rose Corder, Miss Alexander, Carlyle, Lady Archibald Campbell—paintings so well known that it is useless now to do more than mention them. And

really to me the importance of this new exhibition is less in any special contributions to it than in the estimate which, as a whole, it gives of Mr. Whistler's true rank as an artist and of his influence over the younger generation of painters. There is nothing more striking about the collection than what seems, as one first goes through the gallery, its intensely modern character. With the Champ de Mars in one's mind, with the latest efforts of the New English Art Club fresh in one's memory, even not forgetting Monet's forty impressions of a haystack, Mr. Whistler's work might be thought the very latest outcome of the most modern movement in art. The fact is, that Mr. Whistler was a quarter of a century or more in advance of his contemporaries. 1855 is the date on one canvas, the greater number belong to the sixties. He was an Impressionist almost before the name impressionism in art had been heard. The world wondered when Monet a year ago showed those forty haystacks under forty atmosphere conditions, is wondering now at his almost as many treatments of a poplar tree to be seen at Durand-Ruel's. But what are most of Mr. Whistler's "Nocturnes" but impressions of the river as he watched it from his Chelsea window, looking over to the plumbago works and the church spire and up to old Battersea Bridge.

No wonder that not so many years ago everyone, with Ruskin, could find in his genius merely the insolence of a coxcomb flinging his paintpot in the public's face. He had not then had time to educate his critics. Indeed, his wide, far-reaching influence over modern painting is only beginning to be felt, and probably it has never been so emphasized as it is now by the collection at Goupil's. I have heard it argued that it was because he was so determined to force the public to see just those qualities which he considers most essential in art, that in his Nocturnes he has so often sacrificed all others to them. It seems unlikely to me that Mr. Whistler ever had the public—Carlyle's majority—sufficiently at heart to consider them at all. But had he been charitably inclined, and, for the benefit of the ignorant, willing to illustrate that now famous explanation of his in court that a Nocturne of his represented, not merely a morning's work, but the knowledge of a lifetime, he could not have done better than to exhibit, as he is doing now, those of his earlier canvases which are strongest in color and most filled with detail. At these no one can look and continue to believe that it was to conceal his weakness of drawing and indifference to color that he recorded in paint his impressions of twilight and night when form is vague and indistinct and color subdued. Pictures like the "Little White Girl," with the exquisitely worked out geraniums against the muslin gown; the "Gold Screen," with the girl in sumptuous Japanese robes, Jap-

anese fans at her feet; "The Lange Leizen—of the Six Marks," an arrangement of beautiful rich Japanese drapery and china; "The Music-Room," with the old-fashioned furniture and dress and the elaborate design on the window curtains reflected in the mirror; "The Balcony"—pictures like these are distinguished by a masterly rendering of detail which few of the old Dutchmen could rival, much less surpass, a beauty of color which the Venetians might have envied. And it is because he can, when he chooses, paint like this, that Mr. Whistler is qualified to create his Nocturnes, his Symphonies, his Arrangements—because he can, if he wants, paint the sea as brilliantly blue as the sky above, breaking in white foam on solidly handled rocks, as in the "Blue Wave, Biarritz," which Mr. Henry Moore might have taken as his standard, that he knows how to suggest the pale neutral grays and greens at the end of a dull day, just as the "Oyster Smacks" are pushing out from shore. It was the apparent simplicity of his methods, the supposed ease with which the work was done, that so disturbed and puzzled the critics—the fear that he was making a jest of them that led them to lose their tempers and seek to overwhelm him with the storm of their abuse through which he has steered his course so gayly. But the last twenty or thirty years have proved that what seemed child's play to the uninitiated was the most difficult problem to the student, a problem to be solved only by genius. And perhaps the most curious as well as interesting fact in connection with the Goupil Gallery exhibitions is the way papers and critics whose sayings are quoted in the catalogue have, with a few exceptions, veered around and consented to recognise something besides the jester in Mr. Whistler. For his next catalogue he will not have so many choice quotations.

But if his show reminds one of the influence he has had on the present generation, it also reveals the influences which have been most active in his own development. He himself has written his confession of faith in Velásquez and the Japanese masters. But even if he had not, his portraits, especially that of Miss Alexander, that fine harmony in gray and green, would be sufficient proof of the debt he owes to the one; while his careful study of the art of Japan is marked, not so much in his renderings of purely Japanese subjects, the "Gold Screen" and the "Lange Leizen," for example, as in the Chelsea Nocturnes and Symphonies, where a spray of leaves distinctly Japanese in character rises in the foreground, or figures as Japanese in treatment stand and walk on the banks of the Thames. Again, there is something of the feeling, something of the color scheme of Terburg, who might have been a student of Whistler's, in a portrait like the Carlyle. But, accepting all that the masters with whom he was most in sympathy

could give, he added far more of his own. For the truly original man is he who knows how to make his own use of great work that has been already produced, not to imitate it, but to create a new masterpiece out of the old material. Is this not exactly what the Rossettis and Swinburnes of our time have done in poetry—what the greatest men have done throughout the ages?

It should not be forgotten in America that Mr. Whistler is an American of Americans; it may therefore be appropriately asked, What has America done for him? It has treated him with—if possible—even more ignorance and coldness than England, this, of course, coming from the desire of the Anglomaniac to out-English the English. It is true that the "White Girl" is, or was, in the Metropolitan Museum, it is also true that the portrait of his mother went travelling around America, only to be bought in the end for the gallery which has the best chance of assuring immortality to the artists represented within its walls. There is in Boston, I believe, at the present moment a public building in process of decoration by Americans. Has Mr. Whistler, the greatest decorator America has ever produced, been asked to give distinction and importance to what otherwise may be only a striking failure! If he has not—and I am almost sure this is the case—it is at least not too late for Americans at once to endeavor to obtain from him one, if no more, of the few examples of his work still in his possession, which, however, before long may be distributed among galleries everywhere except in his native land.

After N.N. began reviewing for The Nation, *its art writing became decidedly Eurocentric, though always with an American readership in mind. It was as if the writers were acting as surrogates for readers who were unable to make the transatlantic crossing yet wanted to be as up-to-date and cosmopolitan as possible.*

—

POSTERS IN LONDON

NOVEMBER 15, 1894

N.N.

London, October 28, 1894.

AMONG COLLECTORS, THE poster is the latest fad; and this in New York as in London and Paris. Attention has already been called to

it and its artistic possibilities by an article in *The Century*. I do not doubt that shows of American collections have already been held. But the first English exhibition has just been opened at the Royal Aquarium in London. Within its limits, it is so thoroughly representative that from it one cannot fail to learn what has been done, and what is being done, to justify the prevailing interest in modern methods of street decoration.

I say within its limits, since, as the editor of the catalogue explains, the collection has been all but entirely restricted to French and English work. There is nothing from Germany, nothing from America—an omission much to be regretted. But, after all, it was in France that the artistic treatment of the *affiche* was first accepted seriously, and the French artists who have had such an influence upon the designers of other countries have been here gathered together in full force. On the unaccustomed walls of the Aquarium hang almost all of Chéret's most famous designs, almost all of Grasset's and Willette's. Lautrec challenges comparison with Ibels, Guillaume with Steinlen. So little favoritism has been shown that from Aman-Jean and the Rosicrucians you may pass on to Lunel and the Realists, from Anquetin to Bonnard, from Vallaton to Boutet-de-Monvel. Not one man of note or pretension has been overlooked. And the English series is as complete. If opportunity be given to study the really admirable achievements of Dudley Hardy and Beardsley, whose inspiration is frankly French, you are also confronted with the failures of Herkomer and Walter Crane, who, had they been less independent, might have proved more successful, while even the promising cartoons of men whose names are as yet unknown have been included. A collection so exhaustive must give to the least observant some idea of the present condition of the art it illustrates.

Due allowance may be made for indifferent hanging—the posters are unnecessarily crowded, without the smallest space between—and for the drawback of seeing indoors designs intended to be looked at in the open street, but even then it cannot be denied that the impression received is, in a measure, one of disappointment. For, though just now in Paris the system of outdoor advertising is carried to such an excess that one foresees the inevitable reaction in the immediate future, the exhibition proves indisputably that artists are only beginning to realize what a poster should be. There was a time, but two or three years ago, when Chéret was believed to have brought it to the highest possible degree of perfection. He came honestly by his reputation; for if he was not the first to design posters (you may see now at the "Exposition du Livre" examples published

in France far earlier in the century), if he was not the first to con-
sider their artistic as well as commercial requirements (Fred Wal-
ker's poster for the "Woman in White," hanging at the Aquarium,
and Herkomer's early attempts in the same direction, anticipated
him in this respect), to him still belongs the credit of having created
a demand for the artistic, as opposed to the purely commercial,
variety. His designs, however, already seem miniature and experi-
mental when compared to the work of men whose master he vir-
tually was.

The reason is not far to seek. There are three all-important es-
sentials to be remembered in designing a poster; it must draw and
hold the attention in the very streets and squares and stations
where the attention is most readily distracted; it must fulfill its com-
mercial purpose by explaining its meaning at a glance; it must ac-
complish its artistic end by its beauty of color and line, and the
manner in which the given space is filled. What happens when the
commercial needs are unduly emphasized, it is needless to point
out: whoever has waited for a train in an English railway station, or
passed by the hoardings of London streets, knows to his cost. But,
so far as the poster is concerned, failure is well-nigh as disastrous
when the artistic interest preponderates. Take, for instance, Aman-
Jean's fine design to advertise the Rose-Croix exhibition, what did
its loveliness of line and tenderness of tone avail when it was called
upon to compete with gay announcements of a new pill, and
"florid invitations to the Moulin Rouge" Or, again, take two of the
most delightful examples in the collection: Bonnard's *affiches* for
the *Revue Blanche* and "France Champagne"; in the first, a delicate
harmony in gray, the inscription (commercially foremost in impor-
tance) is so fantastically lettered that it is all but impossible to read;
in the second, the tender ambers and subtle curves and twirls with
which the feeling of champagne has been carried throughout
would not tell in the least when seen from the necessary distance.
Chéret has not erred by going to either extreme, but in the ugli-
ness and vulgarity of lettering he has made too great concession to
commerce—in the elaboration of detail, too great concession to
art. His "Loie Fuller," with the swirl of its rainbow-hued drapery; his
Saxoleine, with its well studied rendering of reflected light, his
"Pastilles Géraudel," with its gayety and grace—all too familiar now
to need description—could not well be surpassed. But even in
them is something of that confusion, due to excessive detail, which
is now felt to be a defect in the majority of his designs, as well as in
those of Grasset, for all their stateliness and elegance. Lautrec,
more almost than anyone, has shown what can be done by intelli-

gent leaving out. His simple, flat surfaces, his sharp, well-defined outlines, his broad masses are, in the end, far more effective than Chéret's careful modelling and lingering regard for tone and atmosphere. The simple figure of "Aristide Bruant," for example, silhouetted against a dead-white background, leaps out from the wall; while Chéret's nymphs and dancers, by contrast, become confused and shadowy. Certain violence there must be, thus, Lautrec's own *affiches* for "L'Estampe Originale" and "Confetti," charming as they are, because of their more refined color and composition, lose, when placed by the side of his "Moulin Rouge" and brutal, but fine, "Reine de Joie."

The importance of the silhouette in the poster, thanks chiefly to Lautrec, is being more and more realized—the younger men are using it almost exclusively. Certainly, the best designs in the show are those in which it has been adopted. Probably there is not one that answers its purpose as advertisement better than Gausson's "Lessive Figaro." In the well known *affiches* of Ibels and Guillaume and Steinlen, the silhouette is also accentuated; and again, though not quite simplified enough, in Willette's girl in purple against a rich wall-paper, which she might be supposed to advertise rather than the cocoa she is meant to force upon you.

But while a tremendous stride in advance has been made since Chéret led the way, the cleverest and most distinguished. French designers have still much to learn. They do not seem as yet to understand, as the Japanese understand, the value of beauty and grace in long flowing lines; they have not yet developed that wonderful sense of proportion and balance which delights in the simplest kakemono and woodcut. Nor, indeed, have they mastered the first principles of artistic lettering. Boutet-de-Monvel alone realizes that the inscription should be part of the design, and this realization makes his little red-and-rose poster for someone's dentifrice far more satisfactory to the eye than the more ambitions "Bruant" by Lautrec, or "Yvette Guilbert" by Ibels.

Lettering really is better appreciated in England. Merpes and Steer both turn it to good account in the posters designed by themselves for their own shows, posters, unfortunately, which have no other merit. But the English designers mostly reveal the same virtues and vices as the French, from whom they have borrowed so largely, and this is the reason why I may seem to have less to say about them. Of course I do not mean Walter Crane, who, pursuing his own methods and filling his poster for the Paris Hippodrome with detail that would not be out of place in an illustration, is so absolutely ineffective that, had I not consulted my catalogue, I should not have dis-

covered his presence—nor of Prof. Herkomer, who, though to be applauded as a pioneer, has not known how to express his sometimes excellent ideas. But Dudley Hardy, in the yellow figure, with its amusing angular outlines, that announces *ToDay*, in his mass of red skirts that advertise the "Gaiety Girl," like Lautrec, gains his effects by the strength and simplicity of his silhouette—like Lautrec, mars it by the commonplace of his inscription. And so again with Greiffenhagen, whose vivid red figure against yellow proclaims the existence of the *Pall Mall Budget*, and with Raven-Hill, who introduces "Pick-Me Up" by somewhat similar means; and so again with Beardsley, who balances his simple spaces of color on a white background with a dexterity that lends new interest to the "Pseudonym" and "Autonym Libraries," to which he invites notice.

However, so far in England nothing at once so original and effective has been done as the designs of Messes. Beggarstaff, the name by which the two young artists choose to be introduced to the public, and so far, naturally, no man of business has had the courage to publish them. These designers also rely upon the silhouette, but they have simplified it still further. Thus, in one cartoon, for the "Blue" of the first manufacturer who has the sense to see its good points, a black figure is outlined in white against a black background, and the only color is the one spot—a large spot—of blue in the tub at her feet. It is badly hung in the Aquarium, and the Steinlens and the little Gausson are not far away. But it asserts itself with unmistakable power, and is as distinguished as vigorous. The other three are only less striking, and the artists, once the chance to decorate the hoardings is offered, seem destined to inaugurate a new departure in the art of poster-designing.

—

WILLIAM MORRIS

OCTOBER 22, 1896

N.N.

London, October 6, 1896.

IT CERTAINLY SEEMS, as Mr. Gosse wrote in the *St. James's Gazette* immediately after the death of William Morris, "as though the dying century were bent on sweeping its stage clear of all its greatest figures before it makes way for its successor." Perhaps one realizes this

the more acutely now since there are few of its famous men it could so ill afford to spare as Morris. Of all the group of artists and poets with whom he must ever be identified, his is by far the most pictur-esque and striking personality, his the strongest influence. If Ros-setti's name has come to be a symbol of picturesqueness, it is only for the elect. If Swinburne's long seclusion in this age of noisy ad-vertisement has its element of romance, future generations will ap-preciate it more keenly than the present. But William Morris was a man ever before the public, known familiarly to the many as to the few; he was to be found always in the thick of the fight, commercial or political, literary or artistic. And once seem, once known, he was not easily forgotten. His personality impressed itself upon you whether, unbelieving, you listened to him preaching the poetry of socialism in the little, bare, whitewashed hall at Hammersmith, whether you watched him—a short, sturdy figure in blue—leading the socialist procession through the streets of London, or whether you sat under him, still unbelieving, in the lecture-room of the Arts and Crafts Society. You might disagree, you might disapprove; you could never remain unimpressed, unmoved. And there is as little question of the influence he exercised; if any vital Pre-Raphaeltism has survived, it is due to him rather than to the original Pre-Raphaelites themselves.

The strength of his personality exerted itself from the very begin-ning. He was somewhat younger than Rossetti—he was sixty two when he died—belonging, rather, to the generation of Burne-Jones, his friend and fellow-undergraduate at Oxford. But he had not left the university before he had become one of the most gallant and active champions of the special cause advocated by the Pre-Raphaelite Brotherhood. It was he—for he first studied to be a painter—who, with Rossetti and others, decorated the Union, thus proclaiming the new gospel in the very stronghold of learning; an easy matter, however, where every new thing (in art, at least) good or bad, is accepted with equally rapturous applause. It was he who not only contributed to the *Oxford and Cambridge Magazine*, which aspired to be a second *Germ*, but financed it for a while, its chief prop and support. It is just here, I think, that one great reason of his strength and power is found. Morris was a rich man, the son of a prosperous merchant, really one of the class he despised. It was within his means to put to a practical test, to give definite form to many of the doctrines which Rossetti, Ford Madox Brown, and Burne-Jones could never have carried beyond the stage of theory. His capital, as well as their designs, was essential to the establishment of the house of Morris, Marshall, Faulkner & Co., which helped

more to spread Pre-Raphaelite ideas than any work done single-handed in the studio. But for Morris, despite Faulkner, who also had some money, the chances are the firm would never have come into existence, and all the Victorian horrors of horse-hair and antimacassars and war-flowers under glass cases might have lingered on to the very end of the century.

But do not let me be misunderstood. Money alone could have accomplished nothing; money, backed by a good design, could have been productive of but little more. But Morris brought to the enterprise the still more splendid, the still more useful gifts of energy and enthusiasm and daring, tempered by honest commercial ability and sense, inherited from his merchant father. In a word, his was the talent for success, the genius for making things go, that rarely deserted him through life—never, one might say, except when the spirit of adventure and poetry led him to play the socialist.

As an artist I think it is likely that Morris will be remembered less for his own personal accomplishment than for the enormous influence which his position enabled him to extend from his immediate friends to the general public: first, through his shop, and, later, through the Arts and Crafts Society and his printing-press. He made, it is true, designs for wallpapers and carpets and embroideries. He was the fine colorist who converted Burne-Jones's weak black-and-white cartoons into gorgeous pieces of tapestry and glowing, jewel-like stained-glass windows. But the list of his designs might be longer than it is, and it would still be true that it was not so much in these that he displayed his originality (indeed, they were but so many examples of his sham mediævalism) as in the great revolution he worked in the decorative arts of England. If this meant merely that the few who could afford it adorned their houses with "Morris papers" and "Morris hangings" and "Morris chairs" (which, as a rule, were not "Morris chairs" at all), the gain would have been too small to prove worth recording; but he did much more than this. He set people thinking on the subject of decoration, he awakened them to the hideousness of the standards then accepted, he stimulated them to fresh efforts and new departures. His large and often wholesome influence reveals itself not exclusively in designs and furniture that bear the Morris stamp, but in decoration which he probably would have been the first to condemn, for no man was narrower in his artistic creed, and, though he might be responsible for an artist's escape from the yoke of the ugly, he was not therefore ready to accept that artist's idea of the beautiful. If the exhibitions of the Arts and Crafts Society hitherto have contained all to which he was

willing to lend his approval, they have by no means exhausted the work that is as truly the outcome of his influence.

With the Kelmscott Press at Hammersmith it is the same as with the shop in Oxford Street. Attention has been called here too recently to the merits and faults of the books he printed for these to be criticised anew. They might be an improvement upon the old printers' work; it is not so certain that they could complete with the modern printer's accomplishment. And yet Morris, even before he had established the Kelmscott Press, from the time Reeves & Turner published his "House of the Wolfings" (1889), roused printers and publishers and artists to a realization of the possible beauty of type and margins and spacing and title-pages, even as he had forced the public to prize beauty in furniture and all utensils in daily use.

It is too curious a fact to be ignored in any estimate or appreciation of William Morris as an artist, that, while he initiated so healthy a general reaction, his immediate influence was often unfortunately bad. Decorators who have based their style essentially upon his have been as apt to tumble into the pitfall of affected commonplace as the painters who have lavishly copied Rossetti. But it is, above all, in the decoration of books—for he was impatient of the term illustration—that his teaching and example have been most fatal. Surely, he could have no worse crime to answer for than the creation of the Birmingham School! The trouble was that he was for long one of the Examiners at South Kensington; and students, and, more important, masters paid by results, knew well that nothing had so good a chance, if any chance at all, as the drawing made with the Kelmscott book as a model. The result was that the younger generation of designers have all devoted themselves to the manufacture of the Morris border, the Morris initial, the Morris woodcut, not because their sympathies have lain in that direction, not because they have found therein the most natural method of expression, but simply because their object was to win prizes in the schools, and, afterwards, at the publisher's and bookseller's, to cater to a passing fad. A worse master, really, than Morris could not well be imagined, since in his books he was always the imitator, never the original man. And, moreover, no one could have been narrower and more prejudiced in the old standard thus revived. Good printing, good decoration, for him, ended with Albert Durer, who was as dangerous a red rag to him as any modern illustrator. However, there is no doubt that Birmingham will pass away—it is passing now—and that the good effect of his propaganda will endure. Even as I write I hear that the Kelmscott Press will be stopped for ever; a monument, as

it were, to the distinguished man who founded it. This is fortunate. His books, interesting as the intelligent, if mistaken, experiment of an artist, will survive. The foolish phase to which they gave the initiative will come to an end, as Morris, of all men, would have had it cease. He reserved his approbation for work done in accordance with his teaching, but he also withheld it when that work was too successful a tribute. Before he died, had the law allowed it, he would have sought legal redress, it is said, against some of the too flagrant imitations in Boston and Chicago.

If I have spoken, so far, wholly of Morris as an artist, it is because I believe that it is as an artist his greatest work was done. Already, in the few days since his death, his English critics have not been slow to point out that his later achievement in verse never fulfilled the promise of "The Defence of Guenevere." Mr. Gosse, the most lavish in his praise, has likened the "Earthly Paradise" to Spenser's "Faerie Queene"; the chief point of resemblance is, I fancy, that few people have read either poem to the end. William Morris was too fluent, too facile. It may be wonderful that, writing so much, he wrote so well: but the pity is that, writing so well, his fluency gave him no chance to write still better. He has often been found fault with for his War-dour-Street English, and the reproach is not unwarranted. It is a question whether even the next generation will preserve a taste for such long-winded, consciously archaic stories as "The Roots of the Mountains" and the "House of the Wolfings." But here again, were there but space, it would be interesting to trace his influence for good even when wrought by that work which contributes least to his own reputation.

On the other hand, as a Socialist, I think he will be more admired in the days to come than at the present moment. Now, one sees only the weakness and evils of the cause into which he threw himself heart and soul, only the conceit and stillness and self-advertisement of too many of his "comrades." And never by argument or eloquence could he make good his claim, for he was quite the most illogical and fanatical of speakers. But posterity will remember only the romance of his crusade, will see his political career only in the poetic light through which he himself saw it always. For, perhaps, he was never more the poet, never more the artist, then when he strode through the streets at the head of his weak-kneed, timid followers, when he thundered from his platform at the Hyde Park or Trafalgar Square demonstrations, when he argued with the rabble of Tower Hill or Edgeware Road. It was of art he was ever thinking in his long campaign against capital and commercialism. Change the social conditions, and art would flourish as it had never flourished before—

that was his great doctrine. And so it was always in the cause of art he labored, even on that famous Sunday when he descended with the mob upon Westminster Abbey, and all London held its breath, fearing to see renewed in its midst the worst vandalism of the Paris Commune. It is natural that men who feared the follies and worse to which his fanaticism might lead could have no sympathy with his heroism. But in the history of the nineteenth century, yet to be written, he will figure as a very Savonarola among artists.

During this period, Bernard Berenson, the connoisseur and art historian generally credited with pioneering scholarship on Italian Renaissance painters, and also known for his shadowy dealings in helping American robber barons assemble their art collections, wrote several pieces for The Nation, *all on aspects of Italian art.*

—

BOTTICELLI'S ILLUSTRATIONS TO *THE DIVINA COMMEDIA*

NOVEMBER 12, 1896

Bernard Berenson

Florence, October 22, 1896.

THE PUBLICATION IN a form almost popular of Sandro Botticelli's drawings for Dante's *Divina Commedia* has long been called for, and is at last accomplished. Something has been lost in reducing the illustrations to half the size of the originals. One or two have become quite inextricable in their entanglement, and the first sketching in with silver point has nearly disappeared. But these slight losses are more than recompensed by the comparatively small price and the extreme handiness of the present edition, bound in book form. Dr. Lippmann's introduction and commentary leave little or nothing to be desired in the way of information or elucidation.

To many these illustrations will be disappointing. They have heard that Botticelli was a great artist, and they expect him to give them, to an even intenser degree, feelings of the kind and quality that they have had in reading Dante. None of the gloom, the chill dread, the passion, the despair, the luridness of the "Inferno" will be brought home to them as they turn over Botticelli's designs. They will find scarcely an attempt at dramatic expression; they will find

many more instances of the unconscious grotesque than of the re-
alized sublime; and, throughout, conceptions as infantile as Fra An-
gelico's, but seldom so winning. Nor, taken as real illustration, are
matters much improved in the "Purgatorio." There is no trace in
Botticelli of the feeling of hope and convalescence and early morn-
ing which penetrates you as you read these cantos of Dante. And
Sandro's "Paradiso" fails no less in communicating the one essential
quality of this part of the poem—its sublimity. Here again the artist
remains shut up in the Fra Angelico world. All in all, Rossetti's
"Blessed Damozel" would have been a fitter subject for Botticelli's
fancy than Dante's *Divina Commedia*.

As illustrator, then, to the *Divina Commedia,* Botticelli, it must be
acknowledged, disappoints, partly because his genius was not at all
Dantesque, but chiefly because the poem does not lend itself to
satisfactory illustration. Although Dante describe with a vividness
and tangibility surpassing all other poets', his effects seldom result
from an appeal to vision only. Yet visual form, so small a part of the
poet's outfit, is the illustrator's entire tool-chest. All his effects must
come through it, and can come by it only. Think of making mere
outline, as in the case of Botticelli's illustrations, convey all the man-
ifold sensations, all the passions and emotions, which rapidly suc-
ceed each other in Dante's verses! One might as well attempt to
render Beethoven's Ninth Symphony or Berlioz's "Dies Irae" with
no other instrument than the French horn.

And even if it were possible to make outline convey feelings as
full and penetrating as Dante's, which episodes should the illustrator
choose? They follow each other in bewildering number, with no
connection in the realm of visually representable things, held to-
gether by nothing more tangible than the emotional tone of each
canto. The fact is that Dante is not a great epic or dramatic poet.
He has none of those stretches of culminating narrative, none of
the working up to a climax, which lend themselves so admirably to
the exercise of the visual imagination. In spite of the fact that he
wrote one of the longest real poems in existence, and that this is
apparently a narrative, Dante as a poet is great only as a master of
the lyric, or (to make a concession) of the "dramatic lyric." Now the
lyric is beyond the reach of the illustrator.

Dante does not lend himself to illustration; and, even if he did,
Botticelli was not the man for the task. Then, pray, what is the value
of these drawings? The answer is simple enough. Their value consists
in their being drawings by Botticelli, not at all in their being draw-
ings for Dante. And at this point the honest showman should warn
the public that a drawing by Botticelli is something very peculiar. It

does not so much as attempt to be correct; it is not a faithful reproduction of anything whatsoever. A hundred "artist-journalists" now at work publish daily drawings which are far more exact, more lifelike, more clever, and more brilliant than any you will find in Botticelli's designs for the *Divina Commedia*. If that is the only kind of drawing you care for, you will be no less disappointed in Sandro than if you went to him for interpretative illustration. His real place as a draughtsman is not among great Europeans, but with the great Chinese and Japanese, with Ririomin, Haronobu, and Hokusai. Like these, he is a supreme master of the single line. He gives it a swiftness and a purity which in the whole world of sensation find their analogy only in some few ecstatic notes of the violin, or in the most crystalline *timbre* of the soprano voice. His universe was of the simplest. It consisted of things that could and of things that could not furnish themes for rhapsodies in swift, pure lines. Dante happened to find himself among the blessed in this simple division, hence Botticelli chose him as a subject for his art. These illustrations required of our artist no coloring—with him always an afterthought— and scarcely any stereotyped composition. Here he could be free as nowhere else, and here, therefore, we see him in his most unadulterated form. The value of these drawings consists in their being the most spontaneous product of the greatest master of the single line that our modern Western world has yet possessed.

Now let us look at a few of these designs, beginning with the "Inferno," where Botticelli, feeling himself most weighed down by the story, is least himself. What do we see as we turn to the drawing for the opening canto? In the first place, a fretwork arrangement of exquisite pen strokes, by itself as pleasant as light on rippling water. Looked at closer, this smiling fretwork becomes a wood of graceful stems, whose branches cross and recross like the rapiers of courteous fencers. In rhythmic balance to the mass of this dainty forest you have a tangle of flower-bushes. Between, romp three heraldic beasts, performing a figure with four men whose long cloaks fall into lines as swift and almost as pure as those of the tree stems. I defy anyone to read gloom and terror into this piece of lineal decoration. Or turn to the illustration for Inf. xiii [*Inferno*, Canto XIII]. Again a marvellous fretwork of lines which, seen closer, resolve themselves into a tangled wood where decorative dogs leap at decorative nudes, while even more decorative harpies sit upon the branches. We are in the pound of the suicides, but it would take a child with a feverish imagination to get a shiver out of this design. I will not deny that, in other sheets—indeed, in many of those for the "Inferno"—there is somewhat more correspondence with the

text, but I doubt whether it ever is enough to be satisfactory as expression, while it is precisely in such drawings that the artist is least satisfactory as pure art. What does occur at times is a fortunate accord between the way Botticelli would naturally treat a subject and Dante's feeling about it. This occurs rarely in the "Inferno," where it would be hard to instance another example than that of the hypocrites under their copes of lead (singularly Japanese, by the way, in movement of line); but, out of the "Inferno," as we shall see, this accord gets more and more frequent.

But Botticelli's strength was not in arrangement alone. He was, above everything, master of the line in movement. He loved to make it run and leap, to make it whirl and dance. He was truly great only when he had a theme which permitted the exercise of this mastery. Such themes the "Purgatorio" and "Paradiso" offered him in plenty. Examples become too many to cite, and I shall confine myself to a few of the best. You will rarely see a frieze of greater decorative beauty than is formed by the nudes leaping into the purgatorial flames, as if they were the waters of the Fountain of Youth, while Virgil and Statius and Dante pass by discoursing on the relation between soul and body. This is the illustration to Purg. xxv, and, after this one, every consecutive drawing becomes, if possible, more and more beautiful. The flames leap even higher, and the nudes are worked in with them even more harmoniously. And presently you come to a design whose beauty keeps you spellbound: rare trees shoot up with exquisite grace, and between them you see the poets breathing gladly and gazing at the pure ether. One lady, with fascinating movement of figure and flutter of drapery, is gathering flowers, and another addresses the poets. Are we in Dante's terrestrial Paradise, or in Poliziano's Realm of Venus? No matter which, it could not be more lovely. This is followed by a succession of scenes in which Botticelli's talents find their completest satisfaction: the car of the Church, the grandly draped elders, the dancing, flower-scattering angels, the torch-bearers, the streaming smoke, the heraldic beasts—each and all so many exquisitely drawn laughing, leaping, whirling lines in wonderful arrangement. But the crown of the whole work is still to come: it is the design for Par. i. The daintiest trees ever drawn wave softly over a smooth meadow wet by the water of Eunoe's placid stream. Behind the rare leafage of the reed-like trees, Beatrice and Dante, with faces of ecstasy, are wafted gently up to the higher spheres. To convey in words a sensation corresponding to the singular beauty of this page would require Dante himself, or perhaps Shakespeare or Keats. Line, movement, and pattern can go no further. None of the remaining illustrations can be

put beside this one; yet they are all lovely. The type of them is the one for Par. vi—a pure circle studded with exquisite flamelets, Beatrice pointing upward as she floats, and Dante with his face and hands expressive of the utmost ecstasy. The flicker of the flamelets, the flutters of the draperies, the bending towards each other of the two figures, with the whole enclosed in a pure circle, from one of those happy patterns which, for the very reason of their childlike simplicity, one can gaze at for hours, being soothed and refreshed.

To the few scores, or let us hope, hundreds the world over, who feel the difference between art and illustration, as well as between art and fidelity to nature or mere dexterity. Dr. Lippmann's publication is one of the great events of recent years.

Back in London, N.N. endures a retrospective of Victorian art, which she hardly considers to be a Renaissance.

—

ART IN THE VICTORIAN ERA

JULY 1, 1897

N.N.

London, June 11, 1897.

THIS HAS BEEN in London a season of Victorian reminiscences. It was inevitable that the sixtieth anniversary of the Queen's accession should be the signal not only for Jubilee celebrations, but for a general summing up of the chief events that have given distinction to her reign. You cannot take up a paper or a magazine just now without coming upon memoirs and recollections, sketches and histories of the last sixty years. And while publishers, perhaps superflously, groan over the dull times the Jubilee has brought with it, they could not but admit a large sale for the books that relate to the same period. We have had the personal story of the Queen, with all the familiar and domestic incidents dear to the heart of the sentimental Briton. We have had the story of her prime ministers and the great soldiers of her United Kingdom and her colonies. We have had the survey of Victorian literature and Victorian drama. And space has even been found for Victorian art, which might have been left out of the reckoning, and the public relied upon to accept the omission with equanimity.

But, really, the record of art should have proved the easiest of all to make. Here was a chance, not for statement of fact alone, but for actual display of accomplishment, where art is concerned, the walls of the exhibition gallery are always more eloquent than pages of printed description. The chance has not been overlooked. Among the innumerable other Victorian demonstrations, we are having the Victorian picture show, and, in two cases at least, it has been prepared with an apparent effort to represent seriously the entire period in question. One is at the Guildhall, the city corporation having of late busied itself with art and begun to give admirable loan exhibitions of earlier work, at a time when the Royal Academy seems to have wearied of the old masters it was once its pride to show in midwinter. The other is at Earl's Court, where the Gardens that have been, in turn, American and Italian and Indian and much else besides, have very naturally become Victorian in deference to the all-absorbing interest of the moment.

To be honest, nothing could be more disappointing than these two shows, each in its own way. The galleries at the Guildhall are small, but still, by careful selection of the pictures that best illustrate the important movements and tendencies of the last sixty years, much might have been done. It is hard to say, as it is, upon what principle the selection has been made, but the result is a collection that tells little except that there were a few painters of landscape and architecture at the beginning of the reign; a group calling themselves Pre-Raphaelites towards the middle; and, at the end, a handful of Royal Academicians of no special talent or distinction. At Earl's Court matters are worse; probably because there more pictures have been gathered together to as little purpose. Indeed, the very name Victorian, which has come to be a synonym for all that is meretricious or common, which is hopelessly associated with ugliness, has had a most disastrous effect upon the entire exhibition and its Gardens. I speak the more feelingly because in the new (the July) number of the *Century* I am rather lavish in my praise of the same scene of summer entertainment. However, last year and the year before it was nominally Indian and, therefore, according to Shandyan philosophy, not doomed to commonplace. But the court, that was then very lovely, with its great white spaces and simple lines of light, is now as ornate and garish as the most ardent Victorian heart could desire; the illuminations, that then were so harmonious because of the simplicity of their scheme, are now all discord and clashing of many colors: while high above the Garden, triumphant tribute to the commercialism of the Victorian age, the great wheel thrown out

a flaming advertisement against the sky. What could be more appropriate?

It is hardly a surprise, after this, to find that the pictures in the gallery are chosen at haphazard. A faint effort seems to have been made to follow some sort of historical sequence, but with most indifferent success. Here you come upon a Turner, and there upon a few water-colors by Cotman, as a reminder of the artists who were at work when the Queen came to the throne. Here a few etchings by Mr. Whistler, a few prints by Turner's engravers, a few drawings by Charles Keene, or for Dalziel's Bible, serve as scanty proofs of the wonderful development in the art of black-and-white during the Victorian era. But the rest of the collection consists chiefly of many and awful portraits of the Queen, who, whatever her virtues, cannot count love or patronage of art among them; and of perhaps the most trivial and mediocre canvases which the modern Academician has ever hung upon the walls of Burlington House. Never elsewhere has the failure of the Academy to preserve a high standard or respect its own great traditions been more pitifully exposed.

And now, to realize the tremendous interest that might have been given to these two exhibitions, consider for a moment what the history of Victorian art has been. The very word, I know, suggests all the abomination of sham marble and horse-hair in house decoration, of the crinoline and chignon in costume, of anecdote and sentiment in painting. But these things mark a Victorian interval, not the whole Victorian period, and the revolt against them, affected as its main manifestation was thought at the time, has proved the healthiest movement in art of the second half of the century. It is true that, in 1897, the outlook was depressing enough. The days of the great portrait-painters, the direct descendants (it might be said) of Van Dyck and Rubens, were over, Sir Thomas Lawrence, the last, had died in 1830. The men who had brought landscape painting to a perfection never before dreamed of, men who, with Hogarth, were the most original painters England had yet produced, were disappearing one by one; Bonington and Crome had been already dead for a decade or more, Constable's career came to an end the very year that the Queen's began; Cotman was to follow in 1842, and Turner alone was to survive long enough to take his place for us among Victorian artists. But he was ever a man apart, no favorite with his contemporaries, no influence with the younger generation. Were I writing at greater length, I might add a few other names— Muller, Barker, David Roberts, Linnell. But the painters, in 1837, already or fast coming into evidence, fast winning popularity, were

Mulready and Maclise and Wilkie and Etty and Landseer and Egg and Eastlake and Leslie. These were the heroes in the Academy and the studios, the painters approved by royalty and by that nobility which, as poor Haydon's pathetic memoirs and correspondence show, was still expected to play the munificent patron of art. Among them were a few not lacking in painter-like qualities. Etty had a good feeling for color. A suggestion of something like style gleams through the bituminous depths of an occasional canvas by Wilkie. Even Landseer, when he was content to sketch and willing to forswear sentiment, could paint for you a canvas not without merit. But there is no space here to enter into a critical study of schools and standards in the opening years of Victoria's reign. The prevailing degeneracy is realized at a glance when, in the National Gallery, you leave the rooms filled with Hogarths, Sir Joshuas, and Gainsboroughs—rooms still sacred to fine conventions—for those crowded with the little trivial anecdotes and trashy popular sentiment of the early Victorians.

As for sculpture, it is useless to speak of it, since hitherto there have been no sculptors in England, if I except Flaxman and Chantrey, and neither is to be ranked with the artists who were their successors. Some of the masters of water-color—Turner, Cotman, David Cox, Cattermole—were still at work, but this essentially British art was already stooping to the tedious detail and sentimentalities of William Hunt and his kind. Black-and-white, on the other hand, had not degenerated, chiefly because the influence of Bewick was only beginning to make itself felt, and the importance of Senefelder's invention only beginning, one might say, to be realized. The illustration of books was in the transition stage; Turner, Stanfield, David Roberts, and the others still working for the steel engraver. But Prout, Cattermole, Lane, Harding, Lewis were only now bringing the new art of lithography to a perfection unrivalled elsewhere, save in France, where the great lithographers had already published their best prints.

On the whole, however, it must be admitted that I am right in saying that the outlook was depressing. It was the all but universal lowering of standards, the vulgarizing of art, with full Academical authority, that was the most discouraging feature of the time, as we look back to it. The story of the sudden rise of Pre-Raphaelitism from the slough of commonplace seems all the more wonderful in its romance when one appreciates the full measure of this commonplaceness. I have no intention of repeating the story here—it has been repeated often enough quite recently, nor do I propose to discuss the creed of the Brotherhood. What is important in this very

rapid sketch is to point out the part the Pre-Raphaelites played in the revolt against Victorian vulgarity. For theirs was a revolt as truly as the Romantic movement, some twenty years earlier, had been in France. Ruskin, the prophet, Madox Brown, the master, and Rossetti, Millais, and Holman Hunt, the brave crusaders, threw down the gauntlet no less boldly, no less uncompromisingly, than the young men of the *Cénacle* when they rallied around the red waistcoat of Gautier on that famous night at the Théâtre-Français. But reaction was in the air. The evil had gone too far not to be righted. The Pre-Raphaelites were the most conspicuous rebels simply because, by banding themselves together, they gained the strength of numbers. Mr Watts, in his way, was proclaiming his belief in the Gospel of Individuality in preference to old outworn Academical dogma. Not so many years later, Mr Whistler was producing the plates which were to make the England of the nineteenth century as classic ground for the etcher as the Holland of the seventeenth, and the pictures which, disdained and ridiculed then by critics and public, are now finding places in the world's national and municipal museums. Because he happened to live and work in England, Mr Whistler, the American, has been the most distinguished figure, the strongest influence, in the art of the Victorian period. Pre-Raphaelitism, naturally, is fast dying out, but his power over the younger generation makes itself more and more felt with every day.

In other directions, too, the rebellion, the reaction found full expression. The art of sculpture for the first time in England had a great artist—Alfred Stevens—for its interpreter. House decoration was being modified, improved, almost revolutionized, thanks to the initiative taken by the Pre-Raphaelite firm of Morris, Marshall, Falkner & Co. By 1860 illustration had reached a perfection that, the chances are, will not be for many years surpassed. Whistler, again, the Pre-Raphaelites, Keene, Leighton, Walker, Pinwell, Boyd Houghton—these were a few of the men working for the wood-engraver. Altogether the second period of the Victorian era was as promising as the first had been discouraging.

The stimulus then given has had its effect in the work of the last thirty years. Some might think the conditions had changed but little. The Academy—the official representative of art—raises no higher standard in 1897 than it did in 1837. At the National Gallery today, as years ago when it was first exhibited at Burlington House, Mr. Frith's "Derby Day" is the picture that holds the crowd. But the change can be seen now in the work of individual men—of Fred. Walker, of Cecil Lawson, of Boyd Houghton, who died all too soon for their own fame, now in the aims and objects of new artistic

organizations—the new English Art Club, the Glasgow school. There has been, I do not deny, too much talk of art, too determined an attempt to manufacture the artist. For one Ruskin, a score of cheap and ready writers, calling themselves critics, make no fair exchange. The multiplication of schools is fast sowing the seeds of new evils. Affectations flourish, increase of knowledge weighs like a burden upon the conscientious, self-conscious craftsman of the day. And for all the agitation, for all the talk, for all the study, the artist, the genius, is as rare as he ever was. But, on the whole, conditions are healthier than when the Eggs and the Landseers and the Eastlakes were accepted as masters. Then the English artist had forgotten what art means, now, at least, he understands. You can see it in his portraits, in which—though he may not always succeed—he endeavors to give you something more than a stupid likeness; in his landscapes, for, at last, he respects the teaching and example of Bonington and Constable, which long bore fruit only in the studios of Paris. For this improvement, to be sure, you need not look to the Academy, forced to open its doors to distinguished foreigners like Mr. Sargent and Mr. Abbey, forced to recognize sculptors of the eminence of Mr. Gilbert and Mr. Ford. The Academy has never yet, until it could not help itself, extended its approbation or sympathy to the genuine movements, the vigorous pronouncements of the younger men. To its shame be it said, it has remained at a standstill, while the art of England has progressed. And since you cannot find the record of this progress within the Academy, it is the more to be regretted that the special exhibitions of Victorian art should prove no less unsuccessful. The record, rightly made, is one full of romance and interest and hope.

With the outbreak of the Spanish-American War, N.N. (though safely in London) offers a more sweeping view of the role of art in society.

—

from PICTURES IN LONDON

MAY 12, 1898

N.N.

London, April 30, 1898.

THAT ANYONE should have time to show pictures, or think of pictures, or write about pictures at a moment when war has been de-

clared, and such tremendous national issues are at stake, seems on the face of it absurdly, almost wickedly incongruous. And yet it is curious to remember that it is to just such crises in the history of the past that we must look back to the greatest periods of art, and to the making of many of the masterpieces now preserved among a nation's treasures. To take but a single instance, but one especially appropriate at this juncture, have we not the "Lances" of Velásquez as a record of Spain's cruellest and most vindictive wars in the days of her might and power? And it is as curious to consider that while the wars have passed and gone, while the evils they brought in their train have been long since righted and forgotten, while incidents that were the most stirring and important at the time have become the dry facts of history or the myths of romance, the art alone has survived. Philip and Alva are now but names, but memories, but shadows. The picture of Velásquez is, and will be until the last bit of paint has faded or dropped from the canvas, a supreme possession not only for Spain, but for the whole world. It is no wonder that there have been many men to believe that art is the one reality in life. Art alone lives, while the artists who created it, and all things with them, perish.

I am not sure, however, even if this truth justifies our interest in exhibitions opening in London at the very moment when newspaper posters are announcing the bombardment of Havana and the premature invasion of New York—in other words, that much in either the New Gallery or the Royal Academy is destined to outlive the generation that produced it. The painters are many, but the artists are few, and work fairly pleasant and often very skillful somehow seems more trivial than usual this spring. I have looked carefully through the two exhibitions, and I have found nothing really of vital importance, nothing to which one could imagine students in the future turning with delight and interest and profit, but the portraits by Mr. Sargent and an occasional landscape.

I wish that Mr Sargent would do for the commanders and generals of our navy and army what Velasquez did for those of Spain, and that someday we might have in Washington a series which, though they could not compete with the portraits of the Prado, would, like them, serve as a great record of great and stirring times.

One of the greatest controversies ever to surround a single work of art centered on Rodin's statue of Balzac, now considered one of his masterpieces. The unveiling of the statue, which shocked many with its seemingly unfinished and unflattering portrayal of the writer, and its subsequent rejection by various official entities, provoked

emotional debate in Paris and elsewhere. Here are N.N.'s reports from the front:

—

from THE PARIS SALONS

JUNE 30, 1898

N.N.

June 2, 1898.

I ALMOST HESITATE to speak of M. Rodin's "Balzac." It has become a byword, a standing joke in Paris. Everyone now knows that the Société des Gens de Lettres has refused it, though a definite commission was given; that the Municipal Council will not have it at any price, even as a gift. The critics have been at loggerheads over it, and abuse and praise have alike been overdone. Raoul Ponchon has made it the theme for the most jingling rhymes of nonsense he has ever yet contributed to the *Courrier Français*; songs are sung about it by the clever young poets of the Tréteau de Tabarin, the latest rival to the old Chat Noir and the Cabaret of Drumont. In a word, it is enjoying exactly the sort of *réclame* for which the manufacturer of the Salon *machine* would sell his soul and from which the artist shrinks. If it were nothing more than the *machine*, it might be overlooked altogether. But it is the work of quite the most distinguished sculptor of our day; of one who cares too much for his art to degrade it by a mere piece of *blague*, or sensationalism. It is really no wonder that the public and artists too have been puzzled by this huge, shapeless, uncouth mass, set upon a pedestal. Balzac stands, his head well thrown back, wrapped in a great cloak, the sleeves of which hang empty. He has large, protruding—I was on the point of saying melodramatic—eyebrows; his massive throat, in its width and volume, suggests some rare and unpleasant variety of goiter. There is absolutely no form beneath the cloak, except where the arms are vaguely indicated and where one casual foot protrudes from underneath the heavy folds. I could defy anyone who saw the back of this curious monument first, not knowing that it was the Balzac, that it was the figure of a man, to understand what the statue is meant to represent. I give my impressions honestly, for certainly they are genuine; I had come prepared to admire. If I did not admire, however, I was far

from scoffing. And the longer I looked, the more I was fascinated by this strange work; the more I felt the dignity, the emotion, the grandeur really in the artist's intention. Had I seen it in his studio, had it been exhibited as a sketch, I should have detected in it the germs of a masterpiece. But, in a finished statue, as in a picture, we must have more than beauty or greatness of intention, and I cannot blame the Société des Gens de Lettres and the Municipal Council for their refusal.

Perhaps the most curious part of it all is that Rodin should be willing to exhibit as complete, perfect—that is, as he can make it— this figure which artists whisper among themselves is hardly yet begun. There can be no question of incompetence in such a master of form, no question of shirking work in so true an artist. Could we forget the many lovely designs he has already shown, there is in the same exhibition a group, "Le Baiser," to remind us of his knowledge. If there is no form beneath the graceless heavy cloak, if there is so little modelling in the throat it amounts to disfigurement, you may be sure that Rodin intended it should be so, that the inchoate expression he has given to his conception of Balzac is deliberate. To me it seems but another proof of the modern artist's disdain of technical accomplishment. Centuries ago the Greeks brought the sculptor's art to a perfection never yet surpassed. Today there are dozens, if not hundreds, of men who can model the human figure almost faultlessly. To escape from the lifeless, the soulless learning of the schools, the master sculptor now seeks to animate his marble or clay with an intensity of emotion or passion that could best find voice in music or in verse. The form counts for little; it is the feeling that must transfigure it. But I think those modern critics come nearer the truth who believe that the real artist is he who divines the secret of beauty in actual life, and can make us see, either by his paint or his clay, how really great and poetical we are in our stiff cravats and patent-leather boots.

—

from THIS YEAR'S SALONS

JUNE 15, 1899

N.N.

Paris, May 1, 1899.

M. RODIN, PROBABLY to his own great satisfaction, has not created the excitement of a year ago. The now famous "Balzac" is succeeded by a life-size "Eve" in bronze—an Eve after the fall, sad and ashamed, her arms crossed over her breast, her head bent low. It is beautifully conceived, full of emotion, subtle and strong in the modelling, but it seems to me that M. Rodin never succeeds quite perfectly in his larger designs. I like better the small, spirited bust of M. Falguière which he is also showing.

One wonders if the exhibition of this bust is not M. Rodin's way of explaining to the public that he does not in the least resent the fact that the commission for the "Balzac" monument has been handed over to M. Falguière. The new "Balzac" is, for me at all events, what the French would call the *clou* of the Champs-Élysées Salon. M. Rodin's "Balzac" was so indisputable a failure, and yet, at the same time, so fascinating, so exasperating because it came so near being the work of genius he meant it to be, that it is inevitable curiosity should mingle with one's desire to see the attempt of the man who has had the temerity to come after, him and so challenge comparison. M. Falguière, evidently, has been overwhelmed by the delicacy of his position, and, as if convinced that imitation is really the sincerest form of flattery, has made his "Balzac" as much like M. Rodin's as a sculptor of so opposite a temperament could. The new "Balzac" sits, where last year he stood, his hands no longer concealed, but crossed comfortably and inelegantly over his knees; he wears the same indefinite garment, partly dressing-gown, partly great coat; he is quite as shapeless and still heavier; and if there is less of melodrama in his pose, there is more of clumsiness. M. Falguière is commonplace, colorless, while M. Rodin's fault was an excessive individuality or daring of treatment. The latter tried to express too much—the whole history of romance, so his admirers insisted, instead of the character of one man. M. Falguière has tried to express too little, and has let the great genius go masquerading mod-

estly as an amiable bourgeois taking his ease by his own fireside. If he but succeeded M. Falguière is reported to have said, "Cela en fera deux de beaux." But he has not succeeded, and the result is two failures, not two masterpieces.

Bernard Berenson, while enjoying considerable fame as an art expert, was also apparently doing a brisk business as an "advisor" to Joseph Duveen, the most aggressive and successful art dealer of the time. Berenson would sometimes provide now-questionable attributions about the artists of particular paintings, to ensure that Duveen's customers would not hesitate to make their purchases, and would tout various pictures to collectors who sought his advice. While details of this rather shady arrangement would not emerge until well after Berenson's death, it is clear that there were at least suspicions of impropriety early in his career.

—

THE DONNA LAURA MINGHETTI LEONARDO

MARCH 17, 1904

Bernard Berenson

TO THE EDITOR OF *THE NATION*:

Sir, I beg you to give publicity to the enclosed note. Its appearance in print will dispel a rumor which has been spreading for I know not how long before faithful friends made me aware of it—Yours truly,

B. BERENSON

New York, March 10, 1904

Bernhard Berenson, Esq. New York:

MY DEAR BERENSON: Referring to the rumors that you purchased for me the picture known as "The Donna Laura Minghetti Leonardo da Vinci," and that you received a large remuneration for so doing, etc, —I purchased the picture without your knowledge or advice. You had not the slightest connection with the purchase, and did not know of it till some weeks thereafter, when I told you.

You may make such use of this letter as you please—Always yours,

THEO. M. DAVIS

Luxor, Egypt, January 7, 1904

5

GILDING THE
WATER LILIES

While The Nation *had dutifully reviewed Manet, Monet, and their Impressionist followers from time to time, it did so mostly in a cursory way, until N.N. filed this report from London.*

—

THE IMPRESSIONISTS IN LONDON
FEBRUARY 9, 1905
N.N.

London, January 16, 1905.

THE WORLD DOES, indeed, move. A few years ago, London would have been the last place chosen for probably the most representative exhibition ever given of the French painters who are grouped together, for convenience, as the Impressionists—a few years ago, the very name of Impressionism being as a red rag in the face of an Academy-bound public. And yet, to London, to the Grafton Gallery, M. Durand-Ruel is now able to bring a collection of their work so large that his gallery in Paris would not hold it; so fine that never

before, within my knowledge, has there been such a chance to study one of the most interesting and defiant phases in the art of the last century. Many of the pictures, of course, have been seen at different times at M. Durand-Ruel's and in other galleries, but never all at the same time; and if several of the most remarkable examples shown at the Paris Exhibition in 1900 are not here, on the other hand, there are several as remarkable from M. Durand-Ruel's own private house that have rarely, if ever, left it before. The result is that, though one may not have anything very new to learn about these men and the movement they instituted, one is able to judge better than ever the value of their influence on modern art, and the reason, perhaps, why it has not been as great as, at one time, seemed likely.

The collection, wisely, has been limited to nine painters. More is to be learned from those who may be called the leaders or inaugurators, than from all the followers, imitators, and hangers-on, who, in trying to carry further a movement they did not originate, usually end by reducing its principles to the last absurdity. The nine are Boudin, who may not seem at first altogether in touch with the others, but whose seas and groups of fisherwomen along the shore, if carefully studied, explain why he has a place with a school devoted to problems of atmosphere; Manet, Degas, and Monet, the three dominant figures (though that Degas should have come to be classified and pigeonholed with Manet and Monet is one of the most curious features in the whole episode); Madame Morisot, whose debt to Manet is great, but who added to what she got from him a very personal note and charm of her own; Renoir, Cézanne, Pissarro, and Sisley, who, it must be confessed, are left by closer acquaintanceship in the secondary rank, where one was from the first inclined to place them. Little by little, the public—even the British public, thanks to the International—has got used to seeing their work, and is therefore no longer scandalized, much as it may still disapprove. The old days of storm and stress, when to their admirers they formed "l'Avant-Garde" of M. Duret's memorable phrase, when, like Zola's hero, they set out to "conquer" Paris, when the discussion of *la peinture claire, plein-airisme,* broken brushwork, the division of tones, led to deadly feuds in the studios and ribald mirth among the critics—those old days have long since gone. Today, it is only when we remember what painting was in the sixties and seventies that we can understand why Impressionism—a term convenient to use for the meaning time has given to it—was considered such an unparalleled revolt. A revolt, however, it really was, and one that struck deeper at the root of things than the many that preceded

it. The Romanticists were rebels to their generation, and yet they rebelled only against the academic, they had no quarrel with the great conventions of art sanctified by the great past. But the most defiant Impressionists, in their eagerness to see Nature for themselves, to avoid known types, to express their own *personality*—in their determination never to compose a picture, never to arrange Nature—rebelled against everything that had gone before, in theory at least. They disdained whatever smacked of the Louvre, though one can now trace in their work enough of the Louvre to have driven them to despair had they discovered it in the first heat of rebellion. To see Nature for themselves meant inevitably to record it for themselves in their own way, and the methods they evolved in the attempt to put upon canvas effects no one had before attempted, bewildered the critics, who could not look below the method, and the then starting results, to underlying principles. That was why Impressionism was denounced as a short cut, a labor-saving device for the artist who was too indolent or conceited to go through the usual training and apprenticeship as student. That such a reproach should have been made against it seems incredible, now that the excitement has calmed down. In an exhibition like the present, nothing strikes one so much as the fact that knowledge, experience, and technical skill are the solid foundation for the most daring experiments of the men who wanted to use their eyes for themselves, and to say what they had to say in their own fashion.

It is amusing to remember the howl of execration Degas raised in London, not more than ten or twelve years since, when the daily press was filled with the immorality of his pictures, and Academicians joined in the attack to expose the unscrupulousness with which he shirked his work. There are thirty-five examples of Degas now at the Grafton; the ballet-girls, the washerwomen, the women at the bath, he never tires of studying. To look at them is to feel how little the question of morality enters into his scheme of art; how these subjects attract him simply because of certain truths he finds nowhere else as strikingly presented; how, so far from evading anything, he seeks in every figure, every arrangement, a new problem of form, or pose, or movement, or foreshortening, or perspective. It is true that often Degas appears indifferent to all beauty, save the beauty of truth. There is one astounding picture of "Miss Zaza," at the end of her performance in mid-air, letting herself down on the long uncoiled rope; and the rendering of the lithe, muscular form, in the tights that allow of no shirking of drawing or modelling, the foreshortening of the legs, the way the strain on the arms and neck

is indicated, are all wonderful in their truth and in the simple state-
ment of it—a statement so destitute of the muscular exaggerations,
the heroic proportions, dear to the old masters, that the learning
upon which it is based is lost upon the casual observer. But then to
Degas nothing else has counted except the figure; a picture was not
attempted. As often, however, Degas is absorbed in the beauty of his
subjects—the beauty of composition as the dancers group them-
selves for practice or the performance, the beauty of the play of
light on their shimmering skirts, the beauty of atmospheric effect as
they come and go, now in the flare of the footlights, now in the
shadowy distance. There are two large pastels in the collection, un-
like any I have hitherto seen, half-length groups of ballet-girls, with-
out background or accessories of any kind, arrangements of their
heads and necks and arms as they meet in some pose or movement
of the dance; but groups as full of dignity and grace of form, as
harmonious in color, as the figures decorating the walls of many an
old Italian palace or church. The titles of the paintings and pastels
by Degas are seldom a very definite clue—"Ballet-Girls," "Ballet-Girls
in Pink," "Ballet-Girls in Green," "The Ballet"; how many of his pic-
tures and drawings would not these describe? That is why I can do
no more than refer in the series as a whole. One comes from it
more than ever impressed with the great accomplishment, the great
seriousness of Degas, more amazed than ever that his ballet-girls
should have been accepted as a symbol of decadence, his own un-
conventional conventions as the makeshift of the indolent or the
untrained.

The seriousness of the indefatigable student, of the accomplished
craftsman, is what impresses one most also in Manet—what, I fancy,
M. Durand-Ruel meant should impress the British public. For the
Manets sent are mostly those in which even the British public could
not see, or pretend to see, indolence and incompetence. There are
no pictures like that amusing "Déjeuner sur l'herbe," like the mar-
vellous still-lifes exhibited in Paris in 1900, like some of the later
open-air impressions, that I should have liked to find in such a
collection. But, after all, the work included, forming a fairly large
series, is perhaps the most appropriate to the present exhibition. It
shows the stages by which Manet reached his latest and most per-
sonal manner. There is a surprising little "Garden of the Tuileries
in 1860," crowded with people in the absurd costume of the day, all
the infinite detail worked out with a minuteness that would have
put Frith and his "Derby Day" to shame, and with a skill altogether
beyond the grasp or comprehension of Frith. Then come pictures

like the large full-length "Beggar," the huge group of "Wandering Musicians," reminiscent of Velásquez and the inspired days which Manet, not yet quite emancipated from the schools, must have spent in the Prado; pictures like "The Bull Fight" and "Spanish Dancers," memories of Goya in the color, the movement, the spirit. And as characteristic of Manet in his development are the portraits of Mille. Eva Gonzales which horrified the world at the Salon of 1870, and of "Petruiset the Lion Killer," with its touch of humor that might have been the germ from which Tartarin was evolved, though I am not sure enough of my dates to say whether it was not Tartarin who colored Manet's impression of the lion-killer posing, apparently, in a suburban garden. The study of fish is not one of his most amazing still-lifes; it cannot compare to that triumphant cabbage upon which he lavished as much beauty of handling as painters of old would have devoted to saints and Madonnas; but still so fine is it that, with the others, as well as studies of Manet's own garden, commonplace save for the magic of his brush, and a sketch, all action, of races at Longchamps, it will give people who have only seen occasional Manets here and there, a fair idea of why artists look up to him as one of the greatest and most original of modern painters.

Monet is better represented, though, unfortunately, not by any of the earlier works done before light and atmosphere were to him all engrossing—not by anything like that unforgettable French interior at the breakfast hour, in which every fact of the breakfast table, from the napkins in their rings to the grapes for dessert, every fact in the family group from the baby in its chair to the *bonne* in her cap, is set down on the canvas with the painstaking fidelity, the uncompromising accuracy, of a description in words by Zola; a "human document," if ever there was one. There are, however, paintings of a fairly (if not quite) early period, before which the critic who has been pleased to think Monet cannot draw, must find himself silenced forever. One of these is a study of "Pheasants," from M. Durand-Ruel's dining-room, the birds drawn with a skill I thought no modern, except Manet, had ever attained, the plumage, the color, the play of light on the feathers, the white tumbled cloth over the table where they lie—all these things rendered as only a master could render them, and all kept in such perfect tone that out of such very simple materials a pictorial whole, splendid in its beauty, has been created. Really, I have never seen anything of Monet's I thought so masterly. After this, it is easy to follow him from the canvases, like the Gare St.-Lazare, with its effect of sun and smoke, and the Vétheuil and Argenteuil, in which he still seems

conscious of the beauty of line, the importance of design, down to examples of the famous haystack and Rouen Cathedral series, in which he disdains everything save the passing effect. I admit he gets this effect in a very astonishing manner. But I cannot help feeling again at the Grafton Gallery as I felt at the Paris Exposition in 1900, that something had been lost, something sacrificed, by his indifference to everything but the momentary phases, the ephemeral changes of atmosphere and light, if the nature, to which the painter has made his vows, is at the trouble to arrange a picture for him, well and good, if not, it makes no difference. He is satisfied with nature, whatever may be the mood or the aspect. And yet art would not be art were it not above and beyond nature.

This haphazard selection of motives—or, rather, this absolute non-selection—leads to more unfortunate results in the lesser men of the group. Not one of them (to me, anyway) illustrates so well the snares and pitfalls of what has come to be called impressionism, as Renoir. Every distinction has been shown to him here. Almost sixty of his studies and pictures have been hung, and well hung. Some are as well-known as the often-reproduced picture of a man and woman in a box at the theatre; others, probably, have never been publicly exhibited before. But a smaller series would have done him more honor. For, while one comes upon exquisite passages— the painting of the nude in sunlight, a child's face in profile, a cat on a woman's lap, flowers, or fruit—one comes as often upon passages discouragingly vulgar, Nature having her vulgar moods, which it should be the business of the artist to correct, which he does correct when he is not as confused and blinded by his theories, as completely a slave to them, as Renoir. I think the same is true of Sisley and Pissarro, though less obvious in the case of Pissarro, who found his most sympathetic subjects in the streets of Paris, a city which seldom fails to offer a composition, made to the painter's hand. Cézanne's pictures are few, and, with the exception of his still-lifes, do not prepare one to accept him altogether as unreservedly as the most devoted of his following. As for Madame Morisot, as now seen, she calls for little reserve in one's tribute to her. She places a model before the mirror at a not very interesting moment of the toilet, or a sitter doing nothing at all in a garden, and her color is so delicate, her values so right, that one sees only the tender harmony of grays or pale golds. And if her little marines point without mistake to their origin in Manet, they are the work of an intelligent pupil. Few other women who have ventured to practise an art for which their sex seems to disqualify them, can approach her.

One of the most noticeable trends in art in America was the newfound mania for collecting. Often called the dean of American art criticism, Frank Jewett Mather, Jr., an avid collector himself, taught art history at Princeton (where he taught Alfred Barr, who became director of The Museum of Modern Art), directed its art museum, and was later the art reviewer for the Evening Post. *In this unsigned piece, he ponders the relationship between art and commerce.*

—

ART PRICES AND ART VALUES

JUNE 1, 1905

Frank Jewett Mather, Jr.

UNQUESTIONABLY, THE GAYEST branch of the "Dismal Science" is that which deals with prices regulated by fashion or fancy. In fact, this whole class of values puts economic analysis to its trumps. One may say pretty definitely that the price of a bushel of wheat, for example, is essentially its value as food, plus or minus the difference caused by a shifting, and at times speculative, supply and demand; but what may one guess is the warrantable price of, say, the first purple carnation? The wide gap between art values and art prices was strikingly illustrated last week. We pass over the price of $81,375—paid on Friday for a Renaissance crystal cup of questioned authenticity—as inexplicable on any rational theory. A few days earlier, at Christie's, Thomas Watson's mezzotint after Sir Joshua Reynolds's "Lady Bamfylde" fetched $6,100. Thus a skilful black-and-white reproduction— of which many examples must be in existence—brought a price within which a careful buyer may get a very fair original of Sir Joshua. Or, to put the matter in another light, a day or two after the record sale of what at best was a clever bit of copyism, a fine example of that master of the brush, Chardin, sold at Paris for $5,500, while at the same sale a veritable Sir Joshua Reynolds brought only $2,640.

Now recall that for the price paid for this single reproductive engraving one could buy a score of the best engravings by Dürer, in the finest states, or a dozen of Rembrandt's finest etchings, an original by Watteau, a cabinet full of Hokusai's sketches and woodcuts—works of art far superior to, and of greater scarcity than, any translation of Reynolds by the cleverest wielder of the rocker and burnisher—and it will be clear that values, as perceived by artists

and connoisseurs, by no means agree with the prices paid by collectors. To account for the discrepancy, many theories have been advanced, as that rarity is the principal criterion; but this is discredited in the case of the mezzotint engravers, whose works are far from rare. If only a few meritorious impressions were pulled from each plate, nearly all were promptly framed, and thus are preserved to this day. Of the small sheets of Dürer and Rembrandt, on the contrary, there has been unquestionably great loss and absolute destruction, so that no principle of rarity would justify a collector in preferring to theirs the work of such engravers as Raphael Smith, the Wards, Watson, or Valentine Green. But an even more convincing proof that rarity alone does not necessarily attract amateurs was found in the publication of a catalogue of "unique" books, by a London bookseller. If Mr. Voynich had believed that bibliophiles are attracted by mere rarity, he had only to put his *rarissima* (some scores of them there were) into the auction-room and retire immensely rich. As a matter of fact, he chose the wiser part of offering them by catalogue at very moderate prices.

If both absolute art value and rarity have rather little to do with price-making, we are reduced for an explanation to the madness that proverbially afflicts collectors, and to occult powers that set collecting fashions. That collectors are subject to malign lunary influence is beyond denial. A new Dibdin, for example, would find material for comment in the stewardship of a famous bibliophile, who, in the behoof of a local Y.M.C.A. Library, became executor of a purveyor of the unrefined vaudeville of our fathers. Such books as that Y.M.C.A. library possessed would move a Locker-Lampson to verse, and possibly a revivalist to tears. The Bibles, in St. Jerome's Latin mostly, were from the early presses of Cologne, Strassburg, Venice, and Paris. Books of Hours and Chorals there were, both printed and cunningly engrossed and illuminated by hand. The youthful Christians were invited to read Dante in the superb edition which Botticelli or a pupil illustrated; to peruse Chaucer in blackletter. Thus, through the mediation of a bibliophile *pur sang*, the moneys proceeding from the shapeliness of a Lydia Thompson in "Black Crook" days were converted ultimately into grave divinity, and deposited on the shelves of a Young Men's Christian Association. From this pardonable digression we wish to extract the lesson merely that nothing a collector does is surprising, and that his infatuation lays him open to all manner of hypnotic suggestion, including autohypnosis.

Whoever studies fashions of any sort is sooner or later driven to take counsel of tailors. Somewhere or other there is a high tribunal

which decides whether our pockets shall open inside or out, shall be few or many, whether our trousers shall favor the ankle, the knee, or the thigh, and a hundred other niceties necessarily obscure to the layman. And sometimes we are prone to imagine that somewhere or other there is a committee of art dealers which convenes and lays out the fashion for the next decade. One may fancy that, just as the humbler sort of tailors accept the ordinances imposed from above, concerning tape and trimmings, so the smaller art dealers chime in with a central authority when it whispers now, "Sell Barbizon," and again, "Play Early English." But, of course, if it were not for human vanity the high court of tailordom would sit in vain, and if there were not an enormous number of collectors more enthusiastic than well informed, these passwords of the dealers would fall idly on the air, and the absurd prices produced by reckless competition in objects approved as the latest fashion would yield to an appraisal based, in part at least, upon permanent art values.

The shocking murder of architect Stanford White (which led to the first tabloid "Trial of the Century") prompted this obituary, which may have been written by Frank Mather. While not especially kind to White, it is even more damning of the Gilded Age and its acquisitive relationship to art.

—

THE ARTIST IN OUR WORLD

JULY 5, 1906

THE FOLLIES OF the time and his own frailties did everything possible to undo the great artist in Stanford White, but, fortunately, did not wholly succeed The pleasure-house which was the scene of his murder remains an imposing monument to his genius; a few more fine buildings testify to the playfulness and exuberance of his inspiration. Many structures of his firm (McKim, Mead & White), the credit for whose work was rather indiscriminately given to the member most in evidence, bear the sign manual of his taste. Yet a review of the work definitely assignable to him shows that it is small in comparison with his powers and with the impression he made upon his colleagues. In actual creative quality, probably only Richardson among American architects was his equal. In physical force he was indom-

itable. Once he rode all night over the roughest of mountain trails to keep an appointment which he was in danger of missing because he had gone from New York to New Orleans to witness a prize-fight. Why was it that, with the energy and knowledge of the great architects of the Renaissance, and with a wealthy patronage fairly rivaling that of the Medici princes and popes, his work seems so incomplete and episodical?

Severe moralists will find the cause in his devotion to pleasure. Many another great artist, however, has been overmastered by the flesh, with no apparent detriment to his art. His colleagues explain that he was in a sense misplaced, being by temperament and gift rather a painter and decorator than an architect. But this does not really explain anything. It is the essence of genius to make its own opportunities, and his was genius of a high order. An achievement that would be creditable for a smaller man, is confessedly inadequate for him. Surely, then, we have to do with a capital case of unutilized or even perverted energies. He seems to have been in a large degree the victim of the society which he sought above all else to please, to which he was the titular arbiter of taste.

His own aesthetic standards were the highest; but insensibly, as he sold his taste to a wealthy but half-trained society, he condescended to their ignorance and vanity. The time that he should have given to creative design, he spent in despoiling French and Italian country houses of their fittings and furnishings, and he adorned many an American mansion with irrelevant plunder of this sort. Enormously profitable as an incident to his profession, this traffic was naturally congenial to a passionate collector of every sort of art. The fallacy of the undertaking will be realized when it is noted that the shiploads of antiquities he furnished to his plutocratic clients contained very few objects above respectable mediocrity, while he himself, one of the most-talked-of collectors of our time, has left personal accumulations inferior to those of amateurs of far smaller wealth and opportunity. In other words, he offered the tragic spectacle of a taste gradually adjusting itself to that of its market. Though immensely the superior of his world, he was content to be its purveyor. His career, as you choose to regard it, is that of a magnificent condottiere in architecture, who won brilliant skirmishes, but avoided the laborious operations of sieges and great campaigns; or of an aesthetic major domo to an opulent world, whose especial vanity was the possession of fine works of art. Stanford White gave his clients quite as good as they deserved or wanted, but meantime, in such brokerage, he wasted precious days that should have seen a succession of his own masterpieces.

We have thus dwelt upon this remarkable career because it is typical: it illustrates with singular and pathetic emphasis the defects of art patronage among us. It is, we believe, the business of the artist to please his public, but it is also his privilege to educate his patrons. In the great periods of art the painter and his patron have met on something like equal terms; in fact, the man who pays the money has been very willing to learn from the artist. Between the two classes, under these circumstances, there is a lively and profitable interchange of ideas. Such was the case in the courts of Philip of Burgundy, the Emperor Maximilian, of Charles the Fifth, the Medicis, Sforzas, D'Estes, Louis the Fourteenth; such was the case in the republics of Athens and Florence, and in the Venetian oligarchy. But the artist in America who today addresses himself to his natural patrons in the wealthiest classes, meets either a disheartening indifference or a more positively demoralizing vanity.

Possibly, indifference is the more sinister attitude. There is no greater enemy of the artist than the man who, while he fills his house with objects of art, as he fills his greenhouses with orchids, or his stables with thoroughbreds, neither knows nor loves the splendid things his money buys. To the artist, appreciation is the breath of life. For him to be in the position of merely giving a money's worth is suicidal; to be habitually and consciously giving less is artistic death in life. Yet this is the danger that constantly threatens the artist in a day of indiscriminate accumulation. It was a danger that diverted and diminished the career of the artist we have lost. With the arrogance that pretends to know, Stanford White was able to cope. To the vanity that did not care but could pay lavishly he became a victim.

His career points the difficulty of the middle way that the artist must follow to succeed. A generation earlier or later, we are fain to hope, the flowering of such a genius would have been more normal, and the fruit more abundant. Our age has tended to debase the artist to its own standards, or to shut him up in the musky atmosphere of adoring cliques. The frittering away of genius, as illustrated by the apparently successful career of Stanford White, is an exhortation to all true artists to master that most difficult art of being in the world, but not of it.

Kenyon Cox was well-known as a painter and muralist. He studied with the French academic painter Jean-Léon Gérôme in the early 1880s and then turned his attention to both murals and writing. He was commissioned by Cass Gilbert, the architect of the Woolworth Building, to create a mural for the Supreme Court Chamber in Essex County,

New Jersey. When Gilbert discovered that one of the mural's figures bore a striking resemblance to the actress Ethel Barrymore, he implored Cox to change it. Cox refused. Like so many artists of the period, Cox longed to escape the shadow of Europe and in his writings, he eloquently sought recognition of a uniquely American art.

—

from THE WINTER ACADEMY

DECEMBER 27, 1906

Kenyon Cox

THAT AN AMERICAN school of painting, with characteristics of its own, is disengaging and affirming itself, there can no longer be any doubt. The imitation of this or that foreign school or master is less and less apparent and technical fads and movements are of decreasing importance. The work shown is not only eminently vigorous, but is eminently sane. The excesses of Impressionism, for instance, are already of the past. Almost the only work in the exhibition which shows the Impressionist influence in a noticeable degree is that of Childe Hassam, and Mr. Hassam has profoundly modified the Impressionist method, has bent it to new ends and to the expression of a new personality, so that his production is essentially original as it is essentially artistic. There is nothing in him of Monet's temper of scientific demonstration—it is beauty he is after, a new beauty revealed in a new way—not a theory of light. His "Little June Idylle" is delicious, alive with the shimmer of sunlight and the tremble of leaves, as modern as Monet, yet as poetic, as classic, as Corot. The tradition of Whistler and Monet is visible in the work of Robert Henri and of a few others, but here again the tradition has been modified, and Mr. Henri, in particular, has an unmistakable personality of his own, rude at times, but vigorous and capable on occasion of subtlety, as in the "Girl in the Fur Cape." The methods of the modern Dutch school are reflected here and there, and other evidences indicate that our painters are still willing to take lessons where they can find them; but the most notable pictures are of native inspiration, and can be attached to no foreign school. Take, as examples, Winslow Homer's "Gulf Stream" and George De Forest Brush's "Mother and Child"—both, one is happy to say, the property of public museums; Mr. Brush's picture being lent by the Corcoran

Gallery, while the Metropolitan Museum has done itself honor in accepting the suggestion of the Academy Jury and purchasing Mr. Homer's [work], the first American picture to be bought by the Wolf fund. "The Gulf Stream" is, in spite of evident crudities, a masterpiece of extraordinary power; perhaps the greatest work of our most original painter. The "Mother and Child" is one of the richest and most sober productions of a master of elevated style. Neither of them could conceivably have been produced in any other country than this or by any other than its author.

There are still sketches and studies and notes to be found in this as in all our exhibitions, but they are no longer, even numerically, in the ascendant. Everywhere there are evidences that our artists are ready to produce real pictures, conceived, designed, and composed; that the qualities of thoroughness of design and power of color which mark the two great canvases just mentioned are to be the characteristics of the American school of the future.

The following art "note," mercifully unsigned, goes beyond a mere exhibition notice, and gives some insight into the social strictures that existed in turn-of-the-century America, even in The Nation.

—

ART NOTE

FEBRUARY 7, 1907

IT IS ONLY the extraordinary lack of pictorial achievement by the Jewish race that could make the work of Ephraim Mose Lihen seem worth celebrating as "The New Art of an Ancient People," as M.S. Levussove celebrates it in a thin volume published by B.W. Huebach. It contains fourteen specimens of the skill of a black and white designer neither more nor less able than many others of the modern German school. A certain racial accent in subject and types, possibly even in imagination, marks the best of these designs, and at times they reach a weird power, but in general they are only not commonplace because the convention in which they are executed is not yet threadbare. When it has become so, it is doubtful if there will be found enough substance in the drawings to make them anything more than examples of a temporary fashion in book-illustration.

The tradition of artists writing about art would continue, off and on, in
The Nation *until the 1960s. The following, most likely by Frank
Mather, uses a book by* Nation *critic Kenyon Cox as a springboard for
exploring the theories underlying that tradition.*

———

THE ARTIST AS CRITIC

NOVEMBER 28, 1907

KENYON COX, IN the preface of "Painters and Sculptors," the second
series of his collected essays, raises the familiar topic of the artist as
critic. His contribution comes very much to this—that the artist per-
force must have opinions better worth while, from the mere fact of
being a practitioner of the art he discusses, but that he will almost
inevitably suffer from lack of literary skill, hence of carrying power.
We are to suppose an innumerable host of artists who are admirable
critics *in petto*, but inarticulate, lacking the time and opportunity to
master an alien art.

When Mr. Cox speaks of lay criticism, he means presumably that
of competent persons, and not the casual outgivings of half-trained
writers in the daily press. He measures, that is, to take recent ex-
amples, the writings of W.C. Brownell or Gustave Geffroy against
those, say, of R.A.M Stevenson and Fromentin. Carrying such a com-
parison through the whole range of serious writing on art, the ad-
vantage unquestionably lies with the artists. No one can deny that
the memoirs of painters, for example, are our most valuable docu-
ments for the judgment of painting. From Leonardo, through Va-
sari, Reynolds, Constable, Delacroix, Millet, Carrière, Segantini, and
our own John La Farge, we have from artists an enormous and pre-
cious mass of opinions about their art. Professional criticism can
make no such showing.

Yet a summary verdict against the defendant would be premature,
for the reason that lay criticism is in its adolescence. Indeed, only
in very recent times has criticism had its necessary basis in an ac-
curate history of the art of the past. And this brings us to the sig-
nificant fact that in the new connoisseurship artists have had a very
small part. The ungrateful but certainly indispensable drudgery of
determining what a given artist under consideration actually painted

or modelled has been conducted almost exclusively by laymen. We hasten to say that this is not criticism at all, but merely the ascertainment of its materials. Yet it is at least remarkable that artist-critics have not only been averse to this humble pursuit, but also suspicious of its more certain results, and in general prone to express opinions as if it didn't really matter whether a picture under discussion were by one artist or another. Such an attitude is an almost inevitable result of the artist's confidence in his own instincts and of his lack of minute scholarship.

We concede readily that criticism lies in a region of appreciation where minute scholarship is not of the first importance. On the other hand, one must distrust any criticism that is not sure of its data, and we may suppose that the criticism of the future will be more systematic than the *disjecta membra* which constitute the interpretation of art by its past practitioners. In other words, there seems to be more hope that connoisseurship may rise to criticism as its lesser task is accomplished, than that we shall always depend upon the casual excursions of artists in an art which is not theirs.

The real weakness of the artist as critic lies in the fact that the arduous practice of his craft must restrict his opportunities for wide observation. A real critic who would devote a third of the time to galleries that is given by the average connoisseur would gain an equipment with which no active artist could possibly hope to vie. The artist, in short, may speak from perfect insight, but, unless he be an *artiste manqué* (and these the malicious say make the best critics), from imperfect knowledge, whereas the professional critic has every opportunity, not only for immediate observation, but also for the study of the writings of artists and for present and valuable association with the best practitioners of his time.

We do not believe that the artist-critic will ever be superseded. There will always be painters who indulge a curiosity about the theory of their art and have something worth saying on the subject. But we feel that the alleged rivalry between the two sorts of critics rests at bottom upon a pure misconception. Mr. La Farge has somewhere marvelled that critics so seldom write anything worth an artist's reading. What an unfair demand to make of a critic! As regards the artist, the critic necessarily deals either in banalities or in startling inferences, which may, however, be just the kind of interpretation which his real public needs. In short, the professional critic addresses the general public, the artist usually his own craft. Thus they are allies, not rivals. And if the opinions of artists on art have become more or less the common property of the cultivated, the merit accrues largely to professional criticism.

The sum of the whole matter seems to be that the critic should stand upon the sure ground that he, too, is an artist—an artist in letters; congratulating himself that his material is not unassorted nature, but its beautiful interpretation in another art, and accepting gladly as a potent source of suggestion all expressions of artists about their own art. Such a critic will be free from the crude notion that he is a preceptor to artists. Towards the public his responsibility will lie, and his judges will be found, not among artists, but among the cultured, that is to say the competent minority of that public.

In 1908 Alfred Stieglitz's gallery at 291 Fifth Avenue mounted the first exhibition of works by Henri Matisse held in the United States. It was not reviewed by The Nation. *A passing mention of the artist, however, was made in a short note about the Paris Salon of that year, which inspired Bernard Berenson, one of the earliest American supporters of Matisse, to send this scolding letter.*

—

DE GUSTIBUS

NOVEMBER 12, 1908

Bernard Berenson

TO THE EDITOR OF *THE NATION*:

SIR: In a note which appeared in your issue of October 29, regarding the autumn Salon at Paris, there occur the two following sentences:

Some of the younger artists have surprisingly good and new work, along with direct insults to eyes and understanding. Such is Henri Matisse, who forgets that beholders are not all fools, and that it is not necessary to do differently from all other artists.

Will you allow one of the fools whom Matisse has thoroughly taken in to protest against these phrases? They are more hackneyed than the oldest mumblings in the most archaic extant rituals. There is nothing so hoary in the sacrificial Vedas. They have been uttered with head-shakings in Akkadian, in Egyptian, in Babylonian, in Mycenæan, in the language of the Double-Ax, in all the Pelasgic dialects, in proto-Doric, in Hebrew, and in every living and dead tongue of western Europe, wherever an artist has appeared whose work was not as obvious as the "best seller" and "fastest reader." Of what great painter or sculptor or musician of the last century has it not been said in the cant phrase of the Boulevards—"C'est un fumiste. Il cherche à épâter le monde"?

Henri Matisse seems to me to think of everything in the world rather than of the need of "doing differently from all other artists." On the contrary, I have the conviction that he has, after twenty years of very earnest searching, at last found the great highroad travelled by all the best masters of the visual arts for the last sixty centuries at least. Indeed, he is singularly like them in every essential respect. He is a magnificent draughtsman and a great designer. Of his color I do not venture to speak. Not that it displeases me—far from it. But I can better understand its failing to charm at first; for color is something we Europeans are still singularly uncertain of—we are easily frightened by the slightest divergence from the habitual.

Fifty years ago, Mr. Quincy Shaw and other countrymen of ours were the first to appreciate and patronize Corot, Rousseau, and the stupendous Millet. *Quantum mutatus ab illo!* It is now the Russians and, to a less extent, the Germans, who are buying the work of, the worthiest successors of those mighty ones.

B. BERENSON.

Boston, November 8.

PART 2

MODERNISM AND OTHER ODDITIES

6

SOMETHING NEW UNDER
THE SUN

In 1910, Alfred Stieglitz held a show at 291 of drawings by Matisse. This show, perhaps because of fear of another angry letter from Berenson, and certainly because of Stieglitz's tireless promotion of modern art, did get reviewed by The Nation, *probably by Frank Mather.*

—

DRAWINGS BY HENRI MATISSE

MARCH 17, 1910

IT WOULD BE well if the visitor to the Photo-Secession could forget that Matisse is the object of a cult, the reputed possessor of strange secrets and philosophies, the regenerator of the torpid art of the age. It would be well to ignore all this and suppose that these are anonymous sketches which the post has brought to Mr. Stieglitz, and which have so warmed his heart that he has asked his friends in to see them.

Matisse conceives the body as a powerful machine working within certain limits of balance. The minute form of the tackles and levers does not signify for him, what counts is the energy expended and the eloquent pauses which reveal the throb of the mechanism. The important thing is that muscles should draw over their bone pulleys, that the thrust of a foreshortened limb should be keenly felt, that all the gestures should fuse in a dynamic pattern. So much for the vision. It differs in no essential respect from that of great draughtsmen of all ages. A Matisse drawing, looked at without prejudice, is no more bizarre than a study of action by Hokusai or Michelangelo. It belongs in the great tradition of all art that has envisaged the human form in terms of energy and counterpoise. Look at any of these drawings, the walking woman so sensitively balanced, the crouching woman, she who averts some attack, she who stands firmly with her leg doubled back sharply on a chair. In the last drawing note how the bulk, and retreat, of an almost invisible calf of the foreshortened leg are indicated by a single powerful stroke that tells of the tension athwart the knee. Such drawing is odd only because it is so fine that much of it there cannot be. The nearest analogies to these sketches are those remarkable tempera studies by Tintoretto which have recently been discovered and published in part in the *Burlington Magazine*. In fact, Matisse is akin to all the artists who approach the figure with what Vasari calls *juria*. The Frenchman is a kind of modern Pollaiolo.

His originality lies less in vision than in a strenuous economy of workmanship. He will have the fewest contours and the most expressive, will not shirk any syncopation or exaggeration where he seeks an effect. That his method is really more concise than that of Michelangelo may be doubted. Hokusai's is certainly more direct and simple and equally potent. A calculated roughness, which occasionally disguises itself as the queer linear slackness with which Rodin has familiarized us, brings Matisse's manner very close to that of the aboriginal designers who scratched animal forms on bones in time prehistoric, or only yesterday adorned with admirable animal paintings the caves of the South African veldt. These savage masterpieces show the same keen sense for balance and significant action. Matisse is reputed to have individual and novel theories about counterpoise, correlation of gesture, etc. It may be so, but these drawings merely suggest a fresh attitude toward the model, and a desire for unhackneyed poses. That some doctrine may be involved is suggested in those caricatures in which he bloats and distorts the figure, evolving a grotesquely expressive pattern out of a pose that already grazes the impossible. The ingenuity of such studies will escape any

but a trained eye. Perhaps, he is experimenting to ascertain the bounds of the physically possible and pictorially credible. It would be like the eminently intelligent and experimental nature of the man to do so.

There is one question which a plain man might very properly ask, namely: "Is this all there is of it, or is it a preparation for something else?" To us these drawings have a painful, we trust a misleading, air of finality. The few compositions represented in chalks or photography are merely extensions of the single figure or quite commonplace calligraphies. It is possible that Matisse will always be making these magnificent studies. The present exhibition gives small hint of constructive imagination. If so he will merely take his place with other geniuses who have sacrificed themselves in the passionate invention of processes. Pollaiola and Hokusai, to a considerable extent, represent this inability to organize a complicated whole. Meanwhile one is grateful for so much. It is no small gift to have one's vision toned up to this strenuously controlled enthusiasm for the human mechanism. The effect of this work upon modern art can only be beneficial. Matisse as painter is almost unknown to the present writer who suspects that [their] individual and arbitrary caprice may be masking as genial invention. As for these drawings, there is no manner of doubt. They are in the high tradition of fine draughtsmanship of the figure. If, on sufficient acquaintance, they still seem merely eccentric to anyone, let him rest assured that the lack of centrality is not with them, but with himself.

The Society of Independent Artists, established to challenge the dominance of the National Academy of Design, was in the vanguard of modern American art. The group's 1910 exhibition, organized by the artists Robert Henri, Walt Kuhn, and John Sloan, was an important milestone in American art.

—

THE INDEPENDENT ARTISTS

APRIL 7, 1910

Frank Jewett Mather, Jr.

AS AN EXHIBITION that has almost grown over night, that of the Independent Artists is remarkable. In spite of artificial light, the lower gallery is impressive. One feels at ease with the whole, and

sees the individual pictures, each of which has its own electric light, in all comfort. On the second and third floors, it has been difficult to bring the numerous small pictures into decorative unity. The show has grown in an interesting way. A number of artists, for one reason or other out of touch with the Academy, formed a committee and invited a number of men of like minds to send in pictures and pay their shot. There is no jury and a minimum of organization. An old dwelling house has been reduced to a shell, and affords ample wall space. Evidently there are plenty of people waiting for the chance to exhibit, for in a single day 260 paintings and 344 drawings were loaded upon the devoted shoulders of the hanging committee.

How one takes the show itself is largely a matter of temperament. Many, of whom is the present writer, will find it rather variously diverting and disappointing. It is distinctly more amusing than the Academy ever is; it also reveals an amount of rather empty self-assertiveness such as never cumbers the Academic walls. Some of the best exhibitors are Academicians. Robert Henri, whose influence is pervasive, is a full-fledged N.A; George Bellows, W.J. Glackens, and Ernest Lawson are prominent A.N.A's. George Luks, who ought to have been the lion of this show, is preparing an exhibition which he has declined to discount, even for the public good. Now, if such contributions as Henri's "Salome Dancer"—a vivid perpetuation of a moment hardly worth eternizing on this scale; Lawson's admirable "White Horse" in a riverscape, Bellows's gory prize fights and remarkable architectural composition, Glackens's race-course, playground, and nude were withdrawn, the glory of the exhibition would have departed. In other words, the best contributors to the anti-academical demonstration are by men the Academy has delighted to honor.

Still the residuum would quite justify the enterprise. It is a pleasure to see A.B. Davies torn from precious surroundings and exposed to the average chance. He stands the test well. His picture "As Movement of Water" is one of the memorable impressions. In a narrow channel deeply blue waves, as they race through, are tossed back upon themselves; beyond is a pearly and serrated mountain. In the foreground little nudes unconsciously mimic the rush and backset of the waves. Here is a real vision carried out with perfect clearness. Work of this character is rare anywhere. We advise a visitor to adjust his eye by this picture. It will help him to see that much of the most emphatic work is weak and vague expression of something imperfectly visualized. Everett Shinn's vivacious studies of dancers and actors, Jerome Myers's poignant transcripts from the Ghetto, John Sloan's sub-satirical versions of the East Side themes—

these names recall tried pleasures; it is merely advantageous to see this work well hung and in a large company.

Among those who are wearing the shoes of Cézanne, the most skilful are Prendegast, Blashki, and Schamberg. In sacrificing his old staccato precision in favor of greater bulk, it may seem that Prendegast is substituting a less for a more congenial product. Time will tell. Blashki's three seasonal studies, Summer, Autumn, Spring, are beautiful in color, and ring true in tone.

Rockwell Kent is willing to take a hint from so old-fashioned a body as Winslow Homer. Mr. Kent's big road roller, with its straining horses, and his two marines are large in scale, and vigorous enough for anybody whose daily food is not Dorothy Rice's nightmares from the slums. From the emphatic persons who, to judge by their works, paint in horrid orgasms, one turns to the brooding spirits. Mr. Swett's crystalline Château Gaillart, with its exquisitely adjusted planes, J.B. Yeats's sensitive portrait of a bearded old man, James Preston's vernal river bank with little girls bathing, Nankivell's alluring park scene with Liliputian players so alertly spotted in—these were the things that called one away from the general atmosphere of excursions and alarums.

In sculpture, Gutzon Borglum's colossal head of Lincoln lords it. So touching is its character of strength, tempered by benignity, that it would not be surprising if the people should accept it as the standard portrait of their greatest representative. James W. Fraser's portraits, and Albert Humphreys's animals are otherwise, perhaps, the most interesting sculpture exhibits. The entire top floor has been devoted to drawings and etchings. Glackens shows the pastel sketch for his big nude downstairs. It is a fine study and an excellent lesson in scale. Henri's caricatures represent a side of his talent unknown to the public. They are capital in character and economy of means. For sheer drastic character, Jerome Myers's and George Bellows's slum sketches are extraordinary. Mr. Bellows, in fact, forces expression to the danger point. John Sloan's etchings for Paul de Kock's novels have as much character and less naïveté. The line is at once sensitive and austere, the mood realistic but supremely elegant. It is illustration and draughtsmanship of a high order. Glenn O. Coleman and May Preston Wilson, popular illustrators both, are represented by large groups of drawings. Leon Dabo's studies in miniature seem more interesting than his pictures. Two big drawings from the nude, by Gutzon Borglum, have a large accent.

The show is so large that one is easily lost in casual observation. The half would be better than the whole. On the smaller issue, do we need a large annual exhibition beside the Academy? there can

be only one answer: We do. Here is a great deal of vivacious or positively accomplished work that for one reason or another is never seen in the Academy and rarely elsewhere. On the large issue, is this ferment of issues promising a new and finer art? It would be sheer folly to give a dogmatic answer. The instinct of one old-fashioned writer is that there is more green, yellow and red sickness about than positive talent.

The sinking of the Titanic *in 1912 killed more than a thousand people, among them the artist and* Nation *contributor Frank Millet, whose obituary was written by his fellow painter and critic William Coffin.*

—

FRANCIS DAVIS MILLET

APRIL 12, 1912

William A. Coffin

TO THE EDITOR OF *THE NATION*:

Sir: A well-known gentleman who fortunately saved his life by keeping up in the sea and being picked up in time by one of the boats, has told us that he saw our friend, Frank Millet, very shortly before the *Titanic* went down, standing quietly on the deck while he waited placidly for the ship's inevitable sinking. He tells us that the smile that always played over his face had not altogether left him, and we know that he met his end like the brave man he was, no doubt regretting while he thought of his wife and children, that he was powerless in that hour of calamity to save others as well as himself. For it was one of Millet's fine qualities that no matter how much he might be beset with the troubles and difficulties that were a part of the never-ending activity of his life, he always somehow found time to give effective help to others. He did this, too, very often without being asked, for to his sympathetic nature was joined the quality of divination in such cases, his intuition being keen and his impulse to act a habit. I have often heard him say: "When you have a good idea, put it into execution at once"; and this was a rule of his own life, as well as his advice to others. If it had not been so, he could not have accomplished so much as he did in his useful and brilliant career, nor would a score of undertakings which came to success through his efforts, have remained to testify, as they do to-

day, to his fine executive ability, his tact, and his knowledge of men and how to bring definite results out of suggestions, tentative plans, and, very often, complications of authority.

While Millet's mural decorations, which were his chief occupation as a painter in late years, are more in mind at the present moment than his easel pictures, it is worthwhile to speak particularly of his work as a painter of English *genre*. Born in Massachusetts of English stock, he remained absolutely American in his English surroundings in Worcestershire, but in his art he entered into the spirit of the Elizabethan age as completely, for instance, as did Abbey. At Broadway he bought an ancient ruined abbey which stood on ground adjoining Russell House, his residence in that now celebrated village, and at a time when I visited him there, early in 1895, he was restoring the building, both with stone and timber. One of his London friends, an architect, came there for a day or two at the same time, and he told me that though he thought his own knowledge in restoration was pretty thorough, he found Millet had made no mistakes whatever, and had, by his study at odd times, made himself perfectly competent to carry out the restoration unaided by professional counsel. It was in one of the ground-floor rooms of this old abbey that Millet posed his models and painted such pictures as "Rook and Pigeon," "The Black Hat," "Between Two Fires," and others equally well known. This series of pictures, which must comprise as many as two score that may be called "important compositions," are of excellent technical quality. Pushed to a marked degree of finish, they recall in a way the work of the Dutch and Flemish masters, but they are quite different in their color schemes and lighting. All, or nearly all, of them are painted in a high key of light. Millet studied in Antwerp, but the style and conception of his work are distinctly his own. He could never have been satisfied with anything but painstaking endeavor, though he had a fine sense of ensemble and achieved that quality in his pictures.

His occupations and the missions he undertook for various public enterprises, not all of them connected with art, but at times more or less allied with it, took Millet pretty much all over the world. His life began early, first as a drummer-boy with a Massachusetts regiment in the Civil War, and he was correspondent for a great London newspaper in the Russian-Turkish war no more than eight years after he graduated at Harvard. His acquaintance was very wide and embraced many prominent men in official life, both at home and abroad. He was American, however, wherever he went, and preserved his American speech. It was indeed remarkable that he did so during his long residence with his family in England, participat-

ing intimately as they did in the life of the county people. He rarely made use of a foreign word or phrase in conversation, though he spoke at least two European languages besides his English, and could make himself perfectly well understood in several others. The clean, straightforward style of his English is shown in his literary work, most of which was ephemeral.

Coming to town from the country a few days ago, I have heard Millet's name on every lip, even before I could myself speak of him, asking information, and I am sure that no man on the *Titanic* is more keenly regretted than he. This regret and sense of loss is not at all confined to friends in what we call "the art world," whether we mean it here in New York or in London or Paris. His friends were legion in many spheres, and wherever he was known he was as much esteemed as he was loved. His place cannot really be filled by any one man that we can think of, for he was capable of filling a number of responsible positions at the same time, and filling them all rather better than anybody else could do.

WILLIAM A. COFFIN.

New York, April 22.

Rarely does an art critic get to "discover" a new talent, but Kenyon Cox's review of Paul Manship certainly did that for the virtually unknown young sculptor. Manship would be best remembered as the creator of the giant gold statue of Prometheus above the skating rink at Rockefeller Center, a commission he worked on at about the same time that Diego Rivera was painting his now-vanished mural a few hundred yards away.

—

A NEW SCULPTOR

FEBRUARY 13, 1913

Kenyon Cox

THERE IS NO rarer or more delightful sensation than the recognition of a new and genuine talent. This sensation I have experienced at the present exhibition of the Architectural League. What is known as the Academy's Room at the galleries of the American Fine Arts Society is, for this exhibition, given over to work from the American Academy in Rome, and among the things there exhibited is a group of some ten pieces of sculpture by Paul H. Manship, a young man

who has just returned to this country after the close of his three years' study at the Roman school. The group consists of a high relief in plaster, a plaster statue of heroic size, a bronze fountain figure a little smaller than life, five or six little groups or statuettes, and a commemorative medallion—enough to give one some clear notion of a personality still in the making but already full of originality and charm.

The high relief, entitled "The Woodland Dance," is, I should judge, the earliest of the pieces exhibited. It represents a capering centaur and a dancing nymph, and is competent naturalistic work; the figures, almost in the round and semi-detached from the ground, like those in a classic metope are well modelled, the composition is successful, and the characterization of the heads is pleasant and slightly humorous. But the manner shows no particular individuality, and the only thing that distinguishes this production from that of almost any other clever young sculptor is the entire absence of the influence of Rodin—an influence found nearly everywhere today.

The heroic statue, or group, "The Mask of Silenus," pleases me less than Mr. Manship's other works. The idea of the masked figure is ingenious, and the half-frightened child is well done, but the modelling seems less solid and thorough than in other things, and the archaistic treatment of certain details has an ambiguous effect. One is left wondering if the face under the mask is not like the mask itself, as, apparently, it should be to agree with these details. I do not know if this statue is, in reality, earlier in date than the little groups, but it looks like the first fruits of Mr. Manship's interest in archaic Greek sculpture and a tentative effort to appropriate its piquancy.

The little groups and statuettes, "Centaur and Maid," "Lyric Muse," "Motherhood," "Playfulness," etc., seem to me almost uniformly successful and charming. Here there is no confusion and uncertainty; these satyrs and centaurs are not wearing archaic masks; it is their own faces that are archaistically treated, and the figures themselves are simplified in a manner which reminds one of the sculptures of Ægina, and which harmonizes admirably with the elaborately plaited draperies and the conventional treatment of the hair. Yet these groups are full of the direct observation of life and of an essential modernity. The archaism is, after all, only the acceptance of a method and a limit, as if one should choose to write a *ballade* or a *chant royal,* but to express one's own mind in it. And to see this archaistic manner applied to figures with a quite unarchaic freedom of movement, doing things that no archaic sculptor would have

thought of making them do, is oddly exhilarating. Perhaps the best of them all is the Playfulness; the slim young mother with the wide-open archaic eye, slightly uptilted at the corners, gayly playing at ride-a-cock-horse with the baby.

These are minor works, with a distinctly sub-humorous intention, and the peculiarity of method seems to me a quite legitimate way of attaining the desired effect. They do not seem to me to be, as one of the newspaper critics has called them, "extremely mannered." Rather they seem the experiments of a young man in search of his manner—a young man who has, fortunately, an eye for the art of the past as well as for the nature of all times, and who is not willing to submit himself to the dominating influence of his own time. And if the mixed style he has employed in them should harden into a premature mannerism, as I do not believe it will, it would, at least, have the merit of being his own mannerism, not that weak reflection of the mannerism of Rodin which seems to be the stock in trade of most of our younger sculptors.

Yet if these statuettes were all that Mr. Manship had to offer, I should much as I like them, be less confident of his future than I am inclined to be. It is in his fountain figure, The Duck Girl, that he shows what he can really do. If this be not the latest of his works, it is certainly the best, the most thoroughly considered and completed; and the fact that he has put it into bronze would lead one to think that he so regards it. Here there is very little archaism; only that degree of restraint which marks the best sculptural tradition. The hair is elaborated into little rings, and the ivy crown lies flat to the head; the drapery is slightly formalized and stiffened; the modelling of the whole figure is simplified, and the accents are everywhere kept slight. In these things it reminds one of the best Pompeian bronzes, and, as in these bronzes, everything is there under the simplified contours. This is living flesh and tissue, the movement profoundly studied, each bone and muscle and tendon in its place and functioning under the smooth skin. The figure, with its large hip and slender yet well developed bust, is probably that of some precocious Italian girl of today; the lovely head, which reminds us vaguely of many things seen before, is apparently a refined portrait. We are as far from the mechanically constructed pseudo-classic ideal as from vulgar realism. Finally, the composition of line and mass is admirable, especially in the way the wing of the duck falls upon the girl's thigh, and the ornament, with its conventionalized fishes' heads for spouts, is delightful. It seems to me an original work of true classic inspiration, which the ancients themselves would have cared for as I do.

Will this new sculptor fulfil his promise? Can he go on, clarifying and defining his style, his talent becoming stronger and more supple, until he stands forth indubitably a master? It is dangerous to prophesy, and we have all been often disappointed. The ugly duckling who develops into a swan is less common than the cygnet who turns out, after all, to be a goose. But, to me at least, Mr. Manship presents so swanlike an aspect that I shall watch his future with the deepest interest, and shall hope that he will prove to have the enduring patience, the indefatigable industry, the high seriousness of purpose, which are, no less than the talent which he assuredly possesses, necessary to the making of a great artist.

While Stieglitz had shown works by Cézanne, Picasso, Matisse, and others at his gallery, the Armory Show of 1913 was the first major American exhibition to highlight the new art that would revolutionize both how art was seen and how it was made. The show was a defining moment in the history of art, but to many, including some Nation *reviewers, it seemed disturbing at best.*

—

from THE INTERNATIONAL ART EXHIBITION
FEBRUARY 20, 1913

THE ASSOCIATION OF American Painters and Sculptors has deserved well of the city in exhibiting, along with a somewhat limited selection of recent American work, a comprehensive series of the earlier revolutionary painters with an adequate representation of the very latest anti-realistic schools. Thus materials for a public verdict on Post-Impressionism, Cubism, and Futurism are generously offered. The exhibition will run long enough for readjustment to these novel types of invention; the battle of the critics may be fought within eyeshot of the hostile lines, and the discriminating minority of the public, the ultimate judge in these matters, may take its position for or against the new movements. Obviously, if sculpture and painting are to be utterly revolutionized along anti-naturalistic lines, as certain critics confidently predict, why, the sooner the turn-over is made the better. If, on the contrary, as we believe, these new tendencies are mainly the insignificant seething of crude and undisciplined personalities, the sooner this fact is perceived the better. In either event, good must result from bringing the new art out of the incense of clique and special pleading into the light of every day.

Aside from this special aspect of the show, President Davies and his associates have provided pleasure of a non-contentious sort by assembling works of highly individual flavor which escape the categories of movements and schools. Few New Yorkers have had the chance of enjoying the rich fantasy of Redon, of estimating the morbid power of Van Gogh, the barbaric intensity of Gauguin, the stalwart constructions of Cézanne. It is interesting also to have the chance to view the painting of that pride of otherwise despairing British art, Augustus John. In the foreign exhibits the Association has handsomely lived up to its programme of Internationalism, Internationalism being, of course, defined as a technical and revolutionary word.

Not the least valuable feature of the exhibition is the close juxtaposition with the newest work of paintings of the so-called Impressionistic schools—Manet, Monet, Renoir. All those revolutionists of thirty years ago now assume the sedate aspects of classics. Ingres, his rival Delacroix, and their successor Degas harmonize on the wall, with an old-masterly assurance. The fact that these leaders of a couple of generations ago now plainly fall into the general tradition of great painting, emphasizes the reality of the revolution on foot. The romantic Delacroix belongs with the classic Ingres; it is safe to say that Picabia and Matisse never will belong with either. Art is at the brink either of genuine revolution, or, as we believe, of a monstrous aberration. Either way, something like a new thing has been found under the sun, even if the newness turns out to derive from such venerable sources as excessive boredom; ignorant self-assertiveness, or over-ingenious pursuit of novelty and notoriety. If the newest art is really to be the art of the future, plainly *homo sapiens* must become a new creature—

> 'Ban, 'Ban, Cacaliban
> Has a new master: get a new man.

—

from OLD AND NEW ART

MARCH 6, 1913

Frank Jewett Mather, Jr.

UPON THE CUBIST work of Picasso, Picabia, and Marcel Duchamp I cannot dwell. We seem to have to do either with a clever hoax or a

negligible pedantry. I am told that these experimenters are working at the problem of mass, weight, and spatiality. Finding that these third-dimensional qualities are most vividly conveyed by the simpler geometric solids, they adopt these as units of expression. Picasso conceives a head as so many facets, leaving the junctures sharp. Frans Hals or Chase or Sargent would make much the same synthesis, but would soften the junctures as nature does. Picasso shows a bronze bust in conical forms. It has a sinister impressiveness, and looks like a badly carved Gothic thing. Picasso's early painting had much grim power and decorative balance; only a portrait represents him in this phase; his latest work, in which geometry dominates, is singularly dreary in color and morbid in expression. From this charnal suggestion Picabia is free. He has recently passed from a kind of Post-Impressionism to Cubism. He frames his figures and landscapes from cubes, hexagonal crystals, and the like. His color is interesting in a rather obvious and garish way. Both Picasso and Picabia mineralize their world and present it in terms of crystallography. The transposition is often ingenious; both men are evidently accomplished mechanical draughtsmen, but none of their work reveals to an eye that has honestly waited either spatial quality, mass, or handsome decorative effect. Marcel Duchamp, whose units of expression are slabs and shavings, is said to have out-geometrized the Cubists themselves. His pictures are monochromes in brown with the general look of an elevation of a volcanic cliff. In the stratifications we are told by the catalogue to look for nudes, faces, and groups; but I advise no one to make the attempt. If any images there be, these are mental and symbolic. These paintings, so far as genuine, are merely expressions of anti-naturalism reduced to the absurd along ratiocinative lines, just as Post-Impressionism is merely the emotional reduction to the absurd of the same anti-naturalistic fallacy. The Futurists were invited to the exhibition, and declined. Their absence need not greatly be regretted. Their origins reek with charlatanry and shameless puffery, and this genesis their work has done nothing to belie.

And here the question of taste comes in. The trouble with the newest art and its critical champions is that fundamentally they have no real breadth of taste. These people are devoted to fanaticisms, catchwords, all manner of taking themselves too seriously. Where something like taste exists, the new brusque procedures are readily assimilated. The studies of Othon Friesz, for example, are tense and nervous, fine in color, discreetly exaggerated. Augustus John, who is very fully represented by paintings, silver-point drawings, and aquarelles, can go some way with Matisse because he never forgets

Manet and Botticelli. John's drawings are exquisite, a sublimation of the familiar method of the Slade School. His watercolor sketches achieve remarkable character and mass with the slightest means. His larger works tend to fall into affectations which are atoned for by austere and distinguished workmanship. It is as if Puvis and Degas had joined forces not quite amicably. John makes the high attempt to achieve fine decorative effect without the usual waiver of the characteristic and individual. The ambition marks him a remarkable personality. He may achieve where Besnard has rather splendidly failed. A glance at the coquettish sensual designs of the late Charles Conder, at the delightfully intimate landscapes with figures by George W. Russell, and at Jack Yeats's keen visions of Irish political humors will tend to efface the irresponsible nightmares of Matisse, and the calculated discomforts of the Cubists.

On the whole, the case calls for cheerfulness. Either these new movements are aberrations and will promptly vanish, or else there is to be henceforth no art as the world has formerly understood the word and the thing. But this, I am assured by a friend of the new art, is highly desirable. In the future every man is to see nature and his own soul with the artist's eye, and the artist and the work of art will naturally become superfluous. Humanity has merely to breed a race of little Post-Impressionists and Cubists, and the thing is done. Let common-sense hesitate to thwart or defer so evidently desirable a consummation.

—

THE ARMORY EXHIBITION

MARCH 13, 1913

Frank Jewett Mather, Jr.

THE ARMORY EXHIBITION shifts bewilderingly day by day through changes of hanging and admission of new pictures. This keeps the interest up, but adds to the difficulties of a critic. In considering the American contributions only the most general treatment is possible. The show is representative only of the extreme left of our art. A mere geographical survey will tell what may be expected. The entrance hall is dominated by George Barnard's colossal group, "The Prodigal Son," while on the wall Robert Chanler's clever zoomorphic screens afford a piquant background for the sculpture exhibits. Nervously drawn, fancifully colored, composed on formulas skilfully

adapted from the Japanese, these screens are the most novel and interesting feature of the American display. In certain larger screens Mr. Chanler sinks to mere jumboism in design and mere prettiness in color. Jo Davidson's adroit and charming sculpture shares the honor of the floor with Solon Borglum, Aitken, Beach, and a newcomer, Arthur Lee, whose work shows that combination of youthful freshness with archaism which is the present mode. Behind the entrance hall is a gallery containing no less than a dozen Albert Ryders, a fine snow scene by John Twachtman, and a couple of minor pieces by Theodore Robinson. Two nocturnes by Ryder, with the "Diana" and "Interior of a Stable," represent about the best America has produced in purely imaginative painting. The glamour of this sort of thing is unearthly and exquisite. Arthur B. Davies, who is rather slightly represented in the exhibition by two of the Grecian series, cultivates this vein with more versatility and executive capacity. Without such dreamers an art is poor indeed; with them alone it is not quite rich. These secluded and highly individualized talents refresh, but in the nature of the case cannot provide leadership. Some principle of leadership appears in the tenuously firm work of John Twachtman. It is an austere and fastidious art, refusing the customary compromises. To fill a space with air and not sacrifice significant line and mass, to procure depth without forcing contrast—these were the problems that Cézanne and Twachtman were working at simultaneously in Provence and Connecticut. It was possibly only the chance of a too early death that prevented Twachtman from reaching the level of his French colleague. The defect of both is a kind of impersonality, a proud withdrawal of the painter behind his work. It is the ungenerous attitude of Flaubert in letters. How definitely the tense and aristocratic landscape of Twachtman was symptomatic, let the work of Ernest Lawson and James Preston in the present show attest. They are entirely representative talents as regards both the qualities and the defects of our American impressionism.

As you pass to the right from the entrance, successive halls are dominated by George Luks and Lawson, George Bellows and Prendergast, Childe Hassam, Alden Weir, and D. Putnam Brinley, whose "Emerald Pool," a stirring vision of a snow gorge, is again a fine example of what we may roughly call the Twachtman tradition. Weir and Hassam, both well represented by retrospective groups, shine with old masterly serenity amid the strident new work. Except Ryder, they are the only older men honored by a group exhibition. In fact, C.H. Davis, Edward Rook, H.D. Murphy, and Reuterdahl are about the only other regular exhibitors at the Academy who have seemed

progressive enough to hold their own in the militant atmosphere of the Armory of the gallant Sixty-ninth. Upon Weir and Hassam I long ago exhausted my vocabulary of praise, which I could only repeat here with emphasis. Both are marvelous eyes and fine hands. Weir is as well a brooding spirit which invests its creations with an especial significance. He paints as in better days Henry James used to write.

George Luks, with a large double portrait and two character sketches, shows his usual competence. There is trenchancy in his brush stroke, as if he were not merely representing something, but sweeping the nonsense from it. None of his three paintings represents the full impact of his gusto, but a lot of little sketches of men and beasts, observed with an impartial relish, amply make amends. Luks is a powerful humorist as the word was used by Ben Jonson, and practiced by a rare line running through Hogarth and Rowlandson to Charles Keene and Phil May. Of the same tribe, but a shade more superior and sardonic, are John Sloan and Guy Dubois. Although I have known Dubois's work for a matter of ten years, its characterfulness and discretion struck me the other day like a new discovery. In the room where Luks and Lawson lord it we have the Prestons, Elmer McCrae, Philip Hale, and Jonas Lie in a rather flimsy decorative vein which I hope will prove transient. With Luks, George Bellows is a fount of gusto, but he seems to have nerves, with the corresponding impatience. His apostolic descent from St. Francis Rabelais is by no means so clear. In the "Polo Crowd," the "Circus," and the "Docks" restlessness is pushed nearly to the breaking point. Such spectacles are restless, and yet it may possibly be the business of the artist to see the turmoil in some calming eternal aspect. Something of this clarifying quality there is, for example, in the misanthropy of Degas, and occasionally in the frank sensuousness of Renoir. Bellows's portrait of a dancer has the sober excellences which his big illustrations often lack. His talent is great, and evidently has not yet found itself.

Prendergast has had the odd fate to be a Neo-Impressionist and a Post-Impressionist without knowing it. He splits the world up into a coarse mosaic of the primaries and recombines it in brusque and animated suggestions. It is not an art for slow eyes. There is plenty of sunlight and joy of life in it, and enough keen observation of men and women in any one of his three big pictures to fit out an Academy show and leave a surplus. Jerome Myers's swiftly caught visions of toil and play in New York are almost equally summary and more reflective. He is not bound by formulas and his grasp of the eloquence of the body, which is great, does not, as in Prendergast's case, imply sacrifice of the eloquence of the face. In his grimmer vein Myers has done nothing better than the benchful of sleepers

on a sweltering roof which hangs in the gallery to the right of the entrance. Glackens and Henri are the greater gods of this particular Olympus. Both are fitful painters somewhat after the type of the heroine of Longfellow's best-known poem. The petulance which makes and limits the art of Henri is well expressed in a nude, which at a certain peril I must call an Academy, and a more engaging head of a lad. The portrait of a gypsy, intensely conceived and worked out firmly in saturated browns and rose, is one of the best Henris I have ever seen. Glackens too often paints with the chip from his shoulder, instead of the palette-knife of commercialized art. A large group of young women done in the colors of Renoir, which, of course, may also have been those of the thing itself, is more ambitious than satisfactory. The figures lack relation and tend to fall out of the frame. Starting from the tempered blacks of Manet, Glackens has been making a resolute and interesting attempt to reform his style along lines of frank color, with results as yet uncertain. There could be no better rebuke to some particularly blatant and dreary Post-Impressionism which disfigures this hall, then the real expressiveness of the drawing of Myers and Dubois. The next gallery gathers about the charming "Boy Playing with Goat" of Karl Anderson a number of canvases chiefly representing the luministic idea. A mountain scene by Catherine N. Rhoades is spacious and rich in color. Beyond, towards the Cubists, are several galleries of sketches in color and black-and-white, something of a refuge from the intermittent blare of color in the painting halls. In fact, the whole arrangement of the exhibition is exemplary in avoiding the monotony of most big shows.

Remaining impressions must reduce themselves to bare mention. The crepuscular Bolton Brown and the nocturnal Leon Dabo are agreeably represented. Charles Hopkinson shows a delightful group of children, all tea-rose and pale blue. Cimiotti's landscapes are decorative and colorful beyond the common. Allen Tucker's portraits and landscapes have a quiet distinction; one would gladly see them in non-competitive conditions. John Marin's water-colors of the Woolworth building are attractive in color, but there seems an odd immodesty in depicting to its ultimate stages the vertigo or worse that the giant tower produces in his sensorium. Kenneth Hayes Miller is decoratively effective in a fashion that equally recalls Blake, Ryder, and the first manner of Pablo Picasso. Margaret Wendell Huntington achieves a remarkable effect of solidity and just placing in her Torquay cliffs and a powerful impression of the landward run of long waves below.

I have left myself no space to do justice to the sculpture, which

presents assured excellence in the figurines of Bessie Potter Vonnoh and Abestemia St. Eberie, and a piquant novelty in the tiny caricatures of current modes and their feminine victims by Mrs. Myers. In general, the exhibition gives a sense of alertness and youthful vim. There is nothing of the somewhat funereal and dutiful atmosphere that habitually rules in our large stated shows. In the Armory people fall into talk, wrangle amiably, readily exchange enthusiasms. To a critic who has been accustomed to see his ministrations accepted with the resignation appropriate to those of the undertaker, all this is inspiring. And it can only be for the good of art among us that the public begins to realize that the artist is not displaying an elegant accomplishment with apologies, but trying to say something that he really wants to be heard. I do not wish to say anything too old-fashionedly distrustful of the numerous young talents who are treading the gaudy primrose path of Henri Matisse. Nor am I even prepared to insist that there are merely fireworks and disillusion at the end. My business is not with artists, who, I assume, know their own affairs; but with the public, which in this matter emphatically doesn't. And I wish to warn open-minded people against certain persistent sophistries which are urged in favor of the strident color schemes of the Post-Impressionists. You will be told that the color of the new work puts down everything older. Concede that immediately, and say it doesn't necessarily matter. So can a stentorian fool put down a company of well-bred people, or the mere drums the entire orchestra. Ask your tempter if he is Ruskinian, believing the primary colors to be intrinsically holy. Or ask him if he thinks Velásquez a feeble painter because he found a palette of black, white, and red entirely adequate for portraiture. Or, better yet, go from Matisse and Segonzac to Ryder, or Davies, or Hassam, or Weir, to Renoir's peonies or the lily pool of Monet. Or pass directly from the insistent blare of the Post-Impressionist gallery to some pale sketch of Augustus John's, austerely executed in cool blues and grays. If after such comparisons you honestly feel that the older painting is in any sense put down, and find you crave the new, why, you are entirely welcome to it.

—

THE NUDE AND THE STAIRCASE

MAY 8, 1913

J.R.

TO THE EDITOR OF *THE NATION*:

Sir: I have been waiting feverishly to see if any one else would see it. No one has. I alone have been able to understand—I and the painter, M. Duchamp.

I discovered the key to it on the very first day of the exhibition as I stood in the crowd of private-viewers before that masterpiece, "A Nude Man Descending a Staircase." It is a picture calculated to explain itself; it is, in fact, *Automatic Art*; and yet, as I looked round me a moment after making my discovery, I saw that no one else had understood. No one was doing what I had just done.

Now, the picture had made me open and shut my eyes a number of times very rapidly, and what I saw between those eyeflashes made me continue the process. Obviously, that was precisely what the artist had counted on, for the whole thing was then perfectly plain to me. Of course, it is possible that I am an exception, that no other human being can open and shut his eyes as rapidly as I can; but even a person who can open and close his eyes only some three hundred times a minute, let us say, would have been sure to get glimmerings of the meaning of this revolutionary picture, had he the least affinity with the genius of the painter. To me, at my high speed of eye-flashing, the secret lay open. Striking a thousand-wink-a-minute pace, both eyes keeping perfect step, what did I see? I saw precisely what the title of the picture had told me I should see—I saw a nude man *descending* a staircase. He came down one step at a time, gracefully and repeatedly disappearing off the margin of the picture at the bottom as long as I continued to wink. Slats? Shingles? Nothing of the sort. Those bags of golf clubs, oh, poor, blind, unwinking Public! are *motion-states*. Wink, and a glorious young Apollo starts at the top of a polished stair and descends to his bath—which is somewhere off the margin at the bottom. Stop winking, and instantly he flies to pieces, to atoms of motion, that is; for motion breaks up into its relative states, and each atom of motion resumes its unkinetic, unsynthetic *atomtudes*. Do you realize the genius required to locate accurately in the time and space

of the picture these multifarious unsynthetic atomtudes? This is the mere A B C of Futurism and the Cubist schools.

Now try winking with alternate eyes, at the rate, say, of five hundred a minute per eye. What happens? Before you, motionless and *collected* as a god, the nude stands on the middle step of the staircase. Also, he is now no longer nude. His clothes, evening dress under an expensive fur coat, which had hung somewhere amuck the atomtudes, are now upon him. In short, he has returned from his bath, and is waiting for his wife—who is tying her veil upstairs off the margin of the picture. In one hand he holds an opera hat, in the other a cane. What else he might acquire with increased speed of winking, I cannot say—perhaps a cigar, possibly his wife herself. A more remarkable effect, an actual effect, is to be had, however, by slightly decreasing the speed of alternate winks. You can then see the nude assembling, synthesizing, on the middle step, and his clothes assuming their faultless atomtudes upon his godlike form. The genius of the artist was so all-comprehending that the nude's clothes arrive from the different times and places of the picture in an infallible order.

Only one mystery remains. By no amount of optical ambidexterity can it be discovered just where the nude keeps his clothes. If, for example, you stop unwinking abruptly in the midst of the nude's process of undressing, the atoms of motion so instantaneously resume their unkinetical atomtudes that even the fur coat is whisked out of all recognition. Of course, it lurks somewhere in the times and spaces of the picture—but where? Ah, what a sense of infinite genius does one have in contemplating that question!
Bloomington, Ind., May 1.

Nearly three years after the Armory Show, Frank Jewett Mather Jr. was still having a bit of trouble coming to terms with modern art. This excerpt is from his review of a Cézanne exhibit in New York.

—

from PAUL CÉZANNE

JANUARY 13, 1916

Frank Jewett Mather, Jr.

THERE IS NO mood in a Cézanne—just superior vision and athletic workmanship. All the values that come from civilization are absent in

his case. When one recalls that he adored Poussin, the Dutchmen, the Venetians, even Courbet, Couture, and Delacroix, and yet, save in a few youthful romantic experiments, kept all these influences out of his art, one must admit that he achieved the very difficult task of decivilizing himself. In an epigonic era he contrived to be a genuine archaic, to cope at first hand and naively with his problems. This is both his distinction and his limitation. It explains his intransigence. For that plus quality of lovely workmanship which the civilized artist rarely fails to value he cared absolutely nothing. He was capable of it, as many of the still lives attest, but generally his surfaces are raw, the touch as nondescript as assured. The preciousness which would make any detached square inch of a Fra Angelico, a Titian, a Vermeer, a Watteau a desirable possession, is completely absent from a Cézanne. And this preciousness—what is it but the artist's desire to please, his acceptance of a social code of beauty—in short, his civilization? Of course, I am aware that this is utter sentimentality to those for whom artists of Cézanne's type are the greatest. Yet at the risk of seeming sentimental I am willing to give the values of sentiment their place in the sun. The most radical trouble with Cézanne, in my opinion, is that, not caring to please anybody but himself—which is at once a defect in civilization—he did not really care greatly about nature. He cared tremendously to be right about nature; his own rectitude was what engrossed him. This Calvinistic tinge—or, since he was a good Catholic, let us rather say Augustinian—is what limits his art. It has next to no humanity in it, no humanity, no love.

In view of these facts, it seems to me quite absurd to speak of Cézanne as a great artist. He lacked the requisite greatness of soul. He was an honest and valiant investigator, a pointer of the right way in a moment of hesitation. No landscape painter can relive Cézanne's experience without benefit. With all his limitations, he is sound and central. His problems were real problems, and his solutions real solutions. Nothing, I take it, would disgust him more than the charlatanism which the Post-Impressionist and Cubists are practicing in his name. If he paid personally and artistically too high a price for his austere attainment, that is ever the hap of the investigator. His fecund and athletic genius should assure him a kind of immortality, but he will be remembered rather with experimenters like Uccello than with the great masters. His example is generally so sane and, by reason of its very restrictions, so readily understood, that I am a little ashamed of suggesting the possible misunderstanding that might arise from the study of Cézanne. It is that one may be great simply by refraining from being charming. This is so easy

a path to greatness that many are already treading it. These pilgrims of eternity may well be reminded that whatever greatness Cézanne achieved was not by reason of his lack of charm, but in spite of it.

Rodin died in 1917, and Kenyon Cox wrote his obituary for The Nation. *It prompted a letter from Joseph Pennell who, in the midst of World War I, had returned to the United States with his wife, Elizabeth.*

—

RODIN'S MEMORIAL TO WHISTLER

DECEMBER 13, 1917

Joseph Pennell

TO THE EDITOR OF *THE NATION*:

SIR: Mr. Kenyon Cox in his article on Rodin has referred to most of that artist's works—save those he did for America. One of those, the memorial to Whistler, to which some of your readers subscribed, Rodin wrote me he finished last spring, and was only waiting for the time when bronze could be had for art, instead of being used for war.

JOSEPH PENNELL

Cleveland, O., November

In what would be one of her final pieces for The Nation, *Elizabeth Robins Pennell took the rare step of temporarily abandoning her pen name of N.N. to write, appropriately enough, about the curious absence of women from the history of art.*

—

ART AND WOMEN

JUNE 1, 1918

Elizabeth Robins Pennell

IF, UNTIL RECENT years, there were no women physicians, if in most countries there are still no women lawyers, the reason is simple. The ability may have been there always, but not the chance to develop

or use it. Why the woman artist has been rare is not so easy to explain. The hindrances in her path certainly have been less.

We know from Dürer's wife selling his prints in the market-place, from Saskia posing for Rembrandt—only one of many artists' wives to render their husbands the same service—that women were not banished in the past from the studio and the workshop, where, no doubt, a training would have been theirs had their genius imperatively called for it. But from the Louvre to the Uffizi, from the Prado to the Rijks, you may look in vain for a woman to rival Velasquez as portrait painter, or Tintoretto as decorator, or Michelangelo as sculptor, or Rembrandt as etcher—or rather, you may look in vain for almost any woman at all. We know, too, that there was no social commandment forbidding her the right to paint or model or etch if she could. Indeed, when the ladylike virtues were most at a premium, art was never included among the unladylike vices. To dabble in paint was a polite accomplishment for the ladies initiated into their "Whole Duty" by the omniscient Hannah Woolley in the late seventeenth century and her followers in the eighteenth. The accomplished housewife, after she had passed triumphantly through kitchen and stillroom and sickroom and nursery, after she had finished her day's needlework and embroidery and gardening, was encouraged to devote the leisure left over to producing a feminine masterpiece with her brushes and paint and canvas. And if the desire to turn a pastime into an occupation had ever seized her, no doubt she could have obtained a more serious training than the authorities on Polite Behavior in a Female could give. One of the grievances of women artists in England today is that they are shut out from membership in the Royal Academy, though two women were included in the original list: Mary Moser, now forgotten, and Angelica Kaufmann, better remembered for no special merit in her work, but because she was a conspicuous personage in her generation and because a ceiling she decorated survived in a delightful old corner of London and found its way into Baedeker. If these two women could adopt art as a profession and succeed so well as to be made Royal Academicians and receive important commissions, other women could surely have had the same chance had they possessed as much as the same slight talent. But Mary Moser and Angelica Kaufmann had no successors in England until more modern times, and no competitors anywhere except Madame Vigée Le Brun in France. The Frenchwoman was a better artist, craftsmanship in France ranking higher than in England, and the training to acquire it being there esteemed a necessity even for a woman. But I doubt if there are many people who without consulting a book of reference

could say exactly what Madame Vigée Le Brun had done beyond painting that charming, well-known portrait of herself and her daughter.

Between her and Rosa Bonheur I can remember no woman to fill the gap. Rosa Bonheur was a woman of unusually masculine physique and temperament, and something of his virility is in her work. She was not afraid of a big canvas or of a big subject. That a woman should want to paint cattle and deer and horses was enough to bring her into the limelight. That she could paint them with the exactness of a photograph and get her pictures into museums insured her popularity among her contemporaries, and no woman artist ever enjoyed a greater success. And yet today even less than Madame Vigée Le Brun would she be ranked among the masters. We see her overshadowed by two younger women who could not compete with her in popularity. One was Berthe Morisot, scarcely known, but an artist. She was closely associated with the Impressionists, and so studied in a good school. What she did was a re-echo of the right thing intelligently understood. Her most ardent admirer, however, would not claim for her originality. She was surpassed by Mary Cassatt, pupil of Degas, as closely identified with the Impressionist group. Miss Cassatt had the same advantage of studying in a good school, thus getting a sound training, and the artistic sense to understand that it was an advantage. She is the disciple, not the prophet, but an artist in all she does, and a fine craftsman. She works as a man works.

Mary Cassatt belongs to the second half of the nineteenth century. When she began to work, women artists were few. Now they are numbered by the hundreds, by the thousands. The schools everywhere are as open to them as to men. They can brave the Latin Quarter without danger to their reputation. American scholarships send them to Paris, American philanthropists arrange for them while they are there, sparing them the incentive of struggle, cloistering them so well that they know as little of Paris when they leave as if they had never strayed from Kalamazoo or Oshkosh. Societies of women artists are many; so are their exhibitions. The Salons of Paris, the Academy, the International, and other galleries of London welcome the work of women to their walls. But the world still waits for the woman genius. I can recall many French women among the exhibitors, but not one who equals the most distinguished of the men with whom all must there compete. The Brooklyn Museum is just now showing the interesting collection, retrospective and contemporary, organized by France for the San Francisco Exposition. Only one woman is included in the retrospective section, which dates no further back

than 1870, and she is the widow of Fantin-Latour, whom few, save her friends, knew to be a painter. Six or seven are in the contemporary section, and their names are strange to me, though I have gone regularly to the Salons, year by year, for over a quarter of a century. Women have captured the schools and studies and the exhibitions, but they have scarcely as yet invaded the Luxemburg in greater numbers than the Louvre. It is not more promising in London. There are women who paint, illustrate, model, etc., women who exhibit, women whose work sells. But it is not women who redeem the Academy from commonplace, who gave the International its distinction during the short period of its greatness. I have been to most of the big international exhibitions in Europe for many years past, but in them I have seen no sign that Scandinavia, or Italy, or Spain, or Holland, or Belgium, or Germany has produced the woman who towers above the average, as an occasional man does, head and shoulders—or produced, for that matter, many who attain the average. Of America, I hesitate to speak. I have long lived away from my own country, and I have not yet had the opportunity I hope to have to study its art. I know that America has its women portrait painters, women mural decorators, women illustrators, women sculptors, and has been more generous than most countries in supplying them with commissions, with that definite purpose for work which is an inspiration in itself. But out of America, anyway, they have not yet been exalted to the heights with Whistler and Sargent and St. Gaudens and the illustrator Abbey.

However, if the rare exceptions exist in America, they are still the exceptions. They do not alter the facts. In the past hardly any women adopted art as a profession. During the last fifty years or so, they have rushed into art in crowds. And art is as unchanged by their rush as it was by their indifference. The many find in art a pleasanter way to make a living than by school-teaching or typewriting, which is as true, I am afraid, of many men. But these do not count. The few are serious, have studied seriously, work seriously, are workmanlike in what they do. They do count; but even from their midst has there arisen a creator, an originator?

As I said in the beginning, so I say at the end, it is hard to understand why women have accomplished so little in art. But the reason, when it is understood, may explain our true limitations as women better than any theory hitherto offered by the student of sex.

The war tended to eclipse much of the routine coverage of art exhibitions and the like, but art and society still managed to intersect.

—

DISPATCH

MARCH 7, 1918

THE SALE OF a well-known collection in New York again draws attention to the curious fact that war has not by any means spoiled the art market. Newly rich Danish, Norwegian, and Swedish millionaires complain that they cannot compete with native wealth at the German auctions. From Paris and London agents of American connoisseurs and dealers send in similar reports. What is the reason of this in times of unprecedented income taxes, with capital taxes threatening in the offing? Various explanations have been given. The art-buying class never was very large, at best. It would take only a very moderate increase of this handful by war profits to make itself felt. And the new recruits would, for the most part, be of the spending, "easy come, easy go" temper. In the Central Powers region there has been the additional explanation that many people lacked confidence in the currency and bonds issued from Hamburg to Constantinople by practically the same printing presses and preferred to invest in pictures. In short, in central Europe the signature of an artist has become more potent than that of a monarch.

—

DISPATCH

JUNE 8, 1918

ON THE MORNING of April 30, the shells of the super-cannon fell upon Paris, bombs rained from enemy aircraft, and the dread battle was raging but seventy miles away. Many people had fled the city. But the Paris Salon opened its doors. The *Vernissage* took place. The Grand Palais, the old home of the Salon, has for nearly four years (since the last exhibition of the Salon) been a Red Cross hospital,

so the present exhibition is housed at the Petit Palais. The butterflies of fashion, if such still exist in France, were not there. People went, not to note "creations" in toilettes, but to look at pictures, to admire or criticise sculpture. Clemenceau's bust was there, and that marvellously active Prime Minister was also there and once more expressed his discontent with Rodin's work. Many of the painters and sculptors who formerly made the Salon are now fallen, crippled, or captured by the enemy. But some are still able to guide brush and chisel even amid warfare, and a new group of artists has grown up since 1914. This is essentially a war Salon; opened as it was amid shell fire, it is almost a Salon at the Front. And it is the finest proof to the enemy and to the world that the "moral offensive" has utterly failed.

7

THE AGE OF MACHINES: BEWITCHED, BOTHERED, AND BEWILDERED

Marsden Hartley, who The Nation *described as "a painter and art critic particularly associated with the Société Anonyme in New York City," was one of the pioneers of American modernism. He first exhibited at Stieglitz's gallery, and was also known as a poet and writer. This essay, which had a lasting influence on future critics and painters, continued the often impatient sentiment of Kenyon Cox and others that American art should be seen as a legitimate equal to the art of Europe.*

—

DISSERTATION ON MODERN PAINTING

FEBRUARY 9, 1921

Marsden Hartley

IT IS FOR everyone to comprehend the significance of art who wishes so to do. Art is not a mystery, never has been, and never will be. It is one with the laws of nature and of science. Art is the exact personal appreciation of a thing seen, heard, or felt in terms of itself.

To copy life is merely to become the photographer of life, and so it is we have the multitude in imitation of itself—one in the undeniable position of copying another one, without reference to the synthetic value of imitation. It is the privilege of the artist then to reform his own sensations and ideas to correspond according to a system he has evolved, with the sensation drawn out of life itself. It is a matter of direct contact which we have to consider. There can be no other means of approach. To illustrate externals means nothing, because the camera is the supremely edifying master of that. It means nothing whatsoever for a painter to proceed with ever so great a degree of conventional flash and brilliancy to give sensations which nature or the mechanical eye of the camera can much better produce. The thing must be brought clearly to the surface in terms of itself, without cast or shade of the application of extraneous ideas. That should be, and is, it seems to me, the special and peculiar office of modern art: to arrive at a species of purism, native to ourselves in our own concentrated period, to produce the newness or the "nowness" of individual experience. The progress of the modernist is therefore a slow and painstaking one, because he has little of actual precedent for his modern premise. It must be remembered that modern art is, in its present so-called ultra state, not twenty years old, and it must likewise readily be observed that it has accomplished a vast deal in its incredibly prodigious youthfulness.

Art in itself is never old or new. It began with the first morning. That the eye trained accurately to observe its essence is of such recent existence, may be the real object of surprise. All the great races had a mission to perform. They had race psychology to perfect, and, therefore, art with them was allied with all the elements of symbolism. Symbolism can never quite be evaded in any work of art because every form and movement that we make symbolizes a condition in ourselves.

We derive our peculiar art psychology from definite sources, and it is in the comprehension of these sources, and not in the imitation of them, that we gain the power necessary for the kind of art we as moderns wish to create. We are intrigued into the consideration of newer qualities in experience, which may or may not be eternally valuable, yet may hold contemporary distinction. We must think ourselves into the Egyptian consciousness in order to understand the importance of art to the Egyptians, and we must likewise perform the same function as regards our own appreciation of art, the art of our modern time.

It will be found that there is a greater interest in this newer type of pristine severity than in the more theatric and dramatic tenden-

cies of the romanticists. It is no way to disparage a romanticism as fostered by Delacroix, but we are finding a perhaps greater degree of satisfaction in the almost flawless exactitudes of an artist like Ingres, whose influence in his time was doubtless considered (certainly was considered by Delacroix and his entourage) detrimental in its coldness and its seeming severity and lifelessness. Art is not a comfortable or an emotional issue. It is a stimulating intellectual one. We have learned that Ingres was not cold, but clear and durable as crystal, and we in our day are made to admire the indescribable loveliness of steel and glass for the strength and unadorned splendor they contain in themselves, devoid of the excessively ornate incrustation of art as applied by the Orientals and by the artists of the Renaissance. With them it was worship of ornamentation. Surfaces were made to carry heavy burdens of irrelevant beauty. Today we have admiration for the unadorned surface itself. We have a timely appreciation for the mechanistic brilliance and precision of this era; we care for the perfect line and mass, the unornamented plasticity of workable objects, such as the dynamo and the steam drill, as well as the cool and satisfying distinction which electricity contains.

We may say then that in matters of experience generally all progress is a plunging toward discovery. With amazing yet typical rapacity the world of Europe, that is, the major part of it, has turned to art for its speedy salvation, and the revival of modern painting alone in Europe is, while utterly characteristic, nevertheless startling in its reality. The peoples of Europe know through the experience of a majestic background the importance to racial development of the development of art. They are perfectly aware that the only solution of their civic problem is to come through the redirection of public interest toward matters of taste and cultivation. For it is through art and art alone that peoples survive through the centuries. Their arts have been their most important historical records.

The question on the lips of the rest of the world is naturally: Why is there no art in America? There is already a well-defined indication that American may one day possess a literature of its own. We need not depend entirely upon our own private exotics such as Emerson, Poe, and Whitman, who, it can be said, would never have sprung from any other soil. The last few years have shown that America has a type of poetry all its own, a poetry that is as peculiar to it as the Acropolis to Athens. There is an indication that the art of painting is quite conspicuously on the ascendant in America. Of these two arts in our own country much more indeed can be said than can be said for music and for the drama, in which we seem but for a small

and slowly emerging group to be practically negligible as creators. It is because we have not yet learned the practical importance of true artistic sensibility among us. Yet there is possibly more hope for the arts of painting and poetry because they are the last to be bought and sold as valuable merchandise. It is in this, possibly, that their salvation lies, as it is in freedom that all things find perfection, in freedom that all functions find their truest gifts for expression.

Anatole France (Jacques Anatole Thibault) was awarded the 1921 Nobel Prize for Literature. He was considered a mentor by Marcel Proust, who enlisted him to support Emile Zola's defense of Colonel Dreyfus. In his twilight years, France often wrote works of political satire, mostly for periodicals. When The Nation *recruited him to its masthead in the amorphous position of contributing editor, his few pieces for the magazine, including the one below, were usually transcripts of conversations with him (anticipating by decades articles in Andy Warhol's* Interview *magazine).*

—

THE OPINIONS OF ANATOLE FRANCE

MAY 17, 1922

Recorded by Paul Gsell; Translated by Ernest Boyd

Rodin

ANATOLE FRANCE WENT one day to call on Auguste Rodin at Meudon. Rodin was doubtless greatly flattered by the visit of M. Bergeret. Yet these two prophets did not profess unreserved admiration for one another.

In private conversation Anatole France is in the habit of commenting freely upon the inspiration of the celebrated artist.

"He is a genius. I am sure of it. I have seen some nudes of his, palpitating with life. But he is not one of those great decorators such as France has known, especially in the seventeenth and eighteenth centuries. He seems to me to know nothing of the science of grouping."

Rodin, in his turn, sometimes spoke of M. Bergeret in rather harsh terms. Of course, he praised highly the wit of Anatole France

and the charm of his style, but he had scanty esteem for the varying shades of his thought, which he considered specious and instable.

"He has the gravy," he declared bluntly, "but not the rabbit."

It should be explained that rabbit was Rodin's favorite dish. It was a remembrance of the time when he was a figure-carver and ate his meals in cheap restaurants. Rabbit seemed to him a food of the gods. Obviously, Anatole France lacked something essential when he had no rabbit. Consequently, he would never model the bust of M. Bergeret.

Rodin invited M. Bergeret to admire the work which he had on the stocks, and his collection of antiques. Then they went into the dining-room. . . .

The dining-room in which we sat was as spring-like as an idyl. The windows looked out on the bluish slopes of Meudon and upon the valley of the Seine, winding lazily beneath a silver sky.

Rose served up a huge dish of rabbit, and Rodin himself fished out rashers and placed them politely on the plate of Anatole France, whom he wished to honor. . . .

"We are invaded by ugliness," growled the sculptor. "All the things we use every day are an offense to good taste. Our glasses, our dishes, our chairs are horrible. They are machine-made, and machines kill the mind. Formerly the slightest domestic utensils were beautiful, because they reflected the intention of the artisan who made them. The human soul ornamented them with its dreams. . . ."

M. Bergeret admitted that our decorative arts had fallen very low.

"If it were only our decorative arts!" said Rodin. "But it is art, art pure and simple, which has dwindled to nothing. No distinction can be made between decorative art and art. To make a very beautiful table or model the torso of a woman is all one. Art always consists in translating dreams into forms. We no longer dream! People have forgotten that every line, if it is to be harmonious, must express human joy and sorrow. And in what is called great art, in sculpture, for example, as well as in the making of ordinary things, machinery has put Dream to flight."

This prophetic outburst disconcerted M. Bergeret a little, for it is not his wont to take such dizzy flights. He brought the conversation down to a more modest level.

"How can machinery influence sculpture?" he asked.

"How?" replied Rodin still grumbling. "Why, because casting is a substitute for talent."

"Casting?"

"Yes; nowadays this mechanical process is commonly employed by our sculptors. They are satisfied to make casts of living models. The

public does not know this yet, but in the profession it is an open secret. Modern statues are nothing more than casts placed on pedestals. The sculptor has nothing more to do. It is the maker of plaster casts who does all the work. . . .

"Sculptors have ceased to give their work the stamp of thought which transfigures objects and illuminates them with an interior light. They have sought only vulgar substitutes. Not content with casting nudes, by a fatal descent they have reproduced exactly real clothing. In women's costumes they have imitated ribbons, laces, trimmings; in men's clothes, frock-coats, trousers, cuffs, collars, the whole department of latest fashions. Thus our streets and the fronts of our national buildings have become branches of a wax-work museum. . . .

"The artists of today do not know that the function of art is to express the human soul; that science cannot be represented by machinery, but by a thinking forehead and brooding eyes; that courage cannot be represented by cannons and dirigibles, but by virile features and resolute breasts. Accessories are their supreme resource because they no longer know how to reveal the mind. . . ."

The two great men naturally drifted into conversation about the changes which have been made in Paris. They were both born there, and M. Bergeret, who was brought up in a bookshop facing the Louvre, on the banks of the lazy Seine, tenderly cherishes the memory of the landscape of friendly edifices and trembling leaves which enchanted his gaze as a child.

"They will end," he said, "by making our Paris ugly."

"As a matter of fact," said Rodin, "the old houses which are its noblest ornament are being everywhere destroyed. The politicians, engineers, architects, and financiers of today are plotting a damnable conspiracy against the grace which we have inherited from the past. The most brilliant remains of the seventeenth and eighteenth centuries are being demolished by the strokes of innumerable pickaxes. Did they not recently ravage the delightful Ile-Saint-Louis where Dream, hounded everywhere, seemed to have taken refuge?

"Virgil has related a dramatic legend. In order to feed the flames of a sacrificial fire Æneas breaks the boughs of a myrtle tree. Suddenly the broken branches begin to bleed and a groan is heard: 'Stop, wretch, you are wounding and tearing me!'

"The tree was a man metamorphosed by the will of the gods.

"The poet's fable often comes to my mind when I see the vandals laying the ax to the proud dwellings of long ago. Then it seems to me that the walls are bleeding, for they are alive and human like

the myrtle tree of Virgil. In the harmonious rhythm of their buildings do we not hear the voices of the Frenchmen of old? To break a sixteenth-century stone mask, a seventeenth-century portico, a delicate eighteenth-century frieze is criminally to sear the faces of our ancestors, to strike them on their eloquent lips. What a crime to stifle their voices! If the buildings were even beautiful which are erected in the place of those demolished! But most of them are hideous."

"They are all too tall," Anatole France replied. "The modest height of the houses was the chief charm of old Paris. They did not hide from view the soft sky of the Ile-de-France. As ground was cheap they developed laterally. That was the secret of their charm. Ground has become very expensive, and the houses of today grow higher simply because they cannot spread out. That is the reason of their ugliness."

"They present neither proportion, nor style, nor pleasant details. People have forgotten that architecture, like painting, sculpture, poetry, and music, is an expression of the soul. Taste is dying, and taste is the mind of a people expressed in its everyday life; its character made visible in its costumes, its homes, its gardens, its public places. Our society hates the mind. It kills Dream."

Rodin continued:

"Are they not now talking of substituting an enormous iron bridge for the light Pont des Arts, in front of the Louvre? It is maddening! There should be only stone in front of the Palace of the Kings. This mass of iron, which threatens us, will cross the river just beside the Pointe du Vert-Galant, it seems.

"In this way they will spoil the amazing view composed of the two banks of the river, the Louvre, the Palais Mazarin, the Monnaie, the verdant prow of the Ile-de-la-Cité, and the Pont-Neuf, majestic as a tragedy of Corneille or as a canvas of Poussin. If that view is perfect, it is because from generation to generation Parisians bequeathed to each other the task of embellishing it. Just as the strains of Amphion's lyre raised the obedient stones which formed divine monuments of themselves, so a secret melody has grouped in irreproachable order all these radiant edifices around the Seine, in whose waters their reflection trembles.

"Now, all of a sudden, this great masterpiece must be ravaged!"

"Practical utility, they say," responded Anatole France. "But, is there anything more useful to a nation than the charm of a city which visibly expresses the mind of the race, sociable, daring, well-balanced, clear, and joyous? That is a lesson which, in my opinion, is worth all the iron bridges to the life and the future of a people."

After coffee we went out into the garden, and on to the edge of a slope from which the eye could take in the immensity of Paris. As far as the most distant horizon there spread out an ocean of domes, towers, and steeples. Through the fleecy clouds the gold and opal rays of the sun shone upon this vast billow of stone. But frequently the smoke from the factories which hummed in the valley spread gigantic black ribbons over this fairyland.

"Was it so difficult," asked France, "to remove from the city these nauseating factories? Is it not absurd to allow the air of Paris to be poisoned continually by the lofty chimneys that surround it? Is it not an odious sacrilege against so lovely a city?"

"Our epoch, in which money rules, tolerates the worst outrages upon the right of all to both health and beauty. It infects and soils everything. It kills Dream! It kills Dream!"

"But Dream always rises again, and perhaps it will take vengeance. Perhaps it will soon create another social order less basely utilitarian, and less contemptuous of the spirit."

Such was the sad discourse held by these two prophets on the hill of Meudon.

"In the Driftway" was a regular feature of the magazine from 1918 to 1935 and was always signed "The Drifter." In this particular piece, the Drifter was Lewis S. Gannett who was a frequent contributor to the magazine. Gannett also wrote for the Manchester Guardian *and later had a daily column in the* New York Herald-Tribune *called "Books and Things."*

—

IN THE DRIFTWAY

AUGUST 30, 1922

Lewis S. Gannett

"YOU CAN'T EAT pictures," remarks our penetrating Secretary of Labor, Mr. Davis of the Loyal Order of Moose. "You always slice the colored label off the loaf and eat the bread and throw the art away. . . . Keep working and you'll get the chromo." The Drifter must admit the accuracy of the Secretary's remarks. In fact it never occurred to him that the purpose of the artist was to make things good to eat. He is not quite sure what is the purpose of art or even civiliza-

tion. That is, to be sure, a problem which has disturbed the meditations of wiser men than the Drifter. But the gentleman who writes the monthly bulletins of the American Exchange National Bank—business prognostications mixed with philosophy—has no doubts. Hearken to his wisdom:

As time moves on and the ultimate supremacy of the ideas associated with material progress becomes more certain the louder grow the wails of those who fear the decay of the spirit and the destruction of the finer things of life. . . . It never seems to occur to these backward-looking prophets that the spirit of today is perhaps finding expression in new forms and that it is they who are losing step with the infinite. . . . There should be as much mental excitation and spiritual exaltation in tunneling through a mountain or harnessing a Niagara or even in modeling and producing a pair of shoes as there was in following the flight of a swallow in poetic fancy or shaping a Venus de Milo. All are sensible of the debt owed by material progress to the finer things of life, but these contributions have been made; they were steps, and we do not believe that it is necessary that we cling to them forever—make a fetish of them. . . . The alleged culture of which we hear so much is static, sterile, senile, a performer on the melodeon and the harpsichord in the day of the phonograph and the automatic piano. . . . That form of culture will be forced to stand aside for jazz and the man headed for a mountain with a pick. So away with poetry; away with the man who makes music for himself or creates new beauty out of his own imagination. That has been done; it is of the past. This is the age of chromo prints made by the million, which we cannot eat and therefore throw away; the age of canned peas in summer boarding-houses, of canned fish at the seashore, whence the fishermen ship all their catch to the canning factories, of canned music that whines its way into wilderness camps where it frightens and silences the hermit thrush and the winter wren; yes, even of canned thought. Give up your dreams; excite yourself making shoes—or rather, ten thousand times a day, making an identical slash or stitch in ten thousand identical pairs of shoes, Model 607A, size 8D; wind up the phonograph to play a third-rate imitation of last year's jazz successes, and head for the mountain with a pick.

The celebrated critic Thomas Craven was a fiercely patriotic proponent of American art in general and of American regional art in particular. The two pieces that follow elicited two of the most scathing (yet delightful) responses to an art critic ever to appear in The Nation.

—

JOHN MARIN

MARCH 19, 1924

Thomas Craven

THE REPUTATION OF John Marin has not been founded on the sensational elements of modernism. Always averse to schools and dogmas, and equally opposed to the fashionable eccentricities of cubes and cones, this distinguished painter has, quite simply, abandoned himself to nature. Year after year he has contemplated the Maine coastline; he has observed shrewdly, and with great intensity, the lines of cliffs, the spurs of small islands, and the shapes of trees and clouds; he has been a student of ships and the moods of the sea; and occasionally, with an ambition somewhat foreign to his temperament, he has recorded in terms of design the geometry of the New York skyscrapers. The result has been an annual production of watercolors which unquestionably will rank with the best ever done in this department of art. His most recent pictures, now showing at the Montross Gallery, represent the complete Marin: here we have the many phases of a devout and venerable passion for nature, and here we may see a technical mastery surpassing anything in modern times. Every resource at the command of the water-colorist has been utilized: the glowing washes of rich and original color have been applied in delicate transparencies to render the variegated play of sunlight on the sea; in most cases the white, untouched spaces serve to accentuate prominent forms, but in the Palisades group the paper has been fully covered in the dramatic manner of Turner; there are landscapes and sea-pieces, sketches of schooners, waves huddled together in a curiously compact fashion, and a number of things which frankly are no more than antic experiments.

Latterly Marin has suffered from the extravagant praise of his supporters. An impressionist in an age when impressionism has been repudiated, he has been counseled or instigated by his admirers to try his hand at intellectual design—thus, I suppose, to get in line with the classic trend of modern thought. But his efforts in this direction, as witnessed by his New York studies and some of those psychic fantasies containing brilliant splashes of color and wanton

streaks of charcoal, are explosive and unintelligible. Marin's painting is in no sense intellectual; primarily it is a matter of strong feelings and vivid impressions, an art of subtle arrangements and omissions, akin to Whistler and Monet, though strengthened a little by an acquaintance with Cézanne. One has only to compare it with a truly composed art, that of Claude Lorrain, for instance, to realize the difference between the classic and the romantic points of view. A landscape by Lorrain is not merely an interpretation of nature but a reconstruction as well; it is a symbol of the artist's experiences; based on a fine perception of relationships in which line is arrayed against line, contour added to contour, and mass superimposed upon mass, it attests with power and precision the structural unity of great art. But it would be unjust to Marin to say that his watercolors represent only sensuous reactions to optical phenomena—his poetical concern with trees, waves, and skies is charged with solid conviction, with the desire to project meanings into his pictures. If this were not true his drawing would be nothing more than clever illustration. His ideas are vague, but as a musician of moods and nuances he is unrivaled. The lapses of form characterizing all of his painting, that is, the slurring of unmanageable spaces, cannot be attributed to naturalistic impulses—he has set himself to emphasize what he regards and feels as significant in his immediate impressions. He is not of those who build sequences of forms, who reconstruct the world in a philosophic order; but, on the other hand, he is not trying to play a losing game with the camera, and to imitate with expert mechanics little corners of atmosphere.

With the close of the first cycle of modernism, Marin finds himself in an anomalous position. Of all Americans who have come to the front in that remarkable plastic revival emanating from Cézanne, he is the most finished and mature—yet he is practically without influence. Younger painters disapprove of his poetry, and assert that his conceptions are wanting in measure, completeness, and design. As regards the poetry, I can only say that it is his most valuable asset. In truth, his pictures are held together by the warmth and fervor of his first impressions, and without the poetic content even his supreme technical skill could not raise his water-colors above the level of descriptive sketches. It is only the narrow-minded advocates of lifeless abstractions who object to poetry in art. Design is another matter. It is through this constructive element that the hand of man enters art, that painting is humanized and differentiated from the lawless world of nature. Design, of course, being a product of reason and imagination, robs art of its spontaneity and freshness; and those

who prefer these qualities, with the added charm of color and fine workmanship, will continue to back Marin against the intellectuals.

—

ART AND THE CAMERA

APRIL 16, 1924

Thomas Craven

THE PHOTOGRAPH HAS two qualities capable of stimulating the aesthetic faculties. The first of these is concerned with the rendering of textural distinctions; the second lies in the simple reproduction of the physically beautiful, that is, of the beauty which nature has so lavishly provided. To bring out accurately in black and white the harsh and the delicate tones and the fine shades of colored surfaces demands a small measure of creative thought—the end must be visualized and the chemistry of printing regulated accordingly. But creation of this sort has no more significance than the plates made by astronomers and metal-lographers aiming wholly at practical results; and it is a waste of time to lay much emphasis on the artistic merits of such performances. The process is largely a matter of chemistry and mechanics, and the fact that the operation of light can be controlled, that the tonalities of prints are susceptible to infinite variation, in no respect alters the original objective nature of the undertaking. The second quality, the preservation of the beauty inherent in natural objects—the charm of faces and flowers, the disposition of clouds, the fall of snow—is merely a transfer of values. When a photographer opens his lens upon a given scene he leaves behind him the emotional force of direct experience, and has nothing to substitute for this indispensable aesthetic factor. The interest in the transfer is determined entirely by good taste and by the intelligence and by the ingenuity manifested in the selection of the subject matter. As emotional creation it is comparable to the activity of a sentimentalist before a beautiful sunset.

One of the commonest errors committed by dilettantes and amateur aesthetes arises from the belief that the whole content of an emotional experience before nature can be rendered pictorially by reproducing the scene which has set the feelings into motion. This is an old superstition: years ago it was prevalent in a conventional English school where the actual failure of such a belief when put

into practice caused naive painters to append poems and literary rhapsodies to the frames of their landscapes.

Alfred Stieglitz, probably the most accomplished photographer in the world, shares the delusions of the laborious old botanical copyists. He asks us to believe that the reduplication of natural phenomena carries an emotional freightage identical with that of creative art; that the transfers of his camera are as intense and exciting as the canvases of imaginative painters whose forms are not the result of simple impressions but the product of knowledge, reflection, and a genius for construction. I think that Stieglitz feels unconsciously the meager success of his intentions, and for this reason discovers symbolical meanings and curious psychic values in what are only remarkable transcripts of nature. His bewildering explanations are not only unnecessary but damaging to the value of his photographs as such. In his third exhibition at the Anderson Galleries he has a series of cloud formations—unusual selections beautifully printed. These pictures are better than the clouds of Tarr's Physical Geography because they are printed by a man with an uncanny understanding of his medium; but aesthetically there is little to choose between them. They are not, as Stieglitz seems to have convinced himself, portraits of human souls, and the effort to exploit them in this light is too transparent in its psychology to go very far. In the last analysis, work in this world will have to stand on its intrinsic merits. It is as fine photography that Stieglitz's prints will stand and not as monuments of the creative will.

—

SKY-SONGS

MAY 14, 1924

*Alfred Steiglitz,
John Marin*

TO THE EDITOR OF *THE NATION*:

SIR: The mail this morning brought me from the offices of *The Nation* a marked copy of Art and the Camera cut from *The Nation* of April 16. Coincidently I received a copy of the April *Arts*. It is most amusing how very divergent are the reactions of Mr. Craven and those of Virgil Barker, the associate editor of the *Arts*. Mr. Barker says:

Can a photograph be a work of art? An entire number of that un-periodical periodical entitled *Manuscripts* was devoted to a symposium of that question. And all those words by all those writers, whether for or against, are turned into empty chatter by the wordless sky-songs of Alfred Stieglitz. To one individual they came as a revelation—a call to adventure, an enlargement of experience, a spiritual release. A perceiving soul has trapped sublimity in a machine and on sheets of paper a hand's breadth wide has fixed immensity.

In the number of *Manuscripts* referred to, Mr. Craven is one of the contributors. As for Mr. Barker, to whom the tiny "sky-songs" (they are not "*photographs* of clouds") came as a revelation, perhaps it will be of interest to your readers to know that they also came as reve-lations—to many hundreds of painters, sculptors, poets, writers, lay-men, women and men, quite as sensitive, quite as critical as Mr. Craven. Among those agreeing with Virgil Barker are: Lachaise, Ma-rin, Dove, Demuth, O'Keeffe, Ben Benn, Coomaraswamy, Eilshem-ius, Bel-Geddes, De Zayas, Varèse, Ernest Bloch, Halpert, Ornstein, Gilbert Cannan, Sherwood Anderson, Zona Gale, Professor Ehren-fest (of the triumvirate Einstein-Lorentz-Ehrenfest), now lecturing in this country, and many more.

I have a letter before me from Gilbert Cannan: ". . . I have grave doubts about the Woolworth Tower but none about your photo-graphs. . . ." In a letter from Leo Stein (December 4, 1922), he writes: "Your kind of photography seems to me essentially nearer the best of painting, the Giorgiones, the Rubens, the Renoirs—not of course in aspect but in spirit—than any contemporary painting that I know."

Incidentally I might quote Willard Huntington Wright in his "Cre-ative Will" (*Art and the Individual*, page 246):

> The emotionally limited critic denies the inherent existence of aes-thetic beauty in a work unless he is personally capable of reacting to it and at the same time questions the sincerity of the man who re-sponds as the result of a more highly developed sensitivity. For the meagerly equipped the science of aesthetics is useless: it is without the substantiation of *emotional experience.*

I have seen Mr. Craven stand before paintings as well as before photographs and I have every reason to feel that he belongs to the class of "critics" alluded to by Mr. Wright. As for his knowledge of

photography in its significant sense I know it to be negligible—even if he may be the proud possessor of a Brownie.

New York, April 20 ALFRED STIEGLITZ

TO THE EDITOR OF *THE NATION*:

SIR: Just so often along comes the "Wonder Man"—he who puts us crooked—pardon—straight of course—at the cross roads—follow his pointing and you'll leave Worry behind—if you would want to hook up with worry again—assume you've been led astray—come back and you'll find your friend—Worry there awaiting you

Monuments—huge monuments
 to him—of him
at every cross road—with a push button—out comes an arm pointing—pointing the way—

Along came my friend Alfred Stieglitz—he was met with a bucket full of cold storage stuff always kept on tap—he says he heard shouts of glee back in the bushes—he got it for photography's sake or Art's sake or Creative Will's sake

They are all three nice sounding Academic terms
 Some of it spills like this
"Unusual selections beautifully printed"
—there we agree—

In one instance he addresses them as "pictures"—why this flattering appraisal
too—the admission to a small amount of "creative thought"—
this opening might lead some one to assume—a larger amount—

Seems to me selection covers quite a field—there can be
a kind of selection
a why of selection
and purpose of selection
Does he unwittingly give Stieglitz this privilege because when you haul in selection you're close to the tree of "Self expression"
One can follow discussions—admissions—convictions until one comes upon a stamp of self imposed finality like this "in the last analysis" then he himself proceeds to the putting of the stamp of "last analysis" on Stieglitz's work
So that one is forced to the term "Wonder man"
 here's Something
Could it be that the work of Alfred Stieglitz wasn't seen by "Wonder man" after all

Cliffside, New Jersey, April 23 JOHN MARIN

*Craven was an early supporter of the painter Thomas Hart Benton,
whose later students included Jackson Pollock. This review not only
defends Benton against some of his critics but also promotes an almost
xenophobic hostility toward non-American (in this case French)
painting.*

—

AN AMERICAN PAINTER

JANUARY 7, 1925

Thomas Craven

IN HIS RECENT exhibition at the Daniel Gallery, Thomas H. Benton
has demonstrated the fertility and beauty of the American scene.
Here is a painter who has returned to his native State for inspiration,
and who has extracted from the virgin soul of the Southwest a
graphic message of twofold significance. In the first place, these
water-colors and drawings, aptly catalogued under the title "In Mis-
soura," should stand as a warning to those artists who seem to believe
that painting is essentially a French accomplishment, and that Con-
tinental mannerisms are indications of modernity; second, knowl-
edge of the structure of form and of the means of presentation has
been applied with a definite purpose—that is to say, Benton has no
faith in the popular fetish, "organization for its own sake," but has
concentrated his energies on the epic spirit of a civilization that is
organically his own. The trouble with most of the self-styled new art
is simply that technical issues have overridden all aesthetic meaning;
in Benton's pictures the technical barriers have been torn down,
and as a consequence we have an explicit and massive rendering of
a phase of American life now rapidly passing into history. The artist
has brought together a gallery of Southwestern types—white men
and black, politicians, lawyers, and rustics—and to provide an ap-
propriate background for his characters has hung them in company
with scenes of local industry and idleness. There are no stylistic tricks
in these heads, no cubes and cones, no Gallic abstractions. To my
knowledge the characterization is without a parallel in contempo-
rary art. One drawing, for example, bearing the title "The Old Cam-
paigner," is strongly reminiscent of ex-Governor Dockery. It may or
may not be a good likeness—certainly it is not a literate portrait—
but it is a powerful conception of the old-fashioned politician, a
permanent record, we might say, of a type which, when at last ex-

tinct, will have robbed our campaigns of color, unction, and humanity. Another head, "Plug Cut and Blackstone," creates the atmosphere of musty calfskin and shrewd pettifoggery—the small-town lawyer in all his shabby glory. A third, "A Negro called Jim," carries in his ugly features the tragedy of his race. It is caricature, but it is done with the strength of sculpture and with intense sympathy.

Benton's past performances have given rise to a good deal of speculation, most of it hostile and unintelligent; and his critics, while admitting his powers as a composer, have regarded the curious evolution of his technique as an affront to the canonical limitations of painting, even modernist painting. His ability, as witnessed by his most recent exhibition, to seize the spirit of a community, to sweep aside the loose, the careless, and the unnecessary elements, and to present the scenic essentials in terms of enduring form, comes as an unexpected revelation. His painting of an old ramshackle foundry is almost uncanny in its suggestion of dirt, rust, and obsolete method. One feels instantly that the number of operatives is small, that work is seldom finished on time, and that nobody cares. It is a desolate place—filled with the pathos of wornout things. Those who have considered Benton exclusively as an intellectual experimenter, an expositor of compositional theories, will have need to revise their opinions. He is too much of an artist to confine himself to one pursuit, and too much a lover of life, as these water-colors show, to deal always in pure abstractions. That he is deeply concerned with the constructive problems of his work is undeniable, but what genuine artist is not? Nor is it conceivable that the pronounced tri-dimensional aspect of his painting is the result of chance or haphazard procedure. For the sources of his technique we must turn to the art of the old Florentines. It may seem a far cry from the characters of southwestern Missouri to the saints and madonnas of the Italian Renaissance, but if we examine the highly relieved forms and the complicated linear rhythms of the American's painting, we shall understand the validity of the comparison. Benton's work is wanting in suavity and grace, in the mellowness and ease which mark the fruition of a long and cultivated period of plastic expression; his art is hewn out of granite; it is stiff and solid, and frequently terrifying. in its reality. But it is not therefore devoid of beauty—for the path of beauty, as Havelock Ellis has written, is not soft and smooth but full of harshness and asperity.

This painting, with its sharp edges and its bulk strength, is tinged with a poetry and a sadness peculiarly adapted to the treatment of American life. In fact, it is of the same texture as American life,

which contains beneath its harshness an undercurrent of sadness and idealism. And this painter, as distinguished from the majority of our younger men who go on producing abstractions and still-lifes, has been occupied for several years with a pictorial history of the United States, a vast undertaking which, when completed, will comprise sixty-four canvases of monumental size. The Missouri series is only an interlude in his more ambitious work, but it is important as an example of Benton's command over native material and as an object lesson to artists who are imitating the latest French tendencies.

Often the most coherent appraisals of an artist's career appear in The Nation *as an obituary rather than as a review of an exhibition. This unsigned piece, occasioned by the death of John Singer Sargent and written by Glen Mullin who wrote for the magazine about art from 1920 to 1934, demonstrates that phenomenon.*

—

JOHN SINGER SARGENT

APRIL 29, 1925

Glen Mullin

WHEN JOHN SARGENT emerged from the studio of Carolus-Duran in Paris almost half a century ago he had acquired—instinctively, it seemed—a virtuosity of technique, a style so distinguished, especially in the painting of portraits, that his contemporaries hailed him as the inheritor of the most eminent traditions of the past. His name was linked with those of Frans Hals and Velásquez. He was the one almost undisputed "immortal" of the day. His Wertheimer portraits were hung in the National Gallery in a special room, an unheard-of honor to a painter still alive in the flesh. It was as if the prophetic shades of the old masters had spoken and imperiously welcomed him into their ranks, contemptuous of the slow process of time which had sifted and tested their own fame. A tradition of Sargent as the impregnable reincarnation of all that was great in the painting of an elder Spain and Holland took shape and persisted in America for many years.

We clung to him proudly as an American, although like Whistler he spent most of his life abroad, and revealed little in his art that could with any great show of eloquence be interpreted as American.

During the present century the remote, Olympian spell he had cast upon the national imagination began to dim as a younger generation came on. His portraits were not so frequently seen. Then came the exhibition of his work last year at the Grand Central Palace, which afforded young America an opportunity to view a characteristic assembly of his portraits and to understand some of the reasons for the extraordinary vogue which he has so long enjoyed.

From the standpoint of sheer technical authority—the deft manipulation of pigment, the wizardry of brushwork—Sargent indeed approaches Hals. It is difficult to see how posterity can fail to ratify contemporary enthusiasm for the candor and audacity of Sargent's brush. Every subject he attacked offered problems to be solved by suave and brilliant execution—and he carried them off with a spontaneity that was astounding. Painters who understand the technical difficulties which he challenged still marvel at the cunning twists of the brush that carry just the right weight, tone, and quality of pigment to suggest with startling economy certain truths of modeling or texture. His dispassionate, intellectual preoccupation with the rendering of surfaces led him at times to scamp fundamental form, leaving frequent passages aesthetically empty. His virtuosity, however, despite the plastic limitations of his art, carries an aesthetic delight of its own to all but the most intolerant of the modernists.

Sargent had a sharp eye for character, the knack of disengaging and presenting without overstatement the significant truth about a sitter. At one time there was a legend concerning his uncanny, diabolical penetration into the innermost recesses of the human soul. This legend had its influence upon his vogue, and women in particular petitioned sittings from him with all the thrill of embarking upon a fearful adventure. A story is current that a lady once asked him if he really had the power to rend the veil that conceals the hidden deeps of personality. Sargent is reported to have scoffed at the suggestion, replying that if there was a veil to be removed all he could do was to paint the veil. This, of course, sums up the truth of the matter. Sargent merely was a consummate and dispassionate reflector of what he saw.

Although as a craftsman Sargent was richly endowed, his art was deficient in design and in color, potentially the two most profoundly moving elements in painting. He revealed in his portraits a certain felicity in the "placing" of sitters on the canvas, but in real composition he showed small understanding or originality. His forms seem to lack the organic harmony and aesthetic vitality which result from a truly creative synthesis. His usual attitude toward nature as a fascinating problem of surfaces inviting facile transcription was fatal to

any vital approach to composition. He did astonishing snapshots like "The Hermit," in the Metropolitan, and the water-colors in the Brooklyn Museum. These are often subtle in values and magnificent always as technique, but they are done impersonally and affect one only in the degree that life itself does.

So, too, Sargent thought in terms of pigment and values rather than in terms of color. For him values superseded color and were of vastly greater importance. Of color in its deeper functional significance, as it was understood by Renoir and Cézanne, Sargent had no glimmering. He never conceived it as a source of pure sensuous delight. And this being so, he never achieved the vibrant color chords which knit all the elements of a composition together in the painting of the supreme colorists.

No doubt the present tendency among the younger artists to underrate Sargent is swinging too far. The pendulum will swing as far in the direction of extravagant detraction as it once swung toward intemperate and uncritical adulation. Sargent will in the end occupy a niche in the hall of fame a few pegs lower than that assigned him by his idolaters of a generation ago; but no real modern craftsman who respects sound workmanship will dismiss him as a merely facile portrait-factory. His keen grasp of character and his prodigious dexterity in his chosen medium should command honor and respect in all the time to come.

What has been Sargent's influence upon his fellow artists in America? Surely he has not stimulated them profoundly toward native and personal forms of expression. He was scarcely affected at all by his great French contemporaries—Manet, Degas, Renoir, Gauguin, Cézanne—those disturbing innovators who were plowing up the very roots of art and fertilizing and enriching them by new forces that were intensely personal, authentic, and vital. Old artistic domains were resurveyed; old frontiers were pushed back; restless expeditions set out into the stirring, mysterious darkness and returned with rich spoils of conquest. In the midst of it all Sargent painted on urbanely in a temple dedicated to the portrait traditions of the English school. Bankers, academicians, princes, lords, and ladies scattered incense while the serene shades of Van Dyke, Reynolds, and Gainsborough piped softly in the background.

If Sargent did not sow dragon's teeth upon the fallow soil of art it was because the seed was not in his possession. He did well that which was set apart for him to do, and lived his art life with great-hearted humility and noble dignity. Such traits of personality shed fine gleams, surely, into the memory of men.

Louis Lozowick was a modernist artist who was a frequent contributor to The New Masses *as well as* The Nation. *His work often featured machine-age iconography, urban skylines, and bold contrasting forms. Here he writes about an artist who certainly must have had a great influence on his work.*

—

FERNAND LÉGER

DECEMBER 16, 1925

Louis Lozowick

TAKEN IN A purely formal sense every art movement of any consequence is a congeries of certain technical methods which in their totality differentiate it from every other movement. Cubism, essentially intellectual in its nature, has a well-articulated system of principles and is supported by a goodly amount of analytic reasoning. Cubism begins by a rather conservative revision of an academic formula. The academic picture shows as many facets of an object as can be seen at one glance. Cubism assumes it to be perfectly logical to show more: its back and bottom along with its sides and front; its internal structure along with its external aspect (*simultanéisme*).

If carried to great length this procedure would result in an ultra-realism and end in confusion. The cubists, therefore, took the method early under control. Since their aim is not objective truth but plastic significance, they have ever been ready to sacrifice the former to the latter whenever the two come into conflict, as happens not infrequently. For the utilitarian and aesthetic functions of concrete objects are disparate. The structure of a chair or a teapot answers to a definite function. The chair is built to sit on, the pot to boil water in. Now these objects, however useful in their practical application, may be, in whole or in part, entirely superfluous as compositional units in a picture. In such cases doing violence to natural appearance is entirely justified. Accordingly, to obtain certain harmonious or contrasting relations it sometimes becomes necessary to seek in one object the elements lacking in another. Certain objects might be welded into a unit and kept in one place (*complémentarisme*); other objects, on the contrary, might be dissected and distributed through several planes (*divisionisme*). In this manner would be established a measured coordination among all the ele-

ments—volume, plane, line, color, light—which produce a self-contained work of art.

This is not the whole of cubism, but this is as much as Léger's work illustrates in various degrees (Société Anonyme: Anderson Galleries). For the rest, he differs from most cubists in his predilection for bright, decorative color-combinations and in his preference for mechanical and urban subjects. And while his themes make him the most contemporary of all cubists his polychrome effects in geometric pattern (common to many cubists) endow his work with a wide appeal. For it is one of the few fairly established laws in the more than dismal science of aesthetics that ornamental design in all ages and among all peoples, whether it begin by imitating the shape of man, of animal, or of plant, tends to assume a geometric pattern, so that frequently its origins become unrecognizable.

Léger's work is in this quality akin to all folk art both in its genesis—reflecting a contemporary theme—and in its goal—creating a harmonious pattern. This is, probably, also the reason why Léger's work lends itself so readily to application. His decorations for the Swedish Ballet ("Skating Rink," "Création du Monde"), his sets for the cinema (Marcel L'Herbier's "L'Inhumaine"), and his book illustrations (Ivan Goll's *Chapliniade*, Blaise Cendrar's *La Fin du Monde*) are excellent.

Léger himself is of the opinion that the utility of anything does not necessarily detract from its beauty (La Beauté est partout). In fact, he unhesitatingly affirms that the proportion of beauty among machine-made things manufactured with the aid of anonymous artisans is greater by far than it is among pretentious pictures turned out by titled academicians. But he is careful to point out ("L'Esthétique de la Machine") that these factory products are to be enjoyed for their own sake, because like all beautiful things they are uncopiable.

The influence of mechanical industrial civilization on art is indirect and, therefore, all the more subtle. The economy in the use of materials, the logic of their coordination, the precision of their functioning, the abstract geometric contour of their mass fill our environment, affect our vision, enter our consciousness, fashion our tastes.

The theory of an artist is usually a rationalization of his own practice. Léger's work is charged with the rhythm of the present mechanized world. Some forms employed by him are borrowed from it and used in novel combinations, others are suggested by it and transmuted beyond recognition. In the end objective verisimilitude yields to aesthetic reality.

French art has had a wide though not always salutary influence on modern art in America. Léger is one of the very few whose work pleads with American artists for an American orientation, a closer contact with their industrial civilization so rich in plastic possibilities, and a consequent florescence of an original indigenous art. By a common perversity of circumstances this is precisely the message least heeded.

Walter Pach, author of the review that Stieglitz complains about below, had more than a passing knowledge of the introduction of modern art to America, since he was one of the key organizers of the Armory Show of 1913. A painter, Pach was part of Gertrude Stein's circle in Paris and a friend of Marcel Duchamp and Bernard Berenson.

—

MR. STIEGLITZ AND MR. PACH

JANUARY 12, 1927

Alfred Stieglitz,
Walter Pach

TO THE EDITOR OF *THE NATION*:

SIR: I believe *The Nation* is interested in the truth. My attention has been called to an article on Brancusi, signed by Walter Pach, in *The Nation*, December 1, 1926. Mr. Pach's opening sentence reads:

> In 1913, when the Armory Show gave to America its first sight of the post-impressionist schools, etc.

Matisse was introduced to America at 291 Fifth Avenue in 1908; the post-impressionists Maurer, John Marin, Marsden Hartley, Marius De Zayas in 1909; Max Weber, Arthur G. Dove, Cézanne lithographs, Henri Rousseau's paintings and drawings in 1910; Cézanne's watercolors and Picasso in 1911; sculpture of Matisse in 1912, etc., etc.

The history of these shows, attended by more than 60,000 people *before the Armory Show*, is recorded in *Camera Work*, to be found in the Metropolitan Museum of Art.

"Cubists, Post-Impressionism," by Arthur Jerome Eddy, published by A.C. McClurg, 1914, states:

During a number of years prior to 1913 Alfred Stieglitz gave exhibitions of extreme modern work in his Small Photo-Secession Gallery, 291 Fifth Avenue, New York, and the International was the outcome, the logical culmination of these earlier efforts.

Royal Cortissoz, "Personalities in Art," page 419, says he saw at 291 "pioneering exhibitions of Matisse, John Marin, Marius De Zayas, Max Weber, Picabia, Brancusi, Picasso, Gino Severini and so on."

Sheldon Cheney, "A Primer of Modern Art," page 232, calls 291 "an oasis in New York for many years. . . . Cézanne, Matisse, Picasso . . . were introduced to America . . . like . . . Henri Rousseau, De Zayas," etc.

New York, December 23, 1926 ALFRED STIEGLITZ

To the Editor of *The Nation*:

SIR: Alfred Stieglitz's "tiny laboratory," as he calls it, could not and did not give the country as a whole a sight of the post-impressionist schools, although important work in forming a nucleus of appreciation for them was done at 291. Mr. Stieglitz's very valuable exhibitions at 291 were visited principally by a public already familiar with the modern men, as were the artists who gave the Armory Show. "America," to repeat the word which justifies my sentence, was unaware of the existence of the later schools, and it was at the Armory Show in New York, Chicago, and Boston that America, as distinguished from the frequenters of the laboratory, got its first sight of works like Brancusi's "Mlle. Pogany" and Duchamp's "Nude Descending a Staircase." Had the title of my article been "The History of the Development of Knowledge of Modern Art in America" it would have been a pleasure to record Mr. Stieglitz's share in the matter.

New York, December 25 WALTER PACH

Early in her career Katherine Anne Porter, later the author of Pale Horse, Pale Rider, Ship of Fools, *and* Collected Short Stories *(which won the 1965 Pulitzer Prize), wrote this charming art piece, the first of several articles she contributed to* The Nation.

CHILDREN AND ART

MARCH 2, 1927

Katherine Anne Porter

IT BEGAN AS an international show of children's drawing, painting, and clay modeling, but when I went to the Whitney Studio Club they explained that it had turned out to be a joint exhibition of the Mexican and American schools only. There were two rooms lined with delirious spotches of color. Being familiar with the work of Mexican children and knowing nothing about the new school of painting founded by American children, I said: "This is the Mexican room."

It was the American room. Children are the true internationals. They don't know the meaning of the word "art." In Mexico the individual child learns the word in his own season. In this country the teachers are inclined to protect him from this knowledge as long as possible. For the past five years plastic art has been in the curriculum of every public school in the Mexican Republic, a serious item in their national program of education. This collection comes from schools in the country and in small towns.

The American pictures are largely the work of students in private schools, in experimental courses conducted by individuals. Among those represented are the Ethical Culture School, the Walden School, Elizabeth Irwin's classes in Manhattan Public School No. 61 and Bronx Public School No. 45, under the guidance of Angelo Patri, all in New York City. Others represented are the Rosemary Junior School in Greenwich, Connecticut; the Woodward School in Cambridge, Massachusetts; the Tower Hill School in Wilmington, Delaware; the Parker School in Chicago, and the Keith Country Day School in Rockford, Illinois.

I expected to make interesting comparisons between the temperaments of the two races of school-children. On examination, I saw differences of costume, distinct preferences in subject matter, a slightly stronger feeling for design and more patience in the Mexican pictures, a certain lack of detail and an ampler sweep of line in the American pictures. No other important differences. Of

course we know that academic painters of all nations paint the human body in so uniform a style that it is hard to tell a German from an Englishman. The modernists of all countries also resemble one another to the extent that they all appear slightly French. But children, strictly speaking, are not artists and, unless they are trained, might be expected occasionally to strike upon a new notion of the human shape, or see it in some fashion approximating the vision of his elders. Not at all. Children all draw figures alike, and they all resemble gingerbread men a trifle warped in the baking. And this satisfies them until some one tells them it is wrong, or they grow up.

Looking at these jocund, delightful, perfectly irresponsible records of what a child sees and thinks, and what he feels about color, you can hardly blame certain grown-up artists for struggling to regain this paradise. They call it being primitive, and name it a virtue. But a primitive is one not fully equipped who does his best; he does not throw away a developed technique in order to be simple once more. These children are true primitives. There is an earth-shaking amount of energy, concentration, and effort in these pictures— cheerful, happy effort unvexed by aesthetic problems. Each one has done his gorgeous best, and it is an encouraging spectacle. Some of these paintings contain many elements of art. In one there will be revealed a fine sense of movement and rhythm, another has harmonious color, many have space and atmosphere. I might go on naming things it is natural to look for in a painting, but the teachers avoid placing emphasis on the thing produced, they do not criticize with the vocabulary of art and neither should I. They do not set a target of excellence for the child to aim at, he is not set to copying objects, but is left free to evoke his own images. This serves another purpose too, in revealing the range of interest in the individual, his sense of color and form, and what it is that catches his proper eye. All of them reveal a talent for human contacts, they imply a potential equipment for effective living. It is constructive work for the child and furnishes living data for the teacher.

If I feel that on the average the Mexican children have done a little better than the American in the Whitney Club show it may be because I know them better; I saw the very beginning of this work in Mexico, which amounted there to a revolution in educational methods; I saw their first exhibitions, and I know the type of tiny rural school they came from. I have seen the children. There is a certain hardihood in their pictures of fruits and plants and animals, in their small-town street scenes they do funerals with gusto; they

write "soap" on the upturned box before the fruit vendor's stand. One child illustrates his physiology lesson, choosing digestion, a homely subject at best. He illuminates it with a charming picture of a boy and a girl eating ears of corn. This is his world, and he sees it in admirably clear terms. An American child records his loving memory of the beach and boardwalk at Atlantic City in a composition that in an adult would argue satirical gifts of no mean order. There is no death in the funerals, only a procession, and there is no real gloom in the little American boy's picture of people sitting carefully in church.

I believed that color was heaven's unique gift to the Mexican child. Give him three colors and he will invent a new rainbow. So, and I say it with triumph, will the American child. These young children who paint with such vigor and splash are not artists. They do not need to be; they are our future, and some of them are the artists of our future. It is not necessary to choose them in advance out of this exhibition.

—

DISPATCH

NOVEMBER 2, 1927

TOLSTOI, TROTZKY, AND now the United States customs service, have tried to define art. When Edward Steichen brought in an ovoid piece of metal shaped by the sculptor Brancusi and labeled "The Bird," the literal-minded customs authorities said it was not art and assessed it 40 per cent duty as a "manufacture of metal." Mr. Steichen protested, and now the United States Customs Court is earnestly at work. "Would you recognize it as a bird if you saw it in a forest, and would you take a shot at it?" the judge asked one artist on the witness-stand. "It is a matter of indifference to me what it represents," came the intelligent answer. "If the artist calls it a bird so would I." The artist remarked that the profile might suggest the breast of a bird. "Or the keel of a boat, or the crescent of a new moon?" asked the judge, still seeking wisdom. "Or a fish or a tiger?" added the learned Assistant District Attorney. We confess that some modern art has left us as unmoved and frivolous. But the whole discussion seemed somehow to be lifted to clean wind-swept mountain-peaks when Jacob Epstein, a very great modern artist, an-

swered the question, "Why is this a work of art?" with the simple but final words: "It pleases my sense of beauty. I find it a beautiful object." When the judge persisted "So a brass rail, highly polished and harmoniously curved, could also be a work of art?" Epstein answered "It could become so." "Then a mechanic could have done this thing?" the customs lawyer interrupted. "No," said Epstein impressively. "A mechanic could not make a work of art. He could have polished this, but he could not have conceived it."

—

DISPATCH

NOVEMBER 30, 1927

THOSE WHO ADMIRE Mussolini have said that he has brought about a restoration of the glory that once was Italy. And yet it is not fantastic to assume that a recent comment of the Premier may well have caused Raphael to revolve rapidly within his grave. Howard Chandler Christy who does covers, painted Mussolini after three brief sittings. "Many artists have placed my face on canvas," remarked the Duce, "but you are the first to have placed me there." Later he told the wife of the American illustrator: "It is a better portrait than was ever-painted of me." Somewhat irrelevantly the Associated Press correspondent who described the meeting of the creator of the Christy girl and the founder of the new Italy added that Mussolini had brought his country "from the confusion of five years ago to its present position." Accordingly, if digressions are to be permitted, one may be allowed to recall a poem by another American, Franklin P. Adams, during a Christmas era in which it was announced that Mr. Christy would illustrate the poems of Walter Scott:

> The stag at eve had drunk his fill.
> "I fear," he said, "I shall be ill-
> Ustrated"—here his eyes grew misty—
> "By artist Howard Chandler Christy."

John Sloan, a member of the group of artists known as "The Eight,"
was a former editor of The Masses *and the president of the Society of*

Independent Artists. He often wrote letters to The Nation *in an effort to steer its readers to local exhibitions of note.*

—

INDIAN TRIBAL ARTS

APRIL 29, 1931

John Sloan

TO THE EDITOR OF *THE NATION*:

SIR: Among your readers are many who are interested in the welfare of the American Indian and in the preservation of his arts. Few Americans know that Indian artists of great talent, now living in the United States, are producing works of real beauty and excellent craftsmanship. Their poetry, paintings, textiles, and sculpture deserve wider appreciation among white Americans. At present there is in Europe more recognition of their extraordinary contribution to the pure and applied arts than in this country.

The Exposition of Indian Tribal Arts now being organized will be the first comprehensive and truly representative exhibition of the work of contemporary Indian artists. This exposition will include fine specimens from private and museum collections and modern work of outstanding excellence. It will open at the Grand Central Art Galleries of New York in December, 1931. After a month's showing there it will be exhibited in the leading cities in this country and, it is hoped, in Europe.

The national office of the Exposition of Indian Tribal Arts, Inc., is at 578 Madison Avenue, New York. The project has been endorsed by the American Federation of Arts, the College Art Association, the American Anthropological Association, and by museums of art throughout the country.

New York, May 1 JOHN SLOAN

Paul Rosenfeld was a novelist, essayist, and critic who was also the music editor of The Dial. *He was also known for the salon he held at his Gramercy Park apartment where, according to Edmund Wilson, "poets read their poetry and composers played their music." Rosenfeld's circle included Gertrude Stein, Marianne Moore, and e.e. cummings. He wrote for* The Nation *from 1931 to 1945.*

—

from BREAD LINES AND A MUSEUM

FEBRUARY 11, 1931

Paul Rosenfeld

GRAY BREAD LINES wound about city blocks refer us to the Museum
of Modern Art. Pardon, this connection of the miserable state of
things with the conduct of an institution for the appreciation of
painting and sculpture is not frivolous, the phantom of a narrow
aesthetic preoccupation, given to moonraking among splendid ob-
jects. It is a very pertinent and realistic one. Together with its purely
aesthetic virtue, the work of art has a property, possibly identical
with its aesthetic one, of intense practical value in a practical world;
it has a power of quickening, orientating, humanizing. And when
the effects of arrogance, insensitivity, and mismanagement shriek
on every side, it is perhaps anything but irrelevant to recognize the
partial responsibility of all those in whose hands are of society's best
means of consciousness, vision, and self-knowledge is consistently
misused—and, because of its strategic position, that of the well-
meaning but pathetically blind management of the museum in the
Heckscher building in particular.

Art—one is obliged to say it again and again—is not an enter-
tainment. Art is a shock of reality, a communication of the sense of
life. What is revealed to the colorist, the sculptor, the draftsman in
inspiring visual and sensuous images or material balances is the pres-
ent way of things and the forces at play in man, the wonder of
creation in its affinitive horror and splendor, the exquisitely artic-
ulated structure of life. The pregnancy of his medium, the problem
of the relationship of lines and shapes and volumes demanding so-
lution by whatever means the artist has or can invent, is but the
effect of the stimulating impact of life on his intimate philosophy,
referred by his aesthetic nature to his material. The quality of the
object he produces is itself merely the result of complete respon-
siveness to the vision or image or material balance; the power to
reproduce itself in the mind; inhering in proportion to the force of
the inspiring idea, and the relentlessness of the selection of detail
making for clarification. In the beginning, there is the sense of life,
the picture of things, the shorthand expression of what exists. And

in the end, there is the sense of life, the system of values, the short-hand expression of what is at work and going on.

And what in the world is more generally useful than direct, untheoretical contact with things, to the man who wishes to sell a pair of shoes no less than to the statesman and philosopher in their watchtowers? The success of the narrowest as well as the widest interests very largely depends on it. It quickens and orientates and humanizes. It adjusts the balance. It yields intimations of the trend of the world, the state of human forces. Flaubert was perhaps not merely boastful when he asserted that had the authorities comprehended "L'éducation sentimentale," the Franco-Prussian War might have been avoided. And whether or not it can actually control the course of events, the sense of life can at least prepare for them, forearm for them. Even in distress and defeat the recognition of an impersonal, almost abstract adventure is the most serviceable of possessions, standing with the poor devil in the bread line, modifying even the ultimate agonies.

But the virtue inclosed in art as richly as in any other human product renders its light to society only when a sense like that which produced it presents it to the world. If the work of art is to function, the feeling of livingness, the intuition of the forces at play in man and in the continually changing balance of nature, must be as largely present in the showman, the museum director or curator, as in the artist himself. The director too must have the compulsion to clarify what is in process of creation, the sense that certain representations are well-nigh categorical and salutary because of all that is living today. Existence itself must always have an absolute meaning, interest, and satisfactoriness for him, no matter what its condition; even though tomorrow the heavens themselves should fall. Perception of quality is ultimately dependent on such artistic feeling; and the efficient showman must not only be able to recognize quality, he must be able to recognize what expressions are relevant to and illuminant of the present moment, and what ordering and disposition can help them to effectiveness. Above all, he must be able to understand the new expression almost unbearable because of its radicalism, its relation to what folk are living today and still not aware of—the truth that has not yet a name.

—

MATISSE, WITHOUT PURPOSE

DECEMBER 2, 1931

Paul Rosenfeld

THE SHOW OF the works of Henri Matisse bespangling the walls of the museum in the Heckscher Building excites a curiosity, a suspense, not at all concerned with Henri Matisse. The quality and motive of his pretty paintings themselves are fairly evident, and quite uninteresting. What remains a problem, if only for the reason that it appears unfathomable, is the aim of the directors of the young institution. Ostensibly interested in the establishment of the idea of modern art in the shape of a museum, and the development of the public appreciation of "the true, the good, the beautiful" as revealed by the great recent painters, they are now to be found lending their rooms to a show mainly composed of the facile canvases of an extremely clever colorist who was once a daring visionary artist. And the questions, To what end, this display? What idea is established, what taste developed, by such decadent work? are ineluctable among these gaudy images.

That Henri Matisse deserved an exhibition at the Museum of Modern Art is certain. During a portion of his career he was the banner man of the great tradition in painting, the tradition recaptured for the modern world by Cézanne and Van Gogh. The tradition which culminated before these giants in the paintings of Ingres, Courbet, Manet, and the impressionists, the conception of the business of art as the production of the perfect illusion of reality, the perfect imitation of objects, was after all a minor one, original in the materialism and naturalism of the dying Renaissance. The great art people had always conceived the work of art primarily as an organization of the formal elements of the medium, of line, shape, and color, in sympathy with an idea; recognizing that the material subject was of interest merely through its state of union with abstract, sheerly pictorial values. This wisdom is the secret spring of all directly affecting, sensuously communicative art. And in conceiving their pictures as totalities of form made up of formal units, and thus identifying the means and the object of art, Cézanne and Van Gogh actually restored the aesthetic of the Egyptians, the Orientals, the

Byzantines, and the painters of the early Renaissance. Cézanne's unity was depth of space, Van Gogh's totality of plane, as in Japanese art. However dissimilar their techniques, both achieved a perfect unification of pictorial elements; and modern art was the inevitable consequence of this radical return to the wisdom of the ages.

Accepting Van Gogh's format of unity, totality of plane, Matisse took a step farther in the direction of the construction of abstract, purely pictorial values in painting by simplifying and enlarging Van Gogh's units of line, shape, and color. An incentive to this simplification, in particular the technique of abbreviating and accentuating human forms for the sake of rhythmical organization, undoubtedly came to Matisse from Persian stuffs and enamels and African wood-carvings. These works undoubtedly supplied him with a final authority for his broad planes of rich tones, his decorative use of form, his brilliant suites of unconventional, fascinating spaces; and a pattern for the world of his paintings. In that world, to quote further from Willard Huntington Wright, "every form has an interest, every line a completion, every space a plasticity; and everything is visibly interrelated." Possibly Matisse lacked a powerful rhythm and an eminent gift of organization even during his hour of leadership. A certain wanness, a certain laxity, breathes from many of the canvases representative of the period. "La Joie de Vivre," that spring piece of his indirectly emulative of Botticelli's "Primavera," is far less vigorous than its Florentine prototype. Neither is a certain crudity of technique to be overlooked. One has merely to examine one of the best pieces of this period in the current show, the "Blue Nude," in particular the daub of blue placed beside the abdomen of the figure for the purpose of accentuating its rotundity, to be convinced of the deficiency. None the less, the formal distributions, "distributions in the flat sense," and the color oppositions of the best of these pieces are dazzling. The vision of the human form displayed by them, the rhythmical relation of its various parts are fresh and original and happy. The rosy back of the crouching woman in the "Bathers with a Turtle" is certainly a miracle of simplification and organization.

To be sure, there were difficulties in the path of an assemblage of Matisse's work in the grand tradition. The strongest and most exquisite of these canvases, the "Portrait de Famille" in particular, are in Russia. Matisse had a patron in Moscow named Stschoukine; and Stschoukine's houseful of Matisses is now the proud property of the Soviets. Still, the obstacles in the way of the show were not necessarily unnegotiable. A strong impulse could probably have suc-

ceeded in surmounting them, and such an impulse was decidedly in order. A representation of the sturdier, living, futuristic Matisse in the Museum of Modern Art would have affirmed modern art by exhibiting some of its achievements in the great tradition. In affirming the great tradition, the museum would both have educated its public by giving it a criterion, and encouraged the younger artists who have taken up the tradition where Matisse at least has left it hanging. And in educating the public and inspiriting the younger workers, the show would have supported the spiritual life of America. For the grand tradition is important not only as superior technique. Its greatest importance lies in the approach to creation as a whole implicit in it and communicated by it. That approach bears on something behind the tangible and the visible, some unity and equilibrium in things themselves reflected and laid hold of by the unity and equilibrium of the medium of art. And need it be repeated that the feeling of the whole, the conscious participation in general things, is the great bath of life?

The actual show in the Heckscher Building certainly affirms neither spirit nor art nor any high approach to life. The few early nudes, and the better of the decorative war-time canvases, such as the blue interior with the gold-fish and the green interior with the iron chair, are compromised by the mass of decadent recent painting. The total effect is melancholy: and whose good was ever served by the discovery of the nakedness of the drunken Noah? Matisse is surely very sober and very aware and a French gentleman in the flower of his age. Still, the fact of his decadence as an artist is lamentably clear. In quitting the grand front of the art of painting during the war, Matisse did not even return to the lesser tradition of Courbet and Manet and the impressionists, noble in their fidelity to the visible object, passionate in their zeal for the truth of the eye, the illusion of reality. Fully in possession of the decorative technique acquired during his years of experimentation, Matisse now appears very near the level of those who understand the function of art as the reproduction of pretty objects. His color juxtapositions are still brilliant; his sense of the decorative possibilities of the nude, delightful. But the color is shallow, the compositions facile, the purely pictorial values almost negligible. The attraction of these pictures is ultimately the magnetism of luxury—pretty colors, pretty models, pretty striped stuffs, windows on the Riviera, Spanish shawls, wallpaper designs backing wealthy-looking nudes, summer beaches on the Channel, fine feathers, good breakfasts, flowered hats. A spirit half of bourgeois complacency, half of ennui, breathes from them.

One takes it that a French gentleman is doing something which comes fairly easily to him, between the hour of the horseback ride and the hour of a very fine *déjeuner*.

Hence one's search among these paintings for what, if anything, was in the minds of the directors who organized this show; and one's incessant questioning, To what end, this display? If the museum is interested in art, why does it not show the work of a creative artist? If it could not get the prime Matisse, why did it not have a show of Bracque or Picasso or Marin or O'Keeffe or any other painter at work in the great tradition? And if the best traditions of art are not its concern, then why all this twaddle about modern painting, or any painting at all?

—

Mr. Rosenfeld and Matisse

December 30, 1931

Meyer Schapiro

To the Editor of *The Nation*:

Sir: Mr. Rosenfeld's review of the Matisse exhibition in *The Nation* of December 2 is petulant and irresponsible. To his austere, historic eye the paintings are "bespangling," "gaudy images"—"pretty paintings," of which the quality and motive are "quite interesting." They have even "a certain crudity of technique." The earlier Matisse, i.e., the Matisse presented to America by Mr. Stieglitz and Mr. Rosenfeld, was a good painter, but since the war "the fact of his decadence as an artist is lamentably clear." His subject matter has become bourgeois and luxurious, "the purely pictorial values, almost negligible." Hence the *"total effect"* of the exhibition, which contains thirty-nine paintings of the Rosenfeld period and thirty-nine of the bourgeois decadence, "is melancholy." "To what end this display?" he calls out twice in the name of the "great tradition." "If the museum could not get the prime Matisse, why did it not have a show of . . . Marin or O'Keeffe or any other painter at work in the great tradition?"

Now the prime, pre-bourgeois Matisse seems to be in Moscow and in the very private Barnes Foundation. Mr. Barnes would lend nothing, although he visited the exhibition with a secretary to dictate aesthetic analyses for a probable book on the subject. Without inquiring into Soviet policy and the exact nature of the museum's efforts, Mr. Rosenfeld has accused the latter of laxity (and a sort of

betrayal of the grand tradition) in not obtaining the pre-bourgeois canvases in Moscow ("Stschoukine's houseful of Matisses is now the proud property of the Soviets"), which reveal the "sturdier, living, futuristic [!] Matisse." The Russian government also sent nothing to the recent Byzantine exhibition in Paris despite all solicitation.

MEYER SCHAPIRO

New York, December 4

—

EMPIRE STATE

DECEMBER 30, 1931

Frank Lloyd Wright

TO THE EDITOR OF *THE NATION*:

SIR: Speaking of the skyscraper, why sentimentalize over a silhouette? Why thrill with the glint on an aluminum erection? Look at the thing, not as it says it is or as it would like to be, but as it is— an unethical monstrosity, a robber, going tall to rob the neighbors. Were the neighbors to go tall, too, all would be worthless because all would be stalled—dead—no thrills. The thing has the same "picturesque" as has any piling up of wreckage by means of blind forces. This space-enclosure is rooted in greed. It rises regardless of human life or human scale to impose exaggeration on a weak animal. The herd instinct of the human animal is easy to exploit. The deserted farming areas of the United States testify to that. And this tall monument to the white-collarite is also testimony.

As a minor point, skilful engineering inside and stone draped on outside by the architect-tailor do not make architecture except by grace of such sentimentality for lies as has "built" the nation to a standstill. Cathedral? All the little houses round about the cathedral each trying to be a cathedral? And the devil for the shortest?

FRANK LLOYD WRIGHT

Spring Green, Wis., December 8

—

THE PHOTOGRAPHY OF STIEGLITZ

MARCH 2, 1932

Paul Rosenfeld

ONE OBJECTIVE OF the young Stieglitz was triumphantly achieved by
the show of 127 Stieglitz photographs until recently on the light
walls of An American Place. It was the aim of the youthful photog-
rapher to demonstrate the parity, at the very least, of his means with
all sacrosanct aesthetic means; to exhibit its special, pertinent, and
perhaps unlimited capacities as a medium of pure expression. And
the theorem is now demonstrated; and with a grand emphasis which
the ardent champion of forty years ago could scarcely have antici-
pated. The prints, representing forty years of growth, actually con-
veyed, with the foreseen immediacy of music, or poetry, or painting,
an unpredictable immensity of human experience. And the matur-
ity, the subtlety, the tragedy of the feelings of the forces of life com-
municated by them go far to place the man's entire work among
the prime realizations of our world.

Previous shows of Stieglitz's photography had proved that in his
hands, and perhaps in his alone, the straight photographic medium
was as capable of creating, out of the welter of characteristics present
to the dead eye of the camera, forms as complete, self-declarative,
and living as those accessible to pencil or chisel or brush; and that
it was able to rank with any means communicative of the forces
confessing themselves through form alone. In fact, from the begin-
ning, none of the itinerant young American's plates had been
merely descriptive and documentary. All had been objectivities. All
had given rhythmic organization, by means of the architectural pow-
ers latent in the medium of the camera and felt by Stieglitz, to the
appearances focused by the lens. All had represented these appear-
ances as the elements of two mutually complementary, significant
movements, respectively recessive and progressive. Still, this most
recent of all Stieglitz's photographic shows was surpassingly happy
in the interest of the forms exhibited, and the inclusiveness of the
experience of life conveyed by them. Here, if ever, one saw abstract
photography; photography projecting feeling purely and almost in-
dependently of the instrumentality of the subject matter. Indeed, in
some of the photographs based on cloud shapes, subject matter was

entirely non-existent: what one saw was mere fabulously delicate markings in black and white.

In all cases, the subject matter and artist were one: what confronted one was simultaneously the momentary appearance of the object registered with the delicacy and precision of the scientific apparatus, and a system of relationships of black and white representative of the system of values created in the artist by his experience, and expressive of the unseen forces at work in things. In themselves, these systems of black-and-white relations were extremely subtle. They included dramatic dispositions of almost infinite blacks and whites; lines prodigious in their fineness and forcefulness and liveliness.

What these machine-made products conveyed was of particular moment to us here in America. It was the state of life of New York during many years, more finely, deeply, definitely grasped by Stieglitz than by any other recorder. One felt the cheapness, the chaos, the vaulting ambition, the crass bulk and push, the miserable collapse, of pressing forces. Other prints expressed a wonderfully lofty feeling of the wonder and tragedy of life in general; there was something supremely high and inclusive in these images of the tragic career of spirit itself, errant, aspiring, fragile in the infinite abysses of the universe.

We owe this expression of lofty feeling to a long-mature appreciation of the spiritual fact, accompanied by a capacity to release the feeling of the whole of things engendered by this receptivity in the terms of the photographic medium. The psychic process evidently involves a very prompt ability to read from the appearances of things the forces of life which produced them and whose presence they attest, a swift capacity for appreciating the contrasting values which give these traits significance, and a capacity to conceive the entire mass of characteristics as a significant play of chiaroscuro. Precisely how the formless play of light presented by things to the dead eye of the camera becomes an orderly, expressive system of references and relationships, borders upon the miraculous: for there can be no attribution of persistent, multiform photographic organization such as that exhibited by the entire work of Stieglitz to accident. It is true that nature is rhythmic, that moving skies and the textures of skins form patterns. Nevertheless, the persistent ability to convert, without interference or prearrangement, the kaleidoscopic play of light and shadow presented by the turmoil and movement of the streets into the notes of a complex pictorial organization, into the notes of a structure in which everything has significance and beauty, forces us to conceive a certain readiness within the artist for the instantaneous cast of appearances destined

to form the base of his expression. And, behind that, it forces us to conceive a relative equivalence between what exists without the photographer in the form of an object and what exists within him as a system of values. What is photographed and what photographs appear to be almost identical.

At the base of this entire photographic work there stands a certain force in things themselves, a certain impulse of ideal aspiration and spiritual growth. It appears to be both the motive and the object of Stieglitz's work: we feel its presence in his characteristic forms, in his characteristically perpendicular, aspiring, extensive shapes that appear both to reach upward to some perfection and simultaneously plunge their roots downward into the bowels of things. We recognize it as the spirit which Stieglitz has affirmed by the exhibition of its works in the shape of paintings, for it is the spirit of the cubists and Marin, O'Keeffe, Demuth, Dove, and the rest of the two-ninety-oners, too, in some degree. And it is as the direct affirmation of that spirit, not through its works but through its "picture," as the affirmation of the motive of all the other affirmations, that the recent show of photographs was finally important. For it is the spirit of ideal aspiration and spiritual growth that the whole of Stieglitz's work is about, that the whole of his life has been concerned with. And, made as it was at the end of forty years of incessant championship and production, this affirmation of what was both the source and the aim of a great public life has the supreme value of a fresh act of fealty toward and faith in a spring of action, on the part of one it has long consumed.

Florine Stettheimer's life intersected with at least two Nation *critics: she studied with Kenyon Cox at the Art Students League and designed the stage sets for Virgil Thomson's* Four Saints in Three Acts, *which was based on a scenario by Maurice Grosser. She may also have been a visitor to Paul Rosenfeld's salon during her years in New York.*

—

THE WORLD OF FLORINE STETTHEIMER

MAY 4, 1932

Paul Rosenfeld

THE SENSATION OF the show of the American Society of Painters, Printers, and Gravers at the Whitney Museum this season was surely

Florine Stettheimer's witty and satiric apotheosis of popular American art, splendor, and ceremonial entitled "Cathedrals of Broadway." All the hieratic domes and columns and beds of golden lights of the Roxies, the Paramounts, the Capitols, and the Strands, and their ritualistic scarlets and golds and parades of uniformed ushers, their banners, "art" galleries, and magnificent custodians, were essentialized in it; and built up into a kind of gaudy shrine about a central rectangle of silver solemnly inscribed with the vulgarly handsome mask of Jimmy Walker opening the baseball season; the derby still on his head; the face of him hard as a wisecrack; the baseball offensive in his twisted hand. And the hubbub the picture provoked was a perfectly legitimate one. The "Cathedrals" was observed of all observers not merely for its satiric humor. It is a piercing, an amusing, and elegant piece of work, and very brilliantly pigmented. Originality of idiom distinguishes it from the mass of derivative and compromising pieces necessarily evident in any omnibus show, and certainly not without representation in the exhibition at the little museum. Besides, the rarity of the occasions on which works of its gifted author have been displayed to the public gave the picture the further distinction of novelty, and tended to set it apart from the productions of the other gifted but better-known craftsmen which figured on the many broken walls.

The canvases of Miss Stettheimer, indeed, stand well among the exceptional works of art now being produced in the United States. Their spirit and their style are quite as individual as the technique by which the painter achieves her luminosity of color, marvelously responsive even to poor and to half lighting. There are serious people who claim that she is one of the three important women painters in the country, the other two being Georgia O'Keeffe and Peggy Bacon; and that the three of them compare somewhat as the three typical operas "Tristan," "The Barber of Seville," and "La Belle Hélène" compare with one another—O'Keeffe representing "Tristan," Peggy Bacon the Offenbach masterpiece, and Miss Stettheimer the masterwork of Rossini. From this comparison it will be gathered that the art of the latter lady is an ornate, a feathery, a spangled one, full of trills and coloratura and fioritura. Indeed, it is a witty, an elfish, a humorous affair; almost a Christmas-tree art, but the art of the most tastefully and exquisitely trimmed of all Christmas trees. Those brilliant canvases of hers do resemble gay decorations in colored paper, and lacquered red and blue glass balls, and gilt-foil stars, and crepe streamers, and angels of cotton wadding, and tinted wax tapers. That is because she has a highly refined decorative sense combined with a certain predilection for the ornamental, the friv-

olous, the festive; indeed, a sense of the poetry and humor and pathos of what is merely embellishing. Many of her graceful, delicate shapes are imitated from festoonery, plumage, tassels, rosettes, fringes, bouquets, and all kinds of old-fashioned trappings. Others are the forms of some Oriental elfin world in which everything is sinuous, diminutive, and tendril-like; and huge bees and dragonflies and glorified insects and all sorts of non-human, vermicular, and winged creatures are the norm. She seems to delight in garish, tinselly, glittering colors; the colors of "paste" and bric-a-brac and paper flowers; and induces her paint to form tiny sparkling brilliants. It is a fabulous little world of two-dimensional shapes with which she entertains us; but beautifully, sharply, deliciously felt; and perfectly communicative of the pleasure with which it was created.

It is an expression of aspects of America, tinged with the irony and merriment of a very perceptive and very detached observer. A number of her paintings represent personal and intimate experiences; for the artist ranges herself emphatically among those who find the personal record one of the opportunities of art. They include portraits of the members of a genteel family circle, and portraits of friends such as Carl Van Vechten, Marcel Duchamp, Stieglitz, Louis Bouché, and Virgil Thomson. Others are Americana: let it hastily be stated that the idea of grandiose documentary caricatures of the land of the free found expression in Miss Stettheimer's art some while before it was popularized by the *American Mercury*. Besides the "Cathedrals," this series contains a very dainty "Atlantic City Beauty Contest," a "Spring Sale at Bendel's" full of exquisite, capricious shapes and figures, a golden "Beach at Asbury Park," rich in amusing Negro silhouettes; also a "Fifth Avenue," a "West Point," and several syntheses in a similar vein.

But of course the artist has expressed those aspects of the reality which harmonize with her own idea and way of feeling. Thus, the figures of the family and its adherents have a certain very Parisian dollishness, as befits inhabitants of a rarefied and not quite probable world. The characteristics of the persons and their surroundings are combined in a dreamily fanciful way, and conceived in terms of archaic popular images. The ignorant and devoted Irish nurse stands masterfully beside her dressing-table as beside an altar, and about her head float the cherubically winged heads of the five children she reared and made over in her idea. A romantic sister, her cheeks ablaze beneath huge dream-bewildered eyes, floats through the erotic night, beneath a blazing Christmas tree on the crimson couch on which her dream has stretched her. As for the various floral American fantasies, they are full of marvelously chic and quite diaphanous

persons; and if these puppets have the American seriousness mixed with the American childishness, and are all exalted and pompous about ridiculous things, they also have an elegance and elfishness which is not quite of this world, and of one whose inhabitants might have larked in the train of Titania and Bottom. In fact, the values and relations and accents of Florine Stettheimer's art are so fastidious and incorporeal and weightless that we seem to be moving through them upon a planet smaller than ours, some large asteroid swimming joyously in its blue ether—the asteroid "Florine"—and getting both the experience of this delicate, remote little sphere and a sense of the grossness and preposterousness of our own earth.

8

"AND AFTER ALL. . . . IT'S MY WALL . . ."
TRIALS AND TRIBULATIONS (PART II)

Douglas Haskell, who wrote about art and architecture for the magazine from 1929 to 1948, contributed this ominous report on the emerging Nazi regime.

—

THE CLOSING OF THE BAUHAUS

OCTOBER 19, 1932

Douglas Haskell

FOR THE SECOND time in the past ten years the Bauhaus in Germany has been closed by political decree. A Nazi burgomaster and his council, for the time being ruling the city of Dessau, home of the Bauhaus, took exception to the conception of culture that was being taught. It had come to be international instead of pure German; it

was increasingly rationalist instead of the outgrowth of vague mystical groping; it was suspected of being tinged with economic radicalism.

So once more there comes a pause in the career of what has become perhaps the leading architectural school of the present day. At a time when the Beaux-Arts in Paris survives by virtue only of the sentimental support accorded by its American "old boys," the Bauhaus has come to occupy a position similar to that held by the Beaux-Arts in its palmiest days: the center of enthusiasm, of the greatest designing gifts, of the active molding ideas of its time. Though the Bauhaus was organized as a school of all the fine arts, with painters on its staff, and modern sculptors, photographers, and cinematographers, it is architecture that has been held central, with the other arts ancillary; and the great glass box that the school has occupied since it moved to Dessau after its last suppression at Weimar has come, even in our own belated country, to serve as a sort of trademark.

For the director, Mies van der Rohe, the suppression is an ironical event, for no other prominent progressive architect in Germany has paid less attention to politics. Perhaps this is a postmortem Nazi revenge on the former director, the Communist Hannes Meyer. At any rate the Nazis appear to be displaying a sound instinct. For them to hate the Bauhaus and all its works would seem natural. The technique or manner it has helped to foster is one that appeals, paradoxically, to those mutual opponents, the leaders of the massed workingmen and the aristocrats of wealth. For the pudgy-fudgy middle class that makes up the nucleus of Herr Hitler's Nazi hordes it can have little appeal. The aristocrat likes to feel, in accordance with principles already expounded by Thorstein Veblen, that he can afford to dispense with gewgaw and ornament, because his designer commands the superior art of perfect proportion, pure form, an absolutely competent grasp of functions, impeccable taste in colors, textures, and materials—and then the necessary and appropriately expensive force of trained workmen to finish his building with the flawlessness which its nudity demands. Only the perfect body can dispense with clothes. Yet at the other end of the scale, quite opposed to this elegance or preciousness, to which Mies van der Rohe gives the richest expression and Le Corbusier the most exciting, there stand the socialistic workers, with their own rough and ready version of the same "style" worked out for them by architects interested primarily in sociology and in mass housing. They too will forgo gewgaw and romantic pretense, because these are essentially perquisites of the bourgeoisie. They will be proud of rational houses,

all very similar: equal premises will lead to equal results for all; moreover, to secure for every German citizen the decent house to which the constitution of the German Republic is pledged, there must be utterly rational organization and no waste. With democracy grows science. Then, too, a country such as Germany, flattened by defeat—so ran the argument in the early days—can rise again only by grim attention to work, such as shall impress her neighbors with the German masses' pacific sincerity.

From Hitler, the pudgy hero, and all his fuzzy hordes neither of these attitudes can receive any affection, because they are both directed straight at his existence. The closing of the Bauhaus, at the present juncture, is therefore—if I read the confused events aright—in the nature of fate, and there can be no use in protests.

Nelson Rockefeller was put in charge of his family's new office complex, Rockefeller Center, taking a special interest in selecting works of art to decorate the buildings. Rockefeller, who also became president of the board of the new Museum of Modern Art, boldly commissioned a mural from Diego Rivera, then had it destroyed. E.B. White, in his famous poem "I Paint What I See," imagined the pivotal conversation:

> "And though your art I dislike to hamper,
> "I owe a little to God and Gramper,
> "And after all,
> "It's my wall
> "We'll see if it is," said Rivera.

While Rivera was in New York, journalist and critic Anita Brenner closely followed the mural's progress. Brenner, an ardent Trotskyite who later asked Rivera to help Trotsky secure political asylum in Mexico, also wrote for the New York Times Sunday Magazine, The Atlantic, The Dial, *and many other publications.*

—

"HALF-BREED MEXICAN BOLSHEVIST"

APRIL 5, 1933

Anita Brenner

DIEGO RIVERA, CONSIDERED by many competent critics the foremost living mural painter, recently completed what he considers his mas-

terpiece on the walls of a court in the Detroit Institute of Arts. No sooner were these paintings unveiled than they precipitated an acrid controversy. A group of the clergy supported by the Detroit *News* has demanded that the murals be blotted out by a coat of whitewash. One Dr. Berry charges the curator of the art museum, Dr. Valentiner, with attempting to "sell out the best walls of the city art museum to an outside half-breed Mexican Bolshevist," and denounces the paintings, which express the artist's concept of Detroit's contribution to our civilization, as "Communist propaganda." The Reverend H. Ralph Higgins, senior curate of St. Paul's Episcopal Cathedral, condemns the "vaccination panel" as a caricature of the Holy Family. This painting depicts a nurse holding a child whom a doctor is vaccinating. In the foreground are the domestic animals from which vaccines and serums are derived. In the background are scientists at work, with a microscope, retort, and vivisection table. If this group is intended to suggest the Holy Family it does so in a spirit that only the sanctimonious could consider irreverent. In opposition to his critics, Rivera has received scores of letters of appreciation from every quarter; Albert Kahn, the architect who designed almost every important Detroit building, declares that art lovers the world over will make pilgrimages to Detroit to see the Rivera frescoes long after the present critics are dead and forgotten. Possibly a solution may be found in the happy thought supplied by the Detroit *Times* that Rivera has supplied the art institute with the "best advertising it has ever had." Detroiters should consider the possibility that the Rivera frescoes may bring visitors and revenue to the city. What has become of Detroit salesmanship?

—

DISPATCH

MAY 17, 1933

Anita Brenner

The suspicion grows that an art gallery is no place to take the pulse of the nation, and this reviewer is willing to stop and cast a clinical eye instead at automobile shows, for example, where surely the nation's aesthetic joys are in active evidence. As for excitement caused by painting, it has been seen in the small mobs of watchers who somehow crashed the formidable gates of the unfinished RCA tower in Radio City, to watch Diego Rivera and his gang doing big

things in a big way. The sight of painters working like bricklayers in
the clangor and dust of building seemed to arouse large feelings in
the fascinated audience—students and workmen mostly—who
gazed beatific and concerned as excavation-watchers. Somebody was
on hand with a watch—they got half an hour—because it seemed
that there was always another shift waiting at the door.

—

THE ROCKEFELLER COFFIN

MAY 24, 1933

Anita Brenner

BY A STRANGE coincidence, at dawn of the day when Hitler was
having Germany purged of everything Marxist, modern, and Jewish
in its literature, the Rivera murals at Radio City were nailed into
what may turn out to be a coffin. The wake was attended by a body
of resolute gentlemen who the doorman said were tenants, two rep-
resentatives of the owners, an army of guards and some mounted
police, and some fifty carpenters. The mourners were Rivera and
his assistants, three students who stayed outside the door when all
visitors were ordered out of the building, and this writer, who did
likewise. Also a photographer who learned at the door that there
was a ban on pictures and reporters.

The operation was dramatic. It was plain that the operators meant
to be quick, efficient, and still. It was plain, too, why; for the Rocke-
fellers were caught between two nasty choices. Either they allowed
the mural, Lenin notwithstanding, to be finished as a monument to
their financial and intellectual generosity as patrons of the arts, and
faced possibly seventy-two stories of empty office building; or they
removed, destroyed, or wall-papered the painting and suffered a
considerable loss of prestige as public uplifters and benefactors,
which no doubt was the ideal they meant to serve when they en-
gaged Rivera, one of the recognized great among living artists, to
decorate the most prominent wall in the biggest building of Radio
City.

Many critics have hastened to note that they erred in engaging
Rivera at all, knowing that his political convictions and his aesthetic
creed were inseparable. But the real error at the root of this and
the rest of Radio City's misfortunes was the idea that they could at
the same time build a cultural and artistic center for the public

benefit, and make it pay. No critic would have laughed or carped at the Roxy fiasco if so much emphasis had not been laid on the artistic marvels that we were to acquire in Radio City; if, indeed, the public had not been informed so insistently that Radio City was the product of high-minded philanthropy. For no one expects high art to be sponsored as a piece of business and we are all familiar with the fact that when art is joined with business in shotgun wedlock, the offspring is usually crippled, sick, or monstrous.

Perhaps the depression changed the Rockefellers' mind, so let us sympathize with their losses. We won't look down on them if they *are* poorer by a few hundred millions. People who own seventy-two-story buildings just off Fifth Avenue can't fill them with rent-free laboratories, libraries, and studios. But is it necessary to say that Rivera violated the agreement, that his work doesn't harmonize with the architecture, that it isn't suitable for public view, and that the colors are too bright and the concept not imaginative enough, instead of admitting quite frankly that most business men object to renting space in a building where they and their customers must look at Lenin?

The canon Rivera has violated is the second-rate architects' creed that decoration, to be "harmonious," must be practically invisible; that neither in color, idea, nor style should it be anything that you stop to look at. Otherwise it isn't "restful," and it wastes time and may congest traffic, like the murals at the Boston Public Library. None of the great muralists of the past seem to have known this rule, perhaps because most of them were good architects as well as good painters.

The ban on Rivera has been good copy, and adds another comic footnote to the history of art. It has also encouraged a body of academicians to form a kind of society for the suppression of foreign art. They are going to break a lance in defense of the startling idea that an artist born outside of the American tariff wall is not necessarily superior to the artist sheltered within it. In the name of American art, we shall hear, down with purchases and contracts rewarding creatures not citizens of the United States! We note with patriotic alarm that one of the founders, Ulric Ellerhusen, was born in Germany, and we wonder about Jes Schlaijter; and would it be proper for a New Yorker to buy the work of Dean Cornwell, a Californian?

Let us ignore the law that interbreeding of ideas as well as of peoples makes for fertility and vigor; forget that Greco, the great Spanish painter, came from Greece, and that Picasso, the giant of France, is a Spaniard; decide that Durer betrayed his art when he went to Italy to study. And why bother to remember that the Italian

Renaissance thought that it was what its name implies—a rebirth and rediscovery of Greece? Instead, let us recommend that American art look carefully into the citizenship papers of Maurice Sterne, Max Weber, Noguchi, William Zorach, Lord Duveen—and let us have a bonfire in Radio City.

——

Diego Rivera at Work

September 6, 1933

Walter Pach

The best show in New York at the moment is on view at the New Workers' School at 51 West Fourteenth Street. The New Workers' School is an extremely modest institution situated over a store as shoddy as the neighborhood itself. One climbs three flights of stairs, almost vertically, for there is no turn at the tiny landings; one goes past some partitions that break up the loft into schoolrooms; one pays an admission price (minimum) of ten cents; and suddenly one is back in the Florence of the fifteenth century. Or at least the decorations which Diego Rivera is painting on the wall there are in the *fresco buono* of the old Italians, that sovereign method of painting which Michelangelo, mannerless old anti-feminist that he was, called the work of men, while oil painting, he said, was for women. Few artists since his time have taken up the challenge to use the difficult medium; indeed, it had been so nearly forgotten that considerable experiment was needed to recover the old tradition. It is in respect to the style of painting, its absolute permanence, and its sober and powerful effect, that one may speak here of Florence and the Renaissance. Otherwise, in respect to the ideas expressed, one is in the full tide of modern life and, what is especially notable considering that Rivera is very Mexican even among Mexicans, it is safe to say that most visitors will find themselves plunging deeper into the history of our country than they have done for a long time.

The first scene he has painted is of New York at the time of its colonization; the second is of the Boston Massacre; the third gives us Shay's Rebellion (with a scroll bearing Jefferson's glorious words that the tree of liberty must be watered from time to time with the blood of martyrs and of tyrants); the fourth shows Margaret Fuller, Emerson, Thoreau, and Samuel F.B. Morse, the intellectual leaders of their time, and at the same time the country's material expansion

through Hamilton's banking system, the trading of the Astors, and the drive for more territory under James K. Polk. Other scenes from American history are sketched on the panels which Rivera will complete before he goes to Mexico at the beginning of October in order to decorate there the School of Medicine, formerly the Palace of the Inquisition, an assignment which will give full scope to his sense of dramatic contrast and—for all the traditionalism of his medium— his sense of the triumph of our modern time over the dogma of the past. As for his rendering of our own history, the most sluggish and indifferent person must be stirred to pride in his country, even if its darker aspects are recorded with an unsparing hand.

For a month more, then, anyone may watch one of the greatest living mural painters at his work. The admission charge goes toward a fund for preserving the frescoes, which are so made that the separate panels may be detached from the wall whenever the school can move to better quarters. P.T. Barnum, could he come back to earth, might see the chance for showmanship here, but the press has almost ignored it so far, and the New Workers themselves have failed to capitalize the event.

And these paintings are for the public. If the appeal of the ripe development of modern art and of the sight of the man at work are lost for us, we may at least profit by the reminder that the great frescoes of the past, perhaps the supreme testament of the European races, were created for the eyes of all men.

Margaret Marshall often wrote for The Nation *and served as its literary editor from 1937 to 1953.*

—

IN THE DRIFTWAY

OCTOBER 4, 1933

Margaret Marshall

A MURAL OF the Sermon on the Mount Without Christ is about to take its place beside a picture of the Revolution Without Lenin in Rockefeller Center, which a less kindly person than the Drifter might be tempted to describe as the Skyscraper Without Tenants. Frank Brangwyn, the English artist, was recently reported by the press, which is not always without error, to have said that he was finding it somewhat difficult to do justice to the Sermon on the

Mount and at the same time please the managers of Rockcfcller Center, who had requested him to omit the principal speaker. As soon as the dispatch was printed, the managers, with much haste and very little logic, said that there was no controversy and then proceeded to divulge the details of the quarrel whose existence they had just denied. John R. Todd, head manager, handed out an explanation that sounded very plausible:

Doubt was expressed [he said] as to whether any artist should attempt the practically impossible task of painting a figure which would satisfy the conceptions of Christ represented by a light shining down from heaven.

The Drifter was inclined to sympathize with Mr. Todd, who is obviously a sensitive soul as well as a manager. But he was even more won over by Raymond Hood, who said: "Some people here felt that it would not be fitting to put the figure of Christ in a business building." The Drifter has been wondering ever since which would alienate more tenants—Mr. Hood's remark or the head of Christ in the corridor.

—

OFF WITH HIS HEAD

FEBRUARY 28, 1934

Margaret Marshall

THE LATEST INCIDENT in the Rivera-Rockefeller controversy occurred when the panel containing the head of Lenin was "removed" in a cloud of plaster dust from the wall in Rockefeller Center in New York City, where it had stood under a concealing screen since last spring. In other words, the Rockefellers, well known as patrons of art, have destroyed, for purely commercial reasons, an important work by the world's most famous mural painter. But it is difficult to see what Rockefeller Center has gained, even commercially, from the petty squabble which it has pursued even to the point of destroying an original and irreplaceable creation of a fine artist. To be sure, Lenin's head is no longer on the wall to scare faint-hearted tenants. But what sightseer will not ask to see the place where it once was? And will Rockefeller Center ever be separated in the public mind from Lenin, Rivera, and communism? We doubt it. Moreover, the present agitation by artists and intellectuals—the darlings of Rocke-

feller foundations—to boycott the Center will not be the last, and even a renting agent must recognize such agitation as bad publicity. Altogether, the Rivera episode was one of the Rockefellers' less successful ventures in oil.

—

ART AND ROCKEFELLER

APRIL 4, 1934

Margaret Marshall

THE ARTISTS OF New York, having weathered one Rockefeller tempest by accepting Rockefeller shelter, have now run into another and worse storm blowing from the same quarter. It will be recalled that in the midst of preparations for a huge Municipal Art Exhibition to be held in Radio City at the invitation and expense of America's eminent art patrons, the Rockefellers, Diego Rivera's mural in Radio City containing the head of Lenin was destroyed by America's eminent real-estate owners, the Rockefellers. Radical and non-radical artists alike joined in condemning this destruction of a fellow-artist's work—with the notable exception of the president of the National Academy of Design. "Mr. Rockefeller," he said, "took offense at the political propaganda in this mural, felt that he had been insulted, and had the painting destroyed as he had a perfect right to do." Eleven prominent artists, most of them members of the Society of Independent Artists, announced that they would not show their pictures in Rockefeller Center and called on their fellows to fellow their example. The American Society of Painters, Sculptors, and Gravers formally decided to boycott the Municipal Art Exhibition, and its president, Leon Kroll, withdrew as a member of the committee arranging the show. On the following day the Salons of America, another artists' organization, issued a cryptic statement saying that it would not boycott the exhibition "in view of an anticipated explanation from the officials of the RCA Building, which we think will be satisfactory to those groups invited to exhibit."

The "anticipated explanation" was revealed the next day when Mr. Kroll announced that his society would not boycott the exhibition after all, for the extraordinary reason that Rivera had told the Rockefellers that he would prefer the physical destruction of his mural to mutilation of its conception. It was also said that Rivera

had admitted that he had deliberately introduced propaganda into
his mural. In the Salons of America had predicted, the "explanation"
was "satisfactory."

There were other explanations by artists and critics who were
unable to follow Mr. Kroll's logic. They asserted on what seemed
good and direct authority that the artists had been sharply reminded
by their dealers and others that they could not afford to alienate
what is commonly reputed to be the best market for American art,
namely, the Rockefellers. At any rate, when the show was opened,
most of the prominent former protesters were hanging on the
Rockefeller walls, neatly framed, waiting for customers. Of the
eleven artists who first announced their intention to boycott the
exhibition, however, eight carried out their threat.

It is this group which is now engaged in another battle with
Rockefeller Center. The management had offered free space to the
Society of Independent Artists and the Salons of America for a joint
show following the Municipal Exhibition, and the offer had been
accepted in spite of the Rivera episode. The Independent show has
been traditionally a no-jury show open to all comers. But it was not
surprising that the representatives of Rockefeller Center, having
found the artists so reasonable in the matter of the Municipal Ex-
hibition, should attach certain "reasonable" condition to the mag-
nanimous offer of free space. Obscenity, dishonor to the flag, and
religious criticism, they said, would not be allowed, and to these
conditions the Independents agree though it might easily be argued
that even these restrictions imperiled their tradition of uncensored
shows. They choked however, over the final condition. It was that
works offensive to the Rockefeller family be debarred. The Independents
decided to exhibit as usual in the Grand Central Palace. The Salons
of America accepted the conditions.

The next move will seem clearer to a salesman that to an artist.
The fee for participating in the joint exhibit was to be $3. When
the Independents were forced to return to Grand Central Palace
they had to raise the fee to $4 to cover expenses. Immediately
thereafter the fee for the Rockefeller Center exhibit was reduced to
$2 and the date was advanced a week. Moreover, while one may
exhibit three pictures up to twenty-eight inches with the Independ-
ents, exhibitors at the Center may hand in three pictures up to ten
feet! No wonder John Sloan is alarmed.

> If [the artists] drop a really independent show [he says] for one
> so decidedly dependent upon the whims of private enterprise as our

competitor will be, it can prove the death of art in this country. . . .
We dislike having to pit our puny strength against the Rockefeller
Real Estate Company, but we shall have to do it.

It should be clear to artists in general by this time that Mr. Sloan
is painfully right. They will have to do it. We sympathize with artists
in their search for markets. Like the rest of us they must live. But it
is just as well that they should learn the facts of life.

—

FRONTIERS OF MACHINE ART

MARCH 28, 1934

Anita Brenner

THE MACHINE-ART SHOW at the Museum of Modern Art puts ball-
bearings on black velvet, laboratory glass in rhythmic procession
against a calculated light, and springs, propellers, plumbing, and
stoves against fine woods and fabrics. In spite of its preciousness, it
contains excitement equivalent to a Woolworth store, a hardware
window-display, a smoothly running machine shop, a chemistry,
electricity, motor-boat, automobile, or airplane show. Objects which
have often fascinated and pleased us all are here officially recog-
nized as things of beauty produced by America in the twentieth
century.

Isolated as such, they clarify what the machine can do for beauty
that the human hand cannot do. Artists have always struggled for
rhythmical regularity in order to get symmetry and smooth surfaces,
and though their products may sometimes appeal to us because
"handicraft implies irregularity, picturesqueness, decorative value,
and uniqueness," as Philip Johnson says in the preface to the cata-
logue of the machine-art show, these are not the standards by which
handicraftsmen in a handicrafts culture measure the excellence of
their work. A craftsman's skill consists in his ability to attain regu-
larity, precision, clarity, and he does so by practiced, rhythmic man-
ual coordination and movement; but the machine far outdoes the
steadiest, most regularly coordinated skilled weaver or potter in
achieving the regularity of pressure and movement that the weaver
or potter can acquire only relatively. As a craft instrument the ma-
chine is therefore a perfected, powerfully and skillfully endowed

projection of the human hand. It can cut, press, polish; mold, more perfectly than the most perfect sculptor, and so makes the artisan, technically, a creature of the past.

The modern artist is faced by the need to understand and use machines. New instruments have always in the past produced a new aesthetic. Today the powers of the human hand are heightened and multiplied mechanically, and the camera does the same thing for the human eye. It reveals proportion, motion, texture, and balance, and together with the X-ray and fluoroscope, tells the twentieth-century artist things about the living being that Leonardo struggled to find out from its corpse. Modern chemistry also multiplies materials and colors and multiplies their variability; this fact alone would impose aesthetic revolution on the painter and decorator.

But heretofore artists have been unwilling to recognize the machine as a new frontier in art. When it first began to make inroads on crafts William Morris led a bitter fight against it, on the theory that machines could make only shoddy things, because that was what machines were being used to make. To Morris and his fellow-fighters the machine was a competitor. Nowadays it has come to be looked upon as an oppressor. Plainly it is just an instrument, one that can be as well used for human welfare and comfort as for human discomfort and oppression. To put this idea into practice involves social revolution, just as to put the idea of the machine as an art instrument into action implies aesthetic revolution.

The Museum of Modern Art does not present the machine as an artistic instrument, but as itself a work of art. A screw and a spring and a propeller are surely beautiful, but they are not art unless everything that is beautiful is also to be called art—a tree, a girl, a horse. Ordinarily one assumes that objects made primarily to express emotion are to be called art, though one does not need to say that all products of the artistic impulse are beautiful. None of the objects in the Modern Museum show were made primarily to express emotion. Machines, so far, have been used chiefly to make more machines; secondly, to make scientific instruments; thirdly, to make useful objects. A few by-products of these activities have been used for decorative purposes. In other words, machines have been used by industrialists for industrial purposes, by scientists for scientific purposes, and by business men for business purposes; not yet by artists to make art.

So far the only artists who have made much of a place for themselves at the machine are artists who serve business, collaborating in the design of useful objects in order to make them more attractive to buyers. Occasionally they take some industrial forms into purely

decorative media, and then an elegant shop labels the object art and raises the price. In the Modern Museum there are bowls and vases in one room exactly like the laboratory glassware in an adjoining room, with the difference that as "art" they are labeled Fostoria and Steuben and cost five or six times as much as when they are called Eimer and Amend battery and hydrometer jars.

There is no reason, except perhaps business, why artists should not be served by the machine instead of only serving it. At present, however, it still comes hard to the manual craftsman, such as every painter and sculptor still is, to make his peace with the higher mechanics. In order to do so he must learn his trade all over again, and people tend to defend what they know against what they don't know. Besides, the artist is sentimentally attached to the palette and chisel and quiet studio and easel and Greek fragment. Spray-guns, electric drills, and laboratories imply a terrifying new world, and it takes brave men to master it.

—

HANDWRITING ON THE WALL

MAY 2, 1934

Margaret Marshall

HANDWRITING ON THE wall in the form of mural decorations continues to upset the more solid citizens of America. In Seattle, Washington, out where the handwriting's a little stronger than some church members like it, the Reverend Fred W. Shorter has been expelled from his fashionable pulpit for allowing a young artist, Ross Gill, to paint seven radical murals on the walls of the Pilgrim Congregational Church. The murals depict, among other things, a Southern lynching scene; a disarmament conference at which business men are rolling dice with munitions-makers whose heads are skulls; a starving family huddled beside a vast pile of armaments under a banner, "Protect Our Homes"; a tattered farmer plowing under his crops. The conservative members of the church, little to our surprise, maintained (1) that the pictures have no place in any church; (2) that they are propaganda; (3) that they are "particularly gross in a place where children congregate." Having put the responsibility upon the children, the conservatives won their case, according to Mr. Shorter, by "bringing all the old people—people who hadn't been to church for years" to the meeting that dismissed him

by a vote of 171 to 121. The children, as usual, were not asked. Mr. Shorter intends to start a church of his own. "Art and religion," he says, "should both be revolutionary. . . . I shall continue to preach the brotherhood of man even though church revenues diminish." It is well that he recognizes his problem.

—

In the Driftway

May 9, 1934

Margaret Marshall

On its dramatic showing the Administration should be able to hold out until November, 1936, and get its contract renewed. But the Drifter has misgivings about its ventures into art. Early this year 3,761 artists equipped with paint and brushes and pencils were turned loose at government expense ($1,408,381) on the unsullied canvas, the blank walls, and the plain drawing-paper of the nation and told to make pictures for the Public Works of Art Project and posterity. According to the figures, PWAP was a great success. The federal government now owns some 15,000 works of art, of which several hundred are murals in public buildings. At present 500 selected items are on view at the Corcoran Gallery in Washington and have received favorable critical comment. The fate of the 501st item is what makes the Drifter wonder just what kind of whirlwind the Administration will reap in the next election. The painting in question showed American sailors on shore leave. As the Baltimore *Sun* pointed out, "a close study of the scene leads the observer to believe the sailors have been drinking, that their salutations to the girls were unconventional, and that in not all cases were the advances being resented." It was scheduled for exhibition at the Corcoran, but the Navy Department heard about it. As a result, Secretary Swanson swooped down and with the aid and advice of Assistant Secretary of the Navy Henry L. Roosevelt suppressed it. "It reflected," said Mr. Roosevelt, "unfairly upon the men of the navy." The Drifter suggests that Mr. Roosevelt tell that to the marines. Meanwhile he wonders how many of the 15,000 works of art turned out to be "pictures of teacher." In particular he wonders just what the second- and third-class postmasters of America, as they sit reading the incoming postcards, think of the murals their President has given them. The answer may show up in the convention in the summer of 1936. And

it would be quite true to American form if Mr. Roosevelt lost his job not because he failed to abolish poverty but because he allowed artists to cover post-office walls with pictures that local Democrats happened not to like.

Hugo Gellert, whose work often featured machine-age imagery, was one of the most political painters of his age. He also drew scathing illustrations for The Masses, The Nation, *and the* New York Sunday World.

—

HUGO GELLERT TO ANITA BRENNER

JULY 11, 1934

Hugo Gellert

TO THE EDITOR OF *THE NATION*:

No, my book, "Karl Marx' 'Capital' in Lithographs," does not make Anita Brenner "feel the need to partake in the action of the formula 'Workers of the world unite. '" Certainly it did make her hysterical in your issue of June 27. A better balanced reviewer might have tried to prove her assertions. In this book, thousands of pages of Marx's monumental work are reduced to sixty. It is obvious that these selections would either qualify or disqualify me on the basis of concrete proof—the printed word. But Miss Brenner shies clear of this opportunity. Therefore her remark that "this is a job that requires clear political thinking, a thorough, realistic historical knowledge . . ." is a boomerang. Since I'm restricted, space does not permit me to do more than point out several of the most glaring untruths which characterize her review.

She says: "Gellert believes that to be a Marxist automatically solves every intellectual problem—I have heard him say this." Not true! I do not believe that—therefore I never said it. Further, "If Hugo Gellert were not a Communist he would be a successful commercial illustrator." Why the "if"? When he did do commercial work, his drawings were reprinted and exhibited as outstanding examples of commercial art. That is what Miss Brenner would call "successful," is it not?

Besides architecture (skyscrapers) there is another field of art activity in which the United States excels: advertising propaganda. And everyone knows, save an art critic pumped full of aesthetics,

that its primary requirements arc, precisely, the "mastery of propaganda technique . . . and the ability to translate . . . into telling concepts and designs."

The love of lithograph crayon and the gusto with which it is spread over the crispy surface is "flashy, academic technique" for Miss Brenner. And when she jumps to the "catacombs" and then back again to the "magazine covers" of today, she is plainly rattled. She cannot fit the work into the musty old art-catalogue.

A propos "the forcing of peasants off the land . . . Gellert draws a full page picture of a pair of sheep!" Most readers have imagination. I thought that a picture of the aim and result of the expropriation sufficed. However, let Miss Brenner turn three pages in the same chapter and she will find a picture of a peasant family in the process of eviction; the home burning, the Scot tiller of the soil swears vengeance.

"Marx describes the brutal subjection of the American and other aborigines; Gellert draws a full-sized Christ on a cross!" Is that all? Miss Brenner would do well to look again. I wish I could reprint that picture. It shows a sword. On its hilt a crucified human. The sword's point drips with blood. The implication—Christian colonial expansion at the point of the sword.

We who "wear the uniform of Stalin's Red Army" cannot hope for competent criticism from a Trotzkyite. But is accurate and reliable reporting too much to expect? Miss Brenner, who juggles words so glibly about "science—comprehension and mastery of historical, sociological, and psychological principles," can neither hear nor see straight! The ultra-revolutionary palaver of a lady writer of *The New York Times* coupling me with Rivera "with one foot on the other side of the barricades," is too absurd for consideration.

New York, July 2 HUGO GELLERT

Heywood Broun was a columnist for The Nation, *the* New York World, *and* The New Republic. *He organized the American Newspaper Guild in 1933 and was its first president.*

—

Broun's Page

March 4, 1936

Heywood Broun

THEY HELD A Congress of Artists in New York a few days ago and it started with a lot of speeches in Town Hall. I made one of them. Of course, I got into an Artists' Congress merely as a fellow-traveler. They told me to talk about the possibility of painters coming together along trade-union lines.

Now the detail of that might present many difficulties, and yet it seems to me that art in America must go left or continue to stand and dwindle resolutely in the same spot. This is said all the more sincerely because it is in part an apology. I wrote a column in a newspaper announcing in that dogmatic way which newspaper columnists assume that there had never been a painter of any consequence in America, and that in all probability there never would be.

It just doesn't seem to be a natural form of expression north of the Rio Grande. But once you get into Mexico you see some old Indian who never took a lesson in his life or read a single article by Royal Cortissoz hammering away at silver and sticking in turquoise at appropriate places in a most magnificent manner. Even when the blanket he wants to sell you is a fake, he had at least the artistic sense to buy the best the chain store had to offer. And once you get to a Mexican public building which has a blank wall to offer, you will find a dozen masters struggling to express themselves in color. There are at least three Mexican painters who do not need to doff their hats to any of the dead.

But I am informed, and probably correctly, that this surge of form and color across the border is not justly attributed to native genius alone. It is a response, an artistic liberation, which comes out of the very economic fermentation of Mexico. The worker has begun to get some sense of his own world beneath his feet. And so it would be here, once the ice jam broke. One log leaps free and the rest begin to dance.

Yes, I think that's true because painting has been fed in America upon a wine which is rare and also watery. The vintage is called taste. It has been accepted as valuable merely because there has

been so little of it. Sometimes it is accompanied by emotion, but mostly not. Mr. Morgan the elder used to buy old masters in wholesale lots. The younger head of the house seemed to have aesthetic yearnings when he was investigated in Washington. But they may have been lightly rooted. The reigning Mr. Morgan does not necessarily become a poet because he spoke of the color of the heather in Scotland. Nor should he be elevated to the ranks of critics on the mere strength of the fact that he has from time to time bought a picture.

It would be silly, I'll admit, to contend that all the products of what Upton Sinclair called "Mammon Art" are necessarily bad. Under the patronage of the church there did emerge some men of genius. But even the church had a much broader base than a little group of private collectors. The successful sculptor or painter today must land one or two big fish or perish. And if he does land them he will probably perish spiritually in any case. Nobody can do a good job if he carries constantly with him the idea, "This must be the sort of picture that Mrs. Beamish likes or Junior won't be able to get to college next year."

I am aware that there are portrait painters who pretend a great arrogance to their prospective sitters. They will boast of the manner in which they turned down a commission or left a job in the middle because the lady of the house endeavored to get hoity-toity. Such things have happened, but they are not the rule. When a successful painter takes up his kit of tools and goes home in a high dudgeon it is not the tallest tower which he quits but one of the lesser mansions standing well below the great white house on the hill.

If we are to have better painters we must have better audiences and much bigger ones. There will have to be a contact between those capable of feeling excitement and those capable of creating it. To be specific, I think it would be an excellent idea if the United Mine Workers of America gave a prize at their convention two years hence for the best painting of a mine or miners. The prize could be any kind of laurel you please. I honestly thing that sort of award might well be the proudest possession a painter could win.

It may be argued that as a rule trade-union members have not had the chance to study art forms, and that they wouldn't be interested. The study of art forms does not seem to me a necessary background, and whenever you get seventeen hundred up-and-coming men gathered together you have a reservoir of emotion which makes the taste of one or two connoisseurs seem pretty fragile. A roar of welcome from seventeen hundred workers ought to put more en-

ergy back into the marrow of any painter than a well-modulated "interesting color" dropped over his right shoulder.

Painting must be about something. It must be done by people who are hot and burning and very much bothered. You can't get art from contented cows, and you can't even give it to an equally bovine audience. Of course the same thing is true of writing and acting. No theater of any consequence can be built upon audiences which don't care much one way or the other about anything. Naturally I am not contending that everything which goes under the name of "proletarian art" is good. Some of it is terrible. But it is the beginning of wisdom. Even in the lesser crafts this is true. I'm getting a little bit tired of having people say to me, "You do your best columns when you're mad." The answer is, "Who doesn't?" In a burning world anybody who has any pretensions to any kind of artistic expression must make his choice. He can be either a fireman or a fiddler.

—

ART UNDER THE SWASTIKA

OCTOBER 2, 1937

Elizabeth Berry

DEAR SIRS: In Munich I visited the exhibition of "degenerate" art. It is very comprehensive and instructive but cluttered with a lot of filth. The pictures are hung barbarously—against the light and in very narrow rooms. Inscriptions are everywhere, and red signs read, "Paid for by the tax pennies of German workers." Scrawled with chalk on the frames is the place each picture came from. The sculptures are covered with dust and fingerprints. Lehmbruck's Kneeling Woman has been broken in the middle and at the feet and carelessly fastened together.

If you overlook such barbarities, which isn't easy, the exhibition is magnificent. You can see almost everything of importance that has been done in the last thirty years. People crowd through the entrance in an uninterrupted stream. I heard a few laughing and making silly comments, but the majority were serious and impressed, and angered by the conditions.

What is to be seen there? Nolde, Otto Muller, Kirchner, Heckel— each with some fifteen or twenty pictures. Magical Klees, the finest Kokoschkas, late Corinths, each more beautiful than the other. "The

Blue Horses" and some others of Franz Marc's, Campendonck's Sindelsdorf, Schmidt-Rottluff, Rohlfs, Belling, Archipenko, Kandinsky, Baumeister, Schlemmer, George Grosz, Dix, Gies's "Christ" (barbarously hung in front of a glaring red curtain), wonderful Feiningers— I need not go on. Everybody of importance is there; only Macke, curiously enough, was not represented. One room was closed, and I was told that the Munich artists hung there—Schrimpf, Caspar, and the others. If the arrangements weren't so shameful, if things were properly displayed, the exhibition would be of bewildering beauty.

I should like to go again; there was so much to see. But you struggle in vain against the blinding light, and you can't step back from a picture because the rooms are so narrow. The sculptures are placed too low and the paintings are hung too high. Many of the pictures are those we have long held sacred. The last room especially, which happens to contain almost nothing but first-class things—among them the Lehmbruck—is like a sanctuary.

ELIZABETH BERRY

Paris, August 10

9

ALL SHOOK UP

During the early days of World War II, art writing in The Nation *was sporadic at best, with some notable exceptions.*

—

THE DEMUTH MEMORIAL SHOW

JANUARY 8, 1938

Paul Rosenfeld

THANKS ARE DUE the discoverers of the efficacy of insulin at the very least for one American force. This is the painter whose representations of the inner life of American things now adorn the walls of the Whitney Museum in New York. It is the late Charles Demuth.

As an artist, Demuth came into being but a few years, before he sickened dangerously with diabetes. A painter since his nineteenth year, at one time a pupil of Chase's, this shoot of old Pennsylvania Dutch families did not find himself before he was thirty. Around his thirtieth year, in 1912, he went to Paris. In New York he had seen Marin's water colors. In Paris he digested the new *fauve* and cubist

art, including that of Duchamp, author of the notorious "Nude De-
scending a Stairway." When the war drove him home, Demuth re-
turned with a few sensitive water colors. They were the first original
work of a man destined to become an important agent of American
self-consciousness. And during the next few years he commenced
developing his very personal art.

In point of form some of these subtle, in instances flowery, in
other instances geometrical little designs of the early Demuth might
be called *fauve*. Like Matisse's paintings, they are decorative arrange-
ments of the pictorial elements. Others of them might be called
cubistic, since they are compositions of the inherent straight and
curved lines and surfaces of the depicted objects—acrobatics,
peaked roofs, belfries, fruits and flowers—disposed on serried
planes. Still, there is nothing derivative in the formal details or in
the sums of these modest little pieces. All have a peculiarly American
elegance, an elegance now jazzy and now refined. Again, they might
be charged with a certain preciousness. There is no doubt that their
tendril-like or ruled lines, their somewhat pink-and-blue color har-
monies, their shapes and total forms, are excessively refined. Unlike
Marin's free-running wash, Demuth's almost equally luminous one
was scrupulously wiped and blotted. But there is nothing false, ane-
mic, or merely ornamental in this exquisiteness, any more than
there is anything derivative in the conceptions. Structural details and
sums have vital qualities which make the beholder comprehend cer-
tain of the essences which give American existence its peculiar
graces. Through the arch, half-ironic designs suggested to the artist
by vaudeville stunts, circus acrobatics, jazz-band acts, and the night
life of the streets, he comes into touch with the nervous alacrity, the
devil-may-care momentum, the half-vulgar erotic flush which creates
Broadway, that lane running from New York through the continent
unto Alaska. Through the soberer ones suggested by the contents
of gardens, the sea-light of Gloucester and Bermuda, New England
and Pennsylvania dormered roofs and church towers, he faces the
shy, puritanical, almost unadjustable sensitivity which underlies
other, finer, but equally American expressions. And through the
series inspired by the concrete and iron shapes of the industrial
world, there speaks to him the mysteriously precise spirit, the phys-
ical accuracy, the almost mechanical sensibility, which makes Amer-
icans supremely able machinists and technicians.

Indeed, a deal of the scope of Demuth's feeling was already in-
telligible from this work of the years anterior to his crisis. Yet had
he died at thirty-six, as in the Armistice year it appeared that he
must do, we should be the poorer for an important force. Certainly,

he had discovered his form. The general range of his themes, including the subjects of Zola's and Henry James's novels, had indeed defined itself. A few paintings in tempera and oil had evinced his endowment with gifts for mediums other than water color. Still, in comparison with the feeling which projects itself in his later work, that of his "first period" is relatively superficial and thin. It is no more than an exquisite and affecting minor artist's. Only a few of the strong, high-pitched Bermudan landscapes declare the dawning mastery.

But Demuth lived on for upward of fifteen years. During the war the value of insulin had come to light. Reprieved, almost as much a well man as he had ever been, and he had always been somewhat an invalid, Demuth once again hobbled sociably through the world—as ever very lively and spick-and-span—and in his native Lancaster enjoyed his mother's excellent cookery, and resumed his work. The old humor and impishness reappeared in it. Only, the feeling had deepened. Had death, in touching Demuth, rendered him clairvoyant? Or had he merely attained his normal maturity? We only know that during those last years his pictorial form grew very full. The intricate, partially overlapping washes in his water colors achieved the amazing bloom and depth of tone which give so many of his still-lifes a crystal-like luster. The line, which had sometimes got tangled in his earlier work, became certain and clear. With their beautifully synthesized gross and flowerlike shapes, his designs became broad. The color harmonies were strong, opposing and combining pearly tints with homely magentas, purples, the tones of aniline dyes, and with rare and sumptuous whites. They have been compared, these later lyrical water colors of Demuth's, to immortelles: because of their wax-like immaculateness and "studied" look. A comparison to Indian pipes, the chaste and fictile pine-saps of the American woods, might seem more justifiable. They have the small plant's crispness and translucency, and their roots in humid earth. And a dignity put in its appearance in the large late temperas and oils, with their Christopher-Wren-like shapes and Vermeer-like surfaces. The designs approached monumentality; the harmonies of blues, silvers, and whites, or of dusky reds and grays, a rare profundity. Only in certain of the late posterish designs, where Demuth used the forms of machine-cut block-letters, directive arrows, and other commercial products symbolically, did the inevitable cast its first shadow in the form of a noticeable attenuation.

But his feeling of life had fully been transmitted. Suddenly, as we stand among his later paintings, from one of them there reaches us the peculiar American snap. The communicative medium is a bright

little "cubistic" pattern suggested to the painter by a display of striped and colored shirtings in a haberdasher's window. Instantly our mental eye perceives holiday-making young bucks en route to summer beaches. Even more than their appearances, we comprehend the common inner smartness. And one by one the other late pictures similarly unite us with other American forces; so drenched are they with the quality of the graceful driving powers central to the American being, not only of the past and Demuth's own prosperous epoch, but of the present and for all we know the time to come. Most frequently, like their forerunners among the earlier pieces, although with greater intensity, these works harmonize us with the inner tension which expresses itself in the American's perennially shapely, attractive appearance and love of shapeliness for its own sake. It is the parent of phenomena apparently as various and unrelated as physical style, athletic hardness, and the preference for gemmy, clean-cut contours, and, *mirabile dictu*, the extraordinary plasticity of the output of literary representatives as remote in time from one another as Hawthorne, Henry James, and Ezra Pound. In other instances his pictures connect us with the equally undying puritanical refinement verging upon morbidity and rejecting the flesh in the interests of a perfection impossible in life, possible only in death. In still others, and perhaps the most affecting, they relate us to the power—the artist's and the devoted workman's both— which carries certain of our people above personal ends, and sets them like bell-towers amid prismatic light, or sturdily erect with others of their kind like chimneys in all sorts of weather. We call this power faith in light and love.

Thus Demuth stands among the giant clan. Other artists possibly have given America a wider consciousness of its internal self than he has done. But he has beautifully added to and deepened our self-knowledge. As we quit exhibitions of his work such as his memorial show, we seem to see him standing in the general landscape in the form of one of his own church or factory turrets in blue and in gray weather: shapely, tall, serene, among the high agents of communal life.

—

Art Note

OCTOBER 22, 1938

Margaret Marshall

IN HER BOOK on Charles Sheeler, Constance Rourke discusses the sense of craftsmanship as one of the main lines in the American tradition and poses the problem of maintaining it in a nation which has turned so whole-heartedly from handicrafts to the machine. It is a genuine problem. Yet one wonders whether a nation so thoroughly conditioned to skill—travel through unskilled Russia if you would discover how deep that conditioning is—can ever really lose the sense of craftsmanship; whether the concept of precision, so deeply ingrained, which shows itself alike in the precision dancers at Radio City and the latest machine tools, will not somehow continue to assert itself. The recent exhibition at Julien Levy's gallery of the water colors used in the production of Walt Disney's "Snow White" suggests that it will. The delicacy and exquisite precision of these drawings of ephemeral though charming subjects set one to inquiring hopefully what these unknown workers in Walt Disney's cartoon factory paint in their spare time and suggest that at least in one corner of Hollywood the craftsmanship of the artisan persists. For complete contrast Mr. Levy displayed in a room next to the Disney show a collection of Gracie Allen's "surrealistic" drawings whose utter innocence of craftsmanship added to their comic effect. They were exhibited with a small admission charge for the benefit of the suffering Chinese, which lent an additional "surrealistic" touch. Aside from that I suspect Mr. Levy was also telling certain expert craftsmen among our artists that the mere surprise jumbling of objects, however well drawn, comes no closer to being genuine surrealism than Gracie Allen's effusions. He is planning to continue his course in November with an exhibit of surrealist paintings by Frieda Rivera, wife of Diego. My own curiosity about surrealism exceeds my understanding of it. Let it be said to those in similar case that judging from a limited preview of a few examples of Mrs. Rivera's work, the November exhibition promises to be both instructive and intensely interesting.

At the time Stuart Davis wrote the following response to a critique of the art exhibition at the 1939 World's Fair, he was already becoming a major figure in American modernism. Davis, chairman of the American Artists Congress, had been a contributor to The Masses *and had worked for the WPA Federal Arts Project since 1935.*

—

Art at the Fair

July 22, 1939

Stuart Davis

Dear Sirs: "American Art at the Fair," an article by Christopher Lazare which appeared in your issue of July 1, bears no relation to the facts. As an active participant in all the activities connected with the exhibition, "American Art Today," at the New York World's Fair, I believe I am qualified to give your readers some further comment more nearly in accord with reality.

Mr. Lazare states that the exhibit "violates all the boundaries of judgment and taste," and he says "The reason for this failure is not to be ascribed to the artists but to the judges—and their shockingly chauvinistic emphasis on specific national characteristics." He puts the word democratic in quotation marks when he refers to the exhibit, and speaks of the successful esthetic coherence of the Fair itself in contrast to the "inglorious geographic compendium," as he terms the work of more than 1,000 American artists in this show. He calls their work "canceled tidbits of esthetic slang," complains that they do not speak a universal idiom, and finds the judges of the exhibit responsible for these shortcomings because they have followed criteria the emphasis on which "is the next best thing to fascist censorship of art." He closes by saying that Mr. Whalen was correct in the first place in holding that there was no need for an exhibition of fine arts at the Fair.

The exhibit at the Fair exists because the artists of America asked for it, fought to get it, and won it. It is the most *representative* show of contemporary American art ever held, and it has exerted a powerful unifying force in artists' organizations. It was democratically organized and selected and it stands in the field of art as an historical monument to democratic principles.

When the Artists Coordination Committee, under the chairmanship of Hugo Gellert, first asked for an exhibition of art at the Fair two

years ago, their request was flatly refused. But after repeated efforts meetings were arranged with representatives of the Fair's Board of Design. The Board held out against the show, but the artists were determined, and at last the press took up the fight. Mayor La Guardia added his support to them and the fight was won. Conger Goodyear, then president of the Museum of Modern Art, was appointed by Mr. Whalen to form a committee to organize the show, and the people he chose represented all the elements which had carried on the struggle for the exhibition. Holger Cahill, national director of the Federal Arts Project, was retained as director of the exhibit, and he brought to his job an unequalled firsthand knowledge of the work of living American artists.

The committee decided to hold a national exhibition of work by living American artists, which would be entirely selected by the artists themselves. There were no exceptions to this rule, and all non-artists involved in the organization acted in an advisory capacity only and had no vote. Over eighty juries of artists were set up covering every section of the United States, and every artist in the country was eligible to submit work to these juries. Every jury was balanced by the inclusion of conservative, middle-of-the-road, and modern representatives. Quotas for work were established relative to the artist population of the various regions, and the date of meeting of the juries was widely publicized.

Mr. Lazare knows all this because he refers to the foreword in the catalogue in which these facts are cited, but he nevertheless terms the organizational set-up "chauvinistic" and compares it to "fascist censorship of art." As this comparison doesn't make sense, I think it entirely proper to call Mr. Lazare's article nonsense, and since it was done with knowledge of the facts at hand I should say it was vicious nonsense.

When this strangely democratic "fascist" organization went into action it functioned smoothly. The juries selected work, not reputations. No school or tendency in art was discriminated against, and the quality of the accepted work represents the best of the thousands of works submitted to the juries. I am certain that no other country in the world today can put on a comparable show. It proves that we have a strong and healthy art in the United States today with roots in all parts of the country.

Mr. Lazare's approval of the original stand of the Fair against any art exhibition at all is not "the next best thing to fascist censorship of art," but rather the next thing beyond fascist censorship of art, since it involves complete eradication of art expression.

<div align="right">STUART DAVIS</div>

New York, July 10

Minna Lederman was the editor of the highly influential journal
Modern Music *and a founder of the League of Composers. She wrote*
extensively about music and was a contributor to Saturday Review
and American Mercury.

—

FRANCE'S TURNCOAT ARTISTS

AUGUST 29, 1942

Minna Lederman

SOME WEEKS AGO the *New York Times* ran a picture of Mistinguette,
Parisian music-hall star of lo these many years, taken arm-in-arm with
Georges Carpentier and Max Schmeling. Giving her Nazi compan-
ion the glad eye and a toothy smile, she was valiantly making pub-
licity for Franco-German *Kultur*. As a scene in conquered territory
it was brutally effective. As a symbol of the new cultural tie it was an
understatement, since that front now extends far beyond the level
of the night club and the sports arena. When distinguished men of
arts and letters lend their prestige to the New Order, "collaboration"
assumes a more profound dimension, and Paris, to whose great
traditions all the Western world is in debt, takes on the aspect of a
city captive not only in body but in heart and mind as well.

The recent visit to Germany of several well-known French painters
and sculptors has by its very irony been an extraordinary tribute to
Hitler. During the furious years of the war on *Kulturbolschevismus*,
the School of Paris was one of his favorite whipping boys. Cubism,
surrealism, even impressionism were branded as "excrescences of
lunatics or degenerates." In 1938, after the Munich show of "deca-
dent art," the canvases of Picasso, Van Gogh, Matisse, Laurencin,
Gris, Braque, Derain, Vlaminck, even Pissarro, Gaugin, and Cézanne
were stripped from the German museums. But when Hitler beck-
oned, only a few months ago, five painters—André Derain, Maurice
de Vlaminck, Dunoyer de Segonzac, Kees van Dongen (Dutch by
birth but French by long residence), and Othon Friesz—and the
famous sculptor Charles Despiau, left Paris to make a specially con-
ducted *Studienreise* through the Third Reich. Unmentioned of
course was the expulsion of works by Vlaminck and Derain (Derain's
Valley of the Lot at Vers was salvaged in 1939 by New York's Museum
of Modern Art). After visiting a number of cities, the group wound

up in Berlin and posed for pictures to be distributed all over Europe with captions about Franco-German cultural ties.

Not more than six weeks old is a letter from Banyuls, in southern France, which reports the departure for Paris by the sculptor Aristide Maillol, on the first leg of a similar journey to Berlin. Maillol is of course no modern; his serene "healthy" nudes have long been popular in the Reich. But since he is now over eighty and has been living and working peacefully in his own home in the comparative security of the unoccupied region, news of his decision comes as a shock.

Shortly before the tour of the French artists, the Germans staged a traveling musical show. Composer Florent Schmitt, his seventy-two years giving him the prestige of a dean, and two Swiss musicians whose careers are closely associated with France—Arthur Honegger, composer of the Group of Six, and Robert Bernard, editor of the new, German-authorized, Parisian review *L'Information Musicale*—led a body of respectable publishers and academy chiefs to a Mozart festival in Vienna, where they were welcomed as guests of Richard Strauss at a grand reception in honor, again, of Franco-German cultural relations.

Collaboration, however, is not all parties and junkets. Long before the war, France had its own fascist intellectuals: Abel Bonnard, the essayist, Alphonse de Chateaubriant, whose *La Gerbe des Forces* saluted Hitler at the time of Munich, Jacques Chardonne, novelist and publisher, and Alfred Fabre-Luce. (For such figures there is no counterpart either in the United States, where the openly fascist press is demagogic and illiterate, or in Britain where, if more aristocratic, it has been exclusively political.) Convinced, didactic, learned, elegant, these Frenchmen now dominate the Parisian world of letters. Around them and Drieu la Rochelle, who has transformed the once great *Nouvelle Revue Française* into a medium for every dubious and reactionary opinion, revolve all the lesser writers whose sympathies have long been suspect, and many an aspiring new careerist who sees a future where none was offered before. As leaders, they supply the spinal column to a policy that might otherwise be purely opportunist and fluid. They give the New Order its Parisian accent.

The Germans, too, make a major contribution to this front. They have rigged up a stage-set of "Paris-as-usual" in the midst of a France despoiled by war which is a triumph of Nazi advertising techniques. Forty houses of the *haute couture* are now subsidized so that they may operate freely, unrestrained by the drastic textile rations imposed elsewhere. This supplies the necessary "tone" for visiting Nazi big-

wigs, and for the local bankers and big motor and steel men, collaborationists from way back. Hostesses for the Franco-German set are easily flushed from cover. The Marquise de Polignac (of the champagne family that once employed Ribbentrop) and the Comtesse de Noailles have reopened their salons. Heavy culture jobs are awarded to discreet scholars and artists. The distinguished painter, Georges Braque, becomes director of Les Gobelins. The opera, going full blast, enjoys the enthusiastic services of the French Wagnerian star, Germaine Lubin, whose Mercedes limousines are conspicuous on the not very crowded boulevards. Serge Lifar, Diaghilev's famous legacy to the ballet, is once more packing them in. The pianist Henri Février plays for the troops of occupation. Government-regulated bookshops display the novels of Louis Ferdinand Céline in gaudy covers. Glamor girls and glamor boys are all over the place, when they are not in Berlin: Corinne Ludhaire, daughter of the newly-made publisher and already the past *amie* of the Nazi ambassador, Otto Abetz; Danielle Darrieux (once of Hollywood), Yvonne Printemps, Sascha Guitry, Pierre Fresnay, Raimu (of "The Baker's Wife"). Harry Bauer who accepted an invitation to Berlin was imprisoned there on discovery of his non-Aryan ancestry; Maurice Chevalier, not a collaborationist but ardent for Pétain, at last report, refused to go and now confines his tours to unoccupied France. And with a poetic sense of timing, Jean Cocteau, perennial Ward McAllister of Paris social-artistic life, bobs up again, a piece of Chateaubriant's new magazine *La Gerbe* in one hand and in the other the key to his old night club, Le Boeuf sur le Toit.

Paris even has Picasso, which is perhaps Hitler's shrewdest touch. By every expectation Picasso should have been turned over to Franco with other Spanish anti-fascists caught in France after the Civil War. His political sympathies are irrevocably on record in the mural, "Guernica," which is a piece of surrealism to boot. But as a prisoner of war Picasso would be an international embarrassment both to Spain and Germany. Living unmolested in the French capital, on the other hand, he is a demonstration to all the world of the new Nazi tolerance and sophistication. Thus he visits his old cafés, is courted by Abetz himself, and sees his pictures going, at prices fabulously beyond their pre-war level, to the new German "tourists" who buy French paintings as an investment against possible inflation at home.

"The season is excellent," wrote Georges Auric, a composer of Cocteau's circle, in last year's *Nouvelle Revue Française.* His only regret was the monotony of musical programs, the absence of new works. But, as the emigré composer, Arthur Lourié, pointed out, since that

complaint has been fashionable for many a year, "one gets the impression that 'nothing' has happened except that the Germans are there!"

This noisy parody of yesterday's world is of course no faithful mirror of contemporary French culture. It does not even reflect Vichy's contribution to the New Order. Grouped around Pétain, whose "official" magazine is appropriately the ancient *Revue des Deux Mondes*, are Academicians like André Chaumeix and Henri Bordeaux, the famous pianist Alfred Cortot, now attached to the Department of Education—not one of them a day under sixty-five— and Henri Massis, of the *Revue Universelle*. Vichy is more "correct" than Paris (unlike Février, for instance, Cortot will not play for the German army) and on the whole far duller; the volatile novelist Paul Morand and some of the younger men attached to Radio Vichy— Hugues Panassié (of *Le Jazz Hot*) and a few members of La Jeune France are rare exceptions.

Many of the most impressive of France's intellectual leaders live outside the orbit of the capital and have drawn away from Vichy. André Gide on the Riviera conducts a subtle rear-guard action against Paris. Paul Valéry is philosophically remote at Montpellier. Paul Claudel, no lover of the pre-war order, after paying his respects to Pétain, has publicly protested some of Vichy's more fascist decrees and retired to live at Brangues (Isère). André Malraux, at work on a new novel, remains obscurely in the south, and so too does Louis Aragon, whose poetry is now being translated and published in the United States. Francis Poulenc, another composer of Les Six, lives and works in Marseilles. Henri Matisse, Pierre Bonnard, and Raoul Dufy continue to paint in the unoccupied zone, despite the prevailing shortage of pigment and canvas. Under the conditions of military conquest, most of these men have been rendered politically inarticulate. Even more effectively silenced are two brilliant writers in the occupied region—Georges Duhamel and Francis Mauriac.

In America the number of famous personages coming from France grows steadily larger. Musicians here now include the composers Igor Stravinsky and Darius Milhaud and the great harpsichordist Wanda Landowska. Among the writers are the Catholic leader Jacques Maritain, the surrealist poet André Breton, the novelists Jules Romains, Antoine de Saint-Exupéry, André Maurois, and the playwright Henri Bernstein. The artists include Fernand Léger, Yves Tanguy, Ossip Zadkine, André Masson, Marc Chagall, Pavel Tchelichew, Eugène Berman, Marcel Duchamps, and the sculptor Jacques Lipchitz. Among the cinema lights are the directors René

Clair, Jean Renoir, Jean Benoit-Lévy, and Henry Diamant-Berger, and the actors Michèle Morgan and Jean Gabin. There is also the emigré press, notably Geneviève Tabouis's paper *Pour La Victoire*, for which the ex-deputy, Henri de Kerillis writes his weekly political essay, and *La Voix de France*, of which Henri Torres, the famous lawyer, has just been made editor. In Buenos Aires, Roger Caillois has founded a magazine-in-exile, *Lettres Françaises*. (Jean Paulhan, former editor of the N.R.F., was imprisoned by Abetz after the armistice and is now marooned in Paris.)

This is an impressive assembly of the great, the near great, the talented, the skilful. But it is in no sense a fighting front coordinated in opposition to the Franco-German line. For almost ten years artists and intellectuals in exile have borne witness against fascist doctrine, their very presence being in itself a powerful indictment. But the enormous prestige of distinguished Frenchmen living beyond their own borders has not yet been fully exploited against the order that excludes them.

America and, to some extent, Britain have greatly underestimated the influence of such figures in the strategy of psychological warfare. The Germans, on the contrary, have shown complete mastery in manipulating this power. All up and down Europe, in conquered and even in enemy territory, they have felt out the soft spots. Though the Netherlands government is in exile, Willem Mengelberg makes regular visits to Germany, conducts orchestras in Berlin and Munich, takes part in political conferences. Kirsten Flagstad, leaving America after many years to rejoin her husband, now a member of Quisling's government in Oslo, is routed through Germany by the helpful Nazis, and stops off in Berlin to make a widely broadcast speech of appreciation. P.G. Wodehouse, a prisoner of war, finds himself at the Adlon and obligingly goes on the air to tell millions in Britain and America how comfortable is life in a German hotel.

To these artistic-political maneuvers American reaction has been curiously antipathetic. Stories about European artists who play the Nazi game, even those with a large popular following here, are inadequately treated in the press. There is a tendency to write off the political activities of celebrities as casual and irresponsible, something it is more sporting to forget than to remember. Public opinion, however, can be aroused in this field as in any other. It can be made articulate and conveyed as a warning, by radio, underground press, or any other of our elaborate propaganda mechanisms. A campaign to enlighten France, traditionally sensitive to American reaction—and to the American market—would have its own realism. Even in Paris today, among men of arts and

letters, there must be many not yet completely indifferent to their prestige beyond the German sphere of Europe, and not without some concern for their "historical position." To reach the mind of France is an effort worth making for more than immediate reasons. The obliteration of Paris as a focal center of culture and humane civilization would be an irreparable loss, not only to France but to the whole post-war world.

In 1942, after Clement Greenberg left Partisan Review, *he became* The Nation's *art critic, a position he held until 1949. His writing during those seven years is now legendary, as he championed not only individual artists but entire art movements. Greenberg's writings were instrumental in bringing Abstract Expressionism and Colorfield Painting into prominence, and he had an enormous influence on subsequent critics and art historians. Few other critics can claim the impact that Greenberg had on his times.*

—

"NEW YORK BOOGIE WOOGIE"

OCTOBER 9, 1943

Clement Greenberg

SOMETHING OF THE harmony of the original white square of canvas should be restored in the finished painting. But harmony a thousand times more intense, because it is the result of the successful resolution of a difficult struggle. The simplest way almost of accounting for a great work of art is to say that it is a thing possessing simultaneously the maximum of diversity and the maximum of unity possible to that diversity For lack of the first the new painting by Mondrian called "New York Boogie Woogie," now on view at the Museum of Modern Art with several other new acquisitions, is, for all its sudden originality, something a little less than a masterpiece. The checkered lines of orange squares produce a staccato rhythm— signifying jazz—too easily contained by the square pattern and white ground of the picture. At hardly any point does the rhythm threaten to break out of and unbalance this pattern enough to justify the latter's final triumph. There is resolution, but of an easy struggle.

"New York Boogie Woogie" is a radical step forward in Mondrian's evolution, which since his arrival in this country and to this point has been concerned mainly with the widening of his color

spectrum. Now not only have new and for the first time slightly impure colors been introduced, but the hitherto immutable elements of Mondrian's space composition have begun to break up: the straight black, almost incised, lines into parti-colored chains of squares, and the great dominating rectangles into smaller rectangles and squares of contrasting colors. The artist has not yet possessed himself fully of these new configurations, not yet rendered them controllable to his total purpose, but the gamble is well worth taking. Unless the artist die to the successes of his old work he cannot live in his new. Repetition is death. One more thing: the picture at hand suffers from the absence of that very neat and precise mechanical execution that used always to characterize a Mondrian painting. It is either a failure of manual dexterity, a deliberate effort to be a little more fluid, or simply the impression left by the weak yellow and the purple that appear in a Mondrian painting for almost the first time. The picture has a floating, wavering, somehow awkward quality; the color wanders off in directions that I am sure belie the artist's intent. Yet "New York Boogie Woogie" is a remarkable accomplishment, a failure worthy only of a great artist, and its acquisition was more than justified; it was mandatory.

Of the other acquisitions the Matta painting is slightly untypical, has an almost valid surface charm, and is certainly better than those indescent burlesque-house decorations, style of 1930, he usually paints, which are little more, really, than the comic strips of abstract art. Again, the painting by Masson is one of his better recent ones: turgid and dense, the tone hot but subdued. It has, however, an unpleasant pretentiousness about it. I don't think Masson will ever again turn out work comparable to that he did in the twenties.

The presence of the picture by the Mexican Tamayo evidences, along with that of the Matta and Masson, the extreme sensitivity of the museum to trade winds on Fifty-seventh Street. The museum shows taste in that when it buys the work of inferior artists it at least chooses their best work—untrue here only in the case of Tamayo— but this does not atone for its masochistic fondness for the social and other epigones of the School of Paris.

—

ART NOTE

OCTOBER 16, 1943

Clement Greenberg

MY MEMORY PLAYED tricks when I discussed last week the new Mondrian at the Museum of Modern Art. The painting has no orange, purple, or impure colors. Seeing it again, I discovered that it was the gray which Mondrian uses here in a new way for him that made me remember his scarlet and two shades of blue as purple and impure, and the yellow as orange. But I have the feeling that this after-effect legitimately belongs to one's first sight of the painting. The picture improves tremendously on a second view, and perhaps after an aging of six months or so it will seem completely successful.

—

CHAGALL, FEININGER, AND POLLOCK

NOVEMBER 27, 1943

Clement Greenberg

CHAGALL'S ART TURNS from the main stream of ambitious contemporary painting to follow its own path. It is pungent, at times powerful, but opens up no vistas beyond itself. Chagall's position, curiously enough, resembles that of Odilon Redon in the late nineteenth century. The present exhibition, composed entirely of work done in 1943, indicates a crisis in the painter's career. He is no longer mellowing in Paris; he is being challenged by events and by the imperatives of his artistic development. The soft, blandishing French tones, the harmonic suffusions, that have characterized his painting in the last fifteen years or more—never enough, however, to submerge his native robustness—are on the way out. Returned is something of the flatter, less tonal brushwork of his earlier period, its harshness too, but all much less crude, being modulated by everything Chagall has since discovered about the orchestration of frank colors. A new yellow plays a role, along with more ambitious or more surrealist subject matter—crucifixions and monsters. Usually when

an artist exhausts one phase it takes time and error to assimilate the next. Chagall's two or three new major efforts—major in size and pretension—abound in patches of interesting painting, but none is fused into a complete and organic work of art. The variables of defined form are not related with sufficient visual logic to the murky, indeterminate *fond* that is the constant against which they appear. Yet lack of success in the new is worth any number of successful repetitions of the old. The most achieved picture at the show, the gouache "La Nuit se mêle au jour," happens to repeat Chagall's previous success with royal blue. I would gladly trade it—considerations of size and effort being irrelevant—for the large and unresolved "Crucifixion" with its yellowish malaise.

The Feininger exhibition covers the artist's work from 1911 to 1938. What began as a German marriage of expressionism with cubism evolved after 1915 into a province of Paul Klee's art. Until then Feininger's heavy and obtuse color oppressed his more genuine talent as a draftsman. Klee's influence seems to have lightened and thinned his color and perhaps made him realize that his eyes—like Marin's—conceived instinctively in darks and lights. The best pictures are those altogether in black and white and gray, as the pen-and-ink wash "Feininger am Kal," or those in which the palette is narrowest, such as the water color "The Barque," with its mere black, sky blue, lavender, and white. Feininger always paints with honesty and grace. He is not important in a large sense, but he has a very definite and secure place in contemporary painting.

There are both surprise and fulfilment in Jackson Pollock's not so abstract abstractions. He is the first painter I know of to have got something positive from the muddiness of color that so profoundly characterizes a great deal of American painting. It is the equivalent, even if in a negative, helpless way, of that American chiaroscuro which dominated Melville, Hawthorne, Poe, and has been best translated into painting by Blakelock and Ryder. The mud abounds in Pollock's larger works, and these, though the least consummated, are his most original and ambitious. Being young and full of energy, he takes orders he can't fill. In the large, audacious "Guardians of the Secret" he struggles between two slabs of inscribed mud (Pollock almost always *inscribes* his purer colors); and space tautens but does not burst into a picture; nor is the mud quite transmuted. Both this painting and "Male and Female" (Pollock's titles are pretentious) zigzags between the intensity of the easel picture and the blandness of the mural. The smaller works are much more conclusive: the smallest one of all, "Conflict," and "Wounded Animal," with its chalky incrustation, are among the strongest abstract paintings I

have yet seen by an American. Here Pollock's force has just the right amount of space to expand in; whereas in larger format he spends himself in too many directions at once. Pollock has gone through the influences of Miró, Picasso, Mexican painting, and what not, and has come out on the other side at the age of thirty-one, painting mostly with his own brush. In his search for style he is liable to relapse into an influence, but if the times are propitious, it won't be for long.

—

MIRO AND MASSON

May 20, 1944

Clement Greenberg

MIRO BELONGS AMONG the living masters. He is the one new figure since the last war to have contributed importantly to the great painting tradition of our day—that which runs from Cézanne through fauvism and cubism. During the last ten years his work has maintained a very high level with a consistency neither Picasso nor Mondrian has equaled. The adjectives usually applied to Miró's art are "amusing," "playful," and so forth. But they are not quite fair. Painting as great as his transcends and fuses every particular emotion; it is as heroic or tragic as it is comic. Certainly there is a mood specific to it, a playfulness which evinces the fact that Miró is comparatively happy within the limitations of his medium, that he realizes himself completely within its dominion. But the effort he must exert to condense his sensations into pictures produces an effect to which playfulness itself is only a means. This is "pure painting" if there ever was any, conceived in terms of paint, thought through and realized in no other terms. That Miró's imagination is ignited by its contact with the anatomy of sex takes nothing away from the purity. In Picasso, who is indeed a more profound artist, we can sense a dissatisfaction with the resources of his medium; something beyond painting yearns to be expressed, something which color and line laid on a flat surface can never quite achieve. Miró, on the contrary, seeks the quintessential painting, is content to stay at the center of that exhilaration which is only felt in making marks and signs.

Picasso is more ambitious, more Promethean; he tries to reconcile great contradictions, to bend, mold, and lock forms into each other, to annihilate negative space by filling it with dense matter, and to

make the undeniable two-dimensionality of the canvas voluminous and heavy. Miró is satisfied simply to punctuate, enclose, and interpret the cheerful emptiness of the plane surface. Never has there been painting which stayed more strictly within the two dimensions, yet created so much variety and excitement of surface. With an exuberance like Klee's, Miró tries other textures besides canvas and paper—burlap, celotex, sandpaper—a kind of experimentation. Picasso usually finds irrelevant to his concerns. Picasso piles pigment on the surface; Miró sinks it in. Yet despite the restricted scope of his ambition, one or two of the large canvases which Miró executed around 1933 are in my opinion more powerful demonstrations—because more spontaneous and inevitable—than Picasso's "Guernica" mural. And Miró's smaller pictures frequently during the last five or six years before the war manifested greater conciseness and lucidity than anything produced by Picasso during the same period, except for his drawings and the "Femme endormie" of 1935, the "Femme assise au fauteuil," and the "Girl with Rooster" of 1938.

The present Miró exhibition (at the Matisse Gallery, through June 3) contains paintings done between 1934 and 1939, with one oil dating from 1927. Most of this work has not been seen in New York before, and it confirms, if it does not raise, Miró's standing.

André Masson has been an ambitious painter from the beginning, one who accepts and tries to solve the most difficult problems proposed by art in this age. Very little he has done is without interest; yet little so far seems capable of lasting. There is some lack in Masson of touch or "feel"—a lack dangerous to an artist who relies, or professes to rely, so much on automatism or pure spontaneity. A line either too Spencerian or too splintery weakens his drawings; an insistence upon multiplying and complicating planes, while combining two such color gamuts as violet-blue-green-yellow and brown-mauve-red-orange, renders his painting turgid, overheated, and discordant. Energy is dissipated in all directions.

Masson strains after that same *terribilità* which haunts Picasso, is obsessed by a similar nostalgia for the monstrous, the epically brutal, and the blasphemous. But being nostalgia, it has something too literary about it—too many gestures and too much forcing of color, texture, and symbol. The latest showing of Masson's oils and drawings (at the Rosenberg and Buchholz Galleries respectively, through May 20) does reveal a small advance, especially in two recent oils, "Pasiphae" and "Histoire de Thésée." In the first, black-brown, a dull red, and a mouldy yellow-green are unified into a whole that is cooler and more clarified than any of its parts, with a surface which

is alive but not restless. In the second, happily, almost everything except calligraphic line is eliminated. Self-control, elimination, and simplification would seem to be the solution for Masson. But not as these operations are exemplified by two paintings in a new style, which permit thin, curling lines to describe figures over diluted lavenders, mauves, pinks, and greens, arriving at a kind of fermented-sweet decoration. This is impoverishment, not simplification. But even here, possibilities can be glimpsed of better things. There is a chance Masson will surprise us all some day.

—

BAZIOTES AND MOTHERWELL

NOVEMBER 11, 1944

Clement Greenberg

ALL CREDIT IS due Peggy Guggenheim for her enterprise in presenting young and unrecognized artists at her Art of This Century gallery. But even more to her credit is her acumen. Two of the abstract painters she has recently introduced—Jackson Pollock and William Baziotes—reveal more than promise: on the strength of their first one-man shows they have already placed themselves among the six or seven best young painters we possess.

Baziotes, whose show closed last month, is unadulterated talent, natural painter and all painter. He issues in a single jet, deflected by nothing extraneous to painting. Two or three of his larger oils may become masterpieces in several years, once they stop disturbing us by their nervousness, by their unexampled color—off-shades in the intervals between red and blue, red and yellow, yellow and green, all depth, involution, and glow—and by their very originality. Baziotes's gouaches had their own proper quality, which is the intensity of their whites and higher colors. But many of his pictures were marred by his anxiety to resolve them; the necessity of clinching a picture dramatically, also the sheer love of elaboration, led him to force his invention and inject too many new and uncoordinated elements into the coda, so to speak. This coda was usually found near the upper left-hand corner of the canvas, where *shapes* would first appear, while the remainder of the surface would have been dealt with in terms of the division and texture of *area*, and asked to be resolved according to the same logic. Baziotes will become an emphatically good painter when he forces himself to let

his pictures "cook" untouched for months before finishing them. He already confronts us with big, substantial art, filled with the real emotion and the true sense of our time.

Robert Motherwell's first one-man show, also at Art of This Century (through November 11), makes Miss Guggenheim's gallery almost too much of a good thing. Motherwell is a more finished but less intense painter than Baziotes, less upsetting because more traditional and easier to take. One is Dionysian and the other Apollonian. Motherwell's water-color drawings are of an astonishing felicity and that felicity is of an astonishing uniformity. But it owes too much to Picasso, pours too directly from post-cubism. Only in his large oils and collages does Motherwell really lay his cards down. There his constant quality is an ungainliness, an insecurity of placing and drawing, which I prefer to the gracefulness of his water colors because it is through this very awkwardness that Motherwell makes his specific contribution. The big smoky collage "Joy of Living"— which seems to me to hint at the joy of danger and terror, of the threats to living—is not half as achieved as the perfect and Picasso-ish "Jeune Fille," yet it points Motherwell's only direction: that is, the direction he must go to realize his talent—of which he has plenty. Only let him stop watching himself, let him stop thinking instead of painting himself through. Let him find his personal "subject matter" and forget about the order of the day. But he has already done enough to make it no exaggeration to say that the future of American painting depends on what he, Baziotes, Pollock, and only a comparatively few others do from now on.

—

GORKY

MARCH 24, 1945

Clement Greenberg

ALTHOUGH TO MY knowledge Arshile Gorky is having his first one-man show (at Julien Levy's through March 31), he is by no means a fledgling painter. Examples of his work have in recent years appeared in many group exhibitions. From the first there has been no question about the level of his art, regardless of the varying quality of individual pictures; his painting early won a central position in the main stream flowing out of cubism and until recently stayed

close to the most important problems of contemporary painting in the high style.

The critical issue in Gorky's case was how much of the value of his work was intrinsic and how much symptomatic, evidential, educational. He has had trouble freeing himself from influences and asserting his own personality. Until a short while ago he struggled under the influences of Picasso and Miró. That he fell under such influences was ten years ago enough proof of his seriousness and alertness—but that he remained under them so long was disheartening. He became one of those artists who awaken perpetual hope the fulfilment of which is indefinitely postponed. Because Gorky remained so long a promising painter, the suspicion arose that he lacked independence and masculinity of character.

Last year his painting took a radically new turn that seems to bear this suspicion out. He broke his explicit allegiance to Picasso and Miró and replaced them with the earlier Kandinsky and—that prince of comic-strippers, Matta. Formerly he had adhered to the cubist and post-cubist convention of flat, profiled forms and flat textures—the convention within which the main current more or less of high painting since Seurat and Cézanne has flowed. But now he changed suddenly to the prismatic, iridescent color and open forms of abstract, "biomorphic" surrealist painting. And these lately he has begun to cover with the liquid design and blurred, faintly three-dimensional shapes of Kandinsky's earlier abstract paintings.

This new turn does not of itself make Gorky's painting necessarily better or worse. But coming at this moment in the development of painting, it does make his work less serious and less powerful and emphasizes the dependent nature of his inspiration. For the problems involved in Kandinsky's earlier abstract paintings were solved by Kandinsky himself, while the problems of "biomorphism" were never really problems for modern painting, having been dealt with before impressionism and consigned since Odilon Redon to the academic basement. What this means is that Gorky has at last taken the easy way out—corrupted perhaps by the example of the worldly success of the imported surrealists and such neo-romantics as Tchelitchew. Certainly, his paintings register success within their own terms more consistently than before, but those terms are lower than they used to be. And certainly his art radiates more charm and has become much easier for the uninitiated to take. But it all goes hand in hand with the renunciation of ambition.

Yet perhaps Gorky was meant to be charming all along; perhaps this is his true self and true level; perhaps he should have pastured

his imagination in the surrealist meadow long before this; perhaps his "corruption" was inevitable.

And yet again, it is not quite that simple. For one thing: whether or not he is a first-rate artist, Gorky is definitely a first-rate painter, a master of the mechanics and cuisine. He does far, far more with the "biomorphism" of Matta *et al.* than they themselves can do. For another thing: Gorky still continues to show promise! The most recently executed picture at his show, called "They Will Take My Island"—black looping lines and transparent washes on a white ground—indicates a partial return to serious painting and shows Gorky for the first time as almost completely original. It is not a strong picture and still makes concessions to charm, but it is a genuine contemporary work of art.

The retrospective show of Wasily Kandinsky's work at the Museum of Non-Objective Painting (now the Guggenheim Museum)has been seen as a pivotal influence on the art of Jackson Pollock.

—

from KANDINSKY, MONDRIAN, AND POLLOCK

APRIL 7, 1945

Clement Greenberg

ACADEMICISM SHOWS ITSELF nowhere more nakedly than in painting and sculpture, being much more immediately depressing there than in literature. One brief glance at the recent annual exhibition of the National Academy of Design was enough to fill the visitor with gloom. Van Wyck Brooks's resentment of advanced literature's lack of "affirmation" would find greater justification if it were directed to backward art. These painters of purple and emerald landscapes, of glazed figurines and wax flowers, these nigglers, these picklers of nudes and bakers of mud pies plumb depths of negation and pessimism T.S. Eliot or Joyce, much less Picasso, could never remotely reach. But it is in the very nature of academicism to be pessimistic, for it believes history to be a repetitious and monotonous decline from a former golden age. The avant-garde, on the other hand, believes that history is creative, always evolving novelty out of itself. And where there is novelty there is hope.

The hope shining from Piet Mondrian's white canvases with their crisscrossed bands of black has little to do with his platonizing the-

ories except in so far as they express an almost naive faith in the future. Rationalized décor—rectilinear lines and bright, clear colors—means the conviviality and concord of an urban tomorrow stripped of the Gothic brambles and rural particularities that retarded life in the past. Mondrian's pictures are an attempt to create conditions of existence and stabilize life itself. They are not "interesting" the way Titians are; you are supposed to go on with life in their presence. Aside from the fact that he was a pioneer who pushed the implications of modern art to their last consequences, Mondrian was one of the greatest painters of our time. Unfortunately, the memorial show at the Museum of Modern Art (through May 13) includes too few of his works to give a really adequate notion of the scale of his art and the heights it reached in his best periods. (I realize that Mondrian's paintings need lots of empty wall around then, but then the show should have received more gallery space.) It is also unfortunate that the white areas in many of his pictures have by now become discolored or dirty. The artist himself should have foreseen that; and while his art is inseparable from the qualities induced by canvas and oil, he might have done more wisely and equally beautifully had he used tempera on board or gesso panel. Perhaps the fact that he made many changes and over-paintings during execution kept him away from the relative inflexibility of tempera. In any case it suffices that he put together pictures that are completely at rest—solid, unshakable—and at the same time tense and dramatic.

Along with the memorial exhibition a sixty-four-page book containing six of Mondrian's essays on art has appeared, edited by Robert Motherwell and Harry Holtzman. (The assistance of Charmion von Wiegand, who practically put one of the essays into English, is for some reason or other not acknowledged.) Acquaintance with Mondrian's theories may expand one's idea but will hardly deepen one's experience of his work. They are real feats of speculative imagination but seem to have been more a rationalization of his practice than a spur to it. Theories were perhaps felt necessary to justify such revolutionary innovations. But Mondrian committed the unforgivable error of asserting that one mode of art, that of pure, abstract relations, would be absolutely superior to all others in the future.

The late Kandinsky, Mondrian's only true compeer, whose life work is reviewed in a splendid exhibition at the Museum of Non-Objective Painting (through April 15), fell somewhat short of Mondrian in practice but maintained a better concept of what was going on. His chief mistake was to draw too close an analogy between painting and music. And while he did not give "non-objective" art

the absolute primacy, he did hold that only through the non-objective could "absolute" works of art be approximated. Like Mondrian he spoke of "liberation"—from the past, from nature—and was optimistic, anticipating a future of inner certainty and the "growing realization of the spiritual." (As far as I can make out, Kandinsky's "spiritual" means simply intensity and seriousness and has no religious connotations.)

Kandinsky was more a landscape painter at heart than anything else. Even before developing his abstract "lyrical" style he seems, according to the evidence, to have proved himself the best of all the *Blaue Reiter* artists in Germany. His parti-colored expressionist landscapes are better than we, who have been brought up on the School of Paris, may rightly realize.

Jackson Pollock's second one-man show at Art of This Century (through April 14) establishes him, in my opinion, as the strongest painter of his generation and perhaps the greatest one to appear since Miró. The only optimism in his smoky, turbulent painting comes from his own manifest faith in the efficacy, for him personally, of art. There has been a certain amount of self-deception in School of Paris art since the exit of cubism. In Pollock there is absolutely none, and he is not afraid to look ugly—all profoundly original art looks ugly at first. Those who find his oils overpowering are advised to approach him through his gouaches, which in trying less to wring every possible ounce of intensity from every square inch of surface achieve greater clarity and are less suffocatingly packed than the oils. Among the latter, however, are two—both called "Totem Lessons"—for which I cannot find strong enough words of praise. Pollock's single fault is not that he crowds his canvases too evenly but that he sometimes juxtaposes colors and values so abruptly that gaping holes are created.

—

HANS HOFFMAN

APRIL 21, 1945

Clement Greenberg

HANS HOFMANN IS in all probability the most important art teacher of our time. Not only has his school sent out good painters; the insights into modern art of the man himself have gone deeper than those of any other contemporary. He has, at least in my opinion,

grasped the issues at stake better than did Roger Fry and better than
Mondrian, Kandinsky, Lhote, Ozenfant, and all the others who have
tried to "explicate" the recent revolution in painting. Hofmann has
not yet published his views, but they have already directly and in-
directly influenced many, including this writer—who owes more to
the initial illumination received from Hofmann's lectures than to
any other source. (Whether this redounds to Hofmann's credit or
not I leave to others to decide.) Hofmann practices what he teaches,
and his second one-man show of painting in this country—his first
was held only last year—is now running at 67 Gallery (through April
21). It would be unfair of me to pretend to critical detachment with
regard to it. I find the same quality in Hofmann's painting that I
find in his words—both are completely relevant. His painting is all
painting; none of it is publicity, mode, or literature. It deals with
the crucial problems of contemporary painting on its highest level
in the most radical and uncompromising way, asserting that painting
exists first of all in its medium and must there resolve itself before
going on to do anything else. Perhaps Hofmann surrenders himself
too unreservedly to the medium—that is, to spontaneity—and lets
color dictate too much: his pictures sometimes fly apart because they
are organized almost exclusively on the basis of color relations. Per-
haps he insists too little on the resistances of his own tempera-
ment—in every artist there must be something that fights against
being set down in art and yet whose setting-down constitutes part of
the triumph of art. Be that as it may, the works of the teacher do
not betray his teachings. Hofmann has become a force to be reck-
oned with in the practice as well as in the interpretation of modern
art.

I may have seemed high-handed in my disposal two weeks back
of Mondrian's theories. The irritation caused by any sort of dog-
matic prescription in art was most likely responsible. Mondrian at-
tempted to elevate as the goal of the total historical development of
art what is after all only a time-circumscribed style. That style may
be—I myself believe it is—the direction in which high art now tends
and will continue to tend in the foreseeable future. But in art a
historical tendency cannot be presented as an end in itself. Anything
can be art now or in the future—if it works—and there are no
hierarchies of styles except on the basis of past performances. And
these are powerless to govern the future. What may have been the
high style of one period becomes the kitsch of another. All this is
elementary; yet it needs to be repeated in Mondrian's case. These
reservations made, one can proceed to value Mondrian's theories—
which are logical deductions from the results of his own practice

and from the evidence of the world around him as to the aesthetic and social implications of abstract art—for the brilliant insights they are. With Marx, he anticipated the disappearance of works of art— pictures, sculpture—when the material décor of life and life itself had become beautiful. With Marx, he saw the true end of human striving as complete deliverance from the oppression of nature, both inside and outside the human being. With Marx, he saw that man has to *denaturalize* himself and the things he deals with in order to realize his own true nature. He saw that what is wrong at present is that man only partly denaturalizes his own nature and his environment, and through this partial denaturalization—that is, capitalism, the suburbs of Chicago, radio, movies, vicarious experience, popular taste—attains precisely the opposite of what he really wants. Mondrian's art was not "inhuman"; it did not aim at "perfection"; it aimed at nothing beyond itself. But it was guided by an ideal, as all human action in or out of art should be.

Although Paul Rosenfeld had extolled Georgia O'Keeffe in the early thirties and The Nation *even ran a personality profile on her as part of a series called "Americans We Like," Greenberg was never one to go along with any sort of orthodoxy.*

—

GEORGIA O'KEEFFE

JUNE 15, 1946

Clement Greenberg

GEORGIA O'KEEFFE'S RETROSPECTIVE show at the Museum of Modern Art (through August 25) confirms an impression left by the "Pioneers of Modern Art in America" exhibition at the Whitney Museum last month—namely, that the first American practitioners of modern art showed an almost constant disposition to deflect the influences received from twentieth-century Paris painting in the direction of German expressionism. This tendency was more obvious and general in the period that saw Miss O'Keeffe's debut (1915) than it has been since, but it survives even today.

The first American modernists mistook cubism for an applied style; or, like many German artists, they saw the entire point of post-impressionist painting in *fauve* color—or else they addressed themselves directly to German expressionist art as a version of the

modern which they found more sympathetic and understandable than that of the School of Paris. In any case they read a certain amount of esotericism into the new art. Picasso's and Matisse's break with nature, the outcome of an absorption in the "physical" aspect of painting and, underneath everything, a reflection of the profoundest essence of contemporary society, seemed to them, rightly or wrongly, the signal for a new kind of hermetic literature with mystical overtones and a message—pantheism and pan-love and the repudiation of technics and rationalism, which were identified with the philistine economic world against which the early American avant-garde was so much in revolt. Alfred Stieglitz—who became Miss O'Keeffe's husband—incarnated, and still incarnates, the messianism which in the America of that time was identified with ultramodern art.

It was this misconception of non-naturalist art as a vehicle for an esoteric message that encouraged Miss O'Keeffe, along with Arthur Dove, Marsden Hartley, and others, to proceed to abstract art so immediately upon her first acquaintance with the "modern." (It should not be forgotten, however, that the period in question was one that in general hastened to draw radical conclusions even when it did not understand them.) Conscious or unconscious esotericism also accounts largely for the resemblances between much of these artists' work and that of Kandinsky in his first phase; this being less a matter of direct influence than of an a priori community of spirit and cultural bias.

Later on, in the twenties, almost all these painters, including Miss O'Keeffe, renounced abstract painting and returned to representation, as if acknowledging that they had been premature and had skipped essential intermediate stages. It turned out that there was more to the new art than the mere abandonment of fidelity to nature; even more important was the fact that Matisse and the cubists had evolved a new treatment of the picture plane, a new "perspective" that could not be exploited without a stricter and more "physical" discipline than these pioneers had originally bargained for. A period of assimilation of French painting then set in that has led American artists to a more integral understanding of what is involved in modern art. But the cost has been a certain loss of originality and independence. Today the more hopeful members of the latest generation of American artists again show "Germanizing" or expressionist tendencies; and these, whether they stem from Klee, surrealism, or anything else, seem to remain indispensable to the originality of our art, even though they offer a serious handicap to the formation of a solid, painterly tradition.

The importance of Georgia O'Keeffe's pseudo-modern art is almost entirely historical and symptomatic. The errors it exhibits are significant because of the time and place and context in which they were made. Otherwise her art has very little inherent value. The deftness and precision of her brush and the neatness with which she places a picture inside its frame exert a certain inevitable charm which may explain her popularity; and some of her architectural subjects may have even more than charm—but the greatest part of her work adds up to little more than tinted photography. The lapidarian patience she has expended in trimming, breathing upon, and polishing these bits of opaque cellophane betrays a concern that has less to do with art than with private worship and the embellishment of private fetishes with secret and arbitrary meanings.

That an institution as influential as the Museum of Modern Art should dignify this arty manifestation with a large-scale exhibition is a bad sign. I know that many experts—some of them on the museum's own staff—identify the opposed extremes of hygiene and scatology with modern art, but the particular experts at the museum should have had at least enough sophistication to keep them apart.

In 1946, Nation *critic Paul Rosenfeld died and was memorialized in* The Nation *by his close friend the poet Marianne Moore.*

—

PAUL ROSENFELD

AUGUST 17, 1946

Marianne Moore

PAUL ROSENFELD WAS an artist. In his performances one finds "a level of reality deeper than that upon which they were launched"; his experiences have not been "made by fear to conform with preconceived theories." Now to be thus "strong in oneself is to be strong in one's relationships. Give and take is effected, that feeds the powers"; powers that have afforded us "a great panorama of conclusions upon the contemporary scene"; a "miscellaneousness" of acknowledgment that baffles enumeration. The mind which has harbored this greater than greatest Noah's ark of acknowledgments was characterized by an early compliment to it in *The Nation,* as "courageous, clear, and biased."

Biased? Biased by imagination; and the artist biased by imagina-

tion is a poet, as we see in Paul Rosenfeld's mechanics of verbal
invention. Mass epithet would not do; sensibility fevered the noun
or the adjective. John Marin was "a timothy among the grasses";
"The Enormous Room" had "a brindled style"; "love and aversion"
were "darts of light on a stilly flowing stream, wave-caps cast up and
annihilated again by a silently rolling ocean."

Matching the ardor of the method, there was in Paul Rosenfeld
a republicanism of respect for that *ignis fatuus*, liberty; a vision of
spiritual fitness without visa; of "inner healing" for white America's
black victims, those "splintered souls" whose "elasticity of young
rubber is weakened and threatened and torn, in bodies of young
girls become self-centered and men playing in vaudeville theatres."
Though a bachelor, Paul Rosenfeld was not inimical to woman, as
Margaret Naumburg, Gertrude Stein, my timid self, and many an-
other might well have testified ere 1946. He even understood chil-
dren, their "infantine works and little houses"; their way of "cooking
a meal without friction of personalities," since "the end irradiates
the means."

The artist is no "lily-leaning wistful willowy waning sentimentalist,"
but "a man of stomach," producing "hard form which reveals itself
the larger the more it is heard." "Heard" suggests music, and in this
regard there is an Amazon to explore; an Amazon that was a river,
flowing and branching throughout a continent. It was without "axes
to grind and sadism to exhaust."

In objectifying what poets, critics, novelists, educators, painters,
photographers, sculptors had "given" him, Paul Rosenfeld exempli-
fied most touchingly his conviction that possession involves respon-
sibility. He toiled to benefit his benefactors; or to put it exactly, to
benefit benefaction; to justify justice. It is not merely D.H. Lawrence,
E.E. Cummings, Gaston Lachaise, Nodier, El Greco, Marsden Har-
tley, Mozart, or Stravinsky, to whom he was grateful, but to sculpture,
painting, writing, music.

Nor was critical rectitude in Paul Rosenfeld something apart from
supposedly more prosaic manifestations of conscience. "Michelan-
gelo," he said, "does not stand entirely besmirched for having ceased
work on the Medici tombs in order to fortify Florence against brutal
Emperor and treacherous Pope." Paul Rosenfeld cared what be-
comes of us. "America," he said, "must learn to subordinate itself to
a religious feeling, a sense of the whole life, or be dragged down
into the slime."

Flamboyant generalities are the refuge of the lazy, things that
sound well, but in this instance *are* well. Paul Rosenfeld, in his im-
passioned and varied books, was a poet. He was a scientist of music;

a musician; the rescuer of Tristram and Iseult from the half-scholarship of judicious translating; "contended," "refreshed," "rejoicing," "gladdened" by his multifariousness of gratitude—a figure best praised by his own myriad chivalries, drudgeries, and masteries. When everything has its price, and more than price, and anyone is venal, what a thing is the interested mind with the disinterested motive. Here it is. We have had it in Paul Rosenfeld, a son of consolation, a son of imagination, the man of deeds.

Albert Pinkham Ryder, one of the most strikingly original artists of the late-nineteenth and early-twentieth centuries, had been dead for nearly thirty years when Greenberg wrote this review of his centennial exhibition. Jackson Pollock considered Ryder, who was woefully neglected compared to others in the modernist canon, to be his favorite American artist.

—

ALBERT PINKHAM RYDER

NOVEMBER 15, 1947

Clement Greenberg

THE TOTAL IMPRESSION made by the centenary exhibition of Albert Pinkham Ryder's paintings at the Whitney Museum (through November 30) is that of an unrealized vision. The vision itself, had it been more completely precipitated, would have sufficed to establish the artist beyond dispute as the greatest American painter. As it is, taking the evidence of this show into account, I would find it uncomfortable to argue his case against Eakins's and Homer's.

The evidence is unsatisfactory because of its scantness and because of the bad physical condition of many of the canvases themselves. As Lloyd Goodrich explains in a well-written catalogue note, Ryder "strove, half-consciously and without adequate training, for the richness of the old masters. His pictures were built up with under-painting and layer on layer of pigment and glazes . . . Unfortunately he had little knowledge of traditional techniques, and in trying to secure his effects he used dangerously unsound methods. He painted over pictures when they were still wet, thereby locking the under surface in before it had dried and hardened, so that the different surfaces dried at different rates of speed, causing serious cracking. He used strange mediums—wax, candle grease, alcohol;

and he made much too free use of varnish. In showing visitors his paintings he would wipe them with a wet cloth or literally pour varnish over them." Among the most unhappy effects of these procedures, aside from cracking, has been the radical obliteration of gradations of value by excessive darkening, so that one color mass merges into another. Given Ryder's fondness for heavy greens, blues, and browns, the result is sometimes altogether disastrous, making it impossible, as in "Moonlit Cove" and "Macbeth and the Witches," to tell what the picture was meant to look like when it left the artist's hand.

Ryder was beyond question one of the most original and affecting painters of his time, whether in Europe or this country. In the task of stating his originality he seems to have had no help at all from his contemporaries. Taking his departure from the academicism that dominated his age—he mentioned Corot and Maris as his favorite painters—he had to cut his art out of the whole cloth and search in isolation for a means to convey the surprisingly new things he had to say. He knew little or nothing of those of his early and late contemporaries—Daumier, Monticelli, and Munch—who in their various ways were exploring some of the same realms of pictorial sensation.

The loneliness of his effort condemned Ryder to aesthetic as well as personal eccentricity. We can understand why he took so long to finish pictures to his own satisfaction: in his endeavor to make concrete the dramatic, visionary nature of his idea he had nothing he could use to guide him at least part of the way—as Cézanne, for instance, had impressionism. He was on his own almost from start to finish. What we miss in his work, as a result of this, is amplitude of realization, pictures that come off conclusively because the painter has created himself a style, with the aid of his time and milieu, secure enough to contain and redeem his inevitable mistakes. The few masterpieces in the present exhibition—"The Forest of Arden," "Moonlight on the Sea," "Sunset Hour," perhaps "Under a Cloud"—seem happy accidents unsupported by sufficient testimony from the pictures surrounding them. It is as if the artist exhausted himself in these rare completely successful pictures and had each time to begin all over again.

Ryder's main impulse was to simplify nature into silhouetted masses of darks and lights; color was a matter of dark and light modulations within these masses. The primary effect is of simple, blocked-out pattern, startling because of the emotion discharged by the novelty of a relatively few shapes, novel in their contours and in their placing. Yet his most successful canvases—I think here of

"Moonlight on the Sea" and "The Forest of Arden"—owe more of their final effect to a subtle, rhythmic weaving together of color and value tones. Where the picture did not stand or fall entirely by the placing of three or four large shapes, the artist was able to retrieve his uncertainty and clumsiness by imposing a general, all-inclusive tonal harmony. Here Ryder resorted to more conservative means and renounced in effect such complete correspondence between his vision and its embodiment as he attempted in his more startling but less successful pictures—where he attempted to qualify the solid simplicity of the silhouette by building up a thick, enamel-like surface that by reflected light would intensify the few color tones.

The moral is that one should never go too fast in art. It is the tragedy of Ryder that he attempted to go too far too fast—alone. I say tragedy, because Ryder had, obviously, gifts enough to have made him a major artist in a better place and time. Once again it is necessary to register another casualty of American provincialism.

Ryder left behind a manner rather than a style. This made him a plausible victim of forgers, who could by diluting his invention, in one instance at least, contrive a painting more harmonious than many of his: I mean "A Spanking Breeze," which is included in the present show as an example of a faked Ryder—with a placard underneath, pointing out the "weak drawing," "unpleasant color," and "crude, direct handling." One wonders more than ever whether museum people ever see things with their own eyes. Forgery that it is, "A Spanking Breeze," manages to be a rather good picture precisely because it takes nothing from Ryder except his manner, leaving out the difficult intensity and originality of emotion he could not realize often enough in his own work. While Ryder could not always meet the high terms he set himself, the forger, even though he was only a hack, could meet them when reduced.

—

from DE KOONING

APRIL 24, 1948

Clement Greenberg

DECIDEDLY, THE PAST year has been a remarkably good one for American art. Now, as if suddenly, we are introduced by William de Kooning's first show, at the Egan Gallery (through May 12), to one of the four or five most important painters in the country, and find

it hard to believe that work of such distinction should come to our notice without having given preliminary signs of itself long before. The fact is that de Kooning has been painting almost all his life, but only recently to his own satisfaction. He has saved one the trouble of repeating "promising." Having chosen at last, in his early forties, to show his work, he comes before us in his maturity, in possession of himself, with his means under control, and with enough knowledge of himself and of painting in general to exclude all irrelevancies.

De Kooning is an outright "abstract" painter, and there does not seem to be an identifiable image in any of the ten pictures in his show—all of which, incidentally, were done within the last year. A draftsman of the highest order, in using black, gray, tan, and white preponderantly he manages to exploit to the maximum his lesser gift as a colorist. For de Kooning black becomes a color—not the indifferent schema of drawing, but a hue with all the resonance, ambiguity, and variability of the prismatic scale. Spread smoothly in heavy somatic shapes on an uncrowded canvas, this black identifies the physical picture plane with an emphasis other painters achieve only by clotted pigment. De Kooning's insistence on a smooth, thin surface is a concomitant of his desire for purity, for an art that makes demands only on the optical imagination.

Just as the cubists and their more important contemporaries renounced a good part of the spectrum in order to push farther the radical renovation of painting that the Fauves had begun (and as Manet had similarly excluded the full color shade in the eighteen sixties, when he did his most revolutionary work), so de Kooning, along with Gorky, Gottlieb, Pollock, and several other contemporaries, has refined himself down to black in an effort to change the composition and design of post-cubist painting and introduce more open forms, now that the closed-form canon—the canon of the profiled, circumscribed shape—as established by Matisse, Picasso, Mondrian, and Miró seems less and less able to incorporate contemporary feeling. This canon has not been broken with altogether, but it would seem that the possibility of originality and greatness for the generation of artists now under fifty depends on such a break. By excluding the full range of color—for the essence of the problem does not lie there—and concentrating on black and white and their derivatives, the most ambitious members of this generation hope to solve, or at least clarify, the problems involved. And in any case black and white seem to answer a more advanced phase of sensibility at the moment.

De Kooning, like Gorky, lacks a final incisiveness of composition,

which may in his case, too, be the paradoxical result of the very plenitude of his draftsman's gift. Emotion that demands singular, original expression tends to be censored out by a really great facility, for facility has a stubbornness of its own and is loath to abandon easy satisfactions. The indeterminateness or ambiguity that characterizes some of de Kooning's pictures is caused, I believe, by his effort to suppress his facility. There is a deliberate renunciation of will in so far as it makes itself felt as skill, and there is also a refusal to work with ideas that are too clear. But at the same time this demands a considerable exertion of the will in a different context and a heightening of consciousness so that the artist will know when he is being truly spontaneous and when he is working only mechanically. Of course, the same problem comes up for every painter, but I have never seen it exposed as clearly as in de Kooning's case.

Without the force of Pollock or the sensuousness of Gorky, more enmeshed in contradictions than either, de Kooning has it in him to attain to a more clarified art and to provide more viable solutions to the current problems of painting. As it is, these very contradictions are the source of the largeness and seriousness we recognize in this magnificent first show.

The poet, painter, and musician Weldon Kees wrote about books and the arts for The Nation, *the* New York Times, Partisan Review, *and* The New Republic, *and one of his paintings was in the 1950 Whitney annual. Kees filled in when Greenberg left* The Nation *in 1949, but soon moved to the West Coast. In 1955, his car was discovered near the Golden Gate Bridge, and he was presumed to have committed suicide, although his body was never found. Kees was forty-one. He was a natural enemy of Congressman George Dondero, who, as a fellow traveler of Joseph McCarthy and a precursor of Jesse Helms, made something of a career of attacking art and artists.*

—

DONDERO AND DADA

OCTOBER 1, 1949

Weldon Kees

SINCE EARLY IN March a Congressman named George A. Dondero, from the Chicago *Tribune* section of Michigan, has been sounding

off in the House of Representatives from time to time on the subject of modern art. Like Hitler, Sir Alfred Munnings, R.A., Winston Churchill, and Stalin's art critic Kemenev, who calls modern art "hideous and revolting," Mr. Dondero is a most vocal and impassioned enemy of modernism. "Human art termites" in this country, it seems, are "boring industriously to destroy the high standards and priceless traditions of academic art." Subversive elements are at work throughout the art world—among the critics of all the New York papers and art magazines, in the Museum of Modern Art, the Art Institute of Chicago, the Fogg Museum, and even on the board of judges of the Hallmark Christmas Card Company. Things have reached a stage where "most of the finest artists that our nation numbers no longer exhibit at all." (It would be interesting to have the names of these manacled creators, but Mr. Dondero keeps a dignified silence as to their identity.)

Although the Congressman has admitted he seldom visits an art gallery or museum, he has picked up a fairly wide range of aversions. In a warming spread-eagle manner that any servant of the people might envy, he calls "the roll of infamy without claim that [his] list is all-inclusive: dadaism, futurism, constructionism, suprematism, cubism, expressionism, surrealism, and abstractionism. All these isms are of foreign origin and truly should have no place in American art."

Now Mr. Dondero is something of a Dadaist himself, and though his performance thus far does not quite rank him a place with, say, either Tristan Tzara or the Ritz brothers, he is improving as he goes along. Indeed, Dondero's most recent performance, late this summer, is far and away his most impressive. Currently there are at least four highly esteemed methods of attacking modern painters: (a) they are insane; (b) they "cannot draw" (cherubs, picturesque old houses, pigs killing reptiles, pretty girls, etc.); (c) they are engaged in a sinister conspiracy to make the bourgeoisie nervous and unsure of themselves; (d) they are Communist propagandists.

On August 16 Mr. Dondero chose the last method, and charged that modern art is—lock, stock, and barrel—a weapon of the Kremlin. The fact that the nationalist academicism he approves is also the official and only permissible art under the Stalinist dictatorship does not appear to trouble him at all—a Dadaist maneuver of the highest order. To add to the comic spirit of the affair, Stalin's American followers, the most devotedly solemn Dadaists of our time, have been busy with manifestoes protesting against the Congressman's line, even though many of the artists he attacks—Kandinsky, Braque,

Duchamp, Ernst, Miró, Seligmann, Dali—are precisely those branded in Russia as "bourgeois formalists" and "degenerate lackeys of a dying capitalism."

While there is a school of thought which believes Dondero should not be mentioned by name, since he is motivated, it is said, solely by a desire for publicity and enjoys seeing his name in print in any context, I cannot believe that a man of his talents can be publicized too much. What the Washington spokesman for the most reactionary wing in American art circles has to say ought to have the widest possible notoriety. When Mr. Dondero refers to Thomas Craven as the "foremost art critic in the United States," as he does, or echoes Thomas Hart Benton's charge that "many . . . effeminate elect . . . blanket our museums of art from Maine to California," or declares that "art which does not portray our beautiful country in plain, simple terms . . . is therefore opposed to our government, and those who create and promote it are our enemies," let his remarks reach audiences as sizable as those of Arthur Godfrey and "John's Other Wife." When Mr. Dondero follows the Marxist line that art is a weapon, as he does throughout his latest attack, the metropolitan press should give his remarks the fullest space.

Look, Mr. Dondero, art is not a weapon, no matter how insistently you, the Nazis, and the Communists maintain that it is. Persons desiring to make weapons do not become artists—a very difficult, uneasy, and ambiguous proceeding—but engage instead in pamphleteering, speech-making, gunpowder manufacture, advertising, the designing of flame-throwers, and so on. The man who looks at a painting and inquires about the political opinions of the artist may be an idiot or merely tiresome; he is totally unconcerned with the nature of painting. As painters we have no concern with politics; as men we are in the midst of them. Our world entails a vast individual schizophrenia, and not to grasp this is to enter a community of dwarfs. The painter who "takes no interest" in politics may be that much less a human being; the painter whose political opinions are fashionable or vicious is that much less a human being, though the machinery for evaluating the purity of one's political opinions, Mr. Dondero's and others, has not yet been perfected. I throw out these dogmatisms and one other: works of art have been created by Populists, Whigs, Tories, Laborites, Liberals, Jacobins, Democrats, Socialists, Republicans, Anarchists, Monarchists, and men with no political opinions worth speaking of. None, whether American, French, German, English, Spanish, Swiss, African, Dutch, or of any other nationality known to me, have attempted to portray their

countries in plain or simple terms. They have been engaged in tasks much more arduous, complex, and enduring.

Weldon Kees, in addition to his many other pursuits, was also a bit of an activist. He was part of a short-lived group of painters that were nicknamed "the irascibles," and used this piece in The Nation *to promote their views.*

—

THE METROPOLITAN MUSEUM

JUNE 3, 1950

Weldon Kees

FOR YEARS THE Metropolitan Museum has been under attack for its lack of interest in contemporary art. Its cushy Hearn fund, bequeathed to it generations ago for purchasing work by living American artists, has been left in the vaults, most of it, and what little has been touched has been spent for paintings that might as well have been chosen by a committee of Congressmen or the ladies of the Elkhart Bide-a-Wee.

The present director of the Metropolitan, Francis Henry Taylor, makes no secret of his hostility to advanced trends in contemporary art—he reached some sort of high in philistinism, where competition is keen, when he compared Picasso's "Guernica" to "The Charge of the Light Brigade" and remarked that Picasso "has only substituted Gertrude Stein for Florence Nightingale." Recently, the cries of discontent at the Museum's policies have become louder; several influential voices have made themselves heard, among them that of James N. Rosenberg, a Museum member and New York lawyer, who not long ago wrote a series of sharp and high-flavored letters which must have been embarrassing even to the elephant-hided Mr. Taylor. Whether knuckling under to such pressures or acting for its own mysterious reasons, the Metropolitan has suddenly become a beehive of activity directed at "recognizing" and "supporting" American art of the present. In a few weeks it promises to open an exhibition of twentieth-century paintings from its own collection—a collection hastily reinforced in the last few months by a spree of apparently frantic buying in an attempt to fill up the gaping

holes so long in evidence. This show, says the Museum, will "remove certain misconceptions in the critical and public mind which for one reason or another have arisen in recent years." I wonder.

In addition to its long-delayed purchasing binge, the Metropolitan has announced a jumbo national competitive exhibition, "American Painting Today—1950," to be chosen by a number of regional juries, with prizes totaling $8,500. Already, across the nation, painters' mouths are watering. The general idea suggests another proportional-representation show of the Pepsi-Cola variety; the list of the jurors—almost a solid phalanx of such academics as Jerry Bywaters, Everett Spruce, Lamar Dodd, Leon Kroll, Paul Sample, Franklin C. Watkins, etc., etc.—suggests not eclecticism or proportional representation but intrenched timidity and conservatism of the purest ray serene. It has been suggested that this jury "may surprise us" by picking an adventurous and valuable show. I look forward to this with the same warm expectations that I have of the American Legion building a series of marble shrines honoring the memory of Randolph Bourne or of Baudelaire being voted the favorite poet of the Cicero, Illinois, junior high schools. Preparations for this endeavor have been under way for "nearly a year," says the Metropolitan; it is clear that the selection of a jury as humdrum as this must easily have consumed that long a period of time.

The following letter, which I was pleased to sign, was addressed to Roland L. Redmond, president of the Metropolitan, and recently made public. It bore the signatures of eighteen painters—among them such distinguished and prominent artists as Jackson Pollock, Hans Hofmann, Adolph Gottlieb, Robert Motherwell, William de Kooning, William Baziotes, Ad Reinhardt, and Mark Rothko; they speak, I should guess, for a considerable number of other artists.

[We] reject the monster national exhibition to be held at the Metropolitan Museum of Art next December, and will not submit work to its jury.

The organization of the exhibition and the choice of jurors by Francis Henry Taylor and Robert Beverly Hale, the Metropolitan's Director and the Associate Curator of American Art, does not warrant any hope that a just proportion of advanced art will be included.

We draw to the attention of those gentlemen the historical fact that, for roughly a hundred years, only advanced art has made any consequential contribution to civilization.

Mr. Taylor, on more than one occasion, has publicly declared his contempt for modern painting; Mr. Hale, in accepting a jury notoriously hostile to advanced art, takes his place beside Mr. Taylor.

We believe that all the advanced artists of America will join us in
our stand.

For the first time, avant-garde painters in this country have taken a
united position against the Academy; this is their historical role; the
Academy itself drew the lines.

*Although Greenberg had resigned as art critic of the magazine, a review
in* The Nation *by the British critic David Sylvester of American art
at the Venice Biennale provoked his angry defense of Pollock, de
Kooning and Gorky.*

—

THE EUROPEAN VIEW OF AMERICAN ART

NOVEMBER 25, 1950

Clement Greenberg and David Sylvester

ANYTHING IN ART that is surprising enough to be puzzling usually
causes discomfort. It depends on the critic's sincerity whether he
will suspend judgment and endure the discomfort until he is no
longer puzzled. Often, however, he is tempted to ease himself by
immediately pronouncing "bad." All that is likely to deter him is the
fear, a lively one of late, that he might be making an egregious
mistake on the order of those made by the first critics to witness the
development of modern art. In Europe, apparently, this fear does
not operate in the case of art coming from the United States. It
seems to be assumed that since America has not yet produced any-
thing very important in the way of art, there is little likelihood that
it ever will.

The reception given by European critics to the American paint-
ings they saw at this year's Biennale in Venice is what provokes these
remarks—not, however, the appropriately contemptuous one given
to the collection of "Magic Symbolists" or "Realists" sent to London
this past summer under the auspices of the indefatigable Lincoln
Kirstein; that show was sent with little blessing from this side either.
I gather that the treatment our painters got at the hands of Euro-
pean critics was at best condescending, at worst indifferent or im-
patient. Aline B. Louchheim wrote in the last of her reports on the
Biennale, in the *New York Times* of September 10, that "in general,
our pavilion has been given not the 'silent treatment' [as claimed

by *Time*] but merely cursory consideration." And she went on to say: "I am inclined to believe that this attitude has little to do with the show itself, but that its explanation lies in two other factors." The first, she says, is the "habit of Europeans to think of Americans as cultural barbarians"; the second, their resentment of their present military and economic dependence upon us.

Sight unseen, I tend to agree with Mrs. Louchheim. Still, this does not prevent me from being taken aback when Douglas Cooper of England dismisses John Marin as "convulsive and somewhat inept" and Jackson Pollock as "merely silly" (I cull these words from Alfred Frankfurter's column in the September *Art News*). Nor was I any less taken aback by the remarks of another British critic, David Sylvester, which *The Nation* published in these pages on September 9. What surprises me, however, in both cases is not the prejudice but the signs of a lack of critical competence.

I have had harsh words of my own to say about contemporary American art, and would still repeat a good many of them. And I do not hold a brief for all the American artists represented at Venice. Hyman Bloom and Lee Gatch are respectable painters, but the one lacks form and the other is thin, while Rico Lebrun strikes me as an out-and-out *pompier* whether he paints abstract or not. It is also possible that the examples of the others were badly chosen. I can see easily how Marin might be found clumsy in his bad pictures, of which he has painted a good many. Yet I feel sure that a few of the Marins at Venice must have been at least good enough to give pause to a competent eye. And the Gorkys, de Koonings, and Pollocks, whether good or bad examples, should have given more than pause, since their originality is larger and more impersonal than Marin's— which is not to say that they are necessarily better painters. I do not think that it is merely patriotism or provincial myopia that makes us take these four artists seriously in this country. We have had the chance to look at them repeatedly and we have compared them with the best of modern painting, of which there are as many examples here as in Britain. When I claim that Gorky, de Kooning, and Pollock have turned out some of the strongest art produced anywhere since 1940, it may be that I am insufficiently acquainted with the latest work done abroad. But it is with the masterpieces of Matisse, Picasso, Klee, and Miró in mind that I say that some of their work warrants a place of major importance in the art of our century.

Mr. Sylvester's remark about "the tradition of ham-fisted, paint-curdling illustration which stems from Albert Pinkham Ryder and Max Weber" makes one wonder whether he ever saw a picture by either artist. If he did, it must have been a very fleeting glance. And

the glance he threw at Gorky must have been just as quick, for to connect Gorky, who was second to no painter of our time in sheer finesse, with anything "ham-fisted" and "paint-curdling" reveals a failure, not to appreciate Gorky, but to see him—that is, to make elementary use of one's eyes. There is in all this a negligent haste that forces me to suspect condescension on Mr. Sylvester's part toward things American; which is borne out by the dispatch with which he sums up our national character in a pair of clichés.

Like many other English critics, Mr. Sylvester approves of Alexander Calder among American artists—because he "makes things work"—and thought Rufino Tamayo, the Mexican, the best of all the new painters he saw at the Biennale. These preferences give us an excellent touchstone by which to estimate the taste that tried the Americans in Venice and found them wanting. We have known Calder and Tamayo longer than Europe has. The prompt, easy facility with which Calder handles a vocabulary of shapes taken over wholesale from Miró provides a kind of modern art one is prepared for. There is novelty—even if only mechanical—and an abstractness that seems racy and chic. This is modern the way it looked when it was *modern*, and the old excitement and up-to-dateness seem recaptured. But a longer look reveals the lack of inner necessity and the jejune reliance on tastefulness and little more. Tamayo is in his own way similarly destined for those who want to be let off easy by modern art, but not as easy of course as, say, Lincoln Kirstein. Up to a point he is a very accomplished painter. His lowering, warm color makes a first impression of strength, there is a Mexican fierceness of imagery, and it all has a high finish; here is discipline, apparently, ordered energy and invention. But this impression disappears when the eye begins to seek unity. All the excellent qualities in Tamayo's painting—the warm, intense color, the sumptuous yet clear surfaces, the neo-archaic, neo-Cubist drawing in the details—are offered separately, as it were, without unity of design, unfused. And finally one begins to perceive that the fierceness is really made to order and that the drawing is too Picassoid anyhow. Still, it is modern painting the way they have got used to it in Europe these past thirty years, and with a certain twist, a new *mise en scène* that protects it at first glance from the reproach of lacking originality. It is exactly what the enlightened critic has been ready to welcome ever since 1940.

The kind of art that Pollock, de Kooning, and Gorky present does not so much break with the Cubist and post-Cubist past as extend it in an unforeseen way, as does all art that embodies a new "vision." Theirs represents, in my opinion, the first genuine and compelled effort to impose Cubist order—the only order possible to ambitious

painting in our time—on the experience of the post-Cubist, post-1930 world. The formal essence of their art is penetrated through and through by this effort, which gives their works their individual unity. At Venice they must have looked too new—new beyond freshness, and therefore violent; and I can understand why the Europeans were puzzled, given also that the experience conveyed is American experience, and still a little recalcitrant to art. But I did not anticipate that the critics of the present would be no more humble in the face of the surprising than their predecessors. I now see why Jean Dubuffet, the one new French painter since 1920 with something important to say, receives a cold shoulder in certain "advanced" circles abroad. And why Graham Sutherland gets away with it in England. They are still looking forward to the Picasso of 1928, even if it is only an academicized pastiche of him.

Mr. Sylvester Replies

IGNAZIO SILONE HAD said that the trouble with Communists is that they can never believe that any criticism of them is made in good faith. Conversely, starving Asians who have found some hope in communism are looked upon by Congress as perverse and evil. In the world of politics, where no one is disinterested, there is some excuse for attributing base motives to opinions that differ from one's own. Transported into the world of art, it becomes inexcusable as well as naive. Yet it is precisely what Mrs. Louchheim and Mr. Greenberg have done in explaining away European indifference to the American pavilion at the Venice Biennale as the product of anti-American prejudice. The falsity of this is shown by the enthusiastic reception which other American artistic manifestations—say, recent books by Trilling, Bowles, Powers, and Maner—have had over here. Yet it is assumed that we consider you "cultural barbarians" because we criticized a single exhibition of paintings which makes no explicit claims to being a representative anthology of American art. Anyway, if our criticisms of your painters are the consequence of our "resentment" against our "economic dependence" upon you, your worries will soon be over so far as England is concerned; for after 1952 we shall need no more Marshall aid, and then we shall be able to give your art its due.

As to myself in particular, it is understandable that Mr. Greenberg reads an attitude of "condescension toward things American" into my habit of aphorizing glibly about the American character. Yet, in fact, this habit is due to a tendency to romanticize things American.

I have not even a condescending attitude toward American art other than Calder's, and if the American pavilion had contained works by, say, Feininger, Shahn, Baziotes, and Hare, I should have been full of praise for it. It just happened that I disliked what it did include, just as I disliked—for a variety of reasons—the British pavilion, the Spanish pavilion, the French pavilion, and a number of other pavilions. I disliked it because most of it represented a brand of American romanticism which, whether its outlet is painting, literature, or the theater, I find repellent and contemptible, because it is incoherent, modernistic, mucoid, earnest, and onanistic, because it gets hot and bothered over nothing and reminds me of Steig's drawing called "I can't express it."

Still, the more important part of Mr. Greenberg's answer to my criticisms is that in which he set out "to estimate the taste that tried the Americans at Venice and found them wanting." As "touchstones" he uses my preferences for Calder and Tamayo. I think he dismisses Calder far too hastily. It is true that Calder has taken over a ready-made vocabulary of forms from Miró, and that in doing so he has divested them of their folkloric poetry. But he has made them serve a new and valid concept: that a piece of engineering can simulate the organic life of a plant—not only by its physical movement but by its power to convince the imagination that it is capable of growth. Something more than tastefulness and technical originality were required to achieve this. On the other hand, I think Mr. Greenberg's criticisms of Tamayo are eminently sound, though that does not mean I've gone back on my opinion of his merits in relation to those of the other youngish painters at the Biennale—who, by the way, did not include any of the Europeans I admire.

Where Mr. Greenberg goes wrong is in trying to infer my critical standards from insufficient evidence. If I regarded Tamayo as the Messiah of present-day art, if I had any liking for the work of Graham Sutherland, I would indeed be "still looking forward to the Picasso of 1928." But I don't. I'm afraid I can't vindicate myself in Mr. Greenberg's eyes by professing an admiration for Dubuffet. But I can say that two years ago I published in the Tiger's Eye, No. 6, a short article on Klee's later work which carried the implication that the art of Picasso belonged to the past—though I would now qualify this by saying that some vital influence might still be drawn from those paintings and lithographs of 1948 and after in which the object has become as it were a hole in space. I can also affirm that, contrary to Mr. Greenberg's belief, I was not disconcerted by the work of Gorky, Pollock, and de Kooning because it caught me unprepared. Actually, it seems to me that nobody familiar with Kan-

dinsky's first abstracts and perhaps Ernst's Histoire Naturelle could be caught unprepared by it. That is debatable; this is a matter of fact. I first encountered Gorky's work at the International Surrealist Exhibition in Paris in 1947 and was then rather impressed by it; when I encountered it again, fresh from looking at masterpieces of cubism and fauvism, it stood up less well than Tamayo's. Pollock's approach has long been familiar to me, though at a more mature level, through the work of such European painters as Wols, Fin, and Ubac. So Mr. Greenberg is not quite accurate when he holds up Tamayo's art as exemplifying "modern painting the way they have got used to it in Europe these past thirty years."

Mr. Greenberg's great error is his notion that Pollock, Gorky, and de Kooning represent an exclusively American conception and that this conception is what is most contemporary in art today. I believe that something akin to what they are doing is being done very much better by Hartung and Kermadec. And I believe that this conception is not the last word; to me, the new vision means the less "modern" but more truly contemporary work of Masson, Tal-Coat, Gruber, Bacon, and, above all, Giacometti. I await Mr. Greenberg's revision of his former judgment in favor of one that I am still waiting for the Picasso of 1908, since these artists have turned aside from the Cubist order which he believes is "the only order possible to ambitious painting of our time." Is Mr. Greenberg prophet or dictator?—or does he intend to do all the ambitious painting himself? If not, how the hell does he know so much?

Once upon a time there was a critic called Baudelaire who had the advantage of being a genius. Like Mr. Greenberg, he affirmed the necessity of being absolutely modern. All the same, he failed to appreciate what really was modern in his time (Courbet, Manet) and put his faith in a romanticism which had been modern a few years before.

After Greenberg left the magazine in 1949, several writers wrote about art on an ad hoc basis. One of the most colorful of them was Manny Farber, a well-regarded painter who also served as The Nation's *film critic from 1949 to 1954.*

—

COMIC STRIPS

JUNE 16, 1951

Manny Farber

TOP COMIC-STRIP ARTISTS like Al Capp, Chet Gould, and Milt Caniff are the last in the great tradition of linear composers that started with Giotto and continued unbroken through Ingres. Until the Impressionists blurred the outlines of objects and diffused the near, middle, and far distance into a smog of light and dark, design had been realized in terms of outline and the weight of the inclosed shape. Today the only linear surgeons carrying on the practice— except for some rear-guard opportunists like Shahn—are the pow-bam-sock cartoonists, whose masterful use of a dashing pen line goes virtually unnoticed in the art world. (Once in a lifetime a cu- rator takes time off from Klee, Disney, and Dadaism to throw up a slipshod "retrospective" like the recent show "American Cartoon- ing," at the Metropolitan.) The rococo, squiggling composition of the average comic strip is too intricate, difficult, and unorthodox for cultured eyes grown lazy on the flaccid drawing-with-color tech- nique and the pillow-like form of modern painting.

The comic stripper—a funereal-faced craftsman who draws with his hat on and usually looks like an ex-saxophone-playing Republi- can—has good reason to wear a Ned Sparks expression. To start with, he has to meet over four hundred deadlines a year—one daily plus two on Sunday—while serving up his uniquely personal Karak- ters in a format squeezed to a fraction of its original size because his colleagues multiply like rabbits. He is bedeviled by aesthetic and moral do-gooders for contributing to a "debauch in flamboyant color and violent drawing," for his "fishing about in the murky depths of mass reactions." His earliest slapstick creations were re- buked for glamourizing "the cheeky, disrespectful child"; then the girlie-girlie strips were hounded by cheesecake censors; some of the religious newspapers run his stuff but jerk out pipes, cigarettes, and clouds of smoke; the newer strong-arm brigade catches monthly blasts from psychiatrists like Wertham and psyched-up little maga- zines like *Neurotica*. Worst of all, he is continually criticized for not being "funny"—when from the beginning, from the first "Yellow

Kid" strip in the 1890's, his humor has been of a jaundiced, whi-plashing, Goyaesque type, too sour for articulate laughs.

The key to the success of cartoons is not the vulgar, violent subject matter but the dinky, cocky pen stroke, which unfortunately gets less virile every day. Gilbert Seldes's complaint about the weak con-ception and execution of the "Katzenjammers" was an apt damna-tion of Knerr's designs but completely unjust to the small, beautifully well-fed details: readers drool over Knerr's just-baked pies drawn rather sloppily but with bloated, seductive lines that stream taste and texture out of the page; his plump and sassy roadster tires, his stylish oval rumble seats have more aesthetic kick than the effects of his most industrious competitor—Peter Paul Rubens. Despite their latter-day shortcomings, the strippers still have a full grasp of the objects in our world and throw them up with a quick spendthrift exhibitionism delightful to Americans who have been raised on the idea that drawing skill is hard won.

At that, the comic creators start with stolidly traditional tactics. ("First learn how to draw—then go to a good art school and get a firm foundation in the arts"—Billy DeBeck, Barney Google's accou-cheur.) Bisect almost any box from "L'il Abner" with two diagonals and you will find the lines crossing all important details: bosoms, hag's face, fleeing bachelors, six-shooter barrel peeled back like a banana. Capp, a veteran of four art schools, also spots his ducks in a circular path with a firm anchorage in one corner or another—a typical student maneuver. Another old-master orthodoxy is his ser-pentine pattern of figures across the page, each slob aimed this way or that so as to contrast and link with his neighbor. Yet every panel is distorted into life because Capp plays enough rage and gloom into each Dogpatch person and thing to bury his conventional moves under a forest of weird lettering and decisively stylized curi-osities.

Unfortunately, Capp and his contemporaries have softened car-toonism by overdrawing figure and overworking the intellectual-literary vein. The old standbys were arrogant show-offs who confounded their fans with ambiguously brilliant-bitter touches. George McManus stuck a hideously aggressive face on Maggie and then gave her a beautiful body and legs; this insidious combination was drawn with the clean sharp elegance of a Botticelli nude. An-other unforgettable resolution of contradictions was DeBeck's sag-ging, ponderous Spark Plug, who always found graceful fluid motion in the home stretch.

There have been three major "periods" in American cartooning, and each step has been a change for the worse. The founding fa-

thers—Swinnerton, Outcault, Dirks—were strictly caricaturists, hardly bothering about backgrounds: their stock in trade was exposing the smashable character of ordinary people with a style based on doodles. When adults started reading the funnies, style changed to suit their timid suburban outlook. Domesticity and illustration crept in for the benefit of the henpecked and the lovelorn; rooms were drawn in perspective, lamps were with a ruler, potbellies shrank, and everything suggested a solid hunk of marital doom. The most dispiriting change was ushered in by "Tarzan" in 1929. With this, funnies turned into pseudo-movies—taking over close-ups, tricky lighting, and the rest. There have been some miraculous cinematic inkers like Caniff ("Terry," "Canyon"), who draws incredibly sharp and delicate faces with a crowquill pen and exciting clothing with a shadownicking brush; yet even Caniff fondles his troubled adventurers like a cosmetic man making up a glamour girl.

Good or bad, uphill or down, comic strips are read by sixty or seventy million daily devotees. They satisfy a demand for inventiveness, energetic drawing, and a roughneck enthusiasm for life that other plastic arts cannot meet.

10

SEEING RED
TRIALS AND TRIBULATIONS
(PART III)

In March 1951, The Nation *sued Clement Greenberg and* The New Leader *for libel based on a letter that Greenberg had written accusing* The Nation*'s foreign editor, J. Alvarez Del Vayo, of being a pawn of the Soviet Union. Greenberg originally wrote the letter to* The Nation, *which refused to print it, so he sent it on to* The New Leader. *It reads in part:*

"I protest simply against the fact that The Nation *permits its columns to be used for the consistent expression of any point of view indistinguishable from that of a given state power.* The Nation *has the right to side with the Stalin regime when it holds itself compelled to by principle (though it does it so often that that constitutes another, if lesser, scandal) but not to put its pages at the regular disposal of one whose words consistently echo the interests of that regime; nor has it the right to make that person its foreign editor."*

The Nation*'s editor in chief, Freda Kirchwey, filed the suit even though Del Vayo himself reportedly preferred to simply "punch Greenberg in the nose" and avoid a lawsuit, which probably would have been just fine with Greenberg, who was no stranger to fistfights.*

In this editorial, presumably written by Kirchwey, The Nation *tried to defend its actions.*

—

WHY THE NATION *SUED*

JUNE 2, 1951

ON MARCH 31 *The Nation* announced that it had initiated a libel suit against Clement Greenberg and *The New Leader,* a political weekly published in New York. The suit resulted from the appearance in *The New Leader* of a letter by Greenberg making false and extremely vicious charges against *The Nation* and its foreign editor, J. Alvarez del Vayo. The letter had previously been submitted to *The Nation* in two versions and had been rejected as untrue and libelous, with the statement that its publication elsewhere would be actionable. We repeated this to *The New Leader* when it notified us that it was printing the second version of the Greenberg letter. As soon as the issue containing the letter appeared we started suit against the magazine, Mr. Greenberg, and those concerned with the printing and distribution of the letter.

We have since received a number of communications, both friendly and critical, most of them asking our reasons for refusing to print Greenberg's letter and then taking legal action against him and *The New Leader.* The assumption of several writers, based on that journal's presentation of the Greenberg attack—featured under the heading, "*The Nation* Censors a Letter of Criticism," and accompanied by an editorial enlarging on the theme of censorship—was that we had deliberately suppressed criticism of our policies relating to Russia and communism. In effect they accused us of dodging a fight on the central and most controversial issue now facing this country and the world.

These correspondents obviously did not realize that until the complaint had been filed we were inhibited from discussing the suit in the columns of *The Nation* or in correspondence; to have done so, in fact, would have jeopardized the suit itself. Meanwhile *The New Leader,* aware of this temporary disadvantage has devoted several columns of each issue to "letters *The Nation* will not print," together with editorial comment to the effect that we had added to our original sin of "censorship" by resorting to a libel suit and then "cen-

soring" protests against both. Now that the complaint has been filed, we are for the first time free to make a clear statement of our position. We are glad to publish this statement if only to relieve the minds of those readers whose letters suggest that they were genuinely concerned or puzzled. However, we have no intention of trying the case in the columns of *The Nation*. Had we thought the issue was one that could be debated in print, we would not have taken it to the courts. Every journal with a sense of editorial responsibility exercises discretion in accepting and rejecting letters for publication. Custom and common sense dictate certain criteria which are used in passing on letters as well as articles, and among these none is more universally recognized than the condition that such material must not be libelous or defamatory. Yet several of our critics seem to feel that *The Nation* was under a moral obligation to publish a libelous letter simply because the libel was directed against this journal and a member of its staff. This seems to us absurd.

In instituting this suit we are fighting for a principle that includes, but greatly transcends, our own interest. The Greenberg attack was not directed against the views of either Mr. del Vayo or *The Nation* as such; had it been we would obviously have printed and answered it. But Mr. Greenberg explicitly disclaimed any such intention. The single point of his letter, as he was frank enough to admit, was to accuse this journal and its foreign editor of acting in behalf of a foreign power—in still plainer words, of being "committed" to the service of the Soviet government.

This accusation is unquestionably the most damaging that could be leveled, in a time like the present, against any institution or person. Under the terms of recent federal and state legislation and court decisions it constitutes a criminal charge, carrying with it the threat of drastic legal penalties and endangering the reputation and earning capacity of those attacked. Such a charge is literally unarguable. Even to publish and deny it would have the effect of condoning and spreading abroad a libel which was at the same time a false denunciation. To give the name of "censorship" to our refusal to print the Greenberg letter is to distort the entire meaning and purpose of that document.

No one who has read the pages of abuse and criticism of this journal which we have published through the years will honestly accuse *The Nation* or its editors of suppressing criticism or avoiding debate on political issues. But we propose by this action to establish the right of a journal or an individual to discuss in the freest terms any issue of public interest, including the most controversial, without being subjected to the threat implicit in the Greenberg libel.

Liberals were disgusted by the tactics of Senator McCarthy; disgusted by the spectacle of conviction through vilification. But McCarthy's success is registered every day—in the campaign against Secretary Acheson, the slurring references to Owen Lattimore in the Senate inquiry, the timidity and silence of college students and professors, the disappearance from radio and screen of liberal commentators or actors whose names have appeared on unofficial "lists." This is the legacy of McCarthyism, and it continues to pile up.

One can expect, if not condone, reckless denunciation from a demagogue who has made witch-hunting his Congressional stock in trade; McCarthy and his kind are known for what they are. Is the McCarthy technique less deplorable when applied by a man or a journal that calls itself liberal? Certainly Greenberg and *The New Leader* are not McCarthys; yet the very fact that they act under the banner of liberalism gives their charges a certain acceptability. They can even venture a note of sorrow over the necessity of assailing those they would prefer to love! Greenberg went so far as to cite his seven years as art critic for *The Nation*—1942 to 1949—as evidence of his right to expose our sins. Apparently it did not occur to him that readers would wonder how he had managed to endure in silence his long relationship with a paper whose policy was then what it is now and whose foreign editor was the same man.

A time is upon us when frightened men turn with venom to crush those whose views they hate. Victims of the witch-hunt multiply, and few are in a position to fight back. *The Nation*, we need not say, is going to continue to print what it believes without asking permission of Greenberg and *The New Leader*—or of the Russians either. And when libeled in this manner, it is going to fight back—for itself, for those who cannot risk a fight, and for the freedom its opponents seem bent upon destroying.

Among the many letters received by The Nation *regarding the Greenberg suit was one by Thomas Emerson, a law professor at Yale who later wrote* The System of Free Expression, *and is regarded as one of the key architects of the progressive free speech movement. Emerson's students later included Bill and Hillary Clinton, Clarence Thomas, and Victor Navasky, who would become editor, then publisher and editorial director of* The Nation.

—

THE NATION SUIT

JULY 7, 1951

Thomas L. Emerson

Dear Sirs: Generally speaking, I am in accord with the views expressed by Mr. del Vayo in his *Nation* column. In fact, Mr. del Vayo seems to me to be one of the very few persons who is still capable of writing intelligently about foreign policy. By the same token I am strongly opposed to the views, and particularly the attitude, of Mr. Greenberg. Nevertheless, I believe that *The Nation* was wrong in refusing to publish the Greenberg letter and in suing *The New Leader* for publishing it.

I am not expressing any opinion on the legal issues. Nor am I considering the problem of an individual citizen who has been gravely injured by irresponsible smears and has no way to vindicate himself except through a law suit.

The Nation is a publication engaged in the business of discussing public affairs. The letter was written by a former regular contributor and dealt, in general, with important public issues. Under those circumstances it seems to me that *The Nation* should have met the attack in the arena of public discussion rather than by bringing suit. Resort to the courts cut off further argument and, in effect, brought a breakdown in the rational exchange of ideas. I do not think *The Nation* should have been so quick to abandon the basic principle of full discussion to which its long and honorable existence has been devoted.

As a matter of fact, had *The Nation* kept the controversy on the level of public discussion, a valuable purpose might have been served. The Greenberg letter is a perfect illustration of the irrational approach to problems of foreign policy so common in this country today. *The Nation* could have made a searching reply that would have furnished an important object lesson for *Nation* readers.

I realize that the Greenberg letter must be considered in a broad context, and that it represents an increasing tendency to oppose the expression of certain views by appeal to prejudice rather than to reason. This tendency, spearheaded by the Committee on Un-American Activities, constitutes a dangerous threat to the free expression of ideas. Under some circumstances the danger should be

combated by libel actions, but not, I believe, in this case. The facilities for discussion are available to *The Nation* in its own columns, and I think it would have done much better to slug the question out there. The democratic process implies not only that the participants will be reasonably tolerant but that they will be reasonably thick-skinned.

THOMAS L. EMERSON

New Haven, Conn.

The Greenberg suit slowly made its way through the legal system until 1955, when Carey McWilliams said he would agree to succeed Freda Kirchwey as editor of The Nation *on the condition that the magazine drop the suit. On a much lighter note, back in the pages of the magazine Manny Farber launched an attack on Henri Matisse. Apparently, no lawsuits were filed.*

—

MATISSE

FEBRUARY 9, 1952

Manny Farber

AMERICAN ART CRITICS, from Leo Stein on, have worked so hard at creating a new hierarchy of painters that to try to knock down one of their idols now is as useless as trying to chip through a bank vault with a teaspoon. Yet one must speak one's mind, and to me the recent Matisse show at the Fifty-third Street Barr and Grill spilled a scandalous secret about "the greatest master of the twentieth century." Far sketchier than it was cracked up to be, the display did touch on most of the high spots of his career, and clearly showed his long industrious progression from thin to thinner painting, both tangibly and philosophically. The inescapable revelation is that the philistines of thirty-odd years ago were nearer than they knew to the truth: Matisse may be skilful and ingenious, but only by the wildest idealistic rationalization can he be credited as a dedicated, ripened artist who has given himself over to feeling, sensuality, "love and life."

The crux of the great myth is that this magnificently endowed pagan has been the most adept of all painters in selecting and juxtaposing exotic, dynamic, gleaming colors; that he flies you close to the sun, in fact, with colors like so many bursts of jet exhaust. Trudg-

ing around through those rooms full of dead fish, heavy-breasted nudes, copper vases, flowers, fruits, costume jewelry, silk curtains, Milanese pigeons, and musical bric-a-brac, I found it a collection of embarrassingly insipid themes imprisoned in listless, lusterless, somewhat dirty tones of superficial color. There was on every hand the look of taut old icing plastered thinly over an excessively impelling surface, an icing now going vaguely ocher since the surfaces themselves are yellowing with the passage of time. And the assertive black outlines—on which Matisse has depended as trustingly as Rouault to make his reds and yellows sing—have held their power while everything else has faded, so that today the blacks overwhelm and over-darken almost every harmony. The exhibit verified a long-held hunch of mine that the jolly hedonist's glory has been felicitously created in large part by the brilliancy, gloss, and sparkle of the products of the reproduction industry. The plates in Barr's new book, for instance, are beautiful and scintillating, but hold any one of them up to its original and you will get an awful jolt.

Though miles of criticism have been published about Matisse's early use of Manet's simplicity and flatness, Monet's fragmentation and illumination of color, Cézanne's hatching, modeling, and composition—and finally of the synthesis and maturity that emerged when he picked up some decorative things from the Orient—a glance at his early trivial experiments in impressionism and post-impressionism should convince anyone that M. Mati$$e is an egocentric who cares little, and understands less, about any style other than his own. (If he is really indebted to any of his colleagues, it is to the tricky mannerist putterers who decorate cheap pottery.) Painting with a bland stroke, hardly mixing color on palette or canvas, working neatly, quickly, deftly, and a bit hygienically—like an Old World gentleman—over his "spontaneous" projects—indeed, "tickling" his way along, to borrow frenemy Picasso's devastating verb—he seems never to be deeply involved or even slightly carried away by his work. This was made pretty apparent in a two-reel film of Matisse at work released here a few years back, but nobody paid any attention to it; so the myth goes on that Matisse and sensuality are synonymous, while the latest retrospective showing of his pictures yawns with barrenness, baldness, and an inescapable faggish pseudo-sensibility.

Yet his position *fairly* far up in Western painting—say 73 on a scale from 0 to 100—is insured, I think, by both the variety of his compositions and his superb elegance and mobility as a draftsman. He moves on to a new compartmental arrangement after about three pictures, where a Breughel or a Corot spends from a decade

to a life-time on the same crowded figure eight or inverted pyramid; and his line is as much a thing of genius—if somewhat glib genius— as Cary Grant's dark nonchalant glitter. With one swift, sure, unbroken flip of the wrist he can do more for the female navel, abdomen, breast, and nipple than anyone since Mr. Maidenform.

Aside from this, what has Matisse really given the world to keep for the next thousand years? Certainly nothing more, in the last analysis, than a gigantic dose of that kind of "charm" which has enabled the butterfly battalions, during his reign, to take over almost exclusively in almost every field of creativity from the short story to the symphony, from the straight chair to the department store. The only trouble is that—as we all know but none of us admit—this charm is sterile; it is also getting dated, as are the paintings that were its source. Sterility is the key to the chapel at Vence which Matisse and everybody else call the climax and summation of his career. Here if anywhere is symbolized, in cold white bathroom tiles, cold black doodles, and cold tinted sunlight, the modern artist breakout of the ego and breakdown of technique and feeling—to say nothing of religious feeling, on which I am no authority. It is a movement in which the artist gets to say whatever he bloody well pleases with an oversimplification and rapidity that make one yearn for the distant era when craftsmanship was so complex that you started at the age of nine as an apprentice, learning to mix colors, prepare panels, and so on. The chapel has naivete, "charm," and a confident slickness; it also does things with filtered light that are breathtakingly pretty. But is the prettiness valid or vulgar, and is this church designed for the worship of God or Matisse?

Henri Matisse never seems to have sweated over a work long enough to give it deep values, plastic or human. It will be said in rebuttal that Matisse himself has never pretended to be more than a nice old rocking chair of an artist, whose goal was to soothe the soul with a pure, calm, equilibrated art. The impoverished surfaces, the absence of rich color chords, the lack of muscle, the lack of heart, make even this claim appear questionable.

No account of the 1950s would be complete without at least a cameo appearance by Richard Nixon, who was about to be inaugurated as vice president of the United States. At issue were his thoughts on a mural by Anton Refregier. The McCarthy witch-hunts were far from over, which is perhaps the reason that the writer of this piece thought it prudent to use a pseudonym.

DICK NIXON: ART COMMISSAR

JANUARY 10, 1953

San Francisco

"George V. Sherman"

THE BUSINESS OF rooting out the Communists and Communist sympathizers who infest the federal government should be fairly difficult—there are so many of them, according to the Republican press. But it should not be difficult at all to rid our federal buildings of Communist art. For one thing, no trial is necessary. And for another, no less a person than Vice-President-elect Nixon himself has already labeled much of that art as Communist.

As long ago as July 18, 1949, Mr. Nixon, then a member of the House, wrote to C.E. Plant, past commander of an American Legion post, regarding the paintings by Anton Refregier in the Rincon Annex of the San Francisco post office:

> I wish to thank you for your letter as to whether anything can be done about removal of Communist art in your Federal Building. . . . I realize that some very objectionable art, of a subversive nature, has been allowed to go into federal buildings in many parts of the country. . . . At such time as we may have a change in the Administration and in the majority of Congress, I believe a committee of Congress should make a thorough investigation of this type of art in government buildings with a view to obtaining removal of all that is found to be inconsistent with American ideals and principles.

In the matter of the Refregier murals Mr. Nixon's stand has powerful backing. Gordon A. Lyons, department adjutant of the California American Legion, in a letter to California Congressmen dated August 6, 1951, declared that the same view had been expressed by the American Legion, the Veterans of Foreign Wars, the Associated Farmers of California, the Sons of the American Revolution, the Republican Women's Council, the San Francisco Chamber of Commerce, the Society of Western Artists, and various other groups.

There is one thing, however, which may slow up the elimination of Communist art. That is the fact that the major part of the Re-

publican press, which has complained for so many years about Communist art in federal buildings, is now generally silent on the subject. For example, after the Nixon letter quoted above was published by *The Argonaut,* a San Francisco weekly magazine, on November 14, a staff worker in one of the three major wire services, each of which received a copy, wrote a story about the letter and controversy which was air-mailed to the New York office of the wire service. This story, however, never appeared. Even the four San Francisco daily papers, all strong supporters of the Eisenhower-Nixon ticket, let the subject severely alone, though earlier they had eagerly taken part in the Refregier-murals controversy. They continued to let it alone, as did the wire services, when *The Argonaut* on November 28 published the Lyons letter under the heading "Support Grows for Nixon in Ousting Red Art." And they also reserved comment after the staunchly Republican *Argonaut* took them to task on December 19 in a lead editorial entitled "The S.F. Daily Press and the Refregier Murals."

The reason for this evident conspiracy of silence is an interesting speculation. It could scarcely be unwillingness to offend Refregier, for though he won the Hallmark Greeting Card Company's annual $2,000 prize for a Christmas-scene painting last month, he is still the subject of a seven-page dossier in the files of the House Committee on Un-American Activities and thus by Congressional standards fair game, at least as a "fellow-traveler." It certainly could not be that the Republican press, surfeited with denunciations and viewings-with-alarm, feels that with the Republicans in power communism is no longer a danger and Red art no longer appealing.

Could it be fear of offending Mr. Nixon? Presumably the main office of the wire service queried Mr. Nixon about the story. Presumably also it would have used it if he had not objected. But to suppose that Mr. Nixon was opposed to publication of the story is to suppose that he has changed his mind about the murals, which implies either that he can no longer distinguish red so clearly as in the days of the Hiss trail or that his vision was cloudy then and is improving as he finds himself one heartbeat from the Presidency. Whatever the cause, his change of mind would be news, worth at least a stick of type in any paper or wire service that was not chiefly interested in sparing him embarrassment and thus sparing Eisenhower, who has already been sufficiently embarrassed by his teammate.

Perhaps the most plausible explanation for the silence imposed on the press is that Mr. Nixon's flat statement about Communist art in federal buildings was made solely for campaign purposes, in the

intcrcst not of the country but of his own advancement, and that
being now safely in office, he does not wish to have the matter
brought up again.

*A more comprehensive view of the Refregier affair and the Republican
assault on art was provided by the historian Matthew Josephson, whose
books included from* The Robber Barons *and* Sidney Hillman
Statesman of American Labor.

—

THE VANDALS ARE HERE
Art Is Not For Burning
SEPTEMBER 26, 1953
Matthew Josephson

Your writers, your artists, and your composers . . . are not going to be
conformists in any sense, and in my view it is a good thing they are
not, too. They are the people that, when they are really good, carry
the ball for civilization.—*Henry Allan Moe, director of the J.S. Guggenheim
Memorial Foundation, at hearings of the House Committee to Investigate Tax-
exempt Foundations, Dec. 11, 1952.*

THE TROUBLE IS that our triumphant Babbitts, in this time of witch-
hunting and scapegoats, have at last turned their attention to art
and culture. America's poets and artists used to lament that their
works were neglected by the hard-headed type of citizen who ran
the chambers of commerce and the American Legion posts. Now
all this is changed. Amid the delights of waging the cold war at
home, Babbitt and his political allies have been discovering books
in libraries, pictures in museums, and murals on the walls of public
buildings, and have scented heresy on every hand. This new interest
in belles-letties lately reached such a pitch that even Mr. Eisenhower
was led to reproach our overzealous culture seekers. But apparently
they will not be denied: after studying the movies, radio, comic
strips, and twenty-five cent thrillers, they have begun to move in on
art.

While our art schools, museums, galleries, and studios, not being
media for mass communication, have so far been spared the kind

of policing that has improved the movies and radio beyond all rec-
ognition, individual artists have lately been coming under fire.
Those who long ago contributed to medical aid for Loyalist Spain
or were associated with similar organizations listed by government
hindsight as "subversive" have been denounced as unfit to have their
works exhibited to the public view or to be awarded prizes in com-
petitions.

In Congress, Representative George A. Dondero, Republican, of
Michigan, a lawyer admittedly without training in aesthetic matters,
has been carrying on a one-man campaign against modern art,
especially against artists who work in the abstract or use effects of
distortion—indeed, against all who have advanced beyond mid-
nineteenth-century canons of taste. "Modern art is communistic
because it is distorted and ugly, because it does not glorify our beau-
tiful country, our cheerful and smiling people"—such is the burden
of Mr. Dondero's speeches. He has not suggested that exponents of
the new techniques should be placed in the penitentiary, but he has
urged that art critics in the newspapers "who glorify vulgar, per-
verted modern art" be subjected to control. The pages of *The Con-
gressional Record* are spread with the names of hundreds of our
leading artists and art critics who he charges are "enemies within,"
breeding "dissatisfaction" or spreading "sinister ideas," and in his
opinion "opposed to our government."

Of course remarkably similar phrases were once uttered by a frus-
trated Austrian artist and sometime paperhanger who denounced
modern painters as "un-German," "degenerate," and "bolshevistic."
The Nazi Brown Shirts then made bonfires of some pictures they
found offensive and sold abroad those of greater market value.
Friends of theirs who were devoted to old-fashioned art took over
the jobs of museum curators and art teachers guilty of having a few
ideas. Likewise, though out of different social motives, the Bolshevist
dictator, Stalin, censured modernism in art and called for the rep-
resentation of "ideas of patriotism." According to a study made by
Alfred H. Barr of the Museum of Modern Art ("Is Modern Art Com-
munistic?" *New York Times Magazine*, December 14, 1952), a most
promising Russian school of modern art was suppressed by official
censorship in the 1920's, and its works supplanted by paintings in
the manner of Repin.

The Roosevelt Administration launched one of the most enlight-
ened art programs ever attempted by any democratic government—
first through the WPA, later under the federal government's Section
of Fine Art—and artists who benefited were subjected to a minimum

of official censorship. After the war, under Truman, the State Department paid $50,000 for 117 paintings by contemporary Americans, which it planned to send as a traveling exhibition through Europe and South America. The purpose was to tell the world that ours was a nation not of mere money-grubbers but of free men and lovers of art. At once the Hearst newspapers, certain radio commentators, and some members of Congress assailed this enlightened venture. Most of the artists whose works were to be exhibited belonged to the modern movement that had been developing all over the world in the fifty years since Cézanne. This was scandal enough to cause the dispersal of the collection after one showing in the spring of 1947 and to block any further effort by the government to sponsor international art exchanges. Behind this unhappy incident lay the jealousy of a group of artistically reactionary painters and commercial illustrators, the American Artists' Professional League, whose works had not been included in the State Department's traveling show. Their denunciation of their successful competitors as "subversive" started the cold war in the art world.

Since then, Representative Dondero of Michigan has made the Menace of Modern Art his favorite theme, and curiously enough he has shown considerable foreknowledge of goings-on in New York art circles, such as recent plans for international artists' gatherings under the auspices of UNESCO. He has "smeared" the Artists' Equity Association, a non-political national guild of 1,400 artists, the Museum of Modern Art, the Whitney Museum, and many other groups and institutions as pro-Communist and un-American. Last year one of his bursts of scattershot was directed at the very citadel of traditionalism, the Metropolitan Museum of Art. For in the winter of 1950–51 the Metropolitan had at long last opened its halls to a show of contemporary American painters of *all schools* and in the following year to a similar show of living sculptors.

Again a number of our more backward-looking artists, officers of the National Sculpture Society, went into action and staged a public protest at the showing of so-called "left-wing" sculptors in the Metropolitan and the award of prizes to them. Some retired admirals and doctors added their names to the artists' petition for the rescue of the grand old Metropolitan from a bunch of wicked modernists— in the name of the "sound normal American people." It must be noted that several of the most distinguished members of the National Sculpture Society, namely, Paul Manship and James Barle Fraser (former presidents) and Cecil Howard, strongly opposed this

action. It was engineered by such people as Wheeler Williams, Donald de Lue, and Mrs. Katharine Thayer Hobson, who invariably equate communism with modern art. Significantly their charges against the show and their totalitarian vocabulary ("wholesome art" against "subversive art") were echoed immediately afterward in a Dondero speech in Congress.

Recently self-styled patriotic groups have demonstrated against modern art in places as far apart as California, New York, and Indiana. At a city-sponsored art exhibition in Los Angeles, in 1951, the jury's award of second prize to an impressionistic picture of a sailboat bearing an emblem thought to resemble the hammer and sickle was used by the local Philistines as the occasion for a near-riot which was followed by an alder-manic investigation. The offending insignia turned out to be the regular trademark of a purely capitalistic ship-building concern, and the Los Angeles chuckle-heads were covered with ridicule. They might as well have rioted—as one witness remarked—against the new moon, which when crossed by a wisp of cloud might appear to the idiot's eye to be making Communist propaganda.

More ominous are the attacks on Anton Refregier's large mural paintings portraying the history of California in the lobby of the Rincon Annex Post Office in San Francisco. In this instance you can fairly smell the bonfires of the Brown Shirts being ignited in America. Criticism of the murals has been voiced for several years, ever since they were unveiled in 1949. It reached a climax on March 5 of this year, a few weeks after the Republicans took control of Congress, when Representative Hubert Scudder, Republican, of Sebastopol, California, introduced a resolution calling on the federal government to remove all the twenty-nine Refregier murals from the walls of the post office. As grounds for this unprecedented action Mr. Scudder asserted that the murals were "artistically offensive and historically inaccurate; and . . . cast a derogatory and improper reflection on the character of the pioneers and history of the great State of California." In support of these charges he cited the opinion of such art scholars as the Associated Farmers, the D.A.R., the American Legion, the Native Sons of the Golden West, and the Society of Western Artists—the last being a group made up largely of commercial illustrators. Refregier's murals are painted directly on the walls in casein tempera. Their "removal," according to experts in such matters, would mean their destruction.

Refregier won the commission for the Rincon Post Office murals

in 1940 in a nation-wide competition conducted by the federal Section of Fine Art, in which eighty-two artists submitted sketches and plans. Execution of the murals, which extend for 240 feet around the lobby of the big post office, took five years and brought the artist a fee of $26,000, the largest ever paid by the government for such work. Refregier is widely esteemed as one of the ablest and most resourceful of contemporary American artists, and his studies of California, are considered by an informed art public to approach in dynamic effect the work of the great Mexican muralist, Orozco; they are "some of the finest, if not *the* finest murals anywhere in the United States," Dr. Ernest Mundt, director of the California School of Fine Arts, has testified.

Half-French, half-Russian, Refregier was born in Moscow in 1905, brought to France by his parents when he was fifteen, and then, several years later, to America. He studied at the Rhode Island School of Design and also in Germany and France. By the time he began to work at his craft in New York the great depression was upon us. It is difficult in these days of armed prosperity to convey the mood of desperation in which artists young and old struggled to exist by purveying their "luxury product" during the years when millions of practical workers were idle and hungry. Like others, Refregier was aided by the WPA art program, which allotted him $23 a week. In the climate of opinion of the late 1930's it was natural for him to become "socially conscious"—pro-New Deal and pro-labor. Many great artists of the past have glorified absolute monarchs or painted in the service of the church. Others, like Goya, Daumier, Courbet, and Picasso, have been on the side of the popular revolutions of their time. Refregier absorbed the new disciplines of the "abstract" and "primitive" schools, but his direction has been toward an art imbued with social criticism and protest. And like most American artists he has desired to stress democratic and human values rather than the acquisitive virtues. He has long specialized in the "public-art" of the mural, for he has a flair for historical research, also much humor and the spirit of irony characteristic of the artist with a social conscience. When he won the award for the San Francisco murals, he was already nationally known for his wall paintings in hospitals, business buildings, steamship salons, and hotels.

Work on the California pictures was begun in 1941 but was interrupted by World War II. In 1946 Refregier stationed himself on a scaffold in the lobby of the Rincon Annex Post Office and painted steadily for two years, in full view of the public. A man of verve, he greatly enjoyed exchanges, as he worked, with his "sidewalk super-

intendents," some of whom came to jeer, while others offered suggestions—about such events as the San Francisco earthquake—that he was able to put to good use.

He was enthralled by the story of California, surely the most fabulous of all our states, its brief history a telescoped dramatic parable of America's destiny. His pictures show the century of pastoral slumber under the Spanish missions; then the gold rush, the vigilantes, and the flood of settlers; the coming of the railroads, the rise of large-scale farming, the great labor and race conflicts. It is a world of beauty and violence, of man as builder and destroyer. In the earlier panels are scenes touched with a tender humor (Pioneers Receiving Mail); the artist has caught the sadness of the pioneers as well as their bold achievements. One is penetrated with a sense of the stormy past and feels how the artist has related this clearly to the present. "A mural painting must have something to say," Refregier points out. He has skillfully adapted the techniques of the modern school to the uses of history. Our tastes may change; painters may now be retreating from "naturalism" toward the abstract or symbolic. But these emotionally charged, emphatically colored murals, so dynamic in composition, surely represent a high point in the prewar movement toward an art of "social content."

Patriotic Mrs. Grundys have found but three or four of the twenty-nine panels tendentious or controversial: the anti-Chinese riots of the 1870's, the Mooney case, the San Francisco waterfront strike of 1934, and a United Nations panel. Some complained that the mission priests were too fat, the pioneers too thin. From my own readings in California I judge Refregier to have been tactful enough and to have shown respect for his subject. Did not the historian H.H. Bancroft tell us of the long years of California's "moral, political, and financial night" after 1849? Refregier might have included the pitiless railroad baron, Huntington, or the settlers' fight against the land-grabbers, as described in "The Octopus" by Frank Norris. But one who works in the field of "public art" must adjust himself to the conditions of the building, the feelings of its architect, and the views of his employer—in this case, the federal government. So Refregier "slenderized" his pot-bellied priest, regretting the loss of an amusing detail. Veterans' groups protested at the presence of a man with a V.F.W. cap among the 1934 strikers—as in newspaper photographs— and this too was painted out. A plan to incorporate a gigantic head of President Roosevelt in the final panel on the founding of the U.N. was also dropped very reluctantly at the demand of the federal authorities. In the end, after ninety-one conferences, or inspections,

everything was approved by the government's Commissioner of Fine Arts and the work was paid for as agreed.

Nevertheless, after the unveiling of the completed murals San Francisco's legionnaires became vocal. And on January 18, 1949, Representative Richard Nixon wrote to an officer of a San Francisco American Legion post a letter on the subject of "objectionable art" in public buildings. (He tried to keep this letter out of the newspapers, but it was cited in *The Nation* for January 10, 1953) In it he said: "At such time as we may have a change in the Administration . . . I believe a committee of Congress should make a thorough investigation of this type of art with a view to obtaining removal of all that is . . . inconsistent with American ideals and principles."

* * *

What was objected to, as Refregier himself remarked at the time, was that he had pictured a few unhappy passages of California history without resort to the "big historical lie." His typical critics, he said, would have liked him to paint his pioneers "dressed in the Hollywood fashion, shaven and manicured," and guided by a "spirit" of something or other, perhaps oil or grapes. "Had I painted the murals when I won the competition, in the calmer days of the Roosevelt Administration, there would have been much less fuss, and the only question would have been—did I, as an artist, perform the job well?"

But the change has come. Mr. Nixon's party is in the saddle, and Mr. Dondero is now chairman of the House Committee on Public Works. The intellectual-moral achievements of the Roosevelt-Truman era are now to be liquidated; its paintings along with its social plans are to be consigned to the rubbish heap. The "inquisition" of New Deal artists and their works was begun promptly after the conservatives took over in 1953, with Anton Refregier as first defendant. After Scudder's resolution was introduced in Congress, hearings before a subcommittee of the Committee on Public Works were held on May 1.

Most people in the American art world were filled with shame by the news that the Refregier murals were to be put on trial and perhaps destroyed at the will of a group of self-styled patriots. What many had long feared was happening: the Vandals had come to sack our treasures of art. When a book is burned, thousands of copies are left. But destroy a great painting and its likeness may never be seen again. This time a vigorous defense action was quickly prepared by Artists' Equity in conjunction with the country's leading art associations and museum directors. In cosmopolitan San Francisco decent people were fully aroused to the danger. With Dr. Grace M.

Morley, director of the San Francisco Museum of Art, as informal secretary, a Citizens' Committee to Protect the Rincon Annex Murals was formed and support for it obtained from the city's three art museums, its wealthy art collectors, its business and professional leaders, and the daily *Chronicle.* Representing the committee, Thomas C. Howe and Chauncey McKeever went to Washington to plead for the preservation of Refregier's murals at the hearings. A representative of the American Federation of Arts, in behalf of 390 museums and college art departments, also appeared for the defense. John Hay Whitney, on behalf of the Museum of Modern Art, wired his protest at the proposed "act of vandalism," which would dishonor the nation. The London *Times* voiced its disgust at this latest atrocity of the American heresy hunters.

* * *

Representative Scudder, however, reiterated his condemnation of the artist's distorted figures, "cadaverous, soulless pioneers," and "sadistic" scenes of riots, earthquakes, and strikes. Why were there not more such "beautiful things as wine, cattle, and grape-growing?" asked the Congressman from wine-raising Sonoma County. Against him the testimony of experts in California's history was calmly presented to show that Mr. Refregier, in his studies of the padres and pioneers, had reproduced with great accuracy the impressions of old engravings and early photographs; Professor George R. Stewart, California historian and novelist, declared that he had been "remarkably sensitive in his feeling for early American physical types." The Democratic Representative from San Francisco, John Shelley, commenting on scenes of mob violence, said, "It's history and you can't change it." As a Roman Catholic he found nothing offensive or anti-clerical in the murals.

Scudder and the American Legion delegation objected to the picture of a Russian representative as one of the founders of the U.N., to a Soviet flag placed among the others, and even to a man wearing a red necktie! Refregier's past membership in various organizations listed by the Attorney General as "subversive" was also cited as cause for the "removal" of his wall paintings. Above all, Refregier's accusers insisted that he had used "subtle ridicule" in painting the U.S. representative at the United Nations as if he had an ass's ears extending from both sides of his head. These objects, green in color, proved to be canopies of laurel hung between the square columns of the U.N. rostrum at San Francisco, as originally designed by Jo Mielziner and sketched at the time, 1945, for *Fortune* magazine, by Refregier, its artist correspondent.

To all such charges Representative W.S. Mailliard, Republican, of

San Francisco, answered that Congress should not be moved to drastic action in this case by the opinions or prejudices of special groups having no competence in matters of art; though some might not approve of Mr. Refregier's ideas, authorities in the field had testified to the artistic value and historical truth of his murals, which should be treated as a public trust; in any case, he urged, we must not turn this country into a state like Communist Russia, where artists are not allowed to function unless they conform to the views of the ruling party.

The enemies of art were plainly taken aback by the stout defense they encountered, their ignorance and folly had been laid bare. Moreover, the subcommittee's chairman, J.C. Auchincloss, of New Jersey, conducted the hearings with great fairness. The "Vandal resolution" is being studied, and while it may be reported favorably by Mr. Dondero's larger committee, its passage through both houses of Congress may take longer than its advocates reckoned. But liberals of the art world will need to be alert and energetic if they would not have our painting and sculpture degraded to the level of calendar art.

Are we to conceal our beliefs of yesterday, "rewrite" history, curtain the paintings of another decade—as the New School for Social Research has done with its Orozco murals—because one political party rather than the other squeaked through at the polls? Against such counsels of intellectual and moral panic, the "trial" of Refregier's pictures has brought forth courageous answering voices, as in the statement by Dr. Ernest Mundt to Mr. Scudder: "If the spirit of these murals runs counter to the tastes of some individuals at this particular moment of history, please do not forget that the great art of all ages soon stands above the issues of the day. Neither you nor I would have wanted some authority in the past to have removed the frescoes of Michelangelo or the murals of Giotto because they disagreed with some aspect of them. The world of the human spirit and its artistic record would have become unforgivably poorer."

Our Babbitts who have come blundering into the art world are trying to turn back the whole current of art, which for fifty years has been flowing toward new areas of knowledge and expression. Our conservative artists know well that the modernists, so-called, including Refregier, would be censured and suppressed in Communist Russia as "bourgeois." Why, then, do they extol a Dondero for uttering his characteristic nonsense about the new art movements? In art circles it is a matter of common knowledge that Dondero has been supplied by a few more or less anonymous artists with information intended to injure the faction they are opposed to.

* * *

In their hard struggle for survival artists depend a good deal upon the periodic award of prizes and teaching appointments to supplement the money they receive from the sale of their pictures. Of late the academic fellows have definitely been losing favor with the growing art public in America. A few of the more embittered and frustrated ones have attributed their misfortunes to "subversive plots" or "sinister" influences. Artists have fought among themselves over aesthetic theory for centuries, but never before has one faction exploited public hysteria and the ambitions of demagogues to destroy its professional opponents.

A clue to the mentality of these retrograde artists is given in an article on them by Alfred Frankenstein in the San Francisco *Chronicle* of March 23, 1952. The so-called Society of Western Artists, it will be remembered, alone among such organizations, gave support to the Scudder resolution. Its leading spirit is said to be John Garth, a mural painter who has declared that many years ago he witnessed the hatching of a conspiracy to capture the American public by a group of alleged "subversive" painters. (Have not artists conspired in every cafe of Paris and New York to "conquer the world"?) Their object, Mr. Garth insists, was to "confuse" and "corrupt" in order to prepare the way for revolution. That the Nazis and the Kremlin have held the same hostile view of artistic experiment only shows, according to Mr. Garth, that they were "wise" and that their methods of repression were "nationally strengthening." The former masters of Germany were "social experts," in his view, and the effort to combat a "disintegrating ideology in every social structure is right." Here we meet again the totalitarian program for the state control of a people's culture. Nor is there any doubt that it has begun to attract certain political personages in Washington. We seem to be losing many freedoms nowadays. Will our artists lose the freedom to paint as they please?

John Berger who, at the time he wrote this article, was the art critic for England's New Statesman and Nation, *began his career as a painter and an art teacher. Berger, through his essays on art and politics, and his tireless activism, has become a leading cultural figure on the international left. He has written a number of novels (one of which,* G, *won the Booker Prize), as well as the groundbreaking book* Ways of Seeing, *which was based on the BBC television series of the same name. He now lives in an agricultural community in the Jura region of France.*

—

THE CULTURAL SNOB

There Is No "Highbrow" Art

NOVEMBER 5, 1955

John Berger

London

IN THIS CENTURY the out-and-out social snob has become rare, or anyway is more inhibited in his behavior. The cultural snob, on the other hand, has multiplied and is more and more bare-faced in the expression of his snobbery. There are of course many other current forms of snobbery, besides the cultural variety: car snobbery, sports snobbery, sex snobbery, and so on. But what makes culture snobbery a stranger phenomenon than the others is the fact that one might reasonably assume that an interest in art or literature or history would purge the person concerned of such pettiness. It is easier to understand someone claiming distinction because he patronizes a particular hairdresser than to understand somebody doing so because he appreciates the greatness of Baudelaire. Snobbery is compatible with the hairdresser's world; it is incompatible with Baudelaire's—or Fra Angelico's—or Picasso's. The explanation of course is that the snobs don't appreciate Baudelaire; they appreciate what they think is their appreciation.

On the whole, however, the culture snob is not concerned with the art of the past. (That is the field of the travel snob: "I just felt *quite* uneducated until I'd been to Rome.") The playground of the culture snob is preeminently "Modern Art." The phrase "Modern Art" implies something new, separate, and above all smartly, uniquely up-to-date. It suggests that anybody who has any doubts about it is as *demode* and dowdy as the elderly couples who still believe in chaperones.

The absurdity of this attitude is emphasized even more strongly if one remembers the obvious fact that all art has been "modern" in its own day, and the equally true but less obvious fact that any contemporary art, if it is integrated into its society, if it really communicates experiences worth communicating, will naturally, without any song or dance about it, mean more to the citizens of that society than the art of the past.

* * *

Alongside the worshipping of contemporary art just because it is contemporary, has grown up the belief that all great art is immortal. This is only a half truth. The greatest works do remain moving, interesting, great. But at the same time their meaning changes and in that change they lose some of their original urgency. A Chinese pottery horse, a Greek statue of an athlete, a Renaissance painting of St. Francis can never be appreciated by us *in the same urgent way* as they were appreciated by their original public. It would be truer to say that great works undergo a resurrection, rather than that they are immortal. The belief that they are immortal, however, is the second line of defense of the Modern Art snobs and self-deceivers. First they claim that it requires special sensibility, imagination, and breadth of mind, to appreciate Modern Art; and secondly, in order to justify their own possession of these gifts even further, they claim that in the future the art which they champion now will be seen to be great by the world at large; thus they allot to themselves the noble role of midwife to immortal children.

Now I can see the reader raising two possible objections at this point. First he may quote examples of genius that *have* been appreciated only by small minorities, in their own lifetime—Rembrandt, Van Gogh, Keats. Secondly, he may say: "Why make so much fuss about it? Surely there have always been people who have pretended to appreciate works of art more than they really did. Isn't the lunatic fringe a constant of human nature?"

The answer to the first objection is that the examples of neglected genius, all of which have occurred only during the last 300 years, are the *exceptions* in the history of human culture. As soon as one admits the idea of the neglected genius, one also admits that the tradition of art has broken down—either within itself, or in its relationship to society. Also, the few who did appreciate Rembrandt, Van Gogh, or Keats, did not claim any particular superiority for doing so. The answer to the second objection is that the humbug and self-deception which surrounds so much Modern Art is not in the least important, but unfortunately it has affected art itself and has led to several completely false ideas which are held by many outside the snob-circle. The most dangerous of all these ideas is that of the iron division between the "highbrow" and the "lowbrow."

I have not sufficient space to prove in detail how a great deal of highbrow and lowbrow culture derive from exactly the same attitude of life and differ only in their degree of self-consciousness. Yet as soon as one allows the possibility of this being true and as soon as one has accepted the fact that it is really as easy to be sentimental about a cactus as it is about a kitten with a pink ribbon around its

neck, one finds oneself on fertile ground for new thought and ob-
servation. Obviously some of the serious art of our time does gen-
uinely require specialized appreciation. I don't expect the average
engine driver to enjoy Juan Gris—though so much the worse for
Gris. Obviously, also, there are certain popular works with a mass
appeal (in this country, for example, a Danny Kaye film) which are
neither stereotyped nor banal. But on the whole the flagrantly high-
brow and the commercially lowbrow share the same fundamental
values, while the greatest figures—Chaplin, Einstein, Picasso—can
be fitted into neither category and disturb those with vested interests
in both.

The main characteristic of lowbrow art in comics, magazine stories,
television programs, films, and so on, is that it flatters its public by of-
fering them a context for fantasies or day-dreams in which they can be
tougher, luckier, richer, more adventurous, or more highly sexed
than they actually are. The organization of commercial culture has
been called justly The Dream Factory. The viciousness of it lies in the
fact that the desires and aspirations which it sows and nurtures have
little or nothing to do with world tasks which so desperately need to
be undertaken. Far from encouraging psychological adjustment, the
prevention of war, racial tolerance, the use of science for peace, the
establishment of the true equality of man, commercial culture either
directly discredits such aims or distracts attention away from them by
encouraging every form of petty shortsightedness.

Yet highbrow art—or a great deal of it—does exactly the same
thing. It also flatters its public—and its practitioners—by offering
them a context for fantasies. Only the ingredients of the fantasies are
different: the fruits of false introspection rather than of false action;
cosmic megalomania rather than crude aggression; the pointless
satisfaction of pure "self-expression" rather than that of adolescent
sex; the comfort of having rare "sensibility" instead of that of gang
prestige.

My own subject is the visual arts, but examples of what I am describ-
ing abound in literature and philosophy as well, disguised only by
the most extravagant bluff. Recently there was an exhibition in Lon-
don at our leading "avante-garde" gallery of the works of a highly
fashionable French artist called Jean Dubuffet. I quote from the
catalogue:

> He first made use of tar, pitch and white lead which he stuck in thick
> layers on the props of fiber plaster. His pictures began to weigh about
> twenty kilos—one of their more secondary characteristics. On these

surfaces he drew rudimentary faces. . . . Some of these asphalt pictures, in which a handful of gravel was thrown on to the tar, looked, as his detractors claimed, like a footpath, but the Milky Way itself also looks like a footpath. Material, as cosmic as it was urban, casts its spell. Jean Dubuffet began to evoke the mystery, strangeness, wit, metamorphoses, effervescence and retraction of the substances of which the world is composed. [Later] he went on . . . to more barren ground where only those with the liveliest imagination could follow. . . . As one looked at them [his new works], one could let one's thoughts wander freely through their involutions and almost have the feeling one was on the point of discovering in them the secret of the movements of the universe. [In his sculpture, mostly made out of sponges, he included] objects [letters, inkpots, watches, etc.,] which might be used for invoking the experience of a new kind of witchcraft . . .

Samuel Adler, in 1953 (and perhaps still) an instructor in fine arts in the Division of General Education, Washington Square College, has written: "My picture *Invocation* is but one moment out of my pattern—or perhaps the 'all' of it, carried to its own moment of realization. I cannot say what it means, nor in the final analysis should I wish to. I can only hope that it is . . . all things that have been the world, the world from the beginning to the end of time."

Another American teacher and sculptor, Johnfriend Bergschneider, writes: "For some time I have been fascinated by the nest of the hornet, not because it is a nest as such, but truly because of its form, which is found elsewhere in nature, as in the case of the womb or the pear."

In the official twenty-fifth anniversary book of the Museum of Modern Art, a painting by the well-known Pollock is reproduced in color, with the following comment:

His painting confronts us with a visual concept organically evolved from a belief in the unity that underlies the phenomena among which we live. . . . An ocean's tides and a personal nightmare, the bursting of a bubble and the communal clamor for a victim are as inextricably meshed in the corruscation and darkness of his work as they are in actuality. . . . The picture surface, with no depth of recognizable space or sequence of known time, gives us the never-ending present. We are presented with the visualization of that remorseless consolation— in the end is the beginning.

There are hundreds of similar passages which could be quoted. I am not suggesting that all the paintings in the Museum of Modern

Art are worthless. I am prepared to agree that serious artists often have to suffer nonsense being written about their work—and that sometimes they write it themselves. It is even beside the point that in the examples I have just given the works discussed *are* as footling as the quotations suggest. The mere fact that thousands of such sentences are written, handsomely published, and taken absolutely seriously by men of responsible reputation, that their pretentiousness, irrationalism, obscurantism, and sheer hoodwinking are never even questioned within the highbrow elite—this by itself is enough to show the values on which rest this elite's claim to be cultural leaders. I do not believe that such a far-reaching *traison des clercs* has ever occurred in the history of culture before.

Yet the arbitrary division between highbrow and lowbrow is false, not only because their present taste and values ultimately derive from exactly the same type of irresponsibility, from the same inability to look the world in the face, but also because it is based on a misreading of history.

It is true that even when a tradition of art has been integrated with its society there have been—and there probably always will be— different standards of appreciation. A minority, made up of artists themselves and those who have an unusually developed visual sensibility, will tend to look at works from the point of view of the artist. That is to say, a large element of their appreciation will come from their imaginative identification with the artist, from their awareness of how he has solved esthetic and technical problems which he has faced. The majority, on the other hand, will identify themselves not with the artist, but with the content of the work. They will applaud not the process of creation but the result. This difference, however, is not the same as that between highbrow and lowbrow. Both these attitudes of appreciation are necessary to one another. If the first "specialist" appreciation exists without the second, art becomes increasingly concerned with its own technical and subjective problems and so eventually sterile. If the second "popular" form of appreciation exists without the first, art becomes only concerned with what is said—at the expense of how it is said—and so ends up by being banal.

This is precisely what has happened today, and will continue to happen so long as highbrow and lowbrow taste are directed toward *different* works, so long as a mass and an elite, both demanding the same negative escape, can only pride themselves on their apparent differences. Nor will all the art-appreciation lectures or university courses in the world break the vicious circle. It will only be broken

by a society which is consciously united by a positive, realistic, satisfying sense of purpose.

Walter Goodman, described in his author's biography as "a freelance writer with a penchant for wiretapping the wiretappers of this world," later became an editor at the New York Times, *a member of its editorial board, and its television critic. Here, he provides a glimpse into the dark side of the world of art dealers, in this case the Wildenstein Gallery, which was later accused of colluding with the Nazis to obtain Jewish art collections in Paris.*

—

HUGGER MUGGER IN THE 57TH ST. GALLERIES

JULY 14, 1956

Walter Goodman

ONE MORNING IN the summer of 1954, Emanuel J. Rousuck, vice president of the Wildenstein Galleries—one of the largest international art dealers in the world—received a visit from an old friend, John G. Broady. Now, one might have expected that the entry of Mr. Broady, a private detective who was soon to be proclaimed the nation's foremost wire-tapper, into the rarified atmosphere of Wildenstein's richly appointed East 64th Street salons would have caused at least a small explosion. But the Messrs. Broady and Rousuck had apparently long since achieved a chemical compatibility. In the course of their eight-or nine-year acquaintance, private detective Broady had performed numerous services for Mr. Rousuck. As the latter himself recalls: ". . . from time to time he checked on various people for me, got information for me. When I wanted to get the pedigree of a man or something, he would find out as to what he was and so forth."

On this particular morning, Broady made a point of going to the men's room after the amenities of greeting had been completed—leaving his briefcase behind on a chair in Mr. Rousuck's office. When he returned, he strode to the briefcase, snapped open the lock, accomplished some rapid technical maneuvers and played off for the man of art a tape recording of every word that had been uttered in the office during their brief separation. At the conclusion of this dramatic offering, Mr. Rousuck recalls, his friend advised him

that "it was a very good thing to get information from time to time
. . . and it was perfectly legal."

Mr. Rousuck accepted this statement at face value, but he let the
opportunity pass anyway. Some weeks later, however, after Broady
had repeatedly reminded him of the resource which was, so to
speak, going untapped, the art dealer admitted to the private de-
tective a large curiosity about the operations of an eminently suc-
cessful rival named Rudolph Heinemann. "Do you think you could
get me the information as to what has been going on?" he inquired.

Broady did indeed think so. As a matter of fact he had been
tuning in on Mr. Heinemann's phone calls for the preceding eight
months from his wiretapping headquarters at 360 East 55th Street.
Mr. Heinemann, whose residence at the Ritz Towers put him within
the compass of Broady's extensive East Side operation, is a promi-
nent art expert and dealer who works closely with the Knoedler
Galleries, Wildenstein's arch competitor. With a host of important
and intimate contacts in art centers around the world, Heinemann
is able to lay his hands on valuable pictures for Knoedler to dispose
of at a substantial turnover. As the *nouveau riche* in New York these
days far outnumber the *vieux riche* in Europe, a seller's market exists
here for objects d'art. The problem is getting the merchandise. The
man who can track down and obtain the most desired paintings is
an important man. That Mr. Rousuck should have taken so personal
an interest in Mr. Heinemann's telephone conversations was a trib-
ute to the latter's connections.

Once each week after the agreement had been made, a man
named Louis Arion—another friend of Mr. Rousuck—delivered to
the Wildenstein vice president a record wrapped in a brown paper
package, for which Mr. Rousuck paid "$125 or $150; I don't recall
exactly." The art dealer took the disc home with him and played it
on a phonograph purchased especially for these weekly occasions.
He listened in on conversations in English, French and German. He
heard Mr. Heinemann discourse with Gelbert Kahn, a well-known
patron of the arts. He intercepted many of Heinemann's conversa-
tions with the Knoedler Galleries, as well as with his stock broker
and ticket agent. Once Rousuck called Heinemann himself just for
the satisfaction of hearing his own voice on the next weekly record.

This Heinemann-to-Broady-to-Rousuck arrangement lasted until
February of last year when the 55th Street wiretap den was raided
and Broady and his associates were put under arrest. Mr. Rousuck
told the foregoing story at the trial in November, which resulted in
the sentencing of his old friend to two to four years in prison. The

Wildenstein Galleries announced after this testimony: "Mr. Rousuck has tendered his resignation."

The resignation was still hanging fire four months later when M. Knoedler and Company brought a $500,000 suit against Wildenstein and Company, Georges and Daniel Wildenstein and Mr. Rousuck himself for damages resulting from the wiretap. Although Broady's associates have testified that they had listened in on Knoedler's three lines from February through October of 1954, Mr. Rousuck has declined to accept the credit for authorizing this particular effort. Knoedler nevertheless seemed to take Rousuck's guilt for granted and explained in March why the resultant pain to an art dealer was worth a half million dollars:

> The nature of plaintiff's business requires that it keep confidential a large volume of information, including, but not limited to, the names of its customers and potential customers, the sources of works of art, the prices quoted for works of art and the identity of works which are or may be offered for sale. Important portions of its business are necessarily transacted over the telephone.

The counsel for Wildenstein countered with more vigor than clarity:

> It would appear that Knoedler has instituted this action for selfish business reasons, hoping thus to obtain unfair competitive advantage. The Wildenstein Galleries, established over eighty years ago, have a reputation which is unequalled in this field. The Wildenstein Galleries welcome this opportunity to prove, in open court, that Knoedler and certain persons associated with them, have deliberately perverted the testimony in the recent Broady trial.

At the moment, it appears highly unlikely that Wildenstein will get this fine opportunity, since the case is well on its way to being settled out of court.

Just what return did Rousuck get for his $2,000? Well, once he found out that Heinemann was cancelling theater tickets to a Broadway show and another time he discovered that somebody was giving a dinner party for an acquaintance from Baltimore. The most relevant piece of news he came upon was that the Heinemann-Knoedler team had sold Van Eyck's "Rothschild" Madonna to the Frick Museum for $750,000—the highest price paid for a painting since Andrew Mellon's purchases from the USSR two decades ago. When

the sale was closed, all parties were pledged to secrecy for six months. Within days, the deal was the talk of 57th Street. The Knoedler forces charge the leak to Rousuck.

Perhaps the most provocative aspect of the whole affair is the state of mind revealed by the Knoedler complaint against Wildenstein. It alleges:

> . . . Defendants obtained much information which, in the interests of plaintiff as well as its clients, was of a confidential character, and defendants used such confidential information to compete unfairly with plaintiff. The possession and use by defendants of such confidential information caused plaintiff serious injury in its business, good will and reputation, in that defendants utilized such information to compete with plaintiff for the acquisition and disposition of works of art, and in that doubts were created among plaintiff's clients as to the reliance which could be placed upon plaintiff to maintain the confidential character of information acquired from such clients.

Shades of Sherlock Holmes! No matter that all Mr. Rousuck got for his $2,000 was early news of his rival's triumphs and a great deal of embarrassment. No matter that the $500,000 suit will probably be settled with a quiet handshake. On 57th Street there is more at issue than the matter of keeping secret the immense profit that a middleman runs up on the sale of a single item in a world of ethereal values, where buyers and sellers conspire to perpetrate an outrageous parody of a supply and demand curve.

The significance of the Wildenstein-Knoedler row lies in another realm. It helps to preserve the art world's illusions about itself in an age of disillusionment. By rating its secrets at $500,000, Knoedler's has helped to reassure the fellow denizens of its odd world that they exist apart from the main stream—that they, at least, still cherish Intrigue, Mystery, Romance and other obsolete virtues.

Our art dealers, breathing the air of more regal centuries in their everyday labors, absorbing it from their deep carpets, their red velvet walls, their heavy gold-threaded chairs, as well as from the pictures themselves, have apparently been infected with certain tingling court conventions. It is not unfitting that Mr. Rousuck of Wildenstein, a firm that specializes in eighteen-century French works, should have turned to a wiretapper for an assist. Would Talleyrand have done otherwise? Broady is the contemporary version of that minor, yet indispensable, character in dozens of old melodramas— the shady noble who actually purloins the damning letter, who over-

hears and relays the crucial conversation. When it comes to paint-ings, all conversations are clearly of this character.

The world at large tends to view the small art-dealing fraternity as rather a precious phenomenon. And so it is. But it takes imagi-nation to exploit the imaginative creations of others into a flourish-ing trade. Art dealers are not mere commissionaires; they are adventurers on the high seas of luxury and prestige where other adventurers, learning of the treasures in the hold, the millionaire in the cabin, may swoop down and take all before home port is reached.

Behind the decorous facade of New York's art galleries runs a network of dark and curious alleys. And through these alleys night after night pad nameless men dressed in black, their shapeless hats pulled low over their eyes, their shoulders hunched, the odor of the snooper's world around them. Who is that particularly nasty looking fellow skulking at this very moment in the shadows between those decaying buildings? Why, he's a Wildenstein agent (or is it a Knoed-ler agent?) on his way to a rendezvous with the wastrel scion of a grand old Viennese family which has had a priceless Rembrandt in its possession for six generations. Three hours of debauchery in a Grinzing saloon and the boy will have sold his birthright for a mess of Rhine wine. In the distance, the Orient Express shrieks terribly into the night.

Maurice Grosser wrote about art for The Nation *from 1956 to 1971. A painter of landscapes, portraits, and still lifes, he conceived the scenarios for two operas by Virgil Thomson (who was his longtime admirer) and Gertrude Stein:* Four Saints in Three Acts *and* The Mother of Us All. *A year before he died, he collaborated with Thomson on a suite of lithographs devised to accompany the composer's musical "portraits."*

—

from AMATEUR PAINTERS

MARCH 22, 1958

Maurice Grosser

FORTY PAINTINGS BY the world's most celebrated amateur, Sir Win-ston Churchill, are on view at the Metropolitan Museum through

the month of March. The subjects are still lifes, principally of flowers, and landscapes painted on sunny days. The painting method is a basic impressionism. The painter works from nature, putting down on his canvas with as little rearrangement as possible the flat shapes of the colors he finds in the subject before him, his eye half closed to eliminate detail. He allows himself only the liberty of exaggerating the color intensity of the more neutral tones, of rendering brown by a richer orange or lavender for gray.

Judged by amateur standards, Churchill's work is extraordinarily good. His colors are clean and gay like good English decoration. And several of the canvases are so completely lacking in technical faults that, in the absence of the other pictures, they might well be mistaken for the work of a professional—which is highest possible praise for the talented amateur.

The amateur painter is a great deal more concerned than the professional with the problem of giving his work a professional appearance. He lacks professional training and his painting is likely to be disfigured by faults of drawing, tone relation and composition which the professional painter has early learned to avoid. But even when these faults are absent, the amateur's painting can always be distinguished from the professional's by a quality shared by all amateur work—the complete absence of original ideas.

The amateur painter is in general a cultivated man who has discovered the pleasures of painting and pursues it as recreation and sport. The approach he adopts may be a form of impressionism, or even of abstraction, depending on his age and education, but it will necessarily be a thoroughly familiar one. He is interested in playing a fascinating game, not in making up new rules. He is visiting a world already explored by other painters rather than creating and imposing a world of his own. His real originality has already found its expression elsewhere. Otherwise he would long ago have quit his own profession for that of painter, as Gauguin gave up a career on the stock exchange in his pursuit of art. The price of originality is undivided love.

The naive painter shares with the amateur this lack of originality, but in a different way. The amateur is in general a member of the educated classes, familiar with painting. Consequently, he has available to him for the expression of his ideas, however commonplace they may be, a great variety of possible painting styles. Naive painting, on the other hand, embodies the pictorial concepts of the uneducated, which may be very original. But the naive painter has not been taught to draw, to break up the visual world into its elements

of line, shape, form, color and perspective. He does not paint what he sees; he paints what he knows is there, a conceptual world composed of verbal symbols, where walls have bricks, where trees are green and have denumerable leaves, where faces are composed of eyes, ears, nose, a mouth and hair. These symbols are the material out of which all naive painting is made. Consequently, all naive pictures, in spite of the fresh and charming ideas they frequently contain, are surprisingly alike, even to color and scale. The naive and amateur painters have this in common, that the ones who have gained the public's attention owe their reputation more to accident of publicity and caprice of collector than to their interest to the profession itself.

Painting such as this may have no place in the history of art. It nevertheless provides immense pleasure and instruction to the people who do it. And I, as a professional painter, view with much more sympathy the amateur, seated before his "motif," happily and quietly communing with nature in watercolor, than I can feel for the ubiquitous amateur photographer with his gadget bag and meters, nervously preparing to perform on nature an impersonal and surreptitious extraction. The painter is the more civilized man.

The painter Fairfield Porter began writing about art for The Nation *in 1959. He wrote a monograph on Thomas Eakins and had been a reviewer for* ArtNews *since the early 1950s. Although* The Nation *had a long tradition of commissioning artists to cover art, Porter's writings somehow seem more painterly, more from the perspective of an artist, than the others. He spent much of his life in Southampton, Long Island, where he befriended painter Larry Rivers and poet John Ashberry and was just a short drive away from the de Koonings.*

———

DE KOONING

JUNE 6, 1959

Fairfield Porter

THE EXHIBITION BY Willem de Kooning, which has just closed at the Janis Gallery, was an event. It has always been so with de Kooning; his first exhibition in 1948 established for the public what the painters who went to his studio already knew: that a painting by de Kooning has a certain superiority to one by any other painter, which is

that it is first-hand, deep and clear. A painter of my acquaintance said of de Kooning. "He leaves a vacuum behind him."

The phrase "abstract-expressionist" is now seen to mean "paintings of the school of de Kooning" who stands out from them as Giotto stood out from his contemporary realists who broke with the Byzantine conventions of Sienna. The paintings are very big, approximately square; or if small, in the same big scale; in very broad strokes of a house painter's wide brushes, with a dry speed and some spatter; in deep ultramarine, a brownish pink, a very high-keyed yellow green, a cool bright yellow, white and a little black. They represent nothing, though landscape, not figures or still life, is suggested. The colors are intense—not "bright," not "primary"—but intensely themselves, as if each color had been freed to be. The few large strokes, parallel to the frame and at V angles, also have this freed quality. So does the simple organization, the strange but simple color, the directions and the identification with speed. And in the same way that the colors are intensely themselves, so is the apparent velocity always exactly believable and appropriate. There is that elementary principle of organization in any art that nothing gets in anything else's way, and everything is at its own limit of possibilities. What does this do to the person who looks at the paintings? This: the picture presented of released possibilities, of ordinary qualities existing at their fullest limits and acting harmoniously together—this picture is exalting. That is perhaps the general image. The paintings also remind one of nature, of autumn, say, but autumn essentially, released from the usual sentimental and adventitious load of personal and irrelevant associations. The names of the paintings are misleading ("Lizbeth's Painting," "Ruth's Zowie," "September Morn"). They are partial, they do not tell all, they do not tell what the painting may have come from (which it may be impossible to verbalize) so much as what the painting partly in each case became. The first incorporates a child's hand prints.

Abstraction in these paintings has a different significance from that in other abstractions. Thus there is an abstract element in classical Florentine painting which says that the deepest reality is tactile: what is real is what you can touch. For the Impressionists, light counted most, for the post-Impressionists, geometry. Or the Bauhaus painters said that mathematics is the most real thing. Nor is there in de Kooning's paintings the idea that abstraction is the historically most valid form today; which might be called the sociological basis for abstraction. All these theories put something ahead of the painting, something that the painting refers to, that it leans on, and if this is removed, the painting may often fall.

Once music was not abstract, but representational, representing a secular tale or ballad, or a religious ritual. When the first abstract music was made there was a release of energy, and people expressed something about sounds in terms of some instrument that was not verbal. After this the human significance of music was also released, and in this way, de Kooning's abstractions, which are in terms of the instrument, release human significances that cannot be expressed verbally. It is as though his painting reached a different level of consciousness than painting that refers to a theory of aesthetics, or that refers to any sort of program: in short any painting that is extensively verbalized. His meaning is not that the paintings have Meaning, like certain vast canvases notable for the difficulty of containing them in any given space. Nor is their meaning that They Have Not Been Done Before. Nor is it the romanticizing of nature, as with the West Coast abstractionists. The vacuum they leave behind them is a vacuum in accomplishment, in significance and in genuineness. No one else whose paintings can be in any way considered to resemble his reaches his level.

Congressman Francis Walter was the presiding chairman of the House Un-American Activities Committee; Wade Thompson taught literature at Brown. At the time, Walter's attention was focused on a number of American artists who would be featured in a forthcoming exhibition in Moscow. He predicted that Americans would not "stomach this nonsense." What follows is an interview between Walter and Thomson.

—

from WHAT MR. WALTER LIKES: A DIALOGUE

AUGUST 1, 1959

Wade Thompson

CONGRESSMAN WALTER OF Pennsylvania is a man of affable demeanor but of something less than Sophoclean sagacity. I warned him, when I introduced myself, that he and I might—if we pried into this matter at any length—find ourselves in fundamental disagreement, but that I had no intention of misrepresenting him in this article. I can assure the reader that I could not conceivably exaggerate the murkiness, the impenetrability, of the black fogs in which the following conversation took place. (I am Q., Walter is A.):

Q. *Do you believe that the political convictions of an artist necessarily affect the quality of his work?*
A. *No, no, it doesn't make any difference what an artist's politics are.*

Q. *But you are objecting to the forthcoming American exhibit in Moscow, solely because of the politics—or alleged politics—of the artists.*
A. *Well, but, these Commies are using their art to further an international conspiracy.*

Q. *Then it does make a difference how an artist thinks politically.*
A. *Well, I think that even if a card-carrying Communist were to paint a nice pleasant pastoral, that would be perfectly all right.*

Q. *You wouldn't object to something like that being shown in Moscow as an example of American art?*
A. *No.*

Q. *But if the same man satirizes an American general, then you object.*
A. *Well, he's heaping ridicule on an American general. He's trying to say that a general is a member of the autocracy.*

Q. *Does that mean that you don't like anyone who satirizes American generals?*
A. *No, no. That's all right, but I'm pretty proud of what we've got here and I don't like to see it ridiculed.*

Q. *Then you do object to satire?*
A. *No, no. But this fellow is using satire to further the Communist conspiracy.*

Q. *Oh. Then satire is all right so long as it isn't used by a Commie.*
A. *Mmmmmm.*

Q. *How many American Communists are there?*
A. *27,000.*

Q. *How effective is the House Un-American Activities Committee in combatting this army?*
A. *Well, I have it on the authority of Mr.——(I swear, I was asked to keep his name confidential!) that if it weren't for the House committee, there would be Commie fronts springing up all over the place.*

Q. *Well, do the investigations do any good in changing the personal convictions of the artists, or the people being investigated?*
A. *No.*

Q. *Are you aware that many of the world's greatest artists—throughout history—have been radical dissenters?*
A. *Oh, yes, but you see the original intention of this exhibit was to present works that would give the Russians an idea of what life is like in America. Now, for one thing, the works were supposed to be chosen from a period of over seventy years, and I thought there were going to be some pleasant Whistlers and things like that, but for some reason the committee didn't choose anything that was painted before 1918.*

Q. *Mr. Walter, do you know anything about art?*
A. *No.*

Q. *Do you know what you like?*
A. *Yes.*

Q. *What do you like?*
A. *Well, I like good realistic pictures. Now what I would like to know is how is anybody going to get any idea of what American art is like by seeing just a white strip with a gold block pasted at one end of it?*

Congressman Walter is a busy man and I was beginning to feel too weak to carry on, so we ended our interview by mutual agreement.

Fairfield Porter's brother Eliot was a well-regarded photographer. This review may be the first recorded example of brother reviewing brother.

—

PORTER ON PORTER

January 9, 1960

Fairfield Porter

Holderin's poem, *Nature and Art,* characterizes the Golden Age as a time when the ruler of heaven and earth "uttered no command,

and still not / One of the mortals by name had named him." (Vernon Watkins' translation.) In the Saturnian age the world appeared new: things had no names, there was no past or future, all concepts were unconscious, and all order. The radiance of such an age has been expressed by poets; but has it ever been expressed in painting or sculpture? Perhaps in fifth-century Greek sculpture, and perhaps sometimes by Monet, and oftener by Sisley. But these Impressionist painters expressed it in a generalized way, and only by color. The color of nature is disappearing from painting, even though non-objective painting represents a turn away from conceptualism and toward direct experience. Non-objective painting is more graphic and emotional than open to sensation; and realist painting is less interested in nature than in ideas, as: what is natural, or what should painting be about? An expression of the immediacy of experience—for what else is the namelessness of everything—is proper to poetry and natural to photography. I know no photographs that express this so well as the color prints of my brother, Eliot Porter, who, like Audubon, is known for his record of the birds of America.

He has made a series of color photographs illustrating Thoreau on the seasons, which were shown last month at the Baltimore Museum, and are now on exhibition at the Eastman museum in Rochester. They are not like other color photographs. There are no eccentric angles familiar to the movies, snapshots or advertising, and the color is like a revelation. The color of photographs usually looks added: it floats in a film above the surface; it is a dressing-up. And it is usually rather inattentive. It is inattentive in the way that printers in this country are inattentive to the accurate shade, and the way color reproductions are almost invariably insensitive. It seems that the fact of color itself is considered enough: one knows the sky is blue, and the grass green, and you can let it go at that. But Porter's colors, with all the clear transparency of dies, have substance as well. They are not on top.

 * * *

His range of colors contributes to their namelessness. For photography has limitations comparable to those of paint—there are primary and secondary colors. Memory contracts and symbolizes; and one thinks of his winter photographs as pale yellow and white; spring as blue-green; summer as red and green; autumn as orange and yellow; however if you look again, you discover that you cannot generalize, you cannot conceptualize, the colors do not correspond to words you know, they are themselves, a language that is not spoken. The color indications are all primary, as a poet might use words as though they were new, without precedent or possible future, but

tied to the event. The color is tied to the shape and the context; no habitual meaning is suggested. In the corner of this grayish wall of trees, that blue, is it sky? No, it is ferns. It is as much of a discovery as the broken color of Impressionism. The shadows of leaves are yellow or black, the light on them white or blue. The weed stems in the snow are yellow, better set in and stronger in their contrast than Wyeth's black virtuosity. But you cannot describe one language with another. Drawing and painting have a language, but literature and photography *are* language. This is what Maholy-Nagy must have meant by his suggestion that the illiterate man of the future would be he who could not use a camera. These photographs make wonder the natural condition of the human mind. Have you ever seen before the redness of grass, the blueness of leaves, the orange cliffs of autumn, the two circles of sunflower blossoms, or a kerosene lamp against the sun in a window? Or that where a tree has fallen, it seems to have fallen with intention? There is no subject and background, every corner is equally alive.

Photography is nature, and so critics have thought that it was not art. But if these photographs did not show you what they did, you would never have been able to discover it. The golden age of the child's omnipotence is succeeded by the Jovian world of adults and of art. Adults classify, generalize and ignore. But the ability to distinguish comes first. Can we as adults be sure that we see more deeply, through art, than the photographer who pretends to do nothing but pay the closest possible attention to everything? He distinguishes endlessly and he dares not ignore. What does love come from if not just this scrupulous respect and close attention? The trouble with art is that, in choosing, the artist ignores. The trouble with the realistic artist is that he is indirect, and between himself and his experience he puts concepts: a steely equality of detail, conceptualistic anatomy, or the métier of the old masters. The non-objective artist is closer to the photographer in his reliance on direct experience. But, because he is not interested in objective nature he tends to lose his contact with concrete variety. The trouble with this is that it leads to a loss of a feeling for pluralism, as though all experience were becoming one experience, the experience of everything.

Part 3

From Soup Cans to Nuts

11

HAPPENINGS

It has often been said that in the United States, the 1960s really began after the Kennedy assassination and ended in the mid-1970s, following the Vietnam War. In art, the 1960s arguably began in the mid-1950s, when Robert Rauschenberg, Jasper Johns and others initiated the departure from Abstract Expressionism—a convenient milestone might be the day Rauschenberg erased a drawing by de Kooning—and ended sometime before the art boom of the 1980s. During this time, art institutions and indeed the canon of art underwent at least as many changes as society did.

—

REMBRANDT, RAUSCHENBERG . . .

APRIL 23, 1960

Fairfield Porter

THE FOLLOWING FOUR exhibitions have something in common: the Rembrandt drawings from American collections at the Morgan Library, which closed April 16; the oils, pastels, drawings and prints of Degas at Wildenstein, for the benefit of the Citizens' Committee

for the Children of New York; the welded iron sculpture of Richard Stankiewicz at the Stable, and the painting constructions of Robert Rauschenberg at Castelli. For each of these artists realism transcended and transcends any systematic artistic formality.

Rembrandt created a total world of greater human depth and breadth than any other visual artist. The language of his drawings is, like Chinese, or the English of newspaper headlines, a language without grammar; the part of speech depends on the context. In a Rembrandt drawing a detail is almost meaningless by itself, and there is no form separate from the form of the whole. A line, or lines, or the wash, tells where, before it tells what: where in space, where in action and where in dramatic significance. A figure is analyzed in terms of its presence, which precedes its articulation; and the articulation may be expressed with physical vividness by the expression of a face. The turn of a neck is indicated by the eyes. A line does not mark an edge or change of plane any more often than it marks the center of weight. A line either separates what is on each side of it, or it gives integrity to where it is. Artists have had and still have certain common ways of translating external reality through appearance or tactility into flatness, but for Rembrandt essence comes first. Figures are either emphasized or made unimportant by thicker lines, as one may shout or whisper to attract attention. Wash is color, or shadow, or projection, or recession, depending on the context of the drawing as a whole. Nothing can be abstracted; the parts are meaningless, rubbishy, tattered: the ground which as a whole has its total feel all the way to the horizon, is in detail only muddy litter; the clothes of his figures as a whole may be grand or poor, but they always suggest the temperature, and in detail they are just rags. The unreality of the detail gives connectedness to the whole, which is held together by the artist's compassion. It is interesting to observe his copies of Mantegna and of Indian miniatures, which give the human effect of these works without any attention to the artistic style.

For Degas, the tension of his paintings and pastels is in the conflict between the decorum of art and the unprecedented nature of nineteenth-century society, whose form was more and more determined by the mechanization of industry. Visual form is contrapuntal to dramatic form; what people do is one thing, and art is another. A jockey lies wounded on the ground, while the beautiful motion of the horses continues. Chance dominates decision. The humanity of his dancers has nothing to do with their skill. Degas seems to dislike life for not being art; though he had sympathy for it. The

whole is greater than the part, but since Degas lacked the energy of Rembrandt's compassion, even a whole painting by Degas has something fragmentary about it. Degas could not include an attitude of the whole in one canvas. The grandeur that he could perceive lay more in art than in man; and art for Degas meant Ingres, Delacroix, Holbein and possibly the Florentine fifteenth century, even more than it meant the talent of his fellow artists, or his own. Except for the motion of horses and women, the present inspired sarcastic distaste. And Degas chose to express the disorderly present with the orderly grammar of the art of the idealists, whose remoteness from him made them idealists.

The idealists of New York painting are the non-objective painters, who isolate art from details of actuality. They wish to see profoundly, and they are against illusion. Or perhaps they simply wish to seem to see profoundly. Rauschenberg's art is disorderly in its incorporation of real elements. His red, white and black, or blue, white and black are slapped on with the skill of hand of the New York school. This is his allusion to art; he alludes to his contemporaries, as Degas' classical line and subtle values alluded to the masters of the past. Rauschenberg combines in his paintings a catalogue of real parts: radios that can be turned on simultaneously to different stations, stuffed birds, homemade ladders stained with drips of paint, chair backs, squares from cotton pants, a compass, can opener, light socket with chain, flattened and crumpled metal, photographs and pieces of newspaper, umbrellas opened flat, rough-sawn lumber and assorted hardware. His extremest construction called *Gift for Apollo*, consists of a cupboard door mounted on doll-carriage wheels, with a doorknob and glued-on necktie smeared with green; from this hangs a chain ending in a bar embedded in the hardened cement in the bottom of a battered pail.

There is a resemblance to the scavenged metal work of Stankiewicz, with the difference that Stankiewicz's material has, as it were, spoken to him before he has used it, as the piece of wood in the beginning of *Pinocchio* spoke to Master Cherry even before Master Cherry touched it with his axe. Stankiewicz responds to a preceding life of things, and Rauschenberg does not; for Rauschenberg the life of the parts depends on the final context. When a part of a Rauschenberg construction has its own life, the effect is disturbing, calling attention to a general grubbiness; I never find his stuffed birds sufficiently assimilated. In a Stankiewicz sculpture the life of a part gives character to the life of the completed sculpture. Rauschenberg's work completely counters so many preconceptions that in order to

see what it is one must be open to new form beyond old formalities. He expresses a morality of poverty, inducing a monastic respect for things that no one values. He protests the waste in this society, where we take for granted that automobiles are disposable, and that our trash cans are filled with paper work. He calls attention to the success of industrialism opposite to the way the Bauhaus did, which saw industrialism as it wished to be seen. Maholy-Nagy was like an academician finding beauty in the copying of something already beautiful, with the difference that what he found already beautiful was not the Parthenon, but the skills released by modern machinery. Rauschenberg's work has more personality than anything like it. Its weakness is that it tends to approach the chic.

Rauschenberg is able to assimilate his real elements better than he usually cares to. It is as though in calling attention to the unassimilable, he disparaged art in favor of reality. Stankiewicz's fantasy about plumbing makes him sometimes illustrative, as in the two boiler-bathers playing at the beach. His more formal, abstract and untitled sculptures have greater reality; it is in these that one feels more strongly the human life than has rubbed off into his broken pieces of machinery, or the inevitably inherent life of hardware, like the resistance of things to man's purposes.

—

RHEINHARDT, FIORE, AND TWOMBLY

NOVEMBER 5, 1960

Fairfield Porter

THE EXHIBITIONS OF Ad Rheinhardt at Parsons and Section 11, of Joseph Fiore at Staempfli, and of Cy Twombly at Castelli indicate an assimilation of the Oriental influence in American art. This influence began with the opening of Japan a hundred years ago, and showed first in the work of Whistler and the water colors of Winslow Homer. It appears in a distinctive attitude toward nature and art, something like this: man's relationship to nature is not one of domination, but adaptation; nature is not an object of material conquest, and aesthetics instead of science is the mode of understanding it. From adaptation follows passivity, which leads to subtlety.

Rheinhardt takes the idea of non-objectivity quite literally, His tall new paintings appear at first sight almost evenly black—then you see that they are divided with absolute symmetry into rectangles in

a cruciform pattern. The difference between one color and another is very slight and there is no play of textural variation, except as much as one sees on velvet, brushed in opposite directions. Rheinhardt is not non-objective in order to express the nature of nature or his medium more sharply: like Whistler he could say that the last step in the completion of a painting is to cover all traces of how it was done. Whistler is the painter Rheinhardt resembles most closely. Like Whistler he takes from the art of the Far East its decorativeness. In some of his early paintings the vertical rectangle is made up of a zigzag of horizontal strokes recalling characters incised horizontally on Chinese bowls. The red is Chinese, and the favorite enclosing shape is that of a hanging scroll, or of a screen. Chinese art was Byzantine in its adherence to tradition. Rheinhardt would like to see the establishment of a new and strict Academy. He believes that the proper subject for art is aesthetics, and to the humanists or the socially conscious who say in their various ways that man's chief concern is man, he might answer that man in his smallness should behave with decorum.

That subtlety is not exclusively an oriental virtue, however, can be seen by looking at the Giacomettis across the hall in the Janis Gallery. The figures sitting in rooms, emerging and melting into the gray surroundings, have as narrow a color range as Rheinhardt's abstractions. They are defined by a web of white and dark lines of a delicacy equaled by the closeness of the two colors, warm and cool; the subtlety is obvious and rich. In Rheinhardt's paintings, once you have penetrated his darkness like a mask worn at a fancy dress ball, and found the subtlety of color relationships which do not oppose warm to cool, everything is there on the surface, there is no more; quite the contrary to Giacometti, who keeps on revealing himself.

Fiore's more or less abstract landscapes seem to express the oriental view that man's value inheres in an equality to the other small parts of an immense whole. The paintings, done from memory, are unspecific as to place. He is specific about such things as the quality of a storm from the sea in Maine, the Maine light, the way the land is divided from the water (which is different on different coasts), the blackness of a north wind, the color of deep water over rocky bottoms, the green of short and intense summers; and that nature is continuous beyond any aspect of it. Some painters conquer nature through aesthetics in arrangements of objects. Fiore does not usually paint separate things—isn't a valley, a storm, weather, light, a relationship? His paintings as a whole are less objects than Rheinhardt's, since the relationships imply that each painting is in a sense a frag-

ment. His color, remembered from observed relationships, points to no object or place, but only to itself; and its beauty, that leaves out all dullness, lies in its aesthetic accuracy. Where Rheinhardt expounds the decorum of the aesthetic point of view, Fiore gives an example of it.

Twombly also exemplifies the importance of the little. His little things are not parts of a nature that dwarfs man, but the little things that people do compared to a much larger world of all human activity. He is a humorist, too accepting, too adaptive for satire. For satire, after all, is an angry assertion of man's failure to be heroic. Twombly's huge white paintings are like walls on which incomprehensible dirty jokes have been scribbled—jokes which turned into art even while they were being put down; a few members; a few touches of pink and blue—the doodles in a telephone booth. Like Fiore, he exemplifies the importance of the little in the equality of the small details. In Fiore's paintings these are color atoms; in Twombly's graphic and textural paintings, the atoms are tactile. He expresses himself in the quality of his touch, which is humorous, respectful and very appealing.

—

from ROTHKO

FEBRUARY 25, 1961

Fairfield Porter

AT THE MUSEUM of Modern Art is another retrospective exhibition: the oils and water colors of Mark Rothko. A characteristic Rothko painting is eight feet high by six wide, with an awkwardly placed horizon dividing two fuzzy rectangles of red and orange. His colors range from maroon to the brightest neon scarlet, from brownish to lemon yellow, pale greens, and a somewhat muted French blue. His canvases are divided into smaller rectangles, but not like Mondrian, whose space is cut up as if into servings: Rothko divides without separating, perhaps because of the deliberately awkward sizes, perhaps because of the blurred edges. Whatever the reason, if you add the parts together, the sum amounts to less than the whole. A whole Mondrian equals the sum of its parts, but a whole Rothko is greater than the sum of its parts. Rothko uses color in such a way that, if there are two colors for two rectangles, one inside the other, the

effect is of one color; if there are three colors for three rectangles, one above the other and the two inside the third, the effect is of two colors; when the canvas contains many rectangles of many colors, the effect is again an effect of unity. Two is a weak number, and most Rothko paintings seem to express this number. His paintings have no structural skeleton. What holds them together? Perhaps it is simply the artist's energy, which acts like a magnetic field around plasma. The paintings express breadth and height: they spread. Their simplicity calls for more wall space than they have been given. They look like non-objective murals for no particular place. Like architecture, they provide a spatial background. They are abstract in the manner of modern American commercial architecture, with its inattention to specific space, place, or function. One might call them prefabricated murals. The energy they communicate is proportional to their size and their simplicity: if they were more complex they might fail. Rothko makes no demands on himself beyond his ability. He asserts space as two-dimensional and finite. His color is luminous and without substance, as if it were light instead of pigment. It is reminiscent of the changing colored light that diffused the interiors of movie palaces in the twenties.

Lincoln Kirstein, the dance impresario who, with George Balanchine, cofounded the New York City Ballet, was the brother of George Kirstein, The Nation's *publisher.*

—

from REMBRANDT AND THE BANKERS

DECEMBER 9, 1961

Lincoln Kirstein

The sale of a Rembrandt to The Metropolitan Museum of Art for an unprecedented $2,300,000 came at a time when Lincoln Kirstein was completing for *The Nation* his annual survey of the year's most notable art books The transaction brought to focus in his mind a number of related factors in the management and conduct of our large cultural institutions—factors related also to the publishing of books—and he has written the following essay as a preface to the detailed book evaluations. His listings are therefore postponed one week.

"AND THICK AND fast they came at last, and more and more and more . . ." It's a *Looking-Glass* world of wond'rous art at wond'rous

prices—and a wond'rous, or one hopes, a wondering (not a be-
mused) public that looks at hand-painted-type pictures which some-
body (even they themselves, indirectly) has paid for, that also buys
art books as fast as hi-fi records. From *The New York Times* of Novem-
ber 27 one learns, in a feature story that begins cannily with a sliver
of type on page 1 and then expands on page 32 into a megaton-
crusher of guilty self-justification, how madly keen a new art public
is in its cannibalistic appreciation of (*great*) art—providing it costs
as much as the Erickson Rembrandt, *Aristotle Contemplating the Bust
of Homer.* $2,300,000. Worth every penny. Greatest Philosopher who
ever lived, greatest Poet w.e.l., by the greatest Painter w.e.l. What a
package! With its provenance impeccable, this painting has been
expensive since it was completed in 1653. Director James Rorimer,
quizzed on how he'd wangled it, 'fessed up shyly, "We just put our
pennies together."

The bankers, lawyers, insurance underwriters, real-estate opera-
tors and department-store managers who have ultimate trusteeship
of the Met's pennies were unquestionably able to parlay their avail-
able funds-in-trust, via interest futures, tax-forgiveness, and other le-
gal prestidigitations, to such good effect that they could protect this
uniquely desirable property from provincial Texan oil and cattle
fanciers. Rumor had it these outlanders intended to lasso the whole
Erickson string for a new Lone Star Museum in Waco, Abilene or
Forth Worth. Actually, given our tax structure and fictive economy,
even this Rembrandt probably cost no one a *very* pretty penny. So,
in a glare of maximum attention, New York gets to keep this year's
most sensational painting. Twelve months from now, few will re-
member just how big the tab was or just which picture was on the
block. It is a moderately great painting—not Great, like "The Mill"
in the Mellon Collection, or "The Polish Rider" in the Frick, but
still a real Rembrandt.

Big museums—those as big as the Met and The "National" Gallery
in Washington—specialize in a peculiar brand of luxury item, be it
painting, sculpture or drawing. It must be of "museum quality." This
term is not easily defined, but a fairly small picture which is also
expensive is seldom of "museum quality." Our public is myopic, so
really fancy prices had better be paid for work large enough to be
seen across a big gallery. That, no doubt, is why the Carlo Crivelli
tempera panel, the single finest (and rarest) thing in the Erickson
sale (Roger Fry called it "one of Crivelli's greatest designs") went
for a measly $220,000 to a very intelligent private collector who
makes leather goods of exquisite craftsmanship. (Take a long look
at the Crivellis in the Met or the "National" then compare them

with those in the catalogue of last summer's Crivelli show in Venice. Either museum should have delighted in the Erickson panel.)

If a museum's acquisition committee is willing to spend the consolidated income of two or three years on a *single* item, it gets the cover of *Time* (edged with gold, no less). More important, it saves busy bankers endless hours of wrangling in tiresome committee meetings, listening to the well-meaning if foolish pleas of responsible curators, each of whom has some expert bee in his bonnet. The grand gesture is the fitting gesture. Meissonier's Napoleonic super-epic, *Friedland, 1807*, which Henry Hilton bought for the Met, for $66,000 (in 1887!) is still on view, a sight corroborating Degas' famous *mot*: "All is metal save the cuirasses."

And the science, for it *is* a semi-demi social science, of public relations can be Aliced around so that it is even profitable to purchase expensive fakes, like those whopping Etruscan terra cottas still displayed for the benefit of a fascinated public, as quaint examples of the *manque d'expertise* of the present director's naive predecessors. Speaking of which, whatever became of those two parcel-gilt reliquaries that were once his pride and joy at The Cloisters?

It is bankers' psychology to compete against bankers, and with the rich haul of the Rembrandt, the Met. diddled, among others, the museums of Cleveland, West Germany and Texas, as well as Paul Mellon and Chester Dale, the two principal patrons of the "National." It is true that for a mere $800,000 Chester Dale purchased the Erickson Fragonard. Mr. Dale, a member of the Legion of Honor, is partial to French art if in "good taste" (i.e., eighteenth or nineteenth century); he is also celebrated for having commissioned Salvador Dali's obscene "Last Supper," which daily affronts our national innocence in our "National" Gallery. The Fragonard he got is not first vintage, and only the ninth or tenth Fragonard that the "National" already has. They need it like a hole in the head, but *quand même*. As for the Rembrandt coup, it is just possible that responsible curators in Cleveland, West Germany, Texas and Washington decided that enough was enough. Each of them already has a good many Rembrandts; there are really a good many Rembrandts around, even in New York City. Bankers manage banks, one hopes they do it well, for we depend on our friendly financiers. But sometimes the Met's psychology, as with that of other luxury manipulators, is more akin to the methods of advertising managers at Bloomingdale's and Macy's, who frame their daily journalistic displays less to attract the public than to crush their opposite numbers at Macy's and Bloomingdale's.

It does not happen often, for there is no gainsaying that the Metropolitan Museum of Art is the greatest museum in the Western World, and is in fact our National (without quotes) Gallery. This is due to a tradition of heroic, selfless and enlightened patronage, to such great amateurs as the senior Morgan, Altman, Blumenthal, the junior Rockefeller and a present generation of connoisseurs and collectors like the Wrightsmans, Judge Untermeyer and Walter Baker. It is also due to the dedication and abnegation of a magnificent staff (and a couple of rotten apples with tenure, as is normal in any complex institution; but, thank God, time wounds all heels), whose taste, intelligence, imagination, moral elevation and historical sense are incomparable in this hemisphere. But how would you feel if you worked in one of those wond'rous new bank buildings in Lower Manhattan (all glass, filled with real modern art and designed by Skidmore, Owings & Merrill) and got a company hand-out on your return from the Thanksgiving holiday, saying that your bank (more a father than an employer) had decided to forgo those indicated raises for the time being. Instead, you as co-worker would contribute toward a magnificent stainless-steel scaffold (designed by the late Eero Saarinen), hung with three crystal balls (by Steuben), as a sorta institutional memorial to the Medici (who invented art patronage and banking). The purchase of the Erickson Rembrandt will inhibit the acquisition of many small, odd, useful items, long recommended by a long-suffering staff.

The Met offers a great service to the industrial life of New York City, our cultural capital, and not alone to the fashion trades. That is why it is the Nation's Gallery, while the "National" Gallery in Washington is far more an agglomeration of gentlemanly taste, with some incomparable masterpieces and much trash. The Met's print collection alone, the library, the armor, ceramics, metal-work, jewels, in endless profusion, give life and energy to the arts and crafts of our day. Curators not only manage to acquire these documents; they love them. Their love has made the Met the greatest systematic repository of documentary resources in this country, if not in the world.

What bankers run are banks, Lincoln Centers; Washington Culture Centers, film companies, colleges, opera houses and publishing companies. There is little that the compulsive, restless, aching energy of businessmen can resist trying to control. Few of them have pleasure in the employment of the mind; finally, they are bored by bridge and the entr'actes of the opera. The vacuum produces a blind, somatic need for control. Control for what, control of whom?

Just control of everything, including artists and curators. Artists are untidy, and not of much consequence unless they are dead, have cut off an ear or can be depended upon to jolly up a high bohemian party. Curators are eccentric, dress badly, have tedious habits of re-iteration. Also they are unsuccessful (i.e., badly paid, who knows that better than a banker?): It is a Christian banker's duty to save artist and curator from themselves. Since most bankers, lawyers, insurance dealers and real-estate operators, who remain the trustees of our chief goods and services, primarily understand negotiability and competitive status, they seldom have a sense of quality, the intention of the artist, the real condition of a given work; or the historical process. Some of them think they have "taste," meaning good taste, but what about the Dalis of Chester Dale and Huntington Hart-ford—or the Met's own *Crucifixion?* Their depressed curatorial staffs must approve their more elephantine purchases in the hope that for condign approval they may be allowed to squeeze at least a frac-tion of their real needs into the annual budget. Such purchases as the Erickson Rembrandt reduce curatorial funds to a perfunctory pittance. If this is untrue, then just how rich *is* the Met?

Publishers are bankers, too, and they will pay to get expensive books expensively printed, if the profit odds are good. A few uni-versity presses are still so handsomely endowed that they can avoid the long hand of sensible efficiency experts. A few eccentric schol-arly amateurs still risk bankruptcy when they are in love with a sub-ject, an author, an artist or an idea. But these are surely immoral plungers, and their hell is the remainder counter at the Marboro thrift shops.

When, gentle buyer, you consider purchasing art books this Christmastide, note that increasingly they assume the heft of phone books, including the yellow pages. A few publishers are starting to make a killing in small-format paperbacks; they must have studied the sales charts of Rambler and Studebaker-Lark. Reflect, buyer, on how an object called *The Greece I Love* (Tudor) got itself published, considering the hundreds of other books that take care of Greece pretty well from Crete, Cycladic Art and Mycenae, through Perga-mun and Miss Mercouri. One imagines a bright young editor re-searching the American Express travel receipts over the past five years. Boy, did 'Hellas zoom!' Here's the perfect Christmas package for every alumna of a Cunard cruise. How does *Time-Life* make its wond'rous compendia available at such—well, moderately—reason-able prices? Or *Horizon* or *American Heritage?* For one thing, they hoard those beautiful color plates, issue by issue, until they have the

basis of a brand-new book. Then there are the Picasso industry, the Great Collections industry, the Great Periods, Epochs and Eras industry, and the Modern Art industry.

Max Kozloff wrote art reviews for The Nation *from 1961 to 1969. He was awarded the 1962–63 Pulitzer Prize for critical writing, largely for his work for the magazine. Kozloff also was an editor of* Artforum *and is an accomplished photographer.*

—

from JIM DINE

JANUARY 27, 1962

Max Kozloff

THIS QUEER, DROLL young fish, Dine, creates what technically might be called combine paintings. They are canvases upon which are pasted articles of apparel ties, rubber pearls, suspenders, etc. These items are pictorially isolated, except when they are labeled over prominently with their own names. Like mail-order catalogues to especially slow farmers, Dine's images thus make redundantly certain that no one has any doubt as to what is being shown.

But this very condescension proves illuminating, especially in the great tour de force of this show, a concoction entitled "Hair." To the average New York viewer of 1962, its swirling handwriting, and squeezed-from-the-tube ribbons of pigment denote one thing—"action" painting. An "action" painting, though, which turns into an enormously magnified view of hair, growing chaotically, and with almost indecent energy upon a ground suspiciously fleshlike in color. High on the surface Dine insolently letters in the word HAIR. In this, just as elsewhere with some crossed stripes that are in fact suspenders when seen close up, he outwits our cherished illusion of the nonrepresentational. Here, then, is a *humor noire*, willing to throw itself away on one bagatelle after another, and designed to show us, by the most absurdly obvious jokes, that there is perhaps no such thing as abstract painting. It is quite defensible, of course, to say that Pollock's skeins, for example, are *concrete*, because they are nothing else than themselves—actual presences. In that sense too, so are Dine's, but he shows us that, at the same time, they can't help representing anything they remind us of.

Cautiously, I would say that the Dine exhibition is the most me-

thodical and subtle, not to speak of hilarious, critique of New York
Abstract Expressionism, since Robert Rauschenberg and Jasper
Johns appeared on the scene a few years ago. But while he may owe
something to them, Dine's attack is both more existential, and par-
odistic. The two slightly older artists incorporate some of the pro-
cedures of their mentors, Dine simply mimics them, in transposing
their terms. Thus, if Pollock blew up a detail of Soutine for special
use, Dine does the same for the scalp; and if Barnet Newman hyp-
notized himself with great expansive blocks of color, so does Dine,
with the same space-dividers—only now they are the suit-coat fronts
of giants with enormous, frightening buttons. In the end, Dine not
only works a switch, but comments upon it in each canvas—partly
by his labels, but partly also by his dime-store, comic-book and "hard-
sell" imagery, casting aspersion, as it does, on the impotence of some
recent painting no less than on our popular culture and advertising.

It is in his canvases that Dine finally indicates his potentiality as
well as his direction. Brushy, sensuous, these piquant obsessions with
neckwear effect an exciting bargain with the creative act. In "Twelve
Green Ties Hidden in a Landscape," for instance, the real ties look
illusory, whereas the pigment likens itself to greenery. But it is the
execution, at once completely "abstract" and "concrete," that au-
thoritatively sustains this witty, mysterious and slightly batty charade.
Dine is an inspired middle man between the simulated and the re-
created, reselling them at his pleasure; he is, if you will, the mad
jobber of art. His exhibition offers a maze of experiences whose
vulgarity conceals a sensitiveness to the most interesting contradic-
tions. I am extremely glad this work exists.

—

THIEBAUD

MAY 5, 1962

Max Kozloff

THE TRADITION OF Western still life was never struck as serious a
blow by the twentieth century as was suffered by a number of other
genres, landscape and portraiture predominantly. Yet this was not
because of any enduring value of still life as a "mode." Indeed, if
our vision has not rejected the old categories and distinctions of
subject matter outright, it has hopelessly devalued them. Rather, a
taste for the inanimate and serene survives because modern paint-

ing, for the first time, has approximated the condition of still life itself. If one wants to think here of the origins of abstraction, it is relevant.

But still life is by no means that incarnation of "pure painting" it is popularly supposed to be. For every Cézanne or Braque, there exists a Soutine or de Chirico. And frequently it happens that artists who experience an impasse with their habitual motifs turn to still life as a means to discharge energy, and to work through their problems without the distractions that ambitious themes imply. Because of its very neutrality, the still-life subject can be all the apter a vehicle of feeling, and the clearer a crystallizer of tension. No more natural pretext for the display of structure and/or expression is available— short of the non-representational.

Under these circumstances, I was considerably taken aback by the New York debut of Wayne Thiebaud (Allan Stone). He is a painter who not only has the effrontery to create still lifes in the most conventional sense of the word, but whose interest in his subjects is not submerged by his own pictorial conflicts. Thiebaud paints barbecue beef sandwiches, ice cream cones, pie wedges, drink syrups, gum ball machines, cup cakes and hot dogs. In sum, he delights in the pseudo-fresh, fluorescent-lit staples of our roadside diners, automats and dime-store lunch counters. He is the poet laureate of the coffee break, or the truck driver's dream. Moreover, he does not so much arrange his compositions, as display his wares. They are aligned in monotonous files, as never ending in quantity as they are undistinguished in quality. Occasionally one is found by itself, a leftover getting stale in a corner. Compare this with the way a pheasant would nobly rot, or a petal poetically fall, in the seventeenth and eighteenth centuries, and you will see that Thiebaud's is not exactly a heroic vision of still life. Yet even his most modest lollipop is a personage, of sorts. It was André Malraux who remarked amusingly (but hardly accurately) that "the Dutch may not have invented still life, but they were the first to stop treating it as food for the apostles." Thiebaud leaps back in time, yet stays modern, by giving us food for the common man.

He is, therefore, an outrageously topical painter, whose sociological insinuations and banal iconography would hardly account by themselves for the disturbing impact with which his work greets you. If Thiebaud had chosen to employ a bacon, lettuce, and tomato sandwich merely as a formal construct, the results might have been piquant, but hardly memorable. And if he had decided to provide only an illustration of this edible, they would have been commercial. No doubt his art reminds us of illustrations or effigies: the charaded

malts and corny signs that abound in American ice cream parlors. But the popular style of these images has been incorporated into the still life without being responsible for it. What one sees is neither naturalism nor abstraction, but an artistic satire of commercial illustration which, in turn, is a vulgarization of Western still life.

It is fruitless to work back to the actual object through all these reflected removes, because, said object no longer exists—only the various manipulated means of seeing it. Hence the mystery and discomfort, but above all the irony, of Thiebaud's work. Just as the victuals themselves are fictional, so too, he seems to be saying, is the creative sensibility. But in acknowledging his bondage to the most absurdly generalized and anonymous of idioms, he invents a new freedom. For, by intensifying the already ostentatious phoniness of the palette, luminosity and texture of popular illustration, he has arrived at previously invisible sensations, and a modest truth. This shifting of the context has not only netted a formal gain, but produced the striking implausibility of these works. Far from being a mere proletarian in an old genre, Thiebaud interrogates the nature of the *real* itself.

Such are the processes which I interpret as evidence for the vitality, perhaps even the uniqueness, of this vision. Thiebaud, however, can be associated with the luminaries of a burgeoning group that has already been labeled by one writer as "the kitschniks," or "American Dreamers." But he stops far short of their fond and illusionistic portrayal of our billboard culture. If their technique requires that they avoid or disguise any visible execution (in order that their images simulate the real thing), a canvas by Thiebaud is a veritable palimpsest of manual gestures: strokes, brush marks and wrist movements. This forty-three-year-old Californian is an exponent of the dash and floridness we associate with painting from the Far West. Yet he has now locked in and focused his passages within ridges of pigments that reveal the strictest control. His over-all tonality is like calcimine, set off by hues as pungent as a chartreuse mustard, or the azure shadows of his occasionally revealed underpainting. By some alchemy, however, Thiebaud does not seem to be working with oil paint at all, but a substance composed of flour, albumen, butter and sugar. If it is a cup cake he shows us, then his pigment is frosting, and if a pie, his material resembles nothing so much as meringue. (The show is like a kid's party for grown-ups.) This uncanny mimetic quality of Thiebaud's handling is the essence of his wit, because the paint apes the edible, while obviously asserting itself as inorganic matter. At the same time, it mocks, perhaps unwittingly, those old

master still lifes whose rationale was to incite the glutton. Come to life, a grape by the Dutch de Heem would be a succulent marvel; but a superficially luscious sweetmeat of Thiebaud's would gag in our throat.

Of course, a knowledge of art history is not necessary to respond to these cabalistic still lifes. Thiebaud paints with all the virtuosity of Manet or Morandi, although undoubtedly his world is harsher and less humane than theirs. His surfaces are juicy (the sign of a constant appetite for paint), but his thought is arid. As magnetic specters of our most immediate commerce with matter, these images remain self-sufficient.

Nevertheless, he satisfies one of the age-old principles of the still-life tradition: that a practitioner discover some virtue, not in inanimate objects as such (most elements of visual experience may have that virtue), but in the *isolation* of the inanimate object. He invests many of our poor nutrients with a sardonic, bright pathos, partially because of this isolation. After seeing a Thiebaud, one can no longer walk into a hamburger stand with the same casual familiarity. But it is the contribution to art that I applaud the most. I am not sure whether it is "pure" or "impure," but I do know that contact with it has enriched my inner and aesthetic life.

—

GUSTON

MAY 19, 1962

Max Kozloff

AS AN ENVIRONMENT in which to exhibit an artist whose works don't "carry" well past ten or fifteen feet (a painter, furthermore, of some discretion and delicacy), the Guggenheim Museum is not a success. Under the blinding lights of the museum, and crowded monotonously together in rows, Philip Guston's canvases are in a police lineup. On the occasion of this retrospective, moreover, his cause is not helped by a stuffy and elementary exhibition catalogue. Yet the kind of justice his paintings crave is not easily given; they have a way of eluding formal analysis and of tripping up rhapsodical interpretation.

This exhibition pitilessly reveals that, for all his stature as one of our foremost painters, Guston suffers many, and not always de-

liberate, restrictions. Thus, his figurative work of the forties has a parochial bathos which verges on commercial illustration. It is one of the significant facts of his development that in the crucial years 1941 to 1948 the artist was in the Midwest, removed from all that was vital in the contact of New York painters with European modernism. It is only charitable to pass by early Gustons which are less compelling than Blumes, Shahns, Kuniyoshis or Evergoods of the same period. And for a quite different reason, notably his present great *crise de conscience*, I feel obliged to write off his production of at least the last three years. The museum was particularly undiscriminating in selecting examples from this period, in which Guston is most out of step with himself, and in which there is a breakup of his previously quite magically balanced tensions. Just as his brush frequently stops short of the confines of his canvases, so too the meaningful part of his career to date recedes in from both its extremities.

But even in that central bloc (his art by then had become totally abstract), we are dealing with an artist of great limitations. He relies on unitary color contrasts—scarlet against gray-pink being one of his typical harmonies. Then too, his treatment of shapes as they shift between trapezoids and tongue lickings, and clot no more interestingly than around, or just off, picture center, is a conservative element in Guston. Finally, one notes the even, if rich wet on wet impastoes of his central masses, not varied in responsiveness to each other from work to work, and only altered abruptly after a certain mental distaste for them has set in.

Like the Impressionists, Guston is a very unassuming composer (although he works on a much vaster scale, and has had occasional leanings toward the kind of ordering of Mondrian's plus and minus series). But unlike the Impressionists, his inventiveness of stroking, luminosity and nuance, far from being hyper-stimulated by nature, has to issue from within himself. With all his hesitancies, this burden was periodically too great, and has produced that quiet anguish in which much of his pictorial explorations tremble. Fluctuating between narcissism and self-disgust, unwillingly forced to accept ever newer responsibilities, and pondering his problems past alertness into fatigue, Guston gives the impression of an enormously timid artist.

Yet, how moving is that timidity. Upheld in a brief span of only four years, 1953 to 1957, is not merely Guston's moral courage, (which was shared by those American *avant-garde* artists who launched themselves free from pre-made, mostly European directives) but a sin-

gular poetry as well. Of all the Abstract Expressionists, Guston is here the most haunted by his own condition, and sensitive to its pathology. Lacking all bravado, he huddles over his sensations, and distills from them an exquisiteness that would be quite French, if the dilemmas that had given them birth were not so much a part of his own experience. In terms of what was happening in American art, Guston represents a link between the gyrating-explosiveness and gesture-oriented abandon of Kline, de Kooning and Pollock, and the contemplative, atmospheric "total" color environments of Still and Rothko. In his role as mediator between such conflicting impulses, he is equivocal, sometimes *illustrating* the dissolution of brushy energy into color (by increasing the saturation and extent of his spotted hues), and at other times *expressing* it by fudging more graduated transitions. This ambiguity is precious.

Despite its deficiencies, therefore, this exhibition contains some specific joys. One of them is to see Guston's reserve in 1954 melt, like wax under a slow flame, by a kind of warming of the imagination. The whole metabolism of his pictures changes, and there begins to appear a more voluptuous rate of "respiration" As if they were contrasting and expanding auricles and ventricles, Guston's reds suffuse the adjacent tissues of the canvas with a blush. Admittedly, the interior paint substances grow plump, but only to accentuate the airy looseness of the surrounds, and the tactile character of the surface now gives Guston his structure, even as it reveals an artistic quickening. He applies paint not to register through it a particular state of emotion, nor even to deposit some mineral correspondence to the movement of his hand, but to savor the pulsating aliveness of the pigment itself. In this, of course, he is neither Abstract nor Expressionist, but rather strives to ideate sense—that is, to set a conceptual premium on sensation as sensation. In so doing, he injects his work with Symbolist overtones and, like the late Bonnard and Monet, goes beyond sensation. Guston's canvases of the mid-fifties live as invitations to contemplate the oneric changeability of light and color. The beholder falls into a reverie in which his optical pleasure is enhanced and dazed by stimuli that seem to lose their materiality.

In the beginning, his palette is no less Symbolist than the overall metaphor of his works as breathing organisms. He loves his own coloring, with all the anxiety of the owner toward his own possessions, and wants to preserve it from the day-to-day rhetorics that threaten his resolve. For a time, he seems aware of taking refuge within certain self-imposed artistic limits, and that in refuge, half-

tones and low harmonics are appropriate. His is a concentration of feeling on colors which is powerful and rare.

But presently his chromatics grow more hectic, and Guston adds glittering oranges, blacks, greens and blues to his habitual cool reds. Masterpieces still follow upon one another, so that "Beggar's Joys" and "The Room," 1954–55, are succeeded by such ripe, memorable performances of 1957 as "The Mirror, Oasis" and "Native's Return." Along with the brightness, one finds an increased tumult of jagged tiltings. And with their fiery iciness, the new colors no longer hold their place, but jump out belligerently. For some reason, however, the tone does not become gayer, only more desperate. We are in a resurgence of what I want to call Guston's harlequin complex. It is hard, after all, to ignore the wistfulness of his drooping motions, his superb stuttering and willowy drawings and, above all, the tattered, writhing loneliness of his forms. They conjure up the mentality of the sad clown. Here is a valid, though transient, extraction from the world of his alienated mummers of the forties. Mingled, then, with his speculations about sensation, is Guston's toying with psychosis and self-pity.

With various exceptions, and under auspices hard to explain, the latest area of his work is pretty much of a shambles. Not only has it ceased to coincide with his point of maximum relevance to the "scene" (hardly a criticism), but it has become a victim of his worst impasses. Disaggregated, unraveled, the current forms boggle abortively against one another. The paintings are no longer the embodiments of struggle, but the prisoners of it. Whatever their malaise, however, they have the virtue of at least thrusting into relief, and making us more thankful for, the work of the earlier fifties.

Without Guston's achievement in mid-career, American painting would have been considerably the poorer. He gave to his environment an apparent calm at a moment when it was most needed to temper the excesses, on one hand, of Expressionist convulsiveness, and on the other, of overly mystical or mannered tendencies. Then, too, Guston matured somewhat later than his colleagues, thus extending by his example a momentum already beginning to falter. Yet, beneath his hedonism, one must not underestimate his passion and his unease. Concerning Guston, I am reminded of a remark of Giacometti's as he once passed from Pollock to Bonnard: "At last, real violence!"

Oddly enough, the conservative writer Hilton Kramer was The
Nation*'s art critic from 1962 to 1963. A former critic for the* New
York Times, *he is now the editor and publisher of* The New
Criterion *and the art critic for the* New York Observer.

—

WRONG TARGET

NOVEMBER 17, 1962

Dore Ashton

DEAR SIRS:

Hilton Kramer began as a literary critic and he has remained one.
What he criticizes in his piece on the Mark Tobey exhibition [*The
Nation,* Oct. 6] is only the literature that has flourished around the
artist.

But even as a literary critic Mr. Kramer commits a number of
blunders. . . . He says that Tobey's art will not support aesthetic and
philosophic burdens that have been assigned to it. Assigned by
whom? By Mr. Kramer. For it is Kramer's idea that Tobey is "illus-
trating" the tenets of his religion. He taxes Tobey for his titles, for
his renown in Europe (a childish resentment, surely), for his ab-
sence from New York, for his philosophical convictions and for the
things he *doesn't* do in his paintings (he doesn't, for example, use
large formats which would make a strong physical impact on the
spectator, Kramer says). All these things are patently extraneous. . . .

Why should [Mr. Kramer] make a false statement which his lay-
man reader is helpless to detect, such as that the press has joined
Mr. Seitz in heaping praises on Tobey? The fact is that with one
small published exception, the entire art press to date has conspired
to treat Tobey as a "minor" artist whose reputation in Europe is
ludicrous. Once labeled minor, of course, the question of what To-
bey is doing becomes unimportant. No critic is willing, it seems, to
take the time these contemplative paintings require to enter into
Tobey's universe and try to experience it. But then, Mr. Kramer has
never cared to enter paintings. He likes literature and makes it well.

DORE ASHTON

New York City

The New Realists

November 17, 1962

Hilton Kramer

THE SHOW CALLED "New Realists," which is currently installed at the Sidney Janis Gallery and in a temporary street-floor annex at 19 West 57 Street, is full of things to talk about. There is a small refrigerator whose door opens to the sound of a fire siren. There is an old-fashioned lawn mower joined to a painting (on canvas) and mounted on a wooden box. There are collections of old sabers and discarded eyeglasses under glass. There are even paintings (like, you know, with *paint* on canvas) of pies and sandwiches and canned soup. There are bath sponges dipped in blue paint; tidy arrangements of toilet articles in boxes; huge blow-ups of details out of comic strips; and mural-size, montage-like paintings and constructions on themes out of movie advertisements. There are also soap dishes, hand tools, radio parts, electrical sockets, old valentines, a kitchen table, and various other "found objects," which are painted, glued, nailed and otherwise arranged and redesigned for the purposes of aesthetic display.

The show is thus crammed with visual incident of a kind that abounds, unfocused, in the world around us, but which is here converted to artistic purposes. The conversion to art of this commonplace material is said to carry with it, or at least to imply, some profound commentary on the nature of modern life. Here are the real objects of our civilization, and here is a new generation of artists intent upon dealing with them, openly and honestly—or so we are invited to believe. In his essay for the catalogue, John Ashbery invokes for comparison the role of objects in the works of Robbe-Grillet and Antonioni; and in an excerpt from a work called *A Metamorphosis in Nature*, Pierre Restany brings us the astounding news that modern life is characterized by factories and advertisements. Mr. Janis, perhaps nearer the point, nominates the New Realists (who include Americans like Dine, Lichtenstein and Oldenburg, and Europeans like Tinguely and Baj) as the rightful successors to Abstract Expressionism, and provides them with an impressive historical lineage. (Like all new wonders in art today, the New Realists are acclaimed as both radical innovators and heirs to

tradition.) Mr. Janis correctly separates the new work from the mo-
tives of the old Dada group, and he goes on to suggest that, in
"eschewing pessimism," the New Realists have made something im-
portant out of their delight in the objects of modern life. I can
report that many visitors to the show find it diverting, amusing and
meaningful in precisely these terms.

Nowadays a new style of art that showed itself capable of making a
clear and powerful statement about life would indeed be an event.
But does this exhibition really constitute a serious comment on con-
temporary life? I don't think so. Like nearly all current art, it is only
a comment on art. Though born of a yearning to attach itself, some-
how, to the vulgar public culture from which formalist art has irrev-
ocably separated itself, it none the less remains hostage to the
attenuated highbrow aesthetics from which it seeks so strenuously
to escape. Its artistic failure is thus twofold: it neither revivifies the
moribund abstract language which determines all its internal deci-
sions, nor does it succeed in conferring new meaning on the objects
and motifs of popular culture it seeks to utilize.

 This latter failure is perhaps the more notable. The New Realism
attempts to take artistic possession of popular culture by means of
an irony that is too puny and slack, too thoroughly lacking in ideas
or intuitions about anything but art, to do the job it sets itself. Am-
bitious as the New Realists are to make a raid on the world that
exists beyond the limited confines of aesthetic self-consciousness,
they only dramatize the radical inability of current aesthetics to deal
with worldly experience. Their irony is not comprehensive enough
to encompass the brute visual power of the material it attempts to
domesticate. Their vision is too tame and accommodating, their con-
cept of art too diffident and insecure, even to conceive of triumph-
ing over the experience they are ineluctably drawn to, and their art
thus becomes the victim and satellite of the very energies they yearn
to harness and affect. The visual dynamics of mass culture are simply
too robust, too ubiquitous and resourceful, to submit to so feeble a
challenge.

Only a radical and comprehensive vision could hope to penetrate
the armor of popular culture and divert its force to some artistic
end, and this is what the New Realists conspicuously lack. Neither
in ideology nor in aesthetics are they equipped to bring us a new
view of the world they seize upon for their material; instead there
is the usual attempt to disguise an essentially conformist and Phil-
istine response to modern experience under a banner of audacity

and innovation. The main expressive impulse in the New Realism derives not from an original perception of common objects but from devices already widely used (often with great ingenuity and finesse) by sophisticated commercial designers—window decorators and display artists—for exhibiting them in department stores and supermarkets. In aping and adapting these devices (but rarely, I think, improving on them) they add, at best, only the same ineffectual self-consciousness from which their commitment to vulgar objects is intended to deliver them.

Behind this effort of artists to attach themselves to something beyond art and to renegotiate a response to their immediate social environment in a way that transcends the visual sectarianism of abstract art, there lies a poignant, perhaps a tragic dilemma. Art, which once brought us closer to our experience, has now joined forces with the objects of the world which alienate us ever more deeply from having a true sense of ourselves, and it is unclear whether our experience can now be aesthetically explored and repossessed without abandoning art—at least art as we have known it in modern times—in the process. Almost every current development in art, from the revival of figure painting to the staging of "happenings" and the use of found objects, is an attempt to re-establish the *real*, the immediate, and the recognizable at the very center of artistic expression and thus give to experience some kind of hegemony over aesthetics. And yet these developments (of which the New Realism is one) fail precisely to the degree that they cling to the aesthetic precedents they seek to dislodge. Is it perhaps another case of wanting to eat one's cake and have it too?

—

GERMAN POSTERS

JUNE 15, 1963

Hilton Kramer

EVERYONE INTERESTED IN the visual expression of political emotion—one is tempted to say, everyone interested in both politics and art—will want to see the exhibition called "Weimar-Nürnberg-Bonn" which Paul Mocsanyi has organized for the Art Center of The New School for Social Research. Consisting of more than eighty German posters from the period 1919–1961, the exhibition is at once a stun-

ning documentary survey of the political life of Germany in the years of the Weimar Republic, the Third Reich and the Adenauer regime, and a vivid demonstration of the ways in which modern visual styles (expressionism particularly) have been adapted to political purposes. The focus of the exhibition is emphatically political, yet it is no less important as a commentary on the uses to which politics, and especially extremist politics, has put modern visual aesthetics. It thus raises a question about the appositeness of *avant-garde* styles to political goals.

Modern art as a whole has had a far more explicit connection with social and political ideologies than is now commonly supposed. The total victory in our own day of middle-class sensibility over *avant-garde* style has obscured for us the degree to which many *avant-garde* movements (certainly a majority) derived a good deal of their force and momentum from an overt attempt to change the quality—and at times, even the organization—of the societies in which they were conceived. Futurism, expressionism, constructivism, Dada, surrealism—these and other movements all had a political component that cannot be completely assimilated to the purely formalistic analysis to which the middle-class temper of the Western democracies has reduced most serious discussion of art. Even artists such as Mondrian and Gabo, whose styles seem totally absorbed in formal considerations, cannot really be understood apart from the social ideologies which acted as an impetus and an ideal in their aesthetic formulations.

Of all the countries in which a significant affinity existed between vanguard aesthetics and political extremism, Germany carried the association to its most compelling realization. The German expressionist movement, unlike its Fauvist counterpart in France, was in large measure conceived as an attack on the stultifying effects of industrialism, commercialism and bourgeois morality. Its orientation was bohemian, vitalist, anarchist and primitivistic; its literary gods were Whitman, Strindberg, Rimbaud. Its social commitments alternated between an idealism that yearned to redeem society on a more life-enhancing foundation and a nihilism that was unconcerned with anything but an aesthetically articulated rejection of the *status quo*.

This expressionist fulcrum gave rise, under the pressures of the First World War, to both Dada and the Bauhaus. The latter, with its Socialist bias and its ultimate acceptance of industrialism, consciously sought to implement the social idealism of expressionism, whereas Dada was for the most part concerned only to make an aesthetic demonstration of its anarchist-nihilist revolt. In no other

movement, moreover, was graphic art given so prominent and cen-
tral a role.

In the historical development from the *Brücke* group through the
activities of the Bauhaus, graphic art enjoyed a status equal to that
of painting, and it was precisely in the graphic medium that aes-
thetics and social ideology confronted each other most explicitly.

The posters that Mr. Mocsanyi has brought together at The New
School all derive, in one degree or another, from this conjunction
of art and politics that the expressionist-Bauhaus ideal made possi-
ble. They are, by and large, extraordinarily powerful as visual state-
ments, and at times absolutely blistering in the brutality of their
appeal. Though drawn from different political sources—Commu-
nist, Social Democratic, Nazi and Christian Democratic—they are
amazingly consistent both in their appeal to crude emotion and in
the artistic devices by means of which the appeal is made. Perhaps
the most disconcerting aspect of this exhibition, which as a whole
leaves a heavy burden on one's conscience and sensibility, is its dem-
onstration of how easily a brutal political idea can turn even the
most humanistically conceived element of style to its own purposes.
Indeed, I should say that the most moving and humane drawing in
the entire exhibition is to be found in a 1932 poster showing a group
of forlorn proletarian faces in a crowd—a drawing entirely in the
vein of Kaethe Kollwitz, and altogether as sensitive and felt—whose
caption reads: *"Our last hope! Hitler!"* And it is no less dismaying to
anyone who has been deeply attracted to the graphic accomplish-
ments of the *Brücke* group to see its revival of the woodcut and the
bold dramatic line placed in the service of the most vicious anti-
Semitism and the murderous German war machine. Just as Nazi
rhetoric is said to have left a permanent scar on the German lan-
guage, the use of expressionist graphic devices by the Nazis and
others has inflicted a deep wound on the aesthetic viability of the
whole expressionist tradition.

In all modern industrial societies, art is constantly being subjected
to the kind of corruption that inevitably follows from the application
of its effects to purposes that are alien to its conception. In our own
society, this corruption (more or less benevolent in intention) is
performed by the advertising business rather than by political
groups. Visual art, which is concerned to make discriminations of
feeling, is converted into graphic design, which is concerned to ma-
nipulate our feelings for the purposes of action. What is clear, I
think, at this point in modern history is that art itself is utterly help-
less in determining the speed and the purpose of this conversion of

its own energy and invention to non-artistic, socially determined objectives. To recognize this helplessness is not to denigrate art itself, but only to recognize the limits that our technological society has placed on it.

What is also clear, I think, is that the particular way in which art is transformed into design provides an extremely vivid profile of the society in which the transformation is made. In this respect, the "Weimar-Nürnberg-Bonn" exhibition leaves one with the image of a society in which technical finesse and brutish feeling live (even today) on the most intimate and reciprocal terms.

Mr. Mocsanyi has announced that this is to be "the first in a series [of exhibitions] depicting the use and value of art as a political weapon," and one is indeed grateful that someone in the timid world where exhibitions are nowadays conceived has at least faced up to this least explored aspect of the art of our time. Mr. Mocsanyi has worked both as an art critic and a political journalist; as a European, he has seen both the art and the political tragedy of our century develop at first hand. He is thus well placed to execute this series with intelligence and tact. The posters in the current exhibition have never before been exhibited outside of Germany, and we are already in Mr. Mocsanyi's debt for an illuminating—if also completely depressing—glimpse of a difficult theme. The story he is unfolding for us is not pretty, but it is at the center of our history.

While Kramer has often been accused of being an "enemy" of modern art, Kozloff generally took a very dim view of Pop Art as an artistic movement.

—

ROY LICHTENSTEIN

NOVEMBER 2, 1963

Max Kozloff

IN 1926, ROGER Fry, the British art critic and proselytizer for Cézanne in England, conducted a famous experiment. Placing his tracing of a Paul Klee line drawing next to a reproduction of the original, Fry nicely demonstrated that the "art" of Klee, even in something so elementary as a few pen marks, consisted of their scratchy, wiry testimony to the nervous pressure of the artist's

hand—a fact clearly shown by Fry's own exact but lifeless copy. Quite recently, in 1963, a New York artist, Roy Lichtenstein, exhibited a canvas which magnifies a linear diagram of a Cézanne. Because he has changed merely the scale and context of his motif, rather than its linear quality, Lichtenstein performs a *volte-face* on the Fry incident, and subverts its meaning. Mechanical reproduction, so culpable for Fry, and overtly utilitarian for the author of the Cézanne diagram, Erle Loran, is—we are obliged to think—"artistic" for Lichtenstein. Behind the borrowing propensities of such new American painting as Lichtenstein's, and illustrated very well by this little event; lies a rejection of the deepest values of modern art. It is a phenomenon worth some study.

After the last six or seven years in New York, it is perhaps no great secret that we have been witnessing an attack upon the notion of originality in painting. When he spoke in 1957 of the *avant-garde* as being the last stand of creative handiwork against manufactured visual objects in American culture, Meyer Schapiro, like the rest of us, had no idea how quickly events were to prove him wrong. The mistake, in retrospect, was in thinking of the *avant-garde* as the single enduring heroic and humanistic fixture in a national artistic life dedicated to Philistinism. A younger generation than Pollock's and de Kooning's, fighting to give itself some identity, was bound to come to certain opposite conclusions about the nature of the *avant-garde*. They implemented these conclusions by interjecting all kinds of reproducible, that is, non-unique, elements into the pictorial field: signs, stripes, maps, flags, rectangles, eventually advertisements. Psychologically, this was an attempt to release the ego from the burden of invention, and visually it turned out to be a rebuttal of painterly "open" contours, and optically unclear forms. Above all, however, there grew a cleavage between the motivating idea and its embodiment, the fusion of which had been the guiding premise of Abstract Expressionism.

There have been two important consequences. One is that the distinction between abstract and representational works is no longer relevant: it is quite as possible to put comic strips through their mechanistic paces, as it is concentric circles. In fact, as conventionalized icons they ultimately have about equivalent non-meanings. The other factor to bear in mind is that this phase in art opposes the straight-forwardness of its predecessor with subterfuge. Until very recently, it was obvious that the apparently manufactured or reproduced images *were* handmade, that the hand, in effect, was counterfeiting the machine. This is an assertion of the

will by means of self-effacement; and of the whole development, one can say that the creative agency has taken an ironic coloring by placing itself deliberately *outside* the physical area of the presented work.

Doubtless, the basic aspect of the new art is that it is contextual as much as it is conceptual. For it is largely by their new context, that is, the gallery, that one is surprised into accepting banal concepts as having any claim upon one's attention at all. Even when the encounter is with certain parallel effects in "abstraction," for which the gallery is not an unusual surrounding, these ironies have allowed a considerable withdrawal from a traditional concern with "formal relationships." (To see how irrelevant this has become, one need only examine the black paintings by Ad Reinhardt and Barnet Newman.)

But the "unoriginal" is in time compromised by irony. The polemical force of the reaction against the exalted egotism and individuality of the Abstract Expressionists cannot be maintained if there is a subversive heroism of sarcasm. Up to now there had perhaps been an equivocal content in the exploration of American *kitsch*: hatred of the image, alternating with a kind of uncertain pleasure in it. Observers were able to feel that they were witnesses to a satire on our mass-produced culture, and as if they too were party to the artist's castigation of the absurd subject. Moreover, the sheer, manual craftsmanly effort to disguise the hand in these works was purposely not successful, and the basic "sincerity" of their attack against the original was, if disliked in certain quarters, never seriously challenged. For any *avant-garde* to perpetuate itself, however, it must eschew rhetorical ambiguity, and keep its audience at bay. In terms of the present *avant-garde*, such aims have led not merely to diminishing the area between the automatically reproduced and the individual imagination—which at least still permitted illusionism—but to upholding the machine-made as art. The two are becoming synonymous.

And, finally, just as the attitude toward the motif became unqualified admiration, so irony dissolved in the manufacturing of canvases which once again repudiated the spectator's intellectual comradeship with the artist. There was, in short, a shift from mimetic art to the quasi-literal. The farthest reaching consequences of this move have been the refusals of artists to *transform* their materials, whether initially created by them or not; and of this whole situation the Lichtenstein painting is a cynical anagram.

* * *

Lichtenstein has already become notorious for his pedantic explorations of the world of "funnies" and the mail-order catalogue. In them, like a Marxist theorist, he demonstrated a logic of approach that has brought many of his less "advanced" colleagues into an almost party-line consciousness of their direction. The change in the work of Tom Wesselman, for instance, who went from renditions of Matisse like nudes surrounded by real-color food ads, to mere aggregations of the latter, is symptomatic of that direction. But Lichtenstein, in the present work, has gone further. In its very choice of "subject" his message exposes itself. It is no accident that Cézanne, the *monstre sacré* of modern art, the fountainhead of all its transformations, is the point at issue. But in addition to Cézanne himself, Mr. Loran, who in his nice American way is trying to explain what those transformations of reality are all about, is mocked. (Certainly those As, Bs, Cs and Ds no longer mean anything, and not merely because they now lack a key.) By making the most thoroughgoing of his borrowings, Lichtenstein has arrived at the "purest" distillation of his thought. One has no other choice but to read his finished product, not as performance, for there is none, but as *intention*, idea. Of course this problem had already been posed in twentieth-century art, and entertaining distinctions of *intention*, as between, say, the way Duchamp mustaches the *Mona Lisa*, and the way Dali does it, are possible. But Lichtenstein is saying here that art is *not* transformation—he copies rather than mustaches—and thus, in his chilly bad faith, is finally even anti-Dada.

Now I must admit that while outlining this sketchy background to the painting under discussion, a rather disconcerting question occurred to me. If, instead of an informed specialist, an interested layman stood before the picture, what would be the possibilities of communication? What could he "do" with the Lichtenstein, or make of it? The answer must wait until he bones up on Cézanne, Loran, Abstract Expressionism, the successive reactions against it and Lichtenstein's earlier work. It is a little bit like an episode in the Marx Brothers' *A Day at the Races*, in which Groucho sells Harpo a tip sheet, for which it is necessary to buy another tip sheet, for which it is still necessary to have another, etc. By the time there is any kind of decipherment, the aesthetic race (it was rather a short course) has been run.

Naturally, it can be objected with some reason that art is not meant for the interested layman. All works of art, and especially great ones, require for their appreciation a quantity of inside information. Even Cézanne, in his attitude toward Poussin and certain old masters, cannot be fully comprehended without historical ex-

pertise. But the point is that he survives one's lack of it beautifully, because, like Mondrian—or Rothko, for that matter—he offers the viewer an amplitude of extra-academic sensuous and emotional experience. The tendency of Pop art, unfortunately, is to grab the spectator by the collar whenever he tries to obey his natural instincts by looking at art as one human being confronting the work of another, and to stuff him back into an airless envelope of contexts. Worse still, all that really counts any more are the contexts and intentions, not the execution and the results. I find it hard to get excited by Lichtenstein's appeal to my special knowledge; still less can I summon up interest for his insult to my general intelligence.

One last point that must be made concerns history again. The present *avant-garde* has subverted not only "action" painting, but also the ethic of most twentieth-century art, as formulated in its structural and expressive aspects by Cézanne. The particular path chosen by this *avant-garde* (it seems to be conscious of fewer and fewer alternatives) is to deny that art is a metamorphosis of experience, and to affirm that it is a copy of artifacts. Fanatical in the sense that Santayana defined the fanatic—as one who redoubles his efforts after losing sight of his original purpose—an artist like Lichtenstein has violently broken through to the notion of painting as imitation.

Paradoxically, therefore, he joins forces with the swarms of pre-impressionist artists in the city who have never understood the lesson of modern art and who are sustained by the possibility that they may one day be recognized by those who have always held that art is a convincing reordering of raw appearances. This coalition of extreme Right and Left, of dullards and confidence men, reminds one of what Senator Fulbright thought certain utterances of Barry Goldwater and the Chinese Communists had in common: that they favor a policy of co-annihilation. Transferred back into the realm of art, the faculties menaced are the saner apprehensions of the possibilities and responsibilities of painting by artists who are aware of their tradition, but are neither slavishly bound nor opposed to it. I very much hope that they prevail.

—

Francis Bacon

November 16, 1963

Max Kozloff

WANDERING UP AND down the ramp of the Francis Bacon exhibition at the Guggenheim Museum, on a sunny afternoon, is a grisly experience. The joys of painting, the presence of a brilliant mind, are not enough to dispel one's morbid embarrassment, as if one had been caught, and had caught oneself, smiling at a hanging.

If these canvases are so frequently about guilt, and unerringly the guilt of aberration and cruelty, they are also confessional. Admitting crime, and probably madness, they intimidate precisely because they are so candid. What I have in common with this English artist, Bacon, what his other spectators have, varies; but anyone, when he leaves this exhibition, will share, I think, a darker and more dreadful view of our condition.

Painting has sought in many ways to impose a pessimistic view of life and death upon its audience. Ordinarily far more important than the subject matter, the paint itself acts out; or becomes infected with, an equivalent of the felt emotion: pain, disease, passion. Bacon's paint, too, functions dramatically. But it almost indecently caresses the surface, and apes a preciousness and rarity whose outrage of the tragic sentiment induces a response totally disproportionate to its physical power. His pleasure both compensates for, and justifies, his self-exposure. The paint, indeed, alienates by its freakish narcissism, which is precisely what Bacon wants. In his state of moral lucidity, in which revelation but not judgment is possible, this is his only means of asserting his superiority. Only upon the closest examination does one realize how very gingerly, indeed squeamishly, his paintings are brushed.

But this doesn't happen, or it didn't with me; until the end—when I finally caught up with Bacon's deepest uncomfort. Earlier, I was aware only of his velvety, featherlike white strokes which tickle the navy blue ground, and form an urgent image all in their own time, as an irritant. It is irritating, that is, to be cajoled, wheedled and finally seduced into an enjoyment of a painted scene whose nature connotes only horror or repulsion. Such are his various tab-

leaux of crucifixion, and murder, although his merely voyeuristic glimpses of male orgies arouse guilt in this same way.

Behind it all, however, is the most uncanny intuition of art. Bacon's split of consciousness may be involuntary, but it enables him to live vitally in two worlds; to sense what is real, but to feign his sense of it. That I perceive his distance from the horror makes his figment all the more persuasive. If I experienced these intense pictures with the intensity they seem to demand, then I ought to be out of my mind. Rather, what I feel is a sustained illusion of intensity, for there is a silent covenant between us: Bacon is not to strain me, and I am not to unmask him. In that manner, the muteness of painting allows his license, while the erected frame of consciousness—the sheer vicariousness of his art—permits me to participate in his emotional sphere more deeply. Painter and spectator build their own climate of belief. Certainly the perception that art is different from life is not exclusive with Bacon. But he is perhaps unique in levering it so *diabolically* into his work.

These ideas came generally to mind, but were transcended by two particular canvases in the exhibit. They are seen side by side, forcing an analogy tellingly anticipated by the director of the exhibition, Lawrence Alloway. In one, on the left, two pink nude bodies, clenched together off to the left margin, sink rapturously into the grass of an indoor hothouse. Above (not beneath), the black blue void of stained canvas is relieved only by spectral white strokes suggesting a grid, or bars ("Study for the Human Figure," 1954). In the other work, two naked men are sprawled on a bed, one in a grotesque, slipping crouch above the other. Their cadaverous white flesh is set off by the dazzling white sheets. Behind, is the same profound blue, pierced by luminous lines that indicate a room. And suspended in the atmosphere are faint, vertical striations of light that penetrate the figures and smear their faces and limbs ("Two Figures," 1953).

Like so many of Bacon's things, these pictures have in common their restricted range of color, their deadpan, muffled flatness of surface, and the powdery, fragile stroking of the imagery. In addition, the subjects are set off by contrasted zones of light and dark, much as if they were jewels on a black cloth platform. There is no source of illumination other than the dead light which, however, emanates fiercely from the protagonists themselves. Finally, the images are in frantic, yet only barely decipherable, bled out, motion.

But immediately after this, the differences assert themselves. For one thing, movement in the former painting is optically perceived

and transcribed, by a concatenation of blots and swishes in the writh-
ing bundle of flesh, and by rhythmic drooping flicks in the vegeta-
tion. One sees the movement before quite interpreting what it is
that moves. It is like a squirrel in high grass, a kind of inspired
pussyfooting in paint. In any event, I feel myself, like Bacon, outside,
looking in, past the erotic blur, upon an actual incident. All this
crumbles in the other picture, which is at once much more explicit
and less real. Here, the vibration of contours, a runny film over the
hyenalike faces, is a free act of the mind. Bacon is in there some-
where, pretending blindness, but with his senses wide open to the
tactile and glandular fantasy. And willy-nilly, nightmarishly, I am
emotionally subpoenaed to follow him.

As in an old dream, however, there is something familiar about
this hallucinated world. I am not in a dark room at all, but, it seems,
looking at a photographic negative. The white on black has a con-
text which reverses the shadows and makes the modeling meaning-
less. Unfortunately, though, or perhaps ingeniously, Bacon returns
much of the latent chiaroscuro relationship to normal, and thus
flusters the new expectation that he alone has set up. Besides, the
catalogue has already informed me that the source for this picture
comes from the late nineteenth-century photographic studies of
men in motion by Eadweard Muybridge. And as if this weren't baf-
fling enough, it is difficult to escape the impression that the painting
itself, with its only two values which are nevertheless so chromatic,
is like a color photograph of a black and white. Insinuated, then,
into this airless pictorial vision, are the reflecting and impinging
echoes of the camera lens.

It is not perhaps farfetched to think of these photographic ref-
erences as credentials for the violent world Bacon explores. In the
"Two Figures" they lend a spurious actuality, as it were, to a real
fiction. But above all, in view of the monstrousness of what he is
showing, they introduce an impersonal documentary note that re-
establishes the observer's distance from the image.

In the end, I feel much closer to the "Study for the Human Fig-
ure," chiefly because it stimulates the observed, and places me in
some tangible relationship with the event, no matter how glamorous
and shivery in itself. Its companion, on the other hand, overwhelms
the emotions, and then careens like a hit-and-run driver into the
vacuum of a tabloid flash. The picture I prefer yields itself slowly,
bit by bit in time; the other goes off in an instantaneous florescence.
After a certain point, however, the major sensation in both is of a
hairbreadth escape from chaos. "He paints," as one critic put it,
"from a sense of the impossible, as though he were driving flat out

into the dark," and then goes on to speak of this as being linked to certain obsessive targets, rather than as being, in any sense, a lyrical response to the creative act. Behind the luxury, therefore, is an extreme anxiety, not even concerning the subject, but about bringing the picture itself into existence. Whether one is deflected from this to the nightmare, or back, however, Bacon loses—that is, he wins.

—

RAUSCHENBERG

DECEMBER 7, 1963

Max Kozloff

ROBERT RAUSCHENBERG WILL continue to be dismissed by many as a belated Abstract Expressionist, one whose dribbles and splatters of paint have merely thinned and shrunk to give way to objects or reproduced images of daily life. Others consider him to be a decorative practitioner of the collage technique originated earlier in the century in the *Merzbilder* of Kurt Schwitters. Perceiving that he is neither the one nor the other, a third group—one could already have guessed—makes him out to be a compromised talent who vitiates none too original ideas by sheer facility. This, however, still leaves those spectators, among them myself, who find something far more poetic than additive in Rauschenberg's sensibility, and who are kindled by an inventive genius they would never confuse with mere slickness. I am convinced that his is the most significant art now being produced in the United States by anyone of the younger generation.

It has only recently become evident that Rauschenberg is using his famed concept of "combine painting" (in which there had been a dialogue between actual objects—Coke bottles or pillows, and the easel picture) as a point of departure for a whole new field of inquiry. Or rather, it is a frame of reference for an imagery that now recedes into the fibers of the canvas, from which it once had protruded. This is accomplished by the silk-screen transfer to the canvas of photographs, originally black and white, and now filtered by as many as four colors. That the new presences do not have the immediate, yet enigmatic, impact of real things is as obvious as that their range in time, space and memory is infinitely greater. Even while surrendering a good deal of physical substance, the artist remains faithful to his original premise that formal relationships alone

are an insufficient reflection of reality; at the same time, he refines his intuition that raw artifacts need some further projection into the pictorial life of the work of art.

The difference between what Rauschenberg now does (which was anticipated by his rubbings, "frottages," illustrating Dante's Inferno, 1959) and his earlier bipartite constructions, is like the difference between the cinema and the theatre. Only two years ago, in *Pantomime*, two opposed fans, plugged into the picture, blew up gusts of paint between them. But at his present show at the Castelli Gallery, the air currents have been cut off, the sound of the motors has ceased, and there is only a flickering, grainy, shadowy ballet of newsprint ephemera, colliding bodilessly with one another on a surface whose continuity their disruptions refuse to acknowledge. Compared to the behavior of these vicariously perceived figurations (which are the traces of things rather than the things themselves—not even such things as pasted photographs would be), the once complex tactics of collage seem primitive and simple-minded indeed.

Initially, one is aware not so much of the contained, visually recorded, objects as of their baffling removal by reproductive means from the sensing eye. The echoing series of negative, print, plate and re-photograph almost duplicate the infinity effect of anything caught between faced mirrors, and there are at least seven (and conceivably ten) stages between Rauschenberg's image and the object "out there." It is doubtless as a comment on the way we receive news of the outer world, on how we have automated all communications as mechanized afterimages—the kinescope, the delayed broadcast—that Rauschenberg presents these works which are neither graphics, paintings, nor collages, but a piquant metaphor of all three.

And yet his statement is not unfriendly toward our technological packaging of sensations, but rather welcomes the inherent language possibilities of the mass media. He wants to make one aware of interference, of visual static for its own sake (just as in *Broadcast*, with its two radios concealed behind the surface, he once did the same with aural static). But now the effect is not cacophonic because the spectator has long been inured to the conventions of photography in tabloids, films and television, and has come to accept them as adequate substitutes for reality. Rauschenberg takes advantage of this comfort, but refreshes and vivifies it by coarsening the visualization and changing its context. If our vision is attuned to photography, even to the extent of expecting to experience paintings in

that medium, then, by reconstituting the photograph within his opened-up perimeters Rauschenberg ironically arrives at a new work of art. What was once the echo has become the substance—but a substance exquisite because, and yet despite the fact that, it is fossilized.

More than in any of his previous paintings, reality fades from sight, literally and figuratively. But it is the great paradox of the latest work that its physical energy is kept whole. Each of these tableaux is part of a continuing badinage between the assertion of paint and the claims of the outside world, now carried on through the mediation of reproductive processes. Thus, in *Windward* there is the following, rather breath-taking archetypal sequence: among color-photographed oranges, the sudden appearance of a painted orange circle; beneath are black-and-white transferred photographs of oranges, the same orange circle, and then a painted black-and-white orange, modeled in gray. Furthermore, all this is done in extremely close values, so that one is forced to discriminate hues optically with great finesse, as well as identify the actual level of existence among the competing artifacts. In assimilating the re-created matter, therefore, one is compelled to absorb the paintings both visually and logically, processes which go at two different speeds in the mind.

Far more dramatic are the analogies, say, between drips and the feathers of a photographed eagle (which recalls the real, stuffed one, in 22 *Canyon*, 1959), or between frequent rainbows and the four-color separation process. Like an oblique reference to Abstract Expressionism, these analyses and syntheses reveal how a "painting" is made. But even further, they go back, past Schwitters, to the discipline of Cubism, with its suggestion of multiple points of view. Finally, a black-and-white orange is inconceivable without Surrealism and, behind it, Dada. Hence this Rauschenberg exhibition is a tribute to the insights of all the great movements of twentieth-century art, but it is also a remarkable extension of them.

Within this general framework, whose implications are inexhaustible, Rauschenberg elicits some very particular associations of his own. Scenes of flag-waving patriotism, the Statue of Liberty, vignettes of sports events, the roof tops and water tanks of New York, aircraft instrument panels, capsules and nose cones, and interspersions of fluttering birds, evoke the excitability of a mind agog with a welter of current events, and vulnerable to the relentless pressure of the urban environment. But it is no inchoate mentality that presents us,

in a daring stroke, with a clocklike electrical diagram superimposed upon Michelangelo's Sistine *Last Judgment.* This is, after all, the artist who has illustrated Dante, who punctuates his imagery with stop signs, and who shows the light going out in a series of four photographs of a glass of water (almost like a lamp dimming behind a film strip). It may be too vulgar to think of the overall *mélange* as hellish, but bright hints of disaster and dissolution are certainly not excluded from Rauschenberg's inconography.

Even the format he chooses—fragments, bleed outs, separations, repeats, superimpositions—mocks the integrity of any object that is caught within the field of attention. One has glimpses of the same image, in different sizes and colors, scattered over the surface, in a Marienbad simile of *déjà vu.* In fact, the whole procedure is reminiscent of the flash-backs, subliminal blips, filters, cut ins, pan shots and dissolves of the modern film, so that the spectator is forced to "read" the picture as if it were on a screen, its narrative consistency perhaps shattered, but its nostalgic poignance thereby heightened.

Other than Rauschenberg, no artist I know (even including Jasper Johns) takes such a polyvalent and imaginative inventory of modern life. It is this fullness of response which gains respect, and which is deeply moving. He stands ultimately aside from the pop art which owes so much to him, not by his methodology—the interjection of a banal motif into a new context—but by his ambition to derive as much sensuous profit from it as he can. One never feels in his work the complacent sentimental attachment to a subject, however evocative, which so easily degenerates into the frequent sado-masochism of what one apologist has recently called "antisensibility" painting. Such are the beauties of Rauschenberg's new colors, eliciting a chromatic transparency midway in effect between Titian and color television—that it would take another article merely to do justice to them. He satisfies an appetite for the contemporaneous, for an explicit crystallization of what art must respond to at this moment, which few can claim even to excite. But he does so in a way that is not only far from self-defeating, but gives every evidence of becoming a classic of our time.

—

JASPER JOHNS

March 16, 1964

Max Kozloff

OF ALL THE younger-generation American painters, Jasper Johns and Robert Rauschenberg are the most famous. Johns, thirty-three, probably has the dubious distinction of being the more problematical, and the more censured. This quiet artist, whose favorite color is gray, and whose characteristic tone is self-effacing, has unwillingly managed to antagonize the greater part of his audience. None of this would have much interest as a situation, however, were it not that Johns, almost single-handed, deflected the course of Abstract Expressionism about six years ago. Today, neither Pop Art, much of current assemblage and abstraction, nor in fact, the whole bright, chilly tenor of ambitious painting would be really conceivable without the example he set in 1958 with his celebrated targets and flags. He transferred the *attitudes* (about flatness versus illusion, for instance) of such painters as de Kooning and Guston to the *mechanics* of his own art. And whatever was irresolute and ambiguous in their artistic disturbances, he made deliberate. It is on this issue of deliberateness that John's work justifies itself, and most often provokes misjudgment.

This month for the first time, one can view the production of Johns in an extraordinarily detailed and comprehensive retrospective at the Jewish Museum—the trenchant swan song of its departing director, Alan Solomon. A question, by no means as easy as it sounds, immediately presents itself: before a Johns painting, what, in fact, is one really seeing? Let me take as an example a very recent and richly thought-out oil—"Field Painting," 1963–4. Two thin, vertical, generally gray canvases, have been separated about an inch from each other, just enough to allow the free turning of wooden letters hinged to their facing edges. Attached to the letters are various objects, summarizing the repertory of Johns's earlier creations: two paint brushes, two cans (beer and coffee), a table knife, a little squeegee and a roll of solder. Above, shines an orange neon "R." The letters spell red, yellow, blue, echoed (in oranges, grays and mauves) on the canvases themselves, as if the painted letters were an antiphonal response to actual ones. Furthermore, the objects

themselves are tinctured with clerkish touches of paint, while off to the left are snappier, broader strokes, not dissimilar to Action painting. Most of the visual material here is sequential, but disarranged, resisting any kind of continuous "reading."

Already it will be obvious that if one sees merely an inventory of the things Johns includes in his "field," one sees nothing—and misses the experience. It is frequently maintained that there is something passive or neutral about his method of working, but in this painting, as in many others, if the emotional environment is flattened out and muted, its operations are a series of the most violent resistances—to logic, pictorial structure and coherent symbolism. What unites John's motifs is his persistent disclaimer that they are what they are. By means of dislocations and driftings out of focus, he contradicts what one knows with what one sees. The very difficulty of settling out the notions of painting, language, movement, color, as they are entangled in his visual scrabble, detonates that unease which is now the perversely proper condition of viewing.

It cannot be reasonably asserted that Johns plays unfairly here. Far from concealing valuable clues to his intention, he gives too many—like any good mystery writer. Yet the enigma, ultimately, is not about some relationship contained within the organism of the painting, but the nature of the organism itself. Can a picture give off its own light, make some of its constituents freely changeable, or finally abandon pretension to style in successfully bringing forth many styles—and still be a painting?

It has never occurred to many concerned spectators that these may be serious issues. Hence, one often hears objections that Johns is eclectic, frivolous and gimmicky (sin of sins!), that he makes the viewer far too conscious of the devices employed, or that he emphasizes the parts of his work at the expense of the whole. But this is to overlook the fact that dismantling intellectual preconceptions and pictorial prejudices can be a complete process of vision in itself, and that it is cliché-thinking to insist on a purity that exists neither in art nor in life. The critical shibboleth which maintains that if one removes the objects from Johns's paintings, they fall short as works of art unknowingly vindicates the integrity of his attack. Imagined as less than itself, any work of art would be unsuccessful. As for Johns, his subtle agglomerations are about as divisible as paint strokes—a fact which the artist underlines by camouflaging artifacts under paint itself.

Still, the question remains: what does he show? Apparently it is not just something disassembled mentally, and reintegrated picto-

rially—but recognizable things, such as flags, maps, targets and letters. But by this token, one is unfortunately not yet entitled to call Johns a representational painter. For one thing, he is much too logical in his choice of motifs. The figure 5 (in his "Black Figure 5"), for example, is not a representation, nor even an image of 5, but the number itself. Theoretically, maps and flags fall into the same category: configurations which are conventionalized to begin with, and cannot be "rendered" or duplicated, without becoming originals. (Spatially too, Johns never employs schemata which are not normally as flat as his surfaces.) As a result, his pictures, familiar as are the objects they present, do not have "subject matter"—for that implies a difference between the visual medium and the thing referred to. What one apprehends are merely so many abstract forms, upon which social usage has conferred meaning, but which now, displaced into their new context, cease to function socially. From this tremendous insight alone, has sprung the momentum of Pop Art, and the huge quantities of abstraction that is emblematic in character. But it is to misunderstand Johns greatly to suppose him intrinsically interested in his motifs—a forgivable boner of early criticism—or to think him concerned with new formal discoveries, an idea repudiated by his employment of systems in which every relationship is predetermined.

What constantly interferes with either interpretation, and tells you that image is not reality, is a nondescriptive brushy activity. Compositionally all over, but delicately pressured and nuanced, Johns's handling acts as palpable *interference* to meaning and metaphor. Once perceived, and it is impossible not to perceive them immediately, the paint marks wedge open the continuity between idea and execution, at least as normally exemplified in the creative process. They call attention to themselves, not as physical equivalents of gestures—as in the Abstract Expressionism from which Johns derives historically—but as calculated intrusions into alien territory. The same goes for his pictorial fudging in the three-dimensional medium of sculpture, or rather—since his themes here are shoes, flashlights and beer cans—objects (or casts of them) which are trying to become sculptures. Their pictorial patina simultaneously dispels their "thingness" and yet emphasizes these works as "representations" of the things they once were, or came from.

Few of Johns's detractors realize that he is an art-for-art's-sake painter—incognito. Discovering this is a question of reading out his intention from one's own puzzlement. Unlike the Dadaists, who juxtaposed objects or images without supplying the connection, Johns

very straightforwardly tells us what it is—paint: precisely the one most incongruous agent. With a rather sinister spirit some observers have mistaken for sadness, he demotes paint to the status of a mere covering, and yet deposits it so caressingly as to make one think that the canvas was once some vast erogenous zone. This is not the usual aestheticism of an artist for whom sensation is precious; on the contrary, what is precious for Johns is whatever doubt he can elicit as to the identity of the thing he creates. Yet from this he is anxious, I think, to make not a riddle, but poetry.

The genesis of Johns's poetic vision began with the flags and targets of 1954 and 1955, installed fittingly in the last room of the upper floor at the museum. At first, the forms are very discrete and precise, the colors strong, but they soon vanish, and give way to gently pulsating façades, generally gray, and loss frequently white (e.g., "Drawer," 1957). Splashier, looser painting is then introduced, roughly around 1959 ("False Start"), in which ganglia of colored strokes spatter a field now stenciled over with the names of hues other than those which they "label." From this time, too, date many of his numerologies, his tentative dealings with rotative actions in paint (caused by moving measuring sticks through it—"Device Circle") and, finally, the extraordinarily varied series of maps. These latter take as their theme the map of America, paint it in a kind of outdoorsy bravura, and make of the stenciled state names a sprinkled punctuation of cold and hot color notes. Johns's color, in fact, has a schematic quality, and is limited in range (usually confined to unmixed primaries and secondaries such as reds, blues and oranges) which the artist unsuccessfully encourages the spectator to view as impersonal.

Documented almost work by work at the museum (and with a solid representation of his drawings), the last three years of Johns's activity accelerates the imaginative complexity of his art, even as it unfolds new images, such as the bronze Ballantine Beer cans, the flashlights, light bulbs, and the metronomically disposed paint bands capped by hand prints (as in the great canvas called "Diver"). And yet these paintings, differentiated as they are, are often merely the basso *ostinato* to the treble of objects, which when the two are joined together, produce the strangely modal orchestration of the Johnsian combine. One thinks of the broom and its sweep in "Fool's House," and the canvas within a canvas of "Viola." By interchanging motifs and techniques, he continually refreshes his development, and halates his realm of inquiry apparently without end. But just as the allusions to Dada, and particularly Duchamp, increase as we near the present, so does the painterly energy, and the curiously muted

spontaneity of the artist's handling—now, more than ever, recalling Abstract Expressionism.

It is at this time, with an *oeuvre* very much in progress, that Johns is incurring the most displeasure. For those to whom the future appears to lie only in a more rigorous conceptualization, he is shamelessly sensual; to others who insist on pure, physical painting, his art is over-intellectualized. This alone should gain him the respect of more detached observers. Clearly, his intention is limited neither by the one goal nor the other, although it draws fuel from them both. What finally happens when one views one of his works, I think, is the slowing down of the perceptual process until it grasps the immobility, and more important, the immutability of visual art. If his theme is permutation and metamorphosis, (delicately underlined by his employment of such equivocal materials as wax encaustic and liquid sculp-metal), he can nevertheless instrument it only by accepting the still point, the "thereness" of the created object. That his results frequently impress us not so much as objects, but as presences, that his incongruous shocks elicit oscillating intuitions of totally opposing possibilities, is a sign of a new power of abstraction. And in no other artist I know, is this more animal and yet sophisticated. One can name the ingredients in his work, but the names are neither usable nor descriptive of the hypnotic experience they give. And the time one can devote to looking at works of art sustains, rather than diminishes, this hallucination. It is Johns's special touch.

—

NEW WORKS BY OLDENBURG

APRIL 27, 1964

Max Kozloff

DURING THE LAST three years in New York, there was to be found among certain carnivalesque exhibitions in the galleries the work of Claes Oldenburg, more ludicrous than dignified, and yet more dignified than frivolous. Like its fellow "Pop" art, it was supposed to be satirizing American commercial culture, but internally found better game in questioning the identity of art itself. Now, at his important show at the Sidney Janis, this question is as much up in the air as before, or perhaps more accurately, merely dissolved in an outpouring of Leviathan laughter.

There is something quite obviously deflated about Oldenburg's outsized artifacts, his telephones and toasters: their bodies have been frankly preboned. His "Soft Typewriter" (vinyl, kapok, cloth and plexiglass) has contours that get on ill with one another, and that can be poked and twisted to go their own ways, often finally making the object look simply like a squishy puddle of a typewriter. Still, the pendulous, sagging quality of his creations is as much the result of the material with which they are composed, flight-bag vinyl, as is their gay, glossy sheen. By this stratagem, so typical of Pop art, Oldenburg pretends to shift responsibility from his own action to the behavior of the medium at hand.

But the artist goes further in presenting us with another line of goods entirely (as the wooden "Outlet with Plug"), which are eviscerated but unlike the gloppy ones still vertebrate. Therefore, as he is expanding his original simile of a retail store to an inventory of Sears-like proportions, he is also materializing works of art in alternate states of matter—hard and soft, shiny and dull. Not merely is this considerate, it is downright enterprising. (Oldenburg also here seems to be the first of a trio of artists—the other two being Johns and Jim Dine—to move from a painterly to a precisely contoured execution.)

If this were the extent of his joke, however, one might write it off as just another folkloric episode in recent art. There exists still a third class of articles, though, whose relation to the above mentioned items is that of preliminary design to finished product, or, if you will, *maquette* to final work. Oldenburg calls them ghost models, and they are usually done up in cloth partially stuffed with kapok. They are the baldest and homeliest of his things, not yet reincarnated in the glossy glamorous hides which are his stock in trade. That Oldenburg has seen fit to exhibit these rather touching sketches, these flabby light switches, with their penciled dimensions for the seamstress, accentuates his interest in process and activity, not merely idea. Far more expressive than documentary, they function like the brush strokes in Abstract Expressionism, displaying the personal constituents of the artist's vision, as it is put together. It can't be helped that they also continue the charade in which the manufacturing operation and aesthetic statement coincide. On second thought, all this overt rationalization of procedure is a bit nervy.

But it is an ingratiating nerve. These templates for bagatelles were both literally necessary and imaginatively inspired. A genuine effort, after all, is required to produce even the absurdly false and synthetic. Aside from this conceit, the conceit of any artist who would

impose the truth of his own vision upon the fiction of the outer world, Oldenburg has two relevantly wild ideas up his sleeve. The first, a carry-over from his earliest shows, is to present each piece as swollen by some kind of aesthetic elephantiasis to proportions that make children or puppets of us all. After a while, the spectator might have the panicky sensation that he, rather than the work of art, is seriously out of scale. One is transported back to that stupefying infantile world in which foodstuffs seemed monstrous, and vacuum cleaners, menacing. Though of thoroughly huge dimensions, this art is anti-monumental, not only in its mockery of the American penchant for size, but because now, unlike his previous plasters, the air has been let out of these grandiose but pathetic concoctions. Or rather toys. For, if parents buy miniaturized versions of grown-up objects for their children, Oldenburg makes amplified effigies—superficially far less sophisticated—of those same objects for his spectators.

The other obvious idea or element in this exhibition is its accent on the theatrical. Even forgetting his now rather well-known organization of "happenings," one is still struck by Oldenburg's deliberate stage-set artifice. More than mock-ups, or industrial samples, these works resemble properties, however limp and magnified. One is simply brought up close to prettified pickles and French fries with ketchup which were meant to be readily identifiable from the back row.

Mingling, then with the allusions I have already mentioned, are the anti-naturalistic optical conventions of, in this case, a rather primitive theatre. Certainly it is impossible to escape them in the present trapezoidal ping-pong table, or in the berserk perspective of the bedroom which Oldenburg exhibited only a few weeks ago in the same gallery. Exaggerated even when one is correctly positioned, these distortions are grotesquely illogical in their current context, slanted as weirdly as the other pieces have been made soggy. With an arming naturalness, the artist switches metaphors under the guise of a predetermined mechanism, and with the sanction of thirty years of surrealism (were it not for the latter, his leopard fur popsicles would have been the sheerest caprice). Everything in Oldenburg conspires to find in the values of overstatement a new kind of imagery, nowhere else explored with a program so consistent, an eye so sharp, and a wit so wicked. Art, which has been given a cloddish buoyancy, survives very well in the process.

—

Pop on the Meadow

July 13, 1964

Max Kozloff

IT WAS HARD this last season to be indifferent to a horde of needling exhibitions, notable for their attack as sheer theatrical environment. Ever more frequently, the galleries have presented such varying delights as fetishism, gigantomachy, nudie movies, kinetic sculpture, billboards and Brillo (both fake), electrically operated noise makers and neon assemblage. This hurly-burly—hard sell, resourceful or sarcastic by turns—might be called the new amusement park syndrome in art. At its mercantile heart are techniques impersonal, even industrial in operation. In fact, the distinction between art and artifact so dwindles as to cause not merely basically equivocal attitudes toward creation, but a uniformity of feeling about it. The ambiguity may conceivably be an advantage, but the uniformity is potentially a drag upon the vitality of modern art. No recent show of contemporary art has embodied these contradictions more completely, or with greater fascination, than the New York World's Fair.

In fairs on the scale of the present one at Flushing Meadow, the free-enterprise system mirrors itself as flatteringly and seductively as it knows how. Neither permanence nor restraint hobbles a project whose aim is an artful fantasy in which individual products are not nearly so important as the spectacular packaging of the business idea itself.

But fairs usually generate the same dilemma: how to implement their rage for symbolism without an awareness of or respect for the advanced architecture of their day. In the past they had recourse to nascent engineering, a solution as inspired as it was appropriate. The industrial revolution could come increasingly out into the open, and after a long-fought battle the machine itself could be exhibited in lieu of, but with all the seriousness of, art. Technology, bathed in an aura of heroism, became self-symbolical, and fairs, as one writer phrased it, penetrated social consciousness as "apotheoses of progress." All this no longer stands as an issue at Flushing Meadow. Instead, we are shown something no less—and no more—than the world of our own experience. And if this gaggle of structures falls short of utter realism in depicting our promiscuous urban-scape, it

is only because they are grouped a bit too cheek by jowl, a trifle too hugger-mugger.

This is not to say that the spectacle ever for one moment approaches the reasonable. Business has for so long been presenting itself throughout the land in vulgarizations of the geodesic and poured-concrete wonders of modern architecture (themselves nourished by engineering), that the fair seems merely a concentrated reflection of them. As a result, an unrewarding (because egalitarian) search for ornament, and the effect-mongering of the present building scene, have been hardened into a caricature and put into the special context of an occasion. This context charges edifices which have the scale and stance of architecture, but not its abstractness, which possess the spatial daring of sculpture, but not its individuality, with the bizarre status of Gargantuan objects. Even this, or perhaps especially this, has its own peculiar relevance and justness in mirroring American life in 1964. (To the extent that the foreign pavilions approach this status—and hence show American influence—they gain interest, and in proportion to their reaction against it, mere distinction.) To gaze upon the forest and egg IBM pavilion (planned by Eero Saarinen) and the Tower of Light (sponsored by private utility companies, and looking like a clot of broken-off searchlight beams) is to witness the curiously sterile excitement required by a childish American imagination. Nothing at Flushing is more frivolous or phony than the religious pavilions, which have been cut off severely from their decorative and ethnic traditions. The New York World's Fair, inevitably, is a fun house for adults.

Under the circumstances, the fair's connivance with modern architecture has been only a trifle more deliberate than its collusion with modern art. The latter has not merely been trying some rather striking new paths of synesthesia; it is also becoming notorious for defining beauty always in the terms of the commercial culture itself. For the first time, the aesthetic qualities of a world's fair cannot be measured against those of contemporary visual art (and of course, found wanting) because the two are now locked together in a symbiotic relationship quite beguiling to behold. On the level of taste, if not intention, there has been such astonishing agreement that the difference between commerce and art begins to dissolve very much as do objects, images and reflections in a hall of mirrors.

Doubtless the man of the hour here is Philip Johnson, whose garrulous control-observation tower with the gaudy plastic canopy, at the New York State Pavilion, is far more uninhibitedly and agreeably *kitsch* than his new theatre at Lincoln Center. There is no more

significant tip-off of the fair's character than Johnson's sophisticated choice of ten artists, mostly Pop, to decorate his set piece at Flushing Meadow. But one wonders if he anticipated the effect of the Lichtenstein or Indiana (a monstrous "Eat" sign), and the excellent Rauschenberg and Rosenquist, blown up to epic proportions, and clarioned outdoors for all to see. Deprived of their intimate gallery atmosphere, the silk-screen-transformed color photographic and billboard montages of the latter two artists are returned to their approximate point of origin, and the displacement which once gave them so much pungency is minimized. These works of art cease to be creative expressions intruding into the world of manufacture, and become instead equivocal flora of that world. An alarming cycle has been completed.

One learns a great deal from such an episode. At bottom, art and commerce have never been genuinely allied, but it took this moment of their greatest convergence to dramatize the full quality of their opposition. Even in their obsession with commercial design, ambitious artists always bracket or contain it. Popular culture is their subject, their nature, so to speak; it is not their artistic form. Business, on the other hand, when it is not collecting art as a corporate display of status, is bent on subjugating, or more politely channeling, it to widespread purposes of cajolery. Each force thus tries to encircle the other. If the captains of industry were pleased to find artists gratuitously affected by the glamour of advertisements, they must by now be disconcerted to see how unaffiliated that interest has become. Art, typically enough, is not playing fair.

Some rather confused intimations of that resentment crop up here and there in Mr. Moses' vast enclave. In the patriotic introductory film at the United States Pavilion, for instance, there is to be seen among an orgy of American flags, the "Three Flags" of Jasper Johns—visible long enough for a quick eye to note the brush strokes. A bit less mysterious was a touch of nervous horseplay at the sparkling IBM show (conceived by Charles Eames). Here, an announcer calls for a work of art to appear on the screen, gets a filmed shot of Andy Warhol's Campbell Soup cans, demands "real" art, and is rewarded with an Ingres Odalisque by an obediently programmed projector. If anyone was aware that monotonously aligned soup cans may contain an oblique comment on computer technology, there was little to indicate that John's painting has nothing to do with nationalism. But there is no reason why the works of art should not be manipulated this way, since they themselves similarly subvert the signs and symbols which were their original motifs. This is another

volte-face in which "communication techniques" triumph over a content which is too simple to stand unadorned in commerce, and too ambiguous to be more than secondary in art. Not what you say, but how you say it: that is the principle.

In this light, the New York World's Fair is a riot of vignettes that, would make many a Pop artist jealous, just as it is a sequence of tableaux that were indirectly influenced by him. And everywhere there are coincidences and parallels between the two. To a person who has seen the latest Rauschenbergs, for example, the possibilities of what that artist could do with the controls of the RCA color television engineers—who "tune in" the complexions of TV stars—are excruciating. And the grotesque wonders Oldenburg might perform if given access to the new synthetics in the duPont labs fairly stretches the imagination. Already his work (and that of Wesselman) suggests that in the "House of Good Taste" industrial life is imitating art. In addition, the all-over lettering on the IBM dome is reminiscent of Chryssa, and a U.S. Pavilion display of a cardboard cut-out crowd waving real placards recalls Marisol. Finally, Disney's auto-parts jazz band (Ford) is a cute variant of an idea that Joe Jones used quasi-electronically in his music-making contraption awhile back at the Cordier show, "For Eyes and Ears." In fact, the environmentalist's dream is a living reality at the fair—if the vicarious sensations it so incredibly amplifies can be called reality.

The most authentic innovation of the fair is its employment of a kind of environmental cinema, which ranges from the 360-degree theaterama at New York State, through the encompassing screens at Johnson's Wax, to the dialogue with real people at duPont, to the flashing, segmented, shifting and sliding screens (showing photographs, movies, prints and diagrams) at the IBM and the United States Pavilions. Coupled with its recorded voices, its Muzak and its conveyor-belt handling of spectators, this cinema presages whole future areas of the audio-visual to be explored by the Pop artists—especially those like Warhol, Conner and Whitman who are going into the movies. It is all a great testament to Yankee ingenuity, shared incestuously by artist and business designer alike.

Of course, artists are hampered by a shortage of funds and materials which are at the limitless disposal of the latter. Or at least they are suddenly made to look hampered when big business decides to gild itself in Veblenian ostentation. Art, however, can take its revenge in satire which, in turn, makes industry look totally wanting in self-criticism.

The final cleavage between the fair and the galleries, however, lies not in appearance, theme or methodology—which are at mo-

ments startlingly similar—but in mentality. The gap is best expressed in terms of innocence and cynicism. Any image or process which the two fields have in common forces a comparison between the enlightened and realistic cynicism of the artists and the unenlightened, dreamy innocence of Madison Avenue. The one shocks, the other lulls. But on the level of ethical comparison the rules are reversed. Thus, products are unscrupulously marketed, and appetites shamelessly pandered to, in a capitalist system whose moral corruption throws the aesthetic world into a light of touching purity and ingenuousness. And yet Pop art gains affluence and recognition essentially through businessmen collectors whose way of life is deeply questioned by the art they patronize.

Hence the ambiguities of the New York World's Fair are moral as well as aesthetic, and its tensions are social as well as technological. Above all, in its waste, opulence, impermanence, falsity, cheeriness and energy, it expresses something quintessential about that hybrid work of art which is American civilization. It also develops eyes to see a new beauty. All in all, the show has considerable color in its cheeks.

—

BARNETT NEWMAN

MAY 16, 1966

Max Kozloff

AT THE GUGGENHEIM Museum this month, we are being offered the latest and most revealing glimpse into *l'affaire* Barnett Newman. I say affair because from the beginning there has always been something extra-artistic, even sociological, about the presence of this painter in the history of postwar American art. It is a presence that has loomed enormously large, on the basis of only a scanty showing of work. For Newman is enjoying the enviable career of having been a radical innovator among his own contemporaries during the forties, and of remaining a viable guide to an entirely younger generation today. Alone among the Abstract-Expressionists, his example still reaps new converts to an area (one is loath to call it a style) of undimmed relevance to the current situation. At one time literally a vast colored surface, with central splits, that area now reveals itself to be variations on the theme of a white canvas, vertically subdivided off at its sides by black bars or lines. His present show consists of

fourteen such black-and-white paintings, 78 inches by 60 inches each (with one additional, having a left-hand orange border) entitled "The Stations of the Cross: Lema Sabachthani."

Elsewhere I have stated that Newman's position has been so fecund possibly because it has been so fragmentary. For his work, to paraphrase Delacroix, is the complete expression of an incomplete mind. With his manipulation of only the fewest elements on a monolithic scale, and his great frontal blankness, he could suggest a ground-breaking post-Cubist idiom without having to make individual statements within that idiom. In the sense that this can be an achievement in its own right, that it could provide a general context for others, more particularizing in their theses, Newman's reputation appears creditable. It would seem that he allowed various factors—color, scale and drawing—to be reinterpreted, if only by their dissociation and magnification as "objects" within the picture entity. The pictorial parts overwhelm the concept of the whole.

From the examples that have been exhibited, Newman's color contribution lies in his insistence that a single hue can dominate all other sensations. The color—red, orange or blue—is neither especially luscious nor particularly restrained; but it is optically all-pervading. Scale, of course, has a great deal to do with this. A museum or gallery is never as appropriate a place to demonstrate the effectiveness of such grandiosity as a private home, where a Newman painting will displace a whole wall and reduce into puniness the knicknacks of elegant living. To keep the impression that the core of the experience is still painting, a margin will contrast with the major mass, or a thin bar will funnel down its middle—not so much as a sketch of relationships but as testimony of unremitting weight and disproportion. If Newman were a musician it would seem as if he had restricted himself to composing for a kettledrum and triangle. He forgoes orchestration in favor of maximum differentiation. Finally, although he can be said to have dispensed with drawing in the conventional sense, he apparently wants it to be made known that any edge, even that of the painting, can purvey a drawing function. Lines, then, are not the only form of demarcation. From this has issued the quite clear critical judgment that the artist is not interested in either shape or closure but rather in an extension that bellies the superficially geometric finiteness of the façade.

Yet I am let down by the elementary ambiguities of this vocabulary. Despite the calculated look of their structure, so many of Newman's paintings escape the responsibilities of ordering. And their sensuous uncommittedness—neither light nor tactility are energized

or altogether dispensed with—leaves one gratuitously suspended and frustrated. Newman, in fact, might be a Puritan who has inadvertently strayed into a big-time context of indulgence, and come out a little confused in the process. On May 1, at the Guggenheim, he publicly permitted himself to say that a non-statement in painting still, after all, provides a statement.

The present suite of paintings, dating from 1958 to this year, are purposeful in visual theme, without in any sense being strictly dependent on one another. Yet, viewed as a group, they play a wide sequence of variations on spacing which, by virtue of the proximity of each canvas, has an unexpected coherence. Here, the idea (one that must go back at least to the mid-fifties), is to contrast a thick left-hand stripe against the foil of a spindle far off to the right. With the latter, by painting over a tape, and then pulling it away, he often gets the effect of a linear absence, thus softening the rather Manichean oppositions within the series. Around about the Sixth Station, he begins to do with line what he had previously done with color masses; and from the Ninth Station to the Eleventh, he plays off the beige unprimed canvas against the suddenly white bars. That Newman is not a finically scrupulous arranger of façade segments (like Mondrian), is testified by the spoliation of many of his compositions by a blatant signature.

The "program" of these paintings, the "Stations of the Cross," has caused a great deal of unnecessary consternation in the popular press (as well as befuddled Lawrence Alloway, who wrote the catalogue). But painters will always insist upon their right to have the most far-fetched ideas, or advance the wildest claims about the content of their work. To fail to see some accord between these faceless abstracts and the story of the Via Dolorosa is as inevitable as it would be false to make an issue out of it. The particular moralistic packaging of his art by an artist known for bombast in these matters has always been unconvincing—despite the credence some have given to his earlier mouthings about the "sublime." Rather, with a great deal of ostentation, Newman has aspired to, and attained the bland.

—

PHOTOGRAPHY

MAY 1, 1967

Max Kozloff

THERE HAS BEEN much comment upon what the so-called "New American Cinema," and its sometime counterpart, serious American photography, aspire to, in the way of aesthetic impulse, as they grapple with our common experience in an anti-establishment context. But it is essential to see in a certain mutual iconography—Hell's Angels, campy, jewel-laden men and women, a fetishism of the skin, visceral or glutinous glances at fruit and meat, social estrangement—not so much a revelation of actuality as a harboring of special inclination, clichés masquerading as protest. On the one hand, these can be farfetched and erotic, but there is a whole school that tends, rather, to elevate the commonplace, the isolated, the transient, the trivial, the incidental, as if these were the real components that made up the American scene. Above all, the themes of abstracted faces in the crowd, of vacant, highly reflective or mirrored surfaces, catching in their planes only the vacuity of the life around them, a haunted loneliness and grotesquerie—such themes, fusing together in a kind of pointless, chance-ridden profusion, provide much of the material to which ambitious young photographers have addressed themselves.

They are, of course, clichés in their own right, stereotyped even when accidental. Yet, for the very reason of having insisted upon them in their obvious accessibility, a group of energetic and imaginative "social documenters" has forced us to reassess the temper and meaning of walking the streets of our cities. Such a development in photography has a dual origin. On one hand there is its own prior history, which is rampant with amateurs, snapshotters and candid photographers, who have unquestionably affected the way the urban and rural ambience rearranges and disports itself under the ultra-mobile camera gaze. On the other hand, there are larger cultural implications which seem to have come, partly from a view of America that has crystallized from Pop art, partly from the viewpoint of certain foreign observers of our scene. Already in the 1950s, Simone de Beauvoir, in *America Day by Day,* commented in repeated astonishment on the plethora of mirrors that everywhere confronted her

in this country. About the same time, Robert Frank, a Swiss photographer who traveled the States on a Guggenheim fellowship, purveyed a sad and pungent scrutiny of the familiar, in terms of the unreal, the anomic, the mindlessness of a wayward technology, and a vastness of landscape, in which people still seem to be camping, instead of having long ago settled. In the view of François Reichenbach,
who made, the film *L'Amérique Insolite* (1960), the very instability of American existence could be examined in terms of liturgies: beauty contests, rodeos, strip teases, water-skiing, baton twirlers, etc., all observed as if by some fabulous anthropologist. And, in a current exhibition of three young photographers—Gary Winogrand, Lee Friedlander and Diane Arbus—at the Museum of Modern Art, these liturgies, though sometimes unrecognizably broken down, still seem to inform, in fact, give remarkable life, to glimpses of our time and place.

What these photographers have in common is a complete loss of faith in the mass media as vehicle, or even market for their work. Newsiness, from the journalistic point of view, and "stories," from the literary one, in any event, do not interest them. They have long since agreed with the innocent message of Philip Roth, in his famous article, "Writing American Fiction" (*Commentary*, March, 1961), in which he despairs of the power of current fiction to surpass the incredibility of the American scene itself, a scene that had elected Eisenhower as its President. Now we have movie stars and racist restaurant owners for governors, and the novelists can't possibly invoke the look of an atmosphere that could ever have permitted them.

Photographs, being mute and visual, tend to abstract or give a curiously immobilized, arrested quality to the situation as it impinges upon us. In place of the Farm Security Administration photographs, perhaps the most archetypal visualizations of the American reality in the thirties, we now have Elliot Erwitt's empty Fontainebleau Hotel hall in Miami, with its swirled vinyl floor and its maddeningly floral-lattice wallpaper. What is caught superbly well is the latent, as well as the outright, hysteria and violence that immediately affect a viewer on his first visit, or after a long separation from these shores. Of course, novels like Selby's *Last Exit to Brooklyn*, can literally spell it out; and television, like a kinescoped Selma march, can drench us with it at its most hateful. But the photographs are, in the end, the more frightening because they are the more "unexplained" in their extrapolations from a reality too absurd and formless to confront in its whole.

* * *

One does not look at a photograph with the attentiveness and re-
sources with which one encounters an ambitious painting. But it is
nevertheless true that the photograph shares with painting the au-
thority, direct or indirect, of the author's particular willfulness. In
its special form of consciousness, camera work theoretically lies be-
tween fiction, with its narrative techniques, and painting, with its
metaphoric ones.

Whenever photography transgresses this territory and moves to-
ward the literary, it opens itself up to adverse criticism. Such would
be Gary Winogrand's image of a little boy, bedecked with Mickey
Mouse hat, traipsing through a Forest Lawn-like cemetery, in tow
behind his mother. I do not quarrel with the mordancy or the justice
of the comment, but with the fact that it *is* a comment, and, however
caught by happenstance, a calculated one at that. Here the docu-
mentary is transcended by the didactic, with the effect of putting
me, at least, in reverse emotional gear. There is a patness about
such a situation, too quick and easy an invitation to see it as a foible.
Similarly, I react negatively to all those scenes of muted despair,
designed, it seems, to reveal the photographer's special sensitivity to
the social attrition of American life. How mechanical an attitude it
is to frame people in their habitual stances of boredom, distraction
and vulgarity. It is a banal tripping of the shutter, with diminishing
literary returns.

For all the sinuous nicety in the way he zones the countryside,
Andrew Wyeth is the most celebrated perpetrator of this literary
cliché, this stylized candor. It is not necessary to argue how much
Wyeth (whose retrospective concluded recently at the Whitney Mu-
seum) has been affected by photography in structuring his pictorial
apparatus. His (not so much respect for, but) indulgence in factu-
ality has about it the incriminating cast of illustration. And yet, as
Lawrence Alloway lately reaffirms, how insufferably pretentious are
the symbolistic aspirations of this farmyard soothsayer as he attempts
to translate his isolated turfs and gnarled physiognomies into state-
ments about *man's condition,* or at the very least, nostalgically sums
up the *spirit* of a whole terrain. In their stiffish dignity, or aged
pathos, his Negroes are particularly bad examples of a false con-
sciousness that mollifies the uneasy prejudices of his middle-class
audience. The effect of Wyeth's work is paternalistic, frequently in
respect to his subjects, and almost always in its "reflex jabbing" (Al-
loway) at its spectators. The same goes for the more subtle of his
affinities with photography: those overhead views and turned backs,
coquettish, accidental shadows, "clever" cropping; the magnified

pores of skin, the crumpled weeds, frayed curtains intimately seen, and preciously empty house corners. All these details are manipulated by an eye for sentimental pungency, just as photographers may lie in wait for similar subjects, like duck shooters for their prey. Studied or unstudied, these effects are alienating because they refuse to acknowledge their own premises, their own slightly vapid seriousness, concealed as a modesty of tone.

Without denying that there have been splendid examples of this genre in photography, without imputing dishonorable intentions to their creators or neglecting the extent that they have enriched the whole field, one turns with relief to an opposite or alternative mode in the medium. I mean that attitude which will always see spontaneity as inherently compromised, and which leans deliberately and unashamedly toward the controlled and the monumental, admitting, as it does so, the immobilized condition that photography imposes upon its motifs. Doubtless, this too is a cliché, or certainly a convention vulnerable to the judgment that it is out of keeping with the nominally intimate scale of photography. There have been as many mistakes in it, as many pretenses, as in the opposite style. In fact, they have a tendency to be more self-evident. However, the hieratic freezing of images has a reputable history. Quite aside from Brady, I can cite the recently published photos of Frances Johnson "documenting" (but more apparently, abstracting) the life of Negroes at the Hampton Institute (1900). Its chief European exponent was Eugene Atget. And its antecedents in painting go as far back as Piero della Francesca, though it is more relevant to think of its efflorescence in the thirties in the work of Paul Strand, Walker Evans and Dorothea Lange. Edward Hopper, for his part, inflected it with particular authority in his easel paintings. At their best, photographers of this persuasion have overcome embarrassment at the frozen, posed look of their images. On the contrary, formal control is as essential to their aesthetic, as accident is to their colleagues. In the work of Diane Arbus, this calculated frontality comes to have a striking modernity.

If Winogrand, from his moving car, lays claim to a reality that seems almost to have been inadvertently stopped in its tracks (the next instant might change it entirely), Arbus wants to heighten reality by its overt solicitation of response. Her transvestites and widows and nudists and Puerto Ricans look out upon us unflinchingly, as though, if not to countenance, to challenge the prurience of the photographic act. The psychological complexity of experiencing these photos has been acutely analyzed by Marion Magid in the current *Arts* magazine: "One does not look," she says, "with impu-

nity, as anyone knows who has ever stared at the sleeping face of a familiar person and discovered its strangeness. Once having looked and not looked away, we are implicated. When we have met the gaze of a midget or a female impersonator, a transaction takes place between the photograph and the viewer. In a kind of healing process, we are cured of our criminal urgency by having dared to look. The picture forgives us, as it were, for looking. In the end, the great humanity of Diane Arbus' art is to sanctify that privacy which she seems at first to have violated."

Not only has the maimed or aberrated subject *consented* to be observed but in effect he seems to have gained a curious aplomb through being observed. Arbus' refusal to be compassionate, her revulsion against moral judgment, lends her work an extraordinary ethical conviction. The glazed eye of Lee Friedlander's television set, playing in an empty room, is not more meaningful than Arbus' hair-curlered fairy, returning our scrutiny, nor is it less of a "set-up"—though it pretends not to be. It does not have that urgent complicity by which the Arbus photo produces in us its characteristic shiver. These unflinching American personages, who are altered by what seem to be glandular disturbances, kinky exhibitionism and general malaise, have the peculiar quality, as the exhibition director, John Szarkowski, has noted, of displacing neurosis onto the unexpected large quotient of "normal" people in her gamut of types. And if they do that, they have also by implication the capacity to impute the same condition to their beholders. This too, is the American reality, but a reality that has risen from the status of cliché to that of hideous insight.

Fifty years after Rodin's death, John Berger wrote this illuminating appreciation of the great sculptor.

—

NOTES FOR AN ESSAY ON RODIN

DECEMBER 18, 1967

John Berger

"PEOPLE SAY I think too much about women," said Rodin to William Rothenstein. *Pause.* "Yet after all, what is there more important to think about?"

• • •

The fiftieth anniversary of his death. Tens of thousands of plates of
Rodin sculptures have been specially printed this year for anniver-
sary books and magazine features. The anniversary cult is a means
of painlessly and superficially informing a "cultural elite" which for
consumer-market reasons needs to be constantly enlarged. It is a
way of *consuming*—as distinct from understanding—history.

• • •

Of the artists of the second half of the 19th century who are today
treated as masters, Rodin is the only one who was internationally
honored and officially considered illustrious during his working life.
He was a traditionalist. "The idea of progress," he said, "is society's
worst form of cant." From a modest *petit bourgeois* Parisian family, he
became a *master* artist. At the height of his career he employed ten
other sculptors to carve the marbles for which he was famous. From
1900 onward his declared annual income was in the region of
200,000 francs: in reality it was probably considerably higher.

• • •

A visit to the Hôtel de Biron, the Rodin Museum in Paris, where
versions of most of his works are to be seen, is a strange experience.
The house is *peopled* by hundreds of figures: it is like a Home or a
Workhouse of statues. If you approach a figure and, as it were, ques-
tion it with your eyes, you may discover much of incidental interest
(the detail of a hand, a mouth, the idea implied by the title, etc.).
But, with the exception of the studies for the Balzac monument and
of the "Walking Man" which was a kind of prophetic study for the
Balzac made twenty years earlier, there is not a single figure which
stands out and claims its own, according to the first principle of
free-standing sculpture: that is to say not a single figure which dom-
inates the space around it.

All are prisoners within their contours. The effect is cumulative.
You become aware of the terrible compression under which these
figures exist. An invisible pressure inhibits and reduces every possi-
ble thrust outward into some small surface event for the fingertips.
"Sculpture," Rodin claimed, "is quite simply the art of depression
and protuberance. There is no getting away from that." Certainly
there is no getting away from it in the Hôtel de Biron. It is as though
the figures were being forced back into their material: if the same
pressure were further increased the three-dimensional sculptures
would become bas-reliefs: if increased yet further the bas-reliefs
would become imprints on a wall. The "Gates of Hell" are a vast and
enormously complex demonstration and expression of this pressure.

"Hell" is the force which presses these figures back into the door. "The Thinker," who overlooks the scene, is clenched against all outgoing contact: he shrinks from the very air that touches him.

• • •

During his lifetime Rodin was attacked by Philistine critics for "mutilating" his figures—hacking off arms, decapitating torsos, etc. The attacks were stupid and misdirected, but they were not entirely without foundation. Most of Rodin's figures have been reduced to less than they should be as independent sculptures: they have suffered oppression.

It is the same in his famous nude drawings in which he drew the woman's or dancer's outline without taking his eyes off the model, and afterward filled it in with a water-color wash. These drawings, though often striking, are like nothing so much as pressed leaves or flowers.

• • •

This failure of his figures (always with the exception of the "Balzac") to create any spatial tension with their surroundings passed unnoticed by his contemporaries because they were preoccupied with their literary interpretations, which were sharpened by the obvious sexual significance of many of the sculptures. Later it was ignored because the revival of interest in Rodin (which began about fifteen to twenty years ago) concentrated upon the mastery of "his touch" upon the sculptural surface. He was categorized as a sculptural "Impressionist." Nevertheless, it is this failure, the existence of this terrible pressure upon Rodin's figures, which supplies the clue to their real (if negative) content.

• • •

The figure of the emaciated old woman, "She Who Was Once the Helmet-Maker's Beautiful Wife," with her flattened breasts and her skin pressed against the bone, represents a paradigmatic choice of subject. Perhaps Rodin was dimly aware of his predisposition.

• • •

Often the action of a group or a figure is overtly concerned with some force of compression. Couples clasp each other (*vide* "The Kiss" where everything is limp except his hand and her arm both pulling inward). Other couples fall on each other. Figures embrace the earth, swoon to the ground. A fallen caryatid still bears the stone that weighs her down. Women crouch as though pressed, hiding, into a corner.

In many of the marble carvings figures and heads are meant to look as if they have only half emerged from the uncut block of stone: but in fact they look as though they are being compressed into and

are merging with the block. If the implied process were to continue, they would not emerge independent and liberated: they would disappear.

Even when the action of the figure apparently belies the pressure being exerted upon it—as with certain of the smaller bronzes of dancers—one feels that the figure is still the malleable creature, unemancipated, of the sculptor's molding hand. This hand fascinated Rodin. He depicted it holding an incomplete figure and a piece of earth and called it "The Hand of God."

• • •

Rodin explains himself: "No good sculptor can model a human figure without dwelling on the mystery of life: this individual and that in fleeting variations only reminds him of the immanent type; he is led perpetually from the creature to the creator. . . . That is why many of my figures have a hand, a foot, still imprisoned in the marble block; life is everywhere, but rarely indeed does it come to complete expression or the individual to perfect freedom."

Yet if the compression which his figures suffer is to be explained as the expression of some kind of pantheistic fusion with nature, why is its effect so disastrous in sculptural terms?

Rodin was extraordinarily gifted and skilled as a sculptor. Given that his work exhibits a consistent and fundamental weakness, we must examine the structure of his personality rather than that of his opinions.

• • •

Rodin's insatiable sexual appetite was well known during his lifetime, although since his death certain aspects of his life and work (including many hundreds of drawings) have been kept secret. All writers on Rodin's sculpture have noticed its sensuous [sic] or sexual character; but many of them treat this sexuality only as an ingredient. It seems to me that it was the prime motivation of his art—and not merely in the Freudian sense of a sublimation.

• • •

Isadora Duncan in her autobiography describes how Rodin tried to seduce her. Finally—and to her later regret—she resisted.

"Rodin was short, square, powerful, with close-cropped head and plentiful beard. . . . Sometimes he murmured the names of his statues, but one felt that names meant little to him. He ran his hands over them and caressed them. I remember thinking that beneath his hands the marble seemed to flow like molten lead. Finally he took a small quantity of clay and pressed it between his palms. He breathed hard as he did so. . . . In a few moments he had formed a woman's breast. . . . Then I stopped to explain to him my theories for a new dance, but soon I realised that he was not listening. He

gazed at me with lowered lids, his eyes blazing, and then, with the same expression that he had before his works, he came towards me. He ran his hands over my neck, breast, stroked my arms and ran his hands over my hips, my bare legs and feet. He began to knead my whole body as if it were clay, while from him emanated heat that scorched and melted me. My whole desire was to yield to him my entire being. . . ."

Rodin's success with women appears to have begun when he first began to become successful as a sculptor (age about 40). It was then that his whole bearing—and his fame—offered a promise that Isadora Duncan describes so well because she describes it obliquely. His promise to women is that he will mold them: they will become clay in his hands: their relation to him will become symbolically comparable to that of his sculptures.

• • •

"When Pygmalion returned home" (Ovid, *Metamorphoses*, Book X), "he made straight for the statue of the girl he loved, leaned over the couch, and kissed her. She seemed warm: he laid his lips on hers again, and touched her breast with his hands—at his touch the ivory lost its hardness, and grew soft: his fingers made an imprint on the yielding surface, just as wax of Hymettus melts in the sun and, worked by men's fingers, is fashioned into many different shapes, and made fit for use by being used."

What we may term the Pygmalion promise is perhaps a general element in male attraction for many women. When a specific and actual reference to a sculptor and his clay is at hand, its effect simply becomes more intense because it is more consciously recognizable.

What is remarkable in Rodin's case is that he himself appears to have found the Pygmalion promise attractive. I doubt whether his playing with the clay in front of Isadora Duncan was simply a ploy for her seduction: the ambivalence between clay and flesh also appealed to him. This is how he described the Venus de' Medici: "Is it not marvellous? Confess that you did not expect to discover so much detail. Just look at numberless undulations of the hollow which unites the body and the thigh. . . . Notice all the voluptuous curvings of the hip. . . . And now, here, the adorable dimples along the loins. . . . It is truly flesh. . . . You would think it moulded by caresses! You almost expect, when you touch this body, to find it warm."

• • •

If I am right, this amounts to a kind of inversion of the original myth and of the sexual archetype suggested by it. The original Pygmalion creates a statue with whom he falls in love. He prays that

she may become alive so that she may be released from the ivory, in which he has carved her, so that she may become independent, so that he can meet her *as an equal rather than as her creator*. Rodin, on the contrary, wants to perpetuate an ambivalence between the living and the created. What he is to women, he feels he must be to his sculptures. What he is to his sculptures, he wants to be to women.

Judith Cladel, his devoted biographer, describes Rodin working and making notes from the model.

"He leaned closer to the recumbent figure, and fearing lest the sound of his voice might disturb its loveliness, he whispered: 'Hold your mouth as though you were playing the flute. Again, Again!'

"Then he wrote: 'The mouth, the luxurious protruding lips sensuously eloquent.... Here the perfumed breath comes and goes like bees darting in and out of the hive....'

"How happy he was during these hours of deep serenity, when he could enjoy the untroubled play of his faculties! A supreme ecstasy, for it had no end:

" 'What a joy is my ceaseless study of the human flower!'

" 'How fortunate that in my profession I am able to love and also to speak of my love!' "

• • •

We can now begin to understand why his figures are unable to claim or dominate the space around them. They are physically compressed, imprisoned, forced back by the force of Rodin as dominator. Objectively speaking, these works are expressions of his own freedom and imagination. But because clay and flesh are so ambivalently and fatally related in his mind, he is forced to treat them as though they were a challenge to his own authority and potency.

This is why he never worked in marble but only in clay and left it to his employees to carve in the more intractable medium. This is the only apt interpretation of his remark: "The first thing God thought of when he created the world was modelling." This is the most logical explanation of why he found it necessary to keep in his studio at Meudon a kind of mortuary store of modeled hands, legs, feet, heads, arms, which he liked to play with by seeing whether he could add them to newly created bodies.

• • •

Why is the "Balzac" an exception? Our previous reasoning already suggests the answer. This is a sculpture of a man of enormous power striding across the world. Rodin considered it his masterpiece. All writers on Rodin are agreed that he also identified himself with Balzac. In one of the nude studies for it the sexual meaning is quite

explicit: the right hand grips the erect penis. This is a monument to male potency. Frank Harris wrote of a later clothed version and what he says might apply to the finished one: "Under the old monastic robe with its empty sleeves, the man holds himself erect, the hands firmly grasping his virility and the head thrown back." This work was such a direct confirmation of Rodin's own sexual power that for once he was able to let it dominate him. Or, to put it another way, when he was working on the "Balzac," the clay—probably for the only time in his life—seemed to him to be masculine.

• • •

The contradiction which flaws so much of Rodin's art and which becomes, as it were, its most profound and yet negative content, must have been in many ways a personal one. But it was also typical of a historical situation. Nothing reveals more vividly than Rodin's sculptures, if analyzed in sufficient depth, the nature of bourgeois sexual morality in the second half of the 19th century.

On the one hand the hypocrisy, the guilt, which tends to make strong sexual desire—even if it can be nominally satisfied—febrile and phantasmagoric; on the other hand the fear of women escaping (as property) and the constant need to control them.

On the one hand Rodin who thinks that women are the most important thing in the world to think about; on the other hand the same man who curtly says: "In love all that counts is the act."

—

KRASNER

MARCH 25, 1968

Max Kozloff

CHRYSALIS AND SCYTHE, the open-eye camouflage of peacock and moth, hairy antennae and splattered fireworks: these are among the keening images of Lee Krasner's latest paintings at the Marlborough-Gerson Gallery. Or rather, they exist as inferences in her art, even below that threshold of recognition that would give these paintings the status of semi-abstraction. Gesture and form are too masticated to evoke the presence of real subject matter. But emerging shape and gyratory rhythm are keyed into a large sense of animal combat and floral growth. Miss Krasner's hooked, flung commas of paint punctuate larger loping mandibles, or swaying tufts and fronds eccentrically sheared off by each other. One can no

longer distinguish between the manual activity of the artist and the magnified flutter of movement in the bush.

Pictorial metaphors this much developed, and paint lashing so loose and yet controlled, do not crop up suddenly full-blown in an artist's vision. For twenty years Lee Krasner had tenaciously pursued some of the options inherent in the style of her husband, Jackson Pollock, and behind him, never so evident as now, the malignant entomology of André Masson, the French Surrealist. But in place of the zigzags and saw-tooths of the European painter, and the un-spooled traceries of the American, there appeared in her work of the early sixties a smudgier, more crumbled dervish of lines, dots and tones. If it was as "all over" as Pollock's, it was a style more of dovetailing than interlacing, more centrifugal than labyrinthine. Out from multiple centers that seemed to funnel across the surface there churned ragged shards of light and dark. Though it already conveyed the force of a strong personality, this art was embroiled in a number of particularly messy problems.

The major difficulty was the conflict between imagery meant to be perceived in one swoop, and complex, episodic passages that detained and absorbed the glance. This condition might have en-riched the overall experience had it not been for an intrusive in-coherence in the relation of part to whole, and means to ends. For instance, calligraphy flailed about without committing itself fully ei-ther to the role of gesture or contour. And space, for this reason, was indiscriminately buckled, crunched or squeezed, preventing a meaningful reading of depth or shallowness. At her 1962 exhibition at the Howard Wise Gallery, these stresses dominated a series of giant, rather monochrome façades, mostly indistinguishable from one another. It was a display of monumentalized irresolution.

The current show, scanning five years of revisions, reveals Krasner first to have pulverized (within much smaller formats) her immense gyrations into a webbing of lines squiggled and smeared from the tube; then to have attacked the problem of color by scraping strong hues into the surrounds as well as assigning them to the handwrit-ing. At first very harmonic, for instance dark cobalt against olive white, this color began to move out into fresher, more surprising combinations for which the precedent is not Pollock but Matisse. Subtle forms of beige and ivory on the unprimed canvas may at any moment counterpoint markings of alizarin, permanent green and cadmium yellow, as in "Pollination," 1968. To the excitement of these contrasts, simultaneously raw and understated, is added the tension of perceiving color as a sharp halo or shadow, rather than as a property or part of the substance of an image. Elsewhere, stri-

ations of color are more decorative and synthetic as they splash over goggling forms or are pincered into corners. "Uncial," "Transition" and "The Green Fuse" are all very recent works sprouting quick and knowing variations on the theme of image and ground. They signify that the burgeoning of a mature art has resulted in an incredibly bright and calamitous vision as well.

Lawrence Alloway coined the term "pop art," though he meant it to denote art that appealed to a mass audience rather than art that took popular culture as its subject. An early English champion of American post-war art, Alloway was a lecturer for the Workers Education Association, and a director of London's Institute of Contemporary Art. He moved to New York in 1961, and became a curator at the Guggenheim, a professor of art history, and The Nation*'s art critic. He wrote several books, including a monograph on Roy Lichtenstein and a study of violence in American cinema. He happened to be writing during a time in which the dramatic changes which helped redefine society were reflected in the arts and exhibitions of the period.*

—

HARLEM ON MY MIND

FEBRUARY 3, 1969

Lawrence Alloway

THOMAS HOVING WRITES, in the book of the show: "To me 'Harlem on My Mind' is a discussion. It is a confrontation. It is education. It is a dialogue."

As a matter of fact, it is an exhibition and we might as well try to determine what kind. According to Allon Schoener, who organized the show, it "was conceived as a communications environment—one that parallels our daily lives in which we are deluged with information stimuli." One of the Metropolitan Museum's press releases does not shrink from using the word that Hoving and Schoener prudently skirt, but which was obviously on their minds—multimedia.

Believing that only a multimedia display can grasp the complexity of 20th-century life, Schoener asserts that "we don't respond, as we once did, to an orderly progression of facts thrust at us in a fixed order." (Schoener relies a good deal, when he writes, on the 20th-century *we*.) But the truth is that his exhibition is nothing but a case of "fixed order." It occupies a traditional suite of rooms, the se-

quence of which is not at all dissolved by changes in lighting. And the material is arranged chronologically, decade by decade, each one aloganized—"Depression and Hard Times." "Militancy and Identity." etc. On the way through *we* (as Schoener would say) go from past to present, from big to little, from quiet to noisy areas, but it is strictly a pilgrim's progress.

En route, there are solid old photographs of grandmothers, brownstones, beauty parlors, veterans and "Jim Europe's Hell-Fighters Band"; sharp, gritty new photographs of Malcolm X, street fights, protest placards and the "National Memorial African Bookstore." In addition to the blown-up images, changing images are slide-projected by clicking carousels overhead. There are aural assists for the images: muffled tapes of interviews and speeches and of period music (the mooch, the twist). The general effect is of a Voice of America broadcast added to "The Family of Man," an exhibition of photographs selected by Edward Steichen to show that, when it comes to birth, love and death, we are all one big family under the skin. That bland show achieved postwar celebrity by its apolitical benevolence, which is about the level of argument possible with unaided visual material. Schoener promises a sensory bombardment with many messages, different for each visitor ("participation" instead of a "passive" intake, he calls it). In fact, "Harlem's" point of view is not multiple at all but unmistakably single and white. The documentary photographs don't communicate much more than evidence that "they're just like us," sharing bad housing, group photographs, World War I, show business and everything else. "Harlem on My Mind" is just another footnote to Steichen's classic collection of blown-up photographs.

If we agree that the correspondence between the complex world and complex display is untenable or, at least, that it does not work at the Met, what is there to see in the show? An exhibition of blown-up photographs, and these are always handsome, getting grainier, more porous, and less lifelike as they reach life size. The only messages that such images can carry are platitudes like "time marches on" and "we're all human." The first theme plays on nostalgia (Duke Ellington, old fashions), and the second on our most automatic reflexes of good will. On the other hand, though Schoener's photographic material is simple in content, its display has an unwholesome ingenuity. In a show which protests so hard that it is being straight and daring, the display is fancy and contrived. Columns with pasted photographs, a corridor lined with giant blow-ups, staggered building blocks, a photograph repeated to symbolize the

hopelessness of the breed line (a group made into a crowd), and so on. "Communications environment" is just a pretentious term for an exhibition of the kind developed for use at trade shows and in the pavilions of world fairs. There is more sensory bombardment in a taxi ride (noisy driver, his cigar, his radio, your companion, the street).

In the January *Bulletin* of the Met, Hoving calls the "Harlem" show "the first major step towards rethinking and expanding our concepts of what exhibitions should do." Does he really not know that the show is simply a routine photographic exhibit in educational-commercial format, or is he talking to cover up the fact, from himself or from others? Either way, one is disturbed by the disparity between the facts and his public statements. The sole novelty of the exhibition is its location in an art museum. During the past ten years, art museums in New York have competed with some frequency for the privilege of putting on the same shows: the Museum of Modern Art and the Guggenheim Museum both wanted to exhibit Francis Bacon and it went to the Guggenheim in 1963; Robert Motherwell was scheduled for the Guggenheim, but went to the Modern in 1965; and the Guggenheim's forthcoming Brancusi show is one coveted by the Modern. In line with this cultural overlap, Hoving put on at the Met a show which belongs to, would have been at home in, the Museum of the City of New York.

Harlem was on Hoving's mind the way Appalachia was on President Johnson's when he wanted a good cause. It is apparently not enough for Hoving to run an art museum; he thinks that the museum must also be at the service of other causes. In the name of education, he seems, in fact, to be anti-art. He is wrong and in ways that already show. I refer less to his reduction of the museum's exhibition schedule to the level of a small-town art center in pursuit of "activity," than to his politicizing of the Metropolitan Museum.

The catalogue of his show has been censured by the Special Committee on Racial and Religious Prejudice, by the Anti-Defamation League of B'nai B'rith, the American Jewish Congress, and by the director's friend and fellow politician, the Mayor of New York. The cause was the anti-Jewish, anti-Irish and anti-Puerto Rican comments in the term paper of a 15-year-old high school girl which was used in the catalogue and called "introduction." The Met is now putting a disclaimer in the catalogue. The absurdity of a museum having to say, in effect, "We're sorry, we're not really racist," can be lost on nobody who has the Metropolitan's future at heart.

The "cultural capital of Black America," as Harlem is gushingly

called in the exhibition subtitle, is not very grateful. Militants have taken the opportunity to lobby for *their* racial interests. A picket at the press preview complained: "There are artists in the black community . . . and they're not represented at all." The word is that the Met is going to give an exhibition of work by black artists in the near future. If this is true, it means that Hoving's way of running the museum is making it vulnerable to any special interests that decide to apply pressure. A hastily scheduled show of Negro artists could only be the result of lobbying and would represent a partial loss of control by its director of the affairs of the institution. Other groups in the country might like to plan shows at the Met. How about: "Salon de Backlash," an annual poor whites' art show; "Swing with the Tongs," a new look at old Chinatown; "The Mafia as Art Collectors;" "Ten Abstract Expressionist Teamsters;" and "Cop Art," arranged for the museum by the Police Athletic League.

—

HAPPENINGS

OCTOBER 20, 1969

Lawrence Alloway

HAPPENINGS, OF ALL art forms, are dependent on a photographic record, if the fugitive actions are not to be confined to the participants' memories. Claes Oldenburg's season of Happenings, 1961–62, the last of the classic first wave, was filmed by Raymond Saroff and will be screened by the Museum of Modern Art (date not set) during the run of Oldenburg's current exhibition. The filmic record is essential to supplement Oldenburg's scenarios (published by the Something Else Press). Peter Moore has photographed with remarkable patience almost everything in the way of Happenings, events and environments through the sixties, as a result, his archives are crucial to a study of the occasional aspects of recent American art. A shift in the forms of visual art, toward the ephemeral and the diffuse, has created a storage problem. Paintings and sculptures persist as objects, but an art of performance and problematic thresholds leaves no original body and can be preserved only in record form. Warehouses and libraries supplement galleries.

Allan Kaprow's "Days Off, A Calendar of Happenings" is a case in point of the uses of documentation. The calendar consists of inscriptions and photographs (including some by Peter Moore) of

ten Happenings, all but one of them enacted last year (the exception. "Moving," dates from 1967). When a new Happening is scheduled there is an announcement like "Those interested in participating should attend a talk by Mr. Kaprow at the Campus Center Cafeteria, the State University of New York at Albany," or wherever it may be. The kind of Happening that Kaprow produces now is totally unlike Oldenburg's more-or-less theatrical form. Kaprow says he "selects and combines situations to be participated-in, rather than watched." The experience of the participants and their memories are the aesthetic constituents of what Kaprow calls "the Activity Happening." The calendar perpetuates such occasions, though a calendar is, in function, expendable and the paper here looks it.

Kaprow describes the publication thus: "This is a calendar of past events. The days on it are the days of the Happenings. They were days off. People played." The kinds of activity are mostly physical and nonreflective; it is not that the action cannot be thought about but that this phase is postponed until the act, for example, of unrolling a mile of tar paper, has been performed. Here are the complete instructions for "Shape": "Shoes, bodies on streets, sidewalks, fields. Spray painting their silhouettes. Reports and photos in newspapers." One Happening called "Transfer" is dedicated to Christo, presumably because the activity here consists of rearranging and resiting metal barrels, objects which Christo used as material for art in Paris in 1961.

Documentation cannot transmit the zeal of the agents, but it brings out an aspect of Happenings which is often lost sight of, or is not known, by the original participants (except for Kaprow). Taking part in a Happening must include individual boredom, facetiousness and uncertainty, but the visual trace, the documentation, has another value. The activities in Kaprow's recent pieces have to do with labor (diverting water, moving furniture), monument building ("triumphal" stacks of barrels, walls of ice), the imprinting of human tracks, as in "Shape," and memorializing the gesture of sitting, for instance, with chairs carried around outdoors and instant Polaroid snapshots of each stop left *in situ.* Kaprow's early Happenings were overtly mythological; now the games concern the body in action and its occupancy of space, a kind of playful human engineering. The calendar, memorializing one of Kaprow's most brilliant periods as a Happenings master, is itself an object of tough grace, with a profusion of grainy, factual and enigmatic photographs. It is obtainable for $2.37 including postage from the Museum of Modern Art (it was commissioned by the Junior Council)

and the original collages of photographs, laconic scenarios and dates are on view through October at John Gibson Commission, Inc., 27 East 67 Street.

It is not usual for Mr. Gibson to show original collages, even collages compiled of documents. He specializes in projects rather than completed works, and also with the records of works that by their nature cannot be seen easily, or at all. Through November, for example, he will be showing scale models, collages and photographs of Christo's "Packed Coast," a million feet of Australian coast line which is to be packaged this month. At the Museum of Modern Art, through November, two of Gibson's artists are presenting "A Report: Two Ocean Projects," a show which places transient art works by Dennis Oppenheim and Peter Hutchinson in an underwater environment. (One of Oppenheim's pieces consists of a square of salt, the dissolution of which he recorded.) Earthworks (Oceanworks?) because of their inaccessibility, like Happenings because of their once-only status, exist only briefly in terms of discrete originals. Thus documentation is essential to disclose and to chart their occurrence.

The expanded role of documentation has become an essential element in the definition of art. It is an extension of the area of artistic control, and it brings new information to an old argument about the relation of originals to reproductions. Works of art consist of both unique and translatable elements. Some things resist reproduction (the interplay of scale and facture in a painting, the collective *élan* of a Happening crowd) and can be experienced only in the presence of the work itself; but other information can be transmitted by reproduction. Many iconographic, formal and intentional aspects of art survive in reproduction. Norbert Wiener in *The Human Use of Human Beings* (the book that should be read in place of its cheap derivative, Marshall McLuhan's *Understanding Media*) has this to say on the subject: "Cultivated taste may be built up by a man who has never seen an original of a great work and . . . by far the greater part of the aesthetic appeal of an artistic creation is transmitted in . . . reproductions."

The only reservation one might have is that reproductions are read best by those who know *some* originals, though not necessarily the ones being reproduced. Wiener's slight overstatement, however, is preferable to the exclusive praise of the uniqueness of originals at the expense of all translations. The unreproducible parts of a work are frequently secondary refinements. It is certain that Breughel communicates to people who have not been to the Kunsthistorisches Museum in Vienna. Kaprow's calendar could convey more

to a reader than some participants could be expected to derive from a performance. The expertise everyone has developed in reading modern reproductive processes impinges at this point on what Walter Benjamin called the "aura" of the original. In fact, documentary reproduction can be the only route of access for some art. Current uses of reproduction as a constituent of art make creative play out of everybody's familiarity with mass communications.

—

Dan Flavin

February 9, 1970

Lawrence Alloway

With Dan Flavin, the Jewish Museum revives the kind of show that has been strongest in its program: retrospectives by artists under 40. The precedents are two exhibitions arranged by Alan Solomon, when he was director: the Robert Rauschenberg show in 1963, when the artist was 38, and the Jasper Johns show in 1964, when the artist was 34. The Flavin show is arranged by Brydon Smith, who two years ago arranged the James Rosenquist exhibition, when the artist was 35. That show and the Flavin were not originated in New York but by the National Gallery of Canada where Smith is a curator. The Rosenquist never came to New York but fortunately the Flavin did. Flavin is 37 and his work occupies three floors of the Jewish Museum.

The museum has seldom looked better. It is not that Flavin's glowing light pieces should be regarded in terms of decor and, thus, as enhancements of the galleries. The relationship is more ambiguous and rewarding than that, but it is true that the works, as they emit visible energy, illumine the space they occupy, which is architectural. The works do have a diagrammatic architectural character, resembling at times pilasters and arcades, fences and gates. These are the works that consist of regularly repeated units. The single, compact pieces often have an obelisk- or urn-like symmetry. The room becomes a container of light and it is the cast light, no less than the formal display of the tubes, that is beautiful. The long pergola-like structure with four colors, for example, is totally changed by the light-order, depending on which end you enter.

The catalogue is full of detailed information, not the sort that a curator digs up but the sort that an artist thrusts on him. He has a

(fantasied?) memory of toilet-training at the age of 2 weeks. The catalogue includes the information that his mother, "a stupid, fleshly tyrant of a woman," destroyed his childhood drawings and that he had a Latin teacher who blushed when reprimanding teen-age Flavin. Such detail wins away from Robert Indiana's catalogue of his 1968 retrospective the prize for overexposure in recent art documentation. Flavin's self-regard and punctiliousness are evident also in the show's balance. Although his mature style does not start until 1963, the drawing of his first fluorescent light piece is No. 73 in the chronological catalogue.

His early work, though overshown, provides information about New York in the early sixties and it expresses awkwardly qualities that are embodied subtly in his later pieces. In 1958–61 he drew in an Abstract Expressionist style, but interpolated long quotations from James Joyce's early poems and *The Song of Songs*. The words, sentimental and exalted respectively, are tangled in a dirty snarl of ink and water color. This sense of art as an exalted text survives in his mature work which, significantly, he calls icons. And it is true that the Fun House flicker of much light art is miles away from the steady glow of his fluorescent gases. He is more like a Keeper of the Flame than a Coney Island technologist.

In 1960 Flavin used found objects, especially flattened cans, the crinkled blobs of which he attached to panels, adding paint. These works have the rusty and grimy texture of much Downtown art of the period (seen, also, in the early work of Jim Dine, Claes Oldenburg and Lucas Samaras, among others). When he shifted from junk to newly purchased and functioning objects, he did as other artists were doing, moved from an expressionistic urbanism to a more highly structured style. But though Flavin's style changed, two constants remained. He moved from found objects to new objects, but preserved his interest in ready-mades. Also, he preserved his custom of dedication—to friends, to artists, to victims; a persistent memorial intention suffuses his work, in contradistinction to the new age/new media slogans of some light artists.

The first work in Flavin's characteristic style is "The diagonal of personal ecstasy," originally dedicated to Brancusi, because of Brancusi's "Endless Column," at once serial in form and archaic in content. Now it is dedicated to Robert Rosenblum, who owns an early Flavin drawing and some of whose lectures on Ingres Flavin attended. All this information comes from the catalogue, as does the artist's description of the work as "a common eight-foot strip with fluorescent light of any commercially available color."

The number of ways that Flavin has deployed standard light fixtures since 1963 is impressive. In the following year he grouped four tubes in two colors vertically and many of his best works have been in this position. Sometimes they are seen in progression along a wall or round a room, sometimes in a series of stepped forms (as with the Tatlin monument). Since 1966, by various stages, he has complicated his work, beyond diagonal or vertical groups, moving from an art of placement to one of construction. He has overlapped strips and angled them at various gradients, thus introducing design as a shadowy linear structure at the core of his glowing light. In the past few years he has sometimes been tricky in a way that is far removed from his beginning, as with the piece that you look through from behind the reflectors that carry the strips; they illuminate a room from which you are excluded.

Flavin has produced an abundance of remarkable work, but the course of his development raises a problem. There is a perceptible drift from economical forms with a maximum of released light to greater complexity and coloristic nuance. Initially he condensed his early diffuse interests, with a brilliant intuition, into his single bar of light. He did it, moreover, without losing his sense of art's sacredness. Later the problem arises—as it has for others who have clenched their art into one thing—how to keep on working. Often this has meant relaxing and a gradual return to a traditional canon of complexity. A successful retrospective, as it presents a contour of a life's work up to date, raises such questions. I wonder if Flavin, as his pieces get more fancy and multicolored, is not starting to suffer from the limits of his ready-made materials. It may be time for him to consider custom-made fluorescent lights as a means of expansion.

—

from THE FLAG SHOW

NOVEMBER 30, 1970

Lawrence Alloway

THE FLAG SHOW at the Judson Memorial Church was an open exhibition on the Stars and Stripes. It was open in that there was no selection committee; delivery of your work at the Judson insured it a place. It was open, too, in the sense that the theme was an exercise in what could be done to the colors. A flier described the show as "a challenge to the repressive laws governing so-called flag desecra-

tion." No doubt the organizers had in mind Stephen Radich, the art dealer who in 1967 was found guilty of violating the General Business Law 136, which covers treatment of the flag. The artist who made the offending object was spared, but four years later Radich's fate is still unsettled as his case is due to come before the Supreme Court.

From the first there was sympathy for Radich, but he remained comparatively isolated, in advance of the politicizing of art in New York. Now not only has a large show been devoted to the problem that he accidentally uncovered but he has company in that three members of the Independent Artists Flag Show Committee have been busted. Jon Hendricks, Jean Toche (both members of the Guerrilla Art Action group), and Faith Ringold were arrested, and Howard Moody, the minister of the church and his assistant Al Carmines also received summonses. Scheduled to run from Monday to Saturday, November 9–14, the exhibit was closed a day early by the District Attorney's office. One work was removed by the police (a phallic flag by Alex Gross of the Art Workers' Coalition) and the other pieces were threatened with confiscation if the show reopened. The police's timing is unclear: the opening, which included a provocative flag burning, was ignored, and the raid came with only one more day of the six to run. The last opportunity to see the show was Sunday, at the morning service, for the works were shown in the church itself.

Howard Moody said in his sermon that "when the flag becomes a sacred idol we are on the way to a tyranny that all of us must resist," a stand in which he has the support of the official board of the church. His idea that enforcement of the General Business Law 136, is based on an idolatrous regard for the flag is a good one, and it seems shared by many of the artists. As Radich had originally contended, artists use the flag to protest against the acts that others commit in its name. On the whole, the best pieces in the show were those by sign users, that is to say, by artists who preserved the basic configuration of the stars and stripes and worked within its format. The combination of mass education and mass media has produced an urban folk art based on visual signs. The city's street signs and ads, the media's fund of trademarks, logos, station identification signals, and what all, have turned everybody into expert visual decoders and encoders. In this sense the Flag Show is a dispute over what a symbol shall mean.

The works at the Judson fell into two main areas, I thought: the schematic (flat and sign-oriented, staying close to the form of the flag) and the scenic. The latter works, which included tormented

heads, brutalized figure compositions and satirical progresses, are a continuation of expressionistic caricature. The impulse toward this kind of art is always around, but it has been intensified by the sudden prestige of political art.

A new form of what used to be called Sunday Painting has appeared, an art of protest rather than of leisure imagery. It could be called lay art, not because of the church context provided at the Judson but because much of it is not the outcome of art as a profession. It is art as a reflex of public problems; it is occasional. Today's lay artists are working in a field in which traditional craft processes have been abbreviated or abolished by the professionals themselves. Marcel Duchamp and Allan Kaprow, among others, have changed the basis of lay art, making it as hip, say, as underground newspapers. Though there were professional artists in the Flag Show, their contributions were absorbed by the vernacular whole, with its vigorous and emotional sense of occasion.

—

The Rothko Chapel

March 15, 1971

Lawrence Alloway

Mark Rothko's art was always putting people in mind of chapels. Robert Goldwater, reviewing an exhibition ten years ago, singled out for praise "the small chapel-like room in which have been hung three of the mural series of 1958-59." At the Phillips Gallery in Washington there is a special Rothko installation, totally unlike the domestic display elsewhere in the house; in appearance it falls somewhere between Dag Hammarskjöld's "contemplation room" at the U.N. and a chapel. Now there is a real chapel full of Rothkos in Houston, Tex.—an indisputably major group of strong, somber paintings.

When the project was first announced, it was to have been a Roman Catholic chapel at St. Thomas University; later it was switched to something interdenominational at Rice University. Now that it has been built, the chapel is attached to the Institute of Religion and Human Development, a part of the Texas Medical Center. The Institute combines ecumenical religion (and interdisciplinary studies) with good works (hospital training, family counseling). The dedication of the chapel of February 27 can be viewed both as an

occasion of ecumenical patronage without precedent and as the re-
alization of a purely artistic project. The donors of the chapel, Mr.
and Mrs. John de Menil, are Roman Catholics and Rothko was not.
To turn again to Dr. Goldwater (from whom we can expect a defin-
itive book on the artist): "Though Mark Rothko had no concern
with dogma or doctrine, he was an intensely religious man." There
was a time when religion as one-man intimation was viewed rather
skeptically, but the ecumenical movement has, among other things,
gone some way to legitimize such intuitions. It is even possible now
to call the building the *Rothko* Chapel, although, to pick chapels at
random, those on which Giotto, Masaccio, Michelangelo and Matisse
worked are not called after the artists.

The difficulties of religious art today are about what they have
been since the 19th century. Art is not essential to worship and there
is no iconographical system that a donor can demand and an artist
supply on an easy basis of agreement. However, there exist, bound
into our culture, grand commonplaces which were revived by the
Abstract Expressionists. In Rothko, for instance, the symbolic value
of light, and by extension of darkness, is a traditional religious topic;
in addition, his restriction of color to one dark area of the spectrum
implies a stance of renunciation. The size of the paintings is signif-
icant, also: they have a grandeur both awesome (as they rear up to
15 feet or so) and sensual: The use of triptychs is a link to Christian
art as the Trinity is to Christian dogma and both are evoked by
Rothko's triple groupings in the chapel. Ironically, the ecclesiastical
elements that Rothko took for personal use in his (secular) art are
now restored to the church. What has happened is that the chapel
accepts as religious art works based on those general topics of hu-
manistic thought which are ennobling, that is to say, ambitious on
behalf of man.

If the paintings are nondoctrinal, the architecture is nonliturgi-
cal—an area bare of everything except art. In a sense, the chapel is
a climax of the long interest of New York artists in immersive space.
The painters of big pictures (Pollock, Newman and Still, as well as
Rothko) developed the concept of large scale as a source of inti-
macy. Instead of stepping back from a large picture to see it as a
whole, the optimal spectator should step toward the painting, into
its ambience.

There are fourteen paintings in the chapel, done between 1966 and
spring 1968, grouped as three triptychs and five singles. The chapel,
which is octagonal, was built solely for the display of the paintings.
The studio in which Rothko executed them was a same-size archi-

tectural mock-up. You enter the chapel from the south, and opposite
is a shallow apse containing a triptych: each of the three canvases is
a monochrome field, a warm purple in the center, flanked by darker
but spectrally close canvases. On the east and west walls are two more
triptychs, less vast than the one in the apse, and with their central
sections raised above the side panels. Each of the four shorter walls
of the octagon is almost completely covered by a large monochrome
painting. Opposite the big triptych is a tall thin painting with a black
rectangular form above a field of flushed browns, reminiscent of
Rothko's earlier works.

Rothko's habitual image, of course, is of stacked rectangles of
color, but the differences between the strata are endless. They are
beautiful in terms of what Rhys Carpenter has called irregularizing
refinements, by which he means nuances of touch and emphasis
within a regular structure. This sensuous resource is still amply pres-
ent but curbed in Rothko's new paintings, which reveal a move to-
ward forms less diversified, more unified, than the stacks. There are
seven monochrome canvases without any interruption of the dense
color and there is repetition, as in the four pictures at the corner
walls of the chapel and the matching triptychs to east and west. All
this has the effect of compressing one's sense of distance, since any
paintings that are distant resemble paintings that are close. An in-
tricate spatial intimacy is brilliantly set up by the correspondences
within the set of paintings.

Rothko's close-valued colors are hard to see: he withholds a clear
picture plane, an absolute surface. When black occurs in these paint-
ings, for instance, it is usually more reflective than the matte browns
or purples, so that it picks up the light in the chapel. Thus the dark
is made lighter, and to register such subtle shifts the spectator needs
a low level of illumination. Only in light dimmer than gallery or
museum norms can Rothko's darker paintings be seen properly.
The architects of the chapel had nothing to do except make the
paintings visible. I don't mean that that is very simple, but it is true
that there were no competing interests. The lighting is disastrous.
A row of primitive fittings fails totally to wash the big pictures evenly;
wherever you try to look, there are spotty highlights and gloomy
tonal gradients.

The architects are Howard Barnstone and Eugene Aubrey and
according to one of them they hope to improve the lighting. No
doubt it will get better; but why design a building like this without
controllable lights and why did the donors accept plans in which
the lighting system was not primary? Rothko is reported to have

wanted only daylight (like Frank Lloyd Wright in his original Guggenheim Museum plans). This would have involved masking the chapel's central dome, either inside or out, to break the sunlight. It was not done and as matters stand, too much light streams in by day, illuminating the middle of the floor like a skating rink, and pushing the paintings back out of the way.

The paintings were done on stretchers of a normal depth, say an inch and a half, and then, shortly before his death last year, Rothko changed his mind and the canvases were remounted on very deep stretchers, a hand span in depth. These lift the paintings forward from the wall and produce deep wedges of shadow under them. I take it that the extra depth is proportionate to the massive scale of the paintings, but it has led to one problem. There are twin doorways each side of the facing triptychs and the paintings are literally only an inch or two from the openings. Because of the increase in the projection of the paintings, traffic flow and paint surface make an uneasy interface.

According to Theodoros Stamos, the triptychs have been placed too high, it being Rothko's intention for the side panels to be 21 inches from the floor, with the raised center panel only 3 inches higher. Both these measurements are exceeded in the chapel at present and the raising has the effect of obscuring the rhythm of ascension set up by the top levels of the paintings, obviously a factor when the artist has relinquished so much in the way of internal incident. The pictures now are all high and close enough in level to be confusing, whereas a lower placing of the triptychs would establish a clear lower zone that would release the taller paintings, freeing them for an upward thrust.

—

BLACK ART

May 10, 1971

Lawrence Alloway

IT HAS BEEN difficult for art critics to assess Black art, not only because of ancestral guilt but because the artists have made it difficult. Every Black art show has been accompanied by a display of withdrawals and of allegations which have made one doubt that each show, as shown, was really representative. Still, time passes and the

shows begin to add up, and a group of present exhibitions gives additional information. It is now possible to stop giving Black art the benefit of the doubt.

First consider the protest stimulated by the Whitney Museum's "Contemporary Black Artists in America" (until May 16). A group of unknown size called the Black Emergency Cultural Coalition complained in a letter to the museum and, of course, to Miss Grace Glueck of *The New York Times*, that "Black curatorial expertise" had not been used and that "the Black community" was insulted by not having been more responsibly involved. The "Coalition" called for a boycott and fifteen artists withdrew from the Whitney, leaving sixty. There is that problem again: can we accept the show as representative after all these abstentions?

Some of the artists who pulled out are to be seen elsewhere: Richard Hunt has a retrospective at the Museum of Modern Art (until June 7), William T. Williams was shown at Reece Palley in March, and Betty Blayton can be seen at the Acts of Art Gallery, 15 Charles Street, where an exhibition called "Rebuttal to the Whitney Museum" runs until May 10. That show includes the works of two artists not invited by the Whitney; they are the co-chairmen of the "Coalition," Benny Andrews and Cliff Joseph. Romare Bearden also withdrew from the Whitney but on a different schedule, reportedly after pressure from activist colleagues; he, too, has a show at the Museum of Modern Art.

The title of Bearden's exhibition is "The Prevalence of Ritual," which the press handout interprets: "the ritual is the choreography of daily life in Black America." The artist defines it as "the only life style that is talking about life." How does this pro-life life appear in Bearden's work? The exhibition offers his collages from 1964. These flat layouts for which the interlocking patterns of late Cubism provide the formal base, are continually being parted, like Venetian blinds, to reveal a gesture or a facial expression, or a meeting. What we really see is the prevalence of genre, done in a creditable but mild way. Richard Hunt gives a similar effect of dull normal style. He has a sound grasp of the clichés of welded sculpture, in which it is easy (1) to join bits together and (2) to set up balancing feats by extending thin forms onward and upward. He calls one group of works "hybrid figures"; the word *hybrid* was brought into American art criticism by André Breton in 1945 with reference to Arshile Gorky. It is indicative of the conservative modernism of Hunt that the word fits his biomorphic sculpture perfectly well.

* * *

The work of both Bearden and Hunt is soundly conceived and developable, though not original. Bearden's attempt to give his abstracted figures a Black aura without abating his formality appears as a problem also for the Abstract painters. William T. Williams paints big bright abstractions; he stands in about the same dependent relation to Frank Stella as does the (white) painter Larry Zox: The title of his last show, however, was "Overkill: An American Consciousness," a political-sounding title that had an undemonstrated connection to the paintings. In a catalogue statement a couple of years ago Williams wrote:

> We are surrealists (or we could not have survived). We are primitives. We are humanists. We are hard edge. We are earth people. We are action painters. WE ARE BLACK

It seems that Black artists, no matter how alert to the internal traditions of painting or sculpture, are haunted by racial obligations. They are caught between their sense of art as art and of art as an instrument to advance Black rights. Blackness must be present, if not as a subject then as a verbal context (in Williams' case) or in some such substitute form.

The nakedly instrumental use of art can be seen in a cluster of caricatural folkloric and expressionistic image makers who turn out Afro-American propaganda. At the Whitney there are Murry De Pillars (he shows an activist Aunt Jemima, an idea lifted from Joseph Overstreet, one of the artists who withdrew), Vincent Smith ("The Super"), Charles White ("Wanted Poster Series") and W.H. Henderson ("The Smile"—on a vast Black head). At the "Rebuttal" show are Dindga McCannan's "Shackles, Slaves, and Prods," in which the objects of assemblage are turned into the symbols of oppression; Cliff Joseph's "The Superman," an inventory of the senile oppressor, and Benny Andrews' "American Gothic" in which the iconography of Aristotle and Phyllis is enacted by a whore (?) astride an emaciated American sergeant.

Nigel Jackson in a new art paper called *Raven Art Rap* (205 Waverly Place, New York) editorializes thus: "The public at large must be educated to the fact that Black culture is a valid part of the entire American way of life. The drive to express ourselves in our artistic works for all the people must exist." Obviously that is so, but, equally obviously, after looking at Black art shows, there is nothing yet in the visual arts that approaches the Black contribution to literature. There are two groupings within Black art: the professional artists,

many of them able, but all of them slightly distracted, I think, by the obligation to refer to their color in their art; and the propagandists. Some of the latter group are professional and others are lay artists, using the term to refer to people who take up art momentarily under the pressure of personal crisis or current affairs. This area of symbolism, figuration and anger is of unrelieved banality and repetition.

It is clear that John Baur, director of the Whitney, was right to make his museum available for the show, poor as it is, and despite the displeasure of some of the Black community. *Raven Art Rap* criticizes Robert Doty, the curator of the show, but it is certain that even if a sympathetic curator had been assigned, the reaction would not have been different. It is only by political agitation that the weaknesses of Black art can be covered up.

—

ANDY WARHOL

MAY 24, 1971

Lawrence Alloway

THE BIG ROOM on the fourth floor of the Whitney Museum looks marvelous now and will until June 20. The Andy Warhol exhibition, arranged by John Coplans for the Pasadena Art Museum, is there and Warhol has finally found a use for the wallpaper he designed several years ago with a large red cow's head as the repeat. It covers the walls, and the pictures, bright and plentiful, are hung against it. Many of the flowers are here, as vivid and insouciant as ever, both the first version, in which green is printed over the grainy black-and-white background of grass, and the later edition which has the bright flowers alone on the black and white, in some ways a prettier effect. The result is something between the Isabella Gardner Museum and a new discothèque.

Warhol has excluded his earlier work and the show begins with the Campbell soup cans in 1961, leaving out the freely drawn and painted works. The soup cans are partly done by hand, partly printed, but the *appearance* of anonymity and the fact of repetition make them characteristic of Warhol's main line a a painter. The silk screen is central to his art and it is used like this: an image is mechanically transferred to a screen which can then be used repeatedly. The amount of paint and the pressure with which it is applied

effect the impression that the screen leaves on the canvas. In one of the Marilyn Monroe paintings, for instance, the image of the star's head ranges from a dark blot to a parched outline. The fixed image takes on a multifarious life. As a byproduct of casual printing, the silk screen gives a kind of automatic "personal handling."

Warhol's pictures all use known imagery, the labels on Campbell's soups, pre-existing photographs, and he has been compared with Duchamp because of their mutual use of the ready-made. However, where Duchamp used the ready-made as an aggressive insertion into the field of art, Warhol uses it to saturate his art with life's traces. All his best pictures are based on photographs in the public domain. When, as in his commissioned portraits, he uses photographs taken expressly for him, or accepts family snapshots, there is a touch of imposture or, at the least, of dullness. The texture of social reality that his choice of public photographs conveys is an essential part of his art. None of his commissioned portraits is among his best works. The literal human presence is much better expressed in his early films. Henry Geldzahler, one of those who sat in front of the camera for Warhol with nothing to do but be there, suggests that "Andy's nature really is [that of] a great portraitist." The quotation is from John Wilcock's first-published book of interviews, *The Autobiography and Sex Life of Andy Warhol* (Colorcraft, Inc.).

That the use of ready-made photographs elicits a certain kind of structure, appears from a comparison of the different formats with which Warhol has experimented. The uniform tessellation of identical images is his best form. When the images are inverted or tilted or moved around to make an internal pattern, they lose their normalcy and become design elements, which abates the quoted material's immediacy, as in "Liz as Cleopatra." Without the constancy of regular repetition, the image tends to jump or float or to collide with the edge of the canvas. It must be straight, though it can be any color, as the electric chair is orange, lavender, or silver. It seems that variation needs to be of a sort compatible with the photographic image. Thus the overlapping of one image to produce a metaphor of motion, as in the Elvis paintings, is absolutely coherent, as are changes in the color and clarity of the image. The fading or the loss of detail within the image is like life itself when it has been photographed and reproduced.

What comes across at the Whitney, as never before in smaller exhibitions, is the exhilaration of proliferating images and quirky, glamorous color. There is a sharp charm and verve to his paintings

and the only precedent I can think of is, perhaps, Picabia. As Warhol works in runs of set sizes his work has a potential for combination, well used in this show. The smaller flowers, electric chairs and soup cans, borrowed from different collections, are grouped together in blocks or rows, like the repeating images within the larger paintings. It looks as if the paintings had discovered self-reproduction. Even the larger paintings can be aligned in new neighborhoods: the two well-known Marilyn Monroe paintings from the Burton Tremaine collection, for instance, have temporarily lost their identity as a diptych and are part of a bigger set of Marilyns. A modular structure, easily extendable and just as easily cut off anywhere, underlies all Warhol's paintings. This infinite checkerboard is a sufficient structure without other forms of ordering. One of the reasons that Warhol did not wish to show his earlier works is that they are outside this module being one-at-a-time, noninterchangeable pictures. John Coplans was evidently interested in showing them, for they are reproduced and discussed in the book, not a catalogue, that accompanies the exhibition (distributed by the New York Graphic Society).

A few points of detail might be raised concerning paintings included or absent. Certainly, the organizers are not to be blamed for all omissions (I, for one, refused to lend a painting to the show because I was worried about the condition of the paint), but I missed a couple of things. It would have been good to see "The Men In Her Life," a painting of 1962, in which four figures are turned into a crowd by blurry overlapping and "1947 White" (1963), one of the best disaster paintings. This is remarkable as an image (a suicide who jumped from a building and fell onto a car, the roof buckled around her body, like a bed or a crusader tomb) and as a painting. It is one of the most successful of the paintings in which Warhol has left irregular margins without interrupting the regular pulse of the repeated image. His most recent work, forty silk screens of flowers on paper, are emptily elaborated with fancy color that swamps and blunts the image; it is the only time I have known Warhol to lose his laconic sense of color and design.

—

Hans Haacke

August 2, 1971

Lawrence Alloway

In April the Guggenheim Museum canceled an exhibition that was due to open that month by Hans Haacke. The abruptness of the cancellation was linked to the fact that the show was not a collection of existing objects but was being prepared specially by Haacke. Environmental and documentary works of art frequently do not exist prior to the occasion of exhibition. This way of working has led to trouble before, as at the Museum of modern Art a year or two ago when neither the selection nor the performance of the artists in "Spaces" worked well. However, poor as it was, the show went on. The case here is very different because the work that seemed to cause the crisis is fully representative of the artist. According to Haacke, the director of the Guggenheim, Thomas M. Messer, objected to (*1*) a documentation of slum property and landlords, and (*2*) a poll of museum visitors. But statements from the museum have mentioned only the former, so I will keep to that.

Here is Haacke's account of the disputed works: "Two of the three works are presentations of large Manhattan real estate holdings (photographs of the façades of the properties and documentary information collected from the public records of the County Clerk's office). The works contain no evaluative comment. One set of holdings are mainly slum-located properties owned by a group of people related by family and business ties. The other system is the extensive real estate interests, largely in commercial properties, held by two partners." This was one part of a three-part exhibition, the other categories dealing with physical and biological systems. Messer described the social systems as "a muckraking venture under the Solomon R. Guggenheim Foundation" and told Haacke so. Haacke, though concerned in his work with concrete, verifiable subject matter, proposed fictitious names for the landlords, but Messer refused on two grounds. First, that he wanted to protect the "aesthetic and educational status" of the museum and, secondly, his fear of a libel action that would impair institutional autonomy. The latter reason can be said to be disproved: both *Arts* and *Artforum* have now printed some of the documentary material and all of the names.

That leaves the other reason given, that the material was unsuitable for museum display because it contravened the museum's educational charter. According to this scenario Messer as director had to turn down the social systems for fear of where it all might lead. He demands: "What is there to prevent an artist-sponsored murder and subsequent insistence upon the irrelevance of ordinary justice?"—a daft extrapolation. This is quoted from a guest editorial Messer wrote for *Arts*. The same issue, June, printed a roster of 100 artists (understood to have grown longer now), from Abish to Zucker, "refusing to allow our works to be exhibited in the Guggenheim until the policies of art censorship and its advocates have changed." (Incidentally, the curator responsible for the Haacke show, Edward Fry, was fired.)

Messer has made such an open avowal of the political implication of Haacke's social systems, despite the artist's denial of advocacy, that one's suspicions are raised. There are institutional reasons that might be considered. The Guggenheim has had, ever since James Johnson Sweeney left, an inward-looking director, by which I mean that Messer has been unusually closely oriented toward the trustees, not to the art world outside where he is something of a stranger. There is a historical reason for this: Sweeney, in his reign, ignored the trustees and ran the museum as a one-man show, his own. The trustees, then as now largely family, appointed Messer with the determination not to have any more runaway directors.

Messer's exhibition schedule has as its target not so much the public (though good box office is as welcome there as anywhere else) but the trustees. The director arranges the shows for their satisfaction and a part of their contentment lies in preserving the museum from problematic art and unseemly publicity. The recent Guggenheim International Exhibition precipitated, it is believed, a crisis in Messer's career of pleasing the trustees. This exhibition not only had art made of mud on the ramps and pencil scribble on the walls; it also received a very bad press.

Thus the Haacke show, to be built like the International Exhibition, *in situ*, with myna birds and growing plants, as well as the social systems, must have threatened Messer with more trouble at the top. If Messer were less concerned with the *trustees as audience*, he might have been more sensitive to Haacke's seriousness and to the risk of antagonizing other artists. I don't know how long he estimated the resentment caused by his decision would last, but three months later it has not abated.

The problem came at a bad time for Messer, if my scenario, or something like it, is correct. This is a period when artists (as well as black, Puerto Rican, and women sub-groups) have become aware of an increase in their power as an interest group. The situation, in this form, has been developing since, say, 1959, when Jasper Johns and Frank Stella in their early twenties went more or less straight into the Museum of Modern Art. Living artists had been shown before in museums, of course, but they were usually older, and if they had trouble with the institutions it remained on a personal level. Through their increased reliance on young artists, museums have become vulnerable to groups of artists, very small numerically compared to the number of visitors, but highly motivated. They are the source or future source of what the visitors pay to see, after all, and they want more influence.

Artists are also moving aggressively in relation to galleries, which is to say collectors: witness the present attempt to enforce an Artists' Reserved Rights Sales Agreement, the purpose of which is to retain for artists the copyright and future profits from resale of their work. A token of the situation is the summer show at the Museum of Modern Art, called with ostentatious topicality, "The Artist as Adversary." It is a catchall for works in the permanent collection that happen to be on the left hand of protest. The show is at least recognition of the artists' new organizational muscle.

It is against this background that Messer has decided that the Guggenheim is a citadel to be defended. He has forgotten or discounted the existence of a fairly widespread distrust of museums among artists and revolutionary students (a part of the future museum audience). As museums embody norms of aesthetic quality they seem supportive of the *status quo*, covertly backing conservative values. Thus Messer was faced in the Haacke problem with a situation not yet reduced to bureaucratic routines. He chose merely to assert the rank of the museum rather than to demonstrate its versatility. His failure makes it harder for all of us seriously interested in working out the future role of museums in a society that is radically different from the one in which they were founded.

—

Comics

August 30, 1971

Lawrence Alloway

The comics are now part of a reciprocal relationship between art and popular culture. On one hand, artists have used comics as their sources and, on the other hand, comics have come to be regarded as art. Before Andy Warhol and Roy Lichtenstein produced their paintings of quoted comics at the start of the 1960s, there had been other points of contact. In the 1940s paintings by Matta and Gorky used distorted images of Pluto (Walt Disney's, not the infernal one), and in the 1950s Francis Bacon used in his paintings of Van Gogh images of a drunken man on a tree-lined road from Wilhelm Busch's *Der Undankbare*. Busch is better known for *Max und Moritz*, an example of which is on view in the exhibition of "75 Years of the Comics" at the New York Cultural Center (September 8-November 7).

The show has been selected by Maurice Horn who in 1967 was co-organizer of an exhibition of "Bande Dessinée et Figuration Narrative" at the Musée des Arts Décoratifs, Paris. It surveyed both the comics and the European artists, using the comics either as quoted imagery or as sequential display. The American end of the assimilation of comics into painting was collected in 1969 at the Institute of Contemporary Art, University of Pennsylvania, under the title of "The Spirit of the Comics." Finally, at the University of Maryland Art Gallery last spring there was an exhibition on "The Art of the Comic Strip."

The cumulative effect of all these shows has been to draw attention to comics as themselves an art and not merely as anonymous, low material subject to transformation by artists. Judith O'Sullivan, for instance, in the solid catalogue for the Maryland show, characterized convincingly the "sinuous line of Art Nouveau in the strips of Winsor McCay" ("Little Nemo" is his most famous work).

"75 Years of Comics" is arranged in five sections which coincide broadly with the development of the art. They are: the Heroic Period ("The Yellow Kid," "The Katzenjammer Kids"), The Great Tradition (humor and family strips of the earlier 20th century). Man and Superman (detective and costume heroes, as they are called in

the trade), and the Current Scene along with the Faraway and the Far-out (from the "sophisticated" strips of the 1950s to "underground" comics like "Zap"). There are more than 300 items, including original art work, tearsheets from newspaper strips, and pages from comic books.

The third section, in some ways my favorite, Man and Superman, is rich in connections to the movies and to pulp magazines with no concessions to grace. The origin of "Dick Tracy" (represented in the exhibition by a late drawing) is worth recounting as an example of the compounding of topical and archaic themes in adventure comics. Chester Gould created Tracy in 1931, prompted by the gang warfare of the 1920s; he explained that he wanted Dick Tracy's profile to be like that of a "young Sherlock Holmes," but he was to be "dressed like a modern G-Man." Thus Victorian Baker Street and modern Chicago, aloof amateurism and pushy professionalism, are combined with a kind of iconographical wit that runs through our popular culture.

Milton Caniff ("Terry and the Pirates," "Steve Canyon") wrote: "Use motion picture technique in the execution. First panel: long shot with the speaking character in the mid foreground. Second panel: middle shot with dialogue to move the plot along. Third panel: semi close-up to set reader for a significant last speech. Fourth panel: full close-up of speaking character with socko line." The depiction of action in these compressed terms, joined to a close-knit system of overlapping forms so that everything contributes to an illusion of real space, produced a crisp naturalism still viable in both adventure and women's strips, such as Ken Ernst's "Mary Worth" and Stan Drake's "The Heart of Juliet Jones."

Recent developments in comics, as opposed to the continuation of earlier forms, have been away from realism, such as Robert Crumb's "Fritz the Cat," a hippie version of "Felix the Cat." Crumb's format is a revival of pre-realistic comics, with their unaccented progression from box to box: this anti-Establishment primitivism suits Fritz's career perfectly. Comic *books*, as opposed to newspaper strips, reached a climax of elaboration in the second half of the 1960s, especially in such Marvel Comics as *Captain America* and *Nick Fury, Agent of Shield*. Their manneristic complexity, which seems to have just faded out, is sampled at the Cultural Center by Jack Kirby's *The Mighty Thor*.

The individuation of comics artists must include reference to Burne Hogarth who, when he took over a "Tarzan" strip in 1936,

brought to it a sophisticated sense of Mannerism (Tarzan as a post-Michelangelesque male) and of Japanese art (in the flat patterning of jungle flora). There may be an analogy here with an artist like Graves Gladney who, in the same period, painted covers for Street and Smith's pulp magazines, including *The Shadow*. His training included study at the Slade School of Art, London, and beneath his lurid gestures lurks art school anatomy and Rembrandt flickers in his chiaroscuro. At present, however, there is no study of the pulp magazines which can be compared to the depth and precision of comics research and preservation (there are several notable collections now).

The purpose of comics research should not be solely the identification of individual hands, because the artists are working with shared, easily accessible subjects. For all the contributions made by individuals, they work within a body of set forms, like song writers, commercial movie makers and science fiction authors. Their work has to satisfy public taste immediately and if it fails to do so it is dropped. A part of their skill is in conforming to fashion. The modulation of their motifs and topics is often dictated as much by shifts of audience interest as by personal creativity. Frequently the artists work to match the demand.

The overall unit to which comics artists contribute is of course the genre, para-individual forms that span generations of readers. Walt Kelly is well-known for his liberal strips, but the form he uses is that of Walt Disney's animal cartoons (he worked for Disney in the 1930s) hence we have Silly Symphonies in seminar form. This is partly Kelly's personal knack, but it is made possible by the strength of the ongoing genre of the speaking animal. The family strips in the present exhibition are as much a part of a continuous soap opera as they are of personal invention. One of the requirements of future comics research now that the artists are known and characterized, is the interpretation of the comics as a part of culture, drawn by artists but also shaped by the socially formed expectations of the audience, ourselves.

—

CALDER

APRIL 24, 1972

Lawrence Alloway

AUBUSSON TAPESTRIES BY Alexander Calder will be on view at the
Leonard Hutton Galleries (April 14 through May). The tapestries
are small, mostly rug-sized, but even so many-time enlargements of
Calder's original gouaches. In their faithful dilation the banality and
coarseness of Calder's forms are inexorably revealed. They are so
bad as to suggest that it is time to consider his position as an artist
in a wider perspective. Are these designs aberrations, the evidence
of decline, or typical work by an artist who has outlived the protec-
tion of his period?

Calder achieved his eminence in the 1930s and early 1940s, at
which time there was not much American competition and not
much work being done in the field of kinetic sculpture. In 1943 he
had a big exhibition at the Museum of Modern Art, in the catalog
of which J.J. Sweeney wrote: "Calder's concern as an artist with me-
chanical forms . . . and his use of new and unconventional materials
link him with the Russian constructivists." Twenty-two years later this
remark was repeated in the catalog of another Calder retrospective,
this time at the Guggenheim Museum, and Sweeney was footnoted
as if he had made a point. In fact, Calder displays neither the tech-
nological interest nor the scrupulous aesthetic that marked the two
wings of Constructivism. It is typical of the non-analytical state of
Calder studies that such a comment should be prized and repeated.

The usual account of the genesis of Calder's mobiles is that after
a visit to Mondrian's studio he was turned onto Abstract art (away
from the bent pipecleaner caricature style of his early work) and
that he derived his bright clear spots of primary color from Mon-
drian. However the jump from Mondrian's structural clarity to Cal-
der's cuteness is too long, unless we introduce Miró. H. Harvard
Arnason has referred to Calder's "free forms which suggest the or-
ganic shapes in Miró's paintings." He is absolutely right to make the
connection, but his phrasing masks the fact that Calder's forms are
not so much "suggestive" of Miró's as totally derivative. Such paint-
ings by Miró as "Le Fond Bleu," 1927 (private collection, Paris),
constitute a fully developed diagram of a hanging mobile, the first

of which was not made until the 1930s. Pure color patches and a meandering connecting line, seen against a sky-blue field, anticipate completely what Calder did with wire and cutout metal.

In the early 1930s Calder investigated various possibilities of motion, both motorized and manual, though it cannot be said that he took them very far. He soon concentrated entirely on wind mobiles, which depend on air currents, or the push of the spectator, to animate them. His native talent for direct handling could operate freely on structures that depended on the balance of contrasting weights and shapes. He could bend wire, cut or hammer metal sheets, and assemble the bits empirically. This method of working explains to some extent the hindered rotational play at the joints and the intercepted trajectories of most of Calder's mobiles. The suspended, counterbalanced form of mobile, with a limited play in movement, dominated kinetic art until the 1950s, at which time the option stressed by Calder was set aside by younger artists.

In recent years Calder has produced an increasing number of drawings and lithographs, in which he returns openly to the pictorial source of his mobiles, and from these are derived the woolen tapestries. His graphics depend on Miró's imagery of suns, stars, flowers, snakes, seaweed (that's from Matisse), petals, butterflies, zigzags, spirals and loops. Calder has said that when he used "spheres and discs, I have intended that they should represent something more . . . the earth is a sphere . . . and the moon making circles around it." However, the shaky lines and casual blotches of color fail to be concordant with larger systems. They are no more than an awkward inventory of exhausted motifs. In the forty-odd years that Calder has used them since Miró invented them they have not acquired iconographical richness in his hands. On the contrary they have lost their original juice and vitality to become merely the means of perfunctory improvisation.

Miró's great ability was to invent biomorphic forms that, while conformable to the flat surface of the picture plane, were yet rich in sexual and somatic emanations. Arp, too, has the capacity to imply vitalist energy within smooth curved form, and that he is another influence on Calder can be seen in "Serpent Presse" in the tapestry exhibition or in the acoustic ceiling of enormous lily pads in University City, Caracas. Since Calder does not possess Miró's and Arp's animistic sense of life, shared by human beings and other life forms, he is using forms whose original meaning is dead to him. Instead of the biosphere, we get Disneyland.

* * *

The usual way to discuss Calder's frivolity is with some variant of the formula invented by Sweeney when he referred to "his unique enlivening of Abstract art by humor." The fact is that Abstract art does not need humor, though it helps Surrealism a lot. Calder is basically a low comedian who entered the art world at a time that matched and magnified his gifts. He was historically exceptionally lucky. Metal sculpture is simple to make and the tools were to hand though, as I suggested above, he made no attempt to overcome their limits when applied to mobiles. The theme of motion in sculpture, at a time when Moholy Nagy seemed theoretical and Duchamp forgotten, fell to him, though he pursued only its narrowest possibility. His simple-minded combination of virtual volume with nature analogies, such as birds in flight or schools of fish or tree branches, had the authority that simple solutions have in their early days, but which wear out fast. The real Calder is in the drawings for the *National Police Gazette*, in the circus toys of 1927, in his jewelry.

—

EVA HESSE

JANUARY 22, 1973

Lawrence Alloway

THE SOLOMON R. Guggenheim Museum's recent exhibitions of contemporary American artists have been pretty boring: Robert Mangold, a pleasant but circumspect painter, and Robert Ryman, a sensualist of low-visibility whites, whose best talent—improvisation *in situ*—was not drawn upon by the museum. However, the memorial exhibition of Eva Hesse (until February 11) is something else, a confident selection of work by a really interesting artists whose irregularly shaped sculptures are well displayed in the broad bays at the top of the ramp. Hesse's handling of fiberglass and latex was brilliant, persuading these materials into an inventory of layered, frayed and patchy forms which were once thought to be ungovernable. Characteristic sculptures consist of: a mare's-nest of cords dipped in latex and suspended from the ceiling; undulating tubes of scabby fiberglass, like a multiple Indian rope trick; rickety panels of fiberglass, out of which wires, bound in cloth and latex, trail twistedly; nine silver-gray husks, rounded and split, put at random on

the floor; a row of poles leaning against the wall, supporting rubberized cheesecloth, with variable folds according to the extension of the piece.

These works defy the traditional divisions of geometric and organic form in art, but critical reaction to her subtle conflations has tended to overemphasize biomorphic readings. To regard her sculpture as body imagery is a one-valued reading of a multivalent imagery, though there are spurious cues in the artist's life for doing so, as we shall see. Hesse's dates are 1936–70, which means that the show presents us, paradoxically, with comparatively new and unfamiliar work which is extremely influential on present sprawling or racked sculptures, though her work has been terminated by early death. The fact of her death raises critical problems in the catalogue texts which I feel free to discuss, since discretion has been dropped by the commemorative impulses of her friends.

Both catalogue essays share a view of Hesse's art as the symptom of suffering or illness: the expression is valiant, "sublime" to one of the writers, but it remains symptomatic. Art is taken as the index of something else, sexual distress or a distant trial, an illness not locked within the body but supposedly eating out and spilling over. Linda Shearer writes that "the body of major work she created during the culminating year of her illness suggests that her awareness of the deteriorating state of her health somehow not only allowed her to grow with the continuing natural evolution of her work, but also provided her with the power to invest her art with mysterious overtones of poignant and painful life." If art is the product of illness (or of drugs), the artist is reduced to comparative passivity, as Shearer concedes when she writes that Hesse grew with the work, as if the work possessed some malignant priority. Shearer hurriedly returns volition to the artist ("provided her with the power"), but as such confusions arise, the thought must occur that illness may not be causative of the art at all.

This view of art as trauma is also applied to earlier episodes of Hesse's biography. "The terror and isolation provoked by the death of the artist's father and the withdrawal of her husband from her—instead of forcing incipient madness [sic]—provoked the crystal lucidity of original creation." Here Robert Pincus-Witten refers to 1966, the year in which Hesse's art really got going. After some earlier objects, awkward pieces but with a potential that was realized in later developments, Hesse hit on that oscillation between regularly phased and loose forms that characterized her formal imagination. The modular and the limp, the fixed and the rearrangeable,

pulse through her work in unprecedented unions from that time on. To me, the fact that she was influenced by Robert Morris seems as relevant to her art as trouble at home. In 1966 she picked up, surely, Morris' objects of 1963-64, in which he combined wooden shelves or blocks set on the wall with tangled or loose ropes hanging from them. Hesse's "Ennead" (1966) and "Addendum" (1967) are among the fruitful derivatives of Morris' formats; they lead into fastidious and rambling forms very different from her point of departure. Pincus-Witten certainly knows this, but he evaluates such information unenthusiastically, as compared to signs of the heroine in torment.

In addition, 1966 is the year in which sculpture of irregular form with a new use of materials went public (in opposition to the rigidity and regularity of Minimal art). Lucy Lippard arranged a significant gallery show in the fall, "Essentric Abstraction," so called on account of the frayed, lumpy and foldable materials of which the sculpture was made (the artists included Hesse, Bruce Nauman and Frank Lincoln Viner). Pincus-Witten reminds us that six months earlier another gallery show, sarcastically and cheerfully entitled "Abstract Inflationism and Stuffed Expressionism," had exhibited similar works, including pieces by two of the same artists, Hesse and Viner. Thus, as an alternative to viewing Hesse's art of the year as spinoff from psychic distress, it is possible to view the year as the point in time when her art individually, and her kind of art in general, received early attention. Encouragement has also been known to help bring out "crystal lucidity," too. I do not want to separate the lives of artists from their art, but it is essential that biography be defined in such a way as to include the conscious experience of current, external events as well as, and maybe even more than, supposed unconscious conflicts and regressions.

Further difficulties of the art-illness theory are indicated when Pincus-Witten refers to the work of 1967–68: "the motif of the trailing cord may be construed in the context of plasma bags and intravenous tubing, although by the period of her life when the surgical reading ought to be most evident, in the last year, this motif had, in fact, been displaced." His observation and his candor lead me to suspect that the hospital-gear analogies may be construed as a projection by the writer, displaced backward in time from his knowledge of her premature death.

This infatuation with Hesse's illness (it was a brain tumor) shows again in Shearer's emphasis on physical weakness as the reason for Hesse's use of assistants to carry out her later sculptures. By this means "she could achieve a greater spontaneity through collabora-

tion." That may be so, but several of the artists mentioned in the catalogue as being close to her (Sol Lewitt and Robert Smithson, for instance) customarily had their sculpture manufactured for them. Why did Hesse have to be sick to do what had become standard practice in New York at the time?

It used to be supposed that Watteau and Keats, because of tuberculosis, felt the fugitiveness of life more intensely than did artists with better homeostasis. Freud displaced the cause from physical to mental illness, which is a change of location but not of structure: it's the same idea, of art as a compensatory activity, making up for trouble and flaws. Although this idea opposes the formalist narrowing of works of art by excising their meaning, it proposes art's dependence on the involuntary states of the artist's body, which devalues both the art and the artist. I don't think of art as pure formal play, but neither do I think of it as a reflex of autonomic body processes. What happened in this case, I think, since neither of the writers substantiates his or her morbid claims for Hesse, is that each felt emotionally compelled by the artist's early death to make the whole work tragic; but the attempt to do so has merely confused Hesse's affecting life with her effective art.

The effect of illness and early death on the art of Hesse is, I think, obvious: it weakened her in the last year or so (not in control but in quantity) and cut off the development of themes which still had a long way to go. Illness was a diversion, not a source of (mysterious-creative-fatal) energy. Jackson Pollock's alcoholism corroded rather than inspired his art and Henri Michaux's mescaline drawings are slight and monotonous—as the artist conceded in conversation once—compared to the earlier visionary drawings made without tripping. It is so in the case of Van Gogh, whose mental illness has been projected upon the form and imagery of his paintings, whereas the real effect of his illness was to *interrupt* the work. He painted, as his letters record, in an effort to arrest the onset of his attacks: the art is a resistance to illness, not its celebration. Hesse's art, in its relation to illness and death, seems to be of the same kind, a brief resistance to being wiped out by an acceleration of the destructive forces of time rather than the romantic agony proposed by her writers.

—

DEACCESSION

OCTOBER 1, 1973

Lawrence Alloway

THE METROPOLITAN MUSEUM of Art has published a *Report on Art Transactions,* 1971–1973, in response to the public outcry at its policy of "deaccessioning" parts of what used to be called the permanent collection. Deaccession "does not mean sale," the report explains, but describes the decision whereby "an object can be removed from the collection"; *then* it may be sold or exchanged. This procedure is defended by a history of deaccessioning prior to the present scandals, including an account of earlier sales and exchanges. The point is to show continuity of practice.

Robert W. deForrest, a former president of the museum, is quoted as saying in 1929 that museums were facing a new problem. "Hitherto their chief effort has been to acquire. Now many of them begin to dispense." Storage difficulties, shortage of exhibition space and delays in cataloguing all followed from the massive input of museums in their founding periods. And for the past forty years an unceasing process of internal weeding out has been a standard but unemphasized activity. Past sales and exchanges are likened to the recent sales by the Metropolitan of thirty-two works from the de Groot collection (including *le douanier* Rousseau's "The Tropics" which alerted public concern) and 6,664 Greek and Roman coins.

However there is a substantial difference between the former policy and its later implementation for which in fact the new word, "deaccession," had to be found. It is essential, if a museum is to function effectively, to assure the stability of the permanent collection. This does not mean freezing all acquisitions but it does mean managing the collection nondestructively and here Thomas Hoving, the director, and the trustees failed. The sudden unloading of an unsatisfactory bequest has, as should have been anticipated, corroded the confidence of future donors.

It is only too clear that the sales of the coins have weakened and not "refined" the collection. The coins, originally assembled when rich stores were available, had a greater meaning together, in series, than now that they are scattered. Comparison between related works is no longer possible. It is probable that numismatics was the field

chosen for this act of dissolution because it is not one that commands much popular interest. However the museum has acknowledged its error by responding to scholarly criticism and canceling a projected third sale of coins. These "pagan pennies" will be kept together and sold to the American Numismatic Society at less than their estimated market value.

Taste changes but in theory museum collections do not. Since a museum is presumed to span generations, unlike private galleries which rarely survive their founders, a museum stores information rather in the way that a library does. It is important therefore not to revise the collection according to topical theories or pragmatic criteria. For instance, the Met used to show 19th-century Academic Art, but withdrew it under the impact of the School of Paris. Now there is a revival in the prestige of Academic painters and sculptors, one example of which is the Met's recent exhibition of Lawrence Alma-Tadema's work under the title, "Victorians in Togas."

Our own heroes are no less likely to oscillate in esteem and value and this is part of the problem raised by the acquisition of a sculpture by the recently deceased David Smith. The museum got the funds for it by selling lesser works by Bonnard, Juan Gris (two), Modigliani, Picasso and Renoir. It is a big sculpture, but so was the price: $250,000 for a piece that had been $100,000 four years earlier. There is no shortage of Smith's sculpture in the United States and, taking the longevity of museums into account, there is no reason to doubt that sooner or later collectors will come forward with donations of Smith, even if the executors of the artist's estate refrain from doing so. To pay such a high market price for this piece raises, at the very least, strong doubts concerning the museum's timing.

On January 14 Hoving told a reporter that "prices paid to the museum are never disclosed." Now all the prices of the deaccessioned works of the past three years are published in the report, including even the unsuccessful bids and who made them. Mr. Hoving is ready with a phrase: "it's a new era of disclosure" (*The New York Times*, June 27). It is, now that he has been found out. The trouble really stems from Hoving's impatience to consolidate his regime at the Met. His policies are not new, only badly administered. What he has done is to "deaccession" brutally what his predecessors "dispensed" with quietly. He has coarsened the process of judgment and management, both in sorting out the collection and in his search for star acquisitions. This report signals a change which one hopes will be real. It is especially encouraging that an agreement has been made between the Metropolitan Museum and the state Attorney General's office which, to quote the latter, "provides for

full disclosure to my office as representative of the public as the ultimate beneficiary of charitable gifts."

—

from PASTA STRIKE

NOVEMBER 12, 1973

Lawrence Alloway

THERE IS AN exhibition of Miró's work at the Museum of Modern Art, but I have not reviewed it, because to do so I would have to cross the picket line of PASTA, which is Local 1, Museum Division of the Distributive Workers of America. It went on strike October 9, and at the same time of writing no settlement seemed in sight. After a dozen or so negotiating sessions, PASTA (the Professional and Administrative Staff Association) and the museum had failed to agree on three issues: a higher minimum wage, participation in policy making at the trustee level and an extension on PASTA's membership to curatorial staff. At present the minimum wage is $6,100, so the first demand is reasonable. Representation on the board has convincing reasons too, one of which was put by two PASTA spokesmen, Joan Rabenau and Susan Bertram, in a letter to Mrs. John D. Rockefeller 3rd on September 4. "The average age of the association's membership is . . . probably at least fifteen years younger than those in managerial positions and twenty to twenty-five years younger than those on the board and its committees." Presumably salaries could be raised and a single PASTA member on the board, which is the demand, could certainly be handled by the existing trustees, though the board's secrecy would be reduced. According to Richard Oldenburg, the museum's director, in a memorandum of October 5, it is the status of the full curators and several associated positions in the International Program, the library and conservation that is the trouble: "This is the issue on which we have in fact reached an impasse, not on any other."

Membership of PASTA is not open to department heads, the assistant treasurer and the assistant secretary to the trustees, all of which are managerial or supervisory positions. The administration wants also to define the disputed titles as management, but PASTA objects. Curators were not included, apparently, in the original certification of PASTA as a bargaining unit by the National Labor Relations Board, and PASTA believes, probably correctly, that the

administration wants to weaken the association by keeping as much of "middle management" as possible out of it. A memorandum of October 2 from curators Kynaston McShine and Betsy Jones to Oldenburg argues "an implied lack of respect for the curatorial function in the suggestion that curators are managers." The stress on managerial duties instead of, as McShine and Jones put it, the "care, exhibition, acquisition, documentation and interpretation" of art is a distortion of the traditional role of the curator, and an increasingly common one. If, as seems to be the case, the department heads have the real power at the Museum of Modern Art, the curators do not in fact possess full managerial responsibility. To the extent that this is so, they should be eligible for PASTA, where their experience and judgment are needed.

PASTA's emergence as the first museum union (followed by the Minneapolis Institute of Art and the San Francisco Museum of Art) is also related to job discrimination. To quote one of the strikers, Susan Bertram, speaking at this year's annual meeting of the American Association of Museums: "Museums have been staffed largely by women, who have traditionally accepted low wages." It is true, the picket line in front of the museum is largely made up of women. This well-known, but as it now appears ugly, fact is certainly a powerful motive within PASTA.

The awareness that led to the formation of the association and has sustained it for two years of contest, coincides with a crisis in museums generally. There are too many of them for the amount of money available for their support. The Modern is responding to this situation by changing its organizational structure. It used to be run by the people who founded it, a group of wayward but brilliant individuals. In an informal situation of that sort low wages were supposed to be, and in fact often were, compensated for by interesting work. Museums now, however, are being rationalized into hierarchic corporate form. The director of the Modern, though the brother of an artist, is himself a businessman; he was promoted to his post out of the Publications Department of the museum. In the second week of the strike, Oldenburg announced that a typical new job had just been created and typically filled. John H. Limpert, Jr. is to be director of Membership and Development. His qualifications include work in two New York advertising agencies; he is a trustee of the Childrens Aid Society and the "activities and university relations chairman" of the Harvard Club (he was at the Harvard Law School). He is, in short, everything except a museum man. It seems that McShine and Jones's fears about the humanistic position of the

curator in a business-oriented regime at the Modern were not merely rhetorical.

It is clear that museums have to be run more like businesses, and to the extent that this occurs they will no longer be able to take advantage of pay scales established at an earlier, informal stage of development. The strikers are certainly correct in wanting better pay and better access to the flow of information within the museum, both in terms of input and output. If in addition they can achieve their third aim, they will be protecting the values of the curatorial profession, as well as strengthening their own position. Large issues underlie the strike and it is being watched with great interest by other museums.

Roy Bongartz, a frequent Nation *contributor, traveled to Nevada to report on the newest (and certainly largest) phenomenon in contemporary art.*

—

EARTH ART

DECEMBER 24, 1973

Roy Bongartz

Overton, Nev.

THERE ARE STRANGE new sights for travelers to see in the desert these days. Made of diggings and trackings in sand and stone, they are known as Earth Art, and the biggest one in the world so far, involving an excavation of 200,000 tons of cliffside on the edge of Mormon Mesa, presides in lonely grandeur out here 80 miles east of Las Vegas.

This reddish-colored mesa, 20 miles long, rises 600 feet above the valley of the Virgin River, where the stream has eaten away concave bluffs and steep slopes, with turrets projecting from between them. Facing the mesa, the Virgin Mountains rise in a jagged line to heights of 8,000 feet. In a pickup truck, I drove up onto the mesa over a narrow, hair-pinning, dusty, ramp-like track, and then jounced along for 5 miles, near the cliffside, hunting for the Earth Art piece, the work of a California-based sculptor, Michael Heizer, who calls it "Double Negative."

To come upon the work suddenly—there is no marker or sign to show where it is—is something of a shock. Here, where the edge of the cliff sweeps inward on a long curve, so that one stretch of the

mesa wall actually faces another stretch, two vast trenches are dug
into the cliffside. One trench is notched into one wall, the other
into the opposite wall, so that their empty, open ends (50 feet deep,
30 feet wide) confront each other, forming an imaginary straight
line right across the open space defined by the curving mesa wall.
They are tremendous, somehow menacing spaces—one notch bor-
ing into the cliffside to a distance of 1,200 feet, its counterpart 400
feet long. Since the end of each trench, at its farthest point into the
mesa, is made in the form of a 45-degree slope, it is possible to walk
right down into either of the trenches, to walk along the floor of
the sculpture in the soft dirt, to eye the featureless, neatly chiseled
walls that the bulldozer cut here.

The fill excavated from the notches was simply pushed out the
open ends of the trenches to tumble down along the steep walls of
the cliffside, finally forming great mounds of spill that reach up to
the mouths of the notches. You can walk out onto this mound and
peer down into the river below. Then you can peer into first one
huge empty notch and then the other, and feel the oblivious silence
of the flat mesa above, and the imperviousness of the line of moun-
tains in the distance across the valley. Some of the menacing atmo-
sphere of that inscrutable humming slab in the film *2001* surrounds
this place; it appears as if these notches could have been the birth-
place of that very slab. Heizer says his "Double Negative" title has a
double meaning: there is the idea of the two vacuums facing each
other and thus somehow forming a paradoxical positive; its nearness
to Las Vegas also reminds him of the zero and the double zero on
the roulette wheels. The reason he made the inner ends of the
notches so steep was, he says, to keep people from driving cars down
inside his sculpture.

It cost Heizer's artistic mentor, Virginia Dwan, $27,000 to buy the
square mile of land required and to pay for the bulldozing. At the
time the work was being completed, she still had her Manhattan
gallery, and Heizer was one of her rising young stars; since then,
three years ago, the Dwan gallery has closed. Some Dwan artists have
followed John Weber, former manager of the gallery, to his own
new place in SoHo, but Heizer is at the moment still on his own.
The question of what any buyer of a Heizer work would actually get
for his money is complicated; that is one reason why Virginia Dwan
has never sold "Double Negative." Heizer insists, for example, on
keeping title to the land right up to the edge of the piece, so that
he can legally prevent anybody from spoiling the scene with build-
ings, parking lots, or anything at all. So if you bought the notches,

you would be buying the empty space, mostly. (With other Heizer works, the buyer must be content with a written description of, say, a hole with a 60-ton rock placed in it, because Heizer refuses to tell the owner exactly where in the Nevada desert it is to be found.)

Of "Double Negative," Heizer says, "This piece is pure size and mass. It's a quantity instead of quality. But still it's the smallest piece I've ever made, in one way, because it is so insignificant in this huge mesa."

Heizer takes a cold view of most buyers of art, and one of his aims is to take art out of galleries, where it serves as a medium of exchange or an object for financial investment. "I want to get rid of the parasites in art. With this thing, you can't trade it or speculate with it the way they do with traditional pieces. I would sell it, yes, but it would still make me sick to my stomach to sell it."

Heizer admits that his breed of sculptor does little of the actual carving with his own hands. "All I have to do is just *want* the piece, and the machines make it for me. There is moral problem in just sitting watching tractors working, while maybe smoking and drinking whiskey. But I compare what I do with what these tycoons, with their mines and oil wells, do to the earth on their way to getting power for themselves." Heizer likes the way the piece loses itself in the mesa. "I climbed down to the river once, to look up at the piece from there, and the way the notches blend into the sides of the mesa, you can hardly see them at all. The way I like to see the things is to drive all along the edge of the mesa, for about an hour, say, just looking out at the scenery, and then just suddenly come upon it, and see it in context that way."

A more sweeping, moonlike view, I thought, might be had by plane, so I drove back down into the small town of Overton, where a high-school teacher will take visitors on flights over the long edge of the mesa, after school is out for the day. We swung out over the valley, and I peered searchingly at the streaky tans and red on the cliffsides until finally I discovered, just below us, the gently falling spills of sandy earth lying soft against the ancient, eroded side of the mesa. We circled back and flew down low over the mesa top, then dipped lower to within only a few feet of the cliff edge—the ride alone was worth the ticket, even if there had been no Earth Art below. Then we floated over the notches, their precision-cut walls and floors shining somehow with a glow of their own, despite the dim light of the ending day. The figures of two art lovers posed at the edge of one of the notches had a pictorial, imagined quality to them. Although the notches are made from real sand and stone and cliffside, there

is nothing ordinary, familiar, or even believable about them. As we made a final pass over the notches I gave a little whoop of sudden, unexpected delight.

When we landed on the airstrip, I walked into town by myself. The desert came all the way up to the drainage ditch flanking the road; the expanses of cactus and sagebrush and tumbleweeds and dry gray twisted bits of tree branches started here and went on forever outward. Beer cans gleamed in the ditch. The schoolteacher pilot drove up behind me, calling out an offer of a ride, but I waved him on. Another Earth artist had told me once that when the world exploded and went up in flames he wanted to be out here in the purity of the desert. But there is no way to keep the desert pure. The beer cans mocked the simple structural dignity of even the simple drainage ditch. Anyway, this ditch, like the notches of "Double Negative," would eventually be obliterated by time.

In the center of Overton, a wide main street with a row of 1-story storefronts on each side, I talked to a small, cheerful little woman in a general store. She advised me against buying one of the $4 Western-style hats, because they would "just disappear" in a rainstorm. I settled for a postcard of a jackalope, the famous Western put-on of a jack rabbit with antlers, and asked the woman what she thought of the notches out on the mesa. "Oh, we like it," she said. "It gives us some place to drive to of a Sunday; a lot of people do that. We like it fine." I watched her guileless eyes for a moment to see whether she might only be trying to say what she thought I might want to hear, but she was really proud of those big strange holes out there.

—

ALICE NEEL

MARCH 9, 1974

Lawrence Alloway

IN THE FALL of 1971 two petitions were delivered to the Whitney Museum of American Art, both calling for inclusion of Alice Neel in the museum's annual, now bi-annual, exhibition. One petition originated at the Figurative Alliance, a broadly based, loosely organized coalition of realists; the other came from women artists whose signatures were collected at various women's groups. Neel has a special status among women artists: she is a symbol of persistent work

and insufficient recognition. She has exhibited honorably and di-
versely since the 1930s, but without receiving an acknowledgment
commensurate with her record and her worth. (It is typical that she
has no entry in a so-called *Directory of Contemporary Artists*, edited by
Paul Cummings as recently as 1971.) The Whitney responded to the
petitions, while denying that it was doing so, and in consequence
we can now see a retrospective of her work (until March 17).

Before discussing Neel's admirable paintings in some detail, I
want to consider the show in the kind of political terms that forced
the museum's hand. She is represented by nearly sixty paintings on
the second floor, in a show organized by Elke Solomon, the associate
curator for Prints and Drawings. Neel is showing only paintings. The
question arises, why did she not receive the attention of a senior
curator accustomed to dealing with paintings? Neither James Monte
nor Marcia Tucker, just promoted to full curatorship in place of
departing curator Robert Doty, took the assignment. To judge from
Solomon's other shows she is not particularly attuned to realism. If
she had given us a marvelous show, one would have taken pleasure
in a wrong righted and in, so to say, the understudy going on so
successfully, but we are denied that reaction. It is not the fault of
Neel's work, but the show looks terrible, badly hung and incoher-
ently selected.

The catalogue lists fifty-eight pictures, twenty of them from before
1958, nine from 1959–64 and twenty-nine after 1965. Partly on the
basis of this show, but also from other exhibitions, the chronology
suggests that the works for which Neel is admired and indeed cel-
ebrated were painted in the last ten years. Solomon gives the most
attention to this period, but I would have liked to see an even more
solid representation. The years 1959–64 seem to amount to a tran-
sitional phase in which Neel's later supple style gradually animates
the stiff, flat early work. The show concentrates on her portraits,
excluding landscapes, which are often interesting in the early work,
so that we get too many early works and sampled lopsidedly in any
case.

As a portrait painter Neel deals with single figures or pairs and
in every instance she probes for the unique lineaments: physique
and personality are joined in her best works. Gesture illuminates
character, posture is permeated with psyche. She emphasizes eyes
and hands, usually subject to a canon of restraint in portraiture, and
handles them in a way that relates to the way in which we watch
people when we first meet. Our reading of other people often de-
pends on our reaction to their eyes, and our sense of contact has

much to do with "what people do with their hands." This sense of personal contact is preserved in Neel's tough presences, pungently evoked. Derived from this sense of relationship is the way in which she emphasizes heads, sometimes at the expense of a fully articulated body. In conversations, the head, where the mouth is, where the brain is, is a natural focus of concentration and she often characterizes her sitters by this kind of cephalic looming.

Her emotional emphasis on the head does not change the fact that she is absolutely a realist. Her early works tend to be schematic, with a persistent flatness that is sometimes shrewdly post-Impressionist (probably out of Gauguin originally), sometimes naive and primitive. Then, in the transitional period, the flatness is opposed: the surfaces of forms become bulky and their boundaries are seen to grow and ripen. Referring to one of the early works, "Child Birth" (1939), Solomon supposes that "the skewed spatial treatment and the figural gestures [are] marked by cubist devices." Not so. The splayed body probably derives from Max Beckman, both in its linkage of anatomical distortion and human suffering and in the supple contour that rounds off the modeled body. Or take "Randall in Extremis" (1959); in which the ripple of paint is equivalent to a body tremor; here one thinks of Soutine.

Beckman, Soutine (and one could add Kokoschka): what these second-generation Expressionists had in common was the purpose of reconciling expressive distortion with a full sense of the body's corporeality. The first generation of Expressionists had flattened and fractured the body; the second returned to a Renaissance-like somatic fullness of body, combined with the stricken insights of the first generation. In the case of Neel, her early work is the equivalent of that first generation, whereas her mature work takes up the problems of the second. That is why I think Solomon was poorly advised to show so much early work; Neel's real victories come later. Among the paintings in which psychological acuity and physical reality interpenetrate with amazing verve are "John Perreault" and "Vera Beckerhoff" (both 1972), and "Robbie Tillotsen" (1973). Such works speak for Neel in a way that her curater has not.

The catalogue is entirely inadequate: 8 printed pages and printing on the cover; one illustration in color and six small black and whites. A 2-page text by Solomon gets nowhere and indicates no grasp of the actual course of Neel's development. One might compare this meager catalogue with that provided in London a few years ago by the White-chapel Art Gallery (hardly a prosperous institution) on the occasion of a Betty Parsons retrospective: 12 pages of text, one color illustration and ten black and whites, on a much

larger page size. The point of comparison is that Alice Neel and Betty Parsons are of the same age, that of the century.

—

THE SMITH HAVEN MALL

MARCH 23, 1974

Lawrence Alloway

THE SMITH HAVEN Mall opened four years ago. Located on a site between Brookhaven and Smithtown, it is a major retailing center for suburban Long Island, and publicity described the mall as being "designed as a show place." A part of its claim to prestige was the cluster of sculptures and paintings displayed in it. Leonard Holzer, an executive of the N.K. Winston Corp., the developer of the mall, commented on the art. It was not, he said, the first time that painting and sculpture had been installed in an EMAC (Enclosed Mall Air Conditioned), but previously the works had been thematic, commissions linked to trade and local interests. Smith Haven, on the contrary, got "bright, exciting modern art" by nine artists, including Alexander Calder, Jim Dine, Larry Rivers and Jack Youngerman.

"Naturally, they're well-insured," Holzer explained, "but the size and weight of the pieces practically prohibits their removal by unauthorized persons. Besides being permanently fixed in place, they'll be constantly in view of countless shoppers during the day, and the center is well patrolled after hours." Holzer is bringing art to the masses with a full sense of the risks of vandalism and theft, but believes that a mix of public opinion and security programs will protect the precious objects. (I am grateful to my student Loreen Szczepanik for her research on the mall.)

It turns out, on visiting the mall, that the works of art are in trouble, mainly from the N.K. Winston Corp. and its executives. Having contributed the art, they show no interest in preserving it. Presumably they have moved on to fresh malls and condominiums new. The Smith Haven Mall is first a shopping center and second a social service for spaced-out (horizontally scattered, that is) suburbanites. The EMAC is used as a meeting place by desperate mothers with noisy children and by teen-agers with unfocused leisure time. The question is, what role has art in this newly constructed environment?

The mall is cruciform in plan, with a large central space and four radiating arms that lead to big stores. Macy's, for instance, and Sears.

Between the center and the climax of each vista are brightly lit, smartly designed, well-kept, smaller stores with varied fascias over identical spaces. The row effect gives a tidy pattern to what might otherwise be guilty abundance. Among these shiny, fresh and well cared for arrays of new goods, there are strange points of dilapidation, nodes of decay in the happy traffic pattern. These islands of entropy in an otherwise elegant and renewed environment are the works that comprise the mall's "$250,000" art collection. Their decayed and collapsing state raises a serious problem. Is it sufficient to put works of art into public places, and then walk away? If you set a work of art into a commercial space, is it moral, after its initial use for publicity has been expended, not to provide for its care and maintenance?

Consider what has happened to the 24-foot-high Calder. It was originally placed in the central court, a sunken area under a dome. The sculpture was an irregular red tripod that rose to a narrow point from which a spray of mobile units opened out. Since its installation it has been moved, however, to one of the malls, where the ceilings are lower. This caused a space problem which was solved with Procrustean simplicity: the free-moving top story was removed to leave only the supporting triangular structure. It really should be seen to be believed: it is the only topless Calder. Who had the authority to move the sculpture in such a way as to destroy it? Is there no corrective mechanism within the corporate structure of the mall to correct such abuses? I can understand the reason for moving it: the sculpture took up space at the center of the mall on which multiple claims are made. For instance, the first time I went there an army band had occupied the area, playing staid rock as part of a recruitment drive. What I cannot understand, however, is that it was possible to move the sculpture in a senselessly destructive manner. As it stands now, your eye is lead upward to a pivot, a constricted and premature point instead of an orbital sweep.

What happens to paintings in the mall? Jack Youngerman contributed a two-sided painting, in which a white, blue and yellow flat pattern is repeated on both faces, though reversed. It hangs high, across the "Peacock Mall," which also has an aviary from which, it seems, the birds keep escaping. As a result, the clean color and sharp boundaries of Youngerman's abstraction are streaked and encrusted with bird droppings. Is there nobody in the mall whose responsibility it is to clean and repair the works of art? Do the artists not feel that their work is being abused beyond bearing? Have the artists' galler-

ies no power or will to protect their artists? Or, does everybody's interest conclude with the *sale* of the work?

This is not a complete list of the deplorable conditions in Smith Haven Mall's short-winded venture into public art. A big Larry Rivers spans one of the malls: it depends on a sequence of lights, which are not working; it is an assemblage of various materials and, in the right half, the plastic background is peeling away and hanging loose. The result is that the most widely seen Rivers in the world is now offered in a form that is a caricature of what he actually made.

What we are faced with here is an exceptionally cynical example of a general tendency of corporate patronage. Art is important to business at one point usually, when new buildings are constructed or an existing plant is extended. That is the moment of the happy marriage of largesse and prestige; afterward the mural or the foyer sculpture exists in benign neglect. However, the mall's failure to provide for the maintenance of its acquisitions is a unique act of destruction. When the works are not deteriorating physically, they are abused in other ways. For instance, Jim Dine has a big four-piece sculpture of a green hand, a yellow moon, a blue star and a red shoe. It stands on patches of threadbare artificial grass and last week a tangle of cables ran through the pieces, supplying power for a special display of vacation trailers which all but concealed the Dine. Some "showplace." I appreciate the necessity for changing displays at the mall, but the works of art should be part of a soundly conceived traffic system that would prevent such tawdry encroachments.

CHICAGO MURALS

AUGUST 3, 1974

Lawrence Alloway

ONE WALL OF an alley on 50th Street, between Champlain and Saint Lawrence Streets in Chicago, is decorated with a mural entitled "Rip Off," which presents phases of black urban life in a sharply patterned style. The painting was placed here because the alley leads to a garage converted to an informal community center where weekly jazz concerts are staged by well-known disc jockeys. To one kind of community activity, therefore, another was added. That "Rip

Off" is a successful example of public art is suggested by its absorption into the neighborhood. When I saw it a group of residents sat and squatted before it, neither defacing it nor at a distance from it.

This close relation of art and the community is central to what has become a mural *movement* in Chicago. The first mural reportedly was "The Wall of Respect," painted in 1967 by William Walker, with the support of the Organization for Black American Culture. The first Latin mural followed two years later and there are now a couple of hundred murals spread through the working-class areas of Chicago. There is no critical literature on them yet and at present the best source of illustrations is a pamphlet, "Cry For Justice," published in 1972, not by a museum but by a union, the Amalgamated Meat Cutters and Butcher Workmen of North America. I was able to see some of the murals, crisscrossing Chicago outside the Loop, through the kindness of LiFran Fort, who drove me around.

The murals, like all public art, depend on a rendezvous of subject matter and site or, to put it another way, on devising an iconography that will be legible to a general audience (general in the sense of not art-oriented). The success of the Chicago muralists is remarkable in this respect: they use narrative and personification with a conviction that dismisses the complex or attenuated content of 20th-century easel painting. One of the most productive artists, John Weber, wrote in the magazine *Youth* (September 1972): "This community-theme approach is in contrast to the impersonal, commercialized, abstractionist emphasis often seen in New York's public wall painting and to the artists' personalistic emphasis in Los Angeles." Weber errs when he seeks to promote his kind of work by comparing it with unlike cases. City Walls in New York—his reference is clearly to that group—works for the most part in rundown sections of the city, but is not attempting to relate to local groups. The grids of City Walls are more like billboards for art, declarations of an aesthetic against urban randomness, and for Weber to regard this as impersonal and commercial is to replace thought with abuse. The New York artists and the Chicago ones have entirely different social purposes.

The strength of the Chicago murals lies in their relation to the daily life and current interests of the working-class neighborhoods in which they appear. The painters' aim is precisely to speak for groups, to create an art of the milieu so that individual works are magnified by their representative character. The sense of place is indispensable to these murals, as in the case of "Rip Off," but also in the work closest to Abstract art in Chicago. In an untitled mural

(19th and Halsted) and in "The Wall of Brotherhood" (18th and Halsted), the side walls of row houses, opened up by demolition, carry a lyrical surge of pre-Columbian ornament. Thus the formal motifs have an ethnic meaning, including historical references to the past of the area's residents. There is a theme of cultural heritage in the luminous, pearly colors of the repetitive forms that climb up above the parked cars. (Lots, used as car parks, are frequent sites for the murals.) The fact that New York murals do not explore ethnicity is not a condemnation, only a difference.

The closeness of the murals to the communities they brighten does not usually rest on a detailed local program. It is more a matter of the standard themes of self-determination, alienation and racism. There is a rhetoric of protest which is now generally legible and which is certainly appropriate to the murals' host communities. The visual clichés generated by social discontent are an enabling factor in winning acceptance of this particular public art. (Cliché is not used here as a derogatory term but simply to refer to imagery that is strong public property.) "Mural of the Race" (1642 Blue Island), for example, shows grave profiles of Mexican and Puerto Rican heroes—Juárez and Villa, Belances, Campos and Hostos, respectively—against a background of flags and maps. It is on a side wall at right angles to the street, so that the vernacular picture slices right up to the sidewalk. Folkloric flatness and hero-cult are found again in "The Crucifixion of Don Pedro Albizu Campos," painted by the Puerto Rican Art Association. Flat planes of color span the wall, flag-like, and the crucified patriot is spread-eagled but composed in formal dress. This mural has an open location so that it commands a wide intersection at North and Artesian.

Aside from a legible iconography, the best murals have a sense of environmental intimacy. "People of Lakeview Together," for instance, occupies a single block between Barry and Sheffield. An elevated railroad crosses one end of the street and a busy main street the other: between the two transportation routes enormous painted figures, reaching to the second story, enact scenes of family unity and community interaction. One of the most brilliant murals is "Peace and Salvation: Wall of Understanding" (Locust and Orleans). It fills the end wall of a four-story house; on one side is a ragged silhouette of rickety stairs and porches; on the other side the street. In front is a waste lot sprinkled with broken glass, a cracked sidewalk and a notched curb. A conventional bouquet of different colored hands binds the white/black iconography of the mural together, but it has a subtler unity. The rough wall, painted on directly, has a texture that is continuous with its surroundings. That this is no ac-

cident is shown by the treatment of the base of the mural: there is a unity march of looming figures, close in scale to ourselves; on the street side is a sequence of painted posters, which runs off toward the street with its real posters. The mural is part of the urban continuum.

The Chicago murals constitute a body of public art divorced from the classical idea of permanence, with no lingering Beaux Arts notion of work for eternity. The first mural, "The Wall of Respect," has been destroyed. Another early work, "All Power to the People" (1969), is in a churchyard at Locust and Sedgwick. Across a dilapidated open space, you can make out, through weeds, the image of a militant black woman, clenched fist, her raised arm emblematically crossing a rifle to make a revolutionary X. "Victory Through Unity" (2100 West Division), a somber mural animated by hunched forward-pressing figures, has been defaced by explosions of white spray paint. In addition, and ironically, the mural's written demand for "homes not slums" has been endorsed by graffiti added to the mural itself. "The Crucifixion," already mentioned, has acquired a big new sign, set into the painted wall, advertising Dr. Edward Bartnick, optometrist: vision may be his business but he lacks a visual sense. "Nation Time" (4141 South Cottage Grove), a remarkable panarama of black imagery in which Cubist patterning is filtered through a Captain America comic-book style, is scheduled for demolition, but at present it shines brilliantly above its pedestal of parked cars. Even as new murals emerge to embody topical concerns of the city, others are sinking back into the texture and the mobility of the street. Their comparatively short life in exposed public places is linked to one of the admirable properties of the murals. They do not represent an interruption or suspension of daily life, as formal and classicizing public art does: they are brief emblems of the city rather than isolated monuments.

I have not ascribed the murals to individual artists in deference to the emphasis placed by the artists themselves on the communities' significant role. The customary work procedure seems to be something like this: the artist functions as director, carrying out the project with the active help of residents, often teenagers. It is clear, however, that the "directors" have personal styles that are unmistakable. Mario Castillo has an exceptional capacity to project, through his team, a delicate and exacting color sense onto 70-foot walls ("Wall of Brotherhood" is his). Ray Patlan gives a folklore vividness of color to his clear, sharp planar imagery (as in "Mural of the Race"). William Walker, with a taste for chiaroscuro and for texture,

is the artist of "Peace and Understanding: Wall of Salvation." John Weber's projects tend toward a monumental figure style, smoothly graded, with references to the mural movement of the 1930s ("Victory Through Unity") and to Léger ("People of Lakeview Together"). The problem of authorship and control does not arise with Mitchell Caton ("Rip Off" and "Nation Time"): his eloquent intricacies seem to be painted wholly by himself. I have given street locations here because the murals, whatever their local character, are an important though scattered body of public art which deserve to be visited, studied and celebrated.

—

POLITICAL POSTERS

MAY 10, 1975

Lawrence Alloway

I WANT TO prepare *Nation* readers for a forthcoming exhibition of unusual interest, but one that will be on for only a weekend. It is "A Decade of Political Posters by American Artists, 1965–1975," and it will be held at 392 West Broadway from Friday, May 16th to Sunday, the 18th (hours, 11 to 6). It is in SoHo, on street level, under the John Gibson Gallery. The show is part of a fund-raising effort for the Attica legal defense. What happened is this. A group of prints by well-known artists had been projected, the sale of which would raise funds for the defense lawyers. As it stands, Frank Stella has produced a poster, rather than a print, and Claes Oldenburg has a lithograph in preparation. Of the other artists approached, Roy Lichtenstein and Alexander Calder gave works to be sold, Romare Beardon made a cash contribution, and Robert Rauschenberg expressed his willingness to make a print. The purpose of the present exhibition is to raise money to meet the costs of printing the Stella and the Oldenburg, with any profits going directly to Attica.

The "Decade" exhibition is therefore a step toward the realization of another project, but it has more than interim significance. The first survey of the political imagery of artists of the past ten years, it reveals, in definite contours, tendencies that have been persistent but scattered. There are three sources of dissenting posters: regular poster designers, whose statements range from scatological cartooning to the ecological-psychedelic; lay artists, driven to protest by circumstances, such as the makers of the *affiches de mai* in Paris, 1968;

and artists. One reason for sanguine expectations, as far as fund-raising goes, is the fact that the "Decade" posters *are* by artists. They are for sale, including a hitherto unknown suite of prints by the sculptor Tony Smith, "Art For Peace," done in 1967.

In 1967 a portfolio (in an edition of 100) was published by the Artists and Writers Protest Against the War in Vietnam, the first group in the art world organized in response to American military action in Southeast Asia. It consisted of six prints and a pamphlet of poems (from David Antin to James Wright). In the prints, Paul Burlin adapted finger painting to simulate smears on a death-chamber wall; Charles Cajori heaped up de Kooning-ish corpses; William Copley did a stars and stripes with the IBM motto "Think" in place of the stars; Alan d'Arcangelo did one of his highway arrows skewered around to point to a patch of red; and Mark de Suvero wrote an indictment of U.S. policy and its results. Rudolf Baranick alone abstained from forcing his style into any sudden relevance. In the "Decade" show one can see other artists who preserved their own style in the new political context. Charles Hinman, Adja Junkers and Mon Levinson, for example, did their ordinary Abstract art, and Louise Nevelson made a photo-collage of her own work. Some artists either cannot incorporate political themes and motifs into their existing style or they believe their style capable of signifying momentous matter allusively.

It is the artists who aim at image making who dominate the "Decade" show. One early piece, by an anonymous artist, shows the U.S. flag with skulls instead of stars, and statistics on genocide making up the stripes. Another flag has the stars blacked out. Faith Ringgold's map of the United States, with lynchings, executions and battles pre-empting the usual place names, is another adversary image. Napalm appears early as a theme, in posters by Jeff Schlanger of ca. 1966, which the artist printed and then posted in the streets himself. A group that called itself A.R.T. 1970 also papered the streets with crude images (skull and tin hat) and accusatory texts ("Only the dead are silent"). A portfolio that I hadn't seen before, "Ten Days to Change the World," was published by the Youth International Party in Miami in 1972. The artists are mostly Pop, including Rauschenberg who, on a visit to Florida three years earlier, had made a series of prints to celebrate a moon-shot. He must be the only artist to mint images for both NASA and the Yippies!

It is important to realize that new protest art is not a programmatic political art. (Nor is it aimed at a specific generation, like many of the anti-Nixon posters and "make-love-not-war" posters, which were

market-oriented.) These artists' posters have no roots in a purpose-
ful alternative system. In this respect what they do is not like the
left-wing art of the 1930s, which assumed the conflict of communism
and capitalism. The new phase of American protest, from outcry to
complaint, is essentially reactive. It has followed the events of the
1960s and is not buttressed by the theory of deterministic history
that communism requires. Though individual artists may believe in
historical inevitability, most protest art has been in the form of spon-
taneous reaction to a series of crises which need not be recounted
here, since we have all undergone the same shocks and provoca-
tions.

The difference between the two phases of protest (one pre- and
one post-World War II) is suggested by America's two senior art
critics, both of whom espoused the early phase. Clement Green-
berg has applied the deterministic view of history to the art world
to show that the sequence of events must issue, if not in commu-
nism, at least in Abstract painting. Harold Rosenberg took the rev-
olutionary act off the streets and into the studio; his term "Action
Painting" flattered the artist by assigning to him a rhetoric of manly
action. The loft became a metaphor for the barricades. However,
neither writer has recorded his interest in the new form of art's po-
liticization, and that suggests the different basis of the second
phase.

The artists' lack of policy is in contrast to the position of tradi-
tional revolutionaries, who have in mind a target, or at least a stan-
dard of effective action. What protest art in its later phase can do
and has done, as this exhibition shows, is to signal the changing
relationship of artists and society. The work of art signifies, but it
does not effect, change. Recent protest art has altered the content
of art by changing what it makes us think about. Admittedly, it is
still the audience for art that is being reached, but that is an influ-
ential and opinion-making sector of society. To measure protest art
by its appeal to an ideal, hypothetical concept of the masses is nos-
talgic and off the point. The demonstrable fact is that ideas of art
are changing and shows like the present one, revealing artists in
trigger responses to society, should not be restricted by prior ex-
pectations of revolutionary form. Artists are giving us at present a
vivid and venomous iconography of the world; the work of art has
been penetrated by political imperatives.

Ad Reinhardt, who is celebrated for his admonitory approach to
art ("No symbols, images, or signs," etc.) applied it to politics in a
print shown in "Decade." It begins, "No war, no imperialism, no
murder, no bombing, no napalm," which lists exactly the concerns

of the artists in this show, but he slips in a couple of malicious prohibitions, "no art from war" and "no art as war." That is to say, a built-in aestheticism compelled him to declare his detachment as an artist. The other artists in the show, however, are extending the traditional modernist aesthetic precisely toward the heretical positions of "art from war" (topical subject matter) and "art as war" (the adversary stance shaping their iconography).

—

GRAFFITI

SEPTEMBER 27, 1975

Lawrence Alloway

GRAFFITI: "WORDS OR phrases written on public sidewalks, on the walls of buildings, etc." The term has been extended now to include works seen in, and executed for, art galleries, and it is interesting to see how it got there. The exhibition, "United Graffiti Artists 1975," is at Artists Space, 155 Wooster Street, on the corner of Houston (until September 27). The relationship between graffiti and modern art begins in Paris with Brassai's photographs, published in the pro-Surrealist magazine *Le minotaure* in 1933. At the time he commented on his rough-textured conglomerations of images: "we are worlds away from the sweetness of child art. All becomes earnest, raw, harsh, barbaric." Jean Dubuffet maintained the undercurrent of savagery in a set of lithographs published in 1950 to accompany Guillevic's poems *Les Murs*. In the background of this interest in graffiti is perhaps a more general interest in the visual potential of written forms, such as Paul Klee's use of hieroglyphs. And in New York in the 1940s there was the study of pictographs by Adolph Gottlieb and of ideographs by Barnett Newman.

Thus people in the arts were predisposed to appreciate the colorful, huge-scale graffiti that appeared in the 1970s. The Mayor's office and the Transit Authority fought it, but many shared Claes Oldenburg's view: "You're standing in the station, everything is gray and gloomy, and all of a sudden one of those graffiti trains slides in and brightens the place like a big bouquet from Latin America." (Quoted from Peter Schjeldahl's text in the catalogue of the show.) It should be emphasized that this kind of graffiti, as it expanded to subway-car dimensions, became a particular kind of message.

It was neither scatological nor political. Though of necessity done

surreptitiously, it did not, like the gnarled tidings in lavatories, stay that way: on the contrary it flourished publicly for a *mixed audience.* Although it was opposed by city agencies it was not stamped out, as it would have been if the messages had been about Che and Mao or if the barbarism Brassai referred to had been evoked. The subject of the graffiti was the names of the writers themselves, or more often the gang nicknames. (Note that the anonymity of earlier graffiti writers is abolished.) Thus the works were correctly taken as genial affirmations of personal identity, first-person celebrations in bouncy calligraphy and "ethnic" colors, which is to say brilliant hues of the kind associated with Latin American culture.

One of the visual pleasures of this work was its brilliant adaptation to the environment. Though the writing amounted technically to vandalism, it was hard to object to the brilliant floralization of complete trains. To see these ebullient logos compete at the scale of architecture and billboards was to enjoy the marks of individualism and of a kind of primitive energy. The interaction of the rotund, zigzagging, bulging letters with the irregular geometrics of the urban environment was a great if unlegislated pleasure. It is from this spontaneously emerging public art that the United Graffiti Artists (UGA) are drawn.

Hugo Martinez describes in the catalogue his sense, after seeing the graffiti, of "the vast potential of Puerto Rican adolescents and what they might achieve by rechanneling their energies." He records that "awareness that the writer could establish his own identity only by violating public, institutional property rights did not deter but rather enhanced the work." Despite this crucial insight, however, the fact of trespass on public spaces counts for very little with him. The "rechanneling" process meant diverting the artists toward the manufacture of commodities. Thus social service (keeping them out of the train yards) converges with career protection (earning money and squeezing out the competition). Since the UGA consists of the best writers, "a vanguard had to be established that would safeguard the art from the fad that would surely follow." These are Martinez's words; to put it another way, a vigorous grass-roots urban art is now packaged for the market and the young men given a legitimate occupation. They are artists, but originally they called themselves writers. The change is important for it indicates the false aestheticism that is associated now with big-scale, sprayed graffiti.

Although the familiar words and numbers are to be seen at Artists Space, they are not on the walls but on stretched canvases. In place of the boundlessness of the city the writers accept severely delimited

smooth areas. This leads to an acute weakening of their work. There is a class of Islamic calligraphy known as "pseudo-inscriptions" or "pseudo-calligraphy," in which the appearance but not the substance of writing is presented. The reverse occurs here: real calligraphy is being transformed into pseudo-painting. As interior decoration these paintings are lively, but they constitute a sharp attenuation of the expressive content and formal inventiveness with which the writers began. Martinez's notion of the artists' productivity is understandable but should not disguise the fact that the writers are now producing an ethnic craft for a sophisticated audience. The celebration of name and self have been compromised.

Three years ago Herbert Kohl published a study of graffiti, *Golden Boy As Anthony Cool* (Dial Press). His material predates the ornamental elaboration of the spray-paint period, but his rough examples of unpolished graffiti are continuous with the later work. He defines the social conditions of the writers and the responses to the environment that produced certain kinds of messages. The verbal patterns are keyed with the experiences and lives of the writers. This is the greatest loss in the gallery-ization of graffiti. The communicative function is dried out and the affirmation of self becomes a routine, like making ashtrays.

—

THE 1970S

MARCH 1, 1980

Lawrence Alloway

THE 1970s IS generally conceded to have been the decade of pluralism in art, but the meaning of this term has been much misunderstood. Carter Ratcliff, for example, who wrote the first of the articles summarizing the decade in art, regarded the period as a kind of failed 1960s. He lamented the shortage of stars and movements. It is true that there were no movements as commanding as Pop Art or Hard Edge, but this does not mean that the art scene was diffuse and uninflected. The horizontal abundance of the last ten years is a continuation of the real condition of twentieth-century art—"a situation of multiplicity" (John Cage's phrase).

It is sometimes supposed that diversity leads to a reduction of intensity, as if stylistic variety expressed cultural uncertainty. Actually, diversity is a property of the field of art as a whole and intensity

belongs to the experience we have of particular artists and works. Let me cite a few works of the past ten years to suggest that the fact of diversity has not blunted the intensity of esthetic contact. This list is more or less random, except for favoring large works. Outdoor sculptures include Robert Smithson's "The Spiral Jetty," an earthwork curling into the sullen waters of the Great Salt Lake; Robert Morris's "Grand Rapids Project," an immense X stamped on a hill; Mary Miss's "Perimeters/Pavilions/Decoys," at several points on the grounds of the Nassau County Museum of Fine Arts. Among assemblages, I remember Robert Rauschenberg's "Rodeo Palace," a glowing three-door collage. Paintings include Leon Golub's "Assassins," based on the war in Vietnam; Benny Andrews's "Bicentennial Series," a panorama of black humor, and Audrey Flack's "Vanitas," a revival of the use of still life as ethical commentary.

Sculpturally, there was a tendency toward open rather than solid forms. This is not new in sculpture theory but the persistent environmental spread is new in achieved works. The floor, the wall, the room, the park, the street serve as the base for works that are larger in scale though sometimes shorter in duration than solid sculpture. Such works range from Sol LeWitt's modular wall drawings to loose repetitive groups of forms, like Carl André's rocks at Hartford. The new scale is demonstrated by the Dada sociology of Christo's "Running Fence," Otto Piene's festival occasions of large inflatable sculpture and Walter de Maria's conspicuous consumption of a gallery for the long-term display of a single monster work, "The Broken Kilometer" at the DIA Art Foundation in New York City. In Los Angeles the act of installation can lead to art's being lost in a mirage of relationships, but the mirages retain the formal probity of the lost object (Robert Irwin, Michael Asher).

Public modes of sculpture received considerable support. On a Federal level, there were the National Endowment for the Arts and the General Services Administration, then the state arts councils, and foundation or corporate patronage: all converged to fund bigger and more sophisticated works. In ironic resistance to this is the tendency toward miniaturization: Joel Schapiro's little bronze houses, like "Monopoly" real estate pieces, set in big spaces on the floor against the wall; or Ira Joel Haber's buildings and landscapes in boxes, with uprooted trees, or burned wood, like Joseph Cornell boxes that have been violated.

The distinguishing features of the 1970s are the renewal of realism and the emergence of women's art. Women contributed substantially to all the varied styles of the decade: environmental sculpture

(Cecile Abish, Alice Adams, Alice Aycock), pattern painting (Cynthia Carlson, Mary Grigoriadis, Joyce Kozloff), paper works. Drawing as a technique has expanded to include not only the marks on paper but also the paper itself as a substance. Thus, drawing acquired a connection to craft and thence to sculpture. Michelle Stuart and Nancy Spero, in their different ways, have explored paper as a structural material. In addition to works that address feminism directly, there is an absolute increase in the number of women artists. The women's cooperative galleries, though few in number, have an importance beyond their size. They keep open the possibility of ideological reform and personal control of one's work. The co-ops are probably the most significant aspect of the alternative spaces that have proliferated in the 1970s to supplement the existing distribution system.

Realism was sufficiently established to be the subject of an exhibition, "22 Realists," at the Whitney Museum of American Art in the first year of the decade. Since then, galleries specializing in realism range from co-ops (Prince Street and First Street Galleries, and the Bowery Gallery now relocated with the Blue Mountain at 119–121 Wooster Street) to commercial galleries (Forum, Allan Frumkin, Robert Schoelkopf). Realism as a style includes Alex Katz's figures, which assimilate visual elements from abstract paintings, and Philip Pearlstein's, which, the artist insists, are antithetical to abstract painting. Realism is not a restrictive term, as it was earlier in the century, but a capacious one. It designates not a prevailing style but a fundamental concern with the signifying function of art.

There were three old-time art movements in the 1970s, by which I mean groups that are stylistically homogeneous and based on galleries. Photorealism was of this sort, pushed first by the O.K. Harris Gallery and given by its owner, Ivan Karp, its mechanical and suburban iconography. None of the innovative painters, the ones who stretched the style, are in the gallery, however: Charles Close, Richard Estes and Audrey Flack are at other galleries and Malcolm Morley is unaffiliated.

Pattern painting is a branch of abstract art in which geometry is turned into decoration, the utopian forms of earlier abstract art transformed into architectural or craft images. The first group show was in 1976 at the Alessandra Gallery, now defunct, followed by the show at P.S. 1 in 1977 for which John Perreault coined the term. It is a loose grouping of artists who orbit around a core of craft metaphors. Thus we get culturally loaded motifs in place of platonic absolutes, discursive grids in the place of Oneness. "New Image Painting" is an awkwardly named but pushy movement. A more ac-

curate label for it would be something like "Flat Figure Painting," but this would lack the evolutionary elan of "New Image." It is actually a conservative movement: It acknowledges the pressure of realism, but softens it according to ideas of color and flat design taken from abstract painting. Figures, one at a time or severally, frontal or in motion, equivocate between realist representation and abstract pattern.

12

SENSATIONS
TRIALS AND TRIBULATIONS
(PART IV)

The 1980s were a time of violence, murder, and political struggle in Central America. Lucy Lippard, then a writer for the Village Voice, *contributed this piece to a* Nation *special issue on the region.*

—

CENTRAL AMERICA

JANUARY 28, 1984

Lucy R. Lippard

THOUGH WE ARE beginning to wipe the grime of neglect and ignorance from our windows on Central America, we continue to look through them with disbelief. Asked to write about "the art scene in Central America," my first response was, There isn't any. There is no art *scene* in El Salvador, Honduras or Guatemala . . . or in Costa Rica . . . or in Nicaragua. But there is always *art*.

There are still galleries and museums, even in Guatemala and Honduras (countries described by a recent returnee as a death camp and a military camp, respectively). But little happens in them. The reasons are political and economic as much as cultural. Visual art plays a particularly insignificant role in these countries compared with movies, radio, popular music, poetry and theater. In San Salvador, the all-pervasive influence of the United States makes high art fashionable in some circles, but since everything indigenous is politically threatening, and since there is no market and little audience, mediocrity reigns. Censorship and self-censorship render art making of all kinds extremely difficult in Central American capitals. Cultural publications such as the lively Honduran *Alcaraván* exist but cannot thrive in a climate of apathy and fear.

All of this has to be understood in light of the fact that only in the 1970s were humanities departments and the Bachelor of Arts degree introduced into most Central American universities. The modest cultural flowering they stimulated was paralleled by renewed aspirations for social change. It was the revolution, for instance, that brought the poet Roque Dalton to a Salvadoran audience and sparked the first independent Salvadoran films. Radio too has blossomed—and not simply as a political tool. Radio Venceremos broadcasts children's plays from the liberated zones, and poetry is broadcast as a matter of course over Salvadoran radio.

Honduras's best-known poet, Roberto Sosa, who has chosen to remain in his native Tegucigalpa, describes his country as "that enormous cultural pothole in Central America." For an artist, he says, "there is no road left but to be in favor of the oligarchies or against them." It is, in fact, impossible to talk about art in Central America without acknowledging the class struggle underlying every aspect of life there, though varying from country to country. Artists still working in San Salvador, for instance, may enjoy the same illusion of making "neutral art" as do those in New York City, yet the fact that they are allowed to make art at all places them high on the social scale and far to the right on the political spectrum. Sosa calls artists in favor of the dictatorships "ideological bodyguards," and poets who write speeches "Walt Disneys, because they make animals talk."

At the other end of the ladder are the Indians, whose art—so admired by North Americans, who have destroyed their own native cultures—has been systematically repressed. The current Guatemalan slaughter was preceded by the Salvadoran *matanza*, the 1932 massacre of some 30,000 peasants, which marked the end of the Indians' free practice of their customs, arts and Nahuatl language.

The loss for non-Indians was less direct but nonetheless devastating. When native cultures disappear, the bourgeoisie too loses its roots— roots many artists have not yet even discovered.

The Central American art we tend to find most attractive is what's left from the indigenous cultures—the little "primitive" paintings sold in the streets and markets, for instance. Educated Central American artists have looked to Mexico, Spain and France for models, and the dominant painting styles parallel the brutal fantasies of Latin American literature. There is a neo-Surrealist darkness, a shadowy, skeptical quality at odds with the Anglo fondness for clarity and sentiment.

Most interesting art in Latin America is more or less politicized (read left-wing), a fact viewed askance by most gringos. Explains the exiled Salvadoran poet Claribel Algería: "In Latin America, politics is always black or white. You are on the side of the oppressed and dispossessed or you are on the side of the oligarchs, the multinational corporations." In the United States, she continues, "politics is basically so dull. You have two major parties, both of them bourgeois and big-business oriented. In other words, a lighter shade of gray to choose from." That may account for the incomprehension with which the smoldering reds and browns and blacks of Latin American art are greeted in SoHo.

Nicaragua, where a burgeoning renaissance of popular culture is being nipped in the bud by threatened invasion, is the exception. Although the Ministry of Culture and the independent Sandinista Association of Cultural Workers have exhibition spaces, there is a shortage of paper for posters and paint for murals. Nevertheless, Managua offers a striking contrast to the other Central American capitals, in which art has retreated to fortified backwaters. Infant Sandinista "tradition" insists that the country incorporate culture into all aspects of social life, including war. Artists' brigades at the front help protect and bring in the harvest as well as make a pictorial record of the *campesinos* and soldiers with whom they work.

For better or worse, Nicaraguan artists are being deprived of separation from daily experience; they are forced to "stay in touch," to make objects whose purpose is to communicate as well as to decorate, to reinforce communality as well as individuality. Yet most of their art is not identifiable as "political" because its consciousness is embedded in forms and conventions that are just beginning to change.

In the meantime, other Central American artists are condemned to die at home of stagnation or repression, or to work abroad, deprived of their roots, of moral and economic support, of contact

with compatriots and sympathetic audiences. Living with fear for those still at home, these exiles are not only victims of psychological pressures and censored emotions but are often torn between shame for the provincialism of their virtually unheard-of countries, pride in the struggles for change taking place there and guilt for not being part of them. The exiled artist's world view tends to be alienated and passive at worst, alienated and passionately active at best.

To help sustain exiled Salvadoran artists, the Institute for the Arts and Letters of El Salvador in Exile (INALSE) was formed in New York in 1982. Director Daniel Flores y Ascencio acknowledges that the 60 percent illiteracy rate, lack of schools, shutdown of the national university and extermination of intellectual opposition have aborted cultural development and have "veiled the real face of El Salvador not only from the world but from its own people."

Working from the exile's double need to maintain the national heritage and to gain support from the artists' community here, INALSE helped initiate Artists Call Against U.S. Intervention in Central America, which has become a gigantic campaign launched this month in some thirty New York galleries, in twenty-one magazines and in twenty-three cities across the United States and Canada. It includes theme and benefit exhibitions of work from, about and for Central America; video, film and performance art festivals; musical and theatrical events. Artists Call was conceived as "an esthetic and political strategy" to raise consciousness not only about political and cultural issues but specifically about the role of art and the importance of international solidarity among artists. Splendidly announced by Claes Oldenburg's poster (a banana monument being toppled) and Peter Gourfain's button (resistant artists brandishing brushes), Artists Call challenges the Reagan Administration's uses and abuses of the "freedom of expression" it denies the artists of Central America, who are viciously suppressed precisely because they are the ones who can show and tell others what is really happening.

Arthur Danto was already regarded as one of America's preeminent analytic philosophers when he agreed to become The Nation's *art critic in 1984. His writings on art soon became as respected as his philosophical writings. He is currently Johnsonian Professor of Philosophy, Emeritus, at Columbia University, and the recipient of the Frank Jewett Mather Prize—named after the early* Nation *critic— which is awarded for excellence in art criticism. A collection of critical essays about him,* The Philosophy of Arthur Danto, *will be published as part of the Library of Living Philosophers series.*

—

DE KOONING'S THREE-SEATER

MARCH 9, 1985

Arthur C. Danto

CHARLES VANDERVEER 3D, the legendary auctioneer of the South Fork of Long Island, is a resourceful and in many ways an idealistic man. Given his relentless curiosity about the archeology of his region, it was inevitable that odds and ends from the kitchen middens of the Abstract Expressionist tribe, which settled in the area in the late 1940s, should turn up as collectibles in one or another of his auctions. Recently, however, he has acquired an object that puts enough pressure on the borderline between art works and curiosities to raise a question about the firmness of that borderline. Since the object is "by" Willem de Kooning, it seems somewhat urgent that the matter be resolved.

The philosophical question of separating art from everything else is given a certain comic turn in the present instance since the object at issue is a three-hole toilet seat from the period before Abstract Expressionists were in command of sufficient resources to afford running water. De Kooning did not so much paint the seat, in the way that a handyman might, as put paint on it, in a way that raises issues of connoisseurship. Yeats assures us through Crazy Jane that love has pitched his mansion in the place of excrement. If love has such a locus, why not art?

The question posed in the headline of *The New York Times* article that reported this find—"But Is it Art?"—has been raised at every stage of modern art since Impressionism, and doubtless it is made inevitable by the fact that the concept of art allows for revolution from within. Still, certain objects very like this one have made it

across the border into museum space, and it was to be expected that someone would instantly draw an analogy between the de Kooning three-seater and one of the most controverted objects in the history of art, that urinal Duchamp titled "Fountain." "Fountain" was signed with the pseudonym R. Mutt and dated 1917, and was rejected by the hanging committee in the jury-free Independents Exhibition of that year, though it is unclear whether the grounds were that it was bad art or just not art at all. Certainly it has been enfranchised as art since, and though the "original" has been lost—it exists only in a photograph by Alfred Stieglitz—it may even today be kicking around someone's barn. Were Charles Vanderveer 3d to stumble upon it, he need have few worries about his children's tuition payments or, for that matter, his old age. Esthetically, however, the urinal's loss is not as important as it might seem, since the relationship between the work and the object is tenuous. Duchamp's work dates from 1917, but who knows when the urinal was made or by whom? De Kooning put paint on the privy seat in 1954, but the seat must have preceded the work—if it is a work—by a good many years. It was crafted by an itinerant carpenter, perhaps, a contemporary of Walt Whitman for all anyone knows.

Not far from the site of the seat stands the structure where, in the first warm days of 1947, Jackson Pollock, in de Kooning's own words, "broke the ice." This was one of the epochal gestures of modern art: flinging skeins of house paint across canvas placed on the floor. Like Duchamp's work, Pollock's was vindicated not only as art but as great art, but in 1947 Pollock himself was far from sure of its status. Barbara Rose cites a very moving memory of Lee Krasner's: "You know, Jackson used to grab me by the arm, shaking, and ask 'Is this a painting?' Not a good or bad painting—just was it a painting at all." By 1954 that question had been massively resolved, though problems might have been created if Pollock's drop-cloths resembled his paintings drip for drip, or if he had flung paint at a field mouse because of his well-known irascibility. Pollock's style spread to the outer bounds of artistic consciousness with the speed of light, and even in nursery schools, children were soon flinging paint "to express themselves."

In painting the toilet seat, de Kooning used what *The Times* speaks of as "angry blobs of black paint reminiscent of the style used by Jackson Pollock, who frequently visited the de Koonings." It is plain that an art-historical reference and an in-joke is being transacted across the punctuated boards: de Kooning put the paint on in just a few minutes, according to Elaine de Kooning, who "authenticated" the object, for the further gaiety of a croquet party. Art-historical

allusions on toilet seats by master painters must be exceedingly rare, so we are dealing with something beyond mere artifact. But, as the question goes, Is it art? And if it isn't, where is the line to be drawn between it and "Fountain," or any of those Pollockian arabesques?

Let me complicate the matter with an example that has some claim to kinship with "Fountain" and with the de Kooning privy. In my student days in Paris, I used to enjoy philosophical conversation with Alberto Giacometti, whose studio I got to know quite well. One part of it I remember vividly: Giacometti's water closet was outside, in the courtyard. It was of an old-fashioned sort known as a *vespasienne*, two foot-rests on either side of a hole. It was a lonely place, it now occurs to me, in comparison with the convivial three-holer of Long Island. In any case, Alberto used to draw while squatting, and the closet was covered with sketches as precious and precise as those in the caves at Altamira. At the time I wondered whether, in the event of Giacometti's death, it should be transported intact to the Musée d'Art Moderne. I was in New York when he died and I have no idea what happened to it, but even if I had been in Montparnasse, I doubt my first or even last thought would have been to ask what was to become of the water closet. Yet I am certain that the walls did bear works of art—if Giacometti drawings are works of art at all. They were products of a restless artistic consciousness coping with the inconveniences of the body. Their being there, in that private space, is perhaps an unintended comment on Yeats's beautiful line. Needless to say, were drawings done by Michelangelo under similar circumstances, there would be little question of their status.

The first thing to note, it seems to me, is that "But is it art?" cannot be asked of isolated objects. There is an implicit generalization in the question, which asks: is a thing of this *kind* a work of art? "Fountain," for example, was one of a class of ready-mades, commonplace objects transfigured into works of art through the acceptance of a theory. There would be questions about the scope and limitations of the theory, as well as questions about whether a given ready-made was good in its kind or bad, but the question of art had to be settled for the entire class. One may ask, What of the first ready-made? Well, even though there was only the single instance, the question of its kind was already settled, and the kind had a natural location in what Duchamp had already achieved as an artist. Also, "Fountain" made it possible for him to go on to the next kind of thing. Artistic kinds are like species, where the possibility of generation is a serious criterion. Much the same thing may be said of Pollock's paintings. They were enfranchised by a theory which

evolved as the works evolved, and they fit in Pollock's corpus with what preceded them and what came next. As for Giacometti's water-closet drawings, there is no problem at all: they were examples of his mature style, placed on an unusual surface.

None of this applies to de Kooning's three-seater. The mock Pollockian marbling is isolated from everything that went before and came after; it has no place in the de Kooning corpus. Objects similar to it were to become accepted in the next generation of artists. Rauschenberg could easily have made a combine out of a paint-streaked privy stool. There are well-known works of his with which this could have fitted: bedclothes, for example, streaked and smeared with house paint and hung on the wall. Critics and curators adore the language of anticipation, but it would be as inane as the principle that generates major exhibitions at the Museum of Modern Art to say that de Kooning was ahead of his time, that his privy anticipated the kind of works that were to supersede Abstract Expressionism, or that there was an affinity between Vanderveer's acquisition and—excuse me—a Johns. Perhaps de Kooning could have evolved in this direction, but he did not, and there is no space in his corpus for an object of 1954 like this. The great art historian Heinrich Wolfflin said, "Not everything is possible at every time." I incline to the view that Johns and Rauschenberg were not possible in 1954, and it would not be possible for this to have been a de Kooning at any time. The corpus is closed.

So here is my thought: this particular object can be a work of art only if it is a de Kooning, and there is no way it can be that; so it's not a work of art. Neither, in compensation, is a sheet of drawings done for an illiterate servant by Michelangelo, illustrating what he wanted for a meal: two rolls, some fish, etc. Nobody is going to throw that illuminated menu away, as there are more reasons for keeping things than that they are works of art. And this, I dare say, will be the case with the three-seater. It has some archeological interest as a reminder of *la vie de bohème* led by artists near Amagansett before they all became famous. Not even de Kooning has the Midas touch, turning everything his brush comes in contact with into the gold of art. It is not just that the intention is lacking here; the requisite intention could not have been formed, because of historical circumstance. Of course I am not saying what it is worth. I imagine it will go for a pretty price, just because collectors will be afraid not to purchase it.

The installation of Richard Serra's controversial steel sculpture Tilted Arc *in a public plaza in New York City inspired these reflections on the role of public art in society.*

—

"TILTED ARC"

JUNE 22, 1985

Arthur C. Danto

RICHARD SERRA'S "TILTED Arc" is a rusted slope of curved steel, 12 feet high and 112 feet long. It sticks up out of Federal Plaza in lower Manhattan like a sullen blade, and its presence there has divided the art world into philistines like myself, who think it should be removed, and esthetes, who want it to remain forever. The controversy is not over taste, since many philistines, myself included, admire it as sculpture, but over the relevance of the hostility it has aroused on the part of office workers, whose use of the plaza it severely curtails.

Esthetes insist that it does not impede but in fact metaphorically represents the human flow to and from the banal edifice it mercifully occludes. Philistines insist that artistic merit notwithstanding, the piece is in arrogant disregard of those most directly affected by its presence; to them it is an obstacle and an eyesore. Serra says that the workers "can learn something about a sculptural orientation to space and place." Philistines agree, but ask whether lessons in art appreciation ought to pre-empt other uses to which space and place might be put. Philistines have no illusions that the plaza will be restored to beauty now that, like Excalibur, the blade is to be removed. But they feel the issues involved to be only marginally esthetic. It is the great if unsought achievement of "Tilted Arc" to have made vivid the truth that something may succeed as a work of art but fail as a work of *public* art.

Up to now it has been assumed that the criteria for good public art are simply the criteria for good art. All a government agency charged with commissioning public art must do is commission good art for public spaces. "Tilted Arc" meets, and perhaps surpasses, current standards for good sculpture, and since it is exquisitely placed in relation to its formal environment, it does all one could ask according to what have seemed the only relevant indexes. The furor that has resulted from its placement suggests, however, that

we must build something more into our conception of good public art. What we urgently need is a criterion for public art that justifies a work's removal if it does not meet it. It is possible that a work might be good public art though bad or indifferent as art, which would then make esthetic criteria irrelevant to the matter. The possibility of irrelevance was missed in the hearings devoted to "Tilted Arc," whose supporters supposed it sufficient to praise it as art. I want to sketch what such a criterion might look like.

First, works of art, and certainly works of public art, do not exist in interest-free environments. There is a public interest in good art, but that is not the only public interest art serves. There is ground for removing a piece of public art when its placement represents interests that the work subverts, even if the work itself is good. Let us consider some cases where these other interests can be served only if the work is good as art, so that bad art would in fact subvert them.

Although not quite public art in the full sense, corporate art is a helpful example. Consider the familiar abstract emblems set against the characteristically inhumane facades of corporate headquarters, there to assure the passer-by that whatever its reputation, the corporation is committed to higher values. The high price of good art serves as a metaphor for the high value art is supposed to connote, and success in projecting its message depends on the wide recognition that the work is of very high value indeed. It would be a genuine embarrassment to the corporation were the work found wanting as art. (Think of the embarrassment to the corporate sponsor when a major exhibition it underwrites proves curatorially defective, as did the very bad Primitivism show at the Museum of Modern Art.) This explains the preference for internationally acknowledged artists: Moore, Calder, Nevelson, Noguchi. Even a bad Picasso is a good symbol of corporate high-mindedness, but in general it is plain that a choice of bad art would subvert the purpose of having art there in the first place.

The philosopher J.L. Austin identified as "perlocutionary" a class of speech acts that do more than convey information. If someone confides that his nanny loved him, he is not just conveying the simple information the sentence contains; he is letting you know that his was a privileged childhood, with parents prosperous enough to afford a nursemaid and pretentious enough to call her a nanny. The corporate artwork is perlocutionary in this sense, proclaiming something about its sponsor beyond whatever the work itself may proclaim.

Federally funded artworks are similarly perlocutionary, and their

message is much the same as that of the corporate ones: despite unpopular wars and policies, a government of, by and for the people is committed to the highest things permitted by the separation of church and state. But unlike a corporation, the government cannot look as though it spends our money extravagantly, so public artists must not be too widely recognized. This may account for the innoc-uousness of much federally funded art and for the practice among better-known commissioned artists, like Serra, to state plainly that they did not make a dime off their project. The last thing the Fed-eral Program of Esthetic Perlocution required was a work like "Tilted Arc," which transmits the message that the government puts the value of high art above the rights and interests of those who find its presence offensive. And here the very goodness of the work conflicts with the message of benignancy the government seeks to convey by funding art to begin with. The contradiction can be re-solved only by removing the work, thereby perlocutionarily convey-ing the crucial message that the will of the public matters and that ours is a responsive government.

Consider the case of Christo, who *does* make a dime and does not cost the public a nickel. Christo's works are wholly self-financed, but he uses the political process in a way that facilitates the final accep-tance of his work: the public to be affected by the work participates in its realization. Although Christo is widely admired in the art world, the art world is not his primary constituency, as it has been for "Tilted Arc." The art world too has its interests, particularly in asserting its authority to determine which works are good art. That authority was never questioned in the public hearings about Serra's sculpture. All that was questioned was its authority to determine whether something is good public art without consulting the public. That what is good for the art world is good for the public is true only on the most paternalistic assumptions.

What, then, should be the criterion for good public art? I find Henry James instructive here, as in most of the cruxes of life. There is a passage in *The American Scene* where he records his surprised admiration for Grant's Tomb. "I felt the critical question . . . carried off in the general effect," he wrote. "The aesthetic consideration, the artistic value . . . melted away and became irrelevant." What was relevant, James goes on to say, was the manner in which the taber-nacle of General Grant embodied the values of a democratic society. He contrasts the monument with the tomb of Napoleon in Paris which, "as compared to the small pavilion on the Riverside bluff, is a holy of holies, a great temple jealousy guarded and formally ap-proached." His point is that these two structures project the deepest

public values of the societies that built them. If esthetic values were a society's deepest values, then "the aesthetic consideration" would not melt into irrelevance unless a work failed artistically. In these two monuments, the two societies embody themselves.

I think something like this has been achieved in Maya Lin's great memorial to the American dead in the Vietnam War. And other examples are easily found. Not far from Grant's Tomb is the "Alma Mater," in the plaza of Columbia University. Its status as public art by this difficult criterion was confirmed in the early 1970s, when students attempted to blow it up. The students were not vandals but revolutionaries, symbolically attacking the public whose values "Alma Mater" embodies, regardless of the statue's value as mere art. Courbet's demolition of the Vendôme column was a parallel acknowledgment, almost conferring value by the violence of erasure.

Public art is the public transfigured: it is us, in the medium of artistic transformation. "The experience of art," Serra argued in his testimony, "is in itself a social function." So it is. But the social is not the public, any more than the individual is the private. Private and public are dimensions of the political. So when Serra's attorney spoke of the "imposition of political considerations into Federal programs related to all of the arts," he was making a mistake of category. The public is already the political. What Serra has insisted is that the esthetic override the political, which it cannot do when the art is public.

This being his position, he ought not to object to having his work treated esthetically. A trustee of the Storm King Sculpture Center in Rockland County, New York—one of the artistic glories of our region—showed me the area in which "Tilted Arc" might stand were Serra to allow its transfer there. In a meadow, with a mountain as background, it could expand in a hospitable space. Its rusting escarpment would contrast handsomely with the green grass, with fallen snow, and would complement the brown and red harmonies of autumn leaves. Going to admire it at Storm King would be a social act. The public has an interest in the existence of museums, but it also has an interest in not having all of its open spaces treated as though they were museums, in which esthetic interests rightly dominate. The delicate architectural siting of "Tilted Arc" in Federal Plaza ignores the human realities of the place. Were he not blind to everything but the esthetic, Serra could learn something about human orientation to space and place. Standing where it does, "Tilted Arc" is the metal grin of the art world having bitten off a piece of the public world, which it means to hold in its teeth forever, the public be damned. Now that its removal is assured, a memorial

scar might be considered—a marker, redeeming the cruel blankness of Federal Plaza, the place where in furious battle the public reclaimed its esthetic rights.

One hundred and twenty years after The Nation *contemplated appropriate memorials for the Civil War (see "Something about Monuments," p. 10), another cataclysmic war was officially commemorated.*

—

THE VIETNAM VETERANS MEMORIAL

AUGUST 31, 1985

Arthur C. Danto

WE ERECT MONUMENTS so that we shall always remember, and build memorials so that we shall never forget. Thus we have the Washington Monument but the Lincoln Memorial. Monuments commemorate the memorable and embody the myths of beginnings. Memorials ritualize remembrance and mark the reality of ends. The Washington Monument, vertical, is a celebration, like fireworks. The Lincoln Memorial, even if on a rise presses down and is a meditation in stone. Very few nations erect monuments to their defeats, but many set up memorials to the defeated dead. Monuments make heroes and triumphs, victories and conquests, perpetually present and part of life. The memorial is a special precinct, extruded from life, segregated enclave where we honor the dead. With monuments we honor ourselves.

Memorials are often just lists of those killed. Herodotus describes a megalith that carried the names of all 300 Spartans slain at Thermopylae in a defeat so stunning as to elevate their leader, Leonidas, to what Ivan Morris once called the nobility of failure. Lists figure prominently in the hundreds of Civil War memorials, where the names of fallen townsmen bear the iconographic significance that those who were lost meant more than what had been won. The paradox of the Vietnam Veterans Memorial in Washington is that the men and women killed and missing would not have been memorialized had we won the war and erected a monument instead. Among the specifications for the memorial's commission was the stipulation that it show the names of all the U.S. dead and missing (the battle-stone of Thermopylae only memorialized the Spartans,

not their Theoan or Thespian allies) and that it make no political
statement about the war. But just being called a memorial is as el-
oquent as not being called a monument: not being forgotten is the
thin compensation for not having participated in an event everyone
wants to remember. The list of names, as a collective cenotaph, sit-
uates the memorialized war in the consciousness of the nation.

The Washington Monument is an obelisk, a monumental form
with connotations of the trophy in Western art. Augustus carried
obelisks to Alexandria, whence they were in time borne off to Lon-
don and New York; Constantine brought one to Rome, where it was
appropriated by Pope Sixtus V for San Giovanni in Laterano; Na-
poleon was obliged to cart an obelisk to Paris. The Lincoln Memo-
rial is in the form of a classical temple, in which Lincoln is
enthroned like a brooding god. It is a metaphor for sacrifice and a
confession of the limits of human power. The Veterans Memorial
carries no explicit art-historical references, though it consists of two
symmetrical walls, mirror images of one another, right triangles
sharing a common vertical base, which point, like a pair of long
wings, east, to the obelisk of triumph, and west, to the temple of
submission. Everything about it is part of a text. Even the determi-
nation to say nothing political is inscribed by the absence of a po-
litical statement. A third stipulation for the memorial was that it
harmonize with its surroundings, It does more: it integrates the two
structures it points to into a moral landscape. Because the two wings
form an angle, the Veterans Memorial together with the Washington
Monument and the Lincoln Memorial compose a large triangle,
with the long reflecting pool as a segment of the base.

The memorial was dedicated on November 13, 1982—Veterans
Day—when there were only the walls and the names, each wall com-
posed of seventy granite panels, with about 58,000 names and room
for several hundred more. Two years later a bronze statue of three
servicemen, done in an exacting realism, was added to the site. Their
backs are to the axis that connects the Monument and the Memo-
rial, as though they are oblivious to the historical meanings to which
the walls return us by pointing. Like innocents who look at the
pointer rather than that to which it points, they see only rows and
columns of names. They are dazed and stunned. The walls reflect
their obsessed gaze, as they reflect the flag to which the servicemen's
back is also turned, as they reflect the Monument and the Memorial.
The gently flexed pair of walls, polished black, is like the back of
Plato's cave, a reflecting surface, a dark mirror. The reflections in
it of the servicemen, the flag, the Monument and the Memorial are
appearances of appearances. It also reflects us, the visitors, as it does

the trees. Still, the living are in it only as appearances. Only the names of the dead, on the surface, are real.

The reflecting walls constituted the Veterans Memorial at the time of its dedication, but before they were in place a concession was made to a faction that demanded figurative realism instead of what it perceived as an abstract monument to the liberal establishment. Thus the bronze servicemen. Those walls could have stood on their own, artistically, but the bronze group could not have. As a piece of free-standing sculpture it is intrinsically banal. Its three figures belong to obligatorily distinct racial types: a black and someone vaguely ethnic—a Jew, perhaps, or some Mediterranean type—stand on either side of a Nordic figure. The central figure has a holstered pistol, but the end figures carry more powerful weapons—though not held in a position for use—and there are no empty spaces in the cartridge belts: fighting is suspended. The garb and gear of this war are precisely documented: visitors will learn how many eyelets were in G.I. boots and that soldiers carried two canteens. More realistic than the military figures that guard the honor rolls in Civil War memorials, they look too much like specimens for a military museum, at least when considered alone. But they are greatly enhanced by their relationship to the great walls. In a way, the harmonization of their presence in the triangle generated by the walls is a monument to the triumph of political compromise rather than a memorial to artistic strife. The dead are remembered in their gaze, even when there are no living to look.

The walls are the design of Maya Ying Lin, who won a competition against 1,421 contestants when she was 21 and a student at Yale University. An Asian-American from Athens, Ohio, she was a child at the time of the memorialized conflict, too young to remember the tumult and the protest, which for her are simply history, like the War of Independence or the Civil War. The bronze group was done by Frederick Hart, a Washington sculptor, who was, ironically, a demonstrator against the Vietnam War. The irony is that artistic realism was associated with patriotism and endorsement of the war in the minds of those who insisted on figuration. They regarded the walls as a symbol for peaceniks. "A wailing wall for liberals"; "a tribute to Jane Fonda"; "a degrading ditch"; "the most insulting and demeaning memorial to our experience that was possible": these were among the nasty things said. The walls are nonfigurative, of course, but they are deeply representational, given the textual nature of memorial art (of all art, when it comes to that), and the question of the meaning of Lin's text was acknowledged by those who rejected what they took to be its supposed representation of

reality. Its being black, for example, was loudly read as a sign of shame until a black general brought an abrupt end to that effort to pre-empt the language of color.

The winning design was the unanimous choice of a panel of eight experts, and it was accepted by the group that pushed the idea of a memorial as an expression of the feelings they wanted to have objectified. It gave a form to those feelings, as public art is supposed to do: the issues are never solely esthetic. It was accepted by 150,000 participants at the dedication. No one has defaced it, no one has tried to blow it up, though there was a threat of this once. It has been accepted by the nation at large, which did not even know it wanted such a memorial. It is now one of the sites most visited in the capital. Still, it was wholly appropriate that the design should have been put in question when a schism opened up, that intense emotion and antagonism should have raged, that terrible and foolish things should have been said by everyone. Lin mounted the same high horse favored by artists whose work is publicly criticized and accused the critics of sexism. Even so, her design held. It was not replaced by a monument, as though the tacit rules that govern the distinction between monuments and memorials finally prevailed. Those who wanted realism finally got their mannequins, not exactly where they wanted them, with the walls to their back and a proud flag flying at the vee, but off to one side, up a gentle slope, and at a certain distance, with the flag still farther away. By a miracle of placement, Hart's shallow work has acquired a dignity and even a certain power. The complex of walls and figures reminded me of a memorial sculpture of Canova, in which a single figure sits in white silence outside a pyramidal sepulcher. A dimension is even added to the triangular walls, wonderful as they are. The entire complex is an emblem of the participation of the public in the framing of public art. It did not, to paraphrase Richard Serra, cost the government a dime. More than 275,000 Americans responded to the call for funds with contributions in small denominations—those bearing the faces of Washington and Lincoln.

Lin's instructor told her that the angle where the walls meet had to mean something, and I asked myself, when I pilgrimed down one hot Tuesday in July, what its meaning was. A writer in the "Talk of the Town" section of *The New Yorker* described it as "a long open hinge, its leaves cut vertically into the ground, which descends very gradually toward the vertex." The hinge is a powerful symbol—we speak of "the hinge of fate"—and it has the mysterious property of opening and closing at once. Still, that is something of a misdescription. A hinge 140 feet long sounds too much like Claes Olden-

burg, who might, consistent with his *oeuvre*, have submitted the Vietnam Veterans Memorial Hinge had he entered the competition. The *New Yorker* writer does better on a nearer approach: "a little like facing a huge open book with black pages." The book lies open now that the episode is closed and all or nearly all the dead are known. A book of the dead. And that would fit with their being listed in chronological order, from the first one killed in 1959 to the last one killed in 1975, when the remaining Americans were evacuated from Saigon as the Republic of Vietnam surrendered, on April 30.

This brings me to my chief criticism of Lin's work, which concerns an incongruity between narrative and form. An effort has been made to make the slight angle meaningful by having the narrative begin and end there: RICHARD VANDE GEER is at the bottom right of the west panel and DALE R. BUIS is at the top left of the east panel on either side of the joint. As though a circle were closed, and after the end is the beginning. But a circle has the wrong moral geometry for a linear conflict: the end of a war does not mean, one hopes, the beginning of a war. As it stands now, we read from the middle to the end, then return to the other end and read again our way to the middle. This means that the terminal panels, architecturally the most important, carry one name each, but the end points of the walls are not the end points of the list. If the first were first, we would read through to the last, from left to right. The panels grow larger, which is to say the space in which the walls are set grows deeper, as we approach the center. So there are more names on the central panels than on the rest. But that exactly reflects the shape of the war itself, our involvement being greatest in the late 1960s. So the angle could represent a high point and a turning point. And you would leave with the Monument before you, as you entered with the Memorial behind you, and the whole complex would acquire the direction of time and, perhaps, hope.

You can read a chronicle of the making of this singular work in *To Heal a Nation*, by Jan C. Scruggs and Joel L. Swerdlow (Harper & Row). The memorial would not exist without Scruggs, a veteran of that terrible war and a man of great vision. I like to think that the voice of the book, optimistic, enthusiastic, conciliatory, is his, whoever did the writing. It also contains some photographs, but there is really no way to imagine the memorial from them, or from any pictures I have seen. For that you must make a visit. If you know someone who was killed, an attendant from the National Parks Service will help you locate his or her name. They are all listed alphabetically in directories near the site.

Be prepared to weep. Tears are the universal experience even if

you don't know any of the dead. I watched reverent little groups count down the rows of a panel and then across to the name they sought. Some place a poignant, hopeless offering underneath: a birthday card, a flag, a ribbon, a flower. Some leave little notes. Most photograph the name, but many take rubbings of it on pamphlets handed out by the Parks Service. You can borrow a ladder to reach the top names. The highest panels are about ten feet high—or, more accurately, their bottom edges are about ten feet below ground level. Someday, I suppose, visiting it will be like standing before a memorial from the Civil War, where the bearers of the names really have been forgotten and, since the theory is that the meaning of a name is its denotation, the names themselves will have lost their meaning. They will merely remain powerful as names, and there will only be the idea of death to be moved by. Now, however, we are all moved by the reality of death, or moved by the fact that many who stand beside us are moved by its reality. I copied down two of the names of which rubbings were made:

EDWARD H. FOX
WILBUR J. MILLER

The controversy over the photographs of Robert Mapplethorpe were at the center of the debate on art censorship in the 1980s, and was one of the first shots in the so-called culture wars that threatened not just funding of the arts, but free expression as well. At the time of this review, Mapplethorpe was dying of AIDS.

—

ROBERT MAPPLETHORPE

SEPTEMBER 26, 1988

Arthur C. Danto

"FIFTEEN YEARS' WORTH of Robert Mapplethrope's prints are represented in a show of nudes, portraits, and still lifes," is how the Whitney Museum's show (through October 23 in New York City) of this dark and swanky photographer is identified in the bright idiom of *The New Yorker*'s "Goings on About Town." How nice! someone in Tarrytown or Katonah might think, having seen this artist's elegant digs written up in *House & Garden*: Let's make a day of it—shop Madison, have lunch somewhere and then see the nudes, portraits

and still lifes. Just the thing! And sure enough, the first of three photographs to one's right just before entering the show is a portrait of the late Louise Nevelson. And right next to that is a nude and a portrait at once, since its title is "Carleton." Carleton is shown from behind, his head bent away from us into the Caravaggian black of the background, thrusting his buttocks forward, which are then pulled slightly apart by his legs, which hang on either side of the table on which he is posed, leaving a triangle at their parting as the focus of the print, as black as the abstract blackness of the background. And next to this is something we soon make out to be a male nipple, a vortex in a network of pores and follicles, skin as it would have been seen by the microscopic eyes of Gulliver on the Brobdingnagian ladies who liked to dandle him. Seen close up, this erotically charged locus of human skin contrasts with the beauty of that which stretches, smoothly and warmly, over the marvelous muscles of the male nude, placed between the dead artists and the leathery button of flesh. Is "Nipple" to be classed as a nude? Or a still life? Or a synecdochical portrait of sorts (you will encounter a double image, two stages of a cock and balls, a portrait by the same criterion as "Carleton" since titled "Richard"). The question of genre will haunt the visitor as he or she works through the exhibition, since the still lifes more and more seem metaphors for displayed sexual parts, which are often the main attribute of nude and seminude portraits. But that question will soon be stifled by others more haunting still.

The three prefatory photographs are high-style, high-glamour studies, reminiscent of an Art Deco sensibility, embodying an aesthetic that Mapplethorpe attained early and steadily maintained. Some of the portraits look as though they belong in the stateroom of a suave ocean liner, in a mirrored frame, beside the chromium cocktail shaker and an artful arrangement of stark flowers of just the sort shown in Mapplethorpe's still lifes. They are elegant, luxurious, sophisticated, impeccable. But they are far more than that. The linking of death and art in the famous sepulchral head of the aged sculptor, the delibidinization of the erogenous in the magnified and distanced nipple, are held together, in one of the great moral syllogisms of our age, through the perfect male nude, viewed from the rear—from its vulnerable side—as middle term. This *memento mari* would not have been there at the beginning of Mapplethorpe's project, in which the high style of the 1930s was appropriated to register a subject matter of the 1970s, when this artist undertook to treat, from the perspective of serious art, the values and practices of the sadomasochistic subculture of homosex-

uals who were into bondage and domination. But it has certainly cast its retrospective shadow over this body of work since 1981, when AIDS was first announced, and the active male homosexual found to be in a population at high risk. A show of Mapplethorpe is always timely because of his rare gifts as an artist. But circumstances have made such a show timely in another dimension of moral reality, and I am grateful the organizers did not stint on the gamy images of the 1970s, for they raise some of the hardest of questions, and comprise Mapplethorpe's most singular achievement.

Consider "Mark Stevens (Mr. 10 ½)" of 1976. Mark Stevens is shown in profile, his powerful body arched over his spectacular penis (Mr. 10½?), which he displays laid out but unengorged along the top of a linen-covered box, on which he also leans his elbow. The picture is wider than it is high, by a ratio of 5 to 4, almost forcing Mark Stevens to bend over, despite which the space is too small to contain him: He is cropped at the shoulder, so we do not see his head, as well as at the knee, and along the back of the leg and the front of the bicep. Little matter: The one anatomical feature that is shown integrally is doubtless where Mark Stevens' identity lay in 1975, and his stomach is held in to give that even greater amplitude. Mark Stevens is wearing a black leather garment, cut away to expose his buttocks and his genitals, something like the tights affected by the sports at Roissy, where "O" underwent her sweetly recounted martyrdoms. And there is a tiny tattoo on his arm, of a devil with a pitchfork and flèched tail, connoting a playful meanness. Formally, we may admire the interesting space bounded by elbow, box surface, belly and chest, a sort of display case in which Mark Stevens' sex is framed as something rare and precious. Cropping, inner and outer space, calculated shadows and controlled backlighting—these belong to the vocabulary of high photographic art, the sort that Weston lavished on peppers in the 1930s, or which Mapplethorpe himself devoted, in 1985, to an eggplant, also laid out on a table, echoing Mark Stevens' recumbent phallus. Still life and nude or seminude portrait interanimate one another, here and throughout the show, and as a photograph, the study of Mark Stevens, quite as the other studies of leather-clad gays, is of an artistic order together different from the images that must have found their way into magazines of that era devoted to pain, humiliation and sexual subjugation, with their advertisements of sadistic gear—whips and chains and shackles, hoods and leather wear (the he-man's equivalent to sexy lingerie) and the pathetic promises of ointments and exercises designed and guaranteed to increase length, diameter and staying power.

Nor are these photographs really in the spirit of documentation, recording a form of life, though in fact and secondly they provide such a record. They are, rather, celebratory of their subjects, acts of artistic will driven by moral beliefs and attitudes. Mapplethorpe is not there like a disinterested, registering eye. He was a participant and a believer. In exactly the same way, Mark Stevens was not a subject but a kind of collaborator: He agreed to display himself, he chose to dress himself in those symbolic vestments, to take and hold that pose. We see him no doubt as he would have wanted to be seen, as Mr. 10½, but as he knew he would be seen by someone he could trust, because the photographer would show their form of life from within. We see him, indeed, from within a homosexual perception, and it is that perception, that vision, that is the true subject of these works. They are not just of gays at a certain moment in gay history, when it all at once seemed possible for this to become the substance of serious art. The images are flooded with a way of seeing the world, given embodiment, made objective, in a suite of stunning photographs.

Analogously to the way in which Mark Stevens' phallus is made focal by the proportions of the photograph, by the cropped figure and the interior space, so, I think, is the phallus as such made focal in the exhibition taken as a whole, and I applaud the curatorial intuition that went into the selection and installation that makes this true. Richard Howard, in an inspired catalogue essay, credits Mapplethorpe with having aestheticized the genitals, drawing attention to the correspondence in form and function between these and flowers, which are "the sexual organs of plants." Howard is doubtless correct, but then, it seems to me, immensity must play an important role in this aestheticizing, and hence in the vision from within which the (male) genitals are perceived as beautiful. And this is disappointingly as reductive and mechanistic an attitude as that which thematizes big breasts in women. In "Man in Polyester Suit" of 1980, the subject, in his three-piecer, again cropped at shoulder and knee, has an open fly through which an elephantine phallus hangs heavily down, shaped like a fat integral sign, a thick S of flesh. In "Thomas," a black male presses like Samson against the sides of a square space that walls him in, and his genitals hang like fruit between his spread legs—like the contextually phallicized bunch of grapes hanging from a string in a picture of 1985. But all the nudes are, as the expression goes, well hung, and one wonders if Mapplethorpe's aestheticizing project would have allowed another choice.

In a famous episode in *A Movable Feast,* F. Scott Fitzgerald expresses concern about the size of his penis, Zelda having said it was

inadequately small; and Hemingway suggests he compare himself with what is to be found on classical statues, saying that most men would be satisfied with that. In my nearly four years as a soldier, I would have noticed it if anyone was equipped like the Man in Polyester Suit, or Mark Stevens for that matter. Robert Burns, in one of his nastier verses, wrote "Nine inches doth please a lady"—but something of that dimension would have been negligible in the baths and washrooms of the 1970s if Mapplethorpe's models are typical. On the other hand, there is a wonderful portrait of Louise Bourgeois, wearing an improbably shaggy coat and grinning knowingly out at the viewer, as if to connect her, us, the artist, and his megaphallolatry in a piece of comedy—for she carries under her arm a sculpture, I dare say hers, of a really huge phallus and balls (Mr. 36½), putting things in perspective. I was grateful to the wise old sculptor for reminding us that the huge phallus was regarded as comical in the ancient world, and there are wonderful images on the sides of Grecian vases of actors wearing falsies to crack them up at Epidaurus. Even so, phallic references define this show (study the relationship between breasts, neck and head in the uncharacteristic portrait of Lisa Lyon, usually seen, as in a book of Mapplethorpe's photographs of her, engaged in body-building).

What is interesting is less the phallocentrism of Mapplethorpe's aesthetic than the politicizing of that aesthetic, preeminently in the images from the late 1970s, to which the portrait of Mark Stevens belongs. That was a period in which gays were coming out of the closet in large numbers, defiantly and even proudly, and were actively campaigning not only to change social attitudes toward themselves but to build their own culture. It seems clear to me that these photographs were political acts, and that they would not have been made as art were it not the intention to enlist art in some more critical transformation. I am insufficiently a historian of that movement, but my hunch is that sadomasochism must have presented some of the same sorts of dilemmas for the gay liberation movement that lesbianism initially did for the women's liberation movement. So this is not, as it were, "The Joy of S&M," but an artistic form of a moral claim on behalf of practices other gays might have found difficult to accept. Even today, it is difficult for his most avid enthusiasts to accept the 1978 self-portrait through which Mapplethorpe declares his solidarity with Mark Stevens; with the scary couple, Brian Ridley and Lyle Heeter, leather boys in their sexual uniforms, Brian seated, shackled, in a wing chair while Lyle stands possessively over his shoulder, wearing his sullen master's cap, holding Brian's chains with one hand and a fierce crop with the other; or with Joe, encased

in leather from crown to sole, creeping along a bench, with some sort of tube whose function I cannot even imagine strapped to his mask. Mapplethorpe shows himself from behind. He is dressed in a sort of jerkin, and in those backless tights worn by Mark Stevens. He is looking over his shoulder at us, his Pan-like head with its small soft beard glowering a sort of defiance. He is holding the handle of a cruel bullwhip up his anus. The visual equation between the phallus and the agency of pain contributes another component to genital aesthetics.

It is possible to appreciate this self-portrait formalistically and draw attention, like a docent, to shadows of graded intensity, for the subtle play of values. In the same way it would be possible to connect Mapplethorpe's own features with the little Pan's head in "Pan Head and Flower"—and the flower itself, its pistil hanging out of the petal, with the penis in "Man in Polyester Suit." Anything that is art can be seen that way. You can pay particular heed to the play of hues and the strong diagonals in Titian's *The Flaying of Marsyas*, which so unsettled us all when it hung in the National Gallery not long ago. But I do not know what sort of person it would be who could look past the blood dripping into a pool from which an indifferent dog laps, or the exposed and quivering flesh, the hanging skin, the absolute agony of the satyr hung by his heels while Apollo carves away, to dwell on niceties of composition. A photograph such as Mapplethorpe's self-portrait cannot have been made or exhibited for our aesthetic delectation alone but rather to engage us morally and aesthetically. It would be known in advance that such an image would challenge, assault, insult, provoke, dismay—with the hope that in some way consciousness would be transformed. Its acceptance as art cannot be the only kind of acceptance in issue. It would have to be a pretty cool cat for whom the triptych "Jim and Tom, Sausalito" of 1978, which shows, in each of its panels, what looks like Jim pissing into Tom's eager mouth, recommends itself as a particularly good example of what gelantine silver prints look like.

A pretty rough show, then, for someone who came to see nudes, portraits and still lifes. It is made rougher still by the inescapable dates on the labels of the stronger images, all of which come from that hopeful, ignorant time when it seemed that all that was involved was a kind of liberation of attitude concerning practices between consenting adults in a society of sexual pluralism. Of course the show has its tenderer moments. There are prints of overwhelming tenderness of Mapplethorpe's great friend, Patti Smith. There is a lovely picture of Brice Marden's little girl. It is possible to be moved

by a self-portrait of 1980, in which Mapplethorpe shows himself in women's makeup, eager and girlish and almost pubescent in the frail flatness of his/her naked upper body. There is a certain amount of avant-garde scrimshaw in the show, experiments with shaped frames, with mats and mirrors; and then finally there are a certain number of just elegant portraits, nudes and still lifes. But the self-portrait as young girl remains in my mind as the emblem of the exhibition, and for the dark reality that has settled upon the world to which it belongs. One cannot but think back to Marcel Duchamp's self-representation in *maquillage*, wearing the sort of wide-brimmed hat Virginia Woolf might have worn with a hatband designed by Vanessa, with ringed fingers and a fur boa. Duchamp even took on a feminine alias, Rrose Sélavy. ("Eros c'est la vie.") Nor can one help but feel saddened that Rrose Sélavy has lost her enduring innocence and changed her name to Rrose Sélamort.

The *Harper's Index* recently juxtaposed the number of deaths due to AIDS with the number due to measles. The former is insignificantly small by comparison with the latter, but numbers have little to do with it, at least not yet. With AIDS a form of life went dead, a way of thought, a form of imagination and hope. Any death is tragic and the death of children especially so, thinking of measles now primarily as a childhood death. The statistics are doubly sad since means for prevention and treatment are available, so the deaths by measles index an economic tragedy as well. But this other death carries away a whole possible world. The afternoon I visited the Mapplethorpe exhibition, I was impressed by my fellow visitors. They were subdued and almost, I felt, stunned. There were no giggles, scarcely any whispers. It was as though everyone felt the moral weight of the issues. And one felt an almost palpable resistance to face the thoughts the show generated, which each visitor had to overcome. It is not an easy experience, but it is a crucial one. Art is more than just art, and the Whitney took on a higher responsibility in supporting this exhibition.

Look at the enigmatic self-portrait of 1986, to your right as you exit the show. It is at right angles to the triad of photographs before which we paused while about to enter the room, and whose meaning is deepened by what we have seen and thought. Here the artist is dressed in a formal way, with wing collar and butterfly bow. With his long sideburns and taut neck muscles, he looks like a tense dandy. His head is turned slightly up and to the left, and the face he shows us wears a serious, questioning look. I expect mine did as well. So, by rights, should yours.

The death of Andy Warhol and the retrospective museum shows that followed inspired one of Danto's most famous essays.

—

ANDY WARHOL

APRIL 3, 1989

Arthur C. Danto

IT IS POSSIBLE—I would argue that it is necessary—to explain the history of art through the past century as a collective investigation by artists into the philosophical nature of art. The significant art of this extraordinary period accordingly has to be assessed as much on grounds of speculative theory as on those of aesthetic discrimination. "Beginning with van Gogh," Picasso said to Françoise Gilot, "however great we may be, we are all, in a measure, autodidacts— you might almost say primitive painters." It was as if each artist was at the beginning of a new era opened up by his own theories. Picasso had supposed that he and Braque had done something more important in Cubism than to have made some works of art: He believed they had created a style of art that would compose a new canon, sparing those who followed them the need to define the essence of art. For a time, neither of them even signed his works—one does not sign a theory—and when Cubism failed to bring back the sense of order, Picasso tried one thing after another, inventing whole art-historical periods that he alone occupied. I recall when Abstract Expressionism was deemed the new paradigm, destined to last for as long at least as the tradition which came to its end in Impressionism. It was the collapse of that faith with the advent of Pop, rather than the irreverence and brashness of Pop Art itself, that disillusioned so many artists in the early 1960s who believed that they knew what art was. Pop violated every component of their theory and somehow remained art. And so the quest went on.

"Art?" Warhol once asked in response to the inevitable question, "Isn't that a man's name?" Well, suppose we think of the century as Art's heroic-comic quest for his own identity, his true self, as it were, and the artworks of the century as Art's discarded theories, which may have had coincidentally some redeeming aesthetic merit. (Art's peradventurous history would resemble that of his second cousin Geist, as comically narrated in Hegel's side-splitting *Bildungsroman, Phänomenologîe des Geistes.*) That would mean that no artist could be

taken seriously who did not, as part of whatever he or she made by way of negotiable works, play a role in Art's stumbling search. So the history of Art proceeds on two levels: as a sequence of objects and as a sequence of enfranchising theories for those objects.

The story has its high and low moments, but it would not be easy to tell, always, from an inspection of the objects alone, without reference to the theories through which they must be interpreted, whether they marked high moments or low. Thus the objects might be pretty unprepossessing and yet specify important stages in Art's coming to philosophical terms with himself. Few aesthetes would be stopped dead in their tracks by certain of Duchamp's blank ready-mades—his grooming comb, his snow shovel—but they are climactic moments in the epic. And few would expect from the crashing tautologies of the 1950s—"Painting is painting, the action of spreading paint"—the opulent glory of the Abstract Expressionist objects they so inadequately characterize. Clement Greenberg's identification of paintings with the flatness of their surfaces went perfectly well with the canonical works his theory championed (and in some cases generated). But except by denouncing as "not really art" everything that failed this austere and reductive definition, Greenberg was unable to characterize anything *except* the canonical work.

Bitter as the truth may be to those who dismissed him as a shallow opportunist and glamour fiend, the greatest contribution to this history was made by Andy Warhol, to my mind the nearest thing to a philosophical genius the history of art has produced. It was Warhol himself who revealed as merely accidental most of the things his predecessors supposed essential to art, and who carried the discussion as far as it could go without passing over into pure philosophy. He brought the history to an end by demonstrating that no visual criterion could serve the purpose of defining art, and hence that Art, confined to visual criteria could not solve his personal problem through art-making alone. Warhol achieved this, I think, with the celebrated Brillo boxes he exhibited a quarter-century ago at Eleanor Ward's Stable Gallery in New York.

A great deal more was achieved through the Brillo boxes than this, to be sure, but what was most striking about them was that they looked sufficiently like their counterparts in supermarket stockrooms that the differences between them could hardly be of a kind to explain why they were art and their counterparts merely cheap containers for scouring pads. It was not necessary to fool anyone. It was altogether easy to tell those boxes turned out by Warhol's Factory from those manufactured by whatever factory it was that turned

out corrugated cardboard cartons. Warhol did not himself make the boxes, nor did he paint them. But when they were displayed, stacked up in the back room of the gallery, two questions were inevitable: What was it in the history of art that made this gesture not only possible at this time but inevitable? And, closely connected with this, Why were *these* boxes art when their originals were just boxes? With these two questions posed, a century of deflected philosophical investigation came to an end, and artists were liberated to enter the post-philosophical phase of modernism free from the obligation of self-scrutiny.

Warhol was, appropriately, the first to set foot in this free moral space. There followed a period of giddy self-indulgence and absolute pluralism in which pretty much anything went. In an interview in 1963, Warhol said, "How can you say one style is better than another? You ought to be able to be an Abstract Expressionist next week, or a Pop artist, or a realist, without feeling you've given up something." Who can fail to believe that, in art at least, the stage had been attained that Marx forecast for history as a whole, in which we can "do one thing today and another tomorrow, to hunt in the morning, fish in the afternoon, rear cattle in the evening, criticize after dinner, just as I have a mind, without ever becoming hunter, fisherman, shepherd or critic." Its social correlate was the Yellow Submarine of Warhol's silver-lined loft, where one could be straight in the morning, gay in the afternoon, a transsexual superstar in the evening and a polymorphic rock singer after taking drugs.

It has at times been urged as an argument against Warhol's extreme originality that Duchamp did it before, inasmuch as there also is little to distinguish one of his ready-mades from the mere object he transfigured by appropriation. But it is the shallowest order of art criticism to say that something has been done before. Two historical moments can resemble each other outwardly while being internally as different as the snow shovel that is a work of art is from one that is a mere tool for clearing sidewalks.

In the early days of Pop, artists were taking over images wherever they found them. Roy Lichtenstein was sued for using a diagram from a famous book on Cézanne. Warhol was sued by the photographer whose image he used and modified in his marvelous flower paintings of 1967. (And I think a suit was threatened by the artist, in fact an Abstract Expressionist, who designed the Brillo carton.) The flower paintings mark a later phase, but in the classic moment of Pop, it was essential to the enterprise that the images be so familiar that "stealing" them was impossible: They belonged to the iconography of everyday life, like the American flag, the dollar sign,

the soup label, the before-and-after shots of transformed faces and physiques. These were wrenched out of their locus in the universal language of signs and given the power of art while retaining their own native power as symbols. Duchamp's objects were often arcane and chosen for their aesthetic blandness. Warhol's were chosen for their absolute familiarity and semiotic potency. It was not merely that Brillo pads were part of every household, as the Campbell's Soup can was part of every kitchen—the one item likely to be found in the barest cupboard, by contrast, say, with a can of artichoke hearts or of pickled quail's eggs—but beyond that, the cardboard container was ubiquitous, disposable and part of Americans' itinerant mode of life. It was the container of choice for shipping and storing books, dishes, clothing, or for bringing kittens home in. It was what everyone threw away.

Duchamp's gestures of 1913–17 were jokes. They were evidence that Art had evolved to a point where Anti-Art was his own doppelgänger. As part of Dada, the ready-made was a kind of thumbed nose at the pretentiousness of art in the scheme of exalted values that just happened to be responsible for World War I. But artistically, really, it was a snigger from the margins. With Warhol, the gesture was mainstream: This was what Art had evolved into by 1964, when his search reached its end. Moreover, it was a celebration rather than a criticism of contemporary life, which is partly why Warhol was so instantly popular. Everyone had been saying how awful contemporary culture was, and here was the most advanced artist of the time saying it was really wonderful—saying, as Warhol in effect did, "Hey, I like it here." Finally, it can be argued that the two moments of Duchamp and Warhol reverse the in-any-case arbitrary Marxian order—a farce the first time around, something deeper and more tragic the second.

There is a contingent of Brillo boxes at the great Warhol retrospective at the Museum of Modern Art in New York City (until May 2), and it was a joy to see them again after so many years. But I could not help but reflect, as I stood for a moment in contemplation (Aristotle is shown contemplating the bust of Homer, but Danto . . .), how different it was to see them as part of an achieved corpus from what it had been to see them in 1964, when they defined the living edge of art history. I have the most vivid recollection of that show, and of the feeling of lightheartedness and delight people evinced as they marveled at the piles of boxes, laughing as they bought a few and carried them out in clear plastic bags. They didn't cost very much, and I believe it was part of Warhol's intention that it should be possible for people to own the art that so perfectly

embodied the life it reflected: I bought one of the flower prints for $5 or $10 from a stack of them at Castelli's. (The opening night crowd at the retrospective evidently felt moved by this intention when they sought to walk away with some of the silver pillows that decorated MoMA's ceiling, to the consternation of the museum guards.)

Fascinated as he was by money, it must have shocked Warhol that his work became so pricey: The thought of a painting of Coca-Cola bottles going for $1.43 million at auction is a real-life cartoon, something that would have aroused some mild amusement had it been drawn for *The New Yorker* twenty years ago. Warhol was fairly tight, as might be expected of a Depression child, but he was not, like Dali, avid for dollars ("Salvador Dali = Avida Dollars" was the famous anagram). Arne Ekstrom once told me that he commissioned some art made with hat forms from a number of artists, and afterward decided to purchase some of the works. One artist, quite famous, wanted $5,000, a lot of money at the time. Warhol said he could have his for 2 cents, which he raised to 3 cents because of the arithmetic involved in paying his dealer a commission. (He cashed the check.)

For many of us, the excitement of the current Warhol show is in part the memory of the excitement of seeing the artist's amazing career unfold from exhibit to exhibit through the 1960s and 1970s. In compensation, seeing it all spread before us, synchronically, as it were, one has available the priceless gift of retrospection, through which we can see where Warhol was heading—invisible, of course, until he got there. I particularly cherish, for example, the fascinating transitional pieces from the early 1960s, such as the Dick Tracy paintings, in which there is a powerful tension between style and subject. There are unmistakable comic-strip personages, down to the word-balloons, but the hard commercial-style drawing wars with the Expressionist paint, as the commonplace imagery wars with the high romanticism of Expressionist art. Everyone is familiar with the story about Warhol showing Emile de Antonio two Coca-Cola bottles, one done in the flat laconic manner of the newspaper graphic, the other in the flamboyant brushy style, and asking which road he should follow when he had already, by presenting that choice, taken the road to Pop. Dick Tracy, like Warhol's Popeye or Nancy or Superman, belongs to that wonderful period of 1957–64, in which Art was putting aside his romantic phase and entering his minimalist-conceptual-philosophical phase. The Dick Tracy paintings belonged to a future no one could know about when they were shown, and experiencing them today is something like walking through one of

those late Romanesque churches, like St. Severin in Paris—that church the Cubists so loved—built at a time when architects were evolving a still-not-well-understood Gothic style.

There is a further compensation. At the opening I had a moment's conversation with a young critic, Deborah Solomon. She expressed the view that Warhol had peaked in the early 1960s, precisely in the Dick Tracy paintings and their peers. I responded that Warhol always peaked, but on reflection it occurred to me that she was privileged in a way I was not, to be able to see Dick Tracy as a painting rather than as a transitional document, and hence aesthetically rather than historically. This show gives us perhaps our first glimpse of Warhol as an artist, and for the first time a perspective on his work is opened up from the standpoint of the future, so that we can see it as we see, for example, the work of the Impressionists or the Sienese masters. The organizers of this exhibition are displaying Warhol as if he had already passed the test of time, as he must have to the sensibility of young people who address his work simply as work.

In truth, I am not certain that I know what it is to view Warhol's creations disinterestedly and from across an aesthetic distance. Nor do I know to what degree an artist so vehemently part of the consciousness of his own time can be detached from that consciousness and held up for critical scrutiny. Lately, art historians have been seeking to restore the Impressionists to their own temporal situation, as if they have so completely stood the test of time that we can no longer see the life to which they were responsive and are blind to the deep human content of their work. The question for me is to what degree it is even possible to see Warhol now in the tenseless light of pure art. And this raises the further question of whether, when there is no longer an audience that shares beforehand the images that compose these works from the 1960s, that is in effect a community *because* it shares those images as part of itself, there really will be much left of the power of the work.

What Warhol had not computed into his fifteen minutes of fame was the curatorial obligation to regard artworks as eternal objects, subject to a timeless delectation. Warhol enjoyed making "time capsules," sweeping up into cardboard cartons the ephemera and detritus of common life. But really, his whole output is a kind of time capsule precisely because of those features that set it apart from the impulses of Dada, especially the celebration of the commonplace. How will all this be perceived when the commonplace is no longer commonplace—when the Brillo people, as they are certain to do, change the design of the packaging? Suppose the old familiar Brillo

cartons get to be collector's items and a market emerges for un-opened cartons with their original scouring pads intact. Or that corrugated paper becomes a camp item in its own right, like bakelite, the technology of packing having moved on to generalized bubble wraps with little stickers to identify content.

Warhol said, "The Pop artist did images that anybody walking down Broadway could recognize in a split second . . . all the great modern things that the Abstract Expressionists tried so hard not to notice at all." But privileging the commonplace depends upon its being ubiquitous, so that only an absolute stranger would not know what, if an image, it is an image of. All Warhol's images in the early works were of this order, and part of the pleasure of his art is in having these utterly banal forms lifted out of the plane of daily intercourse and elevated to the status of art, a kind of revolutionary reversal. The thought of the Brillo box in the art gallery connects with the American ideal of people in high places being still just folks (cf. Barbara Bush). But not only are these images instantly identified: They condense the whole emotional tone of life, of the consciousness in which those who know them participate. A person who has to have Marilyn—or Jackie or Elvis or Liz or Superman—identified is an outsider. Those faces belong with the Campbell's Soup label, the S&H Green Stamps, or Mona Lisa, since everyone knows her. But what happens when there is not this split-second recognition? Was Troy Donahue really the kind of icon Marilyn Monroe was? One panics in front of one of Warhol's iterated portraits of a man nobody knows, thinking one should know him when he was in fact selected for his anonymity. And how many, really, recognize Ethel Scull on sight? I think eventually people competed to be portrayed by Warhol because that appeared to give them an instant immortality, of the sort usually enjoyed only by the greatest of stars or the most celebrated products, as if they were also part of the common consciousness of the time.

The work from the 1980s is less complex from this point of view. It really does become, more or less, just art, connected to the culture only through being done by Warhol, who had by then become as much an icon or superstar as anyone he ever portrayed. When his "Last Supper" was displayed in Milan, in a kind of citywide two-man show with Leonardo, 30,000 people flocked to see it, hardly any of whom went on to see the "other" "Last Supper." Perhaps, then, these late works can be viewed, even now, merely as art. But Warhol's greatest works come from the time when the boundaries between art and life were being exploded, everything was being redrawn and we were all living in history instead of looking backward at what had

been history. The late work escapes me, but here is a prediction: When the final multivolume *Popular History of Art* is published, ours will be the Age of Warhol—an unlikely giant, but a giant nonetheless.

> *The late cultural historian and media critic Herbert Schiller chronicled the increasing influence of corporate sponsorship in the arts in this piece, adapted from his book* Culture Inc.: The Corporate Takeover of Public Expression.

—

PITCHERS AT AN EXHIBITION

JULY 10, 1989

Herbert I. Schiller

FIFTEEN YEARS AGO, the artist Hans Haacke produced an exhibition in New York City called "On Social Grease." The show's six photo-engraved magnesium plates reproduced the statements of six national figures on the utility of the arts to business. Robert Kingsley, an Exxon executive and founder and chair of the Arts and Business Council, gave Haacke his title. "Exxon's support of the arts," announced Kingsley's plate, "serves as a social lubricant. And if business is to continue in big cities, it needs a more lubricated environment."

Today, a walk along Manhattan's museum mile—or through the not-so-hushed halls of major museums elsewhere in the country—is more slippery than ever. Most Americans take for granted that they live in an open society with a free marketplace of ideas, in which a variety of forms of expression and opinion can be heard and flourish. This condition, while not yet entirely transformed, is increasingly unrecognizable. The corporate arm has reached into every corner of daily life, from the shopping mall to the art gallery, from the library to the classroom itself. Like television, advertising and other obvious weapons of America's pervasive corporate culture, museums are also adjuncts of the consciousness industry, a role they play with increasing enthusiasm as the money pours in. Thus, the Chase Manhattan Bank avers that it is committed to "enriching lives not only financially but culturally," and entices the director of the Guggenheim Museum, Thomas Messer, to pose against the Frank Lloyd Wright building for a newspaper advertisement and wisecrack:

"Individual and corporate support has kept us in the black. Not to mention cobalt blue, cadmium yellow and burnt sienna."

Just down Fifth Avenue, at the Metropolitan Museum of Art, an engraved plaque near the entrance offers a long roster of corporate benefactors, among them A.T.&T., Ford, Coca-Cola, Xerox and CBS Inc. An exhibition of Southeast Asian tribal art now on display at the Met is "made possible by Reliance Group Holdings, Inc." Elsewhere in the museum, visitors are prominently advised that the Goya show is sponsored by Manufacturers Hanover and the New York Stock Exchange, institutions not widely noted for their "spirit of enlightenment," the exhibition's subtitle.

The Met, regarded by many as the country's leading museum, also has become a prime party palace for the very rich. Just over a year ago, for example, some 500 guests gathered in its marble precincts to toast the newly married Laura Steinberg, daughter of Saul Steinberg (C.E.O. of Reliance Group Holdings), and Jonathan Tisch, nephew of Laurence Tisch (C.E.O. of CBS Inc.). "Candlelight Wedding Joins 2 Billionaire Families," enthused *The New York Times*, Whose publisher, Arthur Ochs Sulzberger, is chair of the museum's board of trustees.

Tiffany & Company took over the Met in September 1987 to mark its 150th anniversary with an exhibition modestly titled "Triumphs of American Silver-Making: Tiffany & Co. 1860–1900." Later in the year, the firm persuaded another of the nation's major cultural institutions, the American Museum of Natural History, to mount a show called "Tiffany: 150 Years of Gems and Jewelry." In Boston, the Isabella Stewart Gardner Museum had not been used for commercial promotion until 1987, when it leaped into the postmodern corporate age and turned its premises over to the Elizabeth Arden Company, which was introducing a new perfume to local shoppers.

Each week, the art pages of *The New York Times* carry listings of shows in galleries and museums underwritten by the Philip Morris Company. Last year, Canada passed a law expressly forbidding the linking of tobacco brand names to cultural and sporting events. But in the United States, as *The Wall Street Journal* headlined not long ago, "Tobacco Firms, Pariahs to Many People, Still Are Angels to the Arts." In 1987, Philip Morris took out a two-page color spread in *The New York Times Magazine* to promote an exhibition of art in black America, all the while saturating black neighborhoods with cigarette advertising. Charles Simon, a former senior partner of Salomon Brothers and a Whitney Museum of Art trustee, is quoted in *The Journal* as endorsing the company's claim to being "good citizens—not killers."

Much as commercial television responds to its sponsors' pressure for top audience-share ratings by organizing its programming around star-studded, highly promoted, visually dazzling but substantively empty shows, museums now favor blockbuster exhibitions, thus exposing the visiting throngs to the banners and logos of the shows' corporate sponsors. Such exhibits generally are nonprovocative and certainly are unquestioning of the corporate political economy.

"Most corporate sponsors finance exhibitions based on centrist ideals and uncontroversial subject matter," says Brian Wallis, former curator of the New Museum of Contemporary Art and a senior editor of *Art in America*. Thus, the funding of art exhibitions helps to conceal "the conflict between . . . humanitarian pretenses and the neo-imperialist expansion of multinational capitalism today . . . by providing both the museum and the corporation with a tool for enriching individual lives while suppressing real cultural and political differences, for promoting art 'treasures' while masking private corporate interests."

The underwriting of museum exhibitions by big business leads inevitably, as does advertising-supported television, to self-censorship. The result: Public awareness of social reality is continually diminished. As Haacke has observed, shows that could "promote critical awareness [or] present products of consciousness dialectically and in relation to the social world, or question relations of power, have a slim chance of being approved."

Equally damaging, what is generally presented is an alternative, but veiled, ideological message—one that emphasizes the social neutrality of art and its alleged universal essence. This is achieved mainly by mounting exhibits that are assemblages of discrete items, set in ahistorical arrays. The art object is thus abstracted from its social and historical contexts and becomes merely a product in itself—lovely, perhaps, but without meaning or connection. This phenomenon is demonstrated in Debra Silverman's careful scrutiny of two art exhibits on the People's Republic of China, one in a department store (Bloomingdale's) and the other in a museum (the Met).

Appropriately enough, Bloomingdale's, the flagship of affluent consumerism, organized the first of the two exhibits of China's cultural legacy in September 1980. The department store turned its sales floors into display centers of "timeless, aristocratic and rare" Chinese goods, but it was all bogus. Silverman writes: "The dazzling artifacts from the People's Republic were not authentic vessels of ancient mysteries but rather the simulated products of a shrewd business alliance between the Bloomingdale's managers and the

Communist Chinese Government." The "rare" items were made by postrevolution "sweated craft labor."

The Bloomingdale's extravaganza was quickly followed, and *matched*, by an exhibition in December 1980 at the Metropolitan Museum of Art: "The Manchu Dragon: Costumes of China, the Ch'ing Dynasty, 1644–1912." It was organized and installed by Diana Vreeland, grande dame of high fashion and longtime editor of *Vogue*. Silverman compared the two shows:

> Despite the presumed difference between the consumerist [Bloomingdale's] and high cultural [Met] versions of China, the 1980 Met museum show shared the themes and selectivity of the Bloomingdale's packaging of China. The theme of the Met exhibition was the celebration of China as a timeless, aristocratic culture devoted to artistic crafts. . . . Historical specificity was entirely lacking from the exhibition displays; the only guiding principle was the emphasis on the long reign of luxury and opulence signified by the rulers' magnificent clothes and elegant furniture.

The message found at Bloomingdale's and the Met was the same: Art has no social base, it is the product of timeless talent and creative genius. The social conditions present where it originates are irrelevant, thus they do not appear in the show. Individual aesthetic impulses may have found gratification in the exhibit; social understanding could not possibly be expected. The visitor may have gone home believing he or she had been touched by culture. The museum and the store got their crowds and customers; the corporate sponsors filled their quota of visible public service.

The corporate embrace of museums obviously is meant to avoid social instability. Yet whether the millions of visitors who flow through museums nowadays come out of them more depoliticized than when they entered is unknowable. It will remain so unless "exit polls" such as those taken outside voting booths are introduced—a ludicrous prospect. Even then, some fairly detailed questions would be required to elicit useful information.

Actually, Hans Haacke tried this technique in some of his gallery shows, first in 1969 and more successfully in 1972 and 1973. He asked visitors to fill out lengthy questionnaires, tabulating the answers and making them available while the exhibition remained in place. In 1970, Haacke asked visitors to a show that included his work at the Museum of Modern Art (MoMA) in New York City to answer the question: "Would the fact that Governor Rockefeller has

not denounced President Nixon's Indochina policy be a reason for you not to vote for him in November?" At the end of the twelve-week exhibition, the ballot boxes had registered the following results: 25,566 (68.7 percent) yes; 11,563 (31.3 percent) no. This was an especially ironic outcome, for MoMA has been a Rockefeller fiefdom since its founding in 1929. Haacke has not been given another show at MoMA.

For twenty years, Haacke has been stripping bare the consciousness industry and challenging the place of art and the museum in it. His works constitute a searching examination of the connection between art and the system of power and money-making, and of the uses of art to mask and conceal the rankest forms of exploitation: slum landlordism in New York City; apartheid in South Africa and its corporate supporters and beneficiaries; advertising images and the reality behind them. As the critic Leo Steinberg put it, Haacke discovered the secret of what material is *not* acceptable to the consciousness industry. This is no small achievement, since practically everything that creative minds and talents produce can be appropriated and used to the advantage of the industry. Haacke's achievement rests, writes Steinberg, "in asking how money that might be diverted to art is actually made. . . . It is here, in the prurient reversion to the sources of wealth, that we recognize the obscene, the unacceptable."

Haacke and those who do similar work in the arts are hardly serious matches for the consciousness industry. Yet they keep alive a spirit of resistance, like that provided by San Diego artists David Avalos, Louis Hock and Elizabeth Sisco. The three succeeded in eliciting a howl of indignation from the city's establishment by making a three-paneled poster depicting the use and abuse of migrant labor in San Diego. The official outrage was deepened by the wide dissemination of the art as placards on a hundred local buses in the two weeks preceding an anticipated tourist flood into the city to view Superbowl XXII in 1988.

—

WOMEN ARTISTS, 1970–85

Women and Mainstream Art

DECEMBER 25, 1989

Arthur C. Danto

IT IS A tribute to the curatorial intelligence of Randy Rosen and Catherine Brawer that their exciting exhibition, "Making Their Mark: Women Artists Move into the Mainstream, 1970–85," which has been given a suitably celebratory installation at the Pennsylvania Academy of the Fine Arts in Philadelphia, should raise as many questions about the concept of the mainstream, and especially the historical structure of the mainstream in the period under survey, as it does about the artistic relevance of the eighty-seven artists all being female. At least half those artists would turn up as a matter of course in an exhibition titled "The American Mainstream, 1970–85," where the issue of gender had no bearing on the principle of selection; there is certainly no comparable period in twentieth (or any) century art in which as many women would be among its outstanding creative exemplars. I would go even further. Were I asked to select the most innovative artists to represent this particular period through having come of artistic age in it, most of them would probably be women: I can think of few men in those years whose achievement matches that of Cindy Sherman or Jennifer Bartlett, to name but two, and none who come close to Eva Hesse (though 1970 was the year of her sad early death). Nothing like this would be true of the 1960s, a decade of deep conceptual exploration in which women played a relatively minor role, nor would it have been true of the 1950s, despite the flourishing in that decade of Helen Frankenthaler, Lee Krasner, Grace Hartigan and—even today a vastly underappreciated painter—Joan Mitchell. So the question is whether this particular period, and hence this particular mainstream, was made to order for women, even if the work in question might not have any especially feminine—or feminist—content. Of course, a great deal of the work here has both, as might be expected, given the sharp political demands that women were making on institutions of high culture in which they had to that point generally played a secondary and subservient role. But one can beat the gates down

and gain admittance to the precincts of privilege without assuring that significance be attached to one's work, and my question reasserts itself: Was there something in the times, in the structure of the art world, that made this female ascendancy possible and even necessary? This brings with it the question of what kind of mainstream it was.

The 1970s is a difficult period to bring into art-historical focus, though this could be due in part to the assumption that the decade is the basic historical unit in periodizing art, with each thought to have a style of its own. In these terms the 1970s did not materialize as the kind of decade the 1950s and the 1960s were. The other part of the difficulty is that it was widely anticipated that the 1970s *would* become that sort of decade, and the fact that it did not may be the most important fact about it. The 1950s and 1960s were times of extraordinary artistic revolution, and it had begun to seem as though the great sequence of revolutions—Fauvism, Cubism, Abstractionism, Futurism, Constructivism, Dada and Surrealism, to name the high points—was not only to define the structure of art history in the twentieth century but that it was being carried forward in America rather than in Europe. One of the marks of the American artistic revolutions was their extreme philosophical character, in that each corresponded to a different philosophical theory of what art is. Indeed, we can reconstruct this history as moving forward on two levels—the level of artworks and the level of theories of art, with the former supposed to exemplify the latter. And during this development a number of boundary lines were erased, or even exploded, which had been thought essential to the definition of art, as the almost alchemical pursuit for the pure essence of art moved forward through the 1960s. It was taken for granted that this would continue on into the next decade, when in fact what happened was that *nothing* along those lines occurred at all. In an interview he gave a few years ago, Roy Lichtenstein said in genuine puzzlement, "The seventies seem a kind of non-entity. I don't know what to think of the seventies; I don't know what happened."

There is little doubt that the commitment to artistic purism continued in the 1970s through a kind of inertial force. In an interview with Calvin Tomkins, Jennifer Bartlett said, "I imagine there were very few people doing abstract work who were acceptable to Brice Marden, and very few people doing sculpture who were acceptable to Richard Serra." Of herself, Bartlett said, "I didn't really have a point of view like that. I liked a lot of different work." But "not having a point of view like that" came to be, by the end of the

decade, the point of view to have. The New York art world, for perhaps a quarter-century, was defined by intolerance, by the zealotry with which it was insisted that outside a narrowly defined canon, nothing was really painting, or really sculpture, or really even *art* (this dogmatic spirit survives today primarily in the writing of Hilton Kramer). But by the end of the 1970s, the uneasy term "pluralism" began to be used, tentatively and gingerly, to define the direction of art, understood now as perhaps not having any longer the kind of historical direction that had to that point been believed necessary. It was not "anything goes," but it was no longer urgent—no longer possible—to go by adhering to a prescribed line. Miriam Schapiro, whose aggressively feminist work is one of the touchstones of "Making Their Mark," who came up as an artist through the harsh exclusionary imperatives of postwar art history, found a certain liberation from the very idea of this in feminism: "Feminism taught me not to worry about what I was 'allowed' or 'not allowed' to do as a serious artist." But much the same moral revelation was being made all across the art world, if not through feminism then through the discovery that not only had the old dogmas died but the very idea of dogma was itself dead. The German painter Hermann Albert recalls a moment in 1972 when he was gazing with friends at a dramatic sunset in Tuscany. Someone said, "It's a pity you can't paint that anymore these days." Albert writes, "That had been a key word I'd heard ever since I started trying to be a painter. And I said to him, . . . 'Why can't you? You can do everything.' . . . Why should anyone tell me I can't paint a sunset?"

There is a more external and material consideration to place alongside the end of aesthetic ideology. Nobody especially expected to make a living selling art in the 1970s. New York City real estate was not to begin its terrifying climb until late in the decade, and it was still possible to find fairly inexpensive studio space and to support oneself doing nondescript labor while making art one did not expect more than a few people would find of interest. Cindy Sherman worked as a receptionist, and her art was made for a small company of performers and conceptual artists who were her world. Others taught, or did carpentry, or were house painters, and like Sherman made art for the small circle of initiates who understood how the work was to be appreciated. The kind of international market that was to become a reality in the 1980s did not exist in the 1970s, nor did the phenomenon of the "hot artist" or the star system. The interesting question is, why didn't everybody just paint sunsets, which is after all a pretty satisfying thing to do. The answer is that most of the young artists who came up in the 1970s were

graduates of a very few advanced art schools. The number of artists coming out of Yale alone is simply astonishing: Serra, Nancy Graves, Bartlett, Chuck Close, Eva Hesse, Robert Mangold, Sylvia Plimack Mangold, Brice Marden, Janet Fish, Lois Lane, Judy Pfaff, Howardena Pindell are only some of them. These artists inherited from the 1960s the ambition and the imperative to drive the boundaries of art back, to find the *next thing*. And perhaps there was as well an intense competitive drive, like scientists seeking to drive back the boundaries of knowledge, whatever the material rewards for doing so. All this notwithstanding, no single global breakthrough was achieved. Rather, there were a number of individual breakthroughs. There was, in effect, no mainstream as such at all, simply confluences of individual tributaries with no mainstream to flow into. In retrospect, it seems to me that the 1970s was a Golden Age in which artists could pursue individual visions in a permissive cultural atmosphere under livable economic conditions.

All these factors were objective and structural features of the art world, subject to its own laws, and this would have been true had no women been on the scene, or if there had been women but in the traditional proportions of (say) one woman artist per every forty men. Pluralism permitted diversity (while making it possible for artists to infuse their work with political content if they so chose) and economics supported experiment. In these respects, there is a continuity between the profile of work in "Making Their Mark" and what any adequate survey of the art of the 1970s would show. There is, on the other hand, a greater degree of diversity among women artists and at the same time an almost invariably insistent feminist edge to women's art. My sense is that these two facts are sufficiently connected that a speculation is in order as to what this connection is, which requires a few remarks on feminism as such.

There are two forms that feminism took in the art world of that (and indeed of the present) time. One was a demand for justice and equality, the kind of demand that could in effect be met through affirmative action: including more women in galleries, in important exhibitions, in the distribution of grants, in the hiring of faculties and curatorial staff and in promotions within these. These matters are quantitative and can be monitored and measured. The other form is conceptual and, in a loose sense, deconstructionist. Feminists undertook to examine every component in the institutionalized conceptual scheme of art, asking of each if it might not be an insidious form of male oppression. Think of each of these forms in connection with art history. The demand for justice and equality entailed the search for neglected women artists of the past,

resurrecting vanished and almost invisible reputations, giving these neglected female creators prominence in exhibitions. The deconstructionist demand entailed rethinking the very premises of art history as understood in terms of geniuses, masterpieces, the imposition of styles, the domination of space and the definition of genres, with the entire concept of the fine arts construed as exclusionary and invidious and the structure of the art museum as embodying a scheme highly detrimental to women. Occasionally, the two forms collide. There are those who, as feminists, applaud the number of women entering the mainstream. And there are those who, as deconstructionists, deplore the very concept of mainstream as a form of male domination, alien to an entirely different female nature which has not found its institutional form as yet. From the deconstructionist viewpoint, nothing in art is sexually innocent nor, in consequence, politically innocent.

Not even, for example, the easel picture—"the traditional male-heroic genre of the easel painting," to use Thomas McEvilley's phrase—escaped critique. For it conjures up an image of a male presence dominating the canvas as his penile brush violates its white passiveness. And certain ways of modifying matter that would not commonly occur to males, like sewing or stitching, might suggest themselves as alternatives. Women became resourceful seekers of traditional forms of female expressiveness, using their bodies or making patterns or cultivating ornamentation, or raising to a higher power practices like cosmetic modification or dressing dolls or fabricating quilts or making dresses or plaiting hair or tying ribbons. Anything *but* the traditional and hence the male-dominating forms. There are, of course, some easel paintings in "Making Their Mark," but they are in a surprising minority. So there is a feminist answer to why one, if a woman, cannot paint a sunset, which is that women must find their own way in art. And "Making Their Mark" is an encyclopedia of some of the ways found: reassembling furniture, building little houses, forming horses out of mud and sticks, even, in one case, making a gown. And then there are the performances: Women in the 1970s made performance art their own and used it to challenge and attack features of a world they found oppressive. The feminist content generates the wild profusion of untraditional or even countertraditional forms that is the first thing to strike the eye in this exhibition. So one has to qualify the claim that the period seemed made to order for women artists. Had there been only that form of feminism that insists on equality, it might have remained a man's art world despite women entering it in larger and larger numbers. What made it the art world it was, I think, was feminism as

transformed by poststructuralist philosophy, with its possibilities of ultraradical critique. And from this perspective women did not so much enter the mainstream as redefine it, and the *men* who entered it were more deeply feminist than they could have known.

It is possible for work, then, to be feminist without having an obviously feminist content, though much of the work in this show is clearly and even militantly both. Miriam Schapiro is the paradigm figure. Her *Wonderland* of 1983 makes art out of traditionally feminine items—frilled aprons, doilies, a sampler, the kinds of things that might wind up for sale at church socials, products of the needle and the embroidery hoop—arrayed on a quilt. Presenting itself as high art, it calls into question the distinction between high art and the art women unassumingly contrive without thinking of themselves as artists. In just this spirit, Schapiro exhibits a dollhouse she and Sherry Brody made "to challenge," according to the always helpful catalogue notation by Judith Stein, "the limits of what 'art' could be." Her immense *Barcelona Fan* of 1979 monumentalizes a feminine accessory, and does so by combining pieces of fabric in what she terms a "femmage." Nancy Spero's *Artaud Codex* scatters script and sparse images angrily across a scroll that slows down the viewer who intends to read the language Spero has appropriated, much as Sherrie Levine appropriated the Walker Evans photograph of a woman sharecropper, which Levine rephotographed to uncanny effect and conceptual perplexity. Sylvia Sleigh uses the easel format but as a way of subverting its masculine intentions by depicting, in one painting, a group of women artists grouped the way men artists were shown to be in some well-known nineteenth-century works, and, in another, a harem of naked art critics, all men, their penises displayed, one of whom, with his arm coquettishly crooked over his head like an odalisque, is her husband (and my predecessor as art critic for *The Nation*), Lawrence Alloway. Hannah Wilke had herself photographed nude, her skin covered with tiny vulvas (made, one reads, of chewing gum), looking (and intending to look) like the victim of some terrifying skin disease or the gashed and wounded Jesus of Grünewald's savage altarpiece.

This is not, for the most part, work it is easy or even important to appreciate aesthetically. Or rather, the demand that art be judged strictly by aesthetic criteria is itself not a politically innocent demand. In its own way, especially today, it is as political as the explicitly political art it condemns in the name of aesthetic purity. And often the willed impurity of feminist art is a rebuke to aestheticism as being, in the end, a form of repression. On the other hand, this

is art that will mean different things to those of us on different sides of the gender line, and this difference is internal to the meaning and force of such works. It is work that would have failed had I, as a male, not felt myself under assault.

Some of the work, and indeed some of the best work, might not have existed had the artist not been a woman—simply because it's unlikely that anyone but a woman would have had the idea of making it in the first place. Somehow the possibilities available to women to alter their appearance through makeup, costume and wigs enters into Cindy Sherman's project. What is remarkable is that she has achieved something that transcends the differences between the sexes and touches us all in our inmost humanity. I cannot imagine anyone but a woman achieving what Eva Hesse has, just because the fun and fondness toward her often hopeless works seem archetypically feminine and forgiving. But she invented a new language of sculpture, and her followers come from either side of the sexual divide. My favorite work in the show was by a California painter I had never heard of, Joan Brown, and it is called "New Year's Eve #2" (1973). It shows a skeleton in tux and top hat, cakewalking—or is it a tango?—across a large canvas with a spirited woman in a red gown, the skyline of San Francisco in the background and the two of them kicking up their heels in celebration. It may be a painting of reconciliation, it may have no symbolism beyond what meets the eye, but either way it is a wonderful painting and I wish I could see it often.

The show is at the Pennsylvania Academy until December 31 (and if I lived in Philadelphia, I would begin the New Year by paying a last visit to "New Year's Eve #2"). If you happen to be there, be sure to take Miriam Schapiro's message to heart by visiting the exhibition of quilts at the Philadelphia Museum of Art, and the great retrospective of Man Ray under the same roof. And if you missed the show of early Warhol at the Grey Gallery at New York University, it is on view at Philadelphia's Institute of Contemporary Art.

—

LAWRENCE ALLOWAY

JANUARY 29, 1990

LAWRENCE ALLOWAY DIED of cardiac arrest on January 2 at his home in New York City. From 1968 to 1981 Lawrence wrote the art columns for *The Nation* and published four of the six books and five of the nine monographs that were to consolidate his reputation as a major critic of twentieth-century culture. Born near London in 1926, he became a lively, controversial advocate of contemporary American and British artists. In 1961 he settled in the United States. He continued to write, served for four years as a curator at the Guggenheim Museum, cofounded the journal *Art Criticism* and taught.

Lawrence suffered from neurological and spinal diseases, leaving *The Nation* when he became too weak to go to galleries, museums or his classroom. He spent his last nine years in a wheelchair, the immobility of his body in sharp contrast to the mobility of his mind. He was precise, accurate, rigorous, witty, ironic, curious, often mischievous, courageous, outspoken and proud. His conversation could switch effortlessly between anecdote and abstraction. A romantic who loathed sentimentality, he enjoyed the new in art and society. He interrogated change. The critic Robert Rosenblum praised his scholarly and focused work for "clearing up the fact sheet" on Abstract Expressionism and early pop art. Lawrence was one of the few male critics who took women artists and feminist criticism seriously.

Lawrence was married for thirty-five years to Sylvia Sleigh, who, during their long, close union, painted the shrewdest, most loving pictures we have of him. In 1983 he wrote some brief notes for the show "Sylvia Sleigh Paints Lawrence Alloway." Exploring the pleasures of being a "sitter," he said, "The sinuous fixity of these images saves me from being consumed by time, though not immune to its effects." Sylvia and Lawrence fought against the illness that was consuming him, their awareness of its power burnishing their gallantry. His writing is now proof of his deep, sharp intelligence, which tracked indelibly our images, icons and signs.

—

The State of the Art World: The Nineties Begin

July 9, 1990

Arthur C. Danto

If there is a crisis in art criticism today, it is because few who practice it accept the framework defined by Clement Greenberg, and yet no other framework has come to take its place. Greenberg's prestige doubtless rests upon that of the discoveries with which he is associated—of Jackson Pollock and Helen Frankenthaler, Morris Louis and Jules Olitski. But his influence is due to the explanatory theories with which he vindicated his discoveries and the implicit narratives within which he situated them historically. The theories characteristically take the form of persuasive definitions of art, which the discovered artist is held to satisfy in an exemplary way. The narrative then locates the artist in a historical progression of which she or he is the climax or goal. Greenbergian definitions are by and large essentialistic: Painting consists in XYZ and nothing more. And Greenbergian narratives tell the story of how the truth of art is revealed together with the untruth of art. The success of the framework is due to the way in which it makes sense of the present, gives structure to the past and defines the shape of the future. The price of losing the framework is that we are no longer sure what art is, and so are no longer clear about the direction of art history. If there is a crisis in criticism, there must be, for exactly parallel reasons, a crisis in art. The interesting fact is that neither crisis is felt as one, except by those whose practice is animated by a sense of the lost framework.

"It seems to be a law of modernism," Greenberg wrote, "that the conventions not essential to the viability of a medium be discarded as soon as they are recognized." The implied narrative is that of breaking through the illusion in which the merely contingent had been taken as the necessary, and thus coming to a clear philosophical vision of artistic truth. The history of Modernism is an erratic progress of self-purification. Thus the figure was discarded as contingent in pictorial representation by Abstractionists. Pictorial or illusionistic space was discarded as being inappropriate to abstraction, even if not filled with recognizable scenes and figures. Geometrical

forms were discovered to be not altogether mandated by abstraction, which could be achieved by swipes of pigment across a flat surface. The brush stroke was demonstrably unrequired, as the drip-stick showed, and both were retired when it was discovered that pigment could be soaked directly into canvas, producing forms inseparable from their material substance, closing the gap between representation and reality. Even if the culmination of the sequence was not just an expanse of bare canvas, the truth of art must in any case be the history of repudiations and subtractions. The *history* of art will then seek the beginnings of Modernism in artists whose asceticism would have been invisible to their contemporaries, since so much else was taking place in their paintings that we retrospectively perceive as impurities. Manet and Cézanne struggled with pictorialism, ahead of and yet limited by their times. It was in this spirit that Roger Fry once wrote that Rembrandt would have been a far greater artist had he put the psychology for which he is irrelevantly admired into novels instead.

Essentialist theories are by their nature disenfranchising. Perhaps because much of the human meaning carried by art is bound up in the properties thrown overboard in the name of purity, their relinquishment may be perceived as a sacrifice, and it is necessary to compensate by denouncing them as not having been art in the first place. Thus, work that persists in using the figure is dismissed as not art but illustration. Painting that uses hues outside a morally endorsed range is stigmatized as mere decoration. Now, in truth, the posture of disenfranchisement has characterized artistic attitudes in the West at least since Vasari. For Vasari, Michelangelo was the climax and the goal of art history. This evaluation was vindicated by the theory that art is the progressive conquest of visual appearances, the narrative of which Vasari proceeded to write, from its beginning in Cimabue down to his luminous present. Notoriously, Vasari had only contempt for Gothic art. But until well into the 1960s, it was standard for purists in sculpture or painting to draw the boundaries of art around themselves, leaving in outer darkness whatever failed their criteria of austerity.

Only rarely (except in the U.S. Congress) does one hear it said today that something that looks like and is responded to as art is not art at all. Even in his recommendation that the images of Robert Mapplethorpe not be exhibited at taxpayer expense, Hilton Kramer did not insist that they were not art. In a recent amiable debate with Barbara Rose, I was told, with a startling numerical precision, that 60 percent of what is being shown in New York galleries is not art; but I took that merely as a vehement way of saying that she liked

40 percent of what New York galleries show (which is pretty gener-
ous, everything considered). My own sense is that art *has* an essence,
but its components must be specified with such abstractness that no
stylistic imperatives can be derived from them. The consequence is
that if you want to pursue the nature of art in a serious way, you
must embark upon the formal study of philosophy. But the stylistic
neutrality of a philosophical definition leaves the practice of making
art intoxicatingly open.

The collapse of the Greenbergian paradigm might almost con-
vince a skeptic of the dialectical nature of history, for it was very
much a victim of its own success. As less and less was permitted and
more and more forbidden in the name of true art, it became in-
creasingly clear that "progress," if not over with entirely, was close
enough to its end that further advances were apt to be minute in
proportion to the energy of further research. If the all-white paint-
ings of Robert Ryman, the single-stripe paintings of Barnett New-
man, the grids of Agnes Martin were not the end of painting, it was
fairly obvious that the end of painting was to consist of works not
impressively different from theirs. And if there was close to nothing
left to do in the history of art, one might as well forget about making
history and go one's own way. Robert Colescott, in a video that
accompanied his retrospective at the New Museum of Contemporary
Art, said he appreciated that art consisted of making stripes, but
that Newman had already done that. That gave him license to opt
out of history and make those wonderfully funky pictures that, in
his words, "put blacks into art history." Jenny Holzer mused in a
recent interview that she wanted something more than "pretty good
third-generation stripe painting." In my view, since 1970 at least,
artists have been working outside the framework of history as de-
fined by essentialism. In the wonderful Pennsylvania Academy of the
Fine Arts show of women artists, "Making Their Mark: Women Art-
ists Move Into the Mainstream, 1970–1985" [see "Art," December
25, 1989], there were about as many directions as there were indi-
viduals. There was, in the early 1980s, a market-driven effort to put
history back on track with Neo-Expressionism, but this turned out
to be just further posthistorical art pretending to inevitability. The
1980s proved to be a jumble of artistic activity, which anyone can
verify from "The Decade Show: Frameworks of Identity in the
1980's," itself a kind of jumble, on view at the New Museum, the
Studio Museum in Harlem and the Museum of Contemporary His-
panic Art.

So the critic is obliged to navigate the season without compass or
criterion (the "new" criterion is the old criterion, with its obligatory

intolerances). We have just entered a new decade without the sense of having left the previous one. Paradoxically, the 1990s began with a number of remarkable shows, and perhaps I can convey some of the feeling of the historical present—and in some measure make up for not having responded to them while they were up—by offering a few bits of critical writing to suit the heterogeneity of the scene to which they are a disjunctive response. This will be criticism for which I am no better able to give a framework than I am able to give a unified characterization of the works. There is a famous passage in Wittgenstein in which he seeks to replace the old notion of a class, where all members share a set of defining properties, with what he terms a "family resemblance," where members may belong without sharing any obvious properties, though of course there will be members of the family who do share some. The six shows I want to describe have been arranged as a family resemblance group.

Dorothea Rockburne in some ways looks most like an essentialist artist, since her work has seemed rather geometrical and she likes to say that she reads mathematics and logic texts for inspiration and recreation. In recent years, the characteristic Rockburne work has been composed of white or black squares, triangles or lozenges, made of pieces of paper neatly folded back onto themselves, which, though fixed to a background, straddle some border between painting and relief. The folded shapes touch one another and are regimented into larger—one might say molecular—structures. The folds always convey an acute sense of mystery, of concealed secrets, as in sealed messages, eloquently blank. Her show at the André Emmerich Gallery in December-January represented a natural evolution from this format, yet at the same time it was altogether unpredictable. She showed what she called "Cut-Ins"—large paper works in which the principal forms, while recognizably Euclidean, showed deviationist tendencies, as if they were political allegories, and bore colors of a kind it might have occurred to an Egyptian dyer to employ so that Joseph's coat should be a chromatic astonishment: porphyry, lapis lazuli, the gold of gold leaf, the orange of sea urchins, malachite green, rose of Sharon, coral pink and the yellow of maize. The forms overlap and lend their outside edges to a sort of frame, cut in such a way as to surround them precisely, and giving, because of the thickness of the board from which its parts are made, a certain depth. Within the cutout space the florid shapes mingle, rigid and ephemeral at once, to form visionary structures. The titles are often meditative fragments taken from Pascal.

Robert Mangold's work, shown at the Paula Cooper Gallery, is

also, these days, a form of dissident geometry, minimalist work on holiday, fighting off elegance by refusing to endure the tyranny of Euclidean stereotypes. Saul Steinberg once did a marvelous series of drawings in which various shapes and figures dream of their ideal embodiments: There is, for example, a polyhedron that has all it can do to keep its six sides adjacent and its corners reasonably acute, whose dream it is to be a perfect cube, with sharp edges and snappy vertices, labeled with the right kinds of letters, precisely inscribed. Mangold's shapes are the inverse of this, what squares with bohemian aspirations might long to be, with crazy corners and unequal sides, perfectly useless for visualizing important theorems, and with tacky surfaces besides (freestanding, the forms are three-dimensional enough to cast heavy shadows, though only their surfaces count). But they do come in pairs, one of them a frame formed of four triangles which leave a squarish hole in the middle, and one with a roundish shape that, if it belonged to the cross section of an elliptical peg, is clearly wrong for its partner's opening. Nevertheless, they achieve a marvelous harmony and a monumental presence. In some way they belong to the same family as Rockburne's Cut-Ins—if you think of the Karamazovs as one kind of family.

David Reed's paintings make no use whatever of three-dimensionality, with their perfectly classical edges and their surfaces as polished as Ingres's, so much so that one wonders if they might be photographs. Their formats are unusual in being either very wide in proportion to their height or very high in proportion to their width. One is immediately struck by the sense of a wide brush moving up the narrow column of the vertical canvases, or within the tunnellike space of the horizontal ones. But the brush-play is not gestural so much as it is the shape of highly energized spiral or helical forms winding, like abstract snakes or dragons, through dark Baroque spaces. Reed in fact is an altogether Baroque artist, abstracting to his own ends the *figura serpentinata* of the seventeenth-century ecstatic (or agonized) saint or martyr or angel, so the works have the spiritual density of altarpieces. Often, Reed inserts subpanels into his spaces, like predella images, episodes in the churning destiny of his whorled subjects. His colors belong to a different universe than Rockburne's and seem like the products of some polymeric chemistry, with futurist hues. But there was one dramatically vertical piece in his exhibition at Max Protetch's: an upsurge of pale green against dark green, sea colors, and the form like water cascading upward, as if the fluid energy of Hokusai's great wave were trapped in a chasm and forced to ascend with a roar.

I place Cindy Sherman's marvelous show at Metro Pictures next.

Sherman's brilliant appropriation, in the late 1970s, of the format of the "still," with its implied narrative in which she was the nameless starlet, became the focus of so much neostructuralist, radical feminist, Frankfurt School Marxist and semiological hermeneutics that one is convinced there must be whole programs of study in institutions of higher learning in which one can major, or even earn a doctorate, in Sherman Studies. What is remarkable about the stills, despite the excrescence of theory that has attached itself to them like barnacles, is how vivid and immediate they remain as works of art. In her new show she simply took over the genre of the historical portrait, and did so with the same sense of assurance with which she took over a marginal photographic artifact and gave it the deepest human meaning. But her mode of reference to the past is different from David Reed's. Reed brings the Baroque into contemporary sensibility. Sherman imposes a contemporary sensibility onto the Baroque style of portraiture, in which the self-important scholars and courtiers, mistresses and ministers, dukes and reformers, inquisitors and virgins, allowed themselves to be forever fixed; and she applies to them so powerful a sense of their absurdity that all the solemn power leaks out, leaving behind sets of conventions that men and women could put on or take off, like wigs and farthingales. It was an intoxicatingly intelligent show, not least of all because of the way she slipped out from under the clichés of Sherman Studies and stood free of her theoreticians—the bride stripping the bachelors bare, even.

As Sherman appropriated and assimilated the Old Master portrait, Mark Tansey made his own the style of illustration, protophotographic, that one finds in books for boys and girls circa 1912, and whose most familiar representative might be Sidney Paget, whose illustrations for the Sherlock Holmes stories have fixed the great detective's image forever. It is striking how this almost styleless style would have come to be dated, as much so as the postures and costumes it was so good at illustrating, and how a postmodern master should now use it for his artful allegories. Tansey has even borrowed the famous image of Holmes and Professor Moriarty, wrestling at Reichenbach Falls, for a witty painting titled "Derrida Queries de Man," in which the two heroes of contemporary literary theory undertake, at precipice edge, to deconstruct each other to smithereens. The theme of the show at the Curt Marcus Gallery was "the world as text," an essentially Derridian conceit, according to which text and subject are so indistinguishable that the world might just as well be made of language, there being "nothing outside the text." The crags and cliffs at Reichenbach Falls are literally made of words,

though we cannot read what they say, so thickly are they painted over one another. (Well, Derrida is not that easy to read either.) These large, monochrome works are stunning transformations of philosophical ideas, punning and allusive, and they display an almost pyrotechnic virtuosity.

The idea of pyrotechny brings us to Jennifer Bartlett's "Fire Paintings," shown at Paula Cooper's in the chill weeks of January. Bartlett is the least essentialist of artists, though her famous work "Rhapsody," which was intended to "have everything in it," required her to reduce "everything" to some set of primitive elements out of which the universe should then be compounded. The elements of "Rhapsody" were: mountains, trees, water and houses. In recent years, Bartlett has replaced this somewhat homemade cosmology with the traditional pre-Socratic one of earth, air, water and fire; and she has resolved to spend two years on each of these elements. The Fire Paintings represent the first stage of this tremendous ambition, and these vast and brushy paintings, as suitably flamboyant as their flammeous subject and spirited creator, have, if not everything in them, certainly everything that crossed Bartlett's mind as connected with fire as destroyer, foundation and preserver. Certain objects—cones, rings, grills and octagonal tables—appear not just as depicted but also half sculpturally, as protruding from the canvases, and finally as fully sculptural, standing before the canvases to which they refer. One was put in mind of the funeral pyre of Patroclus, of the conflagration of Valhalla, of the Fire Sermon of Buddha, of the flame death of martyrs—but also of the habitat of salamanders, of roast pig, grilled fish and bread fragrant from the oven. Not essentialist, but *of* one of the essences, the Fire Paintings express the exuberant pluralism of the age.

Incurable essentialists now know how to proceed: Anything is a work of art that resembles the works in these six shows as much as they resemble one another. As a constellation (to which several more stars might be added had I space to do so), they do not so much tell us where art is heading as encourage us to ask whether that question any longer heads us in a useful critical direction.

In the midst of the controversy over the funding of the National Endowment for the Arts, Paul Mattick, Jr., professor of philosophy at Adelphi University and a frequent commentator on art and culture, contributed this telling account of the evolution of government funding of culture in the United States.

—

ARTS AND THE STATE

OCTOBER 1, 1990

Paul Mattick, Jr.

VISITING THE EXHIBITION of Robert Mapplethorpe's photographs at the Institute of Contemporary Art in Boston a month ago, it was hard at first to see what all the fuss was about. The controversy that has dogged the show since its organization by the Institute of Contemporary Art in Philadelphia certainly made itself felt in the huge numbers of visitors (tickets sold out well in advance) and in the aura of decorous excitement that enveloped those who managed to get in. Most of the pictures, however, were unexciting. With the exception of a handful of striking images from the artist's last years, we saw celebrity portraits shot in 1940s fashion style, arty flowers, naked black men in a venerable art-nude tradition. In a distinct area, however, reached only by waiting in a patient line of cultured scopophiles, were the pictures which more than the others had called down upon the National Endowment for the Arts, partial funder of the Philadelphia I.C.A., the wrath of America's self-appointed guardians of morality.

There were more flowers, more naked black men and a set of s&m photos that was undeniably gripping. Here the subject matter overcame Mapplethorpe's tendency to artiness and commercial finish in a set of documents with the power of the once dark and hidden brought to light. Here are some things some people like to do, they say; this is part of our world; you can look or not, but now you know they exist, whatever you think of them. In an age saturated with sexual imagery of all kinds, these pictures were perhaps not as disturbing as they might have been to more innocent eyes. At any rate, the visiting public was not so horrified as to fail to crowd the museum store to purchase bookfuls of Mapplethorpe's pictures (along with black nude-emblazoned T-shirts, floral porcelain plates and bumper stickers proclaiming support for freedom of the arts).

Nonetheless, these photographs, in the company of a few other pictures and performances, have evoked a storm of Congressional and popular indignation that now threatens to sweep away the N.E.A. itself. This, in turn, has given rise to attempts to defend the current mode of state patronage of the arts.

It is difficult to speak of real controversy in this area, as the two discourses at work are to a great degree at cross-purposes. That of the naysaying politicians tends toward expressions of traditional American anti-intellectualism, portraying state arts funding as the use, basically for the gratification of a degenerate Eastern elite, of money better spent on local pork barrels and military projects. Art, in this view, has a natural affinity with sex, subversion and fraudulence. On the other hand, the statements of opposition to censorship and calls for arts funding by artists, dealers, other art professionals and liberal politicians take as given the social value of the arts, their consequent claim on the public purse and (with some disagreement) the current mode of distribution of the goodies. Without being in favor of either censorship or the diversion of yet more money to produce new bombers and missiles, one may step back and attempt to rethink the question.

Lacking a feudal heritage, a tradition of princely magnificence such as that which stands behind state cultural policy in European countries, the United States has no long history of governmental patronage of the arts. Under American law, corporations themselves were forbidden to engage in philanthropy, including support of the arts, until 1935. Washington was supposed, in this most purely capitalist of all nations, to spend only the minimum needed to control labor and defend business's national interests. Theater, including opera, functioned in the nineteenth century as a commercial enterprise across the country, and the visual arts were for the most part produced for private purchase. When growing economic power stimulated the mercantile and industrial upper classes of the later nineteenth century to call for the establishment of museums, symphony orchestras and other cultural institutions, they had to put up the money themselves. Thus, while the revolutionary regime in France, for example, took over the King's palace and its contents to create the Musée du Louvre for the nation, the United States did not have a National Gallery in Washington until Andrew Mellon gave his personal collection to the country and started building a structure to house it in 1938.

The arts began to attract more public attention with the start of the twentieth century, as can be seen in the national publicity gained

by the Armory Show, which introduced European modernism to the United States in 1913. Whereas art and all those things called "culture" in general had earlier been largely identified with the European upper class, Regionalism, given national exposure by a *Time* cover story in 1934, claimed to be a uniquely American style. At the time of the New Deal, a few farsighted individuals conceived the idea of government aid to the arts as part of the general federal effort to combat the Depression. Two programs for the employment of artists, one run out of the Treasury Department and a much larger one as part of the Works Progress Administration, represented the national government's first entry into patronage (aside from the commissioning of official buildings, statuary and paintings). In the view of the organizers of these projects, their longterm rationale was support for the arts as a fundamental part of American life; but they could be realized, in the face of much opposition from Congress (and professional artists' associations, true to the principles of free enterprise), only as relief programs, employing otherwise starving (and potentially subversive) artists and preserving their productive skills during the emergency. Both programs died, after a period of reduction, with America's entry into the war.

Institutional concern with the arts developed markedly with the U.S. rise to world supremacy after the war. The war reversed the normal flow of American artists to Europe, bringing refugee artists to New York and California and thus stimulating artistic life, at least on the edges of North America. More important, its segue into the cold war joined to the growing desire of the American upper class to play social roles equal to its expanded global importance a new use for American modern art as a symbol of the advantages of a free society. New York abstraction, still unappreciated by any sizable public, was not only promoted by the mass media that had once publicized Regionalism but was shipped around the world, along with jazz music and industrial design, by government bodies like the United States Information Agency and by the Rockefeller-dominated Museum of Modern Art. In modern art, it seemed, America was now number one; while still incomprehensible (as critic Max Kozloff once observed), art that celebrated the autonomy of the creative individual no longer seemed so subversive. In the realm of classical music, Van Cliburn's victory in a piano competition in Moscow in 1958 was an event of political as well as cultural importance.

More fundamentally, beyond issues of international political prestige and the aristocratic pretensions of the very rich, the idea was gaining ground among America's elite—particularly in the Northeast but in a city like Chicago as well—that art is a Good Thing, a

glamorous thing, even (more recently) a fun thing. This attitude rapidly trickled down to the middle class, whose self-assertion as leading citizens of an affluent and powerful nation was expressed in a new attachment to culture. As interest in art spread throughout the country, the 1950s saw galleries in department stores, rising museum and concert attendance and the commercial distribution of classical LPs and inexpensive reproductions of famous paintings. Studio training and art history departments proliferated in the universities. A handful of corporate executives, in alliance with cultural entrepreneurs like Mortimer Adler and R.M. Hutchins, discovered that culture, whether classic or modern, could be both marketed and used as a marketing medium.

In part this reflected the changing nature of the business class; while fewer than 50 percent of top executives had some college education in 1900, 76 percent did by 1950. The postwar rise of the professional manager helped break down the traditional barrier between the worlds of business and culture, affecting the self-image of American society as a whole. To this was joined—with the growth of academia, research institutions and all levels of government—the emergence of the new professional-intellectual stratum, connected in spirit to the power elite in a way unknown to the alienated intelligentsia of yesteryear. In 1952 the editors of *Partisan Review* introduced a symposium on "Our Country and Our Culture" with the observation that just a decade earlier, "America was commonly thought to be hostile to art and culture. Since then, however, the tide has begun to turn. . . . Europe . . . no longer assures that rich experience of culture which inspired and justified a criticism of American life. . . . Now America has become the protector of Western civilization."

Thus politics, business and culture joined hands. Art's growing value as an area of investment and domestic public relations could only be reinforced by its emergence as a marker of international prestige. The Kennedys' Camelot was a watershed, with its transformation of the Europhilia typical of the American elite into the representation of the White House as a world cultural center. Kennedy counselor Arthur Schlesinger, Jr. put it this way, in arguing for a government arts policy: "We will win world understanding of our policy and purposes not through the force of our arms or the array of our wealth but through the splendor of our ideals."

Such efforts both led to and were enormously enhanced by the founding of the National Endowment for the Arts in 1965 and its rapid development thereafter. While it represented the fulfillment

of ideas bruited about various levels of government since the Eisenhower days, the N.E.A. was realized as an accompaniment to Lyndon Johnson's Great Society, like that program as a whole (and like the W.P.A.), it reflected the principle of the state's responsibility for those aspects of the good life not automatically taken care of by market forces. It should not be thought that it was established without opposition (as of course no Great Society program was); in fact, the N.E.A. achieved legislative reality only as a unit of a National Foundation for the Arts and Humanities, of which the National Endowment for the Humanities was the more respectable half. In addition, the arts were carefully defined to include the productions of the culture industry—movies, radio, fashion and industrial design— along with the traditional "high" arts. The Endowment not only survived numerous challenges to legitimacy but saw its budget rise between 1969 and 1977 from $8 million to more than $82 million, and by 1990 to $171 million. This, moreover, is only a portion of total arts spending, which includes sums directed, for some examples, to museum development, to the Smithsonian Institution and to projects under the aegis of the National Park System. In addition, the big push to culture given by Congress since the mid-1960s included changes in tax laws—in recent years to a certain extent undone—encouraging donations of art and money to museums and other institutions.

One must not exaggerate: The sums spent on its arts agency by the American government have always been derisorily small, both relative to other government programs and in comparison with the spending of other industrialized capitalist nations. West Germany, the world leader, spent about $73 per inhabitant on the arts last year; the Netherlands spent $33, and even Margaret Thatcher's Britain laid out $12; the United States indulged its culture-mongers with a measly 71 cents per capita. This amounted to less than 0.1 percent of the federal budget (the Smithsonian alone receives a larger appropriation than the N.E.A., as does the Pentagon's military band program, budgeted in 1989 at $193 million). Even this, however, has seemed too much to many conservative politicians, and the current effort to eliminate or restrict the N.E.A., must be seen as one more protest by conservative forces against a relatively novel effort with which they have never been happy.

Opposition has typically focused, throughout the short history of government arts funding, on moral and political issues as well as on the sacred character of the taxpayer's dollar. W.P.A. artists were attacked for painting nudes, and a photographic registry of artists' models was held up in Congress as an example of the sort of filth

that visual artists go in for (along with political imagery of the Popular Front variety). In 1940 Senator Robert Reynolds from North Carolina (which thirty years later would send forth the scourge of the N.E.A., Jesse Helms) urged Congress to refuse to fund the federal theater project, with its "unsavory collection of communistic, un-American doctrines, its assortment of insidious and vicious ideologies" and "putrid plays."

The N.E.A. was carefully designed to avoid many of the controversies that had swirled around the W.P.A. The nongovernmental panel system of peer review in awarding grants both tied the endowment to arts institutions and shielded it from direct responsibility for funding decisions. The fact that the N.E.A. provides only partial funding for any institutional project and operates largely in concert with state arts councils established a nationwide base of support and further diluted its accountability. In addition, the bulk of its funds have gone to support politically and aesthetically conservative institutions like major art museums, orchestras and opera and ballet companies.

Nonetheless, the history of the N.E.A. is replete with an astonishing level of conflict for such a tiny agency: struggles over financing "artistic excellence" versus emphasis on "broadening access to culture"; over the support of less-than-high art and over subsidization of experimental work often unrecognized as art by the localities to which it has been offered. In addition, the club of "family values," that basic element of American political rhetoric since the Civil War, was wielded by the endowment's opponents throughout the 1960s and 1970s. Stress was laid on the effeminacy of ballet dancers, and much was made of the fact that Erica Jong thanked the endowment for aid during the writing of *Fear of Flying*.

Meanwhile, what we might call the Congressional Yahoo faction came to be joined, in a curious alliance, by highbrow cultural conservatives like Hilton Kramer, who as art critic for the *New York Times* criticized N.E.A. grant-making policy during the 1970s and continued his attacks as editor of *The New Criterion*, founded in 1982 with money from a number of right-wing sources, including the John M. Olin Foundation. Kramer directed his polemic both at such easy targets as the logrolling habits of the N.E.A.'s grant-giving panels and at the endowment's support for what he called "a dedicated alliance of artists, academics, and so-called activists" attempting "to politicize the life of art in this country." Such people were typically "opposed to just about every policy of the United States government except the one that put money in their own pockets"; giving them that money was "supplying the rope to those who are eager to see

us hanged." The Heritage Foundation's 1981 volume of policy rec-
ommendations for "a Conservative Administration," *Mandate for
Leadership*, contained a paper on the N.E.H. and N.E.A. by Olin
executive director Michael Joyce. After suggesting that "as a true
friend of democracy, the NEH can teach the nation the limits of
equalitarian [*sic*] impulse," Joyce indicated the need for the N.E.A.
to turn from "politically calculated goals of social policy" (like the
promotion of regional folk arts or attempts to reach minority au-
diences) to a renewed stress on "excellence" and the "cultivation of
audiences with a true desire for high-quality artistic experience."

The Heritage Foundation's recommendations suited the tenor of
the times, in this as in other areas of federal policy. Opposition to
arts spending gained strength with the general turn against state
expenditures (other than military ones) during the 1980s. The Rea-
gan government attempted to cut the endowment's funding by half
as part of David Stockman's implementation of what George Bush
once called "voodoo economics." As a member of Stockman's team
explained to Livingston Biddle, then chair of the endowment, the
N.E.A. "was supporting art that the people did not want or under-
stand, art of no real value." The political strength built up by the
arts during the preceding fifteen years was visible, however, in the
success with which this challenge was beaten back by pro-culture
legislators.

The twenty-odd senators who joined Jesse Helms last year in pro-
testing Andres Serrano's "Piss Christ" as "shocking, abhorrent and
completely undeserving of any recognition whatsoever"—especially
that of the N.E.A.—were thus following the example of earlier art-
bashers. One novelty of the situation was the involvement of a num-
ber of conservative direct-mail operations, like the Rev. Donald
Wildmon's American Family Association, whose newsletter is sent to
around 400,000 addresses, including more than 170,000 churches.
This sort of outfit has generally occupied itself on the cultural front
with various forms of "popular" production, from politically liberal
and risqué TV shows to rock-and-roll lyrics to neighborhood porn
shops to movies—such as Martin Scorsese's *The Last Temptation of
Christ*, which Wildmon picketed in 1988. The extension of this ma-
levolent interest to the high arts reflects the national media expo-
sure won by forms of elite culture during the last decade—due in
part to the efforts of the N.E.A. The vast letter-writing campaigns
that organizations like Wildmon's are able to instigate do not seem
to reflect the trend of general public opinion (according to some
recent polls, at any rate), but they do represent a mass of voters
willing to be mobilized, and politicians, especially those not fond of

"atheistic, anti-American" imagery themselves, are ready to respond to them as they have to the anti-choicers on abortion. When Jesse Helms, originally alerted by a Wildmon mailing to the peril to Christian values posed by the N.E.A., followed Alfonse D'Amato in bringing it to the attention of the Senate, he met with virtually no serious resistance, and his now-famous anti-obscenity amendment, tacked on to last year's appropriations bill, passed with ease (its later modification left its bite intact).

However, what the future will bring the N.E.A. is far from clear. Arts institutions and professionals have begun to rally around the endowment, and they seem to have succeeded in mustering support from the art-consuming public. A few restrictive decisions of the N.E.A. have recently been called into question or reversed. The issue will in the short run be dealt with politically, under the constraints of re-election campaigns and Congressional wheeling and dealing. It is possible that the arts have by now risen to such a position of ideological importance, with modernism itself a staple of the status quo, that their claims will override those of more antiquated "family values"—this is certainly true for the social system as a whole, whatever happens in Washington under the pressure of local and national politics.

Defenders of the N.E.A. and of freedom of state-funded expression tend, like their antagonists, to invoke "American values," celebrating the arts as a natural feature of a "free society." A recent advertisement placed in the *New York Times* by the Art Dealers Association of America is typical in citing the Constitution and "the right of free expression which is one of the core values of a democratic society." This ideological unity explains how one and the same organization—Philip Morris Inc.—can support both sides of the controversy, funding the arts lavishly and distributing copies of the Bill of Rights as a promotional gimmick, while supporting the re-election campaign of Jesse Helms, a great friend of the tobacco industry.

The basic liberal argument was concisely stated by Richard Oldenburg, director of the Museum of Modern Art in New York, writing recently in MoMA's *Members Quarterly*. He identified the two fundamental issues at stake as the continuance of government arts funding and freedom of expression. The first is important because "support for the arts is support for creativity, a national resource essential to our future and a source of our pride and identity as a nation." And "creativity requires freedom of expression," including the liberty "to explore new paths which may occasionally test our tolerance." Oldenburg echoes pro-art politicians and N.E.A. chair

John Frohnmayer in pointing out how few grants have been controversial out of the 85,000 made since 1965. Like any investment, investment in creativity can be expected to miss the mark occasionally, but, according to Oldenburg, "this is a small and necessary price to pay for nourishing imagination, for respecting diversity, and for protecting our rights as individuals." From this point of view, the only important issue is control of the grant-giving process, which should clearly be in the hands of art professionals—"experts," as they are regularly called—rather than in the clutches of politicians, whatever their stripe. As Anthony Lewis put it in a summertime column in the *New York Times*, "When politicians get into the business of deciding what is legitimate art, the game is up."

The other side has two basic responses to these claims. According to Congressman Philip Crane, "Funding art, whether that art is considered outstanding or obscene, is not a legitimate, nor is it a needed, function of the federal government." But in any case, he continues, if art is to receive state support, "Congress has a responsibility to its constituents to determine what type of art taxpayers' dollars will support." This does not constitute censorship, such arguments go: No one is preventing artists from doing whatever kind of work they wish; but the taxpayers are under no obligation to pay for work they find senseless or offensive.

Artist friends who listen to talk radio all day in their studios tell me that this sentiment seems to be widely shared, even by many opposed to censorship of expression in the arts (this is also the implication of a recent *Newsweek* poll). In part, this is no doubt a reflection of the enduring American uneasiness with sexuality, visible, for example, in the ambivalence many feel regarding the availability of pornography. But it also seems to express resentment of artists, apparently thought of by many Americans as a species of welfare frauds, living high on the hog on government grants, free to devote themselves to their peculiar pleasures and childish occupations.

Such attitudes have deep historical roots. For one thing, since their elaboration as a distinct domain of activity in the centuries between the Renaissance and the Industrial Revolution, the fine arts have drawn their meaning in part from the contrast between free, creative activity and labor directed toward the earning of money. The noncommercial soul of this department of luxury-goods production, visible particularly in the bohemian flavor of the avant-garde, is essential to art's social role as sanctifier of a commercial society: The love of art marks the bourgeoisie as the legitimate inheritor of the civilization of the past, and heir to its ruling elites. At the same time, it makes the artist at once an impractical, childish

figure and a standing reproach to the devotees of the bottom line. These remain important features of the modern idea of art, though that concept has been changing rapidly in recent decades, as a few artists have achieved wealth and celebrity status, while bourgeois society has become more confident about its own value system, and so more at ease with the commodity character of works of art.

Since one important social function of art in the modern world has been as an indicator of class position, it is not surprising that it is seen by many in low-income brackets as a possession of the elite. In fact it is. Members of the corporate elite dominate the boards of trustees that govern art institutions. And what little statistical survey work has been done indicates that, despite the enormous enlargement of the art-consuming public since the mid-1960s, that public is still overwhelmingly drawn from upper-class and professional groups, with (for instance) blue-collar workers contributing a negligible percentage. This lends a certain plausibility to the efforts made so kindly on their behalf by servants of social power like Jesse Helms "to stop the liberals from spending taxpayers' money on perverted, deviant art," as Helms put it in a fundraising letter. But to begin with, it must be remembered that the public allegedly represented by the politicians who speak for it has very little to do with what goes on at the heights of power. As artist Richard Bolton pointed out in a recent article in *New Art Examiner*, "The recent outrage over art was not fueled by popular rebellion, but by extremists with narrow and self-serving agendas, by politicians who like to be in the news, and by a news media driven by sensationalism." At any rate, those who, like [*New York*] *Times* columnist William Safire, urge an end to "forced arts-patronizing," fail to extend the principle they invoke to other government expenditures: the millions sent to the Nicaraguan *contras*, for example, or the billions expended on Star Wars and the Hubble space telescope. It is true, of course, that the government's money is at base a deduction from the social product, taken from and spent without much say on the part of the producers. To question this arrangement, however, is tantamount to demanding the abolition of the state, something hardly intended by Safire, Helms or the Heritage Foundation.

What they really have in mind, of course, is that the state should fund only art already certified as "great"—that preserved in museums and concert halls, or approved by conservative critics, the aesthetic component of the canon of cultural literacy promoted by such as Allan Bloom (another Olin Foundation beneficiary, incidentally). In a *Times* Op-Ed piece ("Say No to Trash") commending the Cor-

coran Gallery in Washington for its last-minute refusal of the Map-
plethorpe show, *New Criterion* publisher Samuel Lipman, a Reagan
appointee to the N.E.A. supervisory National Council of the Arts,
urged public art support to "more fully concentrate on what it does
so well: the championing of the great art of the past, its regeneration
in the present and its transmission to the future." It should refuse
to promote art whose raison d'être is its ability to outrage the public
by dealing with extremities of the human condition. More, of
course, than sadomasochistic or supposedly blasphemous imagery is
at stake here. What is to go, opponents of the N.E.A. generally agree,
is, above all, artists and institutions on the social fringe—gay and
lesbian performance artists, feminist video makers, Latino photog-
raphers and theater groups, black poets and painters.

We are not speaking here of an avant-garde in the traditional
sense. These artists are not working outside the system, but for the
most part are struggling to improve their places inside it; however
politically motivated or oppositional in form or content their work
may be, they are on the margins of official art or even—like Map-
plethorpe—well ensconced within it. And indeed, while the Con-
gressional philistines tend to disparage the claims of such as Serrano
that they produce art at all, for a more sophisticated critic like Kra-
mer, the issue is not, strictly speaking, an aesthetic one. While he
sadly knew of no way to exclude Mapplethorpe's work "from the
realm of art itself," he wrote in [the *New York*] *Times*, the problem
is that "not all forms of art are socially benign in either their inten-
tions or their effects." Despite Kramer's frequent fulminations
against the intrusion of political values into the realm of art, he here
demanded that a "social or moral standard" be consulted in deter-
mining what sort of art the government should support.

For Kramer, like Lipman, the misdeeds of the N.E.A. reflect the
decline of decency throughout the culture, in high and popular art
alike, and so the erosion of the power of those who think like him.
"Unfortunately," Kramer wrote, "professional opinion in the art
world can no longer be depended upon to make wise decisions in
these matters." For Helms and Co. the arts represent an issue far
easier to campaign on than the savings and loan scandal or the
coming depression. For art institutions, too, the struggle over the
N.E.A. provides a comfortable spot to take a stand. One museum
curator remarked to me how handily protesting the threat of N.E.A.
censorship obviated paying attention to the everyday censorship that
goes on in the bulwarks of culture. Every choice of an exhibition to
mount or a program to perform, of course, implies a decision not
to show or play something else. Such choices are powerfully subject

to forces emanating from donors and potential donors, corporate sponsors and the tastes of the sought-after audience. The most visible case is the deadly limitation of orchestral and opera repertories to a small number of works that can be depended on not to disturb listeners; it is well known that the playing of too much twentieth-century music, for instance, leads directly to a decline in ticket sales and diminished support. A more blatantly political example was the Boston Pops Orchestra's refusal to honor its contract for a performance by Vanessa Redgrave after her statements in favor of Palestinian claims to nationhood; a famous case from the land of modern art was the Guggenheim's cancellation of Hans Haacke's planned solo show in 1971 when the artist refused to withdraw three works judged "inappropriate" by the director of the museum.

The N.E.A. has indeed provided space at the margins which made life easier for many artists and provided an expansion of cultural production beyond that which would have been fostered by the market or private philanthropy alone. To take the case of theater, for example, while there were just fifty-six nonprofit theaters in the United States in 1965, there are more than 400 at present—and every Pulitzer Prize-winning play since 1976 has had its initial production at a nonprofit. Given the endowment's important role in direct arts financing and in stimulating private patronage (on average, N.E.A. funding brings with it three times as much in private and state moneys) in the mainstream as well as at the margins, the Helms amendment and its ilk have a chilling effect on artists and institutions. I am not qualified to judge whether restrictions such as those proposed by Helms are, as some lawyers claim, unconstitutional. But that is certainly political—it is the use of the state to foster some tastes at the expense of others—and it is certainly censorship. Lipman makes the issue clear: "In a free society, it is neither possible nor desirable to go very far [!] in prohibiting the private activities that inspire this outré art," he wrote apropos of Mapplethorpe. But, he continues, to believe that "because we are not compelled to witness what we as individuals find morally unacceptable, we cannot refuse to make it available for others" ignores the dreadful effects of "this decadence" on us and our children and "our responsibility for others." The president of the Massachusetts branch of Morality in Media put it more pithily: "People looking at these kind of pictures become addicts and spread AIDS."

This faith in the power of images for good or evil appears to involve a deep suspicion that seemingly decent Americans will be overwhelmed by dark forces within them that such images might

unleash. It is no accident that the assault on the N.E.A. gathered steam during the regime that produced the Meese Report on obscenity. The current denunciations of "filth" continue key aspects of the traditional discourse on pornography: When Helms displayed the offending Mapplethorpes to his colleagues in the Senate, he first asked that the room be cleared of women and children. Sexual imagery, however distasteful, is permissible as the private possession of (exclusive groups of) males. What has made pictures like Mapplethorpe's an issue is, in Kramer's words, "the demand that is now being made to accord these hitherto forbidden images the status of perfectly respectable works of art," thus eligible for exhibition in public institutions. Kramer, like other antipornographers, is no doubt fighting a losing battle; the principle of the free-enterprise system so loved by all the advocates of decency—we may note here the double celebrity of Charles Keating, once chief enemy of sin in Cincinnati and now defending his haul from the Lincoln savings and loan—that the customer is always right, leads ineluctably to the free flow of all categories of images throughout society. And art, having for centuries been a home of the erotic and (especially since the invention of photography) the documentary, is hardly likely to cease supplying images of powerful and fascinating sorts to publics seeking titillation, exaltation or even the shock of the horrific.

The argument that the state ought not to fund work repugnant to "community standards" is not a good one, since it rests on the idea of a homogeneous community, with clearly demarcated standards, which does not in fact exist. (This is of course a basic problem with the going legal definition of obscenity, even apart from that definition's dependence on such undefined concepts as an appeal to "prurient interest" and lack of serious "artistic value.") On the other hand, the argument that art should be allowed to develop freely typically rests (as in Oldenburg's formulation quoted above) on the assumption that the development of the arts represents an interest of "society"—a unified interest that also does not exist. Present-day society is made up not only of classes with antagonistic interests but of a multitude of groups whose differences are expressed in aesthetic as well as other terms. For this reason, the idea that there exists an aesthetic sphere untouched by social and political meaning is an ideological fiction, one recognized even in the muddled thinking of a would-be censor like Kramer. The problem is not that art has been politicized; the existence of state funding shows that the generally hidden political side of the arts has existed all along. The struggle over the N.E.A. is a struggle for control of this political side.

* * *

If the N.E.A. is eliminated or seriously restricted, the loss of funds will be a tragedy for many artists and art institutions, though a smaller one than the loss of school lunches or federally funded abortions taken away from other sectors of society as part of the same political effort. Despite the stimulus of this threat (and its so-far-piecemeal realization), it is not to be expected that many artists or the art business and its hangers-on will come out in clear opposition to the social order to which they must look for support. We can expect the next year to bring large helpings of explicitly political art, in many cases reflecting no great understanding of the nature of contemporary society but riding what is already visible as a new wave of "official"—shown, funded and collected—art. We may also see intelligent and effective political art, such as the exemplary work done (without benefit of government grants) by graphic artists associated with ACT UP. Other artists will continue to utilize and transform the resources of their mediums to explore and shape their experience in ways not explicitly political. For all concerned with the arts, however, the current struggle over funding constitutes a call to grapple with the political issues inherent in artworks and institutions.

Defending art and artists against both the know-nothings and the champions of Kramer's version of "the high purposes and moral grandeur" of art should lead us not to blind support of the N.E.A. but, for instance, to pondering its function as a facilitator of the aesthetic rituals of upper-class life. We might consider the use of cultural events as meeting places for politicians and businesspeople. We might take on the politics of the art world itself; as an editorial in *New Art Examiner* asked, "While it is necessary to rally the field against censorship by the right, why is it not necessary to rally the field against censorship by insiders? Why shouldn't we deal with the abuses of a closed panel system? Why shouldn't we examine the cronyism of organizations, artist's spaces, and publications, who year after year receive NEA funding, and who supply the NEA with peer review panel members and site visitors?" Short of radical social transformation, of course, few changes are to be expected in the workings of the institution of art. But the discussion opened up by Senator Helms and his friends can lead us to ponder the nature of the institution, and of the different roles that the arts could play for artists and publics seeking to redefine them and their place in social life.

For those of us who take a critical stance toward the existing social system, the Wildmons and Lipmans must be resisted—not, however, in the name of the myths of American democracy or the transcen-

dent value of art but simply in opposition to reaction. What is objectionable about the attacks on the Mapplethorpe exhibition, *Piss Christ*, Karen Finley et al. is not the injection of politics into the sacred precincts of art by a bunch of barbarians. It is the right-wing agenda itself—the call for austerity and the distrust of creativity in all spheres of life other than those of corporate profitability. Opposing this means the effort to explore, in analysis and, where possible, in practice, the complex relations of art to present-day society and to the possibility of changing it.

Sparked by the great N.E.A. debate, Margaret Spillane, who writes frequently about culture and human rights, offered this perspective on the hidden meanings of censorship.

—

THE CULTURE OF NARCISSISM

DECEMBER 10, 1990

Margaret Spillane

> *Do we not mystify the facts*
> *And milk the taxpayer of his tax*
> * By the illusion*
> *That our minds serve much higher ends*
> *Than bending backs and blistered hands?*
> *How much of common good depends*
> * On Education?*
> *—Seamus Heaney, "Verses for Fordham*
> *Commencement," 1982*

When some people say that the N.E.A. selection process in itself is censorship, they are wrong. Art is a profession and has experts, as do other areas. When one applies to a public university there are certain eligibility requirements of excellence. When people say the N.E.A. should end altogether and that private business should fund the arts, they are wrong. Big business uses the N.E.A. as a guideline in knowing who to give money to, by knowing who has gone through the distinguished process of the Endowment.
—Karen Finley, National Association of Artists' Organizations newsletter,
1990

SEVERAL WEEKS AGO, a body was found in my New Haven neighbor-hood. At 7:30 on that Friday morning, a custodian discovered the corpse of a young African-American woman on the asphalt behind Wilbur Cross High School; a single bullet had been fired through her head. At 8:30, Principal John Courtmanche made the grim an-nouncement to students over Wilbur Cross's P.A. system, while the local morning news announced the same story to all of New Haven. The next morning's paper provided her identity—Jacqueline Shaw, 21 years old, of 21 Kossuth Street—but no new information. And that was it. Not another word was said in the press or on television about who she was, no columnist meditated upon that round, ra-diant face appearing in her postage-stamp-sized obit photo.

In fact, for whatever police-blotter reason Shaw might have been killed, her murder was also her punishment for being a woman, as the condition of her corpse clearly displayed. Her shirt was yanked up over her face, all garments below the waist were gone, a handful of twenty-dollar bills were sandwiched between her thighs and more money stuffed into her clenched hand. This part of the story went unreported in the press.

The frequency with which the corpses of female homicide victims undergo some ritualized post-mortem degradation is common knowledge among police officers and hospital morgue personnel. Such degradation committed upon the bodies of living women is even more frequent. This is one of several reasons why I was certain, before I had ever seen "We Keep Our Victims Ready," that Karen Finley was taking on a vital and courageous task. When right-wing columnists Evans and Novak took sneering exception to that "chocolate-smeared woman," I knew that Finley was sending seismic shocks through those secure walls of denial and domination behind which woman-beaters carry out their favorite form of self-expression. Finley's chocolate-smearing sounded like no mere symbol, but straightforward social realism.

With that in mind I was willing to put up with the cute *épater le bourgeois* chitchat with which Finley opened her piece. I thought, No doubt she is making a serious effort to navigate her mostly white educated audience away from the safe ground of their conventional aesthetic expectations to far more perilous places. If she indulges herself and her audience a little, it's not the end of the world.

At one point Finley provided just the sort of revolutionary ground I'd been waiting for. Standing in a ruby-red merry-widow corset, she talked about the availability of takeout containers of Jell-O from corner convenience stores. She held two such containers aloft, then unceremoniously dumped the contents of each into the cups of her

bra. Finley nonchalantly strolled the stage while her Jell-O breasts jiggled with a life of their own. Like Chaplin's wrench in *Modern Times,* Finley's breasts become hilariously emblematic of the way a perfectly safe, normal element of everyday life can be transformed, in a culture of domination, into something whose meaning and destiny are controlled by outside forces.

But what was on both sides of that episode was awful. The awfulness had nothing to do with denunciations from the pulpit of right-wing journalism or censorship by decree of the National Endowment for the Arts. The truly unpleasant surprise about Finley's performance was its utterly conventional treatment of her subject matter. All the controversy seemed to promise a bare-knuckled assault on those barriers separating the privileged from the powerless. But while she seemed poised to indict the short-shrift chronicling of atrocity typified in the coverage of Jacqueline Shaw's murder, Finley presented a laundry-list, headline-formula reading of contemporary horrors. The individual victims she promised to evoke—the battered child, the exploited female service worker, the person with AIDS—turned out to be carelessly assembled amalgams of bourgeois American's cultural shorthand for those they believe exist beneath them. "Southern" accents at times suggested sadistic white male supremacists, at other times work-wearied women, and at still other times fulsome, ridiculous Bible-punchers. Then there were nonspecific "blue collar" women's accents, with none of the music of neighborhood or ethnicity but all of the stereotypes of gum-chewing and bad grammar.

This could have been written off as a disappointing evening at the theater. But Jesse Helms, John Frohnmayer and her own publicity machine have made Karen Finley a symbol. The arts community in general sees Finley and the other three artists who were denied N.E.A. grants as symbols of right-wing censorship. And so they are. But Finley also symbolizes—and collaborates in—censorship of a different sort, censorship that ought to be pondered by anyone concerned about the politics of art and the relationship of the arts community to the broader community. She is emblematic of the art-making population's troublingly restricted notion of who its audience needs to be, and its equally troubling lack of alarm at who is being entirely left out of the art-making,-consuming and-rewarding tracks.

It is easy to identify censorship when someone stands up in Congress and says that the creation of artistic works by certain sectors of the population will not be funded by the government. But no liberal defender of arts funding has seized this excellent opportunity

to ask the most jarring questions of all: Who gets to make art; who even gets to imagine that they might become an artist? And who gets to have their story told through art?

Finley and three other artists got their grants cut by the N.E.A. specifically because their work contained representations of their minority cultures: lesbian, gay and confrontational feminist. But as their cases demonstrate, it's entirely possible to be a member of an oppressed minority and still participate in the privileges of the dominant culture. As white middle-class artists, they must begin to recognize the fact that they occupy a privileged place within the reward system.

If arts journalist Cindy Carr is to be believed, most white middle-class artists accept as natural their place within the networking, promoting and rewarding system. Carr, a *Village Voice* staff member who sits on peer-review panels, provides disturbing testimony of the degree to which contemporary artists have felt immune from any responsibility to examine their corporate-funded dollars for any traces of blood. "In more innocent times, vanguard artists theorized and fantasized about integrating art with life. . . . [Nowadays] all of us are being faced with ethical questions we've never had to think about before. These days, along with their usual worry (how to get money), artists and presenters must add a new worry (whether to *take* the money)."

One wonders how those so quick to express moral outrage when they feel their own rights are violated could have felt so comfortable all those years taking multinational funny money. One longtime and generous contributor to the arts, United Technologies, builds attack helicopters used in Central America. Another generous funder, Philip Morris, has for some years now been aggressively dumping on the Third World the high-tar cigarettes health-conscious Americans have abandoned. And the list goes on. Karen Finley herself, if the quotation above is any indication, understands the hand-in-glove relationship between Big Business and the endowment but utterly fails to question how the very crimes she rails against are created by those corporate patrons whose approbation she hopes to enjoy.

The status of these artists in the reward system makes them members of the affluent class of Caucasians serviced by both the N.E.A. and corporate donors—the Arts Producers and Consumers, or ArtPAC. It's a far cry from those radical artists—painters, poets, composers, actors, playwrights—associated with the Works Progress Administration in the 1930s, who saw government support as a way of integrating the work of artists into the rest of the working commu-

nity. Artists were treated as salaried workers and paid out of the same budget as bridge builders and road crews. Unlike the W.P.A. artists, who imagined art itself as drawn from and returned to the broad stream of American life, ArtPAC elects to converse, select and reward within its own small pool, ratifying and perpetuating its community with peer-review panels drawn from its own ranks.

ArtPAC's specialized, class-bound notion of Those Who Know What Art Is—and those who get to make and judge that art—persistently undermines confidence in the popular creative spirit. What's more, the whole process of art making gets sealed off into a realm of magical, inscrutable secrets. To demonstrate what an effective bludgeon such mystification makes, let's look at the degree of intimidation felt by jurors in Cincinnati's Mapplethorpe obscenity trial. Interviewed after the trial, a number of jurors displayed profound mistrust of their own abilities to observe and analyze. Art is simply a subject on which they feel totally disqualified from holding any opinion, they explained, so they relied entirely on the expert witnesses called by the defense. No arts journalist or First Amendment expert seemed to find that irregular—even though similarly constituted juries make decisions on biological engineering, nuclear-waste disposal and transnational corporate mergers.

To even the most socially conscious members of ArtPAC, such admissions aren't evidence that there is something radically wrong with how and to whom contemporary American art speaks: It is simply a matter of taste, an example of the wonderful "diversity" that exists out there in America. Some people go to museums, they reason, and some people go to tractor pulls—and neither should presume to tell the other which is superior. This cultural laissez-faire attitude was probably best summed up by the late painter Jack Tworkov, who mused, "Those who enjoy baseball are lucky."

That is why someone like Finley can slap together a crude, broad-voweled bray, an occasional Southern twang and the revival-tent punctuation of a "Yea-uh!" to insure that both ArtPAC's journalistic chorus and audience are amply satisfied with her social commitment. The satisfaction that the performance community on both sides of the footlights has demonstrated for this dashed-off, broad-stroke portrait of The People cries out for an adaptation of "The Emperor's New Clothes" in which a child speaks clearly from the back of the theater, "But they aren't *saying* anything!"

Finley's superficial depiction of working people is, again, only one example of the broad condescension displayed by ArtPAC. Not long ago I received a mailing from the National Association of Artists'

Organizations. Over the text of the N.E.A. anti-obscenity clause was emblazoned an American flag and the slogan, "Don't Sound Like America to Me." This is ArtPAC's idea of wrapping itself in the same flag that good ol' Americans love: Real Americans, it knows, are as ungrammatical as they are true blue. Real Americans may not know what art is—only peer-review panels and downtown audiences enjoy that privilege—but they shuuur know censorship when they smell it.

Clearly, alienation from ArtPAC is real—and well deserved. People in communities from East St. Louis to Staten Island sense that their lives and opinions are uninteresting to arts-world decision makers. Their rage was there long before it was tapped by tax-exempt right-wing churches. Is ArtPAC, when it assails these institutions as enemies of the First Amendment, going to continue to condescendingly characterize those anti-N.E.A. letter-writing citizens as dupes while it ignores the genuine exclusion they feel? I wrote support-the-N.E.A. letters to my senators and Congressman in the lobby of Manhattan's Public Theater: While I had been sitting in the audience at the end of a performance of George C. Wolfe's *Spunk*, actress Danitra Vance came forward on the stage and urged people to write to legislators before they left the theater. Does that make me a dupe of Danitra?

Here is a golden opportunity for America's arts community to pause and meditate upon the reasons why such antipathy has flourished beyond their pale, and to learn some respect for that vast majority that's not the usual audience for art.

The arts community must also be concerned with the censorship that happens to people who are not artists, because there is absolutely no vocabulary in their environment to describe that aspiration. It's the experience I once heard James Baldwin describe about his early life: "Growing up in a certain kind of poverty is growing up in a certain kind of silence." You cannot name the sensations, fears, injustices and simple facts of daily life because "no one corroborates it. Reality becomes unreal because no one experiences it but you." When the young Baldwin read Richard Wright, he experienced the first shock of corroboration: "Life was made bearable by Richard Wright's testimony. When circumstances are made real by another's testimony, it becomes possible to envision change." People who grow up in that kind of silence don't know about the existence of a network of grant-giving, rewards-distributing, show/performance/publication/exhibition-sponsoring colleague-rallying ratification.

Like Baldwin before his Wright epiphany, they never see an art describing what they eat, how they sleep, what they dream about, what they fear, what might help them see their way to gather strength. The heartwarming mythology of the American culture industry is that working-class and ethnic artists "emerge" out of their "pasts"—leaving behind all that the culturati consider cheap and ignorant, and striving to find their place in the understanding community of other artists. While plenty of artists act out the swagger of "working-class" macho as a battle against the effete, they really don't care to do the slow, attentive, frustrating excavation through all the heaped-up rubble of history beneath which so many poetic voices lie buried.

It is certainly true that great and successful artists like Baldwin emerge from that silence. But as the novelist and lesbian activist Sarah Schulman wrote recently in *Outweek*, "For any minority artist, part of being admitted to the reward system is that while the benefits are great for the individual, the price for the community is tokenism. . . . [A] single style is declared to be representative of a hugely diverse community that it cannot represent." In fact, says Schulman— who cites her own success as an example—the token artist's isolated acclaim helps "keep other voices from the public arena."

Tokenism may be a strange charge to level at an ArtPAC which throughout the N.E.A. struggle has spoken regularly about multiculturalism. But this comes from a community that so far has interpreted censorship to mean denial of N.E.A. grants to their current and familiar recipients. Artists under attack for being lesbian, gay or feminist can only honestly and effectively articulate their position as silenced citizens by situating themselves squarely within that larger history of silences in America, both past and present.

In the most practical terms, those who have benefited from the reward system must relinquish their presumption to privilege in favor of those the reward system has traditionally excluded. Schulman has proposed reconstituting the N.E.A.'s peer panels so that 80 percent of their members are drawn from traditionally marginalized or excluded communities. That might be a start.

Meanwhile, performance artists searching for a role model might consider the work of Franca Rame, the radical Italian playwright and actress. Like downtown artists such as Karen Finley, Rame specializes in the one-woman play in which she herself is the performer. The difference between Rame and these performance artists lies in the broad audience she achieves and direct content

she provides. Rame performs in conventional theaters and in union halls, on television and in stadiums. In her "Tutta Casa, Letto e Chiesa," for example, Rame presents a serious, hilarious and sometimes devastating look into the minute-to-minute limitations, responsibilities and exasperations of a working-class woman. Her character must maintain heroic stamina to deal with endless incursions of boss, husband, men in the street, children and appliances upon her life. Rame has also made theater out of a horrific event: the night she was abducted from the street by far-right-wing thugs and brutally gang-raped. She spares nothing of the humiliation, the sexual slurs, the cigarette burns to her thighs. Rame has forged her own agony into a passionate social declaration: Those unspeakable details of a woman's brutalization, which a censorious society would quickly close the lid upon and bury, Rame propels into the spotlight of the stage.

Jacqueline Shaw will never be able to tell what unspeakable things were done to *her* soul and body before that bullet was fired through her brain. Even if she hadn't been murdered, it's unlikely we would ever have heard about the details of her life. She belonged to that large group of American citizens who neither get to tell their stories nor get their stories told. Any battle against censorship that fails to clamor in outrage against this massive smothering of voices has already torpedoed its own cause with narcissism.

In the same chilly cultural climate, Christopher Hitchens paid a visit to a re-creation of the infamous "Degenerate Art" exhibit of the 1930s.

—

MINORITY REPORT

FEBRUARY 17, 1992

Christopher Hitchens

DESCRIBING A RIOT of vicious Oxford upper-class "hearties" against weedy "aesthetes" in his *Decline and Fall*, Evelyn Waugh depicted the mob as it "tore up Mr. Partridge's sheets, and threw the Matisse into his water jug; Mr. Sanders had nothing to break except his windows, but they found the manuscript at which he had been working for the Newdigate Prize Poem, and had great fun with that."

The image came back to me after visiting an exhibition titled "Degenerate Art," which detailed the fate of the avant-garde in Nazi

Germany and which made its way, via Los Angeles and Washington, around the country before moving on to Berlin. Here were paintings and sculptures that the Hitlerites themselves had once exhibited, like carcasses on hooks and without their cultural context, to gratify the philistinism of an outraged public. Even the word for art was placed in heavily sarcastic inverted commas (*Entartete "Kunst"*) on the 1937 advertising posters, as if to confirm the opinion of any *Kleinburger* who has ever said, "Call this art? My 3-year-old could do better."

The original exhibit was the result of organized theft from German museums, presided over by something called the Ziegler Commission, which was appointed by Goebbels. Count Klaus von Baudissin was one of its members—he had distinguished himself by cleansing the museum in Essen of "offensive" modern art—and it was his figure that reminded me of the saturnalia of Yahooism sketched by Waugh. What fun they must have had!

When this exhibit opened in Washington last fall, the responsible newspapers and critics cautioned us at once. It was a fine and sobering thing, they said, to see the extent of pillage and desecration inflicted upon German culture by the National Socialists. No doubt some facile people would try to draw parallels between this and the mean, stupid campaign of Jesse Helms and others against the National Endowment for the Arts. On no account was one to fall for anything as propagandistic as that comparison. I went to the gallery with an almost prophylactic reluctance to make any such trite analogy.

But the interesting thing is the near-perfect symmetry between the Nazi critique of modernism and the American chauvinist one. Once Goebbels had made his two general critiques of modern art—which were that it was "incomprehensible and elitist" and that art criticism should therefore be forbidden because it stood in the way of a healthy public making up its own mind—and once Hitler at Nuremberg had warned that "anyone who seeks the new for its own sake strays all too easily into the realm of folly," certain specific offenses began to be defined. Among those were: "Insolent Mockery of the Divine"; "Deliberate Sabotage of National Defense"; "An Insult to German Womanhood"; and "Crazy at Any Price," a reflection of the Nazi loathing of psychoanalysis. By those criteria, Ludwig Gies' *Kruzifixus* carving, for example, was twice damned. First, because it threw Calvary in the spectator's face as few things had since the painting of Grünewald, and, second, because it had been used as a First World War memorial in Lübeck.

Like most people who hadn't seen his work before, I came out

of the exhibition wanting to know more about Otto Dix. His etching series "Der Krieg" alone was worth the price of the ticket, and a Berlin retrospective of his stuff, which I have since visited, is on its way to these shores and must be seen at any cost. Although he was associated with the Dada school, his work on the trenches and gas warfare makes even the most untutored critic say "Goya" almost at once. It is interesting to learn that the young Konrad Adenauer, later the conservative hero of the cold war, stopped the acquisition of Dix by a museum in Cologne as early as 1925. Like the rest of the German right—like the right at all times and in all places— Adenauer could not tolerate attacks on religion or anything else that might lead to the questioning of blood sacrifice in war. Once let that happen and there would be free love and legal homosexuality. This overt and latent connection is present throughout the "Degenerate Art" exhibit, which is particularly obsessed with "family values" and gay life, and quite warrants the contemporary connection that we are not supposed to be making.

So does the red sticker affixed by the Nazi philistines to many of the purloined artifacts. *Bezahlt von den Steuergroschen des arbeitenden deutschen Volkes*, it reads. "Paid for by the taxes of the German working people." Of course, there's nothing like the inciting phrase "taxpayers' money."

E.M. Forster gave two lectures on Nazism in which he correctly pointed out that you had to see what the Nazis had done to Germany if you wanted to imagine what they would do to "us." I had expected the exhibition to be heavily racist and nationalist, which it was, but not in the way I had anticipated. Most of the artists who were held up to hatred in the *Entartete "Kunst"* campaign were, so to say, "pure" Germans, accused of race treason by virtue of their attitudes to war, piety, morality and loyalty. Only six of the 112 artists in the exhibition were Jewish.

Perhaps that's less surprising at a second consideration, since the author of the concept of *Entartung* ("Degeneration") in German and Western culture was Max Nordau, who published a windy and nasty book by that name in 1892. Ridiculing the Symbolists as much as the Pre-Raphaelites, Zola as much as Ibsen, Nordau asserted the superiority of the Germanic culture and wrote that a breakdown was coming, which meant: "To the voluptuary, unbridled lewdness and the unchaining of the beast in man. To the withered heart of the egotist, disdain of all consideration for his fellow-men. . . . To the believer it meant the repudiation of dogma, the negation of a supersensuous world. To the sensitive nature, yearning for aesthetic thrills, it meant the vanishing of ideals in art." George Bernard Shaw

wrote quite a lampoon on Nordau, mocking him and saying, "This theory of his is, at bottom, nothing but the familiar delusion that the world is going to the dogs." Disappointed as a cultural critic, Nordau went on to become, with Herzl, one of the founders of political Zionism. I have no idea how the Nazis reconciled their annexation of his concept of degeneracy, but it teaches one to beware strenuous art critics who know what they like.

Veteran reporter John L. Hess covered the Metropolitan Museum (and its accompanying scandals) for the New York Times *in the 1970s and wrote* The Grand Acquisitors, *a chronicle of Thomas Hoving's controversial tenure as director of the museum. Here he reviews Hoving's* Making the Mummies Dance.

—

LYING AT THE MET

FEBRUARY 8, 1993

John L. Hess

DIGGING WEARILY THROUGH this midden heap of mendacity, I was struck by how much Tom Hoving has in common with Donald Trump. Their tales about the art of the deal and the deal in the art can teach us a lot about the times we live in, provided we don't believe a word they say.

In a preliminary volume of his autohagiography, *King of the Confessors* (1981), Hoving, former director of the Met, boasted about lying "smoothly and amiably" to get his first job there. "I had always been able to lie convincingly and without hesitation," he explained. Convincingly? Compulsively would be better, as illustrated by an incident that he now recounts this way:

The *Times*, in a stunningly good piece of investigative reporting, rooted out the half-forgotten Ingres *Odalisque* in Paris and cast our on-and-off deal with [art dealer] Wildenstein as a classic case of clandestine art shenanigans. The painting was rushed back to the museum—to dead storage.

The truth is less flattering to *The New York Times* and to me, the reporter involved, but more amusing. Early in 1972 critic John Canaday had reported that the Met was secretly peddling a dozen im-

portant French paintings. Arthur Ochs Sulzberger, the publisher, gave equal space to Hoving and then to C. Douglas Dillon, the museum's president, to deny everything, including Canaday's integrity. This was especially remarkable because Sulzberger was a member of the trustees' committee that had "deaccessioned" the paintings Canaday had named, and scores more that he did not yet know about.

Among the latter was the "Odalisque," one of the Met's best-known objects. Acting on a tip (or should I say, following a stunning investigation?), I asked Hoving where it was. He replied, smoothly and amiably, "It's none of your business." When I demurred, he became abusive about the *Times*, Canaday, and me, said the painting had suddenly looked dubious and been sent to an expert for study and finally, "We believe that the painting is not by the master."

The story in the *Times* next morning hit the Wildensteins like a bombshell. The Ingres had an impeccable pedigree, and they already had, so I heard, found a Japanese buyer. Now it was tainted and they were forced to return it to the Met, where it went, not to dead storage but back on the wall, pusillanimously labeled "Ingres and Workshop."

The museum was less lucky with regard to a Van Gogh, a Douanier Rousseau and many other works that Hoving had secretly sold to selected parties at prices often far below the market—not to mention two irreplaceable collections of ancient coins that were dispersed at auction, to finance the purchase of the million-dollar Euphronios krater. Nicholas Gage of the *Times* revealed that the vase had come from an illegal dig in Italy. Now, nearly twenty years later, Hoving says he never doubted that, and he mocks the fantastic story that the Met and its accomplices tried to peddle at the time.

All that was fun and games, and nobody cared much except archeologists. They considered that the Met's display of ruthless greed and the record price it had paid—many times more than had ever been paid before for a Greek vase—would be a huge incitement to more plundering. But buying dear was central to Hoving's policy. He describes an epiphany at a meeting of the Acquisitions Committee. Members dozed as curators presented small items they wanted to buy. "Why bother? I thought." Then a $100,000 acquisition was proposed. "The trustees beamed. So did I. I had suddenly experienced a minor revelation. The hell with dribs and drabs. . . . From then on I'd acquire only the rare, fantastic pieces, the expensive ones, the ones that would cause a splash."

Later Hoving recounts a story about Norton Simon, the billionaire collector, bidding against himself at an auction but not quite topping the record price for a Rembrandt, which had been set by

the Met. Elsewhere, Hoving says that he himself doubled, and doubled again, his own offer for a church lectern, each of which offers had enchanted the seller. His motive, so he says, was to jack up the price to forestall a possible British effort to keep the piece in England. "My collecting style was pure piracy," he boasts, "and I got a reputation as a shark."

One of his early splashes as director was his purchase of a Monet at a then-record price of $1.4 million. "I had stumbled on the masterpiece in 1960," he cannot help saying, though it was shown that year at the Museum of Modern Art and was the top item at the Christie's sale where he bought it. His account of his surreptitious discovery of the picture and the rapture he underwent echoes the fable of the ivory cross that he peddled to John McPhee for *The New Yorker*, then told in a different version in *King of the Confessors*, and now embroiders with a new detail in *Mummies*. The banal truth is that young Hoving had been sent with a chaperone to buy a fine bit of medieval carving that had been widely offered but spurned because it was almost certainly Nazi war loot. Also, scholars question Hoving's identification of it. But it made a good yarn, or yarns, and the price was right: $600,000. The British Museum had just turned it down for $500,000.

For the Met's trustees, who were a cross section of the pinnacle of the financial establishment, high prices were a confirmation of quality, and the shady origin of acquisitions lent a sense of romance and imperial potency. Hoving boasts here of smuggling, of buying stolen treasures, of bribing foreign custodians, of complicity in tax frauds by donors of art at artificially inflated prices. Safely covered by the statute of limitations, he brags of faking missions abroad to justify luxury travel by himself and a crony, including the services of museum staff women and "pricey call girls." Since he had just fired a curator (whom he now names) for embezzlement, he says this was "naked hypocrisy" but "glorious fun." (He was and is married, but among the better orders the rules seem to be different. In the circles where his wealthy parents lived, he remarks in passing, "wife-swapping was the game of choice"—and they played.)

During the days when Donald Trump's *Art of the Deal* topped the best-seller list, its author was widely viewed as an admirable symbol of the go-go eighties; bankers and pretty women were eager to serve him and he was mentioned as a likely prospect for high office. Hoving in his heyday at the Met could be seen as a symbol of the go-go seventies and could seriously consider a future in politics. We have seen less gifted practitioners of hype than those two go farther.

To finance a vast campaign of splash, Hoving and his trustees

sold art, misappropriated bequests, imposed admission fees and cut the numbers of the wretchedly paid staff by nearly 10 percent. Hoving writes that he won his appointment as director in 1967 by scaring the trustees about the threat of unionization and an impending prosecution for sex discrimination. Actually, those crises arose years later. He crushed the union effort, in part by firing two leaders. He says he knew it was illegal and he would have to take them back, but it was "excellent business." The women's suit was settled by a compromise.

Squeezing bucks from the near-bankrupt City of New York appears to have been a breeze for these mendicants. Hoving says that as soon as he was ending his brief tenure as Parks Commissioner to rejoin the Met, he arranged to beef up the city's contribution. Warned that this looked like a conflict of interest, he retorted, "Who'll stop me?" Or so he says. In any case, city officials staunchly defended him during the scandals that marked his tenure at the Met, notably his seizure of a swatch of Central Park for expansion on what he now gleefully calls spurious legal grounds.

Especially vocal in Hoving's defense was his successor as Parks Commissioner, August Heckscher, whom he now characterizes as a "putz." Hardly anybody who ever befriended Hoving escapes such recompense. This is more tedious in the book than it may sound in summary here, and it is likely to be more meaningful to psychiatrists than to lay readers, but it is perhaps significant that Hoving devotes a chapter to describing himself as a "toady," spending months aboard the yacht of the trustee Charles Wrightsman, whom he now calls "a nasty son of a bitch" and "a drunken, foul-mouthed roughneck," who cheated at polo besides.

Hoving has just described his devoted sponsor, former Met director James Rorimer, as a pompous, stuffy, arrogant, jealous, conniving man. Now he adds that Rorimer's death was hastened by the criticism of "crazy" and "evil" Roland Redmond, who was the only trustee to stand forthrightly for law and restraint during Hoving's reign. Nabobs who supported Hoving are here described as "vapid," "cheap," "a vulgar bastard," "slightly scatterbrained" and "strictly an opportunist." One of them made his private curator trim his toenails. And so on. Hoving is just as hard on his staff supporters—but enough.

Any overview of the goings-on at the Met in that era is perforce obscured by the magnificence of its collections, the scope of its expansion and the dazzle of blockbuster exhibitions. There is much to criticize and much left to admire. Judging all that is beyond my scope and, rather oddly, does not seem to interest Hoving very much

anymore. If it ever did, that is. "I wanted to be accepted into the prestige and power of the Metropolitan far more than I really cared about the institution," he says early on. He'd have done well to end his book there.

In 1994 the Russian émigré artists Komar and Melamid teamed up with The Nation Institute to conduct "market research" on what Americans want from art. They hired the professional polling firm Marttila and Kiley to conduct a scientific survey of 1,001 Americans. The results indicated that "America's Most Wanted Painting" was a predominantly blue landscape, roughly the size of a dishwasher, featuring wild animals and people, famous and ordinary, fully clothed. The dissemination of the poll (featured in a special issue of The Nation *as well as in numerous press reports around the country) inspired much puzzlement and debate. Respondents were asked questions like: "If you were given the choice of a gift—a sum of money or a piece of art that you genuinely liked and that was of equal value to the money—which would you choose?" (Fifty-seven percent said they would take the money.)*

Was it all a joke? Should art be produced in response to consumer research, or was there something deeply serious behind the humor? Some of the results are featured below.

—

Painting by Numbers:
The Search for a People's Art

March 14, 1994

Komar and Melamid

COLORS & CONVENTIONS

Blue, by far America's favorite color (44%), is most appealing to people in the Central states (50%) between 40 and 49 years of age (49%), conservative (47%), white (46%), male (45%), making $30,000–$40,000 (50%), who are not sure if they'd take the art or the money (51%) and who don't go to museums at all (50%).

The appeal of bluc decreases as the level of education increases: 48% of people with high school education or less like blue, as against 34% of postgraduates.

The appeal of red—favored by 11% of Americans—increases with education level: 9% of those with high school or less like red, as against 14% of postgraduates.

Red does best among people in the Northeast (15%). It does better among liberals than conservatives (14% vs. 9%).

Conservatives prefer pink/rose a bit more than liberals (4% vs. 2%), and moderates prefer gray a bit more than either liberals or conservatives (3% vs. 1%).

The appeal of black increases as income drops: people making less than $20,000 are almost three times as likely to prefer black as those with incomes over $75,000.

The appeal of green increases with income: people making more than $75,000 are three times as likely to prefer green as those who make less than $20,000.

DIFFERENCE IN THE DETAILS

Blacks read more than any other group: 88% vs. 85% of Hispanics, 83% of whites.

Women read more than men (86% vs. 81%).

Hispanics paint, draw or do graphic arts more than any other group: 44% vs. 26% of blacks, 23% of whites.

Whites garden more than any other group: 55% vs. 45% of blacks, 47% of Hispanics.

People describing themselves as Asian, Middle Eastern or "other" are most inclined to take art over money if given a choice (48% vs. 35% of all respondents).

As people get older, they prefer paler shades of color in paintings that are smaller and simpler. With age also comes greater desire

for brush strokes, soft curves, whimsical designs and people fully clothed. But age is most decisive in the preference for domestic animals: 44% of people 65 and older like paintings with pets, as against 27% of all respondents.

LIBERALS VS. CONSERVATIVES

Liberals dance more (42% vs. 30%)

They also read books a bit more (86% vs. 81%), tend to have art in the home more (82% vs. 75%), tend to like modern styles more (33% vs. 21%) and traditional styles less (55% vs. 71%), and are more likely to choose the artist as a dinner companion (20% vs. 11%).

More liberals prefer pictures that aren't related to religion (71% vs. 59%).

More liberals prefer imaginary objects (40% vs. 31%), while more conservatives prefer exaggerations of real-world objects (56% vs. 47%).

And more liberals prefer nudes (6% vs. 1%).

Given a choice between art or money, more liberals would take the art (44% vs. 30%); more conservatives would take the money (65% vs. 51%).

FROM THE FOCUS GROUPS

"My whole childhood was bathed in blue."

"Someone gave me a car. It was a brown car, and I never drove it. Maybe it was because I didn't like the color."

"My art is a nice car or a nice pair of gym shoes, I wouldn't know anything about 'abstract' or whatever."

"I like what I understand, and even sometimes when I don't understand it, I like it."

"I can't stand a real scene. I want my art to reflect that which is not real."

"I have mixed feelings about art and have absolutely no interest in learning anything more about it."

"I don't think you can sit at a table and ask people what they want. The entire concept . . . is ludicrous. Then you're not an artist."

"He should be nude. He should be 6 foot 4."

"Art is the spiritual side of man. Its purpose is freedom."

"I don't own any paintings. The things I see in stores are things I can't afford—and I never settle."

MONEY TALKS

Those who make less than $30,000 a year and those in the smallest minority groups score highest (about 74%) on the question of whether people should have a say in public art.

Those who make over $75,000 a year score lowest (54%) on this question and highest among those who think the public should have no say in such matters (42%).

QUESTIONS FROM THE POLL

73. Which one of the following would be most important to you in deciding how much money you would spend on a painting:

The size of the piece	3%
The fame of the artist	7
The medium, such as oil paints, watercolors, or charcoal drawings	5
The degree to which you like the painting	62
Whether or not you think it will increase in value	16
(Depends)	4
(Not sure)	3

74. What is the most amount of money you would consider spending on a piece of art you really like?

$25–50	20%

$50–100	27
$200–500	28
$500–1000	9
$1000–$3000	3
Over $3000	5
(Not sure)	8

Now I'm going to read the names of some prominent artists of the past and present. For each name I mention, please tell me if your impressions of that artist's work are very favorable, favorable, unfavorable, or very unfavorable. Some of these artists are not very well known, so if you have never heard of someone, or don't know enough about his work to have an opinion, just say so.

	Very fav	Fav	Unfav	Very unfav	Never heard	Don't know
75. Pablo Picasso	20%	45	14	5	5	11
76. Norman Rockwell	43%	38	5	2	6	6
77. Jackson Pollock	4%	11	6	1	49	28
78. Salvador Dali	9%	23	12	5	31	20
79. Leroy Neiman	5%	20	7	3	40	26
80. Claude Monet	24%	33	4	1	21	16
81. Rembrandt	32%	46	5	1	6	8
82. Andy Warhol	9%	24	21	12	18	16
83. Georgia O'Keeffe	11%	19	3	2	39	26

EXCERPTS FROM AN INTERVIEW WITH ALEX MELAMID

NATION: And how do you respond to people who say the public just doesn't know enough about art to be an adequate judge? Because that's something we heard expressed even by some people who were involved in this poll.

ALEXANDER MELADID: I think it's the wrong premise—which is still in fine arts and the visual arts, and not in almost any other art form—that we need some special historical knowledge in order to appreciate art and make art. Just look at music, all this great American music. People don't know notation and still they create fantastic music. But we ask the people who create art to know a lot about art. I don't think it's necessary; everyone knows about art enough, because we're surrounded. The decoration over here on the wall, all

the architecture, reproductions in magazines—it's all over. Everyone knows enough about art now to use their own judgment. Even if we want to know more, it's the wrong premise. In the poll we have this question, How often do you go to museums? Maybe it's interesting, but as a measurement—if you go to the museums or don't go to the museums—it has nothing to do with our work here. A museum is an institution. You can believe in God without visiting churches. And that's very important: You don't know about religion, you don't know about how many times you go to church, but still you believe. In the poll we use the word "art" as little as possible, because this word rings the wrong bell. It scares people who think they don't know.

What we need is to create a real pop art, a real art of the people, like the music. Because classical music still lingers on—John Cage, something like this. But the country lives on the pop star. And the hip-hop, rock, that's the greatest thing in the world. We need to make art like these people. We have to learn how they work. That's what is an artist. I want to work like those kids from the ghetto. They know a lot about music—it's not that they don't know. But there is no special knowledge involved. It's true that everyone has a talent. You can pick up a kid from the ghetto—if he is talented, whatever, he can express himself, be a famous, great musician. So why not in art?

N: Do you think people in the art world, some of them, will be horrified and upset by this poll, this referendum on art?
AM: Oh, sure, definitely. Because the art world exists on the belief that there's a real great art. I heard once [New York gallery owner] Mary Boone at some seminar say she chooses art because of the quality—and when she sees really good art she makes her decision. I don't believe in this. What is quality, how should we define this quality? Of course she doesn't define, but she believes that there is something inside of the picture which can be qualified as a quality, which from my point of view you cannot say in the modern art. Modernism lived on the idea that art should be new. In the sixties the idea was that something which hasn't been said before, because it's said therefore it's good. There was a very strong idea of what is good and what is bad. And art was judged by this criterion, which is quite a good criterion. Now we're in postmodern times, so we say that we repeat ourselves, and this criterion just collapsed, so then what? Why this artist, not that artist? Why Schnabel is a good artist? Who can tell? I don't know. Can be good, can be bad, but there is no objective truth.

This is the crisis of modernism. Modern art used to reflect a rad-
ical way of thinking. It did this until World War II and then it grad-
ually became more and more established. Eventually, the radical
thinking was totally removed from this. People adapted to this, said
O.K. let there be, say, triangles. But in the beginning painting tri-
angles was a huge statement, a daredevil act—for good or for worse
that's a different story, but that's how it was. But now it's totally
changed its meaning because it's just a bourgeois business. You pro-
duce pictures and you sell them. You keep the form—you can play
with triangles endlessly—but the meaning is lost, so it's a perversion
of the intention of modernism. And nobody cares. The same thing
happened with academic painting and ancient history. Nobody be-
lieved in it anymore, nobody cared, but still they went on depicting
these beautiful women, these mythological figures. But it was totally
obsolete. It lost the common sense; it lost touch with the people.
Modernism was the idea to get back to some sense. Now it is sense-
less, so we have to revise again. And even the idea that art irritates
or angers the people, it's very nice because it captures the people.
You have some communication; even negative communication is
better than no communication at all.

N: But do you think that in America it's not that dissimilar from the Soviet
Union, only here the commissars are the collectors and curators?
AM: Yeah, sure. But you know, that's interesting. I just came back
from Germany and was stunned by the difference between the Eu-
ropean culture and the American culture. In America, the best
which has been produced in culture came from the bottom of so-
ciety. Like music—the greatest musicians of the twentieth century
were illiterate; they couldn't read music. Just the opposite of what
the good European art is. In Europe, basically the aristocrats—by
blood before and now by spirit or by education—invent the culture,
and then they impose this culture on the people. Here it always
worked differently, except in fine arts, which is working the same
way as it is in Europe. Still, these aristocrats of spirit impose their
ideas on people. That's why fine art is the least important cultural
thing in America.

N: What's the role of the collector?
AM: That's another part of why we started this project. I met many
big collectors. Ninety-nine percent of them were either really stupid,
illiterate people or just vicious people. There were some exceptions,
but really very few. And I was wondering, why do you need to be
vicious and stupid to buy art? What—it's one of the requirements

of the whole business? Or can you be smart and buy it? Because the smart people are true exceptions in this field. I know this quite well, because I've been quite many years in this system. I read about one of the greatest collectors of Russia, who collected first all these Impressionists; and early Picasso, Matisse, and he assembled the greatest collection ever. And he was an idiot! So maybe it is a requirement.

But as far as I understand it, here in America there are several types of collectors. Some are just Collectors; they can collect watches or books or pipes, smoking pipes, or collect art. There's no difference; it's a passion and it has nothing to do with art. And the other big group who collects does it because it gives them a certain entrance to the social big events, museums. All of the museums in the United States exist only to serve these people. There's a secret life of the museums. These people, the rich people, the people in power, they build their castles, which are called museums. And the real life of the museum is not the time when the visitors are there; no, the real life starts when the museum closes its doors. Then these great people come in and they have their bar mitzvahs or wedding parties. It's just like the aristocrats and their castles. They let people in for a couple of hours, but it's not why the place exists. They pay money supporting the museum not to serve the people but for their own pleasure—to have this great building, chandeliers, nice company, good food . . .

N: But how do you think people who aren't part of this system express their aesthetic judgment?
AM: They do all the time. Americans are very down-to-earth people, very concrete, and they know precisely what they like—the design of their apartment, the color of the sink—they think about art. And that's a very legitimate way to think about that. I am a modernist artist, and I think even polishing your car, cutting the hedges, is a totally legitimate modernist action. But how to get people to talk about this? In the poll we didn't start out asking about museums and art with a capital A. We asked about color, size—real questions. We start with a common object and go into objects as art. The car as an art object. People like the car not because of its real ability but because it has a particular form. Maybe they don't understand that a car is art, but they buy on their aesthetic urge. They need to buy beauty. And, you know, it's mesmerizing, the shininess. Just visit the showrooms and see this incredible beauty—incredible!

We live in a consumer society, so art and money go together. You cannot separate them. But on another hand, this relation with money is not absolute. Poor people, they spend much more money

for decoration purposes. People in ghettos, these young people, they spend an enormous amount of money for their dress. Percentwise, it's incredible; they care about the beauty of the thing, much more than people with a bigger income. It's not true that richer people have more concern about the beauty of art. At one point in making this poll somebody said he thought there was this hierarchy of importance, that for rich people art came right after food, and for everyone else came first food, shelter, etc. etc. But it doesn't go like that. You cannot say simply first shelter, because people living in shelters decorate their walls, their desks. And I don't have any pictures on the walls of my house.

—

THE EYE OF THE BEHOLDER

MAY 16, 1994

Carl Andre

New York City

So my favorite inspectors-general, Komar & Melamid, have paid a visit to the dead souls at The Nation Institute. In truth Americans are lavish buyers of art & poetry, spending hundreds of millions, if not billions, of dollars yearly. Can you not lure Clement Greenberg out of retirement to review this year's Mother's Day offerings of Gibson & Hallmark? People have the arts & governments they want & deserve. Just look around you.

CARL ANDRE

—

CLEMENT GREENBERG

MAY 30, 1994

Arthur C. Danto

IN ITS AUGUST 8, 1949, issue, *Life* presented to its vast readership images so at odds with what even those with some knowledge of advanced painting might ever have seen, that many must have sus-

pected a hoax of some sort—especially when the subtitle of the article asked regarding the artist Jackson Pollock, "Is he the greatest living painter in the United States?" He was, so the text declared, according to "a formidably highbrow New York critic."

The formidably highbrow New York critic was, of course, Clement Greenberg, who would have been familiar indeed to readers of *The Nation*, where he had been art critic since 1942. Greenberg, who died on May 7, had in fact been attacked in *Time* in 1947 for his exalted views of Pollock, as well as for the seemingly extravagant claim that David Smith was the only major sculptor in the United States. It was perhaps for his early recognition and advocacy of artists whose achievements were in time universally acknowledged, as well as for his almost single-handed defense of what he termed "American-style painting" at a time when it was almost categorical that the School of Paris defined aesthetic modernism, that gave Greenberg his unmatched credibility. But it was the clarity, care and urgency of his critical writing, pre-eminently the pages of this magazine, as well as his tireless efforts come to terms with the most advanced art of his time, finding bases for making critical judgments when there was very little by way of guidance in previous critical practice, that assures him a place in the tiny canon of great art-writers, the peer of Diderot and Baudelaire.

Greenberg's official view of art criticism, that it was almost entirely a matter of visual response without any infusion theory or knowledge, was the counterpart of the theories painterly expression invoked to explain that style of spontaneous gesture commanded by the masters of Abstract Expressionism. But in truth he evolved a very powerful philosophy of art history in which he sought to ground the formalist principles he would invoke to explain what the eye intuitively sensed. By the 1960s, Greenberg's theories of aesthetics and aesthetic explanation defined curatorial, journalistic and academic attitudes nearly to the point of orthodoxy. And what artists with agendas other than those stipulated by formality endeavored to penetrate an art world fortified by Greenbergian dogma, it was inevitable that he should have been villainized: Greenbergian formalism had become the enemy to be defeated.

Clement by name though not by nature, Greenberg was controversialist as well as controversial, and will be remembered for the quarrels, theoretical and ideological, that part of the history he helped make. In 1951, he severed his connection with *The Nation*, which he accused—in the letter magazine refused to publish—of betraying "its claim to a journal of independent and principled opinion." By early 1960s he more or less stopped writing criticism, and,

characteristic of his historical vision, came to believe that art had become decadent; that nothing, as he said in a lecture 1992, had really happened in the past thirty years. But his writings, recently collected in four volumes and just a year ago the subject of a two-day colloquium at the Pompidou Center in Paris, will remain a monument and a model of serious thought about art, history, culture, beauty and meaning, for all that their content was wrested from the fierce artistic and political dramas of his times. Ornery, sarcastic, dogmatic and outrageous as he seems to have enjoyed being, his writing and example remain as important as the art he helped the world understand and accept.

—

TV AND VIDEO

SEPTEMBER 11, 1995

Arthur C. Danto

A DEDICATED COLLECTOR of contemporary art told me, not long ago, that she had become enthralled by video now, perhaps to the exclusion of everything else. "The next time you visit, maybe none of this," she said, sweeping her arm demonstratively around to take in the large sculptures and paintings with which I identify her taste, "will be here." And then, leaning toward me confidingly, she added: "I am thinking of having nothing in my home but video." There is a flourishing branch in the visual arts that consists in the modification of tapes and discs, transduced into images on the television monitor through the mediation of the VCR; but the sweep of the collector's arm made it clear that she was not bent on acquiring a library of tapes and discs but a collection of objects on the order of sculptures and installations in which video images are focal. The television set itself can be regarded as a kind of sculpture in this sense—a three-dimensional cube with a flickering face—but in a great many examples of video sculpture the television set has largely disappeared, and the images, liberated from the cube, attach themselves to objects that convey meanings other than those associated with the familiar purveyor of home entertainment. So two models for her future collection came up on the monitor of my mind, though I imagine that both would find space in the collection she intended to form.

The first model was exemplified by an extravagant constellation

of television sets I once saw, an entire wall in effect, alongside a
swimming pool at the home of a no less dedicated collector in Hon-
olulu. It was a work by the avant-gardist Nam June Paik, who has,
more than anyone, made an artistic vocabulary of aggregated and
modified television sets, often arranged with reference to a kind of
sculptural syntax. The Honolulu work was composed of perhaps a
hundred such sets, in different sizes, sitting in a tangle of wires and
showing different moving images, some iterated and flickering,
sometimes in unison, much in the way in which we have all become
familiar with the bank of monitors in the television studio behind
Lynn Russell as she leafs through her notes for the next half-hour
segment of *CNN World News*. The curator who was showing me
through the collection obligingly switched the work on, and for a
time there was a dazzle of color and movement, too much to take
in and keep track of, but whose iconography was probably as com-
plicated as that of some heavily carved stupa at Amaravati, showing
Buddhist personages and events in the Buddha's life. I wondered if
there were not some distant affinity between such oriental profusion
and, since Paik is Korean by birth, the sensibility one sees in at least
his larger works like "Electronic Superhighway." It consists of tele-
vision sets massed to represent the continental United States, whose
form in neon tubing is superimposed across the whole work, which
is more than fifty feet long and proportionately high. Video images
that emblemized various states—California, Alabama, Texas—
played across that segment of the work corresponding geographi-
cally to those regions, and the work cleverly situated itself in New
York, since it showed, via closed circuit, those in Holly Solomon's
gallery viewing themselves viewing it.

In any case, Paik's work in some sense celebrates the physical fact
of the TV set. Well before video art was invented as a medium of
artistic expression (interestingly enough by Paik himself), Paik was
modifying television sets experimentally. His first exhibition, in 1963
at Wuppertal, showed thirteen sets, altered in the same spirit in
which John Cage altered pianos, but to make aberrant images rather
than deviant sounds. And Paik, who has degrees in aesthetics and
in musical composition, in fact also exhibited some "prepared" pi-
anos of his own. The altered television set and the prepared piano
perhaps belong to a different aesthetic altogether from that genre
of video art based on my second model. There, the emphasis is less
on the television set, considered as a mechanism and an article of
furniture highly charged with a set of social meanings, and more on

the image itself, which makes no reference to the physical circum- stances of its projection, and which, in some of the most powerful examples of the art form I know, seeks entirely to transcend the material conditions of television—wires, rasters, casings—in which an artist like Paik revels. So let us distinguish "TV art" from "Video art," to give names to the models I have in mind. TV connotes pri- marily a form of life—a room in the middle-class household, a fro- zen dinner—that the television set symbolizes and facilitates, so that in modifying "the tube" one is in a certain sense engaging in a gesture somewhere between social criticism and outright icono- clasm. It could be a comment on commercialization and mass cul- ture, condemnatory or celebratory, as in a work shown at the Venice Biennale this year by the Swiss artists Fischli and Weiss, regarding which a correspondent wrote, "The Swiss pavilion is filled with mon- itors presenting over eighty hours of mesmerizing images so inor- dinately ordinary as to be out of place." This leaves "video" to refer to images that owe their provenance to the same technology as tele- vision but that make no internal reference to their origins. Video images, when detached from television sets, belong to the world of dream images, which, though caused by brain circuitry, do not refer to it in any obvious way: We dream about sex, success, fear and flight but never, or rarely, about our brains. Video art, by contrast with TV art, is characteristically spiritual and poetic. TV art is often rau- cous, and fits artistically with performances of a certain sort—at one extreme, perhaps, with the artist smashing the glass tube with an ax, and at the other, with the late lamented Charlotte Moorman (Paik's great collaborator) playing a cello while wearing Paik's "TV Bra for Living Sculpture," a miniature monitor over each breast, showing images that may or may not have something to do with their pro- vocative siting.

My paradigm of video art is a piece I saw in the underground gallery of the American Center in Paris, by the American master Bill Viola, which had a profound impact on me. Admittedly, its unex- pectedness played a role in that: I was being taken for a tour through the building, from the top gallery down, and all at once was led into the underground space where I was hit with a burst of spiritual energy that would not have been out of place at the Sainte Chapelle, or one of the catacombs. The American Center was designed by Frank Gehry, and though it is somewhat untypical of his work, in- asmuch as it uses expensive and even luxurious materials when Gehry is identified with the most demotic of construction materi- als—cinder blocks and chain-link fencing—there is an affinity be-

tween Gehry's aesthetic and TV art, if only because in contemporary culture TV is what Hegel would designate as the demotic. Viola's work is universally human, but in no sense demotic.

The work is titled "Stations," and there would be a wild incongruity in imagining it in the same space with one of Nam June Paik's more typical pieces. It would be like seeing Sarah Bernhardt together with the Keystone Kops, she declaiming Racine while they fling custard pies at one another and fall down in heaps. Or like Ariadne on her island with commedia dell'arte buffoons in the last act of [Strauss' opera] *Aridne auf Naxos*, she singing her heart out while they make mocking obscene gestures. "Stations" consists of five projected panels, three on one wall, as I remember, and two on the opposite side. I estimate the panels to be about nine feet high. The images, which are of human bodies, are reflected in a highly polished black stone slab, like some form of grave marker, placed in front of each of the projected panels—and these slabs are nine feet long by five feet wide. The images can thus be seen twice—once projected and once reflected—and the combination of reflection and projection plays a certain role in Viola's work. They constitute distinct modes of insubstantiality: Like shadows or mental fantasies, in neither of their modes do the images have thickness. So in a way we are free to think of them as souls, if we roughly follow Wittgenstein in saying that the human body is the best image we have of the human soul. They are in black and white, which gives them a kind of ectoplasmic impalpability, but at the same time they are images of the human body, sexed and naked, and bearing the form and feeling of flesh. In my memory, one of the females was pregnant. The figures are upside down, submerged up to their necks in water and surrounded by bubbles. But we do not see their heads. We see only the bodies, with undulating limbs, and bellies, breasts and genitalia. And we hear the water burbling and gurgling as they move. Sometimes one of the panels grows dark. There is a time, between cycles, when they are all dark, which means that there is nothing but the walls and the slabs, so that the underground gallery has the form of a crypt. Then, all at once, there is a rush of noise, of the kind a body plunging into water makes, and one of the figures is vehemently back, its limbs waving like underwater fronds. Then, one by one, with a similar rush, the figure is joined by another and another, until the full array of five tread water around the spectator, and the noise of moving water, as if a fountain were listened to from beneath the surface, fills the space. And then one by one they leave, returning the space to the status of a crypt, and after an interval the cycle begins again. It is a very powerful experience.

* * *

Naturally, we all know that something is being done with computers and switches to create this art, but this is like the knowledge we have about the chemistry of paint when we look at a masterpiece. The interpretation of the work has no room for such knowledge, which forms no part of the intended experience of naked and inverted bodies, submerged in water, and headless, which relate through meaning to the polished slabs but not to the wiring and electrical energy that make the work physically possible: "Stations" addresses us not as nerds but as needers of the kind of spiritual assurance, at the margins of religious disclosure, that is conveyed through the swimming movements of the immersed figures. Naked, headless and inverted: This description could be satisfied by beings who had undergone dreadful martyrdoms—but these figures do not look as if they have been martyred. There is no visual inference that they have been decapitated, or humiliated by stripping, or hung upside down like Saint Peter or Benito Mussolini and his mistress after they were killed. Nor does the fact that they are shown upside down seem arbitrary, as in the signature paintings of Georg Baselitz (on view until September 17 at the Guggenheim Museum). Baselitz has sought to block the inevitable effort to vest upside-downness with symbolic meaning, by saying that *he* paints upside down in order to underscore the autonomy of painting, so that, to invert a famous theorem of Spinoza, the order and connection of marks on his surfaces need not be the order and connection of things in the world.

Viola is not, so far as I can tell, concerned with the autonomy of video. His interests are through and through symbolic, so that the upside-downness, nakedness and headlessness (unless taking away the head conduces to an ultimate nakedness) are to be grasped as metaphors. The viewer doubtless does grasp them that way without necessarily knowing what they are metaphors of. But water is a powerful symbol of rebirth, as the ritual of baptism demonstrates, and one is certain that in some way the figures are undergoing a transformation into a state of purification and renewal. So there is a quality of promise and hope, whatever one's actual beliefs on such matters, and it is difficult to imagine that anything like this could be achieved in another medium. My daughter and I walked in silence to the Bercy metro stop, our silence a sign that we had both been touched by something of great power and beauty—not quite what I had anticipated in entering the *sous-sol* of Frank Gehry's sly and allusive building.

It has since struck me that no other medium has gone from such inauspicious beginnings to this degree of artistic greatness in so

short a time: Video is about thirty years old; it began in 1965 when Sony first shipped portable video recorders to America and Nam June Paik rushed uptown to buy one with the same artistic urgency that, in the forties, brought downtown painters to Brentano's to get the first copies of *Cahiers d'Art* to arrive from Paris. There was a traffic jam that day, caused by Pope Paul VI, and Paik climbed out of his stalled cab to film the passing motorcade. The tape was shown that very night at Paik's exhibition at the Cafe à Go Go, "amid a flurry of proclamations," David Ross (now director of the Whitney Museum) wrote, "including the now-classic line: 'As collage technique replaced oil paint, the cathode ray tube will replace the canvas.'" I don't think even photography traversed such an extraordinary trajectory: "Stations" is monumental, with the scale and intensity of a great "Last Judgment." (It is perhaps impossible to imagine Paik as monumental, however high he stacks his sets.)

Viola is the United States representative this year at the Venice Biennale, where he installed five new works in the United States Pavilion. The choice was a recognition of his stature as an artist, and of video as a mature rather than a marginal medium. I have mixed feelings about not having been able to see Viola's work there. I am not certain that work that aspires to monumentality and, to use an eighteenth-century term rarely applicable to the art of our time, *sublimity* is seen at its best among displays of several pieces. My experience in Paris would, I am certain, have been seriously diluted had "Stations" been part of an exhibition in which it was just one of the works on view. In fact, I have come to have serious reservations about the exhibition as an appropriate format for experiencing art other than that which defines itself in terms of being seen along a gallery wall, work after work, like portraits or comfortably sized landscapes. For example, I suspect that the work of Bruce Nauman, distressing when aggregated noisily and invasively, as in the recent Museum of Modern Art exhibition, might have been found powerful and perhaps even convincing if taken in one installation at a time. I think the widely resented works that composed the Whitney Biennial of 1993 were just not meant to be experienced all together and at once, since each work was intent upon addressing the viewer along different and not necessarily compatible moral planes. And this is perhaps always true of work that demands a different relationship with us than as "viewer"—when it is meant to dislocate, or transform, or even convert those who come within the circle of its power.

* * *

One of Viola's major works is on exhibit, along with works by seven other video artists, in the show "Video Spaces: Eight Installations," at the Museum of Modern Art until September 12. I did make the trip to the Institute of Contemporary Art in Philadelphia, when "Slowly Turning Narrative" had its first venue, and in fact our paths crossed on two other occasions in which I experienced the work on its own terms rather than, as at MoMA, as an *example* of video installation (some of the other works in the MoMA show are decidedly not in its class). "Slowly Turning Narrative" is installed in a darkened space, in the center of which a large panel, one face mirrored and the other opaque and matte, rotates on a pole. The panel describes a circle nearly the width of the room, and one feels, especially when first entering, as if one has to squeeze in quickly, before it comes round next. Various images are projected on the panel, which reflects other images as well, including mirror images of the spectators lining the walls, and these belong to the content of the work. One face of the panel displays a large head, presumably of the artist himself, who witnesses and comments on the narrative, which comes and goes in resolving and dissolving images, e.g., scenes of children playing or of someone being operated upon. The commentary is a kind of incantatory, iterated identification of what one supposes is the subject of the narrative, namely each human being in his or her humanity: "The one who . . ." where the blank is filled with a verb, usually of one syllable: "The one who calls," "The one who stands," "The one who laughs," "The one who . . . ," all uttered without affect and as a kind of heartbeat, the diastole and systole of ordinary life. There are other sounds against this regular percussive rhythm— cascades of children's voices and the like, fading in and out—as the panel itself presents face and obverse, and the images reflected onto the walls dissolve into visual noise. Youth, age, sickness, health is the "slowly turning narrative" in which our images are taken up and covered over and rotated away. Nothing in the show aims quite so high or succeeds at so philosophical a level.

There is a great deal of philosophy *in* the work of Gary Hill, one of whose pieces is included in the MoMA show (a substantial exhibition of his work just closed at the Guggenheim Museum SoHo, but will open at the Kemper Museum in Kansas City in October), without this guaranteeing that the work itself attains a philosophical level. There is, for example, a videotape of a girl of about 10 years of age reading aloud from Wittgenstein's text on color. The girl stumbles over difficult words, but presses bravely on, covering forty-five minutes of reading time in forty-five minutes of real time (reel

= real). I was uncertain what the point of having the text read by a child was—I was reminded of Milton being read to by his daughters in languages they did not understand, like Greek and Hebrew. Readings, recitations, even displayed pages of Heidegger figure in other works, each of which has to be considered to see to what degree the language, being philosophical, contributes to overall meaning. Hill's work is situated somewhere between TV and video art, in the sense that one is often conscious of monitors as monitors, in various sizes and variously arranged, as well as of electrical wires being carefully regimented and treated almost ornamentally.

Let me describe Hill's piece at MoMA, "Inasmuch as It Is Always Already Taking Place." "Always already" is a phrase one finds in the writing of Jacques Derrida, used, I think, to deny that something has a beginning; one might say that human language did not have a beginning, that there was no moment when human beings did not "always already" have language, etc., etc. But let's consider the work, which in fact is really quite beautiful, in the way something quite precious and small, like a set of jeweled ornaments, is beautiful. It has the look of a brilliantly installed window at Tiffany's, in which sixteen monitors of various formats and sizes—some are as tiny as cuff links, some as large as a large photograph—are arrayed tastefully. The black wires, which look as if they make the monitors wearable, exactly like pieces of jewelry, are carefully arranged on the window's floor. On each of the monitors a different fragment of a man's body is shown, one of which consists in what is vulgarly known as "the family jewels" (the man is Hill himself, so the piece is a kind of disjointed self-portrait). The body is shown in some kind of minimal movement, from fairly reflexive ones like swallowing to the voluntary movement of a thumb turning the corner of a page. I can make out the words

> Seemed to me
> The future
> present
> k at he

The thumb moves the page, then moves the page, then moves the page. Future and present are one, and since it is clear that this is a loop, the thumb always already moved the page when it moves it. I eavesdropped on two women discussing the work, who told me they were trying to identify the body's parts. I offered to help. They had trouble with something that looked "like a breast." It did indeed look that way, but the shadowed knob moved in ways nipples don't.

I felt triumphant when I was able to tell them it was an Adam's apple. I studied the piece for a while after they left, but we met up in the Viola installation, where our images mingled and became submerged in the slowly turning narrative. Hill is a gifted artist, but his work vacillates between the sensibility of Radio Shack and that of the philosophy seminar, and it is never easy to decide which side he is really on, and hence what anything really means.

There is a lot for my collector to choose from in New York and Venice this season, and for my readers to experience here at hand. I want to close by singling out the work of an intriguing artist, Tony Oursler. His work at MoMA is not, I feel, fully baked, so I will describe the part I found so singular, and which can easily be imagined detached from the installation. It is a sort of rag doll on the face of which is projected an exceedingly expressive human face. This is the extreme liberation of the image, which is projected onto an external object with which it becomes integral. The face is baleful and suspicious: The eyes look from side to side, the lips are pursed. All at once the doll screams like someone being tortured, "O God, No, No, No . . ." and then resumes that extraordinary expression. The screams and the expression seem disconnected, as if the person they characterize were mad. Video makes the doll a great deal more alive than a ventriloquist's dummy; the doll's body makes it somehow less. There are two pieces by Oursler in a wonderful show given over to portraits, installed by Donna De Salvo at The Parrish Art Museum in Southampton, Long Island, which you will certainly want to visit if you drive out that way. There, faces projected on the dolls' heads are quite ordinary as human faces go but not as dolls' faces go. They are personages with dolls' bodies, and of course souls. One of them says such things as "I enjoy cooking." Or: "I fear doing something evil, to myself or to others." The dolls are in some unaccountable way uncanny, as dolls endowed with life always are, and I am uncertain my collector would want to live with one. But they seem to me to define the threshold of a new age of the video image.

—

OUTSIDER ART

MARCH 10, 1997

Arthur C. Danto

LIKE THE CONCEPT of the masterpiece and the idea of quality in art, the category of "genius" has been consigned to the *index prohibitorium* of politically discreditable notions, the primary use of which has been declared exclusionary. We would be hard pressed, if this were all there were to the matter, to account for the fact that the same triad of politically suspect terms has application to what, since 1972, has been designated "outsider art": The Watts Towers, by Simon Rodia, is a masterpiece by any criterion; the drawings of Bill Traylor have artistic quality that sets them apart from the art of other outsiders; and the reclusive Henry Darger was a genius of stammering achievement. This triad accordingly cuts across, and in that sense obliterates, the boundary between outside and in, which cannot therefore have quite the political function its critics claim. The distinctions it enshrines belong instead to the nature of artistic creation, and would remain in effect even if all the political inequalities believed to affect the art world were dissolved and access to its institutions opened up completely. My sense is that outsider art, for all that the term suggests a state of excludedness, does not correspond to a political boundary between enfranchised and disfranchised. The true outsider is someone deeply outside the institutional framework of the art world.

According to the *O.E.D.*, the earliest citation of "folk art" dates from 1921, and though one supposes the expression had currency before it appeared in print, the date must correspond to a general awakening by the American art world to the visual qualities of quilts, weather vanes and paintings in a rural vernacular, encountered by Modernist artists who left their own urban habitats for summers at the shore or in the mountains. The history of Modernism is the history of appropriations. There is an internal connection between the first acknowledgment of folk art as art in the 1860s and the first episode in the history of Modernism—Manet's effort to exhibit his *Déjeuner sur l'herbe* at the Salon of 1863. Manet began the deconstruction of the traditional representational system of Western art, which went hand in hand with the aesthetic accreditation of art from out-

side the academies and even outside the culture. Van Gogh modeled himself on the Japanese master Hokusai; Gauguin found inspiration in Egypt, China and the folk idiom of Brittany; Matisse and Derain found license in African sculpture to reinvent "planes and proportions" in their own work. Picasso borrowed forms from early Catalan decoration and, famously, from the African and Oceanic art he encountered in the Musée d'Ethnologie at the Trocadéro in Paris—and after discovering a portrait by *Le Douanier* Rousseau in a bin of used canvases, went on to collect the work of the most celebrated *naïf*. It would have been in that spirit that the summering artists at Ogunquit, Maine, in the 1920s, began to see in folk art something more than decorative touches lending local color to their painting shacks. It showed them a means to a less academic, more personal and emotional mode of representation. Klee did not simply admire, he actually pre-empted the art of children; and in 1945 Jean Dubuffet began forming a collection of what he termed *Art Brut*, much of it produced by institutionalized psychotics, which he presented to the city of Lausanne.

In view of this history, it is difficult to credit the proposition, advanced in an editorial in *The New Art Examiner* of September 1994, that "the community of artists and theorists engaged in the politics of identity—women, people of color, lesbians, gays, and others—have created a favorable atmosphere in which to consider the work of self-taught artists within the larger purview of art history." The thought is that these artists "share common characteristics of Otherness with their academically trained colleagues—ethnicity and gender, to name two." Dubuffet sought to distinguish makers of *Art Brut* from those sufficiently within the mainstream of art to aspire to official art-world recognition. The latter may indeed be Other in whatever way gender and ethnicity may make them. But the *deep* Otherness of the white male Henry Darger is of another order altogether. It belongs, one would surmise, to what Dubuffet had specifically in mind by *Art Brut*, "as springing from pure invention and in no way based, as cultural art constantly is, on chameleon or parrot-like processes."

It somewhat abuses the motivation of artists like Matisse and Derain, of Klee and of Dubuffet himself, to speak of them as emulative of the arts of primitives, of children, of "folk" or of the insane. The great Modernists really were engaged in the same deconstructive effort Manet began, to find a role for art other than in illusionistic representations of the natural appearances of the world. What it is that detonated this collective undertaking, which was nothing less

than a crisis of confidence in the values of Western civilization, is scarcely well understood, but I have often argued that anyone who believes that art is a frill, of interest only to an elite, might ponder the powerful political transformations in the world, which the transfer of objects from ethnological museums to museums of fine art—from things we may study to mark progress, to things we admire as beyond our powers—emblematized.

Still, Modernist art remains centrally an art of representation. Cubist and Fauve canvases hardly generate illusion, but they are recognizably pictures, and even abstract painting, when it was developed, was considered pictorial, of a non-objective reality. The Surrealists sought strategies for representing a super-reality we cognize through our dreams—and with which the psychotic may be more consistently in touch (which is why the Surrealists believed they had something to learn from their art). But Picasso, astute as always, insisted that the masks he saw at Trocadéro "weren't like other kinds of sculpture. Not at all. They were magical things. . . . intercessors . . . They were weapons. To help people stop being dominated by spirits, to become independent. Tools." And Picasso felt (he told André Malraux) that the "Demoiselles d'Avignon" was a "tool" in this sense as well—not in terms of forms appropriated but of function intended: "It was my first canvas of exorcism." The aesthetics of Modernism had little to do with such matters. In his great 1920 review of an exhibition of "Negro sculpture" at the Chelsea Book Club in London, Roger Fry praised these effigies at the expense of British sculpture in terms of what he called "expressive plastic form." And whatever he may have meant by this, it corresponded to what Matisse as well as the Ogunquit artists looked for: a language of expressive representation, rather than the kind of dark power Picasso sensed in African art.

There is a question, with the art of psychotic patients, whether it parallels what Picasso sensed in African sculpture as intercession—as dealing with spirits and forces to which they feel themselves privy. It is clear that the same question can be raised and is everywhere today, with regard to the art of women, of lesbians, of gays and of various ethnic minorities. An affirmative answer would require us to say that the art of the West has in that same sense been an art of white straight males. There have certainly been many who have not hesitated to draw these conclusions, though no one, I think, knows the truth in such matters, nor has anyone a clear idea of how to find out. It would, if true, give some basis to the community-of-Otherness thesis, whose supporters, not coincidentally, are not wild about terms like quality, masterpiece and genius. Dubuffet in any

case would have been skeptical: "There is no art of the insane any more than there is an art of dyspeptics or an art of people with knee complaints," he declared. But he would have *had* to say that, because, as a Modernist, he appropriated the outward look rather than the internal motivation—the "expressive plastic form" in the art psychotics produce—which puts him, after all, among the chameleons and parrots. His art was visual through and through. And the same spirit of appropriationism would make it possible for the despised white males to appropriate feminine or gay or ethnic art with the same alacrity with which Pat Boone appropriated "Tutti Frutti" from Little Richard.

The widening of the scope of art through Modernism, to include what would earlier have at best anthropological or psychiatric value, has on the other hand made it possible to appreciate, in visual terms, a good bit of what outsider artists produce—and by "outsider" I simply mean those who produce art without being part of a given art world at a given time. I recently visited a marvelous exhibition at Harlem's Schomburg Center for Research in Black Culture precisely labeled "Bearing Witness: African-American Vernacular Art of the South from the Collection of Ronald and June Shelp" (until March 29). I was struck by the works of Mary T. Smith, a former tenant farmer and cook, who began painting in 1978. Part of what struck me was how much her work looked like Dubuffet's. This is not to raise questions of influence on the artist but on us: Dubuffet opened our eyes to painting that might very well have been the same whether Dubuffet had existed or not, but which is acknowledged as art and even very good art in part because of transformations in vision that are due as much to Dubuffet as to anyone. I could not think of an outsider whose paintings looked especially like Ronald Lockett's 1989 "Homeless People," where three isolated figures are wetly painted black in an otherwise empty field of thick whitish paint. But had I seen a painting just like it by a graduate of the Rhode Island School of Design or Columbia University, I would have been unsurprised. Lockett could have influenced such an art-world artist; in fact, there was probably not a single work in the Schomburg show that could not have been painted by an art-world artist, with academic credentials, rather than by an artist defined as an outsider. There is nothing miraculous in this: It is not as though recent graduates of R.I.S.D. or Columbia paint like the brothers Van Eyck. It is that Modernism has made available all possible styles and modalities of art to trained artists, and that so far as the objects themselves go, with their "expressive plastic form," there would in general be no obvious way to tell whether the artist is a former short-order cook

who took up painting or someone who graduated with highest honors from Cal Art.

The Schomburg show was one of a garland of celebratory exhibitions held in conjunction with the Fifth Outsider Art Fair, held at the Puck Building in late January. The fair offered a sort of eye test for artistic quality, irrespective of provenance, and I was pleased to see a remarkably good piece by Mary T. Smith, in reds and greens, of two brushy figures. But in the bazaar of displayed works, two artists stood out, as one would have known they would simply from seeing a single one of their works. I saw an exhibition of Bill Taylor at the List arts center of M.I.T. a few years ago, and knew immediately that he was a marvelous and unique artist; and when I saw some panels by Henry Darger at an exhibition in Los Angeles called "Parallel Visions," I knew with the same immediacy that he was a great artist. Both these are what I have in mind by deeply outside artists, in that the art world does not enter into any explanation of their work. Or: Each was an art world unto himself.

Henry Darger's is an astonishing story. He lived a life of total obscurity, working at menial jobs in Chicago. When he had to be taken to a nursing home, his landlord discovered an immense body of writing in his solitary room, an epic of about 15,000 densely written pages called "The Story of the Vivian Girls, in What is known as the Realms of the Unreal, of the Glandeco-Angelinnean War Storm, Caused by the Child Slave Rebellion." There were several hundred illustrations, a good many of them done on scroll-length horizontal panels, made of newsprint sheets pasted together. These panels are populated by numbers of preadolescent girls, wearing party dresses and Mary Janes, which Darger traced from illustrations in clothing advertisements, comic strips ("Little Annie Roonie") and the early Oz stories, with their marvelous *art nouveaux* pictures of Dorothy or Ozma. Sometimes the little girls have horns, and, when shown naked, they typically have penises. Darger compiled a dictionary of bodily gestures, in order to achieve narrative meaning; and he collaged flowers, animals, even landscapes onto the same sheets. In a curious way, he seems driven by the same order of artistic vision as Joseph Cornell (who had a personality similar to his in many respects). Cornell also did not draw but used photostats and collage to achieve his effects. But Cornell's art has genuine art-world explanations: He came across one of Max Ernst's books of collaged snippings from old engravings, juxtaposed in a kind of dream-syntax; and his own early collages were shown in Surrealist exhibitions. Darger seems to have come from nowhere, and his vision, by contrast

with Cornell's, was narrative rather than lyrical. The Vivian Girls are constantly menaced by a sadistic militia, and the pictures can get quite violent. But the overall sense is one of peace and domestic security, in which the Girls indulge in innocent amusements in parks, or in airy or cozy interiors, and are protected by ornamental and benign dragon-like animals Darger named Blengins. There is a clarity and exactitude in the complex groupings, and an intoxicatingly improbable matching of style to content, as if Kate Greenway had illustrated the *Mahabharata*. Sixty-three of Darger's drawings, as well as a valuable videotape and some helpful background materials, are on view at the Museum of American Folk Art through April 27, and you "owe it to yourself" to see this wonderful show. It illustrates what Dubuffet had in mind by *Art Brut*, though there is nothing *brut* about it.

We are fortunate that Darger's landlord was a photographer who recognized Darger's genius and preserved his work; it could so easily have been tossed out like old newspapers. I am not certain that the recognition that has come and which will come is in any sense a fulfillment of Darger's ambition, mainly because I do not think he had any institutional goals in mind. I had a brief discussion with the critic Peter Schjeldahl at the Outsider Art Fair, in which he said, with characteristic intensity, that he had no idea *what* was behind Darger's work, even if he could see its immense merit. As with Roger Fry, we respond to the visual qualities Modernism has made us sensitive to, without knowing what it meant to the artist, knowing only that the usual art-historical explanations have no great bearing. That is what deep outsiderness implies.

That is implied for Bill Traylor as well, fifty or so of whose wry and antic drawings are on view at Hirschl & Adler Modern until March 8. Traylor, who was born in slavery, began drawing when he was in his mid-80s. Charles Shannon, a painter, discovered Traylor in the 1930s drawing in the street, and began to buy the work, more in the spirit of a friendship than of collecting. The drawings are simple, brilliant and funny. A goggle-eyed woman, her hat askew and her skirt aslant, is waving one hand while the other holds a bottle to her mouth. She is feeling no pain, as the expression goes, and is unmindful of a child (I read as) pulling at her apron string. Traylor captured this tipsy lady in a crisscross of pencil lines that expresses her condition and it typifies his graphic commentary on the passing scene in Montgomery, Alabama. Traylor's drawings have some of the sharp observation and spontaneity of figures on Greek vases, and in truth they could have been done anywhere humanity is to be found, if one had a pencil stub and some shirt cardboards

to draw on. Shannon (who died last year; Traylor died in 1949 at the age of 95) organized an exhibition during Traylor's life, which evidently was of no great interest to Traylor himself, exactly as Dubuffet would have predicted in the case of the true *Brut* artist.

Clearly, we need a better term than "outsider art." "Self-taught artist" will not serve, since there are too many good self-taught artists who by no stretch of the term's extension could be counted outsiders. If we were Germans we could frame a nice Heideggerian compound such as *Ausderkunstweltkunstleren*—"artists-not-of-the-art-world"—which I do not especially recommend for any forthcoming dictionary of art. Whatever the case, the proportion of masterpieces and genius, and the incidence of quality among outsiders is about what we would find within the art world. The causes, explanations and meanings, of course, differ from what the art world understands and teaches.

More than a century after Barnum's American Museum burned down, the gambling entrepreneur Steven Wynn built an art museum as part of a casino hotel in Las Vegas. Arthur Danto went to investigate.

—

DEGAS IN VEGAS

MARCH 1, 1999

Arthur C. Danto

FROM VARIOUS OF the Italianate terraces of the Bellagio hotel in Las Vegas, looking over an artificial lake, girdled by balustrades no less Italianate and meant to be emblematic of Como, one may see a half-scale simulacrum of the Eiffel Tower rapidly rising across the Strip. The tower is to be one element in a complex of simulative monuments and buildings, to be called "Paris" when it opens later this year. The Arc de Triomphe is already in place, as well as a fragment of a sixteenth-century chateau; another structure—still screened by its scaffolding—may turn out to be the Madeleine or even the Gare Saint-Lazare. Father north along the Strip, a similar complex, this time of Venetian landmarks, is under construction, with the Ca' d'Oro nearly completed and the tower of San Marco not far behind. To the south, "New York—New York" has been open to the public since 1997: The Chrysler Building is nearly adjacent to a stunted Empire State Building; Lady Liberty, with two New York Harbor

tugboats at her feet, looms over the Brooklyn Bridge; steam plumes up from manhole covers—but one encounters vast ranks of gambling devices upon entering a cavernous Grand Central Station. The sense is irrepressible that before long, Las Vegas will be an architectural theme park, in which every edifice known to popular visual culture—Chartres, the Golden Pavilion (Kinkakuji), the Stone Garden of Kyoto (Ryoanji), the Taj Mahal, the White House, the Houses of Parliament, the Golden Gate Bridge, the Colosseum—will have its simulacrum. That leaves the question of whether any of Las Vegas's own buildings would find a place in that landscape of monumentary knockoffs. Caesars Palace, perhaps, since it itself replicates no known structure of Imperial Rome but stands as a fantasy, inspired partly by the Vittorio Emanuele monument and partly by *Ben-Hur*. Or perhaps one of the rapidly disappearing "decorated shacks" that so stimulated the architects Robert Venturi and Denise Scott Brown when they wrote the classic of postmodernism *Learning From Las Vegas*.

It would be reasonable to suppose that were some entrepreneur to undertake an art museum in the Las Vegas spirit, it might be called The Museum of Museums, and feature simulacra of all the world's masterpieces—"Mona Lisa," "Portrait of the Artist's Mother" (Whistler's Mother), "The Night Watch," "The Creation of Adam," "Gold Marilyn," Piero's "Resurrection," Raphael's "The Transfiguration," the Bayeux Tapestry, "Les Demoiselles d'Avignon." Why chase across continents, from museum to museum, when everything one would have gone to see is here in one place, brush stroke by brush stroke, indistinguishable from the prototypes? What difference does it make, visually speaking? One only expects "Reality–Las Vegas" in Las Vegas—like the artificial volcano that rumbles and erupts every fifteen minutes each evening in front of the Mirage, the concrete Trojan Horse at FAO Schwarz or the golden Sphinx, with laser lights for eyes, beaming toward the fabricated pyramid in front of the Luxor Casino and Hotel—and everything is advertised as Magical, Enchanted, Fantastic, Fabulous or Incredible. One does not expect to encounter Reality as such, where things are what they are and not something else they merely look like.

In consequence, visitors are not entirely secure in viewing what it is not hype to describe as the world-class paintings hung in the Bellagio Gallery of Fine Art. Steve Wynn, whose conception the gallery is, asks, "Why, of all things to feature in a new resort hotel in Las Vegas (of all places!) would one select an enormously costly and potentially limited-appeal attraction such as a serious fine-art presentation of paintings and sculptures?" Why indeed, when the pos-

sibility of simulacra indiscernible from the originals exists in principle, and visitors only expect "Reality–Las Vegas" to begin with. When it first opened some months ago, an interviewer from a Las Vegas newspaper questioned me on whether I thought it entirely suitable that there should be an art gallery in a site given over mainly to gambling. Well, casinos vie with one another to attract patrons: Approaching the Bellagio, one passes a looming sign: "Now Appearing: van Gogh. Monet. Cézanne. Picasso," just the way other "now appearing" signs announce Cirque du Soleil or Andrew "Dice" Clay. So Wynn has gambled that a significant population would be as attracted by van Gogh, Monet, Cézanne and Picasso as by the magicians, stand-up comics, feminine extravaganzas and impersonators that form the city's standard repertoire of distractions and entertainments. For that population, of course, the art included must be as familiar a part of visual culture as the Eiffel Tower or the Chrysler Building. Those who have taken Art History 101 and traveled a bit are able to tell a Monet from a Cézanne, a Modigliani from a Matisse, a Picasso from a Pissarro, a Degas from anyone else—even if the paintings themselves have not attained the canonical status required by my imagined Museum of Museums. My interviewer asked if I thought the paintings were *real.* That, she said, was what "folks out here really want to know."

I thought it strange that people worry about the reality of the art when reality is required of little else in Las Vegas. "The popular question that seems to have overshadowed the lively speculation about the Bellagio Gallery itself," Wynn writes, "seems to be 'Why?' " I don't think the overwhelming question is "Why paintings?" so much as "Why real paintings?" when "Reality–Las Vegas" suffices for Paris and Venice. What business does real art have in Las Vegas when we can imagine the Museum of Museums on an ontological footing with "New York–New York"? It struck me that the anxiety the question of reality implies could almost only have been provoked by Las Vegas: In a lifetime of visiting museums and galleries, I have never once wondered if what I was about to see was real. So what is at stake in the Bellagio? And what does it tell us about viewing art? At the very least, real paintings constitute a critique of Las Vegas through the fact that they *are* real. To have installed a collection of real masters is already to have taken a step toward the transformation of Las Vegas from a theme park to something that addresses the "higher sensibilities" of people "who would not easily be fooled by advertising or hype." One outcome of such a transformation would be that the question of whether what one was looking at was real would be as taken for granted as it is everywhere else.

* * *

Wynn is impressed by the fact that "attendance at museums in the past few years has exceeded attendance at professional sporting events throughout the U.S.A." So presumably there are enough aesthetic pilgrims in the country (and elsewhere in the world—one hears dozens of different languages in Bellagio's lobby) to put Las Vegas on their map if there were a superlative collection of art to draw them there. But would enough of them come to Las Vegas ("of all places!") to justify assembling a collection that cost $300 million, let alone the expense of presenting and maintaining the art, and turning a profit besides? The question is not without substance. Las Vegas not long ago decided that "family values" pointed the way to profit. Thus the theme-park atmosphere, where factitious monuments can be thought of at once as fun and educational, and the inexpensive buffets—Las Vegas's contribution to dining—that make it possible to bring the kids along. It *is* fun, a kind of toyland full of crazy surprises, a Disneyland with slots. But the family-values crowd is not made up of big spenders or high rollers, and the profits have apparently not materialized. Besides, as Wynn observes, "All the old ideas of resort attractions have become, well, just old." Hence, the bold idea of a gallery of fine art as an attraction, and hence the possibility of changing the whole concept of Las Vegas. Suppose that "under the circumstances of today's very competitive world leisure market" other Las Vegas resorts add galleries of their own? Already the Rio has become a venue for "The Treasures of Russia"—real enough but objects of a kind compatible with the fantasized atmosphere of "Reality–Las Vegas," and hardly the classy drawing card the Bellagio Gallery aspires to be. The more such galleries the better one might think. But can we imagine Las Vegas as a true art center, even if every casino were to follow suit and build collection?

In a small way, the city already is an art center, consisting of at least a number of exhibiting artists, initially drawn to the graduate fine-arts program at the University of Nevada, Las Vegas, to work with the legendary art critic and theoretician Dave Hickey. There are no real art galleries to speak of in Las Vegas, other than the somewhat awful emporia one encounters when strolling along the various streets of shops attached to the casinos, which display in their windows objects it would be punishing to have to live with if one thirsted to be in the presence of what Wynn calls "singular creative energy." For various reasons, the artists have remained in Las Vegas, traveling to the coasts or to Europe, where their work is exhibited and sold.

In a "Top Ten" guest column in the January *Artforum,* Las Vegas artist Jeffrey Vallance begins by praising "the fabulous Bellagio casino": "Right on the Strip you can see Cézanne, Degas, Gauguin, Manet, Monet, van Gogh, Picasso, Pollock, Rauschenberg, and Warhol." (It is striking that Vallance mentions painters and not paintings—nothing in the gallery would be in candidacy for simulation in the Museum of Museums, for the same reason that few of us are likely to have waxen effigies of ourselves in Madame Tussaud's museum of world personalities, however exemplary we are as people. The important thing is that the art is by artists who have also produced masterpieces by Museum of Museums criteria.) I decided to devote an afternoon to local studio visits, guided by the Rev. Ethan Acres, an artist whose work is shown in Los Angeles and New York. The Reverend—a real Southern Baptist minister—aims, as an artist, to "put the fun back in fundamentalism," and once a week he walks the Strip to preach the gospel in the good old Southern way he learned in Alabama, which he regards as no less religious for being performance art. I was impressed with the quality and interest of everything he took me to see, but it is safe to say that none of it would claim a place in the Bellagio Gallery of Fine Art, not least of all because, as with contemporary art in general, it affords very little by way of a glimpse of beauty.

But there is an important connection between the Las Vegas art scene and the Bellagio Gallery. The latter's collection is made up of works, many of which it would be worthwhile to travel some distance to see—the Miró "Dialogue of Insects," for example, or Modigliani's marvelous portrait of his dealer, Paul Guillaume. There is Willem de Kooning's great *Police Gazette* and a luminous painting of a peasant woman by van Gogh. A Degas of a dancer accepting a bouquet has not been on public view for decades. And everything is deeply authenticated, to settle the question of reality certain to arise in the context. But surely the gallery is not primarily in place to attract specialists and connoisseurs, and one cannot help wondering, whatever the quality, whether by itself it could draw the numbers and kinds of visitors it is intended to do. Those with money enough to stay at the Bellagio have their choice of the world's centers of fine art to visit. So why visit Las Vegas? The answer is obvious. No one, except those professionally involved in the art world, visits distant places for the art alone. They may come for the art primarily, but they are interested in fine restaurants, in shopping, in entertainment. So in an important sense, plain old unreconstructed Las Vegas is in a synergetic relationship with the Gallery of Fine Art, giving

tourists the extra incentive to undertake the trip. What I had not figured in until I got there was a phenomenon of contemporary museum culture: the art tour. The mere existence of the Bellagio collection makes Las Vegas a destination for museum tours from Los Angeles, Santa Barbara and elsewhere—and the mere existence of Las Vegas itself gives the added incentive to subscribe to them. Everybody benefits, and there is even a fallout for the Las Vegas artists. Tour groups really are interested in art, and the curators who lead them will typically be interested in the kinds of contemporary expression produced there. So impromptu exhibitions are arranged and, as often as not, tourists return home with examples of Las Vegas art, as well as with whatever they may have found irresistible in such boutiques as Prada, Chanel, Armani, Gucci, Tiffany & Co. and the other *marchands de luxe* on "Via Bellagio."

In 1963 the world's youngest island erupted into being from the ocean floor in Iceland. It is used as a natural laboratory, enabling scientists to study and observe the stages by which life arrives on a stony tabula rasa of mere rocks. I felt that I was observing something like that in Las Vegas—the formation of an art world. Hickey accepted a job at the university, perhaps to liberate himself from the precariousness of running a gallery of contemporary art and writing freelance criticism. Artists who knew his writing came to work in the graduate program and stayed on, as much perhaps for what Las Vegas offered as for the support they gave one another, and for the kinds of day jobs available to them while making their name: Las Vegas employs as many sculptors as papal Rome. I met one who earns his living executing styrofoam and fiberglass statuary for "The Venetian" hotel. Reverend Acres told me that when he first arrived, at 4 in the morning, he encountered two Elvis impersonators walking along the Strip holding hands, and he knew immediately that Las Vegas was his kind of city. The January/February *Art issues* shows him on the cover, preaching in a white suit in front of the Bellagio, uniting the art scene and the gallery of notable paintings in a single vision that defines Art–Las Vegas. I imagine Wynn would be indifferent to the local art, though its unforeseen existence may ultimately contribute to his gallery's success. So one had better go slow in transforming Las Vegas—man does not live by higher sensibilities alone. I am still uncertain that art alone, even when part of a hotel that exemplifies "the world as it might be if everything were just right," would bring the required numbers of art lovers. The gallery needs Las Vegas–Las Vegas to make a go of it as a high-cultural

attraction. The question is whether the gallery's presence will transform the resort into something higher. Las Vegas is a convention city. Perhaps it should think of hosting an annual art fair!

Wynn himself is about as improbable a compound as Las Vegas with a serious art collection—a showman and a businessman, but also an aesthete, passionately responsive to art. (Warhol did a triple portrait of him in 1983, so he has not just jumped onto the bandwagon of art.) I was able to spend about two hours with him and his curator, Libby Lumpkin, talking about the paintings he has acquired and examining transparencies of works Wynn has his eye on. The gallery has lately added two old masters—a stunning painting by Rubens of Salome in a silken gown receiving the gory head of John the Baptist and a Rembrandt portrait of a mustachioed man in a frogged scarlet tunic. Wynn aims to have exemplary works from each century since the Renaissance. Only someone of the greatest energy and means would have been able to put together, in just three years, an art collection of such quality, given the way the market for Impressionism is. But he is a businessman to his toes, and I cannot for a moment imagine him doing that if he could not justify it on the bottom line. He might not have done it except for the money—but it was not for the money alone that he did it. The gallery is intended at once to be a benefit and to make money, oddly parallel to the way Reverend Acres's sermons are meant to be art and to save souls. The art world is hopeful but cynical, and nothing better testifies to Wynn's status as an outsider than the degree of his optimism and the absence of cynicism. Only someone combining a fierce business drive with an extreme passion for and belief in art would have supposed he could do well by doing good, bringing great art to what Vallance calls "the people."

This combination explains many of the incongruities and anomalies of the Bellagio hotel. A pair of marvelous de Koonings hang on either side of the registration desk, for example. An impressive collection of (real) Picassos—paintings and ceramics—enlivens the walls of Bellagio's flagship restaurant, Picasso. Contrary to the rumor, none of the gallery's works are displayed in gambling precincts, though I was told that before its spaces were ready to receive them, paintings were hung where the high rollers—who are known locally as "whales"—gamble in privacy at the Mirage. But the paintings were there because security is understandably tight, not as a way of enhancing the experience of playing poker or shooting dice. Where better to store paintings worth $20 million each? As if to make the distinction vivid between Bellagio's two functions, one can visit the

gallery without even having to pass through the gaming area, whereas in every other casino I visited, the urgent electronic chirping of the slots and the exhilarating crash of silver coins greet you the minute you walk through the door. Instead, you approach the gallery at the far end of the opulently planted conservatory, which varies its floral displays to mark the seasons' changes (there are, of course, no such changes in the surrounding desert). During my stay, the Christmas display gave way to a planting that celebrated the Chinese New Year. The paths to the gallery and to the gaming area are at right angles, as if one must decide which path to follow. The complex connection between money and art, meanwhile, is embodied in the curious fact that everything in the gallery is for sale— though, that this policy can endure for very long, given the inherent scarcity of, well, blue-chip art, is hard to imagine.

Before leaving Las Vegas, I wanted a photograph of the "Now Appearing" sign with van Gogh's name on it. A man rushed out of the shadows, heading toward the Strip, shouting over his shoulder, "He only sold one painting in his *whole life*!" I wondered if he were a painter himself, when it struck me that this *triste* truth of van Gogh's life is a moral legend for us all. However outwardly like frogs we are, there is within us a prince or princess whose golden men will one day be visible to all. That, I thought was why it was so important that the art be real. It would not be a redemption for van Gogh that a reproduction of one of his paintings, however exact, should hang in Las Vegas, where the only thing real other than art is money. In the game of life, any of us can become big winners. I conclude, brethren, with words by the Reverend Ethan Acres, describing an encounter between Steve Wynn and the Devil. The Devil says,

"Hey Steve, hey buddy old pal, c'mon, who's gonna come to this town, *my* town, to look at a bunch of girlie paintings? Listen, my man, what you need in Bellagio is a roller coaster, or better yet, just ditch the whole Italian crap and go with the Titanic as a theme." . . . Yes, the Devil offered him the easy road, but moved by God, Steven A. Wynn made his highway the hard way. . . . Flesh over paper, substance over style. Hallelluiah!

The "Sensation" show at the Brooklyn Museum was just that. The horrified mayor of New York City (later called "the most important art critic in America today" by Katha Pollitt) threatened to cut off funding for the museum and yards of editorial columns were written on the subject, few more trenchant than those reprinted here.

—

SHIT HAPPENS

OCTOBER 25, 1999

Alexander Cockburn

Camp would have moved on to the Happy Hunting Ground of the old art movement. A new art movement would be in. It would be called Shit. Its test would be: is this object, happening, work, event or production more resonant than it was yesterday? Movies about the Strategic Air Command with Jimmy Stewart, Hubert Humphrey speeches, old Lawrence Welk records, news photographs of Mayor Wagner, Senate testimony by Robert McNamara, interviews with J. Edgar Hoover—these would be the artifacts of the new art movement—Camp was out and Shit was in."
—Norman Mailer, "A Speech at Berkeley on Vietnam Day"
May 25, 1965

THERE HASN'T BEEN a good row about art since Washington went berserk over "The West as America" at the Smithsonian in 1991. That was a fight about history. The comment books were chock-full of spirited exchanges about art and its truthfulness about America's past. In other words, the uproar had content.

It's harder to find much content thus far in the hullabaloo over the "Sensation" show at the Brooklyn Museum of Art, beyond a glorious week of grandstanding by Mayor Rudy Giuliani. Politicians are always at their most comical worrying about art, while simultaneously asserting the primacy of private enterprise. "From what I've read, the exhibit besmirches religion," said George W. Bush, campaigning in the company of Governor Pataki. "It denigrates someone's religion. I don't think we ought to be using public monies to denigrate religion." Pataki wagged his head in agreement. "That's right. When

you use public money to denigrate someone's religion, I think it's wrong."

So the governors apparently agree that privately funded besmirchments—including an image of the Virgin Mary adorned with elephant dung and encircled by crotch shots—are fine. We've come a long way, perhaps not entirely in the right direction.

I saw "Sensation: Young British Artists from the Saatchi Collection" at the Royal Academy in London back in the fall of 1997 and didn't care for it at all. The Saatchi brothers, Charles and Maurice, headed an ad agency that figured largely in Margaret Thatcher's triumph in 1979. They later came a cropper when they tried to take over the Midland Bank. Charles Saatchi had profitably sold off a large collection of better-established artists and started buying up the work of young artists. In *High Art Lite*, an excellent new book from Verso (my own publisher), Julian Stallabrass quotes a sculptor, Richard Wentworth, describing the arrival of Saatchi at a student final degree examination at the Slade art college: "He'll just appear. This little figure in the background. He's gone shopping and he's first in line. . . . a proper collecting culture in this country [is] not there. There's Charles Saatchi, and there's no one else." Stallabrass adds dryly, "Naturally . . . the power is all on one side: Saatchi's usual practice is to buy very cheap and pay very late. Few are in any position to refuse his offers." Chris Ofili, painter of the dung-accoutered "Holy Virgin Mary," has written that "a lot of artists are producing what is known as Saatchi art. You know it's Saatchi art because it's one-off shockers.:..And these artists are getting cynical. Some of them with works already in his collection produce half-hearted crap knowing he'll take it off their hands. And he does."

At the time it planned the "Sensation" exhibit, the Royal Academy was £2 million in debt and desperate to create profitable controversy, intimating that some of the artists displayed might be put up for membership in the academy. The artists dutifully played their role, denouncing the academy as "fat, stuffy, pompous," in the words of Damien Hirst, who specializes in bisected animal carcasses.

The art piece most hotly debated there was Marcus Harvey's "Myra," named for Myra Hindley, convicted in 1966 along with her partner, Ian Brady, for the torture and killing of young children. The Brady-Hindley killings were so nightmarishly depraved that their memory still makes people shiver. Harvey based his painting on a famous photo of Hindley, and to make a pattern of dots to mime the photo as used in newspapers, he used the cast of a child's hand. After some apologias for Hindley (supposedly led astray by her guy), Harvey ventured the final foolishness, that "Myra" is the

"Love Goddess, who secretly, secretly, in our heart of hearts, we all want to shag." Delighted at the prospective uproar, the academy even invited relatives of Hindley's victims to attend the show.

The row there was not at all like the posturings of Giuliani over the use of public money. One artist, Peter Fisher, rubbed India ink into the painting, causing "Myra" considerable damage. Another artist, Jacques Rolé, rushed into Fortnum & Mason, bought half a dozen eggs and pelted the painting with them until he was brought down by an off-duty cop. The *Mirror* hailed the two artists as having "struck a blow for every right-thinking person in Britain." Paul Johnson denounced the culture elite as "perverted, brutal, horribly modish and clever-cunning, degenerate, exhibitionist, high-voiced and limp-wristed, seeking to shock and degrade." Which only goes to show how much Giuliani has to learn in terms of political rhetoric.

As Stallabrass remarks, the row over "Myra" was a real one, mostly about the relation of art to a peculiarly horrible reality. The Brooklyn now is a purely formal joust, no doubt helpful to Giuliani in raising funds from the right for his Senate bid, and perhaps to the museum. The latter might look at the commotion over commodity and history reported by Jeffrey St. Clair in our newsletter *Counter-Punch*. At the Energy Department Museum's gift shop at the Sandia labs in New Mexico, they're selling Fat Man earrings. A Japanese antinuke group has protested. The shop's director is impenitent, saying the earrings commemorate a turning point in history, since Fat Man, along with Little Boy, which killed at least 210,000 Japanese civilians, "ended the war and saved the lives of US soldiers." That's a real row too. The Brooklyn Museum should import the earrings to its shop, set them alongside the memorabilia from "Sensation" and see what happens.

CATHOLIC BASHING?

NOVEMBER 1, 1999

Katha Pollitt

MY FATHER DISAPPROVED of the "Sensation" show at the Brooklyn Museum of Art. He thought it was bad for the Jews. Who owned the art, including Chris Ofili's "Holy Virgin Mary"—the elephant dung—decorated representation of the Madonna surrounded with cutouts from porn magazines that thanks to Mayor Giuliani has become the

most famous religious painting since "The Last Supper"? Charles Saatchi. And who is in charge of the Brooklyn Museum? Arnold Lehman. Two Jews. "Anti-Semitism's just gone underground," my father warned, "but it's still there, and this will bring it out." I felt as if I had wandered into a Philip Roth novel—and my dad's a Protestant!

A prescient one at that. "Why are a Jewish collector and a Jewish museum director promoting anti-Catholic art?" asked Camille Paglia in a subhead since deleted from her *Salon* column, adding a Nixonian touch to her usual insinuating boorishness. Um, I don't know, Camille. Because they killed Christ? Because they think they're so smart? Because they want to make a fast buck? Like most pundits who've inveighed against "Catholic-bashing" art in the show—Peggy Steinfels on *The New York Times* Op-Ed page, Terry Golway in *The New York Observer*, Cokie Roberts ("it's yucky"), George Will, not to mention John Cardinal O'Connor, William Donohue of the Catholic League for Religious and Civil Rights and the Mayor himself—Paglia hasn't bothered to make the trip to Brooklyn, but she knows "Catholic bashing" when she reads a one-sentence description of a painting in a newspaper. Besides, she saw Lehman on TV and found him to be a "whiny slug."

Well, I saw the "Sensation" show and guess what? It's pretty interesting. True, thanks to the Mayor, my sensibilities were heightened by having to go through a metal detector, and the presence of a pair of chic Italian journalists interviewing each other in the museum's entranceway no doubt further piqued my sense of anticipation. Still, I've seen a fair amount of trendy contemporary art, and I was prepared to come away with gloomy thoughts about what Milan Kundera calls the Uglification of Everything. Hadn't a wonderful novelist friend said to me just the other day, I'm tired of defending bad art? But, then, my friend hadn't seen the show either.

"The Holy Virgin Mary" is a funny, jazzy, rather sweet painting, in which the Virgin Mary is depicted as a broad-featured black woman in a blue dress shaped like a leaf. The porn cutouts—mostly too small to distinguish—swarm around her like flies or butterflies, and one of her breasts is represented by that celebrated lump of pachyderm poo, decorated, as is much of the painting's surface, with beads of paint for a Byzantine mosaic effect. It's absurd to call it anti-Catholic—Chris Ofili, an Englishman of Nigerian extraction, is himself a practicing Catholic, and the Virgin Mary was not Catholic, and isn't even a uniquely Catholic symbol. To me, the painting suggests the cheerful mother goddess of an imaginary folk religion— an infinitely happier image of female strength and sexuality than

the pallid plaster virgins and Raphael copies on display at Saint Mary of the Intact Hymen. As for the elephant droppings, there are four Ofili paintings in the show and every one employs it. "Affro-dizzia," an *hommage* to black pop culture, features balls of dung emblazoned with the names of Miles Davis, James Brown and other figures, and no one has said Ofili meant to insult them. "Holy Virgin Mary" may not be a painting for the ages—elephant dung biodegrades pretty quickly—but it's fun to look at, even behind bulletproof glass.

Once again, the people of New York have proved their superiority to the pundits. While phony populist commentators label the show "elitist," people are flocking to see it. Teenagers, not usually caught dead in museums, are going. Black people—for whom an Africanized Madonna does not automatically signal blasphemy—are going. While Steinfels warns that provocative art risks rousing anti-First Amendment beasts and may end in major cuts in arts budgets—a point made also by William Safire, who hadn't seen the show—in fact, Giuliani's play for votes has backfired. A *Daily News* poll showed that only one in three New Yorkers supported him on this. There is no outraged vox populi in this story—there are only headline-seeking politicians and power brokers, and opinion mongers too lazy to get out of their chairs.

Is there awful, even repellent, art in the "Sensation" show? Yes, although there won't be much agreement about which works those are. I, for example, found Jake & Dinos Chapman's mutilated and deformed mannequins truly disturbing—but they haven't even been mentioned in news accounts. Too hard to reduce to a sound-bite, perhaps. Damien Hirst's shark in formaldehyde makes a better target. It's the sort of conceptual art that unimaginative people think they could have thought up themselves, the way they think their 4-year-old's finger paintings are as good as Jackson Pollock. If Hirst palls, one can always profess oneself grossed out by Marc Quinn's sculpture of his own head made from his own frozen blood. In fact, those works bear almost no relation to the mental picture conjured up by the sneers. The shark is eerily beautiful, lonely, fragile, strange; the sculpted head has the dignity of a Roman death mask.

Aesthetic and political conservatives have been complaining about modern art ever since there was any: It's not uplifting, or patriotic, or healthy; it's the work of fakers, perverts and commies; it's promoted and paid for by elitists (i.e., people who actually know something about art) and, as Paglia points out, by Jews. The history of this critique should give us pause—it's certainly led more often to bonfires than to artworks of lasting interest—and it's irritating that it evokes so much automatic sympathy in the *bien-pensant* media.

On the positive side, though, the strain of holding such patently ridiculous views seems to be driving Mayor Giuliani over the edge: In the October 13 *New York Times* he's quoted ranting against putting "human excrement" on walls because "civilization has been about trying to find the right place to put excrement." I guess the Mayor still hasn't been to see the show.

> *This book began with P.T. Barnum's collection of oddities (among them, skeletons and preserved animals floating in chemical solutions) and his promise to rebuild his American Museum and "do a good and great thing." It ends with Charles Saatchi, Steve Wynn, Rudolf Guiliani, and the bisected specimens of Damian Hirst. What to make of this strange symmetry is one of the social hieroglyphics of the intersection of art and American culture. But one senses that Barnum understood that few things on this earth could be as close to what he might call a "spectacular, wondrous, amazing, death-defying, stunt" as a work of art.*

—

DEATH IN THE GALLERY

NOVEMBER 20, 2000

Arthur C. Danto

Damien Hirst

DAMIEN HIRST IS 35 years old, and since 1988, when he organized and starred in the legendary exhibition of young British artists titled "Freeze," he has been what one London critic felicitously called the "hooligan genius" of British art. The hooligan genius belongs to artistic mythology, but we have not had an example of one in the visual arts since perhaps Jackson Pollock, and Hirst's hooliganism is evidently of the same ruffian order we associate with the English soccer fan—he even composed an anthem for that brawling brotherhood in which the only identifiable word is "Vindaloo." There is a photograph of him glowering in a meadow, wearing shorts, low boots, an open jacket; and we cannot but wonder about the fate of the cow standing behind him, considering that Hirst has been responsible for having some of her sisters sliced into sections, immersed in formaldehyde and distributed in no particular sequence in so many glass tanks. Such works, like the affecting lamb or the

bisected pig in last year's "Sensation" show at the Brooklyn Museum of Art, have touched off a debate in ethics as to whether it is a better fate for an animal to wind up as a work of art when its destiny would otherwise be the dinner table—or, in the case of the magnificent tiger shark that was also on view in "Sensation," as dog food.

Whatever the outcome of these disputes, Hirst uses death as a way of expressing thoughts about death. "His most celebrated work," according to a press release, "has never shied away from the terrible beauty that lies in death and the inevitable decay contained in beauty"; Hirst himself, on a web page, is quoted as saying, "I am aware of mental contradictions in everything, like: I am going to die and I want to live forever. I can't escape the fact and I can't let go of the desire." The title of one of his most controversial, and somehow most sublime, works—the tiger shark suspended in formaldehyde solution—is "The Physical Impossibility of Death in the Mind of Someone Living." "It is possible to avoid thinking of death," the novelist Leo Litwak recently wrote me, "but that would require me to stop thinking." The work is very frequently shocking, which is the hooligan side of his genius. Shock is a means, however, of advancing the Heideggerian reflections on death that have driven him from the beginning, very much in evidence in the exhibition of Hirst's work now on display at New York's Gagosian Gallery (555 West 24th Street).

Hirst did a photograph in 1991 called "Self Portrait With Dead Head," which perhaps only a hooligan would have thought of. It shows his vividly youthful face, grinning merrily at the viewer, while his head is placed, literal cheek by literal jowl, with what appears to be the decapitated head of what had been a much older man. Perhaps any such head would be frightening, but this looks as if its owner had been frightening while alive: It is like the convict's head in a particularly scary film version of *Great Expectations*. The photograph could scarcely be in worse taste: It violates our sense of the dignity owed the dead, whatever they may have deserved from us when alive, and it stirs some primordial, ill-understood sense of fittingness. Perhaps only the very young would be sufficiently without squeamishness to pose intimately with a cadaver. However, once one's disgust is overcome, as much with the artist as with his subject, one realizes that he has created an unforgettable image of life-and-death and an artistic path that takes us through the body of his work from that moment on.

The theme of death, at least as expressed through animals and animal parts, is muted in "Theories, Models, Methods, Approaches,

Assumptions, Results, and Findings," as Hirst has titled the Gagosian show. It is, however, obliquely implied in the title "Concentrating on a Self Portrait as a Pharmacist," this time a painting of—and I assume by—the artist. It is a fine, expressionist picture that shows the skeptics not only that yes, Hirst can paint, but that even in an earlier period of art, when painting was art's primary vehicle, he would have been a marvelous artist. It is, however, not on the wall. It is on an easel, from which a white coat hangs down. Painting of this sort being so old-fashioned a medium, one infers that this is an artist's smock. In fact, it is a laboratory coat, of the sort doctors and pharmacists wear. Easel, painting and lab coat are enclosed in a glass booth, itself set into a large vitrine. Outside the booth, hence un-reachable by the artist in the act of painting, is a taboret with brushes, rags and tubes of paint.

Pharmacognosy—to use the old-fashioned word—has obsessed Hirst for nearly as long as death has, and in the present political preoccupation with prescription drugs, the exhibition could hardly be more topical. In 1992 Hirst created an installation specifically titled "Pharmacy"—which, according to the label, contains "medi-cine cabinets, desk, apothecary bottles, fly zapper, foot stools, bowls, honey, glass. Overall dimensions 28'7" 22'7" (variable)." It is like a play drugstore for a privileged child. In "Sensation," there were sev-eral shallow vitrines arrayed like medicine cabinets, with vials and boxes aesthetically arrayed. These were used as decorative items in the instantly fashionable restaurant Pharmacy, which Hirst opened in London in 1997. The present show is like a museum of phar-maceutical displays. There is, for example, a wall cabinet containing "8,000 individually hand crafted model pills"—though I am insuffi-ciently drug literate to be able to identify any of them. The work is somewhat mysteriously—unless the pills modeled are stupifiants—called "The Void." There are in addition two quite large wall cabi-nets with arrays of surgical instruments, anatomical models, skele-tons, basins and the like. One of them is called, somewhat irreverently, "Stripteaser." Perhaps it refers to the skeleton condition in which we are stripped of our flesh by the various items of surgical cutlery (in another room, one finds a glass cabinet displaying several animal skeletons, titled "Something Solid Beneath the Surface of Several Things Wise and Wonderful"). There is an overall tone of nervous merriment, of giggling in the face of our mortality. I can imagine a hooligan joke about the stripteaser who peels the flesh off her bones and, now a skeleton, capers about the stage grinning at the patrons, oblivious of the fact that there are no erotic skele-tons. One of the works in the show consists of a skeleton on a cross

of glass panels, above whose skull a pair of eyes (painted Ping-Pong balls) bobbles in a spirited *danse macabre* on what I guess are airjets. It is called "Death Is Irrelevant."

The show brings together in a way both sides of Hirst's persona, concerned respectively with death and with healing. I got an understanding of one genre of his paintings, for example, that, superficially at least, doesn't seem to have much to do with the preserved carcasses of animals. These are arrays of dots, regularly arranged—like pills—in neat rows and columns. They are painted with glossy household enamel on canvas, and it feels as if Hirst uses the entire spectrum of colors made available by the manufacturer. There is, despite the orderliness of the matrix, no chromatic pattern that I could discern: It is as if the choice of colors were randomly determined, except that Hirst has said that no two hues in a given painting are identical. So there would be no way of projecting the pattern past the edges: There are no "repeats." The paintings have the all-over patterning of wallpaper (a similar thing used to be said of Mondrian). As art, they have the look of Minimalist paintings of a few decades ago, less austere than the dot paintings done by Robert Irwin but generated by comparable imperatives. A recently published dictionary of twentieth-century artists describes these works as "plumbing the repetitious possibilities of painting," as though they were merely formal exercises "produced in seemingly endless series by Hirst's assistants." I previously saw very little in these paintings, nor could I see any way of connecting them with the rest of his work, viewed as a collective meditation on death.

Recently, however, I began to pay attention to their titles. One of the paintings in "Sensation," for example, was called "Argininosuccinic Acid." A chemical involved in the synthesis of arginine, argininosuccinic acid is one of several amino acids used to form proteins, fundamental components of all living cells. Several paintings in the show are named after cobras—"Naja Naja," "Naja Naja Atra," "Naja Melanoleuca," "Naja Flava," "Naja Haje" and so on. "Naja Naja" is the asp, the venom of which is legendarily deadly. According to an ancient authority, the Egyptians employed a form of relatively humane execution by means of asp bites, and it must have been with "Naja Naja" that Cleopatra committed suicide. There are antivenins, made of venoms, however, and one wonders if Hirst has in mind the idea that certain toxins can generate their own cure. Digging around a bit, I encountered reference to the fact that he may actually believe that these paintings have specific pharmacological properties. I was unable to see any relationship between the (not well understood) chemistry of snake venom and the formal prop-

erties of the dot paintings—but in any case, the idea that painting is a form of pharmacology makes it a literal possibility that the artist can be a pharmacist. It is not necessary for viewers themselves to share this belief, but it strongly connects these otherwise incongruous paintings with the rest of the work. And it incidentally underscores the fact that formalism alone will not get you very far in art criticism.

The first thing one encounters upon entering the gallery is a colossal figure, twenty feet high and weighing six tons, in luridly painted bronze. It monumentalizes a toy, called Anatomy Man by its manufacturer and designed so that children can learn the shapes and placement in the body of the major organs. "I loved it that it was a toy," Hirst told an interviewer. "I wouldn't have done it with a teaching hospital one." The fact that the immense figure (titled "Hymn [= Him]") is an enlarged educational toy underscores the element of play that I felt was in the 1992 "Pharmacy" and in "Death Is Irrelevant." A work called "The History of Pain" is a high white box, with a number of knife blades sticking up, threatening a bleached beach ball, suspended above them. It is, I suppose, an allegory of mind and world, the former rising and falling on a jet of air in the spirit of a striptease, as the viewers wait for the ball to fall onto the knives to be shredded. Its message—the ball as consciousness, the world as knife blades—may be somewhat obvious, but I find it difficult to think of another artist concerned to deal with the concept. It is this readiness to take on the questions of the ages that causes my overall admiration of the Young British Artists, even if they cross the line in sometimes trivial, sometimes juvenile ways.

There is nothing obvious, trivial or juvenile about two of the works, titled respectively "Love Lost (Bright Fish)" and "Love Lost (Large River Fish)." As with "Concentrating on a Self Portrait as a Pharmacist"—like most of the works in the show—these are installed in very large vitrines or aquatic tanks. Each of the "Love Lost" tanks contains the furniture of a gynecologist's examining room, with stirruped tables and surgical instruments. In one there is a computer, in the other, more humanly, a clothes stand. The furniture in both is submerged, and fish swim freely, as in aquariums. The works are inevitably mysterious, as there is no clear narrative that connects the examination equipment with the water and the fish, nor is there any available allegory one can easily seize. Any interpretation that occurs to me seems instantly superficial, so I think it best to let the mystery stand. There is, however, one truth worth considering, which is that both works are extremely beautiful,

and while I do not know how to connect beauty with (what I suppose is) abortion, it seems to me that one possibility is that beauty heals, as the artist Robert Zakanich once said to me. There is something universally aesthetic in watching the movements of fish through water, like dancers through space. But in *Love Lost*, this beauty is somehow related to, well, lost love, embodied in the abortionist's setup, and the idea may be that the beauty heals the pain of loss, or that it can. It at any rate suggests a meditation on the pharmacology of beauty. What cannot avoid notice, however, is fish excrement drifting down, beginning to soil the immaculate equipment; and we know, unless steps are taken, that the water will grow murkier and murkier, and the fish will die, and beauty will vanish. Water is not formaldehyde. The beauty cannot be preserved. And the fragility of beauty is like the fragility of life.

The title of the show—"Theories, Models, Methods, Approaches, Assumptions, Results, and Findings"—is also the title of one of its works, which consists of two vitrines, each with noisy blowers and a small population of Ping-Pong balls. It seems a sullen, pointless work, and one cannot but wonder how it connects with the title, which could be a postmodern name for an anthology in the philosophy of science. The work is like one of those devices with which lotteries are decided, where each ball has a number. Here the balls are unmarked, rise and fall meaninglessly, without deciding anything. If I see it as suggestive of anything, it is by way of a pessimistic answer to the meaning of life. Luckily, the desire to go on living does not depend on getting deep answers to our question of why.

In an interview conducted in 1996, Hirst was asked to make Artist's Statement. His first answers were yob irreverences, not worth reprinting here. But then, abruptly, he tells the interviewer that he likes a piece by Bruce Naumann, of which he gives an exceptionally sensitive reading:

> It's a neon sign that's a spiral that goes into nothing in the center
> and you have to tilt your head when you read it and it says "The true
> artist helps the world by revealing mystic truths," and you go "Oh,
> yeah, great" and then you go "Oh god" and there's nothing there.

Naumann did this work in 1967, as a sort of window or wall sign. I had always taken the work as a piece of Naumannian irony, but it is clear that this is not Hirst's attitude. It never occurred to me that part of the meaning of the work is that it gives no answer to the question of which *are* the mythic truths. If one were to see it in a

show of Naumann's work, and look at the pieces it is surrounded by, one would have to say that Naumann is not a true artist by his own definition: His pieces are all more or less jokes, which makes this work a joke. I had not considered the spiraled words just ending in empty space to mean: There are no mythic truths, there is only nothing. As an artist's statement, "Oh god, there's nothing there" is pretty deep.

Whatever your cultural agenda, if you're in New York between now and mid-December, then, you owe it to yourself to pilgrim up, down or over to Chelsea, to look at the spectacular exhibition of Hirst's art in the scarcely less spectacular setting of the remodeled Gagosian Gallery. It is a little early in the twenty-first century to speak of high-water marks, but it's difficult to believe that Gagosian's space—23,000 square feet, the size of a small museum—will soon be superseded; and if a body of work comes along that in ambition and achievement puts Hirst in the shade, we are in for a remarkable era. I cannot imagine what it would be like to afford, let alone live with, one of Hirst's pieces, but someone has to be paying for works of this sort, each of which requires a substantial capital investment in hardware. And I am again overwhelmed by the generosity of the gallery system, which opens its doors to the general public free of charge. Free admission to the other high arts are rare and uncharacteristic. The walls at Gagosian have even been decorated with a tasteful green graph-paper motif, to imply the atmosphere of a natural history museum that Hirst's pieces seem to create. The show really feels, however, like a toyland, a Halloween extravaganza with something for everyone. Take the kids.

IN MEMORY OF SAUL WINEMAN.

INDEX

About the Editor

Peter G. Meyer, a longtime observer of the art world, is the founder and director of The Public Works Project, a nonprofit organization that seeks to revive the American poster tradition by providing graphics to social change groups. For many years, he was executive director of The Nation Institute, where he produced numerous public events and collaborated with artists Komar and Melamid on the People's Choice art poll.